DEAR THEO

by Irving Stone

BIOGRAPHICAL NOVELS

LUST FOR LIFE (Vincent Van Gogh)

IMMORTAL WIFE (Jessie Benton Fremont)

ADVERSARY IN THE HOUSE (Eugene V. Debs)

THE PASSIONATE JOURNEY (John Noble)

THE PRESIDENT'S LADY (Rachel Jackson)

LOVE IS ETERNAL (Mary Todd Lincoln)

THE AGONY AND THE ECSTASY (Michelangelo)

THOSE WHO LOVE (Abigail and John Adams)

BIOGRAPHIES

SAILOR ON HORSEBACK (Jack London)

THEY ALSO RAN (Defeated Presidential Candidates)

CLARENCE DARROW FOR THE DEFENSE

EARL WARREN

HISTORY

MEN TO MATCH MY MOUNTAINS

NOVELS

PAGEANT OF YOUTH

FALSE WITNESS

BELLES-LETTRES

WE SPEAK FOR OURSELVES (A Self-Portrait of America)

THE STORY OF MICHELANGELO'S PIETÀ

WITH JEAN STONE

I, MICHELANGELO, SCULPTOR
(Autobiography through letters)

COLLECTED

THE IRVING STONE READER

Dear Theo

THE AUTOBIOGRAPHY OF
VINCENT VAN GOGH

EDITED BY IRVING STONE
AND JEAN STONE

CASSELL · LONDON

CASSELL & COMPANY LTD
35 Red Lion Square, London WC1R 4SG
Sydney, Auckland
Toronto, Johannesburg

First published 1937
This edition first published 1973

I.S.B.N. 0 304 29293 1

Printed in Great Britain by
The Camelot Press Ltd, London and Southampton
F. 673

FOR

THEO AND JOHANNA VAN GOGH

TO WHOM

VINCENT VAN GOGH

WOULD HAVE WANTED THIS BOOK DEDICATED

. .
.

"All your kindnesses to me, they seemed to me greater than ever today. I assure you that that kindness has been good metal, and if you do not see any results from it, my dear, don't fret about that; your own goodness abides."

"The figure of a labourer — some furrows in a ploughed field — a bit of sand, sea and sky — are serious subjects, so difficult, but at the same time so beautiful, that it is indeed worth while to devote one's life to the task of expressing the poetry hidden in them."

— VINCENT

PREFACE
TO THE 1973 EDITION

VINCENT VAN GOGH was one of the world's loneliest souls. For the greater part of his days he lived by himself, without friends or companions. There was rarely anyone to whom he could confide, to whom he could relate his joys and sufferings, with whom he might share his ambitions and dreams. In the last ten years of his life, from the age of twenty-seven to thirty-seven, during which time he slaved at and conquered the art of painting, he was filled to bursting with all the beautiful scenes he saw in nature, the profound humanity he read in the face of a peasant; he longed with intense eagerness for a fellow being to talk to, to tell everything he thought and felt about his turbulent life and slowly maturing craft. Yet seldom could he find anyone who was interested in him as a friend, who could understand what he was trying to say or do.

That is why the *Autobiography* came into being.

There was one man on earth who understood Vincent, who encouraged him in his work, provided him with the supplies and the money necessary to continue his painting, who had an inexhaustible fund of the love which, above all things, Vincent so desperately needed: his brother Theo.

Each night, when the fourteen to sixteen hours of drawing and painting were over, Vincent sat down with pen and ink and poured out his heart to Theo. There was no idea or thought too small, no happening too trivial, no element of his craft too insignificant, no scene too unimportant for Vincent to communicate to the only other living person who considered his every word and feeling precious.

Thus Vincent wrote the story of his own life.

Theo died only six months after his brother. His young wife, Johanna, came into possession of most of Vincent's drawings and paintings, and a desk drawer full of letters; for Theo could never bring himself to part with any line that Vincent had ever drawn or written.

Despite the fact that Johanna van Gogh had to keep a boarding-house to support herself and her infant son, she spent years of her life fighting for a place for Vincent's painting, and arranging, editing, and translating Vincent's writings to Theo. It was indeed a labour of love.

After Johanna van Gogh's death in 1927, Vincent's manuscripts became the property of V. W. van Gogh, Johanna's and Theo's son. V. W. van Gogh has given the blessing of the van Gogh family to this project which I began while studying Vincent's letters for material for *Lust for Life*. It has been my purpose to keep in every line Vincent wrote that has retained its beauty, significance, and importance, and to eliminate the countless pages of repetition, unimportant detail and comment which have since lost both meaning and value.

My aim has been to edit the 1670 pages of material down to a swiftly flowing, continuous, normal-sized book which everyone can read and enjoy, to be published at a price which every book-lover can afford, thus for the first time bringing Vincent's written work to the general public.

It is my humble opinion that Vincent was as great a writer and philosopher as he was a painter, that he was endowed with one of the most comprehensive gifts of understanding and expression that it has ever been the burden of one man to carry. I sincerely feel that Vincent's writings will bring as much beauty, vision, and emotional richness into the lives of his readers as his paintings have brought to the hundreds of thousands who have stood transfixed in front of his glowing canvases and seen unfold before their very eyes a new, more beautiful, and more meaningful world.

Preface

No line has ever given me more pleasure to write than this one in which I have the good fortune to be able to express my gratitude to my wife, Jean Stone, for her collaboration on this work.

<div align="right">IRVING STONE</div>

January 6, 1937
March 16, 1973

BOOK I
June 1873–December 1881

LONDON, *June*, 1873

DEAR THEO:

OH, LAD, I should like to have you here to show you my new lodgings. I now have a room such as I always longed for, without a slanting ceiling and without blue paper with a green border. I live with a very amusing family; they keep a school for little boys.

I am quite contented; I walk much, the neighbourhood where I live is quiet, pleasant, and fresh, and I was really very lucky in finding it.

I am not so busy here as I was in The Hague, as I work only from nine until six, and on Saturdays we close at four o'clock. One Saturday I went boating on the Thames with two Englishmen. That was very beautiful.

Although the house is not so interesting as the house in The Hague, it is perhaps well that I am here; and especially later on when the sale of pictures shall grow more important, I shall perhaps be of some use. Lately we have had many pictures and drawings, and we sold a great many, but it is not enough yet; it must become something more enduring and solid. I think there is still much work to do in England, and of course the first thing necessary is to have good pictures, and that will be very difficult.

I am doing very well, and it is a great pleasure for me to study London and the English way of living and the English people themselves; and then I have nature and art and poetry, and if that is not enough, what is enough?

At first English art did not seem very attractive to me; one must get used to it. But there are clever painters here, among others Millais, who has painted the 'Huguenot.' His things are

beautiful. Then there is Boughton, and among the old painters, Constable, a landscape painter who lived about thirty years ago: he is splendid, his work reminds me of Diaz and Daubigny; and there are Reynolds and Gainsborough, who have especially painted very beautiful ladies' portraits; and then Turner.

I see that you have a great love for art; that is a good thing, lad. I am glad you like Millet, Jacque, Scheyer, Frans Hals, for as Mauve says, 'That's the stuff.' Yes, that picture by Millet, 'The Angelus,' that's the thing, that is beauty, that is poetry. Admire as much as you can; most people do not admire enough.

I have read a book on art by Van Vloten and did not quite agree with him, and it was very learned. Burger is more simple, and whatever he says is true.

Last Sunday I went to the country with Mr. Obach, my principal, to Boxhill; that is a high hill about six hours by road from London, partly of chalk and overgrown with box, and at one side a wood of high oak trees. Everywhere you see charming parks with high trees and shrubs. Still I do not forget Holland and especially The Hague, and Brabant. What pleasant days we spent together at The Hague! I think so often of that walk on the Ryswyk road, where we drank milk after the rain, at the mill. I will send you a portrait of that mill by Weissenbruch; the merry Weiss, is his surname — that road of Ryswyk holds memories for me which are perhaps the most beautiful I have.

I am glad you like César de Cock so much; he is one of the few painters who understand our dear Brabant intimately. I met him last year in Paris.

You must try by all means to get a good knowledge of pictures. Go to the museum as often as you can; it is a good thing to know the old painters also, and if you have a chance, read about art and especially the art magazine, 'Gazette des Beaux-Arts.'

Try to walk as much as you can, and keep your love for nature, for that is the true way to learn to understand art more and more. Painters understand nature and love her and teach us to see her. If one really loves nature, one can find beauty everywhere.

I am very busy gardening and have sown a little garden full of

poppies, sweet peas, and mignonette. Now we must wait to see
what comes of it. Of late I took up drawing again, but stopped.
Perhaps I shall take it up again some day or other. I am reading
a great deal now. I am glad you have read Michelet and that you
understand him so well. Such a book teaches us that there is more
in love than people generally suppose.

'L'Amour' has been a revelation to me as well as a Gospel. 'No
woman is old.' That does not mean that there are no old women,
but that a woman is not old as long as she loves and is loved.
That a woman is quite a different being from a man, and a being
that we do not yet know, at least only quite superficially — yes, I
am sure of it. And that man and wife can be one, that is to say,
one whole, and not two halves — yes, I believe that too.

From the money I gave you, you must buy Alphonse Karr's
'Journey Round My Garden.' Be sure to do that. Autumn is
coming fast, and that makes nature more serious and more inti-
mate still.

Our gallery is ready now and is very beautiful; we have some
splendid pictures: Jules Dupré, Michel, Daubigny, Maris, Israëls.
In April we shall have an exhibition. You know the 'Margaret
at the Fountain,' by Ary Scheffer? Is there a purer being than
that girl, 'that loved so much'!

Don't regret that your life is too easy; mine is rather easy too.
I think that life is pretty long, and that the time will arrive soon
enough in which another 'shall gird thee and lead thee where
thou wouldst not.'

In a little book containing poetry I sent you, I copied 'Meere-
stille' by Heine. Some time ago I saw a picture by Thys Maris
that reminded me of it: an old Dutch town with rows of brownish
red houses with stepped gables and high stoops, grey roofs, and
white or yellow doors, window frames, and cornices; canals with
ships and a large white drawbridge under which a barge passes
with a man at the rudder. And there is life everywhere. A porter
with his wheelbarrow, a man who is leaning against the railing
of the bridge and looking into the water, a woman in black with a
white bonnet.

I send you a little drawing. I made it last Sunday, the morning when the little daughter of my landlady died. It is a view on Streatham Common, a large grassy plain with oak trees and gorse. As you see, it is sketched on the title-page of the 'Poems,' by Edmond Roche. There are some very fine ones among them, grave and sad. I copy them for you.

Ay, lad, 'What shall we say?' C. M. Van Gogh and Mr. Tersteeg have been here and left again last Saturday. In my opinion they have been too often to the Crystal Palace and other places with which they had nothing to do. I think they might just as well have come to see the place where I am living. I hope and trust that I am not what many people think me to be just now; we shall see, some time must pass.

RAMSGATE, *April*, 1876

THE leave-taking from home on Good Friday I shall never forget. In the morning we went to church at the Hoeve, and received Communion, and Father's text was, 'Arise, let us go hence.' And in the afternoon we did arise and from the carriage window I saw Father and the little brother standing on the road looking after the train. The last thing I saw of Holland was a little grey church spire.

Next morning in the train from Harwich to London it was beautiful to see at dawn the black fields and green meadows with sheep and lambs, here and there a thorn bush and a few large oak trees with dark twigs and grey moss-grown trunks. The glimmering blue sky with still a few stars, and a bank of grey clouds at the horizon. Before sunrise even I heard the lark.

Arrived in London, the train started for Ramsgate two hours later. That is still about four and a half hours by train. It is a beautiful road; at the foot the hills are covered with scanty grass and at the top with oak woods. That reminded me of our dunes. We also passed Canterbury, a city with many medieval buildings, especially a beautiful cathedral, surrounded by old elm trees. I had often seen pictures representing it.

You can imagine that I was looking out of the window for Ramsgate a long time before we got there.

At one o'clock I arrived at Mr. Stokes's. The house stands on a square (all the houses around it are the same) that is often the case here. In the middle of the square is a large lawn, shut off by iron railings and surrounded by lilac bushes, in the recreation hour the boys play there. The house where I lodge is in the same square.

There are twenty-four boys from ten to fourteen years. So the school is not large. The dining-room window looks out on the sea. After dinner we took a walk. The houses on the shore are generally built in simple Gothic style of yellow stone, and have gardens full of cedars and other dark evergreens. There is a harbour full of ships, shut in between stone dykes, where one can walk.

Yesterday everything was grey. In the evening we went with the boys to church. At eight o'clock the boys go to bed and they rise at six. A curious place is the room with the rotten floor where are six washing-basins in which they have to wash themselves; and where a dim light flows through the window with its broken panes on the washing-stand, this is a rather melancholy sight. There is another assistant teacher of seventeen years. He, four boys, and myself sleep in a house near-by, where I have a little room that is waiting for some prints on the wall.

We often go to the beach. This morning I helped the boys to make a fortress of sand, as we did in the garden of Zundert. I teach them elementary French; one boy has started German, and then other things — sums, for instance. I hear their lessons and give dictation. So for the present it is not difficult; of course after school hours I have to keep an eye on them, and on Saturday night I helped six of the young gentlemen take a bath. I also try to make them read; I have some books that are well suited for the boys, as 'The Wide, Wide World.'

These are really very happy days I spend here, but still it is a happiness and quiet which I do not quite trust. Man is not easily content: now he finds things too easy and then again he is not contented enough.

And now today is your birthday. My best wishes for this day, may our mutual love increase with the years. I am so glad that we have so many things in common, not only memories of childhood, but also that you are working in the same house in which I was till now, and know so many people and places which I know also, and that you have so much love for nature and art.

Did I tell you about the storm I saw lately? The sea was yellowish, especially near the shore; at the horizon a streak of light, and above it the immense dark grey clouds from which the rain poured down in slanting streaks. In the distance the town that suggested one of the towns that Albrecht Dürer used to etch; a town with its turrets, mills, slate roofs, and houses built in Gothic style.

That same night I looked from the window of my room on the

roofs of the houses that can be seen from there, and on the tops of the elm trees, dark against the night sky. Over those roofs, one single star, but a beautiful, large friendly one. None of us will ever forget that view.

I have made a little drawing of the view from the window of the school, through which the boys wave good-bye to their parents after a visit. It is rather melancholy. They have so little else except their meals to look forward to and to help them pass their days.

Mr. Stokes says that he decidedly cannot give me any salary because he can get teachers enough for just board and lodging, and that is true. But will it be possible for me to continue in this way?

I am afraid not. It will be decided soon enough.

The time may come when I shall look back with a certain melancholy on the 'fleshpots of Egypt' connected with other situations; that is to say, the bigger salaries and the higher esteem from the world ... this I foresee.

But, boy, however this may be, one thing I can assure you, that these few months have bound me strongly to the sphere that extends from schoolmaster to clergyman, as much by the pleasures connected with those professions as by the thorns that have pricked me. It is very doubtful whether I shall make great progress in either of these professions; whether the six years spent in the house of Messrs. Goupil and Company, during which time I ought to have prepared myself for this situation, will not remain a great obstacle to me.

There is such a longing for religion among the people in the large cities. Many a labourer in a factory or shop has had a pious childhood. But city life sometimes takes away the 'early dew of morning.' Still the longing for the 'old, old story' remains; whatever is in the bottom of the heart, stays there. I am so fond of that 'Tell me the old, old story.' I heard it for the first time in Paris one night in a little church where I often went.

George Eliot describes in one of her novels the life of factory workers who formed a small community and held their services in

a chapel in Lantern Yard. There is something touching in seeing these thousands of people crowding to hear these evangelists.

I think it must be a peculiar profession to be a London missionary; one must go around among the labourers and the poor to preach the Bible, and if one has some experience, talk with them, find foreigners who are looking for work or other persons who are in difficulties and try to help them. I went two or three times to find if there was a chance of becoming one of them, as I speak several languages and have mixed, especially in Paris and London, with people of the lower class and foreigners; being a foreigner myself, it might be that I am fit for it and might become so more and more. However, one must be at least twenty-four years old, so at all events I have to wait another year.

Last Monday I started from Ramsgate to London; it is a long walk and when I left, it was very hot and it stayed so until the evening when I arrived in Canterbury. That same evening I went still a little farther, till I arrived at a few large beech and elm trees near a little pond where I rested for a while. At half-past three in the morning the birds began to sing at sight of dawn and I started again. It was fine to walk then.

In the afternoon I arrived at Chatham, where one sees in the distance between partly flooded low meadows, with elm trees here and there, the Thames full of ships; I believe it is always grey weather there. At Chatham a cart took me a few miles farther, but then the driver went into an inn, so I continued my way and arrived towards evening in the familiar suburbs of London and walked to the city along the long, long roads.

I stayed two days in London and have been running from one part to another to see different persons, among others a clergyman to whom I wrote:

A clergyman's son who, as he has to work for his living, has no time or money to study at King's College, and besides that is a few years older than one usually enters there, would, notwithstanding this, be happy to find a position, related to the Church.

My father is a clergyman in a village in Holland. I went to school when I was eleven and stayed there till I was sixteen. Then I had to choose a profession, but did not know what to choose. Through the intervention of one of my uncles, partner in the firm of Goupil and Company, Art Dealers and Publishers of Engravings, I got a situation in his business at The Hague. For three years I was employed there. From there I went to London to learn English and after two years I left London for Paris.

Compelled by various circumstances, I have left the house of Goupil and Company, and for two months I have been a teacher at the school of Mr. Stokes at Ramsgate. But as my aim is a situation in connection with the Church, I must look for something else; though I have not been educated for the Church, perhaps my travels, my experiences in different countries, of mixing with various people, poor and rich, religious and irreligious, of work of different kinds, days of manual labour and days of office work; perhaps also the speaking of different languages may partly make up for the fact that I have not studied at college. — But the reason which I would rather give for introducing myself to you is my innate love for the Church and everything connected with it, that has slumbered now and then, but is roused again each time; and also, if I may say it, though with a feeling of great insufficiency and shortcoming: 'the love of God and man.'

Last week I was at Hampton Court to see the beautiful gardens and also the palace and the pictures. There are among others many portraits by Holbein which are very beautiful.

It was a pleasure to see pictures again.

I WRITE between lessons. In school the gas is flickering and one hears the cheerful sound of the boys learning their lessons; from time to time one of them begins to hum the tune of some hymn, and in me there is something of the 'old faith.'

Last Saturday week, I made another long trip to London. In the morning I left here at four o'clock; it was beautiful in the park with the dark avenues of elm trees and the wet road through it, and a grey rainy sky over it all; in the distance there was a thunderstorm.

In London I visited some friends and was also at the gallery of Messrs. Goupil and Company, and saw there the drawings that Van Iterson had brought with him, and it was delightful to see once more the Dutch towns and meadows in that way. That picture by Artz, the 'Mill on the Canal,' I think very fine.

I wished you could have seen those London streets when the twilight began to fall and the lamps were lit, and everybody went home; everything showed that it was Saturday night, and in all that bustle there was peace; one felt the need of and the excitement at the approaching Sunday. Oh, those Sundays, and all that is done and accomplished on those Sundays, it is such a comfort for those poor districts and crowded streets.

I heard there about a position that perhaps might do for me sometime. The clergymen at seaports such as Liverpool and Hull often want assistants who can speak several languages, to work among the sailors and foreigners and also to visit the sick; some salary would be attached to such a position.

It was delightful to take a long walk once more. Here at school they walk very little. When I think of my life full of struggle in Paris last year, and compare it with this, where I sometimes do not get out of doors the whole day, I sometimes think, when shall I get back to that other world? If I go back to it, it will be probably in other work than last year. But I think I prefer teaching Bible history to the boys to walking; one feels more or less safe in doing so. No day passes without praying to God and without

speaking about God. At present my speaking about Him isn't much, but with God's help and blessing, it will become better.

You asked me if I still teach the boys; generally I do until one o'clock in the afternoon, and then after one o'clock I go out for Mr. Jones, or sometimes give lessons to Mr. Jones's children or to a few boys in town. And then in the evening and between times I write in my sermon book.

Mr. Jones has promised me that I shall not have to teach so much in the future, but that I may work more in his parish, visiting the people, talking with them.

Tomorrow I shall get for a second time some small salary for my new work, and with it buy a pair of new boots and a new hat. I cannot tell you how glad I am that Mr. Jones has promised to give me work in his parish, so that I shall find by and by what I want.

It will soon be winter now. I am so glad that Christmas comes in winter. May God give us a happy meeting then. I should like so much to see my mother again and to see Father and to speak with him. How little we see of each other and how little we see of our parents, and yet so strong is the family feeling and our love for each other that the heart uplifts itself and the eye turns to God and prays: 'Do not let me stray too far from them, not too far, O Lord.'

Theo, your brother preached for the first time, last Sunday, in God's dwelling, of which is written, 'In this place, I will give peace.'

It was a clear autumn day and a beautiful walk from here to Richmond, along the Thames, in which the great chestnut trees with their load of yellow leaves and the clear blue sky were mirrored, and through the tops of the trees one could see that part of Richmond which lies on the hill.

When I was standing in the pulpit, I felt as if, emerging from a dark cave under ground, I had come back to the friendly daylight, and it is a delightful thought that in the future wherever I shall be, I shall preach the Gospel; to do that well, one must have the Gospel in one's heart; may the Lord give it to me.

It seems to me I have grown years older in these few months.

The 'Imitation of Christ' is a splendid book that gives much light. It expresses so well how good it is to fight the Holy Strife for duty, and the great joy given by being charitable and by doing one's duty well.

It is true that every day has its own evil, and its good too. But how difficult must life be, especially farther on when the evil of each day increases as far as worldly things go, if it is not strengthened and comforted by faith. And in Christ all worldly things may become better, and, as it were, sanctified.

Theo, woe is me if I do not preach the Gospel; if I did not aim at that and possess faith and hope in Christ, it would be bad for me indeed, but now I have some courage.

Last Sunday I was early at Turnham Green to teach in Sunday school; it was a real English rainy day. On weekdays I have to work up interest for the Sunday school; there are children enough, but the difficulty is to get them together regularly. Mr. Jones and his boys and I went in the afternoon to take tea with the sexton.

Tomorrow I must be in the two remotest parts of London, in Whitechapel, that very poor part about which you have read in Dickens; and then across the Thames in a little steamer to Lewisham.

Last Thursday Mr. Jones made me take his turn. I went to Acton Green, that grass plot which I saw from the sexton's window. It was very muddy there, but it was a beautiful sight when it grew dark and the fog began to rise and one saw the light of a little church in the middle of the plain.

One Sunday I had to go in the evening to Petersham, to a Methodist church. I told the congregation that they would hear bad English, but that when I spoke I thought of the man in the parable who said, 'Have patience with me and I will pay you everything.'

While I sit writing to you in my little room, and it is so quiet, and I look at your portraits and the prints on the wall: 'Christus Consolator,' and 'Good Friday,' and 'Women Visiting the Tomb,'

and 'The Old Huguenot'; 'The Prodigal Son,' by Ary Scheffer, and 'A Little Boat on a Stormy Sea'; and — and when I think of you all and of everything here, of Turnham Green, Richmond and Petersham, then I feel: 'O Lord, make me my father's brother. Finish Thy work in me that Thou hast begun.'

Shall we go together to some church some day, being sorrowful but always happy, with an eternal joy in our hearts because we are the poor in the Kingdom of God?

A few days ago Mr. Braat from Dordt came to visit Uncle Vincent, and they talked about me, and Uncle asked Mr. Braat if he had a place for me in his business, if I should want it. Mr. Braat thought so, and said that I must come and talk it over. So I went there early yesterday morning. We arranged that I should come for a week after New Year to try it out, and after that we can see. There are many things that make it desirable, the being back in Holland near Father and Mother, and also near you and all the others. Then the salary would certainly be better than at Mr. Jones's, and it is one's duty to think of that, because later in life a man needs more.

How often we have longed to be together, and how dreadful is the feeling of being far from each other in times of illness or care, and then the feeling that want of the necessary money might be an obstacle to coming together in time of need.

As to the religious work, I still do not give it up. Father is so broad-minded and so many-sided, and I hope in whatever circumstances I may be, something of that will unfold in me. The change will be that, instead of teaching boys, I shall work in a bookshop.

So it is quite possible that I shall go there.

I AM getting along pretty well at the store and am very busy. I go there at eight o'clock in the morning, and leave at one o'clock at night, but I am glad it is so. Work is always a good thing.

Sometimes I am so delighted that we **are** living again on the same soil and speaking the same language.

The window of my room looks out on a garden with pine trees and poplars, and the backs of old houses covered with ivy. 'A strange old plant is the ivy green,' says Dickens. The view from my window can be so solemn and more or less gloomy, but you ought to see it with the morning sun on it; how different it is then.

Last Sunday I was in the French church here; it is very solemn and impressive and has great charm. After church I took a walk on a dyke along the mills; there was a splendid sky over the meadows, mirrored in the wet ditches. In other countries there are curious things. On the French coast at Dieppe the rocks are covered with green grass, and the sea and the sky, the harbour with the old boats is like a painting by Daubigny, with brown nets and sails. And then the London streets in the rain with the lanterns, and the night spent there on the steps of a little old grey church, as happened to me this summer after the excursion to Ramsgate. There are in other countries also curious things ... but as I walked last Sunday alone on that dyke, I thought how good it was to feel the Dutch soil under my feet, and I felt, 'Now it is in mine heart to make a covenant with the Lord God,' for I recalled all our childhood memories, how often we walked, in those last days of February, with Father to Rysbergen, and heard the lark over the black fields with young green corn, the radiant blue sky with the white clouds in it — and then the stony path with the beech trees — O Jerusalem, Jerusalem! or rather, O Zundert! O Zundert!

I have been very busy today with a great many little nothings, but they belong to my duty; if one had no sense of duty, who would be able to collect his thoughts at all? The feeling of duty

sanctifies everything and binds things together, making one large duty out of the many little ones.

Last night I left the store at one o'clock and walked around the cathedral and then along the canals and past that old gate of the new church and then home. It had been snowing and everything was so quiet; there was only a little light here and there in the upper windows of some of the houses, and the black figure of the night watchman standing out against the snow. It was high tide and against the snow the canals and the ships looked very dark.

To think of Jesus in all places and circumstances, that is a good thing. How difficult is the life of the peasants in Brabant; from whence do they get their strength? And those poor women, what supports them in life? Don't you think it is what the painter painted in his 'Light of the World'?

You do not know how I yearn towards the Bible. I read it daily, but I should like to know it by heart, to study thoroughly and lovingly all those old stories, and especially to find out what is known about Christ.

There may be a time in life when one is tired of everything and feels as if all one does is wrong, and there may be some truth in it — do you think this is a feeling one must try to forget and to banish, or is it 'the longing for God,' which one must not fear, but cherish to see if it may bring us some good? Is it 'the longing for God' which leads us to make a choice which we never regret?

Let us keep courage and try to be patient and gentle. And not mind being eccentric, and make distinction between good and evil.

In the morning I went with Uncle Cor to Uncle Stricker's, and there had a long conversation. I wrote a letter home to tell them what we did in Amsterdam, and the things we talked over. Today I had a letter from Father. Last Sunday he was not well. I know his heart is burning within him that something may happen to enable me to follow him in his profession; Father always expected it from me. Oh, that it may happen, and God's blessing rest upon it.

In our family, which is a Christian family in the full sense of the word, there has always been, as far as one can remember, from

generation to generation, one who preached the Gospel. Why should not a member of that family feel himself called to that service now? It is my fervent prayer and desire that the spirit of my father and grandfather may rest upon me, and that it may be given me to become a Christian and a Christian labourer, that my life may resemble more and more the lives of those named above, for behold the old wine is good and I do not desire a new one.

Theo, boy, brother whom I love, I have such a fervent longing for it, but how can I reach it?

Oh! might I be shown the way to devote my life more than is possible at present to the service of God, and the Gospel. I keep praying for it and I think I shall be heard; I say it in all humility.

Theo, if only I might succeed in this, if that heavy depression because everything I undertake fails, that torrent of reproaches which I have heard and felt, if it might be taken from me, and if only there might be given to me both the opportunity and the strength needed to come to full development and to persevere in that course for which my father and I should thank the Lord so fervently!

I send you today for your collection another woodcut after Doré, and one after Brion. Keep up your collection and you will get a fine one in time. Accept my small contribution to it. I long so much to keep in touch with you through these little things.

Your letter gave me a feeling of joy, as the woman must have felt who found her mite, for you tell me that the little writing-desk of Aunt Koos has been found by Mrs. Roos, at the spring cleaning. I am so glad. When I shall have started in Amsterdam, I shall want it. It seems to me a new proof and a hint — I have already observed many of them lately — that everything will go all right with me, that I shall succeed in the thing I so fondly desire; something of the old faith grows in me that my thoughts will be confirmed, and my spirit will be renewed. It will be a choice for my whole life!

Mr. Braat has somebody in view for my place, so in May I shall probably be able to put a hand to the plough.

I suppose that for a 'sower of God's word,' as I hope to be, as well as for a sower of the seed in the fields, each day will bring enough of its own evil — and the earth will produce many thorns and thistles — let us continue to help each other, and ask for brotherly love. Much good may be in store for us in the future, let us learn to repeat with Father, 'I never despair,' and with Uncle Jan, 'The devil is never so black but you can look him in the face.'

Time flies and the days pass quickly; we may become richer and firmer of mind, of character, of heart, we may become richer in God, we may become richer in the fine gold of life, the love for each other, and the feeling, 'and yet I am not alone, as the Father is with me.'

Between times I have worked through the whole story of Christ from a catechism book of Uncle Stricker's and copied the texts; they reminded me of so many pictures by Rembrandt and others.

I hope and believe I shall not repent of the choice I made to try and become a Christian and a Christian worker. Yes, all things from the past may contribute to it. The knowledge of and the love for the work and life of men like Jules Breton, Millet, Jacque, Rembrandt, Bosboom, and so many others, may become a source of new thoughts. What a resemblance there is between the work and life of Father and that of those men! I value that of Father still higher.

AMSTERDAM, *May*, 1877

NOT a day without a line'; by writing, reading, working, and practising daily, perseverance will lead me to a good end.

I have a lot of work to do, but still I have the firm hope to succeed. But it will take time; it is what everybody says, and not only Corot: 'It took only forty years of hard work and of thought and attention.' For the work of men such as Father and Uncle Stricker, a great deal of study is needed, just as for painting.

But sometimes a man says to himself: How shall I ever arrive! At night I am tired and I cannot get up as early as I wish. My head is sometimes heavy and often it burns and my thoughts are confused — to get used to and persevere in simple regular study after all those emotional years is not always easy.

When I think of the past — when I think of the future of almost invincible difficulties, of much and difficult work, which I do not like, which I, or rather my evil self, would like to shirk; when I think the eyes of so many are fixed on me — who will know where the fault is if I do not succeed, who will not make me trivial reproaches? But as they are well tried and trained in everything that is right and virtuous, they will say, as it were by the expression of their faces: We have helped you and have been a light unto you; have you tried honestly? What is now our reward and the fruit of our labour? See! When I think of all this, of sorrow, of disappointment, of the fear of failure, of disgrace — then I have the longing — I wish I were far away from everything!

And yet I go on, but prudently and hoping to have the strength of resisting those things, so that I shall know what to answer to those reproaches that threaten me, and believing that notwithstanding everything that seems against me, I yet shall reach the aim I am striving for, and if God wills it shall find favour in the eyes of some I love and in the eyes of those that will come after me.

There is written: 'Lift up the hands which hang down, and the feeble knees,' and when the disciples had worked all night and had not caught any fish, they were told: 'Go out into the deep and cast your nets again into the sea.'

If we are tired, isn't it then because we have already walked a long way, and if it is true that man has his battle to fight on earth, is not then the feeling of weariness and the burning of the head a sign that we have been struggling? If I had only given all my strength to it before, yes, I should have been farther now.

This morning I saw in church a little old woman, probably the one who provides the footstoves, who reminded me so much of that etching by Rembrandt, a woman who has been reading the Bible and has fallen asleep with her head in her hand. Ch. Blanc writes so beautifully and with so much feeling about it, and I think Michelet also in his '*il n'y a point de vieille femme*' (Women are never old). The poem by de Genestet, 'The end of her path in life is lonely,' also reminds me of it.

Do you think we too shall be at the evening of our life before we know it? If we feel the days are flying past us faster and faster, it sometimes does me good to believe so, and to remember that 'Man proposes and God disposes.'

A Jewish bookseller who procures me the Latin and Greek books I want has a large number of prints which I can choose from very cheaply. I have taken some for my little room to give it the right atmosphere, for that is necessary to get new thoughts and new ideas.

Yesterday at Stricker's they asked me to tell about London and Paris and when I do so, I see it all again before me; I love so many things over there, and oh! it was so wherever I have lived; how I feel it when I walk through the streets of The Hague, or for instance in Zundert. All that past time can be of help in my work at present. When I occupy a small place in that large Dutch Protestant Church those recollections will furnish many a topic for sermons.

I walked along the Buitenkant and the sand banks near the railroad. I cannot describe to you how beautiful it was there in the twilight. Rembrandt, Michel, and others have sometimes painted it, the ground dark, the sky still lit by the glow of the setting sun, the row of houses and steeples against it, lights in the windows everywhere, and the whole mirrored in the water. And the people and the carriages like little black figures.

Already I have begun to study the Bible, but only at night when the day's work is done, or early in the morning — after all that is the principal thing, though it is my duty to devote myself to the other study and I am doing so. Only if I could, I should like to skip a few years, my boy.

When we are working at a difficult task and strive after a good thing, we are fighting a righteous battle, the direct reward of which is that we are kept from much evil. As we advance in life it becomes more and more difficult, but in fighting the difficulties the inmost strength of the heart is developed. Indeed, life is a battle; we have to defend and protect ourselves, and with a cheerful and brave spirit we must plan and calculate in order to make progress.

Know one thing — we both must try and live through the time between now and the age of thirty years, and beware of sin. We are put in the rank and file of life; well, we must fight a good battle and we must become men, that we are not yet, either of us — there is something greater in the future, my conscience tells me so; we are not what other people are.

When I was standing beside the corpse of Aerssen, the calmness and dignity and solemn silence of death contrasted with the activities of living people to such an extent that we all felt the truth of what his daughter said in her simplicity: 'He is freed from the burden of life, which we have to carry on still.' And yet we are so much attached to the old life, because with our despondent moods we have our happy moments, when heart and soul rejoice as does the lark that cannot help but sing in the morning, even though the soul sometimes sinks within us and is full of fears. And the memories of all we have loved remain and come back to us in the evening of our life. They are not dead but they sleep, and it is well to gather treasure of them.

This morning at a quarter to five there was a terrible thunderstorm here. I have been looking out over the whole yard and dock; the poplars and elderberry and other bushes were bowed down by the heavy storm, and the rain poured down on the piles of wood and on the decks of the ships. But very soon the sun broke through

the clouds, the ground and the beams in the yard were drenched, in the pools the sky was reflected quite golden from the rising sun, and very shortly after I saw the first gang of workmen come through the gates of the yard. It is a curious sight, that long line of black figures, large and small, first in the narrow street, where the sun just peeps in, and afterwards in the yard. There are about three thousand of them; the sound of their footsteps is like the roaring of the sea.

On Dicker's Island there are also many shipyards. When I go there I look at them attentively: he who must learn to work must watch the workers, especially if he has a little study just among the workshops. How many subjects for pictures the artists could find here on the wharf!

When I am writing I instinctively make a little drawing, now and then. This morning, Elijah in the desert, with the stormy sky, and in the foreground a few thorn bushes; it is nothing special, but I see it all so vividly before me, and I think that at such moments I could speak with enthusiasm.

I am very busy making a summary of the history of the Reformation; the history of those days is quite stimulating and attractive. I think if one reads attentively a few books such as those of Motley, of Dickens, of Gruson, and on the Crusades, one gets involuntarily a good and simple view of history in general.

Mendes has given me hope that at the end of three months we shall have accomplished what he had planned we should, if everything went well; but Greek lessons in the heart of Amsterdam, in the heart of the Jewish quarter, on a very close and sultry summer afternoon, with the feeling that many examinations await you, arranged by very learned and cunning professors — I can tell you they make one feel more oppressed than Brabant cornfields, that are beautiful on such a day.

From home I heard that you had a bill from Doctor Coster to the amount of forty guilders; that is a big sum. If only I could help you a little, but you know that I possess neither gold nor silver. By all kinds of devices I must often try to get money for the collections in church — for instance, by changing stamps for pen-

nies in a tobacco shop — but, my boy, by struggling we can keep up.

I have such a craving for thousands of things, and if I had money I should perhaps soon spend it on books, and other things, which I can very well do without, and which would divert my attention from the strictly necessary studies. Even now, it is not always easy to fight against distractions, and if I had money it would be worse still.

And there may come a time in which we can spend our money better than on the best books — when we shall perhaps have a household of our own, and others to care for and to think about.

Mendes told me last week about a very interesting part of the city, namely, the outskirts that extend from the Leidsche Poort, near the Vondel Park, to the Dutch railroad station. It is full of mills and sawmills, workmen's cottages with little gardens, also old houses, everything; it is very populous, and the quarter is cut through by many small canals and waterways full of boats and all kinds of picturesque bridges. It must be a splendid thing to be a clergyman in such a quarter.

How I should love to show you several things here in the Jewish quarter and in other places! I often think of de Groux; there are interiors with wood-choppers, carpenters, grocers' shops, forges, druggists, which would have delighted him.

Uncle Jan intends to go to Helvoirt for a week, on the first of September. I hope to profit by it by staying up later in the sitting-room to write. Now I can sit in my bedroom, but there the temptation is too strong to go to rest when it gets late, and in my little study there is no gas.

I am copying the whole of the 'Imitation of Jesus Christ' from a French edition which I borrowed from Uncle Cor. It means much work, but I know no better way to study it. That book is sublime, and he who wrote it must have been a man after God's own heart; a few days ago I got an irresistible longing for it, perhaps because I look so often at that lithograph after Ruyperez.

This week Mendes is out of town. So having some leisure I could

carry out an old plan to go and see the etchings by Rembrandt in the Trippenhuis. How would a man like Father, who so often goes long distances even in the night with a lantern, to visit a sick or dying man, to speak with him about one whose word is a light even in the night of suffering and agony — how would he feel about the etchings by Rembrandt; for instance, 'The Flight to Egypt in the Night'?

I finally found the house in the Breestraat where Rembrandt lived.

I do not know why, but the whole week I have been thinking of that picture and the etching after it, 'A Young Citizen of the Year V,' by Jules Goupil. It was hanging in my room in London. It has been a remarkable feature in art and will continue to have a great influence on many people.

The many pictures about the days of the French Revolution, 'The Girondins,' and 'Last Victims of the Terror,' and 'Marie Antoinette' by Delaroche, what a beautiful unity they form, together with books such as those of Michelet, Carlyle, and also Dickens's 'Tale of Two Cities.' In all of them there is something of the Spirit of the Resurrection and the Life — that lives though it seems dead, for it is not dead but it sleepeth.

I should like to read a great deal, but I may not, though in fact I need not long for it so much, for all things are found in the word of Christ. I cling to the Church for aid, and to the bookshops; whenever possible I invent some errand to go there.

Well, the dark days before Christmas are already in sight, and back of them lies Christmas, like the kindly light of the houses back of the rocks and the water that beats against them on a dark night.

I keep my work together, all in order to help me to pass the examinations; I consult Mendes in everything and arrange my studies according to what he has done, for I should like to do it in the same way. The study of Latin and Greek is very difficult, but still it makes me feel happy, and I am doing what I longed to do. I may not sit up so late in the evening any more, Uncle has strictly forbidden it, still I keep in mind what is written under the etching

by Rembrandt, 'In the middle of the night the light diffuses its radiance,' and I keep a small gaslight burning low all night. I often lie looking at it, planning my work for the next day.

I went to Uncle Stricker and had a long talk with him and Aunt, for Mendes had been to see them a few days ago. (One must not talk too lightly about genius, even though one believes there is more of it in the world than many suppose, but a very remarkable person Mendes certainly is, and I shall always be grateful for being in contact with him.) I am glad to say he did not make an unfavourable report about me, but Uncle asked me if I did not find the work very difficult, and I had to acknowledge that I did indeed, and that I tried my best in every possible way to keep manfully on. He told me to keep good courage. I do hope Father will be satisfied with what I have done.

But now still remains that terrible algebra and mathematics; after Christmas it is necessary that I have lessons in those also. I have been looking for a teacher in algebra and have found one, a cousin of Mendes, Teixeira de Mattos, teacher at the Jewish pauper school. He gives me hope that we shall be ready for examinations about October of next year. If I should pass the examinations, I shall have done it quicker than I expected, for when I began they told me two years would be necessary for the first four subjects.

And now I am studying; though it may cost a little more, it must be done well; it is a race and a fight for my life, no more and no less. Whoever gets through this course of study and perseveres in it to the end will not forget it as long as he lives, and to have done this will be something to treasure. Everybody who wants to reach a social position must go through a time of great difficulties and exertion; the success may depend on trifles. If one says or writes a word amiss at an examination, that may be the cause of failure. May God give me the wisdom which I need and grant me what I so fervently desire: to finish my studies as quickly as possible and be ordained, so that I can perform the practical duties of a clergyman.

Yesterday I was at the early morning service and heard a ser-

mon about 'I shall forever be at strife with man,' how after a time
of disappointment and grief there can come a time in life when our
dearest longings and wishes may be fulfilled. Shall you ever hear
me preach in some little church?

So another year has passed by, in which many things have hap-
pened for me, and I look back on it with thankfulness. When I
think over the time I spent at Braat's and the months of study
here, upon the whole they are really two good things.

Twilight is falling, 'blessed twilight,' Dickens called it, and
indeed he was right. Blessed twilight, especially when two or
three are together in harmony of mind and like scribes bring forth
old and new things from their treasure. Rembrandt knew that,
for from the rich treasure of his heart he brought forth among
other things that drawing in sepia, charcoal, ink, representing the
house in Bethany.

And the view from my window on the yard is simply wonder-
ful, with that little avenue of poplars, whose slender forms with
their thin branches stand out so delicately against the grey evening
sky, and then the old building of the warehouse in the water, which
is as quiet as 'the waters of the old pool,' mentioned in the Book of
Isaiah; the walls of that warehouse down at the waterside are
quite green and weatherbeaten. Then farther down is the little
garden and the fence around it with the rosebushes, and every-
where in the yard the black figures of the workmen, and also the
little dog.

It does one good to feel that one has still a brother, who lives
and walks on this earth; when one has many things to think of,
and many things to do, one sometimes gets the feeling: Where am
I? What am I doing? Where am I going? — and one's brain reels,
but then such a well-known voice as yours, or rather a well-known
handwriting, makes one feel again firm ground under one's feet.

Father has been here, and I was so glad he came. The most
pleasant recollection of his visit is of a morning we spent together
in my little room, correcting some work and talking over several
things. You can imagine the days flew by, and when I had seen

him off at the station, and had looked after the train as long as it
was in sight, even the smoke of it, then came home to my room
and saw Father's chair still standing near the little table on which
the books and copybooks of the day before were still lying, though
I know that we shall see each other again pretty soon, I cried like
a child.

For Saint Nicholas, Mendes gave me the works of Claudius, a
good and serious book. I had sent him 'Thomas Kempensis: de
Imitatione Christi,' and on the fly-leaf I wrote: 'In him there is
neither Jew nor Greek, nor servant nor master, nor man nor wife,
but Christ is all and in all.'

This week I had a conversation with him about 'The man who
hates not his own life, cannot be my disciple.' Mendes asserted that
the expression was too strong, but I declared that it was the simple
truth. And does not Kempis say the same when he speaks about
knowing oneself and hating oneself? When we look at others,
who have done more than we, and are better than we, we begin
very soon to hate our own life. Look at Thomas à Kempis, who
wrote his little book with a simplicity and a sincerity unequalled
by any other writer, or in another sphere look at the work of
Millet or Jules Dupré's 'The Large Oaks' — that is the thing.

Uncle Cor asked me today if I did not like 'Phryne' by Gérôme,
and I told him that I should rather see a homely woman by Israëls
or Millet, or an old woman by Eduard Frère; for of what use is
such a beautiful body as that of Phryne? The animals have it too,
perhaps even more than men, but the soul, as it lives in the people
painted by Israëls or Millet, or Frère, that is what animals never
have; and is not life given us to become richer in spirit, even
though the outward appearance may suffer from it? For the
figure by Gérôme I feel very little sympathy, for I discover in it
no sign of spirituality, and a pair of hands that show they have
worked are more beautiful than those of his figure.

And greater still is the difference between such a beautiful girl
and such a man as Parker, or Thomas à Kempis, or those Meissonier
painted, and as little as one can serve two masters can one love
two such different things and have sympathy for both. And then

Uncle Cor asked me if I should feel no attraction for a beautiful woman or girl, but I told him I should feel more attraction for, and should rather come in contact with, one who was ugly, or old, or poor, or in some way unhappy, but who through experience and sorrow had gained a mind and a soul.

Last Sunday I spent with Uncle Jan. It was a very pleasant day for me. I had got up very early, and I went to the French church in the morning, where a clergyman from the neighbourhood of Lyon preached; he came to collect money for an evangelical mission. His sermon consisted chiefly of stories from the life of the working people in the factories there, and though he spoke with an effort, still his words were effective, as they came from the heart, and only such are powerful enough to touch other hearts.

Father has advised me to try to make some acquaintances. The last two mornings I got up very early to work on a sketch of the map of Paul's travels intending to give it to the Reverend Gagnebin, as I wanted to put some emphasis on my visit to him if possible, as he is a learned man who perhaps can give me some good advice later on if he sees that my intentions are serious. I want to do such things now and then, for it certainly is very doubtful if I ever shall succeed, I mean shall ever pass all the examinations. If one begins earlier it is so much easier. It is true I can work longer, and can concentrate better, and things that many others care for have no attraction for me, but after all the work costs me greater effort. And even in case I fail I want to leave my mark here and there behind me.

There once was a man who went to church one day and asked: 'Can it be that my zeal has deceived me, that I have taken the wrong road, and have not planned it well? Oh! if I might be freed from this uncertainty, and might have the firm conviction that I shall conquer and succeed in the end!' And then a voice answered him: 'And if you knew that for certain, what should you do then? — Act now as if you knew it for certain, and you will not be confounded.' Then the man went forth on his way, believing, and he went back to his work, no longer doubting or wavering.

So I must push onward, for to stand still or to go back is out of

the question, this would make things more difficult still, and in the end there would be the necessity of beginning all over again.

There are so many, many things one has to know, and though they try to reassure me, it constantly gives me a very anxious feeling, and there is no remedy for it but to set to work again, since it is clearly my *duty* to do this, cost what it may.

We have talked a good deal about our duty, and how we could attain the right goal, and we came to the conclusion that in the first place our aim must be to find a steady position and a profession to which we can entirely devote ourselves. It is wise to do so, for life is but short and time passes quickly; if one is master of one thing and understands one thing well, one has at the same time insight into and understanding of many things.

One must especially have the end in mind, and the victory one would gain after a whole life of work and effort is better than one that is gained earlier. Whoever lives sincerely and encounters much trouble and disappointment, but is not bowed down by them, is worth more than one who has always sailed before the wind and has only known relative prosperity. One must never trust the occasion when one is without difficulties.

As to me I must become a good clergyman, who has something to say that is right and may be of use in the world, and perhaps it is better that I have a relatively long time of preparation and am strongly confirmed in a staunch conviction before I am called to speak to others about it.... If only we try to live sincerely, it will go well with us, even though we are certain to experience real sorrow and great disappointments, and also will probably commit great faults and do wrong things, but it certainly is true that it is better to be high-spirited, even though one makes more mistakes, than to be narrow-minded and all too prudent. It is good to love many things, for therein lies the true strength, and whosoever loves much performs much, and can accomplish much, and what is done in love is well done!

If one keeps on loving faithfully what is really worth loving, and does not waste one's love on insignificant and unworthy and meaningless things, one will get more light by and by and grow

stronger. Sometimes it is well to go into the world and converse
with people, and at times one is obliged to do so, but he who would
prefer to be quietly alone with his work, and who wants but very
few friends, will go safest through the world and among people.
And even in the most refined circles and with the best surround-
ings and circumstances, one must keep something of the original
character of an anchorite, for otherwise one has no root in one-
self; one must never let the fire go out in one's soul, but keep it
burning. And whoever chooses poverty for himself and loves it
possesses a great treasure, and will always clearly hear the voice
of his conscience; he who hears and obeys that voice, which is
the best gift of God, finds at last a friend in it, and is never alone.

I am a little curious to hear your first impressions of Paris. It
is true that first impressions often change, for we know too well
that though there may be a bright dawn, there is also a dark mid-
night and a burning and oppressive heat at noon. But just as the
morning hour is a blessed hour, so it is with the first impressions:
they keep their worth even though they pass, for sometimes they
prove to have been right after all, and one comes back to them.

When one walks through the streets towards Montmartre in the
morning, one sees many a workshop and little room that reminds
one of 'Un Tonnelier,' and it is good at times to see such simple
things. One sees so many people who for different reasons have
deviated from all that is natural and so have lost their real and
inward life, and also many who live in misery and in horror, for
in the evening one sees all kinds of black figures wandering
around, of men as well as of women, in whom the terror of the
night is personified, and whose misery one must range among the
things that have no name in any language.

Today I stepped in at Uncle Cor's. He told me that Daubigny
is dead. I can tell you I was sorry to hear it, just as when I heard
that Brion had died (his 'Benedicite' hangs in my room); for the
work of such men, if well understood, touches more deeply than
one is aware of. It must be a good thing to die conscious of hav-
ing performed some real good, and to know that by this work one
will live, at least in the memory of some, and will have left a good

example to those that come after. A work that is good — it may not be eternal, but the thought expressed in it is, and the work itself will certainly remain in existence for a long, long time; and if afterwards others arise, they can do no better than follow in the footsteps of such predecessors and do their work in the same way.

I AM writing by the light of a little lantern, and the candle is getting too short. Father and I went to Brussels last week, in company of the Reverend Mr. Jones of Isleworth. We saw the Reverend Mr. de Jong and Master Bokma of the Flemish training school. This school has a course of three years, while, as you know, in Holland the study would last for six years more at the shortest. And they do not require you to finish the course before you can apply for a place as evangelist. What is wanted is the talent to give popular and attractive lectures for the people, rather short and interesting than long and learned; they take more account of the fitness for practical work, and of the faith that comes from the heart. Still there are many obstacles to overcome; one does not acquire at once, but only by long practice, the talent of speaking to the people with seriousness and feeling, with fluency and ease; and what one has to say must have a meaning and a purpose, and some persuasion, to rouse one's hearers, so that they will try to root their convictions in truth.

Ces messieurs in Brussels wanted me to come there for three months to become better acquainted, but that would cause too much expense, and this must be avoided as much as possible. Therefore I stay in Etten for the present to do some preparatory work. I shall try to write as well as I can some compositions that will prove of use to me later. Yesterday I wrote a composition on the parable of the mustard seed and it is twenty-seven pages long; I hope there is some good in it. I am writing one now on Rembrandt's picture, 'The House of the Carpenter,' in the Louvre.

When we drove back from Zundert that evening, Father and I walked awhile. The sun was setting red behind the pine trees, and the evening sky was reflected in the pools; the heath and the yellow and white and grey sand were so full of harmony and senti-ment: — see, there are moments in life when everything, within us too, is full of peace and sentiment, and our whole life seems to be a path through the heath, but it is not always so.

The fields are now so beautiful; they are reaping the corn, and

the potatoes are getting ripe and their leaves begin to wither, and
the buckwheat is full of beautiful white blossoms. Here are work-
shops of all kinds that look picturesque, especially in the evening
with the lights, and to us who are also labourers and workmen,
each in his sphere and in the work to which he is called, they speak
in their own way, if we only listen to them, for they say: 'Work
while it is day, the night cometh when no man can work.'

It was just the moment when the street-cleaners came home
with their carts with the old white horses. The drivers with their
dirty filthy clothes seemed sunk and rooted still deeper in poverty
than that long row or rather group of poor people that Master
de Groux has drawn in his 'The Bench of the Poor.' It always
strikes me, and it is very peculiar, that when we see the image of
indescribable and unutterable desolation — of loneliness, of pov-
erty and misery, the end of all things, or their extreme — then
rises in our mind the thought of God.

The other day I made a little drawing after Emil Breton's 'A
Sunday Morning,' in pen and ink and pencil. How I like his work!
I am glad you find things that feed the inner life. For this is what
great art does, and the works of those who apply themselves with
heart, mind, and soul, whose words and deeds are full of spirit and
life. How rich art is! If one can only remember what one has seen,
one is never idle or truly lonely, never alone.

I should like to begin making rough sketches from some of the
many things that I meet on my way, but as it would probably keep
me from my real work, it is better not to begin it. I have made a
hasty little sketch, 'Au Charbonnage.' It is nothing remarkable
indeed, but the reason I made it is that one sees here so many
people that work in the coal mines, and they are rather a char-
acteristic kind of people. This little house stands not far from the
road; it is a small inn attached to the big coal shed, where the
workmen come to eat their bread and drink their glass of beer
during the lunch hour.

When I was in England I applied for a position as evangelist
among the miners in the coal mines, but they paid no heed to it,
and said I had to be at least twenty-five years old. One of the

roots or foundations not only of the Gospel, but of the whole Bible is, 'Light that rises in the darkness.' From darkness to light. Well, who will need this most, who will have ears for it? Experience has taught that those who walk in the darkness, in the centre of the earth, like the miners in the black coal mines, are very much impressed by the words of the Gospel, and believe it too.

Now there is in the south of Belgium, in the neighbourhood of Mons, up to the French frontiers, a district called the Borinage, that has a peculiar population of labourers who work in the numerous coal mines. I should very much like to go there as an evangelist, preaching the Gospel to the poor — that means those who need it most, and for whom it is so well suited — and during the week devoting myself to teaching. If I could work quietly for about three years in such a district, always learning and observing, then I should not come back from there without having something to say that was really worth hearing. I say so in all humility and yet with confidence. I should be ready about my thirtieth year, able to begin with a peculiar training and experience, able to master my work better, and riper for it than now.

The three months' trial demanded of me by the Reverend Mr. de Jong and the Reverend Mr. Pietersen have elapsed. I spoke with the Reverend Mr. de Jong and Master Bokma; they tell me that I cannot attend the school on the same conditions as they allow to the native Flemish pupils — so in order to stay there I ought to have more financial means than I have at my disposition, for they are nil.

So I shall perhaps soon try that plan of the Borinage.

It would not be easy to live without the faith in Him and the old confidence in Him; without it one would lose one's courage.

HERE in the Borinage there are no pictures; speaking in general one does not even know what a picture is. But notwithstanding this the country is very picturesque, everything speaks and is full of character. Of late the ground has been covered with snow; everything then reminded one of the medieval pictures of the peasant Breughel, and of so many others who have known how to express so remarkably well that peculiar effect of red and green, black and white. There are hollow roads, grown over with thorn bushes, and old gnarled trees with their fantastical roots, which perfectly resemble that road on the etching by Dürer, 'Death and the Knight.'

So, a few days ago, it was a curious sight to see the miners go home in the white snow in the evening at twilight. These people are quite black. When they come from the dark mines into daylight, they look exactly as do chimney sweeps. Their houses are very small and might rather be called huts; they are scattered along those hollow roads, and in the wood, and on the slope of the hills. Here and there one sees moss-covered roofs, and in the evening the light shines kindly through the small-paned windows.

Everywhere around one sees the big chimneys and the immense heaps of coal at the entrance to the mines, the so-called *charbonnages*. That large drawing by Bosboom, 'Chaudfontaine,' expresses well the character of the country, only here it is all coal, and in Chaudfontaine it is iron.

As we have in our Brabant the underbrush of oak, and in Holland the willows, so you see here the blackthorn hedges around the gardens, fields, and meadows. With the snow the effect just now is of black characters on white paper, like the pages of the Gospel.

I have rented a small house which I should like to make my home, but now it serves me only for workshop or study, as Father, and I too, think it better that I board with Denis. Still I have some prints on the wall.

The language of the miners is not so very easy to understand,

but they understand ordinary French well if it is only spoken quickly and fluently, then of course it naturally resembles their patois, which is spoken with great rapidity.

I have already spoken in public several times, in rather a large room especially arranged for religious meetings, as well as at the meetings they used to hold in the evenings in the miners' cottages, which may be called Bible lectures. I assisted also at a religious service in a stable or shed, so you see it is quite simple and original. At a meeting this week my text was Acts XVI. 9 — 'And a vision appeared to Paul in the night; there stood a man of Macedonia and begged him saying: Come over into Macedonia and help us.' And they listened attentively when I tried to describe what that Macedonian was like, who needed and longed for the comfort of the Gospel and for the knowledge of the only true God. How we must think of him as a labourer with lines of sorrow and suffering and fatigue in his face, without splendour or glamour but with an immortal soul, who needs the food that does not perish, namely, 'God's word.' And God wills that in imitation of Christ, man should live humbly and go through life, not reaching after lofty aims, but adapting himself to the lowly, learning from the Gospel to be meek and simple of heart.

People here are very ignorant and untaught; most of them cannot read, but at the same time they are intelligent and quick in their difficult work, brave and frank, of small stature but square-shouldered with melancholy deep-set eyes. They are handy in many things, and work terribly hard. They have a nervous temperament; I do not mean weak, but very sensitive. They have an innate, deeply rooted hatred and a deep mistrust of everybody who would try to domineer over them. With the charcoal-burners one must have a charcoal-burner's character and temperament and no pretentious pride or mastery, or one would never get on with them or gain their confidence.

I have just visited a little old mother in a charcoal-burner's family. She is very ill, but patient and full of faith. I read a chapter with her and prayed with them all. People here are rather characteristic in their simplicity and good nature, like the Brabant

people at Zundert and Etten. ⸌ One has a homelike feeling here.
Those who go away are homesick for the country, and on the other
hand the foreigners who are homesick might learn to feel at home.
If with God's blessing I get a permanent appointment here, I shall
be very, very happy.

There have been many cases of typhoid and malignant fever, or
what they call *la sotte fièvre*, that gives them bad dreams like night-
mare, and makes them delirious. In one house they are all ill with
fever, and they have little or no help, so that the patients have to
nurse the patients.

Most of the miners are thin and pale from fever and look tired
and emaciated, weatherbeaten and aged before their time, the
women, as a whole, faded and worn. Around the mine are poor
miners' huts with a few dead trees black from smoke, thorn hedges,
dunghills, ash dumps, and heaps of useless coal. Maris could make
a beautiful picture of it. I shall try to make a little sketch presently.

Not very long ago I made a very interesting expedition. I was
for six hours in a mine. It was one of the oldest and most danger-
ous mines in the neighbourhood, called Marcasse. That mine has
a bad reputation because many perish in it, either in descending
or ascending, or by the poisoned air, or by gas explosion, or by the
water in the ground, or by the collapse of old tunnels. It is a
gloomy spot, and at first sight everything around looks dreary and
desolate. I had a good guide, a man who has worked for thirty-
three years there, a kind and patient man, who explained every-
thing well and tried to make it clear to me.

So we went down together, seven hundred metres deep, and
explored the most hidden corners of that underworld. The *main-
tenages* or *gredins* (cells where the miners work), which are situated
farthest from the exit, are called *les caches*. If anyone would try
to make a picture of the *maintenages*, that would be something
new and unheard of, or rather never seen. Imagine a row of cells
in a rather narrow and low passage supported by rough timber.
In each of those cells a miner, in a coarse linen suit, filthy and
black, is busy cutting coal by the pale light of a small lamp. In
some of those cells the miner stands erect, in others he lies on the

ground. The arrangement is more or less like a dark gloomy pas-
sage in a prison underground, or like a row of small weaving looms,
or rather more like a row of bakers' ovens such as the peasants
have. In some the water leaks through, and the light of the miner's
lamp makes a curious effect, and is reflected as in a grotto of
stalactite. Some of the miners work in the *maintenages*; others
load the cut coal in small carts; this is done especially by children,
boys as well as girls. There is also a stable yard down there, seven
hundred metres underground, with about seven old horses.

As the mariners ashore are homesick for the sea, notwithstand-
ing all the dangers and troubles that threaten them, so feels the
miner; he would rather be underground than above it. The vil-
lages here look desolate and dead and forsaken, because life is
going on underground instead of above. One might live here for
years, but if one had not been down in the mines, one would not
have a just idea of the real state of things.

I am head over ears in work, so that the days pass without my
having time to think of, or to keep an interest in many things
that used to be attractive to me.

It has been thawing tonight; I cannot tell you how picturesque
the hilly country is with the thaw; now the snow is melting, and
the black fields with the green corn have again become visible.
For a foreigner the village here is a real labyrinth, with innumer-
able narrow streets and valleys of small miners' huts. You can
best compare it to a village like Scheveningen, especially the back
streets, or to those villages in Brittany which we know from the
pictures.

A few days ago we had a very heavy thunderstorm at about
eleven o'clock in the evening; quite near our house there is a spot
from which one can see far below in the distance a great part of the
Borinage, with the chimneys, the mounds of coal, the little miners'
cottages, the scurrying to and fro of the little black figures by day,
like ants in a nest, far away in the distance dark pine woods with
little white cottages silhouetted against them, a few church spires,
away off an old mill. Generally there is a kind of haze hanging
over all, or there is a fantastic effect of light and dark formed by

the shadows of the mounds that reminds one of the pictures of Rembrandt or Michel or Ruysdael.

But during that thunderstorm, in the pitch-dark night, there was a curious effect made by the flashes of lightning, which now and then rendered everything visible for a moment. Near-by the large gloomy buildings of the mine, Marcasse, standing alone, isolated in the open field, reminding one indeed of the huge bulk of Noah's Ark, as it must have looked in the terrible pouring rain and the darkness of the Flood, illuminated by a flash of lightning. Under the impression of that thunderstorm, I gave tonight in a Bible lecture the description of a shipwreck.

Lately I have been at a studio again, namely, at the Reverend Mr. Pietersen's, who paints in the manner of Schelfhout or Hoppenbrouwers, and has good ideas about art. He asked me for one of my sketches, a miner type. Often I am drawing until late in the night, to keep some souvenirs, and to strengthen the thoughts raised involuntarily by the aspect of things here.

Spring that is near will bring fresh material for subjects. What has Israëls been making this winter? How are Mauve and Maris? How many things they would find here that would appeal to them! When the cart with the white horse brings a wounded man home from the mines, one sees things that remind one of 'The Wreck,' by Israëls; and so there is every moment something that moves one intensely.

A picture by Mauve, or Maris, or Israëls speaks more, and speaks more clearly than nature itself. '*L'art c'est l'homme ajouté à la nature.*' I still can find no better definition for the word art than this: nature, reality, truth; but with a significance, a conception, a character which the artist brings out in it, and to which he gives expression; which he disentangles and makes free and clears up.

With books it is the same. I often read 'Uncle Tom's Cabin,' these days — there is so much slavery still in the world — and in that remarkably wonderful book the artist has put things in a new light, and that important question is treated with so much wisdom and such zeal and interest for the true welfare of the poor op-

pressed, that one comes back to it again and again, and always finds new things in it.

I am thankful for your visit. The hours that we have spent together have given us at least the assurance that we both are still in the land of the living. When I saw you again, and walked with you, I had the selfsame feeling which I used to have, as if life were something good and precious which one must value, and I felt more cheerful and alive than I had done for a long time, because gradually life has become less precious, much more unimportant and indifferent to me, at least it seemed so.

Like everyone else I feel the need of relations and friendship, of affection, of friendly intercourse, and I am not made of stone or iron, so I cannot miss these things without feeling, as does any other intelligent and honest man, a void and deep need. I tell you this to let you know how much good your visit has done me.

For the moment I do not feel very much disposed to go back and I am strongly inclined to stay here. But perhaps the fault is mine that I do not see it well; so it may be that, notwithstanding my strong repugnance, and notwithstanding that it will be a hard road to take, I shall go to Etten for a few days.

When I gratefully remember your visit, of course I also think again of our discussions. I have heard them before and often. Plans for amelioration and change, and raising of energy, and yet, do not be angry with me, but I am a little afraid — because I sometimes followed them, and the result was poor. How many things have been discussed that yet proved to be impracticable!

How fresh lies in my memory that time spent in Amsterdam! You were there yourself, so you know how things were planned and discussed, argued and considered, talked over with wisdom, with the best intentions, and yet how miserable was the result, how ridiculous the whole undertaking! It is the worst time I have ever lived through. How desirable and attractive have become the difficult days full of care here in this poor country, in these uncivilized surroundings, compared to that! I fear a similar thing will be the result of following wise advice given with the best intentions.

Such experiences are too dreadful; the harm, the sorrow, the affliction is too great not to try on either side to become wiser by this dearly bought experience. If we do not learn from this, then from what shall we learn? To try 'to reach the goal which was set before me,' as the expression then was; indeed, it is an aim which I no longer desire; the ambition for it has greatly abated, and even if it looked and sounded well then, now I look at those things from another point of view, although it is not allowed to have that opinion about them. Not allowed, ay, just as Frank the evangelist thought it reprehensible in me to assert that the sermons of the Reverend John Andry are but little more evangelic than those of a Roman Catholic priest. I should rather die a natural death than to be prepared for it by the Academy, and I sometimes have had a lesson from a hay-mower that was of more use to me than one in Greek.

To better my life — don't you think I eagerly desire it? I wish I were much better than I am. But just because I long for it, I am afraid of remedies that are worse than the evil itself. You would be mistaken if you thought that I should do well to follow your advice literally of becoming an engraver of bill-headings and visiting cards, or a bookkeeper or a carpenter's apprentice, or else to devote myself to the baker's trade — or many similar things (curiously different to combine) that other people advise me. But, you say: I do not give that advice for you to follow it literally, but because I am afraid you are rather fond of spending your days in idleness, and because my opinion is that you must put an end to this.

May I observe that this 'idleness' is rather a strange sort of idleness. It is somewhat difficult for me to defend myself against this, but I should be very sorry if, sooner or later, you could not see it in a different light. Neither do I know if it would be right for me to refute such an accusation by following such advice as of becoming a baker, for instance. That would indeed be a decisive answer (always supposing that it were possible to adopt quick as lightning the form of a baker, a barber, or a librarian), but it would be at the same time a foolish answer resembling more or less the

action of a man who, when reproached with cruelty for riding a donkey, immediately dismounted and continued his way with the donkey on his shoulders.

And now, putting all jesting aside, I really think it would be better if the relation between us became more friendly on both sides. If I really had to think that I were troublesome to you, or to the people at home, of no good to anyone, and if I should be obliged to feel myself an intruder or an outcast, so that I had better be dead — if I thought this really were the case, a feeling of anguish would overwhelm me, and I should have to struggle against despair. This is a thought I can hardly bear, and still harder to bear is the thought that so much discord, misery, and trouble between us, and in our home, is caused by me. When this thought sometimes depresses me beyond belief — then after a long time there rises simultaneously the thought: it is only a bad dream, and later on we shall perhaps learn to understand and look at things in a better way.

But is it not after all the truth, and will it not get worse instead of better? Many people would undoubtedly think it foolish and superstitious to believe still in a change for the better. Sometimes it is in winter so bitingly cold that one says: It is too cold, what do I care if there is a summer to follow, the evil surpasses by far the good. But with or without our permission there comes an end at last to the bitter frost, and on a certain morning the wind has turned and we have a thaw. Comparing the state of the weather to our state of mind and our circumstances — like the weather subject to changes and variety — I have still some hope left for a change for the better.

Now, though it is a very difficult and almost impossible thing to regain the confidence of a whole family that is not quite free from prejudices and other qualities as fashionable and honourable, yet I do not quite despair of the fact that by and by, slowly but surely, a cordial understanding may be renewed between us.

What moulting time is for the birds — the time when they change their feathers — so adversity or misfortune is the difficult time for human beings. One can stay in it, in that time of moult-

ing, one can also come out of it renewed, but anyhow it must not
be done in public, and it is not at all amusing. Therefore, above
all, I think the best thing and the most reasonable for me to do
is to go away, and keep at a convenient distance, so that I cease
to exist for you.

I am a man of passions, capable of and subject to doing more or
less foolish things, of which I happen to repent, more or less, after-
wards. Now and then I speak and act too quickly, when it would
have been better to wait patiently. I think other people some-
times commit the same imprudences. Well, this being the case,
what must be done? Must I consider myself a dangerous man,
incapable of anything? I do not think so. But the question is to
try by all means to put those selfsame passions to a good use. For
instance, I have more or less irresistible passion for books, and I
want continually to instruct myself, just as much as I want to eat
my bread. When I was in the surroundings of pictures and things
of art, I then had a violent passion for them that reached the
highest pitch of enthusiasm. And I do not repent it, for even now,
far from that land, I am often homesick for the land of pictures.

I knew well who Rembrandt was, and Millet, and Jules Dupré,
and Delacroix, and Millais, and M. Maris. Well — now I do not
have those surroundings any more, yet that thing that is called
soul, they say it never dies, but lives always, and goes on searching
always and always and forever. So instead of giving way to this
homesickness I said to myself: That land, or the fatherland, is
everywhere. So instead of yielding to despair, I chose the part of
active melancholy. I preferred the melancholy that hopes and
aspires and seeks to that which despairs in stagnation and woe.
So I studied more or less seriously the books within my reach, such
as the Bible, and the 'French Revolution' by Michelet, and last
winter, Shakespeare and Victor Hugo and Dickens, and Harriet
Beecher Stowe, and lately Aeschylus; and then several others, less
classical, several great 'little masters.'

Now he who is absorbed in all this is sometimes *choquant*, shock-
ing to others, and unwillingly sins more or less against certain forms
and customs and social conventions. It is a pity, however, when

this is taken in bad part. For instance, you know that I have often neglected my appearance; this I admit, and I admit that it is shocking. But look you, poverty and want have their share in the cause, and a deep discouragement comes in too for a part, and then it is sometimes a good way to assure oneself the necessary solitude for concentration on some study that preoccupies one.

Now for more than five years — I do not know exactly how long — I have been more or less without employment, wandering here and there. You say: 'Since a certain time you have gone down, you have deteriorated, you have not done anything.' Is this quite true?

It is true that now and then I have earned my crust of bread, now and then a friend has given it to me in charity. I have lived as I could. It is true that I have lost the confidence of many; that my financial affairs are in a sad state; that the future is only too sombre; that I might have done better; that just for earning my bread I've lost time. It is true that even my studies are in a rather sad and hopeless condition, and that my needs are greater, infinitely greater than my possessions. But is this what you call going down, is this what you call doing nothing? You will say, perhaps: But why did you not continue as they wanted you to do? They wanted you to continue by way of the university. My only answer to this is: The expenses were too heavy, and, besides, that future was not much better than the one on the road now before me.

I must tell you that it is with evangelists as with artists. There is an old academic school, often detestable, tyrannical, the accumulation of horrors, men who wear a cuirass, a steel armour of prejudices and conventions; those people, when they are at the head of affairs, dispose of positions, and by a rotary system they try to keep their protégés in their places, and to exclude the other man. Their God is like the God of Shakespeare's drunken Falstaff, '*le dedans d'une église!*' indeed, some of those evangelical gentlemen find themselves by a curious chance having the same point of view on spiritual things as that drunken type (perhaps they would be somewhat surprised to find it so, if they were capable of human emotions).

I for my part respect academicians, but the respectable ones are

more rare than one would believe. One of the reasons that I am out of employment now, that I have been out of employment for years, is simply that I have other ideas than the gentlemen who give the places to men who think as they do. It is not a simple question of dress, as they have hypocritically reproached me; it is a much more serious question, I assure you.

You say: 'You have impossible ideas about religion and childish scruples of conscience.' I think that everything that is really good and beautiful, of inward moral, spiritual, and sublime beauty in men and their works, comes from God, and that all that is bad and wrong in men and in their works is not of God, and God does not approve of it. But I always think that the best way to know God is to love many things. Love a friend, a wife, something, whatever you like, but one must love with a lofty and serious intimate sympathy, with strength, with intelligence, and one must always try to know deeper, better, and more. That leads to God; that leads to unwavering faith.

Someone loves Rembrandt, but seriously — that man will know that there is a God, he will surely believe it. Someone studies the history of the French Revolution — he will not be unbelieving, he will see that also in great things there is a sovereign power manifesting itself. Somebody has followed maybe for a short time a free course at the great university of misery, and has paid attention to the things he sees with his eyes, and hears with his ears, and has thought them over; he, too, will end in believing, and he will perhaps have learned more than he can tell. To try to understand the real significance of what the great artists, the serious masters, tell us in their masterpieces, that leads to God. One man has written or told it in a book, another in a picture. Well, think much and think all the time; that unconsciously raises your thoughts above the ordinary level. We know how to read — well, let us read then!

During your visit last summer, when we walked together near the abandoned pit which they call La Sorcière, you reminded me that there had been a time when we two also walked together near the old canal and mill of Ryswyk. 'And then,' you said, 'we agreed in many things,' but you added, 'Since then you have changed so

much you are not the same any longer.' Well, that is not quite true. What has changed is that my life was then less difficult, and my future seemed less dark, but as to the inward state, as to my way of looking at things, and my way of thinking, that has not changed. If there has been any change at all, it is that I think and believe and love more seriously now what I already thought and believed and loved then.

So you would be wrong in continuing to believe that I should now be less enthusiastic for Rembrandt, or Millet, or Delacroix, or whoever it may be, for the contrary is true. But, you see, there are many things which one must believe and love. There is something of Rembrandt in Shakespeare, and of Correggio in Michelet, and of Delacroix in Victor Hugo, and then there is something of Rembrandt in the Gospel, or in the Gospel something of Rembrandt, as you like it. And in Bunyan there is something of Millet, and in Harriet Beecher Stowe there is something of Ary Scheffer.

If now you can forgive a man for making a thorough study of pictures, admit also that the love of books is as sacred as the love of Rembrandt, and I think even the two complete each other. I am very fond of the portrait of a man by Fabritius, which one day we stood looking at a long while in the museum of Haarlem. Yes, but I am as fond of Sydney Carton, in the 'Tale of Two Cities' by Dickens. My God, how beautiful Shakespeare is! Who is mysterious like him? His language and style can indeed be compared to an artist's brush, quivering with fever and emotion. But one must learn to read, as well as one must learn to see and learn to live.

So you must not think that I disavow things; I am rather faithful in my unfaithfulness, and, though changed, I am the same, and my only anxiety is: How can I be of use in the world? Cannot I serve some purpose and be of any good? How can I learn more? You see, these things preoccupy me constantly, and then I feel myself imprisoned by poverty, excluded from participating in certain work, and certain necessary things are beyond my reach. That is one reason for not being without melancholy, and then one feels an emptiness where there might be friendship and strong and serious

affections; one feels a terrible discouragement gnawing at one's very moral energy; fate seems to put a barrier to the instincts of affection, and a flood of disgust rises to choke one. And one exclaims, 'How long, my God!'

Well, what shall I say? Our inward thoughts, do they ever show outwardly? There may be a great fire in our soul, and no one ever comes to warm himself at it; the passers-by see only a little bit of smoke coming through the chimney, and pass on their way. Now, look you, what must be done? Must one tend that inward fire, have salt in oneself, wait patiently yet with how much impatience for the hour when somebody will come and sit down near it — to stay there maybe?

For the moment it seems things go very badly with me, and this has been so for a considerable time, and it may continue so in the future for a while; but after everything has seemed to go wrong, there will perhaps come a time when things will go right. I do not count on it, perhaps it will never happen, but in the event there should come a change for the better I should say: At last! You see there was something after all.

I should be very glad if you could see in me something besides an idle fellow. Because there are two kinds of idleness that form a great contrast. There is the man who is idle from laziness and from lack of character, from the baseness of his nature. You may if you like take me for such a one. Then there is the other idle man, who is idle in spite of himself, who is inwardly consumed by a great longing for action, because he seems to be imprisoned in some cage. A just or unjustly ruined reputation, poverty, fatal circumstances, adversity — they are what make men prisoners. And the prison is also called prejudice, misunderstanding, fatal ignorance of one thing or another, distrust, false shame. One cannot always tell what it is that keeps us shut in, confines us, seems to bury us, but nevertheless, one feels certain barriers, certain walls. Such a man does not always know what he can do, but he feels by instinct: Yes, I am good for something; my life has an aim after all; I know that I might be quite a different man! There is something inside of me; what can it be?

Do you know what frees one from this captivity? It is every deep serious affection. Being friends, being brothers, love, these open the prison by supreme power, by some magic force. Where sympathy is renewed, life is restored.

But on the path I have taken now I must keep going; if I don't do anything, if I do not study, if I do not go on seeking any longer, I am lost. Then woe is me. That is how I look at it; to continue, to continue, that is what is necessary. But you will ask: What is your definite aim? That aim will become more definite, will stand out slowly and surely, as the rough draught becomes a sketch, and the sketch becomes a picture, little by little, by working seriously on it, by pondering over the idea, over the thought that was fleeting and passing, till it gets fixed.

But to speak of other things; if I have come down in the world, you on the contrary have risen. If I have lost sympathies, you on the contrary have gained them. That makes me very happy, I say it in all sincerity, and it will always do so.

If ever I can do anything for you, be of some use to you, know that I am at your disposal. We are rather far apart, and we have perhaps different views on some things; nevertheless, there may come an hour, there may come a day, when we may be of service to one another.

I am busy copying large drawings after Millet, and I have already finished 'Les Heures de la Journée' as well as 'Le Semeur.' Well, perhaps if you saw them you would not be altogether dissatisfied. Because I have already twenty prints after Millet, you can understand that if you could send me some more I should readily make them, for I try to study that master seriously. I know that the large etching of 'Les Bêcheurs' is rare, yet be on the lookout for it, and tell me for what price one could have it. Some day or other I shall earn a few pennies with some drawings of miners, and I should like to have that print.

With no less, but rather more, eagerness I am now copying 'Les Travaux des Champs.' I sketched ten pages. I should have done more, but I wanted to make first the 'Exercices au Fusain,' by

Bargue, which Mr. Tersteeg has kindly lent me. I worked almost a whole fortnight from early morning until night, and from day to day I seemed to feel that it invigorated my pencil.

I feel the need of studying the drawing of figure from masters such as Millet, Breton, Brion, or Boughton. Among the photographs after J. Breton there is one that represents 'Gleaners' — dark silhouettes against a sky with a red sunset.

I have sketched a drawing representing miners, men and women, going to the shaft in the morning through the snow, by a path along a hedge of thorns; shadows that pass, dimly visible in the twilight. In the background the large constructions of the mine, and the heaps of clinkers, stand out vaguely against the sky. I should like very much to make that drawing over again, better than I have done it now. The *pedant* represents the return of the miners, but it did not turn out so well; it is very difficult, being an effect of brown silhouettes just touched by light, against a mottled sunset.

I work regularly on the 'Cours de Dessin,' Bargue, and intend to finish it before I undertake anything else, for day by day it makes my hand as well as my mind more supple and strong. Those studies are excellent. Between times I am reading a book on anatomy, and another on perspective, which Mr. Tersteeg has also sent me. The study is very dry, and at times those books are terribly irritating, but still I think I do well to study them.

I had already made twice in water-colour 'Four dans les Landes' after Th. Rousseau before I succeeded in finishing a large sepia drawing. I should like very much to copy also 'Le Buisson,' by Ruysdael; you know those two landscapes are in the same style and sentiment. I have been making rough sketches of these drawings, without advancing very much, but lately it seems to get better, and I have good hope that it will go better still. Especially because Mr. Tersteeg and you also have come to my aid with good models, for I think it is much better to copy for the present some good things than to work without this basis. Yet I could not keep from sketching, in rather a large size, the drawing of the miners going to the shaft, though changing a little the place of the figures. I hope that after having copied the other two series of Bargue I shall be

able to draw miners, male and female, more or less well, if by chance I can have a model with some character, and as to that there are plenty of them.

If you have the book with the etchings after Michel, I should like to see those landscapes again, for now I look at things with other eyes than before I began to draw.

So you see that I am in a rage of work. Do not fear for me. If I can only continue, that will somehow or other set me right again. For the moment it does not give very brilliant results. But I hope these thorns will bear their white blossoms in due time, and that this apparently sterile struggle is no other than the labour of child-birth. First the pain, then the joy. I think that you would rather see me doing some good work than doing nothing, and perhaps it might prove the way to restore the sympathy between us, and make us of some use to one another.

I have undertaken a walking tour. I had said to myself, You must see Courrières, and M. Jules Breton's studio. The outside of the studio was rather disappointing, as it was quite newly built of bricks of a Methodist regularity, of an inhospitable, chilly, and ir-ritating aspect. If I could only have seen the interior, I should cer-tainly not have given a thought to the exterior. But I had not been able to catch a glimpse, for I lacked the courage to enter and introduce myself. I looked elsewhere in Courrières for any traces of Jules Breton, or some other artist; the only thing I was able to discover was Breton's picture at a photographer's, and in the dark corner of the old church a copy of Titian's 'Burial of Christ.' Was it by him? I do not know, I was unable to discern any signature.

There was a café called Café des Beaux-Arts, also built of new bricks, equally inhospitable; it was decorated with a kind of fresco or mural painting, representing episodes in the life of the famous knight, Don Quixote. Those frescoes seemed to me a poor consola-tion, as they were more or less of inferior quality. I do not know who painted them.

But I have at least seen the country around Courrières, the hay-stacks, the brown earth or almost coffee-coloured clay, with white pots here and there where the marl appears, which seems very

unusual to us who are accustomed to black earth. Even in Cour-
rières there was a *charbonnage* or mine. I saw the day shift coming
up in the twilight, but there were no women in men's clothes as in
the Borinage, only miners, with tired and miserable faces, black-
ened by the coal dust, clad in tattered miners' clothes, and one of
them in an old soldier's cape. Though this trip was almost too
much for me, and I came back from it overcome by fatigue, with
sore feet, and in a more or less melancholy condition, I do not regret
it, for I have seen interesting things, and one learns to take a dif-
ferent but correct view of the hard ordeals of misery itself.

I earned some crusts of bread along the road here and there in
exchange for some drawings which I had in my valise. But I had to
spend the last nights in the open air, once in an abandoned wagon
which was white with frost the next morning — rather a bad rest-
ing-place; once in a pile of fagots; and once, that was a little better,
in a haystack, where I succeeded in making a rather more com-
fortable berth, but then a drizzling rain did not exactly further my
well-being.

Well, it was even in that deep misery that I felt my energy revive
and that I said to myself: In spite of everything I shall rise again;
I will take up my pencil, which I have forsaken in my great dis-
couragement, and I will go on with my drawing; and from that
moment everything seemed transformed for me; and now I have
started, and my pencil has become somewhat docile, becoming more
so every day. It was the too long and too great poverty which had
discouraged me so much that I could not do anything.

Another thing which I saw during that excursion was the villages
of the weavers. The miners and the weavers form a race apart
from the other labourers and artisans, and I feel a great sympathy
for them, and should be very happy if some day I could draw them,
so that those types unknown, or so little known, would be brought
before the eyes of the people. The man from the depth of the abyss,
de profundis — that is the miner; the other with his dreamy air,
somewhat absent-minded, almost a somnambulist — that is the
weaver. I have been living with them for two years, and I have
learnt a little of their original character, at least especially that of

the miners. And more and more often I find something touching and almost sad in those poor obscure labourers, of the lowest order so to say, and the most despised; who are generally represented as a race of criminals and thieves, by a perhaps vivid but very false and unjust imagination.

I know the etchings of Meryon a little. Should you like to see a curious thing? Put one of his correct and masterly drawings side by side with some print by Viollet-le-Duc, or some other architect. Then you will see Meryon in his full strength, because the other etching will serve to set off his work or to form a contrast. Well, what do you see then? This Meryon, even when he draws bricks, or granite, or iron bars, or a railing of a bridge, puts in his etchings something of the human soul, moved by I do not know what inward sorrow. Meryon is said to have had such a capacity for love that now, like Sydney Carton of Dickens, he loves even the stones of certain places.

In Millet, in Jules Breton, in Josef Israëls too, one also finds even more in evidence this precious pearl, the human soul, expressed in a nobler, worthier tone, more evangelic, if I may call it so. Wait, perhaps you will see some day that I too am an artist, though I do not know beforehand what I can do; I hope I shall be able to make some drawings in which there is something human. But I must first draw the Bargues, and do other more or less difficult things. The path is narrow, the door is narrow, and there are few who find it.

It would certainly be my great and ardent wish to go to Paris. But how could I, as I do not earn a cent, and though I work hard it will take some time before I shall have arrived at a point of being able to think of such a thing, for indeed, in order to be able to work as is necessary, I should need at least one hundred francs a month; one can live on less, but then it is hardship and even want.

It is cheaper to live here. But it is sure that I cannot go on very much longer in the little room where I am now. It is but a small room, and then there are two beds, one for the children and one for me. And now that I draw those Bargues, which are rather large in size, I cannot tell you how it inconveniences me. I do not

want to upset the people in their household arrangement, and they have told me already that I could by no means have the other room in the house, for the woman needs it for her washing.

If I could find an opportunity of forming a friendship with some good and worthy artist, that would be of great advantage to me. But to go to Paris abruptly would only be a repetition on a large scale of my trip to Courrières, where I had hoped to meet some living specimen of an artist, but where I did not find any. The thing for me is to learn to draw well, to be master of my pencil or my crayon or my brush; this gained, I shall make good things anywhere, and the Borinage is just as picturesque as old Venice, as Arabia or Picardy.

Though every day difficulties come up and new ones will present themselves, I cannot tell you how happy I am to have taken up drawing again. I have been thinking of it for a long time, but I always considered the thing impossible and beyond my reach. But now, though I feel my weakness and my painful dependency in many things, I have recovered my mental balance, and day by day my energy increases.

So, if sooner or later you could find means or opportunity, think of me. In the meantime I stay quietly here in some little miner's hut, where I shall work as well as I can.

BRUSSELS, *October*, 1880

YOU see it is from Brussels that I write. For I thought it better to change my domicile for the present, and that for more than one reason; in the first place it was urgently necessary because the little room where I was lodged was so narrow, and the light was so bad, that it was very inconvenient to draw there. Boy, if I had stayed a month longer in Cuesmes I should have been sick with misery. You must not imagine that I live richly here, for my chief food is dry bread and some potatoes or chestnuts, but having a somewhat better room, and taking now and then a somewhat better meal in a restaurant whenever I can afford it will help to set me right again. For almost two years I have undergone misery in the Belgian 'black country,' and my health has not been very good lately, but if I can only succeed some day in learning to draw well what I want to express, I shall forget all that, and I shall remember only the good side, which also exists if one only looks for it. But still I must try to regain some strength, for I need all my energy.

Father wrote to me that for the present I may count on receiving through his intermediary sixty francs a month. The expenses here will be somewhat more than that, which cannot be helped. Drawing materials, studies to copy, for instance for anatomy, all these cost money; and yet they are strictly necessary things, and only in this way shall I obtain a fair return, otherwise I could never succeed.

Do not accuse me of extravagance, for really the contrary is rather my fault, and if I could spend more I should get on more rapidly and make more progress.

The expenses of living, wherever it may be, are always at least one hundred francs a month; if one has less, it means want, either physically or of the necessary materials and tools. Financial questions have either advanced or handicapped many people in the world. 'Poverty prevents growth'; that is the old proverb of Palissy, which has some truth in it, and which is perfectly true if one understands its real meaning and depth. But when I think it over,

I must say: Would it be right, if in a family like ours, where two
Messrs. Van Gogh are very rich, and both in the line of art, Uncle
Cor and our uncle of Prinsenhage, and where the younger genera-
tion, you and I, have chosen the same line though in different
spheres, would it be well, I say, if this being so I should not be able
to count in some way on one hundred francs a month for the time
that must necessarily elapse before I can get regular work as a
draughtsman? Now three years ago I quarrelled with C. M.
about quite a different question, but is that a reason why C. M.
should remain my enemy for ever? I would much rather think that
he had never been my enemy and consider it a misunderstanding,
of which I take all the fault on myself, than argue about how much
of it really is my fault, for I have not time left for such things.

I know quite well, no matter how economically or poorly one
may live, life here in Brussels must be more expensive, but I can-
not get on without some instruction and I think if I only work hard,
which I do, possibly Uncle Vincent or Uncle Cor will do something,
if not to help me, at least to help Father.

There are several young men who are beginning the study of
drawing and are in the same position of not being rich either. But
the thing that gives one strength in such circumstances is not to be
always alone, but to be in connection and relation with others who
are in the same position. I should like to enter into relation with
some artist, so that I could continue my study in a good studio; for
I feel that it is absolutely necessary to have good things to look at
and also to see artists at work. For then I feel more what I lack
and at the same time I learn how to do better.

Even from relatively bad artists one can indirectly learn much;
as, for instance, Mauve learned much from Verschuur about the
perspective of a stable and a wagon, and the anatomy of a horse,
and yet how far above Verschuur is Mauve!

It is already a long time since I have seen enough good pictures
or drawings, and the very sight of some good things here in Brussels
has given me new inspiration and has strengthened my desire to
make things with my own hands.

I find about the Dutch artists that it is very doubtful if one

could get from them any clear indication of the difficulties of perspective with which I am struggling. Someone like Heyerdahl would be preferable (as he seems to be such a many-sided man) to many others who do not possess the talent of explaining their method, and to give one the necessary guidance and teaching. You speak about Heyerdahl as of somebody who takes great pains to seek proportions for drawing; that is just what I need. Many a good painter has not the slightest or hardly any idea what proportions for drawing are, or beautiful lines, or characteristic composition and thought and poetry.

There are laws of proportion, of light and shadow, of perspective which one must know in order to be able to draw well; without that knowledge it always remains a fruitless struggle, and one never brings forth anything. I shall try this winter to store some capital of anatomy; I may not put it off longer, and in the end it would prove expensive, for it would be loss of time.

I have been to see Mr. Roelofs, and he has told me that in his opinion from now on I must draw principally from nature, that is, from either cast or model, but not without the guidance of someone who knows it well. And he and others too have advised me so earnestly to work at the Academy that I have felt obliged to try to get admission, though I do not think it is so very agreeable. In Brussels the teaching is free of charge and one can work in a well-heated and well-lighted room, which is a good thing, especially in winter.

I believe the longer you think it over, the more you will see the urgent necessity of more artistic surroundings for me, for how can one learn to draw if no one shows one how? And with all the best intentions in the world one cannot succeed without coming in contact with artists who are more advanced. · Good intentions alone are not sufficient without some opportunity for development. As to the mediocre artists, to which you think I should not want to belong, what shall I say about it? I shall do what I can, but mediocrity in its simple signification I do not despise at all. And one certainly does not rise above that mark by despising what is mediocre. In my opinion one must begin at least by having some respect for the

mediocre and know that it means something, and that it is only reached with great difficulty.

I have made another pen drawing after the 'Woodcutter' of Millet. I think pen drawing is a good preparation, if one should afterwards want to learn etching. The pen is also very useful in accentuating pencil drawings, but one does not succeed in it at once. But for the moment my aim must be to learn to make as soon as possible some drawings that are presentable and salable, so that I can begin to earn something directly through my work. Once having mastered my pencil or water-colouring or etching, I can go back to the country of the miners or weavers and work better from nature than I do now; but first I must learn more of the technique.

I have been busy these days drawing something that gave me a lot of work, but still I am glad to have done it; I drew with pen and ink a skeleton of rather large size, on five pages of Ingres paper. I got the idea of making these from a study book by John: 'Sketches on the Anatomy for the Use of Artists.' There are some more reproductions in it which seem to me very good and clear of hand and foot. And what I am going to do now is to finish the drawing of the muscles — that is of the torso and the legs — which with the others will form the whole of the human body. Then follows the back and side view of the body, so you see I am going ahead with a will.

I have finished at least a dozen drawings or rather sketches in pencil, and pen and ink, which seem to me to be somewhat better. They vaguely resemble certain drawings by Lançon of certain English woodcuts, but they are more clumsy and awkward as yet. They represent a porter, a miner, a snow-shoveller, a walk in the snow, old women, type of an old man. I see perfectly well that they are not good, but it begins to look like something.

I have a model almost every day, an old porter, or some working man, or some boy that poses for me. Next Sunday I shall perhaps have one or two soldiers who will sit for me. I must have, by and by, a small collection of workmen's clothes to dress the models for my drawings. For instance, a Brabant blue smock, the grey linen suit that the miners wear, and their leather hat, then a straw hat

and wooden shoes, a fisherman's outfit of yellow oilskin and a sou'-wester. And certainly also that suit of black or brown corduroy that is very picturesque and characteristic; and then a red flannel shirt or undervest. And also a few women's dresses, for instance, that of de Kempen, and from the neighbourhood of Antwerp with Brabant bonnet, and that of Blankenberg, or Scheveningen, or Katwyk. That is the only true way to succeed: to draw after the model with the necessary costumes.

Only after I have studied drawing thus seriously and thoroughly, always trying to portray truly what I see, shall I arrive, and then, notwithstanding the inevitable expenses, I shall make a living by it. If I might find here some permanent work, so much the better, but I dare not count on it, for I have still many things to learn, though the principal thing is that I shall make progress and that my drawing shall become stronger, then everything will come right sooner or later, after all. Models are expensive, at least relatively expensive, and if I had money enough to have them often I should be able to work much better. But then a studio becomes indispensable.

I have also made again a drawing of a landscape; a heath, a thing I had not done for a long time. I love landscape very much, but ten times more I love those studies from life, sometimes of startling realism, which have been drawn so masterly by Gavarni, Henri Monnier, Daumier, Henri Pille, de Groux. Now, without in the least pretending to compare myself to those artists, still, by going on drawing those types of working people I hope to arrive at the point of being able to do illustration work for papers and books. Especially when I shall be able to take more models, also women models, I shall make more progress. I feel it, and know it. And I shall also probably learn to make portraits.

Uncle Cor so often helps other draughtsmen, would it be so unnatural now if some day, when I needed it, he would show me his good-will? I do not say this, however, to get some financial help from him. In quite another way than by giving money he would be able to help me; for instance, if it were possible to bring me in contact with persons from whom I could learn many things, or,

for instance, to help me to get regular work for some magazine.

In this way I talked it over with Father; I noticed that people talked about the strange and unaccountable fact that I was so hard up, and yet belonged to such and such a family. I replied to them that I thought it was only a passing affair, and would come right after some time. Still I thought it better to talk it over with Father and you, and I wrote something about it to Mr. Tersteeg, but he seems to have misunderstood my intention, as he received the impression that I intended to live on the bounty of my uncles, and this being his opinion, he wrote me a very discouraging letter, and said I had no right to such a thing.

One such as Roelofs does not know what to think of such a crooked position; either there must be something wrong with me or with the others, but he sees there is something wrong somewhere anyhow. So he is rather too prudent, and will have nothing to do with me just at the moment that I most need advice or help.

And such experiences are not pleasant; the question remains whether I do make progress in working on with patient energy. I think I do.

The cheapest way would perhaps be for me to spend this summer at Etten; I can find there subjects enough. I am willing to give in about dress or anything else to suit them, and perhaps would meet C. M. there some day. They will always, either in or outside the family, judge me or talk about me from different points of view, and you will always hear the most different opinions about me. And I blame no one for it, because relatively few people know why an artist acts in this way or that. But in general, he who, to find picturesque spots or figures, searches all manner of places, corners, and holes which another rather passes by, is accused of many bad intentions and villainies which have never entered his head.

A peasant who sees me draw an old tree-trunk, and sees me sitting there for an hour, thinks that I have gone mad, and of course laughs at me. A young lady who turns up her nose at a labourer in his patched, dirty, and filthy clothes of course cannot understand why anyone visits the Borinage, and descends the shaft of a coal mine, and she also comes to the conclusion that I am mad.

But of course I do not care at all what they think if only you and Mr. Tersteeg, and C. M. and Father, and others with whom I come in contact know better, and instead of making remarks about it say: Your work demands that, and we understand why it is so.

In the meantime I work with Rappard. Rappard has painted some good studies, among others a few after the models at the Academy which are well done. A little more fire and passion would do him no harm, a little more self-confidence and more courage. His pen-and-ink drawings of landscape are very witty and charming, but also in those a little more passion, please.

Without my knowing it you have sent me money for a long time, thus helping me effectually to get on. Receive my hearty thanks for it. I firmly believe that you will not regret it; in this way I learn a handicraft, and though it certainly will not make me rich, I shall at any rate earn my one hundred francs a month.

It is a hard and difficult struggle to learn to draw well.

I HAVE been here now a few days, and it is splendid outdoors. I am so glad it is arranged that I shall be able to work here quietly for a while. I hope to make as many studies as I can, for that is the seed which must afterwards produce the drawings.

When it does not rain I go out every day in the fields, generally to the heath. I make my studies on rather a large scale, so I have made among others a cottage on the heath, and also the barn with a thatched roof on the road to Roozendaal, which they call here the Protestant barn. Then the mill right opposite to it in the meadow, and the elm trees in the churchyard. And another of woodcutters busy on a wide patch of ground, where a large pine wood has been cut down. Besides, I try to draw the implements, as a wagon, plough, harrow, wheelbarrow. That with the woodcutters turned out best of all, and I think you would like it.

I bought Cassagne's 'Traité d'Aquarelle,' and am studying it; even if I should not make any water-colours I shall probably find many things in it; for instance, about sepia and ink. For until now I have exclusively drawn in pencil accented by the pen, sometimes a reed pen which has a broader stroke. What I have been drawing lately demanded that way of working because the subjects required much *drawing:* drawing in perspective too; for instance, a few work-shops in the village here, a forge, a carpenter's shop and sabot-maker's.

Rappard told me he was going to buy all the books by Cassagne. He has trouble with his perspective, and I know no better remedy for this ailment; at least, if I may be quite cured of it I shall have to thank those books for it. I put into practice the theory they contain.

There is another thing that is a necessity. I mean white Ingres paper. But no dead white; rather the colour of unbleached linen; no old tones. I brought some of it from Brussels, and worked with pleasure on it, as it is very well suited for pen drawing, especially for a reed pen.

Willemien has left now and I am sorry; she poses very well. I

made a drawing of her and of another girl who stayed here. I put a sewing-machine in that drawing. Nowadays there are no more spinning-wheels, and that is a great pity for painters and draughts-men, but something has come in their place that is no less pic-turesque.

I think I shall find a good model here in Piet Kaufman, the gardener, but I think it will be better to let him pose with a spade or plough or something like that; not here at home, but either in the yard or in his own home or in the field. But what a tough job it is to make people understand how to pose! They are desperately ob-stinate in this respect, and it is hard to make them yield on this point; they want to pose only in Sunday clothes with impossible folds in which neither knees, nor elbows, nor shoulder blades, nor any other part of the body have left their characteristic dents or bumps.

I have made another drawing in the Liesbosch, and now it has become quite hot, too hot to sit on the heath by day, so I work at home. Remembering what you told me once, I have tried to draw a few portraits after photographs, and I think this is a good prac-tice.

It was very pleasant to have you here again, and to have long talks together about everything. Of course I feel much better now. The day after you left I stayed in bed, however, and had a long talk with Doctor Van Gent, a clever and practical man; not because I thought this insignificant *malaise* worth while, but rather because in general, either well or unwell, I like to talk with a doctor now and then in order to know that everything is right. If one hears occa-sionally a sound and true word about health, one gets by and by much clearer ideas about it.

For the rest I am drawing the 'Exercices au Fusain,' on that Ingres paper. It is much more stimulating to draw from nature than to copy such a page from the Bargues, but still I set myself the task of drawing them once more, and now for the last time. It would not be right if in drawing from nature I took up too many details and overlooked the great things. And that was too much the case in my last drawings, I thought. And therefore I want to study again the method of Bargue (who gives only great lines and

forms and simple, delicate outlines). About the time I shall have finished, it will be autumn; that is a delightful time for drawing.

I wish all people had what I begin to acquire gradually: the power to read a book without difficulty in a short time, and to keep a strong impression of it. It is with the reading of books the same as with looking at pictures; one must, without doubt, without hesitation, with assurance, admire what is beautiful.

I have just come back from a trip to The Hague. I left here Tuesday, and now it is Friday night. At The Hague I went to see Mr. Tersteeg, Mauve, and de Bock. Mr. Tersteeg was very kind, and said he thought I had made progress.

With Mauve I spent an afternoon and part of an evening and saw many beautiful things in his studio. My own drawings seemed to interest Mauve more. He has given me a great many hints which I was glad to get, and I have arranged to come back to see him in a relatively short time, when I shall have new studies. He has shown me a whole lot of his studies and explained them to me — not sketches for drawings or pictures, but real studies, seemingly of little importance. He thinks I should now start painting.

I enjoyed meeting de Bock; I was at his studio. He is painting a large picture of the dunes that has much that is fine in it. But the fellow must practise figure drawing, and then he will produce still better things, I think. It seems to me he has a real artist's temperament and we have not heard the last of him. He is very fond of Millet and Corot, but did not these two work hard on figures? The figures of Corot are not so well known as his landscapes, but it cannot be denied that he has made them. Besides, Corot has drawn and modelled every tree-trunk with the same devotion and love as if it were a figure. And a tree by Corot is something quite different from one by de Bock. One of the best things I saw from de Bock was a copy from Corot.

I have now some news: that is to say, there has come a change in my drawing, in my technique as well as in its results. In reference also to some things Mauve told me, I have begun to work from the living model again. The careful study of the 'Exercices au Fusain,' the copying of them over and over again has given me better in-

sight in the drawing of the figure. I have learned to measure and to observe, and to look for great lines. So what seemed to me impossible before is become gradually possible now, thank God.

Five times over I have drawn a man with a spade, 'Un Bêcheur,' in different positions, twice a sower, twice a girl with a broom. Then a woman with a white cap who is peeling potatoes, and a shepherd leaning on his staff, and finally an old sick farmer sitting on a chair near the hearth, with his head in his hands and his elbows on his knees. And of course I shall not stop at that; when a few sheep have crossed the bridge the whole flock follows. Diggers, sowers, ploughers, male and female, these I must draw continually. I have to observe and to draw everything that belongs to country life; as many others have done before and are doing now.

I do not stand helpless before nature any longer, as I used to do. Nature always begins by resisting the artist, but he who really takes it seriously does not allow himself to be led astray by that resistance; on the contrary, it is a stimulus the more to fight for the victory. At bottom nature and a true artist agree. But nature certainly is 'intangible'; yet one must seize it, and that with a strong hand. I do not mean to say that I have reached that point already; no one thinks it less than I do, but somehow I get on better.

More and more I feel that the drawing of the figure is a good thing that indirectly has a good influence on the drawing of landscape. If one draws a willow as if it were a living being, and it really is so after all, then the surroundings follow in due course if one has only concentrated all one's attention on that same tree, and does not give up until one has brought some life into it. As I told de Bock, if he and I apply ourselves for a whole year on drawing the figure, then at the end we shall be quite different from what we are now; if we do not apply ourselves and just go on without learning anything new, then we do not even stay where we are, but slide back. If we do not draw the figure or draw trees as if they were figures, we are people without backbone, or with a weak one. He had to agree with me.

Of course I must pay the people who pose for me. It is not much, but as it is a daily recurrence it is an expense the more as long as I do not succeed in selling drawings. But as it seldom happens that a figure becomes a total failure, I think the expenses of the model will pretty soon be repaid. For at the present time there is some demand for anyone who has learned to attack a figure and to put it well on paper.

By chance Bosboom has seen my studies and has given me some hints about them. I only wish I had more opportunity of receiving such hints. Bosboom is one of those people who has the talent to impart knowledge to others, and make things clear to them.

From The Hague I brought some crayon in wood (like pencil), and that is what I use most just now. I also begin to touch up my work with a brush and stump, with a little sepia and India ink, and now and then with a little colour. It is a fact that the drawings I have made lately resemble very little those I used to make.

Well, as Mauve calls it, 'the factory is in full swing.'

So I have been to The Hague; perhaps it was a beginning of a more serious relation with Mauve and others.

There is something in my heart.

This summer a deep love has grown in my heart for our cousin K., but when I told her this she answered me that to her past and future remained one, so she could never return my feelings.

Then there was a terrible indecision within me what to do. Should I accept her 'No, never, never,' or should I keep some hope and not give up? I chose the latter — and I do not repent of that decision. Of course, since that time I have met with many '*petites misères de la vie humaine*'; even the little miseries of love have their value. One is sometimes in despair, there are moments when one seems to be in hell, but — there are also other and better things connected with it.

My position has become sharply outlined; I think I shall have the greatest trouble with the elder persons, who consider the question as settled and finished, and will try to force me to give it up. For the present I believe they will be very considerate to me, and put

me off with fair promises, until the silver wedding of Uncle and Aunt takes place in December. Then I fear measures will be taken to cut me off.

K. herself thinks she will never change her mind, and the elder people try to convince me that she cannot, yet they are afraid of that change. They will only change in this affair, not when K. changes her mind, but when I have become somebody who earns at least one thousand francs a year. Forgive me the harsh outlines in which I draw things. You will perhaps hear it said about me that I try to force the situation, and similar expressions, but who would not understand that forcing is absurd in love? No, that intention is far, very far from me. But it is no unreasonable or unjust desire to wish that K. and I might see each other, speak to each other, and write to each other in order to become better acquainted, and in this way to get a better insight into whether or not we are suited for each other.

The only one who told me, but very officiously and in secret, that there really was some chance for me if I worked hard and had some success was somebody from whom I did not expect it in the least: Uncle Vincent. He had rather liked the way in which I took K.'s 'No, never, never' — not taking it too seriously, but rather in a humorous way. Well, I hope to continue to do so, meanwhile working hard, and since I have met her I get on much better with my work.

I hope not to leave a single thing undone that may bring me nearer to her, and it is my intention

> To love her so long
> Till she'll love me in the end.

It is very sad that there are so many people who object to it, but I do not intend to get melancholy over it, and to lose my courage. Far from it.

I should not be surprised if this made a more or less strange impression on you. But I hope the impression has been such as to give a view, at least in part, of the whole situation. With long straight charcoal strokes I have tried to indicate the proportions and planes: when the necessary auxiliary lines have been traced, then we brush

off the charcoal with a handkerchief or a wing, and begin to draw the more intimate outlines.

In the first place I must ask if it astonishes you in the least that there is a love serious and passionate enough not to be chilled by many 'No, never, nevers.' I suppose, far from astonishing you, this will seem very natural and reasonable. For love is something positive, so strong, so real that it is as impossible for one who loves to take back that feeling as it is to take his own life.

I really do not think I am a man with such inclinations. Life has become very dear to me, and I am very glad that I love. My life and my love are one. For the present I consider that 'No, never, never,' as a block of ice that I press to my heart to thaw it. Which will win, the coldness of that block of ice or the warmth of my heart? — that is the delicate question, and I wish that other people would not speak about it, 'of course with the best intentions and for my own good,' if they can say nothing better than 'The ice will not thaw,' 'Foolishness.' What physical science has taught them that ice cannot be thawed is a puzzle to me.

K. has loved another and she seems to have conscientious scruples even at the thought of a possible new love. I saw that she always was thinking of the past and buried herself in it with devotion. Then I thought: Though I respect that feeling and though it touches and moves me, that deep grief of hers, yet I think there is some fatalism in it. So it must not weaken my heart. I will try to raise 'something new,' which does not take the place of the old, but has a right to a place of its own.

And then I began — at first crudely, awkwardly, but still firmly, and I finished with the words: 'K., I rove you as myself' — then she said: 'No, never, never.'

When it happened this summer it was at first as terrible a blow as a death sentence, and for a moment it absolutely crushed me to the ground. Then in that inexpressible anguish of soul rose a thought in me like a clear light in the night: Whosoever can resign himself, let him do so, but he who has faith, let him believe! Then I arose, not resigning but believing. When I had firmly resolved not to leave her even if it should cause her displeasure at first, when I

had no other thought than 'She, and no other,' then I felt a certain
firmness come over me. Then all things became new for me, then
was my energy increased.

Whoever has not learned to say, 'She, and no other,' does he
know what love is? When they said those things to me, then I felt
with all my heart, with all my soul, with all my mind, 'She, and no
other.' Perhaps some will say, 'You give evidence of weakness, ig-
norance of the world when you say, "She, and no other." Have
another string to your bow, try to get out of this difficulty.' Far
from me! This my weakness be my strength. I will be dependent
on 'her, and no other'; even if I could, I should not want to be in-
dependent of her.

So I remain calm and confident through all this, and that in-
fluences my work, which attracts me more than ever just because
I feel I shall succeed. Not that I shall become anything extraor-
dinary, but 'ordinary,' and then I mean by ordinary that my
work will be sound and reasonable, and will have a right to exist,
and will serve to some end. I think that nothing awakens us to the
reality of life so much as a true love. And whoever is truly conscious
of the reality of life, is he on the wrong road? I think not. But to
what shall I compare it, that peculiar feeling, that peculiar dis-
covery of love? And then it is a great surprise when you have
found someone and ... and ... if you then find yourself, not before
a 'Yes, and amen,' but before a 'No, never, never,' that is terrible.

Do you think it considerate of the family to insinuate that I
must be prepared to hear soon that she has accepted another
richer suitor, that she has a positive dislike for me if I go further
than 'brother and sister,' that it would be such a pity if 'mean-
while (!!!) I let a better chance go by (!!!) ...?

Only this summer you told me that you thought it better not to
speak about the difficulties of life, but to keep them to yourself.
This impressed me very much, though I was indeed far from sym-
pathizing with it, and know too well that my need for sympathy
has often induced me to seek it from people who, instead of
strengthening me, unnerved me. Father and Mother are very
good at heart, but have little understanding of our inward feel-

ings. They love us with all their hearts, and I as well as you love
them very much indeed, but alas, practical advice they cannot
give us in many cases. That is not our fault or theirs, but it is
the difference in age and in opinion, and in circumstances....
That our home is and remains our resting-place, come what may,
and that we must appreciate it, and from our side respect that
home, I quite agree, though perhaps you did not expect such
a candid declaration from me. However, there is a resting-place
better, more necessary, more indispensable than our home with our
parents, however good, however necessary, however indispensable
it may be, and that is our own hearth and home.

So, man of business, there is a love-story for you! Do you think
it very dull and very sentimental?

Since I really love, there is more reality in my drawings, and I
sit writing to you now in the little room with quite a collection
around me of men, women, and children from the *Heike*. Well, at
present I begin to feel that 'I have a draughtsman's fist,' and I am
very glad I possess such an instrument, though it may be unwieldy
still.

I should like it very much if you could persuade Father and
Mother to less pessimism and to more good courage and humanity.
I have been complaining a little about Father and Mother, but, after
all, except that they do not understand the least bit about it all and
could only call what I did this summer 'untimely and indelicate'
(till I requested them quite firmly not to use such expressions any
more), they are very good to me and kinder than ever. But I
should rather they could understand more of my thoughts and
opinions about many things. Theirs is a system of resignation to
which I cannot resign myself. One word from Mother this summer
would have given me the opportunity of saying many things to
her which could not be said in public. But Mother very decidedly
refused to say that word; on the contrary, she cut off every op-
portunity for me.

She came to me with a face full of pity and with many com-
forting words, and I am sure she had prayed a beautiful prayer for
me, that I might receive strength for resignation. But until now

that prayer has found no hearing, on the contrary, I have received strength of action.

To try just the opposite of some advice is often a very practical thing and gives one satisfaction. Therefore it is in many cases so useful to ask for advice. However, there is some advice that can be used in its natural state, and does not require being turned inside out or upside down. The latter kind is very rare and very desirable, for it still has some special peculiarities. The first kind can be found by the thousands everywhere.

Since the beginning of this love I have felt that unless I gave myself up to it entirely, without any restriction, with all my heart, there was no chance for me whatever, and even so my chance is slight. But what is it to me whether my chance is slight or great? I mean, must I consider this when I love? No — no reckoning; one loves because one loves. Then we keep our heads clear, and do not cloud our minds, nor do we hide our feelings, nor smother the fire and light, but simply say: Thank God, I love.

Whoever feels so sure of himself that he rashly imagines 'she is mine' before he has fought that soul's battle of love, I repeat, before he wavers between life and death, on a high sea, in storm and thunder, he does not know what a real woman's heart is, and that will be brought home to him by a real woman in a very special way. When I was younger I once half-fancied myself in love and with the other half I really was; the result of this was many years of humiliation. May all this humiliation not have been in vain! I speak as 'one who has been down,' from bitter experience and hard lessons.

Theo, if you were in love with the same sort of love as I — and, boy, why should you ever have another kind — then you would discover something quite new in yourself. Such as you and I, who as a rule generally associate with men, and you in a large way and I in a small attend to business of some kind, well, we are used to do most of our work with our brains — with a certain diplomacy, with a certain sharp calculation. But now fall in love and, look here, you will perceive to your astonishment that there is still another force that urges us on to action; that is the heart.

We are sometimes rather inclined to ridicule it, but it cannot be

denied to be true that when in love one says: I do not go to my head to ask my duty, I go to my heart. Especially when, as is now really the case, Father's and Mother's attitude is neither positive nor negative; that is to say, they do nothing openly for or against it. How they can bear this I do not understand; it is like being neither cold nor warm, and that is always a miserable thing.

When I spoke of it to Father this summer he interrupted me with an anecdote of somebody who had eaten too much, and another who had eaten too little; it was quite out of season, and it was an anecdote without beginning or end, so that I thought: What is wrong with Father? It was perhaps from nervousness, as he had not expected it, yet it was under his eyes, so to say, that she and I had walked together and spoken together for days and weeks. Now are those eyes in this mood clear-seeing? I think not. If I were hesitating, doubtful, of two minds, I might agree with their attitude. But now it is quite different. This my love has made me resolute, and I feel energy, new, healthy energy, in me; as everybody feels who really loves. So what I want to say is not more or less than that I firmly believe that any man is unconscious of some peculiar great hidden force, deeply hidden in him, until sooner or later he is awakened by meeting someone of whom he says, 'She, and no other.'

What kind of love was it I felt when I was twenty? It is difficult to define; my physical passions were very weak then, perhaps because of a few years of great poverty and hard work. But my intellectual passions were strong, and I mean thereby that without asking anything in return, I only wanted to give, not to receive. Foolish, wrong, exaggerated, proud, for in love one must not only give but also take, and, reversing it, one must not only take, but also give. There is written: 'Love thy neighbour as thyself.' One can deviate to the right or to the left, but both are bad. To ask everything without giving, that produces those members of society which we call rascals, thieves, and usurers; to ask nothing but give everything, that produces Jesuits and Pharisees, male and female, also rascals, you know! Whoever deviates either to the right or to the left, he falls; there is no help for it. So I fell, but it was a wonder

that I got up again. What helped me more than anything else to recover my balance was the reading of practical books on physical and moral diseases. I got a deeper insight into my own heart and also into that of others. By and by I began to love my fellow-men again, myself included, and more and more my heart and soul revived, that for a time through all kinds of great misery had been withered, blighted, and stricken. And the more I turned to reality and mingled with people, the more I felt new life reviving in me, until at last I met her.

If one has more ambition and love of money than love, in my opinion there is something wrong with that man. Ambition and greed are partners within us that are very hostile to love. The germs of these two forces are in all of us from the beginning. Later on in life they develop, generally in unequal proportions, in one love, in the other ambition and greed! My opinion is that love when it develops, when it comes to its full development, produces better characters than the opposite passion: Ambition and Company. If a man has only love and does not know how to earn money, there is something wrong in him also.

If I saw that she loved another man, I should go far, far away. If I saw that she took a man she did not love for his money, I should plead guilty to shortsightedness on my part, and I should say: I have mistaken a picture by Brochart for one by Jules Goupil, a fashion-print for a figure of Boughton, Millais, or Tissot. Am I as shortsighted as that? But my eye is well trained and steady.

That 'No, never, never,' has taught me things that I did not know before; in the first place, the enormity of my ignorance, and in the second place, that women have a world of their own. Also that there are means of subsistence. I should think it more considerate of people if they said (as the Constitution does, 'Every man is considered innocent until he is proved guilty') that they would consider a man to possess some means of subsistence until the contrary had been proved. They might say: 'This man exists — I see him, he speaks to me, the proof of his existence is that he is interested in a certain case. His existence being clear and evident to me, I will accept as an axiom that this existence is due to some means, which he

gets in some way, and for which he works. So I will not suspect him of existing without means of subsistence.' But people do not reason in this way. They want to see the means in order to believe in the existence of the person.

I sent you a few drawings because I thought you might find something of Brabant in them. Now tell me why they do not sell, and how can I make them salable? For I should like to earn some money for a railroad ticket so as to go and fathom that 'No, never, never.'

But you know you must not tell that intention of mine to the Right Reverend J. P. S., for if I come very unexpectedly he would possibly not be able to do anything but close his eyes to it. Such a Right Reverend J. P. S. becomes quite a different person when one falls in love with his daughter. He then becomes gigantic, and acquires unheard-of proportions, and asks what means of subsistence I have 'in the case in question,' for so the Reverend calls it, or rather he does not even ask about them because he (being a Philistine in the realm of art) thinks they do not exist at all. Well, this being so, we can for the present only show him a 'draughtsman's fist,' not to attack him with it, however, much the less to threaten him with it. But we must use that 'draughtsman's fist' as well as we can.

But that does not change the fact that if one loves his daughter one is not afraid of going to him, but is afraid of *not* going to him. All fathers of girls possess a thing which is called the key to the front door. A very terrible weapon which can open and shut the front door as Peter and Paul open the gates of heaven. Well, does this instrument also fit the heart of the respective daughters? I think not, but God and love alone can open or shut a woman's heart.

He who loves lives, he who lives works, he who works has bread. When she with her lady's hand and I with my 'draughtsman's fist' are willing to work, then the daily bread will not be wanting for us, neither for her boy.

Theo, I must see her face again, and speak to her once more. I want money for the trip to Amsterdam; if I have but just enough

I go. Father and Mother have promised not to oppose me in this, if only I leave them out of the matter. Brother, if you will send it to me, I will make lots of drawings for you from the *Heike*, and whatever you want. And they would not get worse if the 'No, never, never,' began to thaw.

If I could not give vent to my feelings now and then, I think the boiler would burst.

As you know, Father and Mother on one side and I on the other do not agree about what must be done or not done in regard to a certain 'No, never, never.' Well, after having heard for some time the rather strong expressions 'indelicate and untimely' (just fancy you were in love and they called your love indelicate), another term came up. They say now that 'I am breaking up family ties.' The fact that I 'wrote letters' was the real grievance against me. But when they persisted in using so rashly and recklessly that miserable expression 'breaking up family ties,' for a few days I did not speak a word or take any notice of them.

Of course they were astonished at my behaviour, and when they asked me about it, I answered: 'See, that is how it would be if there were no tie of affection between us, but happily it does exist and will not be broken so easily. But I beg you, consider now how miserable that expression "breaking up family ties" is, and do not use it any more.' But the result was that Father grew very angry, ordered me out of the room with a curse; at least, it sounded exactly like it! When Father gets in a passion he is used to having everyone give in to him, even I, but now I was quite determined to let him rage for once and go elsewhere; but because it was said in a passion, I do not attach importance to it.

Here I have my models and my studio; elsewhere living would be more expensive and my work more difficult, and the models would cost more. But if Father and Mother said in earnest to me, Go, of course I should go. There are things which a man cannot put up with. . . .

Yesterday I made another drawing, a peasant boy who early in the morning lights a fire on the hearth over which a kettle is hanging, and still another of an old man who puts kindling wood on

the hearth. I am sorry to say there is still something harsh and
severe in my drawings, and I think that she, her influence, must
come to soften that. When I look around I see the walls all covered
with studies relating to one subject: 'Brabant types.' So that is a
work I have started, and if I were taken suddenly out of these sur-
roundings I should have to start anew another thing and this one
would remain half-finished! That may not be! I have been work-
ing here since May; I begin to know and understand my models,
my work is progressing, but it has cost me a lot of trouble to get on
so far.

Is not that too bad, and would it not be ridiculous for that
reason to stop a work that has been started and begins to succeed?
No, no, that is not the way! It cannot be right.

Father and Mother are getting old, and they have their preju-
dices and old-fashioned ideas. When Father sees me with a French
book by Michelet or Victor Hugo, he thinks of thieves and mur-
derers, or of 'immorality,' but that is too ridiculous. So often I have
said to Father, 'Just read, then, if only a few pages from such a book
and you will be impressed by it yourself,' but Father obstinately
refuses to do so. I told him frankly that under the circumstances I
attached more value to the advice of Michelet than to his own, if
I had to choose which of the two I should follow.

I would not miss Michelet for anything in the world. It is true
the Bible is eternal and everlasting, but Michelet gives such very
practical and clear hints directly applicable to this hurried and
feverish modern life in which you and I find ourselves that he helps
us to make rapid progress and we cannot do without him. Michelet
and Harriet Beecher Stowe, they do not tell you the Gospel is of
no value any more, but they teach you how it may be applied in
our time, in this our life. Michelet even expresses things completely
and aloud of which the Gospel only whispers to us the germ.

Lately Father said to me: 'My conscience has never allowed me
to influence two people to marry.' Well, as for myself, my con-
science tells me exactly the opposite. Michelet luckily never had
those conscientious scruples or else his books would never have
been written. And out of gratitude to Michelet I promise that later

on, when I shall live more than now with artists who so often 'beat about the bush,' I shall do all I can to make it clear to them that they must marry. I add, for the benefit of art dealers who are afraid that 'keeping a family' costs more than not keeping a family, that a married artist with his wife spends less and is more productive than an unmarried one with his mistress. Is a wife more expensive than a mistress? You do pay the mistress, anyhow, Messrs. Art Dealers, and those ladies laugh at you behind your back.

But then they bring up a story of a great-uncle who was infected with French ideas, and who took to drink, and so they insinuate that I shall follow the same career.

The men and women who may be considered to stand at the head of modern civilization, for instance, Michelet and Harriet Beecher Stowe, Carlyle and George Eliot, and so many others, they call to you: 'Oh, man, whoever you are, who carries a heart in your bosom, help us to found something real, eternal, true; limit yourself to one profession and love one woman only. Let your profession be a modern one and create in your wife a free modern soul; deliver her from the terrible prejudices which chain her.'

We are full-grown men now, and are standing in the rank and file of our generation. We do not belong to the same generation as Father and Mother and Uncle Stricker do; we must be more faithful to the modern than to the old one; to look back at the old one is fatal. If the elder people do not understand it, that must not upset us, and we must go on our own way against their will; later on they will say of their own accord: 'Yes, you were right after all.'

Father and Mother are very good to me in this respect, that they do everything to feed me well. Of course I appreciate this very much, but it cannot be denied that food and drink and sleep are not enough for a man, but that he longs for something nobler and higher; ay, he positively cannot do without it.

That higher feeling which I cannot do without is the love for K. I would rather give up the work just begun and all the comforts of this home than resign myself to not writing her or her parents. My work certainly concerns you, for you are the one who has already given so much money to help me to succeed. Now, I am get-

ting on, it progresses, I begin to see some light; and now I tell you
this threatens me. I ask no better than to work on quietly, but
Father seems to want to put me out of the house; at least he said
so this morning.

In order to work and to become an artist one needs love. At
least, one who wants sentiment in his work must in the first place
feel it himself, and live with his heart. I think *she* begins to under-
stand that I am neither thief nor criminal, but, on the contrary, am
inwardly more quiet and sensible than I outwardly appear. She
did not understand that in the beginning — at first she really had
an unfavourable impression of me, but now, I do not know why,
while the sky becomes clouded and overcast with quarrels and
curses, there rises light from her side.

But Father and Mother are harder than a stone on the matter of
'means of subsistence,' as they call it. If there were the question
of marrying immediately I certainly should agree with them.
This is quite another thing, a matter of the heart, and therefore
she and I must see each other, write to each other, and speak to
each other; that is as clear as daylight, and simple and reason-
able.

For Heaven's sake let them for once give in; it would be too
foolish if a young man should sacrifice his energy to the prejudices
of an old man. And really Father and Mother are prejudiced in
this.

What artist is there who has not struggled and toiled, and what
other way is there but struggling and toiling to get a footing? And
since when has a draughtsman no chance of earning his living?

I began again to draw a man busy digging potatoes in a field.
And I put in a little more of the surroundings, some bushes in the
background and a streak of sky. I cannot tell you how beautiful
that field is! When I shall have earned a little more money and am
able to spend more on models, I tell you I shall make still quite
different things. It is hard work for the models too; the more so
because those I have are not models by profession, and perhaps
so much the better for that.

Your opinion about my drawings is more favourable than I de-

serve. Continue writing me about my work. Do not **fear to hurt** me by remarks; I will take such criticism as proofs of sympathy worth a thousand times more than flattery. You tell me practical things; from you I must learn to become practical, so preach me many a sermon, for I do not refuse to be converted and I am greatly in need of conversion.

If you ever have a chance of getting somebody interested in my work, I think you can begin to speak about me with some assurance. But in order to do better work I shall have to spend more on models. Now I spend twenty, twenty-five, or thirty cents a day, but I cannot do that every day, and it really is not enough; by spending a little more I could make more rapid progress.

You understand that I am not the man intentionally to grieve Father and Mother with anything. When I must do something in opposition to their wishes and which often grieves them without cause, I feel very sorry for it myself. But do not think that the late regrettable scene was only caused by hot temper. Alas, previously when I declared that I would not continue my study in Amsterdam, and afterwards in the Borinage, when I refused to do what the clergymen there wanted me to, Father said a similar thing. So there is, indeed, a lasting deep-rooted misunderstanding between Father and myself. And I believe that it never can be quite cleared up. But on both sides we can respect each other because we agree in so many things, though sometimes we have quite different, ay, even opposite ideas.

I think if Father understood my real intentions I could often be of some use to him, even with his sermons, because I sometimes see a text in quite a different light. But Father thinks my opinion entirely wrong, out of order, and systematically rejects it.

I do not think I ever received money more gratefully than those ten guilders from you for the ticket, for the thought was so unbearable to me that if I had to go, I should be unable to. By means of a registered letter I have tried to draw Uncle S.'s attention to some points which I fear he overlooked. There really are no more unbelieving and hard-hearted and worldly people than clergymen and especially clergymen's wives (a rule with exceptions). **But even**

clergymen have sometimes a human heart under an armour of triple steel.

'Greed' is a very ugly word, but that demon does not let anybody alone, and I should be greatly astonished if it had not sometimes tempted you and me, even so that for the moment we were inclined to say: 'Money is the ruler.' Not that you or I really bow to that Mr. Mammon and serve him, but it is true that he worries you and me a great deal: me, by poverty through many a year; you, through a high salary. These two things have in common the temptation to bow to the power of money. Now that money devil may not play you the trick of making you think it is a crime to earn much money, and making me think that there is some merit in my poverty. No, indeed, there is no merit in being so slow in earning money as I am, and I shall have to remedy that, and to do so you will give me many a useful hint, I hope.

You may be sure that I try very hard to change many things in myself. Now the best and most effective way of bettering myself financially is by working hard. But that alone is not sufficient, or rather there are still other things for which I must work. Perhaps it is not bad that I have lived so long 'under the ground,' as it were; that I have been 'one who has been down.' Now I need not go back into that abyss, and I think it right to do away with all melancholy and to take a somewhat broader and more cheerful view of life, walking on level ground, and then I also think it would be good for me to associate more with other people, to renew old relations as much as possible, and to enter into new ones. I shall meet with a rebuff here and there — that may be — but I want to carry it through and try to struggle to the surface.

I have sent Mauve a drawing of a man who digs potatoes in the field; I wanted to give him some sign of life from me.

I have often wondered whether it would not be possible and good to go for a time to The Hague, always considering this sphere of action here and Brabant types as my real work. Notwithstanding all, I must keep hold of this, and now that I have grown familiar with it, I can find here subjects for years and years. But keeping at those Brabant types need not prevent my seeking new relations else-

where, and even living elsewhere for a time. All artists and draughtsmen do so.

I write from The Hague. I'm staying in a little inn near Mauve.

I said to Mauve: 'Listen, Mauve, you intended to come to Etten and were to initiate me in the mysteries of the palette, but I thought that would not be a matter of a few days, so I come to you, and if you agree I shall stay four or six weeks, more or less if you say so; after that time I shall have overcome the first *petites misères* of painting, and then I shall go back to the *Heike.* It is very bold of me to ask so much from you, but you see, *j'ai l'épée dans les reins.*' Then Mauve said: 'Did you bring something with you?' 'Yes, here are a few studies'; and then he praised them a great deal too much, but at the same time he criticized, but too little.

Mauve said: 'I always thought you a dullard, but now I see that it is not so,' and I can assure you that this simple word of Mauve pleased me more than a cartload full of Jesuitical compliments would have done. Well, he at once set me down before a still-life of a pair of old wooden shoes, and some other objects, and he began by telling me: 'This is the way to keep your palette.' In the evening I go also to him to draw.

I cannot tell you how kind and friendly Mauve and Jet are to me these days. And Mauve has shown and told me things which, of course, I cannot do at once, but which I shall gradually put into practice. But I must work very hard.

Meanwhile I have been to Amsterdam. Uncle S. was rather angry, though he gave vent to it in more polite words than 'Damn you.' What must be done now? — for you know I came back no less in love than I went, but not because she encouraged me; on the contrary, she made me for a moment, or rather for twenty-four hours, profoundly miserable.

I went also to see Mr. Tersteeg, and among the painters I met (the merry) Weissenbruch, Jules Backhuizen, and de Bock.

I have now painted five studies and two water-colours and of course a few more sketches. The painted studies are still-life; the water-colours are made after the model, a Scheveningen giri.

But now it is almost a month since I have been here, and I have had a great many expenses. It is true that Mauve has given me several things, paint, etc., but I had to buy a great deal myself, and I have also paid the model for a few days; and I needed a pair of shoes. So I have overdrawn the two hundred francs limit, as this whole trip costs all in all ninety guilders. Father thought it very excessive that I had spent ninety guilders. But this is not unreasonable, for everything is so expensive. But I hate to have to account to Father for every cent I spend, the more so because it is told to everybody, not without enlargements and exaggerations.

I should like to stay here longer, ay, even to rent a room here, for instance, at Scheveningen for a few months, but as things are perhaps it is better for me to go back to Etten.

At all events, through Mauve I have got some insight into the mysteries of the palette and of water-colouring. And that will repay me for the ninety guilders the trip has cost.

Mauve says that the sun is rising for me, but is still behind the clouds. Well, I have nothing to say against that. I have full hope that I shall be able to make something salable in a relatively short time. Ay, I even think that these two would be salable in case of need. Especially one which Mauve has brushed a little. But I should rather keep them for a time myself, in order to remember better some things about the way in which they are done.

What a splendid thing water-colour is to express atmosphere and distance, so that the figure is surrounded by air and can breathe in, as it were. I think I shall make better progress now that I have learned something practical about colour and the use of the brush.

My trip to The Hague is something I cannot remember without emotion. When I came to Mauve my heart palpitated a little, for I said to myself: Will he also try to put me off with fair promises, or shall I be treated differently here? And I found that he helped me in every way, practically and kindly, and encouraged me. Not, however, by approving of everything I did or said; on the contrary. But if he says to me, 'This or that is not right,' he adds at the same

time, 'But try it in this or that way,' which is quite another thing than to criticize just for the sake of criticizing.

So when I left him I had a few painted studies and a few water-colours. Of course they are no masterpieces, but still I believe that there is something sound and true in them, at least more than in those which I have made before. And so I think this is the beginning of my making serious things. And as I now have a few more technical resources at my disposal, namely, paint and brush, all things seem as it were new to me.

But — now we must put that in practice. When Mauve saw my studies he said at once: 'You are sitting too close to your model.' That makes it in many cases almost impossible to take the necessary measures for the proportion, so that it is certainly one of the first things I must attend to. I must try to rent a large room somewhere, either a room or a barn. Besides, I must begin to use better paint and better paper now. For studies and sketches the Ingres paper is excellent, and it is much cheaper to make my own sketch-books, in different sizes, than to buy them ready-made.

Theo, what a great thing tone and colour are! And whoever does not learn to have a feeling for them, how far from real life he stands! Mauve has taught me to see many things I did not see before. And you cannot imagine what a feeling of deliverance I begin to feel when I think of what Mauve told me about earning money.

Just think how I have been struggling along for years in a kind of false position. And now, now, there comes a dawn of real light. I wish you could see the two water-colours which I brought with me, for you would see that they are water-colours like any other water-colours. There may be many imperfections in them; I shall be the first to admit that I am very much dissatisfied; but still they are quite different from what I made before, and look more bright and clear, but that does not exclude the fact that others in the future may become brighter and clearer still; but one cannot do right away what one wants. It will come gradually.

But though Mauve tells me that after having struggled on for a few more months and then coming back to him, say in March, I shall then make salable drawings, still I am now in a very difficult

period. The expenses for models, studio, drawing and painting materials increase, and I do not earn anything as yet.

It is true Father has said that I need not worry about the necessary expenses, and Father is very happy with what Mauve told him, and also with the studies and drawings that I brought back, but I think it very miserable, indeed, that he will have to pay for it. For since I have been here Father has not by any means profited by me, and more than once he has bought, for instance, a coat or a pair of trousers for me, which I should rather not have had, though I need them, the more because the coat or trousers in question do not fit, and are only of little or no use. And now I think that Father is rather hard up himself for the moment. Well, that is again one of the little miseries of human life.

Besides, I hate not to be quite free. Father is not a man for whom I can feel, for instance, what I feel for you or for Mauve. He cannot sympathize with or understand me, and I cannot be reconciled to his system — it oppresses me — it would choke me. I too read the Bible now and then, but in the Bible I see quite different things from those Father sees, and what Father draws from it in his academical way I cannot find in it at all. And when I read — and really I do not read so much, only a few authors — I do so because they look at things in a broader, milder, and more lovable way than I do, and because they know life better, so that I can learn from them; but all that rubbish about good and evil, morality and immorality, I care so very little for it. For, indeed, it is impossible always to know what is good and what is bad, what is moral and what is immoral. The morality or immorality brings me involuntarily back to K.

On a certain evening I strolled along the Keizersgracht looking for the house and I found it. I rang the bell and I was asked to come in. They were all there except K. Uncle S. opened the discussion as clergyman and father, and said that he was just about to send me a letter, and that he would read that letter aloud. But I asked: 'Where is K.?' (for I knew that she was in town). Then Uncle S. said: 'K. left the house as soon as she heard that you were here.' Well, I know her somewhat, but I declare that I did not know then

nor do I know with certainty now, whether her coldness and rude-
ness were good or bad signs. This much I do know, that I never
saw her so apparently or really cool, brusque, and rude to anyone
but me.

'Let me hear that letter or not hear it,' I said. 'I don't care
much about it.'

The document was very reverend and very learned; there was
really nothing in it except that I was requested to stop my corre-
spondence, and the advice was given me to make very energetic ef-
forts to put the thing out of my mind. I felt as if I had heard the
clergyman in church, after prancing up and down, with his voice
say, 'Amen'; it left me just as cool as an ordinary sermon. And
then I said as calmly and politely as I could: Yes, I had heard those
opinions before — but now — what further? And then Uncle S.
looked up. He seemed full of consternation at my not being fully
convinced that the utter limit of human capacity for feeling and
thinking had been reached. According to him there was no 'further'
possible. I got somewhat excited and lost my temper. And Uncle S.
lost his temper too, as much as a clergyman can do so.

But you know that in my way I love Father and Uncle S., and so
I gave in a little. At the end of the evening they told me I could
stay for the night if I wished. I said: 'I am very much obliged, but
if K. leaves the house when I come, I do not think it the time to
stay here overnight.' And then they asked: 'Where do you stay?'
I said, 'I do not know where as yet'; and then Uncle and Aunt in-
sisted they would take me to a good and cheap place. And, dear me,
those two old people went with me through the cold, foggy, muddy
streets, and they showed me, indeed, a very good and very cheap
inn.

And you see there was something humane in that and it calmed
me. I had other talks with Uncle S., but K. I did not see once. I
said that they must well know, though they wished me to consider
the question as settled and finished, I for my part could not do so.
And then they firmly and steadily answered, 'I should learn to see
that better afterwards.'

We who try our best to live, why do we not live more? I felt

quiet and lorn during those three days in Amsterdam; I felt abso-
lutely miserable, and that sort of kindness of Uncle and Aunt, and
all those discussions, it was all so dismal. Till at last I began to
feel quite depressed. And then I said to myself: You are not be-
coming melancholy again, are you? And so, on a Sunday morning
I went for the last time to Uncle S. and said: 'Just listen, dear Un-
cle, if K. were an angel, she would be too high for me, and I do not
think I could remain in love with an angel. If she were a devil, I
should not want to have anything to do with her. In the present
case I see in her a true woman with a woman's passions and moods,
and I love her dearly, and that is the truth and I am glad of it.'
And Uncle S. had not much to say in reply, and muttered something
about a woman's passions. I do not remember well what he said
about it, and then he went to church.

I still felt chilled through and through, as if I had been standing
too long against a cold hard whitewashed church wall. I did not
want to be stunned by that feeling. And — it is somewhat risky to
be a realist, but Theo, oh, bear with me my realism. I told you that
to some my secrets are no secrets. I do not take that back, think of
me what you will, and whether you approve or not of what I did,
that is of less consequence. . . .

Then I thought: I should like to see a woman; I cannot live with-
out love, without a woman. I would not give a farthing for life if
there were not something infinite, something deep, something real.
But then I said to myself: You said, 'She, and no other,' and you
would go to another woman now; that is unreasonable, that is
against all logic. And my answer to that was: Who is the master,
the logic or I? Is the logic there for me, or am I there for the logic;
and is there no reason and no sense in my unreasonableness and lack
of sense?

I am almost thirty years old; should you think that I have never
felt the need of love? K. is still older than I am; she also has had
experience of love; but just for that reason I love her the better.
If she wants to live only on that old love and refuses the new, that
is her business, and if she continues that and evades me, I cannot
smother all my energy and all my strength of mind for her sake.

No, I cannot do that. I love her, but I shall not freeze or unnerve myself. And the stimulus, the spark of fire we want, that is love, and not exactly spiritual love. I am but a man and a man with passions; I must go to a woman, or otherwise I freeze or turn to stone, or am stunned . . . that damned wall is too cold for me. But under the circumstances I had a great battle within myself, and in the battle there remained victorious some things which I knew of physics and hygienics, and had learned by bitter experience. One cannot with impunity live too long without a woman. And I do not think that what some people call God, and others Supreme Being, and others Nature, is unreasonable and without pity.

I had not far to seek. I found a woman, not young, not beautiful. She was rather tall and strongly built; she did not have ladies' hands like K.'s, but the hands of one who works much; but she was not coarse or common, and had something very womanly about her. She reminded me of some curious figure by Chardin or Frère, or perhaps Jan Steen. Well, what the French call '*une ouvrière*.' She had had many cares, one could see that, and life had been hard for her; oh, she was not distinguished, nothing extraordinary, nothing unusual.

Theo, to me there is such a wonderful charm in that slight fadedness, that something over which life has passed. It is not for the first time that I have been unable to resist that feeling of affection, ay, affection and love for those women who are so damned and condemned and despised by the clergymen from the pulpit.

That woman has not cheated me — he who regards all those women as cheats, how wrong he is, and how little understanding does he show! That woman has been very good to me, very good and very kind.

It was a modest simple little room where she lived; the plain paper on the wall gave it a quiet grey tone, yet warm as a picture by Chardin; a wooden floor with a mat and a piece of old crimson carpet, an ordinary kitchen stove, a chest of drawers, and a large simple bed, in short, the room of a real working woman. She had to stand at the washtub the next day. We talked about everything, about her life, about her cares, about her misery, about her health,

and with her I had a more interesting conversation than, for instance, with my very learned, professor-like cousin.

Now, I tell you these things hoping that you will see that, though I have some sentiment, I do not want to be sentimental in a silly way, that I want to keep some vitality, and to keep my mind clear and my health in good condition in order to be able to work.

The clergymen call us sinners, conceived and born in sin. Bah, what dreadful nonsense that is! Is it a sin to love, to need love, not to be able to live without love? I think a life without love a sinful condition and an immoral condition. If I repent of anything, it is of the time when I was induced by mystical and theological notions to lead too secluded a life. Gradually I have thought better of that. When you wake up in the morning and find yourself not alone, but see there in the morning twilight a fellow-creature beside you, it makes the world look so much more friendly.

Often when I walked in the streets quite lonely and forlorn, half ill and in misery, without money in my pocket, I looked after them and envied the men that could go with them; and I felt as if those poor girls were my sisters, in circumstances and experience. And you see that it is an old feeling of mine, and is deeply rooted. Even as a boy I often looked up with infinite sympathy, and even with respect, into a half-faded woman's face, on which was written, as it were: Life in its reality has left its mark here.

That God of the clergymen, He is for me as dead as a doornail. But am I an atheist for all that? The clergymen consider me as such — be it so; but I love, and how could I feel love if I did not live, and if others did not live, and then, if we live, there is something mysterious in that. Now call that God, or human nature or whatever you like, but there is something which I cannot define systematically, though it is very much alive and very real, and see, that is God, or as good as God. To believe in God for me is to feel that there is a God, not a dead one, or a stuffed one, but a living one, who with irresistible force urges us towards '*aimer encore*'; that is my opinion.

So I have acted as I did, from need of vital warmth. I tell you this also that you may not again think of me as being in melancholy

or abstract, brooding mood. On the contrary, I am generally occupied with, and not only thinking of, paint, water-colour, and finding a studio.

I sometimes wish that the three months before I can go again to Mauve were up. But they, too, will bring me some good of their own! Mauve has sent me a painting box with paint, brushes, palette, palette knife, oil, turpentine; in short, everything necessary. So it is now a settled thing that I shall begin to paint, and I am glad things have come so far.

Well, I have been drawing a good deal of late, especially studies of the figure. If you saw them now, you would see in what direction I am going. Of course I am now longing to hear what Mauve will have to say. The other day I made some drawings of children, too, and liked the work very much.

These are days of great beauty in tone and colour; when I have made some progress in painting, I shall succeed some day in expressing a little of that, but we must stick to the point, and now that I have begun the drawing of the figure, I shall continue it until I am more advanced, and when I work in the open air it is to make studies of trees, viewing the trees as real figures. I mean especially with a view to the outline, the proportion, and the construction; that is the first thing one has to consider. Then come the modelling and the colour and the surroundings, and it is about those that I need Mauve's advice.

But, Theo, I am so very happy with my painting box, and I think it better that I should have it now, after having drawn almost exclusively for at least a year, than if I had started with it immediately.

Here in Holland I feel much more at home, ay, I think I shall again become quite a thorough Dutchman, in character as well as in my style of drawing and painting.

And so in March I shall go to The Hague again, and to Amsterdam.

Theo, with painting my real career begins. Don't you think I am right in considering it so?

BOOK II
December 1881–September 1883

THAT which fills my head and my heart must be expressed in drawings or pictures. How will it be with my work a year hence?

At Christmas I had a violent scene with Father, and it went so far that Father told me I had better leave the house. Well, he said it so decidedly that I actually left the same day. The reason was that I did not go to church, and also said that if I was forced to go, I certainly should never go again out of consideration, as I had done rather regularly all the time I was in Etten; that I thought their whole system of religion horrible, and just because during a miserable time of my life I had gone so far into those questions, I did not want to think of them any more. But, oh, in truth there was much more in back of it all, among other things the whole story of what happened this summer between K. and me.

I went back to Mauve and said: 'Listen, Mauve, at Etten I cannot stay any longer and I must go and live somewhere else, by preference here.' Well, Mauve said: 'Then stay.' And so I have rented a studio — that is, a room and an alcove that can be arranged for that purpose — on the outskirts of town, on the Schenkweg, ten minutes from Mauve. It costs only seven guilders a month. The light comes from the south, but the window is large and high, and I think the room will look pleasant after some time. You can imagine that I feel quite animated.

I am in for it now; the die is cast. But some day I should have had to set up for myself, so what shall I say? It is an inconvenient moment, but how can it be helped?

You can imagine I have a great many cares and worries. But

still it gives me a feeling of satisfaction that I have gone so far that I cannot go back again, and though the path may be a difficult one, I now see it clearly before me.

Father said if I wanted money he would lend it to me, but that is impossible now. I must be quite independent of Father. How? I do not know as yet. As to the relation between Father and me, that will not be redressed so very easily. The difference in our views and opinions is too great.

The first of January I shall move into the new studio. Instead of a bed I should be satisfied with a blanket on the floor. But Mauve insists on my buying a bed and a few pieces of furniture. He says: 'I will lend it to you if necessary.' And according to him I must dress somewhat better and not try to skimp too much.

I do not wish to associate much with other painters. Each day I find Mauve more clever and more trustworthy, and what more can I want! I know now the direction in which I have to go, and need not hide myself; so I shall not avoid meeting other people — neither shall I seek them.

The furniture I have taken is in the real 'Constable style,' as you call it; but I think mine is more so than yours, although you have invented the word. I have, for instance, real kitchen chairs, and a real strong kitchen table.

Mauve has lent me one hundred francs for rent and furniture, and to have the window and light adjusted. You can imagine that I at first greatly dreaded the feeling of being in debt, but — well, it was the only possible way, because in the long run it is much cheaper to have things of your own than always to spend money for a so-called furnished room. I had counted positively on your sending me the one hundred francs at least for the month of January.

Mauve gives me great hope that I shall soon begin to earn something. And now that I am in a studio of my own, this will not make an unfavourable impression on the persons who suspected me of amateurism, of idleness.

I shall not consider it as a misfortune that things have gone so: on the contrary, notwithstanding all kinds of emotions, I feel a certain calm. There is safety in the midst of danger. What would

life be if we had no courage to attempt anything? It will be a hard pull for me; the tide rises high, almost to the lips and perhaps higher still, how can I know? But I shall fight my battle, and sell my life dearly, and try to win and get the best of it.

But now, boy, I have a real studio, and I am so glad. I could not dare to hope that it would happen so soon. Mauve himself is very busy with a large picture of a fishing smack drawn up the dunes by horses. I think it delightful to be at The Hague and I find so many beautiful things here. I must try to express something of it.

We arranged that I shall work regularly from the model; it is the most expensive and yet the cheapest way in the end. The worst is that I cannot work with a model until I have again some money in my pocket, so I can hardly do anything, as the weather is too bad to sit outside, though I tried it several times. The last few days I have been faint with suspense. I have been looking for models, and found a few, but I cannot take them. Towards Mauve I must put a good face on the matter; Mauve has really done enough. He has promised me that he will at once propose my name for a special membership of Pulchri, because then I can draw there twice a week in the evening after the model, and have more intercourse with painters.

De Bock does not improve on further acquaintance; he rather lacks backbone, and he gets angry when one says some things which are only the A B C. He has some feeling for landscape, he knows how to put some charm in it, but one gets no hold on him. It is too vague and thin.

In desperation I went today to Goupil's, for I thought I would in Heaven's name ask Tersteeg to lend me something. He has given me twenty-five francs until I should receive your letter. It would perhaps be well if with our mutual consent an arrangement were made with Mr. Tersteeg. For you understand, Theo, I must know for certain what I can expect and I must reckon and count before-hand, and must know if I can do this or that, or if I cannot do so. He can control the spending of it if he does not trust me. But it would be terrible if I could not go on working in the same way as I have done these last three weeks.

It is a time of struggle for you and for me, but I think we are making progress.

You say: 'For the present it is Mauve who attracts you, and so you exaggerate; everyone who is not like him is not to your taste, because you look for the same qualities in everybody.'

Outwardly I put the matter straight by writing again to Father, saying that I had rented a studio, that I sent my best wishes for the New Year, and that I hoped during the new year we should never quarrel again. More I cannot, more I need not do.

You say: 'You will deeply repent it some day.' My dear boy, I think I have done much of that repenting before this. I saw it coming and tried to avoid it; well, I did not succeed, and bygones are bygones. Shall I repent still more? No, I really have no time for repenting. Drawing becomes more and more a passion with me, and it is a passion just like that of a sailor for the sea.

It would have been much better if I had spent this winter at Etten, and it would have been much easier for me, especially for financial reasons; if I began to think and worry about that it would make me melancholy again. Once I am here I must manage to get through. I throw myself heart and soul into my work here, and what shall I say, Etten is lost and the *Heike*, but I shall try to gain something in their place.

As to Mauve — yes, certainly I am very fond of Mauve, and feel sympathy with him. I love his work, and I call myself fortunate to be able to learn from him. But no more than Mauve himself can I confine myself within a system or theory, and besides Mauve and Mauve's work, I love others also, who work quite differently from him. And as to myself and my own work, perhaps there is some similarity, but there certainly is some difference too. When I like somebody or something, I do it in all seriousness, and sometimes with passion and fire, but I do not systematically find only a few persons perfect and all the rest unworthy — far from it.

My studio begins to look well now. I wish you could see it some-time; I have hung all my studies on the wall, and I want you to send me back those you have, for they may be of service to me. They may be unsalable and I readily acknowledge all their defects,

but there is something of nature in them, because they have been made with a certain passion.

I have some flowers too, a few pots with bulbs. And besides that I have got another decoration. I have bought very cheaply some beautiful woodcuts from the 'Graphic,' prints not from the *cliché*, but from the blocks themselves. Just the thing that I have been wanting for years. There are things among them that are superb; for instance, 'The Houseless and Homeless' by Fildes, and two large Herkomers, and 'The Irish Emigrants,' and especially 'A Girls' School' by Frank Holl, and 'The Old Gate' by Walker.

Well, that is just the stuff I want.

And I keep those beautiful things with a certain tranquillity, because, lad, though I am still far from making perfect drawings myself, yet I have hanging on the wall a few studies of old peasants that prove how my enthusiasm for those artists is not in vain, but that I struggle and strive to make something myself that is realistic and yet done with sentiment.

I have about twelve figures of diggers and men who are working in a potato field, and I wonder if I could not make something of it, for here in the dunes I could make a good study of the earth and the sky, and then boldly put in the figures. But still I do not attach too much importance to these studies, and hope, of course, to make them quite different and better still, but Brabant types are characteristic, and who knows if I cannot get some profit from them?

Mauve has now shown me a new way to make something, that is, how to paint water-colours. Well, I am quite absorbed in this and sit daubing and washing out again. I started at once a few smaller water-colours and also a large one. But, Theo, I can assure you that when I went for the first time to Mauve with my pen drawing and Mauve said, 'You must try it now with charcoal and chalk and brush and stump,' I had a deuced lot of trouble to work with that new material. I have been patient and it did not seem to help, then at times I became so impatient that I stamped on the charcoal and was utterly discouraged. And yet, after some time, I sent you a drawing made in chalk and charcoal and with the brush, and I

came back to Mauve with a whole lot of them, in which he, of course, found something to criticize and with reason, but still I had made a step forward.

Now I am again in such a period of patience and impatience. Mauve himself says that I shall at least spoil about ten drawings before I shall know how to handle the brush well. But back of it is a better future, so I work with as much composure as I can collect, and am not disheartened even by my mistakes.

Another bad thing is the weather is very unfavourable, so life is not so very easy for me this winter. Still I enjoy it, and especially the fact that I have a studio of my own is inexpressibly delightful.

They tell me somebody has been to see me today. I think Mr. Tersteeg. I hope so, for I should like to talk with him about a few things. He said he would come back tomorrow morning.

One of the small water-colours is a corner of my studio with a little girl who is grinding coffee. I am seeking for tone, a head or a little hand that has light and life in it, and that stands out against the drowsy dusk of the background, and then boldly against it that part of the chimney and stove, iron and stone, and a wooden floor. If I could get the drawing as I want it, I should make three-fourths of it in a green-soap style, and only the corner where the little girl sits would I treat tenderly, softly, and with sentiment. But you understand I cannot express everything as I feel it, but the question is to attack the difficulties, and the green-soap part is not yet green-soapy enough, and on the other hand the tenderness is not tender enough. But at any rate I have hammered the sketch on the paper, and the idea is expressed, and I think it a good one.

Theo, I have great trouble with the models. I hunt for them and when I find them it is hard to get them to come to the studio. This morning a blacksmith's boy could not come because his father wanted me to pay a guilder an hour. For my part I promise you to work as hard as I can, but with models, for instance, it often depends on the money I have or have not in my pocket, whether I can work full speed, half speed, or not at all. Of course, you understand that I like best to go full speed, but — well, you know what I

mean. I must rein myself in until I have rather more scope and freedom.

Now that I am settled here, small expenses spring up afresh every day. For though one hundred francs a month would be sufficient for my own expenses, I spend what is necessary, though living as cheaply as possible (I take my meals in the soup kitchen); it is quite a different matter when I have to pay models daily and must feed them.... Yet I hope you will not object to my going on.

Now another week has passed. I have had a model regularly, every day from morning until evening, and the model is good. I have been working in water-colours and grow to like it more and more. Tomorrow an old woman will sit for me again.

Meanwhile, I intend to go on making those little pen drawings, but in a different way from that large one of this summer: somewhat more crude and more austere. When I go out, I often make sketches in the soup kitchen or in the third-class waiting-room, and such places. But outside it is so deuced cold, especially for such as I who do not draw as quickly as the more advanced, and who must finish my sketches more in detail if they are to be of any use.

So you see that I do not sit idle, but try to get rooted here. Mauve has come to see me and Mr. Tersteeg also, and I am very glad of that. I am making progress, and I shall learn to make water-colours, and then it will not be so very long before my work becomes salable. Mr. Tersteeg himself said something about it, and when some of those smaller ones turn out well, he will probably buy. I have completed still further the drawing of the little old woman of which I sent you a sketch, and some day it will surely sell.

Believe me, I grind all day long and I do so with pleasure, but I should get very much discouraged if I could not go on working as hard or even harder. As to the size of the drawings or the subjects, I shall readily listen to the suggestions of Mr. Tersteeg and Mauve. I undertook some large ones lately. And now Mauve said to me last night, 'It begins to look like a water-colour.' Well, if I gain that much I reckon to have wasted neither time nor money. And now that I have tried the use of the brush and the strength of the colours on a larger size, I can again risk some smaller ones.

I feel, Theo, that there is a power within me, and I do what I can to bring it out and free it. It is bad enough that you have to pay for everything, but things are not so bad as they were last winter. I shall work hard, and as soon as I have more power over my brush, I shall work still harder than I do now. And if we push on energetically now, the time will not be far off when you need not send me money any more.

What I had feared has happened. I have not been well. I felt so miserable that I went to bed. I had a headache and toothache now and then, and was feverish from worry, because I dreaded this week so much and did not know how to get through it. And then I got up, but went back to bed again. I have been in bed for almost three days with fever and nervousness. I felt so clearly that my strength was failing me, not my ardour or my courage.

Daily small expenses taken all together worry me a great deal. I have relatively still so few drawing materials or else defective ones; for instance, this week my drawing-board warped like a barrel because it was too thin, and my easel also got damaged in the delivery. Sometimes my clothes need repairing, and Mauve already has given me a few hints about that. You know my clothes are chiefly old things of yours that have been altered for me, or a few are bought ready-made and are of poor material. So they look shabby, and especially with all that dabbling in paint it is still more difficult to keep them decent; with boots it is the same. My underwear also begins to wear to shreds. You know that for a long time I have been without means.

I think it really was because I had arranged with Mauve about things I should do with a model out-of-doors, and I had not a cent left, and Mauve will think that I was afraid to do it. And then it sometimes happens that one becomes involuntarily depressed, be it only for a moment, often just in the midst of feeling cheerful; those are evil hours when one feels quite helpless.

If I only continue working hard, it will not be long before I earn something with my work, but until then it hinders me so much when I have to think about too many other things against my will;

while I am in front of my model not to know how I shall pay him, and whether or not I shall be able to go on next day. And I must be calm and quiet in order to work; it is difficult enough anyhow. I think the success or failure of a drawing depends also greatly upon the mood and condition of the painter. Therefore, I try to do what I can to keep cheerful and clear-headed. But sometimes, as now, a heavy depression overcomes me, and then it is damnation. The only thing to do then is to go on with the work, for Mauve and Israëls and so many others, who are examples to the rest of us, they know how to profit from every mood.

Mauve has been to see me and we once more agreed to keep courage through all. But I am so angry with myself because I cannot do what I should like to do, and at such a moment one feels as if one were lying bound hand and foot at the bottom of a deep dark well, utterly helpless.

Now I am better, in so far that I got up again yesterday evening and rummaged around straightening things, and then this morning the model came of her own accord. I arranged with Mauve how to pose her and tried to draw a little, but I could not do it, and the whole evening I felt weak. But if I rest a few more days, it will be over and I need not be afraid that it will come back soon if I am careful. Taken all together I do not feel so strong as a few years ago; then it never happened that I had to stay in bed a day.

Well, my youth is gone; not my love of life or my energy, but I mean the time when one feels so light-hearted and care-free. I really say: There are much better things, after all.

I have some hope that as soon as I am quite well again, things will go better than they do now. Mauve says it will be all right, but for all that the water-colours I make are not quite salable. When my drawings become thick, muddy, black, and dull, Mauve says, to comfort me: 'If your work were transparent now, it would only possess a certain *chic*, and it would probably become heavy later on. Now you are pegging away at it, and it becomes heavy, but afterwards it will go quickly and become light.' If that is true, I have no objection to it. And you can see it now from the little one I am sending you; it was started and finished in a quarter of an

hour, but only after I had made a larger one that became too heavy.
Just because I had worked so hard on that large one, when the
model accidentally took the pose again, I was able to sketch in this
little one on a bit of paper that was left from a sheet of Whatman.
But the experiments with water-colours are rather expensive —
paper, paint, brushes, model, and time.

Still I think the most economical way is to keep going. For this
bad time *must* be lived through. When you were in Etten this
summer, you spoke about my working in water-colours. Then I
did not even know how to start it.

My work becomes more and more absorbing to me, and it is only
with an effort that I tear myself away from it to write a letter or
call on someone when it is necessary. When I went to see Tersteeg,
I took a few drawings with me, and he said they were better than
the others and he told me to make again some small ones. And I
am busy with them now. I made also a new pen drawing of an old
woman who sits knitting. I was very glad that he found the draw-
ings somewhat better. Well, I begin to get more used to my model,
and for that very reason I must continue with her. In the last two
studies I grasped the character much better; everyone who saw
them told me so.

A few days ago I wrote C. M. to tell him that I have taken a
studio here, and that I hoped he would let me know whenever he
came to The Hague and that he would come and see me. Uncle
'Cent also told me this summer that whenever I had finished a
drawing somewhat smaller than those of this summer, and more of
a water-colour, I must send it to him and he would buy it.

You must tell me if you can find out what kind of drawings the
magazines would take. I think they could use pen drawings of
types from the people, and I should like so much to make some-
thing that is fit for reproduction.

Lately I have been out to draw sometimes with Breitner, a young
painter. He draws very well, and in quite a different style from
me, and we often make sketches together in the soup kitchen or in
the waiting-room. Now and then he comes to my studio to see
woodcuts and I go to see him also.

Yesterday I had a lesson from Mauve on the drawing of hands and faces to keep the colour transparent. I must try and forget some things that I taught myself, and learn to look at things in quite a different way. It takes a lot of trouble before one has a steady eye for proportion. I think that in my last drawings the proportions are much better than before, and that has been the worst fault in them up to now; thank God, that is changing, and now I do not fear anything.

It is not always easy for me to get on with Mauve or *vice versa*, because I think we are equally nervous, and it costs him a real effort to show me, and me not less to understand, and to try to put it in practice. But I think we are both beginning to understand each other, and it becomes a somewhat deeper feeling than superficial sympathy. He is very busy with his large picture. It is splendid. And he is also busy with a winter landscape, and some fine drawings. I think he gives in each picture and in each drawing some small part of his life. He is at times tired to death, and lately he said, 'I do not seem to get any stronger,' and whoever had seen him at that moment would not soon forget the expression of his face.

It is now the eighteenth of February. Mr. Tersteeg has bought a small drawing from me for ten francs, and with that I managed this week. But he wants small drawings and only in water-colour. I can assure you once more that I work hard to make progress in things that will be easy to sell — that is, water-colours — but that cannot be accomplished at once. If I succeed in making them by and by, it would even then be rather soon, considering the short time I have been working. But at least one sheep has passed the bridge.

This week I made three other studies besides the one Mr. Tersteeg bought. I am very glad that I feel my drawing is improving; it gives me courage. Drawing is the principal thing, whatever they may say, and it is the most difficult too. It is for that reason that I dare say I shall make something salable within a year. We must keep on and continue, brother, you as well as I, and some day we shall reap the fruit of it.

This afternoon de Bock came to see me, just when I was working

with my model, and when he saw her, he said he would also like to draw from the figure, but with all that he does not do so. I am so glad I have worked on the figure until now. If I had made land-scape only, yes, then I should now probably make something that would sell at a small price, but then afterwards I should be stranded. The figure takes more time and is more complicated, but I think it is more worth while in the long run.

Lately Mauve has done very little for me. This morning I was still in doubt about something that worried me exceedingly, but about which I am now at ease for a time. Mauve is far from well — of course the usual thing. But I have the assurance that it is only because of his illness that he has treated me so very unkindly of late, and that it was not because he thought my work has gone wrong. He said so himself: 'I am not always in a mood to show you things; sometimes I am too tired, and then you must for goodness' sake await a better moment.'

Weissenbruch is for the present the only one allowed to see Mauve, and I thought I would go and speak to him. So I went today to his studio. As soon as he saw me, he began to laugh and said, 'I am sure you come to speak about Mauve.' Weissenbruch then told me that the reason of his visit to me the other day was that Mauve, who was in doubt about me, had sent him to hear his opinion about my work. And Weissenbruch then told Mauve: 'He draws confoundedly well; I could work from his studies myself.'

And he added, 'They call me "the merciless sword," and so I am, and I should not have said so to Mauve if I had found no good in your studies.' Now, as long as Mauve is ill or too busy with his large picture, I may go to Weissenbruch if I want to find out any-thing, and he told me that I need not worry about the change in Mauve's attitude towards me. Then I asked Weissenbruch what he thought of my pen drawings. 'They are the best,' he said.

When I told him, 'I *see* things like pen drawings,' he said, 'Then you must draw with the pen.' Then I told him that Tersteeg had scolded me about them. 'Do not mind it,' he said. 'When Mauve said you were a born painter, Tersteeg said No, and Mauve then took your part against Tersteeg, and I was present; and if it happens

again, I shall take your part also, now that I have seen your work.'

I do not care so much about that 'taking my part,' but I must say that sometimes I cannot bear it when Tersteeg always and always says to me, 'You must begin to think about earning your own living.' I think it is such a dreadful expression, and then all I can do is to keep calm. I work as hard as I can and do not spare myself, and they ought not to reproach me for not being able until now to sell anything.

I think it is a great privilege to visit now and then such clever people as Weissenbruch, especially when they take the trouble — as for instance he did this morning — to show me a drawing that they are working on, but which is not yet completed, and explain how they are going to finish it. That is what I want. Whenever you have an opportunity to see anyone paint or draw, observe it well, for I think that many an art dealer would judge differently many pictures if he knew how they were made. It is true one can understand it somehow by instinct, but this much I know, that I got a clearer insight into many things by having seen artists at work and by trying some things myself.

Today I have a child, who has to rest for half an hour, and that half-hour I use to write.

You must not take it amiss, Theo, or think that I am finding fault with you, but you have written me something which you thought would perhaps please me, but it did not please me at all. You said that small water-colour was the best of mine that you had seen — well, that is not so, because the studies of mine which you have are much better, and the pen drawings of this summer are better also, for that little drawing is of no importance whatever. I sent it to you only to show that it is not impossible that I may work in water-colour sometime. But in those other things there is much more serious study and more character. And if I had anything against Mr. Tersteeg, it would be that same thing, which is that he encourages me, not in difficult study from the model, but rather in a style of work that really is only half fit to render what I want to express, according to my own character and **my own** temperament.

Of course I should be very happy to sell a drawing, but I am
happier still when a real artist such as Weissenbruch says about an
unsalable (? ? ?) study or drawing: 'That is true to nature; I could
work from that myself.' Although money is of great value to me,
especially now, the principal thing for me remains to make some-
thing serious.

Well, the same thing that Weissenbruch said about a landscape,
a field of turf, Mauve said about a figure, and an old peasant who
sits brooding on the hearth, as if he saw things from the past rising
in the blaze of the fire or in the smoke. It may last a longer or a
shorter time, but the surest way is to penetrate deep into nature.

For the rest, I shall run after people less and less, whoever they
may be, neither dealers nor painters; the only people I shall run
after are models, for to work without a model I think, for me at
least, decidedly wrong.

Theo, it is pleasant after all when some light begins to dawn, and
I do see some light now. It is a wonderful thing to draw a human
being, something that lives; it is confoundedly difficult, but after all
it is splendid. I was very glad that you wrote you would come
soon to Holland. When you come, I hope we shall spend some
quiet time in the studio.

Since I received your letter and the money, I have had a model
every day, and I am head over ears in my work. It is a new model
I have now; or rather it is more than one model, for from the same
family I have already had three persons, a woman of forty-five, like
a figure by Frère, then her daughter of about thirty years, and a
younger child of ten or twelve. They are poor people, and I must
say they are more than willing. The younger woman is not hand-
some, but the figure is very graceful and has some charm for me.
They have also the right clothes: black merino and a nice style of
bonnets, and a beautiful shawl. You need not feel too uneasy about
the money, for I made some arrangement with them in the begin-
ning that I shall make up to them later because I pay too little now.

Tomorrow I have a children's party, two children that I must
amuse and draw at the same time. Next Sunday I shall have a boy
from the Orphanage, a splendid type.

l want some life in my studio, and have all kinds of acquaint-
ances in the neighbourhood. It is perhaps true that I cannot get on
very well with people who are very conventional, but, on the other
hand, I can perhaps get on better with poor or so-called common
people, and though I lose on one side, I gain on the other. I let
things go and say to myself: After all, it is right and just that as an
artist I live in the sphere I understand and want to express. There
is something very pleasant in the intercourse with the models; one
learns much from them. This winter I have had some people that
I shall not easily forget.

It is now again the beginning of the month.

Breitner is busy with a large picture, a market full of figures.
Yesterday evening I was out with him to look for types of the
people in the streets, so as to study them afterwards at home with a
model. In that way I made a drawing of an old woman I saw on the
Geest, where the insane asylum is.

I must try to get someone to buy my drawings, but if I could
afford it, I should keep everything I make now for myself. When I
draw separate figures, it is always with a view to a composition of
more figures; for instance, a third class waiting-room, a pawnshop,
or an interior. But these larger compositions must ripen slowly,
and for a drawing of, for example, three seamstresses one must
draw at least ninety seamstresses.

Mr. Tersteeg has been to see me.

In your letter of February 18 you said: 'When Tersteeg was here,
we of course spoke about you, and he told me that whenever you
wanted anything you could always go to him.' But why is it, then,
that when I asked Tersteeg some days ago for ten francs he gave
them to me, but accompanied by so many reproaches that I could
hardly control myself? I should have thrown the ten francs in his
face if the money had been for myself, but I had to pay the model,
a poor sick woman whom I may not keep waiting. So I kept
quiet. But for six months I shall not go to Tersteeg again, or speak
to him, or show him my work.

Dear Theo, you may say, 'You must remain on good terms with
Tersteeg; he is almost like an elder brother to us.' But, my dear

fellow, he may be kind to you; to me for years he has shown only his unfriendly and harsh side.

In all those years, between the time when I left Goupil and when I began to draw (which I acknowledge was a mistake not to do at once); in those years when I was abroad without friends or help, suffering great misery (so that in London I often had to sleep in the open air, and in the Borinage did so three nights in succession), did he ever give me a piece of bread then? Did he ever encourage me? I think not. When he lent me the Bargues, I had literally beseeched him four times. When I sent him my first drawings, he sent me a painting box. I readily believe those first drawings were not worth any money, but you see a man like Tersteeg might have argued, 'I know him of old, and I shall help him to get on,' and he might have known I needed it so badly in order to live.

When I wrote to him from Brussels, 'Would it not be possible for me to work for a time at The Hague, and have some intercourse with painters,' he tried to put me off. and wrote to me, 'Oh, no, certainly not; you have lost your rights'; I had better give lessons in English and French, or I had better try to get copy work from Smeeton and Tilly, though the latter was not exactly in my neighbourhood, and besides, in Brussels several lithographers had refused me this; there was no work, things were dull, was the answer.

When this summer I again showed him drawings he said, 'I had not expected this,' but did not take back his former words. When I came to The Hague, after all, without asking his advice, he tried to cut me out. I hear he laughed at my becoming a painter. I perceived that Mauve thought me a greenhorn, and was quite astonished to find me a different person from the one he had heard described. I did not ask Mauve for money, but he said of his own accord, 'You need money; I will help you to earn money — you may be sure that now your hard years are over and the sun is rising for you, and you have worked hard for it and honestly deserve it.' And the first thing Mauve did was to help me to get settled.

Tersteeg would have the right to reproach me if I did not work, for in fact I am a drudge, or a draught ox (because I work so much

he thinks it is easy, therein he also is quite wrong), but it is unjust to someone who toils patiently, hard, and continuously on a difficult work, to make reproaches like this:

'Of one thing I am sure, you are no artist.'

'One great objection for me is that you started too late.'

'You must earn your own living.'

Then I say, 'Stop; be careful what you say.'

You must understand such things are too unreasonable to let pass, and they grieve me, and I think there must come an end to it now.

When in a moment of great money difficulty I forgot myself and thought, I shall try to make something that has a certain aspect, the result was deplorable, and Mauve had reason to be angry with me and said, 'That is not the way; tear up those things.' But Tersteeg became angry and overlooked the good points in my drawings, and asked straightway for 'salable' ones. Well, you see at once by this that there is a difference between Mauve and Tersteeg.

The substance of what Mauve has said up to now is, 'Vincent, when you draw, you are a painter.' And therefore I have worked for weeks and weeks on drawing, on proportion, on perspective, and Tersteeg does not appreciate this enough and talks only about 'things that don't sell.' I should like to know what the painters would say of his argument, 'To work less from the model because it is cheaper,' when after a long search one has found models that are not too expensive. Neither is it easy to find models and to get them to sit for me. This discourages most painters. Especially when one must save on food, drink, and clothes to pay them. To work without a model is the ruin of a painter of the figure.

Tersteeg even says about my drawing, 'That is a kind of narcotic which you take in order not to feel the pain it costs you not to be able to make water-colours.' Well, that is very finespun, but the saying is thoughtless, superficial, and not to the point. The principal reason for my not being able to make water-colours is that I must draw still more seriously, paying more attention to proportion and perspective.

I wish Tersteeg had to live for a week on what I have to spend,

and had to do what I have to do, he would then see that it is not a question of dreaming and brooding, or taking narcotics, but that one must be wide awake to fight against so many difficulties. If people understood that *nothing is nothing*, and that days without a penny in my pocket are very hard and difficult, I think they would not begrudge me the little I receive from you that keeps me afloat in these hard times, or unnerve me by reproaches for receiving from you. Am I not worthy of the means which enable me to work? I only wish, brother, you would soon come here and see for yourself whether I am cheating you or not.

Enough of that. He condemns my drawings, which have a great deal of good in them, and I did not expect this from him. As to his buying or not, I consider that quite a different thing, quite apart from personal disputes or differences of view on some subjects; I should think his buying or not would depend not on me but on my work. Let him buy my work (as I make more progress) or not buy it because he either likes it or does not. He may buy it for himself or for another amateur, but it is not exactly fair to let a personal antipathy influence one's judgment, or, on the contrary, to be influenced by the personal charm of some artist into overlooking faults in his work.

If I make serious studies after the model, that is much more practical than his practical talks about what is salable or unsalable, about which I do not need so much instruction as he supposes, having been in the business of selling pictures and drawings myself.

Especially in my last drawings and studies, which Tersteeg condemned, my own character begins to show. So I should rather lose his friendship than give in to him in this matter. Perhaps you will find harsh what I write. But I cannot take it back. But I must tell you that I am not opposed or hostile to him, for it grieves me and worries me when there is an unfriendly feeling between us. Well, Tersteeg is Tersteeg, and I am I.

It is already two o'clock and I have still some work to do. Though there are moments when I feel overwhelmed by care, still I am calm, and my calmness is founded on my serious method of work and on earnest reflection. Though I have moments of passion

aggravated by my temperament, yet I am calm. In art one cannot have too much patience — that word is out of proportion.

Believe me, in things of art the saying is true: Honesty is the best policy; rather more trouble on a serious study than a kind of *chic* to flatter the public. Sometimes in moments of worry I have longed for some of that *chic*, but thinking it over I say: No, oh, let me be true to myself, and in a rough manner express severe, rough, but true things.

Perhaps, perhaps I could succeed even now in making a water-colour that would sell if one tried very hard. That would be forcing water-colours in a hothouse. Tersteeg and you must wait for the natural season. I said to him: In due time you shall have your water-colours; now you cannot — they are not due as yet — take your time. And that is all I have to say. I shall not run after the amateurs or dealers, let who likes come to me. In due time we shall reap, if we faint not!

Since Tersteeg's visit I have made a drawing of a boy from the Orphanage who is blacking shoes. It may be this is done by a hand that does not quite obey my will, but still the type of the boy is there. And though my hand may be unruly, that hand will learn to do what my head wishes. So I have made also a sketch of the studio with the stove, the chimney, easel, footstool, table; of course, not quite salable, but very useful for practising perspective.

I am longing for your visit. I count on your judging my work with sympathy and with confidence. When you come, do not forget the Ingres paper. It is especially the thick kind that I like to use and which I think also must be good for studies in water-colour.

Theo, it is almost miraculous!!!

Uncle C. M. asks me to make for him twelve small pen drawings, views from The Hague, *à propos* of some that were ready.

C. M. seemed to have spoken with Tersteeg before he came to see me; at least, he began by saying the same things about 'earning my bread.' My reply came on the spur of the moment, I said: 'Earn bread, how do you mean that? Earn bread, or deserve bread, — not to deserve one's bread, that is to say, to be unworthy

of it, that certainly is a crime, for every honest man is worthy of his bread, but unluckily not being able to earn it, though deserving it, that is a misfortune.' So if you say to me, 'You are unworthy of your bread,' you insult me, but if you make the rather just remark that I do not earn it always, for sometimes I have none, well, that may be so. But what is the use of making the remark? It does not get me any further if you say no more than that.' So then C. M. spoke no more about that 'earning bread.'

The thunder threatened once more, for when by chance I mentioned the name of de Groux, in speaking about expression, C. M. said abruptly: 'But do you know that in private life de Groux has no good reputation?' I could not stand there and hear that said of the brave Father de Groux. So I replied: 'It has always seemed to me that when an artist shows his work to the public, he has the right to keep to himself the inward struggle of his own private life (which is directly and fatally connected with the peculiar difficulties involved in producing a work of art). It is very improper for a critic to dig up a man's private life when his work is above reproach. De Groux is a master, like Millet.'

I began to be afraid that C. M. would be angry, but luckily things took a better turn. I got out my portfolio with smaller studies and sketches. At first he did not say anything until we came to a little drawing that I once sketched at twelve o'clock at night while strolling around with Breitner, the Paddemoes (that Jewish quarter near the new church) as seen from the Peat Market. Next morning I worked on it again with my pen.

'Could you make some more of these views of the city?' asked C. M. 'Yes, I make them for a change, sometimes when I am tired from working with the model; there is the Vleersteeg — the Geest — the Fish Market.' 'Then make twelve for me.' 'Yes,' said I, 'but this is business, so we must set a price at once. I have fixed the price for a small drawing of this size, either in pencil or pen, two francs fifty — do you think that unreasonable?'

'No,' he says, 'but when they turn out well, I shall ask you to make twelve of Amsterdam, but then I shall fix the price myself, so that you will get a little more for them.'

Well, I think that no bad result of a visit which I dreaded more or less. I shall do my best on these little drawings and try to put some character into them. I think, boy, that there is more of that kind of business to be done. With some practice I can make one every day. And look here, if they turn out well they procure me a crust of bread and a guilder for the model every day. Summertime with the long days is approaching; I make my 'soup ticket' — that means the bread-and-model drawing either in the morning or in the evening — and in the daytime I study seriously after the model.

Tomorrow morning I shall go out to find a subject for the drawings.

Also, I just met Mauve, happily delivered of his large picture, and he promised to come and see me soon.

And another thing struck me very, very deeply: I had told the model not to come today, but nevertheless the poor woman came and I protested. 'Yes, but I do not come to pose; I just come to see if you had something for dinner' — she had brought me a dish of beans and potatoes.

There are things that make life worth living, after all.

Well, I say, Theo, what a big man Millet was. I borrowed from de Bock the great work by Sensier; it interests me so much that it wakes me up in the night and I light the lamp and sit up to read. For in the daytime I must work.

It was only yesterday that I read that saying by Millet: '*L'art c'est un combat.*'

I have been working very hard lately, and I am busy from morning till night. I have finished the twelve drawings for C. M. I had hoped he would pay me at once. The drawings were certainly not less good than the specimen which he saw.

I am drawing heads now. I must also draw hands and feet, that is very urgent. And when summer comes and the cold no longer prevents it, I must some way or other make some studies of the nude. Not exactly academical poses. I should like, for instance, so very much to have a nude model for a digger or a seamstress. For learning to feel and see the body through the clothes, and to under-

stand the action, I reckon that about a dozen studies of men and of women would help me a great deal. Every study costs a day's work, but the difficulty is also to find the models for that end. The fear that they will have to 'sit naked' for you is generally the first scruple you have to get rid of. At least, that has been my experience more than once, even with a very old man, who probably would have been very Ribera-like as a nude model.

This evening I was at Pulchri. Tableaux and a kind of farce by Tony Offermans. I did not stay for the farce, because I do not like them, and I cannot stand the close air of a crowded hall, but I wanted to see the tableaux, especially because there was one after an etching which I had given to Mauve, 'The Stable at Bethlehem,' by Nicholas Maes. It was very good in tone and colour, but the expression was decidedly wrong. Once I saw that in reality, not of course the birth of Christ, but the birth of a calf. And I remember exactly how the expression was. There was a little girl in the stable that night — in the Borinage — a little brown peasant girl with a white nightcap, she had tears of compassion in her eyes for the poor cow when it was in throes and had great trouble. It was pure, holy, wonderful, like a Correggio, a Millet, an Israëls.

Intended for the Salon is a Mauve, the large picture of the fishing smack that is drawn up on the dunes; it is a masterpiece. I never heard a good sermon on resignation nor can I imagine a good one, except that picture of Mauve's and the work of Millet.

That is *the* resignation, the real kind, not that of the clergymen. Those nags, those poor, ill-treated old nags, black, white, and brown; they are standing there patient, submissive, willing, and quiet. They still have to draw up the heavy boat the last bit of the way; the job is almost finished. Stop a moment. They are panting, they are covered with sweat, but they do not murmur, they do not protest, they do not complain, not about anything. They got over that long ago, years and years ago. They are resigned to live and work somewhat longer, but if tomorrow they have to go to the skinner, well, be it so, they are ready. I find such a deep, practical, silent philosophy in this picture; it seems to say: '*Savoir souffrir sans se plaindre, ça c'est la seule chose pratique, c'est la grande*

science, la leçon à apprendre, la solution du problème de la vie.' I
think this picture by Mauve would be one of the rare pictures be-
fore which Millet would remain standing a long time and mutter to
himself: '*Il a du coeur, ce peintre-là.*'

I am just now in a period where my former drudgery has become
more of a pleasure. For every week I now make something which I
could not make before, and it is like becoming young again. It is
the consciousness that nothing, unless illness, can take from me the
force that now begins to develop. It is a splendid thing to look at
something and to admire it; to think about it and then to say: I
am going to draw it, and work at it until I have fixed it on paper.

Oh, Theo, why do you not give up the whole thing and become a
painter, boy? You can if you will. I sometimes suspect you of
concealing a famous landscape painter within yourself. I think you
would draw birch trees wonderfully, and the furrows in the field,
and paint snow and the sky.

Theo, until now you were free to do as you please, but if you
ever make an arrangement with Messrs. Goupil and Company,
should you promise to stay all your life with their firm, you would
be a free man no longer. And it seems to me quite possible that a
moment may arrive in one's life when one will regret having thus
bound himself. You will undoubtedly say: The moment may
arrive when one will regret that one became a painter. He who has
so much faith and love that he takes pleasure in what others find
dull — that is, the study of anatomy, perspective, and proportion
— he survives and ripens slowly but surely. With all respect for
your present position as a dealer, unless one has a real handicraft
and can make something with one's own hands, I doubt the solid-
ity of the position. For instance, I think the social position of Jaap
Maris more sound and independent than that of Tersteeg.

Dear me, why should I be afraid? What do I care about Ter-
steeg's 'unsalable' or 'without charm'? At times when I feel dis-
pirited, I look at 'Les Bêcheurs' by Millet, and 'Le Banc des
Pauvres' by de Groux, and then Tersteeg becomes so small, so
insignificant, and all those talks of his become so poor, that my
spirits rise and I light my pipe and set to drawing again.

You will ask, Theo, whether these things are also applicable to you. My answer is: 'Theo, who has given me bread and helped me? It certainly is not applicable to you.' But sometimes the thought comes to me, Why is Theo not a painter, will not that 'civilization' begin to bother him at last?

As to Tersteeg, I have known him in a very peculiar period of his life, when he had just 'worked himself up,' as the term is. Then he made a very strong impression upon me — he was a practical man, extremely clever and cheerful, energetic in small and great things. Then I felt such a respect for him that I always kept at a distance and considered him a being of a higher order than myself. Since — since then I have begun to doubt — more and more — but I never had the courage to probe him with the scalpel of analysis. I used to think that he was somebody who gave himself the air of a business man or man of the world — and who hid much feeling and a warm heart behind that iron mask. But I found his armour to be enormously thick, so thick that I cannot say for sure whether the man is of massive metal or whether there is still, quite deep in that iron, a small corner where a human heart is beating.

When I hear him talking about 'charm' and 'salable,' I merely think: Work on which one has plodded hard and into which one has tried to put some character and sentiment is neither unattractive nor unsalable. Theo, do not become materialistic like Tersteeg.

What fine weather we are having! There are signs of spring everywhere. I cannot drop drawing from the figure, that comes first for me, but sometimes I cannot keep from working out-doors.

I have not many studies yet after the nude; now that I have started, I should like to make about thirty, but there are some that greatly resemble the Bargues; are they less original for that reason? It is perhaps rather because from the Bargues I have learned to understand nature. Of late I have made studies of fragments of the figure — head, neck, breast, shoulder. You know I drew from the 'Exercices au Fusain,' but it is quite a different thing to draw it from life. Those lines are so simple that one can trace them with the pen, but when you are sitting before your model, the question is to

find those principal characteristic lines, so that with a few strokes or scratches the essential is expressed.

It is true, Theo, that lately, since I have been here at The Hague, I have spent more than one hundred francs a month, but if I did not do so, I should not be able to work with models and I should not make any progress. I see it in other painters: they are afraid to take models regularly and they work little and slowly, and even then not always well. The English painters, especially the draughtsmen for the 'Graphic,' have models almost every day. When somebody with years of experience draws the figure from memory, after having studied it a great deal, it is all right, but to work from memory systematically seems to me too risky. Even Israëls, Blommers, and Neuhuys do not do so.

Today I mailed you a drawing which I send to show my gratitude for all you have done for me, during what would otherwise have been a hard winter. When you showed me last summer Millet's large woodcut 'La Bergère,' I thought: How much can be done with one single line! Of course I do not pretend to be able to express in a single contour as much as Millet. But I tried to put some sentiment in this figure. I only hope this drawing will please you. 'Sorrow' is in my opinion the best figure I have drawn as yet, therefore I thought I should send it to you. I think it would look well in a simple grey mount.

Of course I do not always draw in this style, but I am very fond of the English drawings done in this way, so no wonder I tried it for once, and as it was for you, who understand these things, I did not hesitate to be rather melancholy. If I have not fixed your drawing, so that there are spots that have a disagreeable shine, just dash a large glass of milk, or water and milk, over it, and let it dry, and you will see it gives a peculiar saturated black, much more effective than is generally seen in a pencil drawing.

I partly agree with you in what you say about the aspect of some drawings having something that can be best compared to an *eau-forte non ébarbé*. However, I believe that this peculiar effect in drawings, which I think the amateurs rightly appreciate, is caused rather by a peculiar tremor of the hand when working under emo-

tion than by the material one uses (of course with etchings it is different; there it is caused by the *barbe* of the plate). I myself have among my studies a few, which look rather like what I shall call *non ébarbé*. To get that peculiar aspect, *non ébarbé*, I think one ought to use not chalk, but rather charcoal which has been soaked in oil.

One can do great things with charcoal soaked in oil; I have seen that from Weissenbruch; the oil fixes the charcoal and at the same time the black becomes warmer and deeper. But I say to myself: It is better to do it a year hence than to do it now, because I do not want the beauty to come from the material, but from within myself. When I am a little more advanced, I shall dress up nicely now and then; that means, I shall work with a more effective drawing material. And if I then only have some power within me, things will go doubly smoothly and the result will be better than I expected. But first before any success must come the hand-to-hand struggle with the things in nature.

C. M. has paid me and given a new order, but a very difficult one, six special detailed views of the town. However, I shall try to make them, for if I understand it right, I shall get as much for these six as for the first twelve.

Painting is a profession in which one can earn a living. An artist is, at all events, the downright opposite of a man who lives on his income; if one wants to make a comparison, there is more similarity between an artist and either a blacksmith or a physician. I quite well remember that when you spoke at the time of my becoming a painter, I thought it very unpractical, and would not hear of it. What made me cease to doubt was my reading a clear book on perspective, Cassagne's 'Guide to the A B C of Drawing,' and a week after I drew the interior of a kitchen with stove, chair, table, and window, in their place and on their legs, while before it had seemed to me witchcraft or pure chance to get depth and the right perspective in drawing. If you had only drawn one thing right, you would feel an irresistible longing to draw a thousand other things. I must go on drawing for a year or at least a few months more until my hand has become quite firm and my eye steady, and then I do

not see any obstacle to my becoming quite productive in things that will sell. It is just that I want these few months' time. I cannot go on quicker than that; with a little patience I can give good work. If I get my portfolios full of studies, they will repay me in money later on. I should rather learn my profession well than hurry to get a little drawing sold for pity's sake.

Some day when people begin to say that I can draw a little, but not paint, I shall perhaps suddenly come out with a picture. There are two ways of considering painting: how not to do it, and how to do it: *how to do it*, with much drawing and little colour; *how not to do it*, with much colour and little drawing. For it is easier to proceed from drawing to painting than to make pictures without drawing the necessary studies for it. You see, in drawing there are a great many things that many people often overlook. There is a correct perspective of an interior, there are the great lines of a landscape, and then I myself see no chance of doing without study of the nude. All this is essentially *drawing;* once having fairly mastered that, one sees the way out, and I myself go quietly on that way.

And now, yes, I know that Mother is ill, and I know many other sad things besides, either in our own family or in others. And I am not insensible to it, and I think I should not be able to draw 'Sorrow' if I did not feel it. But since summer it has become clear to me that the disharmony between Father, Mother, and myself has become a chronic evil, because there has been misunderstanding and estrangement between us for too long a time. And now it has gone so far that from both sides we must suffer for it.

I mean we might have helped each other more if we had tried on both sides long ago to live in closer understanding and to share weal and woe, always remembering that parents and children must remain one. We did not make these mistakes on purpose, and for the greater part they must be ascribed to the *force majeure* of difficult circumstances and a hurried life.

Well, Father and Mother find comfort in their work and I in mine. There is affinity between a person and his work, but it is not easy to define what that affinity is, and on that question many judge quite wrongly. For, brother, notwithstanding all the little miseries, I work with great animation.

Today I made another nude study of a kneeling woman's figure, and yesterday one of a girl knitting, but also nude. I finished another drawing of such a woman's figure as 'Sorrow,' but larger, and I think better than the first; and I am making a drawing of a street where they are digging to lay a sewer or water-pipes: 'Diggers in a Trench.' It is made on the Geest, in the rain, where I was standing in the mud, amidst all the noise and confusion. My sketch-book proves I try to seize quick impressions. This is for C. M.

I am drawing also a few landscapes; for instance, a nursery here on the Schenkweg. Theo, I am decidedly not a landscape painter; when I shall make landscapes *there will always be something of the figure in them.*

Today I sent you a drawing: vegetable gardens on the Laan van Meerdervoort. Though this be 'only black and white' and 'unsalable'(??), and 'without charm'(??), I still hope there may be some character in it. I should like to know since when they can force or try to force an artist to change either his technique or his point of view! I think it very impertinent to attempt such a thing. In drawing, one must not count on selling one's drawings, but it is one's duty to make them so that they have value and are serious; one may not become careless or indifferent even though disappointed by circumstances.

The weather is very cold and windy, and that worries me a great deal, as I cannot go on with the views of the city for C. M.; but surely the mild weather will come again.

I sometimes think: If my life were somewhat easier, how much more and how much better should I then be able to work. But I do work, and as you must have noticed from my last drawings, I begin to see a light that will conquer the difficulties. But you know there is scarcely a day that, besides the exertion of drawing, does not bring some difficulty or other, which in itself would be hard enough to bear.

It causes me a great deal of worry when those on whom I thought I could depend for sympathy, like Mauve and Tersteeg, become indifferent or hostile and spiteful. Towards the end of January, Mauve's attitude towards me changed suddenly, became as un-

friendly as it had been friendly before. I ascribed it to his not being satisfied with my work, and I was so anxious and worried over it that it quite upset me and made me ill.

Mauve then came to see me and gave me again the assurance that everything would come all right, and encouraged me. But then, on a certain evening shortly after, he began to speak to me again in such a different way that it seemed as if there was quite a different man before me. I thought: My dear friend, it seems as if they have poisoned your ear with slander; but I was in the dark from which side the poisonous wind had blown. Mauve began among other things to imitate my speech and my manners, saying, 'Your face looks like this ... You speak like this,' all in a spiteful way, but he is very clever at those things, and I must say it was like a well-resembling caricature of me, but drawn with hatred. I answered: 'My dear friend, if you had spent rainy nights in the streets of London, or cold nights in the Borinage, hungry, homeless, feverish, you would also perhaps have ugly lines in your face and a husky voice too.'

He said a few things that only Tersteeg used to say about me. And I asked him, 'Mauve, have you seen Tersteeg lately?' 'No,' said Mauve, and we talked on, but about ten minutes later he dropped the remark that Tersteeg had been to see him that day. And I thought: Is it possible, my dear Tersteeg, that you are at the back of all this?

Though I still visited Mauve once in a while, he was moody and rather unkind. And a few times I was told he was not at home. I went to see him less and less, and he never came to my house again.

Mauve also became in his talk as narrow-minded, if I may call it so, as he used to be broad. I had to draw from casts, that was the principal thing, he said. I hate drawing from casts, but I had a few plaster hands and feet hanging in my studio. Once he spoke to me in such a way as the worst teacher at the Academy would not do, and I kept quiet, but when I got home I was so angry that I threw those poor plaster casts in the coal-bin, and they broke in pieces. And I thought: I will draw from casts only when there are no more hands and feet of living beings to draw from. I then said to Mauve:

'Man, do not speak to me again about plaster, for I cannot stand it.'

That was followed by a note from Mauve, that for two months he would not have anything to do with me. But I have not been idle meanwhile, though I have not drawn from casts, I can tell you, and I must say I worked with more animation and earnestness now that I was free. When the two months were almost past, I just wrote to him to congratulate him on having finished his large picture.

Now the two months are long since past and he has not come to see me. And since then things have happened with Tersteeg, which made me write to Mauve: 'Let us shake hands and not feel animosity or bitterness against each other; but it is too difficult for you to guide me, and for me it is too difficult to be guided by you, if you require "strict obedience" to all you say. So there is an end to the guiding and being guided. But that does not alter my feeling of gratefulness and obligation towards you.'

Mauve has not answered this, and I have not seen him since.

What urged me to say to Mauve, We must each go our own way, was the evidence that Tersteeg really influenced Mauve. When Tersteeg told me he would see to it that you stopped sending me money, 'Mauve and I will see to it that there comes an end to this...' then I doubted no longer, but realized: He betrays me. Because I knew what Mauve had told me about that money from you, that it would be very good for me to receive it still for at least another year.

Theo, I am a man with faults and errors and passions, but I do not think I ever tried to deprive anyone of his bread or his friends. I have sometimes fought with people in words, but to attempt one's life because of a difference of opinion, that is not the work of an honest man, at least these are no honest weapons. When you forsake somebody and then try to take his bread from him, that is not considerate, not delicate; that is not good manners; that is not humane. And what am I? Nothing but a man who has a difficult, trying work, for which he needs quiet and peace and some sympathy, otherwise the work is impossible.

I have struggled on this winter as best I could. But can you wonder that it was a shock to me and that it sometimes seems as if

my heart would break? Because — and you know this — I love Mauve, and it is so hard that all the happiness he pictured to me will come to naught.

Tersteeg said to me, 'You failed before and now you will fail again; it will be the same story all over.' Stop — no, it is quite different now, and that reasoning is really nothing but a sophism. That I was not fit for business or for professional study does not prove at all that I am not fit to be a painter. On the contrary, had I been able to be a clergyman or an art dealer, then perhaps I should not have been fit for drawing and painting, and should neither have resigned nor taken my dismissal as such.

Because I really have a 'draughtsman's fist,' I cannot stop drawing, and I ask you, since the day I began to draw, have I ever doubted or hesitated or wavered? I think you know quite well that I pushed onward, and of course little by little I grew stronger in the battle. You have seen the two drawings I sent you. These were not made by chance, but I can produce such work regularly, and it improves as I go on. So it is not unreasonable if I insist upon it being so arranged that I need no longer be afraid that the strictly necessary will be taken from me, or that I must always feel as if it were the bread of charity. The strictly necessary is bread, clothes, rent, model, drawing materials. And in the way I arrange it, that is not so very much, and I can make drawings in return if people will only take them. A workman is worthy of his hire.

I am afraid that the better my drawings become, the more difficulty and opposition I shall meet. I shall have to suffer much, especially from those peculiarities which I cannot change. In the first place, my appearance and my way of speaking and dress. And then even later on, when I shall earn more, I shall always move in a different sphere from most painters, because my conception of things, the subjects I want to make, inexorably demand it.

Now put, for instance, Tersteeg himself before a sand-hole on the Geest, where workmen are busy putting in water or gas-pipes; I should like to see what face he would put on, and what kind of sketch he would make of it. To stroll on wharves, and in alleys and streets and in the houses, waiting-rooms, even saloons — that is not

a pleasant pastime, *unless for an artist.* As such, one would rather be in the dirtiest place where there is something to draw than at a tea party with charming ladies. Unless one wants to draw ladies.

What I want to say is this: The searching for subjects, the living among working people, the drawing from nature on the very spot, is a rough work, even a dirty work at times, and indeed the manners and dress of a salesman are not exactly most suitable for me, or for anyone else who does not have to talk with fine ladies and rich gentlemen to sell them expensive things and to make money, but who has, for instance, to draw diggers in a hole on the Geest. If I could do what Tersteeg can, if I were fit for that, I should not be fit for my profession, and for my profession it is better that I am as I am.

I, who did not feel at ease in a fine coat in a fine store, who especially should not do so now, and should certainly be bored and bore others, I am quite a different person when I am at work on the Geest or on the heath or in the dunes. Then my ugly face and shabby coat perfectly harmonize with the surroundings, and I am myself and work with pleasure. When I wear a fine coat, the working people that I want for models are afraid of me and distrust me, or they want more money from me.

I do not belong to those who complain 'there are no more models at The Hague.' The draughtsmen who work for the 'Graphic,' 'Punch,' where do they get their models? Do they hunt for them themselves in the poorest alleys of London, yes or no? And their knowledge of the people, is it innate in them, or have they acquired it in later years, by living among the people and by paying attention to things that many another passes by? Do I lower myself by living with the people I draw? Do I lower myself when I go into the houses of labourers and poor people, and when I receive them in my studio?

So, if remarks are made about my habits, meaning, dress, face, manner of speech, what answer shall I make?

Am I ill-mannered in another sense, that is impudent or without delicacy? Look here, in my opinion all politeness is founded on good-will towards everybody, founded on the necessity felt by every-

one who has a heart in his bosom, of helping others, of being of use to somebody; finally, the need one feels of living with others and not alone. Therefore, I do my best; I draw, not to annoy people, but to amuse them, or to make them see things worth observing, and which not everybody knows.

I cannot believe, Theo, that I could be such a monster of impudence and impoliteness as to deserve to be cut off from society, or, as Tersteeg says, 'should not be allowed to stay in The Hague.'

When I go to see Mauve or Tersteeg, I cannot express myself as I should wish. But do tell them now, in my name, how things are; tell them in better words than I can, with as much style and grace as is necessary, how they on their part have caused me much sorrow. Make them understand this; they do not know it, they think I am unfeeling and indifferent. By doing so you will render me a great service. I wish they would only take me as I am. Mauve has been kind to me and has helped me thoroughly and well, but — it lasted only a fortnight. That is too short.

I have things to tell you about my plans for the future, how I intend to carry on my work. But first you must come here.

Today I met Mauve — it was in the dunes — and had a very painful conversation with him, which made it clear to me that he and I are separated forever. Mauve has gone so far he cannot retract. I had asked him to come and see my work and then to talk things over. He refused pointblank: 'I will certainly not come to see you, that is all over.'

At last he said: 'You have a vicious character.'

Then I turned around, and I walked home alone.

Mauve takes offence at my having said, 'I am an artist' — which I do not take back, because that word included, of course, the meaning: always seeking without absolutely finding. As far as I know, that word means: 'I am seeking, I am striving, I am in with all my heart.' It is just the contrary from saying, 'I know it, I have found it.'

I have ears in my head, Theo. If somebody says, 'You have a vicious character,' what must I do then?

They suspect me of something — it is in the air — I keep some-

thing back. Vincent is hiding something that cannot stand the light!

Well, gentlemen, I will tell you, you who prize good manners and culture, and rightly so if only it be the true kind: Which is more delicate, refined, manly, to desert a woman, or to stand by a forsaken one? What I did was so simple and natural that I thought I could keep it to myself. It seems to me that every man worth his salt would have done the same in a similar case.

This winter I met a pregnant woman, deserted by the man whose child she bore. A pregnant woman who in winter had to walk the streets, had to earn her bread, you understand how. I took that woman for a model, and have worked with her all winter. I could not pay her the full wages of a model, but that did not prevent my paying her rent, and, thank God, I have been able thus far to protect her and her child from hunger and cold by sharing my own bread with her.

I started a new life, not purposely, but because I had a chance to begin anew and did not refuse to do so.

To express my feelings for K., I said resolutely, 'She, and no other.' And her 'No, never, never,' was not strong enough to make me give her up. I still had hope, and my love remained alive. But I could find no rest. It was a strain that became unbearable, because she always kept silent and I never received a word in answer. Then I went to Amsterdam. There they told me, 'To your "She, and no other," she answers, "He, certainly not"'; your persistence is disgusting.' I put my hand in the flame of the lamp, and said, 'Let me see her for as long as I can keep my hand in the flame'; and no wonder that Tersteeg noticed my hand afterwards. But I think they put out the lamp and said, 'You shall not see her.' Well, that was too much for me, and I felt that the crushing things they said were unanswerable, and that my 'She, and no other' had been killed.

Then, not at once, but very soon, I felt that love die within me. A void, an infinite void, came in its stead. You know I believe in God; I did not doubt the power of love, but then I felt something

like: 'My God, my God, why hast Thou forsaken me?' and every-
thing became a blank. I thought: Have I been deceiving myself? . . .
'O God, there is no God!' The emptiness, the unutterable misery
within me, made me think: Yes, I can understand that there are
people who drown themselves. But I was far from approving of
this, and I found strength in the manly word of Father Millet: '*Il
m'a toujours semblé que le suicide était une action de malhonnête
homme.*' (It has always seemed to me that suicide was the deed of a
dishonest man.)

I received diversion and encouragement through Mauve. I
threw myself into my work. Then, after I had been thrown over by
him and had been ill for a few days, towards the end of January, I
found Christine. When I came back from Amsterdam I felt that
my love — so true, so honest and strong — had literally been
killed. But after death is a resurrection.

In a short time this woman became as meek as a tame dove, cer-
tainly not from forcing on my part, but because she saw that I was
not rough. Well, this one has understood it, and she said to me: 'I
know that you do not have much money, but even if you had less,
I will put up with everything if you only stay with me and let me
stay with you; I am so much attached to you that I could not be
alone again.' If someone says that to me, and shows by everything,
more in action than in words, that she means it, no wonder, then,
that before her I drop the mask of reserve, of almost roughness
that I kept so long.

And now, has this woman been the worse for it, or have I been
the worse for it that things have gone so? I am quite astonished to
see her become brighter and more cheerful every day; she is so
changed that she seems quite a different person from the sick, pale
woman I met this winter. Yet I have not done so much for her; I
only told her: Do this or that, and you will become well again; and
she has not thrown my advice to the wind, and when I saw that
she did not do so, I tried even harder to help her. This winter she
was very weak. When I met the woman, she attracted my notice
because she looked ill. Now, by eating simple food, by walking
much in the open air, and by taking baths, she has become much

healthier and stronger. But the time of pregnancy is a difficult one.

Do you remember our old nurse at Zundert, Leen Veerman? Sien is that kind of person. The form of her head, the line of her profile resemble the 'L'Ange de la Passion,' by Landelle; so that is far from ordinary, it is decidedly noble, but it does not always strike the eye at once. Of course, she is not exactly like this; I say it only to give you an idea of the lines of her face. She is slightly pockmarked, so she is not beautiful any longer, but the lines of her figure are simple and not ungraceful. If you know the large drawing by Frank Holl, 'The Deserter,' I should say she resembles the woman figure in it.

What I appreciate in her is that she is not coquettish with me, goes her way quietly, is saving, has much good-will in adapting herself to the circumstances, and is willing to learn, so that in a thousand ways she can help me with my work.

Perhaps I can understand her better than anyone else, because she has a few peculiarities that would have been repulsive to many others. First her speech, which is very ugly and is a result of her illness; she often says things and uses expressions that, for instance, our sister Willemien, who has been brought up differently, would never use. But I should rather have her speak badly and be good than be refined in speech and heartless; that is just it, she has a good heart. Then her temper, caused by a nervous disposition, brings fits of anger that would be unbearable to most people.

I understand those things; they do not bother me, and until now I have been able to manage them. She on her part understands my own temper. If I get into a passion either about the posing or something else, she knows how to take it, and has seen that it soon passes. In the same way, when I worry or am troubled about something that doesn't succeed, she often knows how to quiet me, and that is what I am not able to do for myself. It is like a tacit understanding between us not to find fault with each other.

That she is no longer handsome, no longer young, no longer coquettish, no longer foolish — that is just the reason she is useful to me. She is no trouble, no hindrance; she works with me. She has

no pretensions of wanting this or that; when there is nothing but bread and coffee, she puts up with it and does not complain. Posing has been very difficult for her, but every day she learns it better, and that is worth so much to me. I have made progress in my drawing because I have a good model. I send you a few studies because you can see from them that she helps me a great deal by posing. The woman with a white bonnet is her mother. Those studies require a rather dry technique; had I worked for effect, they would be of less use to me afterwards.

If I tell you things about her which are rather gloomy, it is because I want to state from the beginning that I do not stand in a garden of roses, but in reality; and because I want to protest beforehand against sentimental considerations, as for instance Father and Mother would not fail to make.

In affairs of love, I do not know whether you have yet learned its A B C. Do you think that pretentious of me? My meaning is that one feels best what love is when sitting near a sick-bed, sometimes without a cent of money in one's pocket. It is no gathering of strawberries in spring; most of the months are grey and gloomy. But in that gloom one learns something new.

Theo, I intend to marry this woman, to whom I am attached and who is attached to me. I want to go through the joys and sorrows of domestic life, in order to paint it from my own experience. Acquainted with the prejudices of the world, I know that what I have to do is to retire from the sphere of my own class, which anyhow cast me out long ago. But that is all they can do. By this step a chasm will be made; I decidedly 'lower' myself, as they call it, but that is not wrong, though the world calls it so. I live as a labourer; being a labourer, I feel at home in the labouring class. I wanted to do this before, but could not then carry it out.

I greatly appreciate what you once said: 'One must be narrowminded or prejudiced to give absolute preference to one rank over another.' But the world does not argue thus, and does not see or respect 'humanity' in man, but only his greater value in possessions, which he carries with him only as long as he is on this side of the grave. The other side of the grave is not taken into any considera-

tion by the world. Therefore the world only goes as far as its feet
can carry it. I myself, on the contrary, have sympathy and anti-
pathy for men as men, and their surroundings leave me rather in-
different.

If I am not to marry Christine, it would be kinder of me to have
let her alone; that is the only way to help her. If she were alone,
misery would force her back into her old road that ends at a preci-
pice. A woman must not be alone in a society and a time such as
that in which we live, which does not spare the weak but treads
them underfoot. Because I see so many weak ones trodden down,
I greatly doubt the sincerity of much that is called progress and
civilization. I do believe in civilization, but only in the kind that is
founded on real humanity. That which costs human life I think
cruel, and I do not respect it.

Very often I let things go, thinking, I will not do this or that, so
as not to give offence to anyone. But in really serious things one
must not act according to public opinion, nor according to one's
own passions. One must keep to the A B C which is the foundation
of every morality: Act so that you can answer for it to God. The
person who was the father of Christine's first child was very kind
to her, but did not marry her, even when she was with child by him,
for the sake, as he said, of his rank and his family. Christine was
young then; she did not know what she knows now. That man's
behaviour was guilty before God, but in the eyes of the world he
was excused — 'he had paid her.'

Now it so happens in the world that opposed to characters of
such persons as he there are characters like mine, for instance. I
care as little for the world's opinion as that man cared for what was
right. To appear right was enough for him; what I think the most
important is not to deceive or desert a woman.

I took to Christine, though not at once with the idea of marriage,
but when I learned to know her better, it became clear to me that if
I wanted to help her I must do it seriously. Then I spoke frankly
to her and said: 'So and so are my opinions on things; in this and
this way I understand your position and mine. I am poor, but I am
no seducer; do you think you can put up with me? Otherwise it

ends now.' Then she said: 'I will stay with you, though you be ever so poor.'

Now, I want to lay a straight path for my feet. She and I will skimp and be as saving as possible, if only we can marry. By and by I shall earn so much that this woman can live on it with me. What I should like best would be to have fixed weekly wages, like any labourer, for which I should work with all my strength and energy. I am thirty years old and she is thirty-two, so we are chil-dren no longer. As to her child, the latter takes away all stain from her. I respect a woman who is a mother.

I accept her past and she accepts my past. Not everybody is fit to be a *painter's* wife; she is willing, and learns every day. I for my part can only marry once, and how can I do better than marry her?

But you will find me very compliant in anything I can do without becoming unfaithful to Christine. If there is any objection to my staying in The Hague, I am not bound to stay in The Hague. And I can find a field of action wherever you like, either in a village or in a city. The figures and the landscape which chance may put before me will always be interesting enough for me to try my best to draw them. But the question of remaining true to Christine is one about which I feel, 'I may not break a marriage promise.'

If K. had listened to me last summer, perhaps she would not have dismissed me so abruptly in Amsterdam, and then things would have gone quite differently. Now the rush of life pushes and urges me on, and the work, and the seeing and finding of new things which I must grasp resolutely if I want to get the upper hand in the fierce struggle. Passive waiting belongs to former years. What I do now, since I have found my work and my profession, is to act and keep wide awake.

It is in life as in drawing: one must sometimes act quickly and decidedly, attack a thing with energy, trace the outlines as quickly as lightning. This is not the moment for hesitation or doubt; the hand may not tremble, nor may the eye wander, but must remain fixed on what is before one. And one must be so absorbed in it that in a short time something is brought onto the paper that was not

there before, so that afterwards one hardly knows how it has been hammered off.

To act quickly is the function of a man, and one has to go through many things before one is able to do so. The pilot sometimes succeeds in making use of a storm to make headway, instead of being wrecked by it. This is not a thing that I have sought, but it has come across my path and I have seized it.

Every day I see more clearly that the step I am taking will open an interesting field for drawing and getting models. That must also be taken into account in judging me. My profession allows me to undertake this marriage, which I could not do if I had another position.

Nobody cared for her or wanted her; she was alone and forsaken; and I have taken her up and have given her all the love, all the tenderness, all the care that was in me; she has felt that, and she has revived, or rather she is reviving.

I shall only know one thing — drawing — and she has only one regular work — posing. She knows what poverty is; so do I. Poverty has advantages and disadvantages, yet notwithstanding poverty we risk it. The fishermen know that the sea is dangerous and the storm terrible, but they have never found those dangers sufficient reason for remaining ashore. They leave that philosophy to those who like it. Let the storm arise, the night descend; which is worse, danger or the fear of danger? For my part I prefer reality, the danger itself.

I am writing late in the evening. Christine is not well and the time for her going to Leyden, where there is a maternity hospital, is close at hand.

Now the crisis has come. To Christine I said: 'Lass, I shall be able to help you until you go to Leyden. When you come back from Leyden, I do not know how you will find me, with or without bread, but what I have I will share with you and the child.' During the first year at least my bread and hers depend on you. So I live from day to day with a dark fear. I also work from day to day, not daring to order more drawing or painting materials than I can pay for, not daring to push on.

Theo, do these things make a change or separation between you and me? If it should not, if we should continue to grasp each other's hands, notwithstanding things which the 'world' opposes, if you let me keep your help, that would be a relief, a blessing so unexpected, so unhoped for, that it would quite upset me with joy; and I put away the thought with all my strength, even while I write about it with a steady hand, so as not to show my weakness.

If unfortunately this should bring about a change in your feeling towards me, I hope you will not withdraw your help without giving me warning some time before, and that you will always tell me frankly and openly what you think.

I believe, or rather it begins to dawn on me, that there might be a shadow of a chance that the thought, 'Theo will withdraw his help,' is perhaps unnecessary. But, Theo, I have so often seen such things happen that I should not esteem you less and should not be angry with you if you did so, because I should think: He knows no better; they all act that way, from thoughtlessness and not from malice.

What I experienced this winter from Mauve has been a lesson for me. It was a mistake and shortsightedness on my part to take literally what Mauve said in the beginning, or to suppose for a moment that Tersteeg would remember that I had had so much trouble already. I think the real reason for Mauve's refusal to visit me is this: when one is without money, one is of course of no account. At the present time money is what the right of the strongest used to be. To contradict a person is fatal, and if one does, the reaction is not that the other party is made to reflect, but that one gets a blow of the fist; that is to say, in the form of 'I will not buy from him again,' or, 'I will not help him again.'

This being so, I risk my head when I contradict you; on your help depends my life; my drawings are in your hands, because you see that I do my best to work, and that some power of drawing, and I think painting also, is in me, and will show itself by and by. I am between two fires: if I answer, 'I will give up Christine,' then I bind myself to commit a vile thing; but to conceal things seems to me underhanded. If, then, this terrible lot must befall me, be it so:

'Off with my head.' But I should rather not lose it, I need it so much for drawing.

I wish those who mean well by me would understand that my actions proceed from deep feeling and a need for love; that recklessness and pride and indifference are not the springs that move the machine; and that when I take this step it is a proof of my taking root deep in the ground. I do not think I should do well by aiming at a higher station, or by trying to change my character. I feel that my work lies in the heart of the people, that I must grasp life to the quick.

I cannot do otherwise; I do not want to do otherwise; I cannot understand another way. If I succeed in making you understand, then Christine, her child, and I myself will be safe.

I received the one hundred francs, and thank you very much for it. I am eagerly looking out for a letter from you. Perhaps you yourself will learn sooner or later that when you are with a woman who is with child a day seems as a week, and a week longer than a month. If I understand you rightly, the only thing I have to do is to work on quietly, without worrying or thinking about it as much as I have done. If I think too much about it, I get that same dizzy feeling which you say a person gets who has not studied perspective, when he tries to follow the fugitive lines in a landscape and to account for them.

To forget it, I lie down in the sand by an old tree-trunk and make a drawing of it — in a linen blouse, smoking a pipe and looking at the deep blue sky, or at the moss or the grass. That quiets me. And I feel just as calm when, for instance, Christine or her mother poses, and I estimate the proportion and try to suggest the body with its long undulating lines under the folds of a black dress. Then I am a thousand miles away.

Now I have finished two drawings: first, 'Sorrow,' but in a larger size, only the figure, without any surroundings. The pose has been changed a little; the hair falls over the shoulder partly in a plait; and the figure has been drawn more carefully. The other, 'The Roots,' represents some tree-roots on a sandy ground. Here I

tried to put in the landscape the same sentiment as in the figure. the clinging convulsively and passionately to the earth, and yet being half torn up by the storm. In that pale, slender woman's figure, as well as in the black gnarled and knotty roots, I wanted to express something of the struggle for life; or rather, because I tried to be faithful to nature as I saw it before me without philosophizing about it; involuntarily in both cases something of that great struggle is shown. Though 'The Roots' is only a pencil drawing, I have brushed it in with pencil, and scraped it off again, as if I were painting.

If you like them, they will perhaps suit your new home; I have made them for your birthday.

I do not say this to hurry you, but I think it will do no harm to show such of my drawings as you think fit to people who happen to come to your room; that may be the beginning of selling them. When there are more and different ones together by the same hand, they show to better advantage, and the one explains and completes the other. What you think the best ought to be mounted in grey; so by degrees you will get a small collection. The thing I value most is your sympathy; if I can win that, the selling will follow. But that sympathy cannot be forced by either you or me. If you say it is not yet ripe, I shall work on without sending them. I must have much more experience, I must learn still more; that is a question of time and perseverance, but I think you should begin to take a few drawings every month. There are days when I make five of them, but one has to reckon that out of twenty drawings only one will be successful; there is one every week which I know to be 'right.' I can do what I can.

Weissenbruch has seen the large 'Sorrow,' and has told me things that pleased me. Therefore I dare speak as I do about it. Here they all criticize the technique, but they all say the same hackneyed things, about the English drawings, for instance. I did not understand the English drawings either at first, but I took the trouble to become acquainted with them. For me one of the highest and noblest expressions of art is always that of the English, for example, Millais and Herkomer and Frank Holl.

I have had no 'guidance or teaching' from others to speak of ; I taught myself, and it is no wonder that my technique, considered superficially, differs from that of others. But that is not a reason that my work should remain unsalable. Before me lies a drawing of a woman in a black merino dress, which I know that if you had it a few days you would be quite reconciled with the technique, and not wish it were done differently. I feel pretty sure that the large 'Sorrow,' 'The Old Woman of the Geest,' and 'The Old Man,' and others, will some day find a purchaser. You began to help me without knowing the result, and when others refused their help. I should be glad if the result were that you could say, to those who think it foolish of you, that you have not lost by it. And that stimulates me to work still harder.

Theo, is my path less straight because somebody says, 'You have gone astray'? C. M. always talks about the right path, just as do Tersteeg and the clergymen. But C. M. calls de Groux also a bad character. I think they would do so much better if they did not bother about my 'path,' but encouraged my drawing. You will say C. M. does so, but let me tell you why his order has not yet been filled.

Mauve said to me : 'That uncle of yours has only given that order because he was at your studio once ; you must understand that it does not mean anything. It will be the first and the last ; then there will be nobody to take an interest in you.' You must know, Theo, that I cannot stand such things ; my hand drops as if paralyzed, especially as C. M. has already said some things about conventions. I have made for him twelve drawings for thirty francs. There was more than thirty francs' worth of work in it, and I don't deserve that I should have to consider it a charity. The trouble for the new ones has already been taken, so it is not laziness ; I had made the studies for them, and there it stopped.

There used to be a better feeling among the painters ; now they try to eat each other up, and are big personages, who have villas and scheme to get along. I should rather be on the Geest, or in any grey, miserable, muddy, and gloomy alley ; there I am never bored, but in those fine houses I am, and I think it wrong to be bored.

So then I say: 'This is no place for me. I shall not go there any more.'

I do not understand Mauve; it would have been kinder of him never to have meddled with me.

Thank God, I have my work, but instead of earning money by it, I need money to be able to work; that is the difficulty. I think there are no signs in my work that indicate that I shall fail. And I am not a person who works slowly or tamely. Drawing becomes a passion with me, and I throw myself into it more and more. I do not have great plans for the future; if for a moment I feel rising within me the desire for a life without care, for prosperity, each time I go fondly back to the trouble and the cares, to a life full of hardship, and think: It is better so; I learn more from it, and make progress. This is not the road on which one perishes. I only hope the trouble and the cares will not become unbearable, and I have confidence I shall succeed in earning enough to keep myself, not in luxury, but as one who eats his bread in the sweat of his brow.

During the last fortnight I have been weak. For several nights I have not been able to sleep and have been feverish and nervous. But I force myself to keep going and at work, for this is not the time to fall ill. Christine and her mother moved to a smaller house, because when Christine returns from Leyden she will come to live with me, wherever I may be. Theirs is a little house with a court-yard, of which I hope to make a drawing this week.

In March the doctor could not tell exactly when her confinement would be, but now he says it will probably be late in June. This time he asked her many questions about whom she was living with, and from what he said I know now for sure, what I had guessed, that she would die if she had to walk the streets again, and that when I met her this winter, it was but just in time to give her the needed help. He found her better than in March; the baby's clothes are ready — of course the very simplest.

I am not living in an air castle, but in plain reality, where one must act with firmness. If it is possible for me to receive this year one hundred and fifty francs a month, then I can undertake the

thing with good courage. If I know for certain that you will with-
draw your help, then it will be misery. What satisfaction would it
give you or anyone else? I should get discouraged, and it would go
hard with Christine.

It has been very stormy for three nights. Last Saturday night
the window of my studio gave way — the house in which I live is
very shaky — four large window-panes were broken, and the frame
was torn loose. The wind came blowing across the open meadows
and my window got it first-hand — the drawings torn from the
wall, the easel upset, the railing downstairs also thrown down.
With the help of my neighbour I was able to tape up the window,
and over the hole, at least three feet square, I nailed a blanket.
There was great trouble to get the window fixed next day, because
it was Sunday. The landlord is a poor devil; he gave the glass, and
I paid for the labour.

I wish it were possible to take the house next to this. It is
exactly large enough, because the attic is so arranged that it can be
made into a bedroom, and the studio is large and light, much better
than the one here. The owner would like to have me; he spoke to
me about it first. The rent is twelve francs fifty a month, a
strong, well-built house; it is rented so cheaply because it is 'only
the Schenkweg,' and the rich people whom the owner expected do
not want to live there. But you surely know, don't you, that I do
not ask imperatively for anything whatever; I only hope that you
will remain to me what you were.

It has been a hard fortnight for me. Now, the middle of May, I
shall have only three francs left after I have paid the baker; and I
have hardly anything to eat but dried black bread with some
coffee, and Sien also, because we had bought some things for the
baby and she had been to Leyden. The first of June I shall have to
pay the house rent and I shall have nothing, literally nothing. The
man will not permit me any delay, but he can immediately sell my
furniture at auction. I say, let us at all events avoid public
scandal.

I received a kind letter from Father and Mother, which would
please me very much if I could only believe that this feeling would

continue. Will they still speak kindly when they know all this? I doubt their competence in judging moral affairs. Their refusal would certainly grieve me, but it would not stop or hinder me.

Many thanks for your letter with its enclosure. I am glad that you told me frankly what your thoughts were about Sien: that she intrigues, and I am letting myself be fooled by her. And I can understand that you would suppose such a thing, because such things happen. You say that what happened between Christine and me does not necessitate my marrying her. This is how we think about it: we both long for home life, and we need each other daily in our work and are daily together. If we do not marry, people can say that there is something wrong, that we live illegally; if we do marry, we are very poor and give up all pretence of social standing, but our action is straight and honest.

The case with Sien is that I am really attached to her, and she to me. My feeling for her is less passionate than what I felt for K. last year, but a love like that for Sien is the only thing I am still capable of. She and I are two unhappy ones who keep together and carry our burdens together, and in this way unhappiness is changed to joy, and the unbearable becomes bearable. Her mother is a little old woman exactly like the women Frère paints. She is very energetic, and has supported a family of eight children for years. She would not want to be dependent; she makes her living as a charwoman.

Now, you understand quite well that I should not care much for the formality of marriage if the family did not care for it, if only I remained faithful to her. But Father, I know for sure, attaches great importance to this, and though he does not approve of my marrying her, he would think it still worse if I lived with her without being married. They would say: 'You are marrying beneath your rank, and you are too poor.' My answer to this is: If I intended to live in style the result would be very bad. But as my way of living will be very simple, it can be done, and two persons living together can live more cheaply than one.

Father's advice would be to *wait*. I am a man of thirty, with wrinkles in my forehead and lines in my face as though I were

forty, and my hands are deeply furrowed, but Father looks at me through his spectacles as if I were a little boy. Only a year and a half ago he wrote to me: 'You are in your first youth.'

He has often told me that my education has cost more than that of the others. I should certainly not ask him for money on this occasion. Sien and I have what is absolutely necessary. The only thing we cannot do without as long as I do not sell my work is the one hundred and fifty francs from you, for house rent, bread, shoes, drawing materials; in short, the daily expenses. I ask but one single thing: to let me love and care for my poor, weak, ill-used little wife as well as my poverty allows me, without Father and Mother's trying to separate, hinder, or hurt us.

I assure you that I often think of home, but alas, the moment has not arrived; I do not say a word about it to Father and Mother. We must first try to get things started. For they, whom I may consider as amateurs, will like the work very much better when it is finished, but the rough sketch that you would understand if you were here would make them dizzy, to say the least. Whether they take it quietly or not will depend three-fourths on what you tell them.

You spoke about speculating on a heritage, but that is quite out of the question, for the reason that there is nothing for me to in-herit that I know of; in my opinion there is literally no money at home. The only person from whom in quite different circumstances I could have inherited, because I am named after him — Uncle Vincent — is somebody with whom I have been on decidedly bad terms for years.

Well, brother, I hope all 'dramatic' scenes will be avoided; that people with a certain untimely wisdom will not meddle in order to prevent my living with her. If there is, after all, some good in my behaviour towards Christine, this is more to your credit than mine, as I was and am only the instrument; without your help I should have been powerless.

Now you will say: 'Vincent, you had better think of the perspec-tive and the "Fish-Drying Barn."' And then I answer: 'You are right, dear brother,' and therefore I am going to work on the draw-

ing, and you will soon receive it as a proof that I like nothing better than to be absorbed in nature and art.

Of course, when you tell me there is nothing wrong with it, I shall certainly finish the order for C. M. To get six good ones I shall have to make more than six besides those I have already made. I do not know how much I shall get for them, but I shall do my best, so I hope I shall get the money in June.

Sien and I have been camping in the dunes from morning until night for days in succession as real Bohemians. We took bread with us, and a little bag of coffee, and got some hot water from a woman in a little shop at Scheveningen. That woman and her little shop are splendid, picturesque beyond description. I have visited there as early as five in the morning when the street-cleaners go there for their coffee. That would be a fine thing to draw, boy!!! To get all those people to pose would cost a great deal of money, but I should love to do it.

At present I am working out-of-doors as early as four o'clock in the morning, as in the daytime it is too difficult to work on the street because of the passers-by and the street urchins; that is also the finest moment to see the great lines when everything is in tone. Today I send to you two drawings, 'Fish-Drying Barn' in the dunes at Scheveningen, and 'Carpenter's Workshop and a Laundry,' seen from my studio window.

There lies before me a volume by Dickens. The illustrations are splendid; they are drawn by Barnard and Fildes. There are some parts of old London in it which through the peculiar wood-engraving have quite a different aspect from, for instance, the 'Carpenter's Workshop.' But I believe that the way to acquire that strength and power is to continue quietly to observe faithfully. As you will see, there are already several planes on this drawing, and one can look around it and through it, in every corner and hole. What is still lacking is vigour — at least it does not possess that quality as much by far as those illustrations do — but that will come.

If it is true that this winter I have had to pay less for paint than other artists, I have had to pay more for making an instrument for studying proportion and perspective, the description of which is

found in a book by Albert Dürer, and which the old Dutch masters also used. It makes it possible to compare the proportion of near-by objects with those on a more distant plane, in cases where construction according to the rules of perspective is not possible. And when one tries to do it with the eye alone -- unless one is an expert and very far advanced — it is always decidedly wrong. I did not succeed in making this instrument at once, but at last, after many efforts, with the help of the carpenter and the smithy I managed it. And after more efforts I see a chance of getting still better results.

I should be very pleased if there were in your wardrobe perhaps a coat and a pair of trousers fit for me that had been discarded by you. For when I buy something I do my best to get things as practical as possible for working in the dunes or at home; my street clothes are getting very shabby. And though I do not feel ashamed to go out in common clothes when I go to work, I feel ashamed indeed of gentlemen's clothes that have a shabby genteel air. But my working clothes are not untidy at all, simply because I have Sien to take care of them, and to make the necessary little repairs.

I quite long to know what impression Sien will make on you. There is nothing striking about her; she is just an ordinary woman of the people, who for me has something sublime; whoever loves one commonplace person and is loved by her is already happy, notwithstanding the dark side of life.

I should perhaps have become indifferent and sceptical if I had not met Sien, but my work and she keep me active. And one thing more I must add: Because she puts up with all the troubles and worries of a painter's life, and is so willing to pose, I think I shall become a better artist with her than if I had married K.

I have now had some luck with a few drawings, and the order for C. M. is almost finished.

Saturday I had a visit from Rappard, and I am glad he has been here. He is a man who understands my intentions, and who appreciates all the difficulties. He saw among others the drawings which I made for C. M. and they seemed to please him, especially a large one of that yard where Sien's mother lives. I wish you could

see that, too, as well as another of a carpenter's shop and yard where little figures are busy. I received two francs fifty from him, because he saw a tear in one of the drawings and said: 'You must have that repaired.' 'That is true,' I said, 'but I have not the money.' Then he readily replied that he would be pleased to give it to me; and he would have given still more, but I would not take it, and gave him a whole lot of woodcuts and a drawing in exchange.

The damaged drawing was for C. M., so, as it was the best of them, the money to have it repaired was very welcome. This drawing will perhaps be sold afterwards for fifty francs or so.

I do wish there were a few other people for whom I could make something on the same conditions as I am doing for C. M. And I hope especially that C. M. will continue to order, for these drawings are much better than the first, and by and by I shall make them better still. And at that price he certainly does not get a bad bargain.

Now, Heyerdahl has seen 'Sorrow,' but I should like to have a draughtsman, Henri Pille, for instance, see those last three drawings. I should like to know if they made any impression upon him, and if they would have his sympathy.

About the carpenter's pencil I reason thus. The old masters, what did they use for drawing? Certainly not Faber B, BB, BBB, but a piece of rough graphite. Perhaps the instrument which Michelangelo and Dürer used resembled somewhat a carpenter's pencil; I know only that with a carpenter's pencil one can get effects quite different from those obtained with thin, expensive Fabers. I prefer the graphite in its natural form to that cut so fine. And the shininess disappears by throwing some milk over it. In working out-of-doors with *Conté* crayon, the strong light prevents one from seeing clearly what one is doing, and one perceives that it has become too black; but graphite is more nearly grey than black, and one can always raise it a few tones by working it in again with the pen, so that the strongest effect of graphite becomes light again in contrast to the ink.

Charcoal is good, but when one keeps at it too long, it loses its freshness, and to keep the delicacy of touch, one must fix it im-

mediately. In landscape, too, I see that draughtsmen, for instance, Ruysdael and Van Goyen, and Roelofs too, among the moderns, used it often. But if someone invented a good pen to use out-of-doors, with an inkstand to go with it, perhaps more pen drawings would be given to the world.

Today I have had news from C. M. in the form of a postal order for twenty francs, but without one written word. So I do not know whether the drawings are to his liking and whether he will give me a new order. But in comparison with the price paid for the first ones, thirty francs, and considering that this package was more important than the first, it seems to me that C. M. was not in a good mood when he received them, or that for some reason or other they did not please him. I will readily admit that to an eye that is used to water-colours exclusively there must be something crude in drawings in which one has scratched with a pen, and lights have been rubbed out or put in again with body colour. But there are people who are not afraid of such crudeness, as there are people who think it sometimes pleasant and invigorating for a healthy man to take a walk during a storm. Weissenbruch, for instance, would not think these two drawings unpleasant or uninteresting.

I had not thought that C. M. would give me ten francs less for these than for the former ones. But if he approves of my beginning another six or twelve drawings for him, I shall certainly do so, because I shall not let any opportunity pass by to sell something. I will try my best to please him, for if it only pays my rent, and makes things somewhat easier for me, it will be worth while.

I have been thinking of you very often lately, and also of that time long ago when you visited me once at The Hague, and we walked together along the Ryswyk road and drank milk at that mill. It may be that this has influenced me somehow when making these drawings, in which I have tried to draw things as naïvely as possible, exactly as I saw them before me.

Looking back on those days of the mill, how sympathetic that time always seems to me! But it would have been impossible for me to put on paper what I then saw and felt. So I say that the changes which time brings do not alter my feelings at heart! I think they

are only developed in another form. My life is not as sunny now as it was then, but I would not go back, because through that very trouble and adversity I have seen some good arise: namely, *to give expression to that feeling.*

When you come, perhaps towards the end of June, you will find me at work again, I hope, but for the time being I am at the hospital, where I shall, however, stay only a fortnight. For three weeks I have been suffering from insomnia and low fever and bladder trouble; so I must stay quietly in bed here, must swallow many quinine pills, and must also have injections now and then, either of pure water or of alum water. So my condition is not at all serious; but you know one must not neglect such things, and should have them attended to at once, because neglect would make matters worse. You will do me a favour by not speaking about this, for people sometimes exaggerate so, and things are enlarged upon by gossip. I tell only you exactly what the trouble is, and you need not keep it a secret if anyone should ask you directly. At all events, you need not be anxious about it.

Sien comes to see me on visiting days, and keeps an eye on the studio. She is preparing to go to Leyden, for I think that now she is better off in the hospital. She wanted to stay here for my sake, but I would not allow that. I think of her often — I hope she will pull through safely.

I have fought against my illness as long as I could and have continued to work, but at last I felt it was urgent to consult a doctor. I had to pay a fortnight in advance, ten francs fifty for all expenses. There are ten patients in a ward, and I must tell you that the treatment is very good in all respects. I do not feel bored at all, and the thorough practical medical treatment does me good.

Father came to visit me during the first days I was here. It was but a short and very hurried visit, and I have not been able to speak seriously with him. I should have preferred his visiting me at another time. Now it was very strange, and seemed to me more or less like a dream, as does this whole affair of lying ill here. Few things have given me so much pleasure lately as hearing from home; it

sets my mind at ease about their feelings towards me. They have
sent a whole package of articles, underwear and outer clothing, and
cigars, and also ten francs. I cannot tell how it touched me; it is
much more than I expected. But they do not know everything as
yet. I am weak and feeble, Theo, and I need absolute rest in order
to recover, so everything that makes for peace is welcome.

But before I came here I felt much worse than I do now, and this
morning the doctor again told me I should soon be better.

The day before I came I received a letter from C. M. in which he
writes a whole lot about the 'interest' he feels for me, and which he
says Mr. Tersteeg has also shown me; but he did not approve of my
having been ungrateful to Tersteeg for his interest. I am lying here
calmly and quietly enough, but I can tell you, Theo, that I should
certainly lose my temper if some person or other came to see me
again with the kind of interest which Tersteeg showed me on cer-
tain occasions.

I have my books on perspective here, and a few volumes of
Dickens, among others 'Edwin Drood'; in Dickens there is also
perspective. Good God, what an artist! I hope my taking this rest
will have a good influence on my drawings, for sometimes one gets a
better view of things when one does not work on them for some
time, as, when you see them again, they seem fresh and new.

The view from the window of the ward is splendid: shipyards on
the canal, with the boats laden with potatoes, rear views of houses
that are being pulled down by workmen, part of a garden, and
farther away the quay with its row of trees and street-lamps, a very
complicated little court with gardens connected with it, and finally
all the roofs. The whole forms a bird's-eye view, but especially in
the evenings and in the mornings through the light effect is mysteri-
ous, like a Ruysdael or a Van der Meer, for instance. Draw it I may
not, but, though I am forbidden to get out of bed, I cannot re-
strain myself from getting up to look at it every evening.

The rest does me good and makes me much calmer, and takes
away that nervousness that has troubled me so much of late. And
here in the ward it is not less interesting than in the third-class
waiting-room.

I can assure you that I long dreadfully to see some green and breathe some fresh air. I have been here more than two weeks already, and I have had to pay in advance for the next two weeks, though if everything goes well I may leave in eight or ten days. I did not recover as quickly as the doctor expected. This morning I asked him if there has been some complication that would make things worse. He said no, but that rest and a stay in the hospital were necessary.

I can read, but I have no more books. It is such a strange feeling for me not to be able to do anything, and see the days pass by so empty.

Sien is at Leyden. I think when she had to leave I was too nervous, and it caused a relapse, but there are moments when one cannot keep calm. She is so alone there, and I should like so much to go and see her, for the days must be hard for her. What are the sufferings of us men compared to that terrible pain which women have to bear at childbirth? In patient suffering they are our masters. Until the last day she came to visit me regularly and brought me some smoked beef and sugar or bread; I have to do without it now, and this makes me feel very faint. I am so sorry that I in my turn cannot go to Leyden to bring her some extras that she might need, for the food one gets there is not particularly good.

Except for Sien, her mother, and Father, I had not seen anybody, which was indeed for the best. Then I had an unexpected visit from Mr. Tersteeg, which in a way greatly pleased me, though we did not talk about anything in particular. A few days later Iterson also came, but I cared much less about that; and then came Jan van Gogh. Involuntarily I often think how much more gloomy things are now than, for instance, when I came to Mauve for the first time this winter. It stabs me to the heart and oppresses me, though I try to throw the whole thought overboard as useless ballast.

I have had a letter from Rappard. Of course I sent him back the two francs fifty at once; then he answered me and repeated what he had already said about my drawings in the studio: that he liked them and felt sympathy for them because of their style and senti-

ment and character; and he suggested that if I had some more I should send them to him, as he thought he would be able to find a purchaser. That does me much good, for it is discouraging and depressing when one never hears: This or that is right, and full of sentiment and character. It is so cheering to perceive that others feel something of that which one has tried to express.

For the first time in several days I am sitting up again. If I were only well! If I could only work here, how I should love to make some studies in the wards! There is one old man who would have been a superb Saint Gérôme: a thin, long, sinewy, brown, wrinkled body with such very distinct and expressive joints that not to be able to have him for a model makes me melancholy. The doctor is exactly as I should wish; he looks like some heads of Rembrandt — a splendid forehead and a very sympathetic expression. I hope to have learned from him to this extent, that in future I shall try to handle my models as he does his patients. How well he knows how to banish their scruples and to place them exactly as he wishes! I believe that the doctor in this ward is a little more abrupt than in the more expensive wards. Perhaps they are less afraid here to hurt the patients a little. Well, so much the better, I think.

It was especially to visit Sien that I asked the doctor if it would be possible to give me a short leave instead of the walks in the garden. Now I have just got back to my studio. I cannot tell you how delightful it is to be better again, nor can I tell you how beautiful everything appeared to me on the way from the hospital; and how the light seemed clearer and the spaces more infinite, and every object and figure more important. But the most delightful thing about the whole recovery is that my love for drawing is reviving, and also the feeling for things around me which seemed almost extinct for a long time, and had left a great void. And then I have not smoked a pipe for almost a month, and it seems an old friend regained. I cannot tell you how happy I am to sit here in the studio after having been surrounded by chamber pots; though the hospital is also beautiful, very beautiful, especially the garden with all those convalescent people, men, women, and children.

But there is still one drawback, for next Tuesday I must again

go and see the doctor to tell him how I feel, and he has warned me that I may have to stay another fortnight in the hospital. Well, those are the little miseries of human life. At all events, it would be a piece of good luck if I did not have to go back.

I have been to Leyden. Sien's mother and little girl and I went there together; you can imagine how anxious we were, not knowing what we should hear, and how very glad we were when we heard: 'Confined last night ... but you may not speak for long with her.' I shall never forget that 'You may speak with her,' and it might have been, 'You will never speak to her again.' I was so happy when I saw her. She was lying near the window that overlooked a garden full of sunshine and green. She was so happy to see us, and in a moment she was wide awake. And was it not luck that we should have arrived exactly twelve hours after the confinement? There is only one hour a week when visitors are allowed. The child, a very nice little boy, was lying in its cradle with a worldly-wise air.

She suffered a great deal; it was a critical case. How clever they are, those doctors! But she forgot everything when she saw us, and even told me that we should begin to draw again soon. I should not mind in the least if her prediction came true right away. There were moments when I was not sorry I had to suffer a little also, rather than stand there in perfect health, for then the suffering would have been too unjustly divided. Deuce take it, but I am so thankful. But the gloomy shadow is threatening still, and Master Albert Dürer knew it well enough when he placed Death behind the young couple in that beautiful etching.

Well, Theo, without your help Sien would probably not be among the living. By years of a life of unrest and worry she had been thoroughly weakened; but now, when she need no longer lead such a life, everything will come right. When she is rid of all that misery there will come quite a new period in her life, and though she cannot get back her springtime, that is past and was but barren, her Saint John's green will be the fresher for it. You know how the trees in the middle of the summer when the greatest heat is over get new, fresh young shoots — a new young cover of green over the old weathered one.

I am writing at Sien's mother's, near a window that looks out on
a courtyard. I have drawn it twice. C. M. has these. I wish you
would see them when you go to see him, for I should like to know
your opinion.

The first person I met here on the Schenkweg was my friend the
carpenter, who has already helped me many a time with some little
jobs. His boss, who owns the house next to this, was in the yard,
and they persuaded me to go with them, and showed me they had
left the room that would be my studio unpapered awaiting my
decision. I said I could not decide now because I as well as Sien was
ill. All right, said the man, but I could choose from different papers
what I liked; then he would paper it, and I should not be bound to
anything. And though I said I did not want this, they have already
started it, as they wanted to show me it finished before Tuesday.

I must say the house is exceedingly comfortable, and looks very
neat and well built. There is a view from the attic window that is
fairylike. As soon as we are better, I shall take it. There is air and
space, delightful to work in, and healthy; light from the north, and
in the other room from the south. There is a little kitchen, which I
hope to draw often, also with a little window that looks out on the
courtyard.

Sien must leave the hospital a fortnight after her confinement.
This urged me to decide about taking the new house, that she may
find a warm nest on her return after so much pain. So I made an
arrangement with the owner: in the first place, that he would help
me to move at once and would lend me a few men from the yard for an
afternoon, to carry over my furniture, because I myself may not lift
heavy things; and secondly, that I should not pay him any rent
before I myself or Sien came to live there definitely — for perhaps
she will come back from the hospital before I do.

If I had planned this house myself and had arranged especially
for a studio, I could not have made it better than it is now. And no
other house on this street is like this inside, though the exteriors all
look alike.

I am feeling much better than I have for a long time; so I hope
to be quite well soon. My fingers are itching to set to work again.

Well, brother, during all the moving I hammered out another drawing, and this time it was a water-colour. It was a sketch that had remained unfinished because of my illness; so that now things are coming to life again. It represents fishing smacks on the beach, big hulls of boats that are lying in the hot sand, and the sea far away in a blue haze, for it was a sunny day, but the sun was behind me; so one must only feel it by a few casting shadows and the vibration of the hot air above the sand. *It is but an impression*, but I think it is rather correct.

The studio looks so real, I think; plain greyish-brown paper, a scrubbed wooden floor, white muslin curtains at the window, everything clean. And of course there are studies on the wall; I should like my studio to look well without antiques or tapestry, but only from the studies on the wall; there is an easel at each end, and a large white deal working table. Then adjoining the studio is a kind of alcove where I keep all my drawing-boards, portfolios, and boxes, and where I also keep the woodcuts. In the corner is a closet with all the bottles and pots, and all my books.

Then the little living-room with a table, a few kitchen chairs, an oil stove, a large wicker easy-chair for the woman in the corner, near the window that overlooks the wharf and the meadows, which you know from the drawing. Beside it is a small iron cradle with a green cover. It is a strong and powerful emotion that seizes a man when he sits beside the woman he loves with a baby in the cradle near them. I hung the great etching by Rembrandt above it, the two women by the cradle, one of whom is reading from the Bible by the light of a candle, while great shadows cast a deep *clair-obscur* into the whole room. I have hung still other prints there, all very beautiful ones: 'The Christ Consolator' by Scheffer; 'The Sower' and 'The Diggers' by Millet; 'The Bush' by Ruysdael; beautiful large woodcuts by Herkomer and Frank Holl, and 'The Bench of the Poor' by de Groux.

Well, in the kitchen there is the strictly necessary, with flowers before the window where she will sit. And up in the attic a large bed for us, and my old one for the child. We have been busy these days, her mother and I. The most difficult thing was the bedding; we

made and altered everything ourselves, bought straw, seaweed, bed-
ticking, and filled the mattresses in the attic. Otherwise it would
have been too expensive.

I do not intend to ask Father and Mother for their advice and
opinions as I did last year. Look you, Theo, Father and Mother are
not the people who understand me — neither in my mistakes nor in
my good qualities. They cannot realize my feelings. This is my
plea: I hope to be able to manage so that I can save ten or fifteen
guilders next month; then I shall beg Father to repeat his trip here
at my expense, and to come and stay a few days with me. I wish
Father could get a fresh and clear impression of a new future for me,
and might have good courage; and that he could be quite reassured
about my feeling for him. See, Theo, I know of no shorter, no more
honest way or means to redress quickly and practically the good
understanding between us.

I shall show him Sien and her little baby, which he does not ex-
pect, and the neat house and studio full of things I am working on.
In a few words I shall tell him how Sien and I struggled through the
hard time of her pregnancy this winter; how you helped us faith-
fully; how she is invaluable to me, first by the love and affection
which circumstances established between us, and secondly because
she has devoted herself with much good-will and common sense to
helping me in my work. So that she and I heartily hope that Father
will approve my taking her to wife.

I cannot say otherwise than 'taking her'; for the ceremony of
marriage is not what makes her my wife; we are bound together by
a strong bond of mutual affection and by the help we mutually give
each other. I have told you that I want to marry Sien, and this as
soon as possible. About marrying, you said: Do not marry her; and
you thought Sien fooled me. I did not want to contradict you
flatly, because I believed, and still believe, that in time you would
grow to like Sien. Only I said this much: There is a promise of
marriage between her and me, and I do not want you to consider
her as a mistress, or as somebody with whom I have a liaison with-
out caring for the consequences. This promise of marriage is two-
fold: first, a promise of civil marriage; secondly, a promise mean-

while to help each other, by sharing everything. Now, for the family the civil marriage is probably the most important; for her and for me it is secondary.

I propose to let the whole question of civil marriage rest for an indefinite time, or until I shall be earning one hundred and fifty francs a month by selling my work, when your help will no longer be necessary. With you, but only with you, I will thus agree for the time being not to have a civil marriage. I only hope, Theo, that what I tell you will show you that I do not want to have my own will in everything, that as far as I can I shall give in to your wishes. What I want is to save Sien's life and that of her two children. I do not want her to fall back into that terrible state of illness and misery in which I found her. I do not want her ever to feel again that she is deserted and alone. This I undertook, and this I must continue.

I have a feeling of being at home when I am with Sien, a feeling that she gives me my own hearth, that our lives are interwoven. This is a heartfelt, deep feeling, serious, and not without a dark shadow of her gloomy past and mine, as if some evil threatened us, against which we should have to struggle all our lives. At the same time, I feel a great calm and brightness and cheerfulness at the thought of her, and the straight path that is lying before me.

It is hard, very hard, ay, quite impossible to consider my love of last year as an illusion, as Father and Mother do, but I say: '*Though it never will be, it might have been.*' Illusion it was not, but our points of view differed. I wish I could only understand why K. acted so, and how it was that my parents and hers were so decidedly and ominously against it, less in their words than in their complete lack of warm, living sympathy. Now, as things are, it has become a deep wound which has healed, but remains always sensitive.

Then could I immediately feel a new 'love' this winter? Quite certainly not. But that these human feelings within me were not extinguished or deadened, that my sorrow awoke a need of sympathy for others, is that wrong? So at first Sien was for me only a fellow-creature, as lonesome and unhappy as myself. However, as I

myself was not discouraged, I was able to give her some practical support; and this was at the same time an incentive for me to remain above water.

But by and by, and slowly, our feeling changed to that of a need for each other, so that we could not bear to be separated — and then it was love. The feeling between Sien and me is *real;* it is no dream, it is reality. When you come you will not find me discouraged or melancholy, but will enter an atmosphere that will appeal to you — a new studio, a young home in full swing; no mystical or mysterious studio, but one that is rooted in real life, a studio with a cradle, a baby's high chair, where there is no stagnation, but where everything stirs one to activity. It has cost what it has cost, and even now I cannot do without your help, but your money has not been thrown away. It is going to produce more and more drawings.

A little time in the hospital, and then I set to work again, the woman with the baby posing for me. To me it is clear as day that one must live in the reality of family life if one wishes to express that family life intimately — a mother with her child, a washerwoman, a seamstress, whatever it may be. By constant practice the hand must learn to obey this feeling for a household of one's own. To try to kill that feeling would be suicide. That the studio and the family life mingle as one is no drawback, especially for a painter of the figure. I remember perfectly interiors of studios by Ostade, small pen drawings, probably corners of his own house, which show well enough that his studio resembled very little those where one finds Oriental weapons and vases and Persian rugs. Therefore I say, 'Forward,' notwithstanding dark shadows, cares, difficulties — often caused, alas, by meddling and gossip.

Do not imagine that I think myself perfect, or that I think it no fault of mine that many people take me to be a disagreeable character. I am often terribly melancholy, irritable, hungry for sympathy, and when I do not get it I try to act indifferently and speak harshly; often I even throw oil on the flames. I do not like to be in company, and it is often painful and difficult for me to mingle with people, to speak with them. But do you know the cause, if not

of all, of a great deal of this? Simply nervousness; I who am terribly sensitive, physically as well as morally, became nervous during those miserable years that drained my health. Ask a doctor, and he will understand at once that nights spent on the cold street, anxiety to get bread, a continual strain because I was out of work, estrangement from friends and family are the cause of at least three-fourths of my peculiarities of temper, and that those disagreeable moods and times of depression must be ascribed to this. But I have a good side too, and cannot they credit me with that?

This is the evening before I go back to the hospital. It is already late; here in the studio it is calm, but outside it is storming and raining, which makes the calm inside the greater. How I wish you could be with me, brother, this quiet hour! How much I should have to show you!

See, brother, I think of you so often, so very, very often these days; in the first place, because all I possess, all that I really have, belongs to you; even my own energy and love of life, for now with your help I can go forward, and I feel the power to work growing in me. But there is another reason why I so often think of you. I know how only a short time ago I came to a house that was not a real home. There was no wife, there was no child. I do not know whether you have had that feeling which forces, at moments when one is alone, a groan or a sigh from one: My God, where is my wife? My God, where is my child? Is living alone worth while?

It may be true that there is no God here, but there must be one not far off, and at such a moment one feels His presence; which comes to the same as saying (and I readily give this sincere profession of faith): I believe in God, and that it is His will that man lives not alone but with a wife and a child, when everything is normal.

I hope that you will understand what I have done, and take it as a natural thing. And, brother, see in Sien only a mother and an ordinary housewife, and nothing else. For that is what she really is, and I feel she knows it the better because she knows the 'reverse of the medal.'

I believe in you, and know that notwithstanding my nervousness there is in both our characters a basis of serenity — serenity *quand*

bien même — so that neither of us is unhappy; for that serenity is caused by our own true and sincere love for our profession and work, and art takes a great place in our minds and makes life interesting.

The last things I bought were a few plates, forks, spoons, and knives, and I thought: Another one for Theo and for Father when they come to visit me. So your place at the window and your place at the table are ready and waiting for you. You will certainly come, won't you?

Well, boy, if you come here to a home full of life and activity and know that you are the founder of it, will that not give you a proper feeling of satisfaction? You know my life has not always been happy, and now by your help my youth comes back and my real self develops. I only wish that you will keep in mind this great change, even when people think it foolish of you to help me still. And I hope that you will continue to see in the present drawings the germ for the next ones.

I have been to see the doctor in the hospital, and he told me that I need not come back. This afternoon I sent him a drawing to show my gratitude. It was a Scheveningen girl knitting, made at Mauve's studio, and really the best water-colour I had, especially because Mauve had put some touches in it, and had watched me make it and drawn my attention to some points.

I should like to take a trip to Scheveningen by car tomorrow morning, and then draw a little on the beach. I get tired and exhausted very soon; it is because I had to keep quiet in bed so long, and that is a queer feeling. But in many respects I feel well and better than last winter, and I am so cheerful and grateful for many things. It is already late, and I want to get up early tomorrow morning and go out with my drawing materials, as if nothing had happened between now and the last time I sat in the dunes at Scheveningen.

A part of your letter describing Paris by night touched me very much, because it brought back to me a memory when I also saw '*Paris tout gris.*' By chance while I was in the hospital an artist made a great impression on me, one who describes that effect with

a master hand; in 'Une Page d'Amour,' by Émile Zola, I found some views of the city painted or drawn in masterly fashion. And that little book has induced me to read everything by Zola, of whom up to now I have known only a few short fragments. He is a clever artist.

There is something confoundedly artistic in you, brother; cultivate it, let it take root, and then branch out; do not give it to everybody, but keep it seriously for yourself. One thing more; there is 'colour' in your short description which is palpable and discernible to me, though you have not carried through your impression till it has taken a more robust form and stands there discernible by everybody. At the point where you drop the description the real throes and anguish of creating begins; but the knowledge of how to create you possess confoundedly well. Do you know that to draw in *words* is also an art which sometimes betrays the slumbering of a hidden force, as the small blue or grey clouds of smoke indicate a fire on the heath?

Sien came home, and now she is here on the Schenkweg, and so far all is well, both with her and the baby; she can nurse it, and it is quiet. I was afraid that perhaps she would have to eat expensive things, but the diet prescribed is really the most economical one can imagine. So I really think that we can manage with one hundred and fifty francs a month.

Luckily it was quite warm, fine weather; it was indeed a delightful homecoming, and Sien was in high spirits about everything. But she was especially glad to see her little girl again; I had given her a new pair of boots for the occasion, and she looked very pretty.

How I wish you could have seen Sien today! I assure you her appearance has quite changed since this winter; it has been a complete transformation. Much credit is due to the doctor who treated her. But where he does not count is in the effect on her of the strong attachment between us two. A woman changes when she loves and is loved; when there is nobody who cares for her she loses her spirits and the charm is gone. Love draws out what is in her, and on it her development decidedly depends. Nature must have its free course, must go its normal way; what a woman wants

is to be with one man, and with him forever. That is not always possible, but when it is otherwise it is against nature. So she has now quite another expression; her eyes look different, her glance is calm and quiet, and there is an expression of happiness on her face, of peace and quiet, the more touching because of course she is still suffering. There is more spirit and sensitiveness in her; one can see that suffering and hard times have refined her.

You will see, from the special attention of the doctor and head nurse for her, that she is a person for whom serious persons have sympathy; indeed, it is quite remarkable that they have taken such care of her. I hope you will not have any scruples about making her acquaintance.

There is now here an atmosphere of 'home,' of 'one's own hearth.' I can understand Michelet saying: '*La femme c'est une religion.*'

Speaking more decidedly about art, I sometimes feel a great longing to start *painting* again. The studio is larger, the light better. I think now that Sien and I live together, and do not keep up two separate houses, I shall be able to spend more of the one hundred and fifty francs a month than I have hitherto on painting materials. It depends on my getting well again, but as soon as there is no danger of a relapse, and I can go out and sit in the open air, I intend to start it, and put some force behind it. As soon as she has quite recovered, Sien will begin posing seriously again, and I assure you her figure is good enough. I should like to go on with studies from the nude as soon as she is able, for one learns much from it. Even if I cannot continue working in the open air for some time, I shall at all events find subjects enough at home and shall not have to sit idle.

The two drawings I made lately are both water-colours, because I wanted to make a trial. When·I gave up painting and water-colours it was because I felt so bad about Mauve's deserting me that I could not look at a brush; it made me nervous. It seems to me that I must now work harder on the real drawings. But I begin to wash in by degrees. As soon as I am quite well I should like to make a decided water-colour on Harding, because this paper allows (more than the Whatman) putting on a solid foundation of black

and white before one begins to wash it in, without spoiling the aspect of the water-colour.

The other day I saw the exhibition of French art from the Mesdag and Post collections. There are many beautiful things. What I particularly admired was the large sketch by Th. Rousseau, a herd of cows in the Alps, and a landscape by Courbet. The Duprés are superb, and there is a Daubigny (of this I could not see enough), large thatched roofs against the slope of a hill; also a small Corot, a pond and *lisière de bois*, on a summer morning at four o'clock or thereabouts. One single little pink cloud shows that the sun will soon rise — a silence and calm and peace which fascinate one. I am glad I have seen all this.

This morning Tersteeg came here and saw Sien and the children. I should have wished that he would show a kind face to a young mother just out of childbed, but that was asking too much. Dear Theo, he spoke to me in a way that you can perhaps imagine.

What was the meaning of that woman and that child?

How could I think of living with a woman, and children in the bargain?

Was it not just as ridiculous as driving my own four-in-hand through the city?

Had I gone mad? It was certainly a thing that came from an unsound mind and temperament.

I told him that I had just received the most reassuring information from more competent persons than he, the physicians from the hospital, as much about the condition of my body as the power of my mind to stand exertion. So he jumped from one thing to another, brought in my father, and, just fancy, even my uncle of Prinsenhage!

He would see to it. He would write.

I asked him if it would not be ridiculous if those at home received an indignant letter from him, and then soon after a kind request from me to visit me at my expense, so as to talk over the same matter. That was not without effect. He said, did I intend to write myself? 'Can you ask that?' said I. Oh! Then of course he would not write.

I tried to draw his attention to the drawings, but he just looked around and said, 'Oh! Those are the old ones.' And at that he went away. There were some new ones, but he did not seem to notice them. Well, you know you have most of the new ones, or C. M. has some of them.

Dear Theo, I think Tersteeg is capable of causing all kinds of misery through his untimely interference: occasioning trouble and worry at home and at Prinsenhage (and Prinsenhage has nothing, absolutely nothing to do with it), can that not be stopped? I am on good terms with Father and Mother now, and who knows but that he will spoil everything again? I think it mean, but he does not feel so, and with him it is always and always that one thing, money; it seems he knows and worships no other god. I myself am not yet strong enough to defend myself as I could at another time. I really cannot stand such visits as that of this morning.

If all this can be a means, brother, of binding you and me more firmly together, of making us understand and confide more in each other instead of being separated by Tersteeg's interference, or anyone else's, then I do not regret this morning's incident.

I repeat, I shall not attempt to keep up my social standing or to live easily; the expenditures needed for the woman are the only ones necessary, and they must be met not by receiving more but by our economizing. This economizing is not a hindrance to us but a pleasure, because of the love between us. The feeling of recovery thrills her, as I am thrilled by the longing to work again, and to become absorbed in it. It has been the first painful hour for Sien and me since our return from the hospital. Sien changed like a leaf on the tree; there came an ugly line of pain, or I do not know what, on her face when she heard Tersteeg talking to me and caught a few words.

Living with the woman I have good courage, and I say: The money from you will make a good painter of me. Sien has become a little mother, so touching, like an etching or drawing or painting by Feyen Perrin. I am longing to draw again with her posing for me. I long for her and my recovery, for quiet and peace.

This winter you heard from Heyerdahl better things about my

work than Tersteeg thinks of it. I now feel so much renewed animation that I have good hope of making some progress this autumn. Perhaps about Christmas, when the year I have allowed myself is ended, I shall send you some small water-colours of which the last little drawings, that already have some touches of brown and red and grey, were the beginning. And sometimes I feel a great longing to paint also, a very great longing and ambition.

I repeat once more that I long so very much for your coming, because I have such a need of sympathy and affection. I should like so much to walk with you once more, *though the Ryswyk mill is no longer there.*

As for me, brother — though the mill has gone and the years and my youth are gone as irrevocably — deep within me has risen again the feeling that there is some good in life, and that it is worth while to exert oneself and to try to take life seriously. Perhaps, or rather certainly, this is rooted more firmly than it used to be, when I had had less experience. The problem for me now is to express the poetry of that time in my drawings.

I promised myself to consider my illness, or rather the remains of it, as non-existent. Art is jealous; she does not want us to choose illness in preference to her, so I do what she wishes. Enough time has been lost; my hands have become too white. People such as I are not allowed to be ill, so to speak. So I have set to drawing regularly from morning until night. I do not want someone to tell me again: 'Oh! Those are the old ones.'

More and more, other things lose their interest. I have had very little conversation with other painters lately. I have not been the worse for it; it is not the language of the painters but the language of nature to which one had to listen. I can now understand better than six months ago why Mauve said: 'Do not speak to me about Dupré; speak rather about the bank of that ditch, or the like.' It sounds rather crude, but it is perfectly true: the feeling for the things themselves, for reality, is more important that the feeling for pictures; at least it is more fertile and vital.

Because I have now such a broad, ample feeling for art and for

life itself, of which art is the essence, the voices of people who try to constrict me sound shrill and false. What I want and aim at is confoundedly difficult; yet I do not think I aim too high.

I want to make drawings that *touch* people. 'Sorrow' is a modest beginning; perhaps such little landscapes as the 'Meerdervoort Avenue,' the 'Ryswyk Meadows,' and 'Fish-Drying Barn' are also a slight beginning. But in these there is at least something that has come directly from my own heart.

Either through figures or through landscapes I wish to express, not sentimental melancholy, but serious sorrow. In short, I want to reach so far that people will say of my work: He feels deeply, he feels tenderly — notwithstanding my so-called roughness, perhaps even because of it.

It seems pretentious now to speak so, but that is the reason that I want to push on with full strength. What am I in the eyes of most people? A good-for-nothing, an eccentric and disagreeable man, somebody who has no position in society and never will have. Very well, even if that were true, I should want to show by my work what there is in the heart of such an eccentric man, of such a nobody.

This is my ambition, which is founded less on anger than on love, founded more on serenity than on passion. It is true that I am often in the greatest misery, but still there is within me a calm, pure harmony and music. In the poorest huts, in the dirtiest corner, I see drawings and pictures. And with irresistible force my mind is drawn towards these things. Believe me that sometimes I laugh heartily because people suspect me of all kinds of malignity and absurdity, of which not a hair of my head is guilty — I, who am really no one but a friend of nature, of study, of work, and especially of people.

I find in many modern pictures a peculiar charm which the old masters do not possess. What I mean as regards the difference between the old masters and the modern ones is, perhaps, that the modern ones are deeper thinkers. There is a great difference in sentiment between the 'Chill October' by Millais and the 'Bleachery at Overveen' by Ruysdael, and also between the 'Irish Em-

igrants' by Holl and the 'Bible Lecture' by Rembrandt. Rembrandt and Ruysdael are sublime, for us as well as for their contemporaries, but there is something in the modern painters that appeals to us more personally and intimately.

Lately I read 'Nana.' I tell you, Zola is really a second Balzac. Balzac was the first to describe society, from 1815 to 1848. Zola begins where Balzac ceases and goes on until Sedan, or rather until now. I think it splendid. Read as much of Zola as you can; that is good for one, and makes things clear.

How he *painted* those Halles! That figure of Madame François stands so calmly and nobly and sympathetically through the whole book against the background of the Halles, in contrast with the brutal egoism of the other women. I think Madame François is truly humane, and in regard to Sien I have done and will do what I think someone like Madame François would have done for Florent. Look here, this humanity is the salt of life; without it I do not care to live, that is all.

I have already spoken about the love of humanity as some people possess it. However, I haven't any humanist plans or projects for trying to help everybody, but I am not ashamed to say (though I know quite well that the word humanism is in bad odour) that I for my part have always felt and shall feel the need to love some fellow-creature. Once I nursed for six weeks or two months a poor miserable miner who had been burned. I shared my food for a whole winter with a poor old man, and Heaven knows what more, and now there is Sien. But I do not think all this is foolish or wrong. I think it is so natural and right that I cannot understand people's being generally so indifferent to each other. I must add that if I were wrong in doing so, you were also wrong in helping me so faithfully — to say that this was wrong would be too absurd.

Now, brother, do you remember last winter I told you that in a year you would have your water-colours?

I have made three water-colours of Scheveningen, also the 'Fish-Drying Barns' — minutely drawn. When I returned to that fish-drying barn, a wonderfully bright fresh turnip green or oil seed had sprouted in those baskets full of sand in the foreground, that

serve to prevent the drifting of sand from the dunes. Two months
ago everything was bare except the grass in the little garden, and
now this rough, wild, luxuriant growth forms a very pretty effect in
contrast to the bareness of the rest. I hope you will like this draw-
ing, the distant horizon, the view across the roofs of the village with
the little church steeple, and the dunes, it was all so fine. I cannot
tell you with what great pleasure I made it.

I have attacked the old whopper of a pollard willow, and I think
it is the best of the water-colours — a gloomy landscape, that dead
tree near a stagnant pool covered with reeds, a car shed of the Ryn
railroad, where tracks cross each other; the sky with drifting
clouds, grey with a single bright white border, and the depths of
blue where the clouds are parted. I wanted to make it as the signal-
man in his smock and with his little red flag must see and feel it
when he thinks: 'It is gloomy weather today.'

I have also a second drawing of the Ryswyk meadows, where the
same subject gets quite a different aspect through a change of the
point of view; and also a bleachery at Scheveningen, direct from
nature, made in one sitting, almost without preparation, on a piece of
very coarse torchon (unbleached linen).

These are landscapes with complicated perspective, very difficult
to draw, but for that very reason there is a real Dutch character
and sentiment in them. They resemble those I sent you last, but in
addition these have the colour — the soft green of the meadow con-
trasting with the red tile roof, the light in the sky contrasting more
strongly with the sombre tones of the foreground, a yard full of wet
wood and sand.

You will see that I am not afraid of a bright green or a soft blue,
and the thousands of different greys, for there is scarcely any
colour that is not grey — red grey, yellow-grey, green-grey, blue-
grey.

As far as I understand it, we of course perfectly agree about
black in nature. Absolute black does not really exist. But like
white, it is present in almost every colour, and forms the greys —
different in tone and strength; so that in nature one really sees
nothing else but those tones or shades. There are but three

fundamental colours, red, yellow, and blue; 'composites' are orange, green, and purple. By adding black and some white one gets the endless varieties of greys; to say, for instance, how many green-greys there are is impossible.

But the whole chemistry of colours is not more complicated than those few simple rules. And to have a clear notion of this is worth more than seventy different colours of paint, as, with those three principal colours and black and white, one can make more than seventy tones and varieties. The colourist is he who, seeing a colour in nature, knows at once how to analyze it, and to say, for instance, that green-grey is yellow with black and hardly any blue. In other words, he who knows how to find the greys of nature on his palette.

Those I have now made are simply to show you that if I study the drawing, the correct perspective and proportion, this enables me at the same time to make progress in water-colour. I made them for a trial after six months devoted exclusively to drawing, and secondly to see where I need to work harder in regard to that fundamental *drawing* on which everything depends.

Of course you will find in my water-colours things that are not correct; that condition will improve with time. But rest assured that I am far from clinging to a system or being bound by one. Such a thing exists more in the imagination of Tersteeg, for instance, than in reality. When I see how several painters here, whom I know, worry over their water-colours and pictures, I often think: Friend, the fault lies in your drawing.

I do not regret a single moment that I did not go on at first with water-colour and oil painting. I am sure I shall make up for that if only I work hard, so that my hand does not falter in drawing and in the perspective; but when I see young painters compose and draw *from memory*, and then haphazardly smear on whatever they like, also from memory, then keep it at a distance, and put on a very mysterious, gloomy face to find out what in Heaven's name it may look to be, and at last and finally make something of it, always from memory — it sometimes disgusts me. The whole thing makes me sick! But those gentlemen go on asking me, not without a

certain air of protection, if I am 'not painting as yet.' I have considered drawing as the only way to avoid that fate, and I have grown to love it instead of thinking it a nuisance.

And I hope you will understand that when I continue to stick to drawing, I do so for two reasons: because before all things I want to get a firm hand for drawing; and secondly, because painting and water-colouring cause a great many expenses which do not at first give back any value, and those expenses double and redouble ten times when one works on a drawing which is not correct. And if I got into debt or surrounded myself with canvases and papers all daubed with paint, then my studio would soon become a sort of hell, as I have seen some studios look. Now, I always enter it with pleasure and work there with animation. But I do not believe that you suspect me of unwillingness.

Mauve himself will understand afterwards that he was not deceived in me, and that I was not at all unwilling. It was he himself who taught me to draw more conscientiously before I did anything else.

I am sure you know, Theo, that it is no more difficult to work in colour than in black and white, perhaps indeed the reverse, for so far as I can see, three fourths depends on the original sketch, and on its quality rests almost the whole water-colour. It is not sufficient to give the effect *à peu près*; it was and is my aim to bring drawing to a higher plane. In the black and white 'Fish-Drying Barns' that is already perceptible, I think, for there you can follow everything and trace the construction of the whole.

Be sure, lad, that I am quite my old self again. The deuce, it is nice working in the studio. The new studio is a great improvement on the old one; it makes work easier, and especially for posing it is much better, because one can take in a greater distance. The more that I pay in rent is, I am sure, made up for by better work.

I must draw the cradle in water-colour some day, when it is rainy and I cannot work outside. But for the rest I want to show you landscape water-colour when you come. Figure water-colour I hope to make this winter, after I have been here a year. I shall first

have to draw more from the nude, and more in black and white too, I think.

It will not be long before Sien earns her own bread by posing. My very best drawing, 'Sorrow' — at least I think it is the best of those I have made — well, she has posed for it, and in less than a year I shall make regularly drawings of the figure; I promise you that. For know it well, though I have much love for landscape I have more love for figure drawing.

In order to make notes from nature, or to make little sketches, a strongly developed feeling for outline is absolutely necessary, as well as to carry it to a higher plane afterwards. But I believe one does not acquire this without effort, but first by observation, and then especially by strenuous work and research; after that, special study of anatomy and perspective is needed.

Beside me is hanging a landscape study by Roelofs, but I cannot tell you how expressive that simple outline is, everything is in it. Another still more striking example is the large woodcut 'Bergère' by Millet. When I see such results I feel more strongly the great importance of the outline. And you know, for instance, from 'Sorrow' that I take a great deal of trouble to make progress in that respect. But you will see that besides the seeking for the outline, I have, just as everyone else has, a feeling for the power of colour.

I do not object to making water-colours; but the foundation of them is the drawing; from it many other branches besides water-colour sprout forth, and these will develop in me in time, as in everybody who loves his work.

I saw yesterday very beautiful little fusains by Th. de Bock, with touches of white and delicate blue in the sky, very well done, which I like better than his pictures.

Brother, I am so very glad you will come. For several reasons it is better for us both, I think, if I do not go with you to see Tersteeg or Mauve. And then I am so used to my working clothes, in which I can lie or sit in the sand or the grass just as I want (for in the dunes I never use a chair, only sometimes an old fish basket); as a result, my dress is rather too Robinson-Crusoe-like for me to go out

paying calls with you. But for the rest you will understand that I actually long for every half-hour that you can spare.

Shall we then really go together through the meadows? Fine. And the sea and the beach, and the *old* Scheveningen? Delightful. I know a few beautiful paths through the meadows, where it is so quiet and calm that I am sure you will like it. I discovered there old and new labourers' cottages and other houses that are characteristic, with little gardens by the waterside, very pretty. It is a road that runs through the meadows of the Schenkweg.

Tersteeg in his judgment of me and my behaviour always starts from the fixed idea that I can do nothing and am good for nothing. I hear it from his own lips: 'Oh, that painting of yours will be like all the other things you undertook; it will come to nothing.' I should think myself too foolish if I ran after him, saying: 'Mr. Tersteeg, Mr. Tersteeg, I am a real painter like other painters, notwithstanding anything you may say.'

No, just because I indeed have the artistic sense in my very bones and marrow, I think it much better to go quietly camping in the meadows or the dunes, or to work in the studio from a model.

You must imagine me sitting before my attic window as early as four o'clock in the morning, studying with my perspective instrument the meadows and the yard when they are lighting the fires to make the coffee in the little cottages, and when the first workman comes loitering into it. Over the red tile roofs a flock of white pigeons comes soaring between the black smoky chimneys. But behind it all, a wide stretch of soft, tender green, miles and miles of flat meadow, and over it a grey sky, as calm, as peaceful as Corot or Van Goyen. This view over the gabled roofs with the grass-grown gutters, at early day, and those first signs of life and awakening, the flying birds, the smoking chimneys, and that figure loitering far below in the yard — these form the subject of my water-colour.

Whether I shall succeed in the future will depend more on my work than on anything else — on my looking calmly through my window at the things in nature, and drawing them faithfully and lovingly.

Of the drawings which I shall show you I think only this: I

hope they will prove to you that I do not remain stationary in my work, but make progress in a direction that is reasonable. As to the money value of my work, I do not pretend to anything else but that it would greatly astonish me if my work were not just as salable in time as that of others. Whether that will happen now or later I cannot tell, but I think the surest way, which cannot fail, is to work energetically from nature. Feeling and love for nature sooner or later find response from people. It is the painter's duty to be entirely absorbed by nature and to use all his intelligence to express sentiment in his work, so that it becomes intelligible to other people. To work for the market is in my opinion not exactly the right way; on the contrary, it deceives the amateurs. The true painters have not done so, but the sympathy they received sooner or later came because of their sincerity. That is all I know about it, and I do not think I need know more.

Of course it is a different thing to try to find people who like your work, and who will love it. And you know that I shall exert all my efforts to sell my drawings soon, for the very reason that I do not wish to abuse your kindness. I do hope, brother, that within a few years, perhaps even sooner, little by little you will come to see things by me that will give you some satisfaction for your sacrifices.

More and more I shall concentrate on art. And although some people may damn me irrevocably and forever, it lies in the nature of things that my profession and my work will open to me new relations, the fresher because they will not be frozen, hardened, and made sterile by old prejudices.

I repeat, everyone who works with love and with intelligence finds in the very sincerity of his love for nature and art a kind of armour against the opinions of other people. Nature is also severe and, so to speak, hard, but she never deceives and always helps us on. All those things make me feel brighter and fresher.

Well, Theo, my drawing has dried in the meantime, and I want to touch it up. The lines of the roofs and gutters shoot away in the distance like arrows from a bow; they are drawn without hesitation.

Dear brother, I am still quite under the impression of your visit. I had really often suppressed the desire to paint; through what you gave me, a new horizon has been opened to me: I think I am privileged above thousands of others because you have removed so many barriers for me. Many a painter cannot go on because of the expense, and I cannot express to you in words how thankful I am. I began later than others, and to make up for that lost time I must work doubly hard; in spite of my ardour, I should have to stop if it were not for you. I think it a delightful prospect to be able to work a whole year without anxiety.

I have bought, first, a large-sized moist colour box containing twelve pieces or tubes of water-colours, with two covers, one of which can serve as a palette; there is also room for six brushes. This is an article of great value for working in the open air, and really absolutely necessary, but it is very expensive; and I had always put off getting one and have worked instead with loose pieces on saucers. At the same time I laid in a stock of water-colours, and renewed my brushes.

Then for oil painting I now have everything that is absolutely necessary, and also a stock of paint, large tubes (which are much cheaper than the little ones), but you can imagine that I limited myself to the simple colours both in water-colour and in oil: ochre (red — yellow — brown), cobalt and Prussian blue, Naples yellow, terra sienna, black and white, completed with some carmine, sepia, vermilion, ultramarine, gamboge, in smaller tubes. But I refrained from choosing colours which one must mix oneself. This is, I believe, a practical palette with healthy colours. Ultramarine, carmine, or the like are added when strictly necessary. The moist colour box fits in my paint box, so that I can carry in one everything that is needed for water-colour and for painting.

I shall begin with little things, but I hope this summer to practise making large sketches in charcoal, in order to paint afterwards in somewhat larger sizes. Therefore I have ordered a new and I hope better perspective instrument, that can be fixed on uneven ground in the dunes. I have just come back from the blacksmith, who made iron points to the sticks and iron corners on the frame.

The instrument consists of two long poles; the frame is attached to them lengthwise or across with strong wooden pegs. So on the shore or in the meadows or in the fields one can look through it as through a window. The vertical lines and the parallel line of the frame and the diagonal lines and the cross, or else the division into squares, are certain to give a few principal points, by the help of which one can make a firm drawing, one which shows the large lines and proportions — at least for those who have some instinct for perspective and some understanding of the reason why, and the manner in which, the perspective gives an apparent change of direction to the lines and a change of size to the planes and to the whole mass. Without this the instrument is of little use, and it makes one dizzy to look through it.

With long and continuous practise it enables one to draw quick as lightning — and, once the drawing is fixed, also to paint quick as lightning. In fact, for painting it is absolutely the thing. The perspective frame is really a fine piece of workmanship. It cost me quite a bit, but I have had it made so solidly that it will last a long time. I attach great importance to having good materials to work with.

I think you can imagine that it is a delightful thing to direct this instrument on the sea, on the green meadows, in winter on the snowy fields, or in autumn on the fantastic network of thin and thick branches and trunks or on a stormy sky. What we saw together in Scheveningen — sand, sea, and sky — is something I certainly hope to express in time.

Yesterday afternoon I was in the attic of the wholesale paper house of Smulders on the Laan. I found there the double Ingres under the name of torchon paper; it has a grain as rough as a piece of canvas. There is a whole stock of it, old and grown yellow, very good and very cheap, left from an undelivered order. This is very suitable for charcoal drawing, and it comes in large sheets.

Of course I have not spent at once everything you gave me, though I must say this: the prices of the different things were much higher than I thought, and there are more things needed than one expected at first.

I have bought a pair of strong and warm trousers, and as I had bought a pair of strong shoes just before you came, I am now prepared to weather the storm and rain. So next Monday I begin to make large fusains with the new instrument, and begin to *paint* small studies. I tried it in January, but had to stop, the reason being that I was too hesitating in my drawing. Now six months have passed that have been quite devoted to drawing.

It is my aim to learn from this painting of landscape a few things about technique which I feel I need for figure, namely, to express different materials, and the tone and the colour; in a word, to express the bulk — the body — of things. Through your coming it became possible for me, but before you came there was not a day that I did not think in this way about it. But for you, I should have had to keep exclusively to black and white, and to the outline a little longer. Now, however, I have launched my boat.

During the days that have passed since you left, I have made some experiments. I have three painted studies: one a row of pollard willows in a meadow; then a study of the cinder path near here; and today I was again in the vegetable gardens of Meerdervoort Avenue, and saw there a potato field with a ditch; a man in a blue smock and a woman were picking up potatoes, and I put those figures in. The field was of white sand, partly dug up, still partly covered with rows of dried stalks, with green weeds between; in the distance, dark green trees and a few roofs.

Those vegetable gardens have a kind of old Dutch character which always greatly appeals to me. I made this last study especially with great pleasure. I must tell you that painting does not seem so unusual to me as you would perhaps suppose; I am very much in sympathy with it, as it is a very strong means of expression. At the same time, one can express tender things with it too, make a soft grey or green find voice amidst all the ruggedness.

I also have a huge mass of dune ground — sticky, and thickly painted.

These studies are of middle size; before I paint larger things I shall *draw* them larger, or I shall make *grisailles* of them if I can

discover the technique — I shall try to find it. Now I should like best to go on making quite a number of painted studies, and hang them in my studio without speaking to anybody about this change. In case someone wonders at seeing painted things by me, I shall say: Did you think, then, that I had no sentiment for that, or was not able to do it? But I have attached great value to drawing, and shall continue to do so, because it is the backbone of painting.

I like painting so much, Theo, that because of the expense I shall have to repress myself rather than urge myself on. It becomes too expensive if one is not economical with the paint; but, boy, it is so delightful to have so many new and good materials; once more, many many thanks. I shall certainly try to take care that you shall never regret your generosity.

This morning I marched to the beach, and have just returned from there with a rather large-sized painted study of sand, sea, and sky, a few fishing smacks, and two men on the beach. There is some sand of the dunes in it.

Last Saturday night I attacked a thing I had been dreaming about for a long time. It is a view of the flat green meadows, with haycocks. They are crossed by a cinder path running along a ditch, and at the horizon in the middle of the picture the sun is setting fiery red. It was purely a question of colour and tone, the iridescence of the colour scheme of the sky — first a violet haze, in which the red sun was half covered by a dark purple cloud with a brilliant fine red border; near the sun reflections of vermilion, but above it a streak of yellow that turns into green and then into blue, the so-called *cerulean blue;* and here and there violet and grey clouds that catch reflections from the sun. The ground was a kind of carpet-like texture of green, grey, and brown, but full of iridescence and vibration — in that coloured soil the water of the ditch sparkles. It is something that Émile Breton, for instance, would paint.

Of these two, the small marine view and the potato field, *I am sure no one could tell that they are my first painted studies.* To tell the truth, it surprises me a little. I had expected that the first

things would be a failure, and though I say it myself, they are not at all so bad. Do not think I am satisfied, but this I believe, that already in these first ones you will see that there is something of the open in it, which proves that I love nature and that I have a painter's heart within me.

Now, since I bought my paint and brushes I have drudged and worked so hard on seven painted studies that I am dead tired. There is among them one with a figure in it, a mother with her child, in the shadow of a large tree, in tone against the dune, on which the summer sun is shining — almost an Italian effect. I simply could not restrain myself or keep my hands off it or allow myself to rest. In my opinion one must not spare oneself when it goes hard. If there follows a short period of exhaustion, that soon will pass, and so much is gained that one harvests one's studies just as the farmer harvests his crops.

There is an exhibition here of the Society of Black and White. In it is a drawing by Mauve — a woman at a weaving-loom, probably in Drenthe, which I think is superb. There are splendid things by Israëls — among others a portrait of Weissenbruch with a pipe in his mouth and his palette in his hand. From Weissenbruch himself beautiful things, landscapes and also a marine view. There is a very large drawing by J. Maris, a splendid city view. It is very stimulating to see such things, for then I perceive how much I still have to learn.

But this much I want to tell you: I feel a power of colour in me while painting that I did not possess before, a sensation of breadth and strength. It gives me such scope, it enables me to see effects that were unattainable before — just those which after all appeal to me most. When in the future something strikes me in nature I shall have more means with which to express it. All these things together make me very happy.

It is now just two years ago since I began to draw in the Borinage!

During the whole week we have had much wind, storm, and rain, and I went several times to Scheveningen to paint. I brought home from there two small marine views. One of them is slightly

sprinkled with sand, but the second one, made during a real storm, when the sea came quite close to the dunes, was covered with a thick layer. The wind blew so hard that I could scarcely keep on my feet, and could hardly see for the blowing sand. However, I tried to get the painting fixed by going to a little inn behind the dunes, and there, after scraping off the sand, I immediately repainted it, returning to the beach now and then for a fresh impression.

Before the storm the sea was even more impressive than while it raged. During the storm one could not see the waves so well, and the effect was less that of a furrowed field. It was a fierce storm, the fiercer and, if one looked at it long, the more impressive because it made so little noise. The sea was the colour of dirty soapsuds.

I have also painted a few rather large studies in the forest, which I tried to carry out and finish more than the first ones. The one that I believe succeeded best is nothing but a piece of dug-up earth — white, black, and brown sand after a pouring rain. I was so eager to continue that I remained at my post, and sought shelter as well as I could behind a thick tree. When the rain was over at last and the crows began to fly, I was not sorry that I had waited, because of the beautiful deep tone which the rain had given to the soil.

As I had begun before the rain with a low horizon, on my knees, I now had to kneel in the mud. It is by reason of such adventures that in my opinion it is well to wear an ordinary workman's suit, which is less easily spoilt. The result of this was that I could bring to the studio that piece of ground — though Mauve once rightly said, while speaking about a study of his, that it is a hard job to draw those lumps of earth and to get perspective in them. So I have now put into practice things that Mauve told me in January.

The other study of the forest is of some large green beech trunks on a ground covered with dry leaves, and the little figure of a girl in white. I found great difficulty in keeping it clear, and in getting atmosphere between the trunks that stand at

different distances (the place and relative bulk of those trunks change with the perspective), and making it so that one can breathe and walk around in it, and smell the fragrance of the wood. I love so much, so very much, the effect of the yellow leaves against which the green beech trunks stand out so well, and the figure no less.

I am longing for the autumn. About that time I must be sure to have a stock of paint and other things.

It was with extreme pleasure that I made these studies. The same is true of a thing I saw at Scheveningen — a large patch in the dunes in the morning after the rain; the grass comparatively green, and on it the black nets stretched in enormous circles, giving the soil tones of a deep reddish black and greenish grey. On that sombre ground, women in white caps, and men who spread or repaired the nets, were sitting or standing, or walking around like dark fantastic ghosts; above the landscape was a simple grey sky, with a light streak above the horizon. Notwithstanding the showers of rain, I made a study of it on a sheet of oiled torchon.

How beautiful it is outside when everything is wet from the rain! I ought not to let one single shower pass. These are the things in nature that strike me most.

So after all I have a few souvenirs. But I again caught cold, which is now forcing me to stay at home a few days.

I have just received a nice letter from home that clearly showed me that your visit and the things you told them about me and my work had made a reassuring impression upon them. I fully agree with you that Father and Mother, with all their good and bad traits, are people of a kind that is becoming rare in the present time, more and more rare — and perhaps the new type is not at all better. I myself do indeed appreciate them.

Now they are perhaps looking out for the 'painting in oil.' It will come at last — and oh! how disappointed they would be, I am afraid, if they could see it; they would notice nothing more than daubs of paint. Besides, they consider drawing as a 'preparatory study,' an expression which for many years I have learned

to hate, and think as incorrect as can be. And when they see
me still doing it as before, they will think I am forever at that
preparatory study. Whenever they see me in future toiling and
pegging away at my work — scraping it out, now comparing it
with nature, now changing it a little so they can no longer exactly
recognize the spot or the figure, over and over again — they
will think: 'He doesn't really know anything about it; real painters
would work in quite a different way.'

Well, I dare not allow myself any illusions, and I am afraid
it may never happen that Father and Mother will really appreciate
my art. It is not their fault; we do not see the same things with
the same eyes, or have the same thoughts raised in us by them.
They will never be able to understand what painting is. They
cannot understand that the figure of a labourer — some furrows
in a ploughed field — a bit of sand, sea, and sky — are serious
subjects, very difficult, but at the same time so beautiful that
it is indeed worth while to devote one's life to the task of express-
ing the poetry hidden in them.

To wish this were otherwise is permitted, but to expect it to
be is, in my opinion, not wise.

What you tell me about their new surroundings is very inter-
esting. To be sure, I should love to paint such a little old church,
and the churchyard with its sand mounds and old wooden crosses.
I had a letter from Willemien, who describes very prettily the
country around Neunen. I have asked for some particulars about
the weavers, who interest me very much. I saw them when I
was in the Pas de Calais — it was indescribably beautiful.

You write about the stretch of heath and the pine wood close
by. I can tell you I feel an everlasting homesickness for heath
and pine trees, with the characteristic figures — a little woman
gathering wood, a peasant digging sand — in short, those simple
things that have something of the grandeur of the sea. I always
carry the wish to go and live somewhere quite in the country,
if I had the opportunity and circumstances would permit. But
I have plenty of subjects here — the woods, the beach, the Ryswyk
meadows near-by.

Lately I read the 'Letters and Diary of Gerald Bilders.' He certainly was unhappy and was often misunderstood, but at the same time I find a great weakness in him, something morbid in his character. What I do not like is that *while he paints* he complains about terrible dulness and idleness. He says too often: 'I was blue this week and have been making a mess of things — and I have been to this or that concert, or theatre, but came home still more miserable than I went.' He is a sympathetic figure; but I should rather read the life of Father Millet, or of Th. Rousseau, or of Daubigny. What strikes me in Millet is that simple 'After all, I must do this or that.' To read Sensier's book on Millet gives one courage; that of Bilders makes one melancholy.

He died at the age when I began. When I read that, I am not sorry that I started late. In his view of life Gerard Bilders was romantic and never got over the *illusions perdues.* I for my part think it in a certain way an advantage that I started only when the romantic illusions were behind me. I must make up for lost time now. I must work hard, but just when one has left the lost illusions behind, work becomes a necessity, and one of the few pleasures that are left. This gives me a great quiet and calmness.

This morning I have put on the walls all my painted studies. I love to have such things in my studio — they remind me of the country every morning when I see them, so that I know immediately what to do that day — and at once have a mind to do something, or feel I just must go here or there. In several of them there are little figures. I worked also on a large one and have scraped it off twice, which you would perhaps have thought too hasty if you had seen the effect. But this was not from impatience; it was because I feel that I can do still better by grinding and trying. and feel compelled to succeed in doing better; it may cost ever so much time, ever so much trouble.

Painting gives me light on different questions of tone and form and materials, before which I have up to now stood helpless. There is in painting something infinite — I cannot explain it to you so well, but for expressing one's impression, it is so delightful. There are in colours hidden effects of harmony

or contrast that involuntarily combine to work together, and which would not be possible if used in another way.

If I have painted so many studies in a short time, it is because for two weeks I have worked from early in the morning until late at night, scarcely taking any time even for eating or drinking. I think it possible that if you saw the paintings, you would say that I ought to go on with the work, not only at times when I want to very much, but regularly, as absolutely the most important thing. But though I myself love to do it, if I continued in this way it would be too expensive as long as I did not sell.

It seems to me that my painted studies are at all events more pleasant in aspect than my drawings. For my part I attach less value to the more pleasant effect, and the goal I want to reach lies in the expression of more severe and virile things, for which I shall still have to drudge a great deal. I should not want to make things that were in principle bad, untrue, and of false conception, because I love nature too much. But this is the question: In order to reach something higher and better, I must still make many studies. Which will be more profitable, to draw those studies or to paint them?

With the same amount of trouble one spends on a drawing, one brings home something that renders the impression much better and is much more agreeable to look at, and at the same time is more correct. In a word, it is more grateful work than drawing. But I should be the first to say: We must meanwhile practise the greatest economy. By drawing much expense is avoided, and one makes solid though slow progress; and I do this with no less pleasure. You told me to try to finish a little drawing in water-colour; I believe that through painting I shall be able to make better water-colours than before, if I start them again. I see also a better chance now of getting results with charcoal; but if you saw from my paintings that they would have the better chance, I want to tell you that I would work on them with great ambition.

I should rather you decided this than I, because I think you are more competent than I to judge financial success, and I have

absolute trust in your judgment. Formerly I could tell better than now what things were worth; now I notice daily that I do not know it any more.

Please do not suspect me of indifference about earning money; I aim at trying the nearest way to that end, if only this means be real and lasting.

However, I am in doubt. Painting comes easier to me than I expected: perhaps it would be better to throw myself into it with all my strength, pegging away especially with the brush. I declare I cannot tell.

It is autumn now in the woods. There is sometimes a soft melancholy in the falling leaves, in the tempered light, in the haziness of things, in the elegance of the slender stems. But also I love the sturdier rude side — those strong light effects, for instance, on a man who stands digging and perspiring in the midday sun. At this time of the year it is doubly beautiful at the beach. There is in the view of the sea a light, tender effect, and in the wood there is a gloomier, more serious tone. I am glad both exist in life.

There are effects of colour which I but rarely find painted in the Dutch pictures. Yesterday evening I was busy painting a rather sloping ground in the wood, covered with mouldered and dry beech leaves. You cannot imagine any carpet so splendid as that deep brownish-red, in the glow of an autumn evening sun, tempered by the trees. The question was — and I found it very difficult — how to get the depth of colour, the enormous force and solidity of that ground. And while painting it I perceived for the first time how much light there was in that darkness; how was one to keep that light and at the same time retain the glow and depth of that rich colour? From that ground young beech trees spring up which catch light on one side and are sparkling green there, while their shadowy side is warm, deep black-green.

Behind those saplings, behind that brownish-red soil, is a sky very delicate, bluish-grey, warm, hardly blue, all aglow. A few figures of wood-gatherers are wandering around like dark masses

of mysterious shadows. The white cap of a woman who is bending to reach a dry branch stands out all of a sudden against the deep red-brown of the ground; a skirt catches the light; the dark silhouette of a man appears above the underbrush; a white bonnet, a cap, a shoulder, the bust of a woman moulds itself against the sky. Those figures, they are large and full of poetry — in the twilight of that deep, shadowy tone they appear as enormous *terres cuites* in moulding in a studio.

I describe nature to you; in how far I have rendered the effect in my sketch, I do not know myself; but this I know, that I was struck by the harmony of green, red, black, yellow, blue, brown, grey. It was very de Groux-like.

To paint it was a hard job. I used for the ground one large tube and a half of white — yet that ground is very dark; further, red, yellow, brown ochre, black, terra sienna, bistre; the result is a reddish-brown, but one that varies from bistre to a deep wine-red, and even a pale blond ruddiness; there is also the moss on the ground, and a border of fresh grass, which catches light and sparkles brightly, and is very difficult to get. There you have at last a sketch which I maintain has some significance, and which expresses something, no matter what may be said about it.

While painting it I said to myself: I must not go away before there is something of an autumn evening feeling in the painting, something mysterious, something serious. But as this effect does not stay, I must paint quickly. So the figures are painted in at once by a few strong strokes. It struck me how firmly those little stems were rooted in the ground. I began them with a brush, but because the painted ground was already so sticky — a brush stroke was lost in it — I squeezed the roots and trunks in from the tube, and modelled them a little with the brush.

Yes, now they stand there rising from the ground, strongly rooted in it. In a certain way I am glad I have not *learned* painting, because then I might have learned to pass by such effects as this. Now I say: No, this is just what I want; if it is impossible, it is impossible; I will try it, though I do not know how it must

be done. How I paint it *I do not know myself.* I sit down with a white board before the spot that strikes me, I look at what is before me, I say to myself that that white board must become something; I come back dissatisfied; I put it away, and when I have rested a little, I go to look at it with a kind of fear. Then I am still dissatisfied, because I have still too clearly in my mind that splendid scene of nature.

But after all I find in my work an echo of what struck me. I see that nature has told me something, has spoken to me, and that I have put it down in shorthand. In my shorthand there may be words that cannot be deciphered. There may be mistakes or gaps, but there is something in it of what wood or beech or figure has told me, and it is not a tame or conventional language, that proceeds not from nature itself but from a studied manner or a system.

Now I feel myself on the high seas; the painting must be continued with all the strength I can give to it. I know for sure that I have an instinct for colour, and that it will come to me more and more; that painting is in the very bone and marrow of me. I feel in myself such a creative power that I am conscious the time will arrive when, so to speak, I shall daily and regularly make something good. I should not be at all surprised if it happened some day. But very rarely a day passes that I do not make something.

Doubly and twice doubly I appreciate your helping me so faithfully and strongly.

When I paint on panel or canvas the expense increases again. Everything costs so much, and the paint is so soon gone. Good painting does not depend upon using much colour, but in order to paint a ground with force, or to keep a sky clear, one must sometimes not spare a tube. Sometimes the subject requires a delicate painting; at times the nature of the things themselves requires a thick painting. Mauve, who, in comparsion with J. Maris, and still more in comparison with Millet or Jules Dupré, paints very soberly, has in the corners of his studio cigar boxes full of empty tubes, which are as numerous as the empty bottles in the

corner of the rooms after a dinner or *soirée*, as Zola describes it, for instance.

Well, those are difficulties all painters have. How many must be overcome before one can express something! Yet in those very difficulties lies the spur. We must see what can be done.

I feel that at all events painting will indirectly rouse other things in me too.

When you were here, you spoke about my trying to send you some day a little drawing of the kind that is called 'salable.' I have made a water-colour of the flocks of orphans with their spiritual shepherd which will show you that I am not averse to choosing sometimes subjects that are pleasant or agreeable, and as such will appeal to collectors more than things of a gloomier sentiment.

Had I remained on good footing with Mauve, I think that had I made a water-colour like this, he would have pointed out to me some changes which would have made it salable, and which would have given it quite a different aspect. With the water-colours or pictures of many a painter, indeed, another painter may work on them — sometimes even quite change them. I often feel a longing and a need to ask the advice of someone on different questions; but I do not give way to it since my experience with Mauve. I do not speak with painters about my work. Somebody may be ever so clever; of what use is that to me when he speaks in a way different from the medium in which he works? I wish that Mauve had told me about the use of body colour, instead of saying, 'In no case must you use body colour,' while he himself and all the others use it almost always, and with the best results.

That is what I miss — though I think it is not exactly a misfortune to struggle on alone. It is with drawing as it is with writing: when a child learns to write, it seems to him almost impossible that he will ever learn; nevertheless, in time every child learns. I really believe one must learn to draw so that it becomes as easy as writing. Ay, lad, if I could do exactly what I wanted, I should undertake painting on a still larger scale, and especially with more models.

Today I go once more to the usual Monday market, to try
to make some sketches while they are pulling down the stands.
To paint there is impossible because of the people; I wish one could
have free access to the houses, and sit down before the windows.
It is extraordinarily curious, but it may serve as an example of
the politeness of the Hague public towards painters, that all at
once a fellow from behind me, or probably from a window, spat
his quid of tobacco on my paper. Well, one has trouble enough
sometimes. But one need not take it so very seriously; those
people are not bad, but they do not understand anything about
it, and probably think I am a lunatic when they see me making
a drawing with large hooks and crooks which don't mean any-
thing to them.

I have made a little sketch of the potato market on the North
Wall. The bustling of the workmen, and of the women with
the baskets that are loaded from the boat, is very curious to
notice. All the poor people from the Geest, from the Ledig Erf,
and all those places in the neighbourhood come running out.
There are always such scenes — one time it is a boat with peat,
then one with fish, then one with coal.

These are the things that I should like to draw and paint vigor-
ously — the life and movement in such a scene, and the types of
people. A general knowledge of figure is needed for it, which
I try to acquire by drawing large figure studies.

I am also very busy of late drawing horses. I should love to
have a horse for a model sometime. Yesterday I heard someone
behind me say: That is a queer sort of painter — he draws the
hind part of the horse instead of drawing it from the front. I
rather liked that comment.

I love to make these sketches on the street; I certainly want
to reach a sort of perfection in it. I always try my best to work
with full strength, for my greatest desire is to make beautiful
things.

Do you know an American magazine called 'Harper's Monthly'?
There are wonderful sketches in it, which strike me dumb with
admiration, among others 'Glass Works' and 'Steel Works,' all

scenes from factories; and also sketches from a Quaker town in the olden days, by Howard Pyle. I am full of new pleasure in those things, because I have a new hope of making things myself that have soul in them. I should love to make, sooner or later, after some more study, drawings for illustration. Perhaps one thing will follow from another. The point is to continue to work.

The days pass quickly, and it is again Sunday. It is beautiful outside now — the leaves have all kinds of bronze colours, green, yellow, reddish, everything warm and rich. During these days I have often been in Scheveningen. I painted a study of a marine view, nothing but a bit of sand, sea, sky — grey and lonely. I sometimes long for that quiet, where there is nothing but the grey sea, with a solitary sea bird — save that, no other voice but the roaring of the waves. It gives me a change from the noisy hum of the Geest or the potato market.

One evening I happened to see the interesting arrival of a fishing smack. Near the monument is a little wooden shed in which a man sits on the lookout. As soon as the boat came in view, the fellow appeared with a large blue flag, followed by a crowd of little children. It was apparently a great pleasure for them to stand near the man with the flag, and I suppose they fancied they were helping the fishing smack to come in. A few minutes after the man waved his flag, a fellow on an old horse arrived who had to go and fetch the anchor. Then the group was joined by men and women — among them mothers with children — to welcome the crew. When the boat was near enough, the man on horseback went into the water and came back with the anchor. Then the men were brought ashore on the backs of fellows with high rubber boots, and with each new arrival there was a great cheer of welcome. When they were all ashore, the whole troop marched home like a flock of sheep or a caravan, with the man on the camel — I mean the man on the horse — towering over them like a tall spectre.

Of course I tried to sketch most carefully the various incidents. I have also painted part of it.

I want to make groups of people who are in action some way or

other. But how difficult it is to impart life and movement, and to put the figures in their places and apart from each other! It is that great question, *moutonner:* groups of figures forming one whole, but of which the heads or shoulders of one rise above the other, while in the foreground the legs of the first figures stand out strongly, and somewhat higher the skirts and trousers again form a kind of confusion in which the lines are quite visible. As to composition, all possible scenes with figures — either a market or the arrival of a boat, a group of people in line at the soup-kitchen, in the waiting-room of the station, the hospital, the pawnshop, groups talking in the street or walking around — are based on that same principle of the flock of sheep, from which the word *moutonner* is certainly derived; everything depends on the same questions of light and brown and perspective.

I am almost at the end of my last guilder. Friday afternoon I have a model, a man from the workhouse, and I shouldn't like to send him away without his money. I have had some extra expense because my painting box was broken when I had to jump from a high bank and collect my belongings as quickly as possible, to get out of the way of a horse that had bolted outside the Rhine station, where they are loading coal.

I painted the heaps of coal where the men were at work, and where a horse and wagon were standing. That little yard and those heaps of coal were so splendid that I couldn't keep my hands off, though I had intended to draw this week, because of the expense of painting. I had to ask permission to paint there, as it is not public property, and I hope to work there often now.

As to sending you a painted study, I have not the slightest objection, but before I do so we must agree on a few things. Somebody like Mauve — or any other artist — certainly has his particular colour scheme, but nobody gets that all at once. With me, for instance, the marine view which I recently made is quite different in colour from the first or second I made. So you should not judge my palette as yet from what I may send you now. I believe that my colour will change a great deal, and the composition too.

Studies made in the open air are different from pictures that are destined to be shown the public. The latter, in my opinion, result from the studies, but they may, or even must, differ a great deal from them. For in the picture the painter rather gives a personal impression, while in a study his aim is simply to analyze a bit of nature — either to make his idea or conception more correct, or to find a new idea; for example, the studies of Mauve, which I myself like very much, precisely because of their soberness and because they are done so faithfully. Still they miss a certain charm, which the pictures that result from them possess in such a high degree.

I believe one gets more sound ideas when thoughts arise from direct contact with things than when one looks at them with the set purpose of finding certain facts in them. It is the same with the question of a colour scheme. There are colours that harmonize wonderfully, but I try my best to paint a subject as I see it before I set to work to make it as I feel it. Yet feeling is a great thing, and without it one would not be able to do anything. Thus, studies belong more to the studio than among the public.

Sometimes I long for the harvest time — I mean for the time when I shall be so imbued with the study of nature that I myself shall create something in a picture. However, that analyzing of things is no trouble to me, nor is it a thing that I dislike to do.

We have very beautiful bad weather here at present — rain, wind, thunder — but with splendid effects; that's why I like it, but for the rest it is rather chilly. The time for working in the open air is drawing to an end, and the important thing is to profit as much as possible before the winter comes on.

Towards winter I shall clear up the studio — that is, I shall take down the studies from the walls and remove everything that stands in the way, so that I may have plenty of room to work with models. The painting of the figure appeals to me very much, but it must ripen; I must learn to know the technique better — what is sometimes called '*la cuisine de l'art.*' In the beginning I shall have to do much scraping, and often begin anew, but I feel that I learn from it.

When you again send money I shall buy some good marten
brushes, which are the real *drawing* brushes, as I have discovered,
to *draw* a hand or a profile in colour. The Lyon brushes. no
matter how fine they may be, make too broad stripes or strokes.
Also for very delicate tree branches the marten brushes are ab-
solutely necessary.

I believe I need to make a great many studies of the figure.
The more variety there is in them, the easier one works after-
wards when it comes to the making of real pictures or drawings.
In short, I reckon the studies to be the seed, and the more one
sows the more one may hope to reap.

It is already late. I have not slept well these last nights. I
think if I were not so much in the open air and found less pleasure
in my painting, I should soon become melancholy. But to be in
the open air and to work with animation are things which renew
and keep our strength. It is only at times when I am overtired
that I feel thoroughly miserable; for the rest, I believe I shall
regain my health.

All that beautiful autumn scenery and the desire to profit by
it is what I have on my mind. But I wish I *could* sleep when it is
time to.

Quite unexpectedly I had a very pleasant visit from Father;
this I think infinitely better than that he should hear about me
through others. I was really very glad to see him and talk with
him. We took a walk on the Ryswyk road; it is very beautiful
there. I heard again a great deal about Neunen, the churchyard
with the old crosses. I cannot get it out of my head; I hope I
shall be able to paint it some day. I should like to make the
churchyard with the wooden crosses in the snow — a peasant's
burial or the like; in short, an effect.

These last few days I have done nothing but water-colours.
You remember perhaps at the head of the Spinstraat the office of
the state lottery of Moormon? I passed there on a rainy morning
when a crowd of people stood waiting to get their lottery tickets.
They were for the greater part old women, and that kind of

people of whom one cannot say what they are doing or how they live. Taken superficially, people who have such great interest in 'today's drawing' seem rather ridiculous to you and to me; but that little group of people — their expression of waiting — struck me, and whilst I sketched it, it gained for me a larger, deeper significance.

One sees in it: *the poor and the money*. Their illusion about lotteries becomes serious when one contrasts the misery of the poor wretches with their frantic efforts to save themselves by buying a ticket, paid for with their last pennies which should have gone for food. So it is often with almost all groups of figures: one must sometimes think it over before one understands what it all means.

I am making a large water-colour of this scene; I am also making one of a church bench which I saw in a little church on the Geest, where the people from the workhouse go (here they call them, very expressively, 'orphan men' and 'orphan women'). I think you would like this collection of old men in their Sunday and in their everyday clothes.

Speaking about orphan men, I was interrupted by the arrival of my model, and worked with him until dark. He wears a large old overcoat, which gives him a curious broad figure. I drew him also sitting with a pipe. He is deaf; he has a curious bald head, large ears, and white whiskers.

I am sure you would like the things I am doing now. What you would notice at once, as I do, is that I need to draw a lot of figure studies; therefore I am working with all my strength and have a model almost daily. More and more I notice how useful and necessary it is to keep the studies close to the model; he who has made them rediscovers the model in them, and they remind him vividly of his difficulties. This week I hope also to have a woman from the asylum, but I am badly in need of money. I have had to buy some Whatman paper and brushes. You cannot believe how many things one sometimes needs.

Nature is so beautiful these days that I must get some of it onto paper. It is real autumn weather, rainy and chilly but full

of sentiment, especially splendid for figures that stand out in tone against the wet streets and roads in which the sky is reflected.

I perfectly agree with what you say about there being times in which we seem deaf to nature or when nature doesn't seem to speak to us any more. I often have that feeling, too. Sometimes one can do nothing but wait until it passes, but many a time I succeed in chasing away that impassiveness by changing subjects. More and more, however, I become interested in the figure.

I remember a former time when I was more impressed by a picture or drawing which rendered well an effect of light or sentiment of landscape. The painters of figure in general inspired me with a kind of cool respect rather than with warm sympathy. However, I remember quite well a drawing by Daumier of an old man under the chestnut tree in the Champs Elysées (an illustration for Balzac). Though that drawing was not very important, I remember being so very much impressed at the time by something so strong and manly in Daumier's conception that I thought: It must be a good thing to think and to feel in that way, and to pass by many things in order to concentrate on things that furnish food for thought, and that touch one as a human being more than the meadows or clouds.

In the same way I always feel a great attraction in the figures of English draughtsmen or English authors, because of their Monday-morning-like soberness, and studied simplicity and matter-of-factness and analysis; I feel them as something solid and strong that can give us strength in days when we feel weak. So, among the French authors, the same is true of Balzac and Zola.

Are there any cheap prints of Daumier to be had? If there are more things of his as beautiful as a print I recently found, 'Les Cinq Ages d'un Buveur,' or like that figure of an old man, he is of greater importance than I thought. I remember we spoke about it last year on the road to Prinsenhage, and you said then that you liked Daumier better than Garvarni. I begin to suspect that I know but a very small part of his work, and that

in the part which I do not know are the very things which would interest me most.

From the window of my studio I have just seen a beautiful effect. The city, with its towers and roofs and smoking chimneys, stands out as a dark, sombre silhouette against the horizon of light. This light is, however, but a broad streak, above which hangs a dark cloud, compact at the bottom, but torn asunder at the top by the autumn wind in large tufts which are driven away. That streak of light, however, makes the wet roofs glisten here and there in the dark mass of the city.

I should draw it, or rather try to draw it, if I hadn't been busy the whole afternoon drawing figures of men who carried peat; my mind is still too full of them to have room left for a new subject.

I think of you so often. What you tell me about the character of some artists in Paris who live with women, that they are less narrow-minded than others, perhaps try desperately to retain a youthful air, I think perfectly well observed. Such people exist there and here. There it is perhaps even more difficult than here to keep some freshness in one's domestic life, because there life is even more a matter of rowing against the current. How many have become desperate in Paris — calmly, rationally, logically, and rightly desperate!

I believe that it may happen that one will succeed, and one must not begin to despair, even though defeated here and there; and even though one sometimes feels a kind of decay, though things go differently from the expected, it is necessary to take heart again and new courage. For the great things are not done by impulse, but by a series of small things brought together. And great things are not something accidental, but must certainly be *willed*. What is drawing? How does one learn it? It is working through an invisible iron wall that seems to stand between what one *feels* and what one *can do*.

We two have in common a liking to look behind the scenes in a theatre; in other words, we have an inclination to analyze things. It is, I believe, just the quality one needs for painting — in painting or drawing one must exert that power. It may be that to

some extent nature has endowed us with that gift; perhaps we are indebted for it to our childhood in Brabant, and to surroundings that contributed more than is usually the case to teach us to think; but it is especially later that the artistic feeling develops and ripens by work.

I shall have a model for a few hours tomorrow, a boy with a spade, a hod-carrier by profession, a very curious type, flat nose, thick lips, and very coarse, straight hair — still, whenever he moves there is grace in the figure, or at least style and character.

I try to work quickly, for that is necessary. At Scheveningen, on the beach, I have had a boy or man standing for me for a moment, as they call it; the result was always a great longing in me for a longer pose, and the mere standing still of a man or a horse doesn't satisfy me. A study that is of any use requires at least half an hour's posing.

I see no other way than to work from the model. Two things remain true and complete each other in my mind: one cannot quench one's power of imagination, but the imagination is made keener and more correct by continually studying nature and wrestling with it. Dickens says: 'Fellows, your model is not your final aim, but the means of giving form and strength to your thought and inspiration.'

I think I shall have some good models this winter; the owner of the yard has promised to send me men that come to ask for work, which often happens in the slack season. I readily give them a few quarters for an afternoon or morning, for that is just what I want.

It is Sunday again, and as rainy as usual. We have had a storm also this week, and there are few leaves left on the trees. But it is beautiful in its way; for instance, the Rhine station. Over it a somewhat yellowish but yet grey sky, very wintry, that hangs low, and from which come bursts of rain now and then, in which many hungry crows are flying about. I can tell you I am glad that the stove is going, for the chilliness penetrates even into the house, and when one lights a pipe it seems damp from the drizzling rain.

It is on such days that one would like to see some friend, and that one has an empty feeling, when one can go nowhere and nobody comes. Just then I feel what work is to me, how it gives tone to life, apart from approval or disapproval; and on days that otherwise would make one melancholy, one is glad to have an aim. I believe that if one wants to make figures one must have a warm feeling, what 'Punch' calls in his Christmas picture 'Goodwill to All' — that means, one must have real love for one's fellow-creatures. I for one try my best to be in such a mood as much as possible. It is for that exact reason that I am sorry not to have any intercourse with painters, and sorry that on a rainy day like today we cannot sit cosily together round a fire, looking at drawings or engravings and stimulating each other in that way.

Working out-of-doors is over now — I mean sitting quietly. I look forward to the winter with pleasure; it is a season when one can work regularly. I have some hope that I shall get on well. But how short a spring and summer we have really had! Sometimes it seems to me as if there had been no time between last autumn and this one, but perhaps it is because of my illness coming between. I feel quite normal now except when I am very tired. It often helps me then to take a long walk, to Scheveningen or some other place.

Just fancy, I received this week to my great surprise a parcel from home, containing a winter coat, a pair of warm trousers, and a warm woman's coat. It touched me very much.

I agree with you in what you say about that small drawing of the bench: that it is done more in the old-fashioned way. But I did it more or less on purpose. However greatly I may admire many pictures and drawings that are made with a decided view to a delicate grey harmonious colour and the local tone, I believe that many artists who aimed less at this, and are called old-fashioned, will always remain green and fresh because their manner had, and will keep, its own *raison d'être*.

To tell you the truth, I couldn't spare either the old-fashioned or the new-fashioned way. Too many beautiful things have been

made in both ways for me wholly to prefer one to the other.
And the changes which the modern age have brought in art are
not in every respect for the better; not everything means progress,
neither in the works nor in the artists themselves, and often it
seems to me that many lose sight of their starting-point and
their aim. People will be obliged to acknowledge that many a
new thing in which one at first thought to find progress proves in
fact to be less sound than the old one, and in consequence the need
of strong men to redress things will manifest itself.

I have at last read 'Ninety-Three,' by Victor Hugo. It is
painted — I mean written — as if by Decamps or Jules Dupré.
The sentiment in which it is written becomes more and more
rare, and among the new things I really do not find anything
nobler.

It is easier to say, as Mesdag did of a certain picture by Heyer-
dahl, painted in the style of Murillo or Rembrandt, which he
didn't want to buy from you, 'Oh, that's the old manner; we
don't need that any longer,' than to replace that old manner by
something as good, let alone something superior. And since
many people in these days argue in the same way as Mesdag did,
without thinking much about it, it can do no harm if others
reflect whether we are in this world to tear down instead of to
build up. The expression, 'We don't need that any longer' —
how readily it is used, and what a stupid and ugly one it is! Ander-
sen, in one of his fairy tales, puts it, I think, not in the mouth of a
human being, but in that of an old pig.

He who dances must pay the fiddler. I'm afraid, Theo, that
many who have sacrificed the old for the sake of the new will end
by greatly rueing this, especially in the domain of art. In short,
there has been a body of painters, authors, artists, who were
united, notwithstanding their differences, and they were a force.
They did not walk in the dark but possessed this light: that they
certainly knew what they wanted and did not doubt. I speak of
the time when Corot, Millet, Daubigny, Jacque, Breton were
young; in Holland there were Israëls, Mauve, Maris.

The one supported the other; there was something strong there.

The art galleries were smaller then; in the studios there was perhaps a greater affluence than now. Those crammed studios, those smaller shop windows, but above all *la foi de charbonnier* of the artists, their warmth, their fire, their enthusiasm, how sublime they were!

Neither you nor I exactly witnessed it, but our love for that period brings us nearer to it. Let us not forget it.

If I saw you oftener and could speak to you about my work, I should make more things, which I am sure might proceed from the studies I have. I am making about twelve water-colours just now, but I believe I could do more with them and make them more directly useful if I could sometimes consult you about it. However that may be, I work with great pleasure these days, and I hope there will be some things in the result which will please you.

This week I had a letter from Rappard, who also is astonished at the behaviour of many painters here who work too little from the model. His picture was refused at the exhibition of Arti. I ask you, is it just that he and I should be counted for nothing?

Well, boy, one thing I can promise you against the time of your next arrival: besides the water-colours and painted studies, I shall beg you to take the trouble of looking through a portfolio with a hundred drawings. When I happened to arrange my drawings this morning, namely, the studies from the model made since your visit (not counting the older studies or those I drew in my sketch-book), I counted about a hundred. I do not know whether all painters, even those who look down on my work to such a degree that they think it below themselves to take the least notice of it, work more than I do.

For the last few days I have been very much preoccupied by a summary of a discourse by Herkomer about modern woodcuts. The managers, Herkomer says, ask for things that are made for effect; correct and honest drawing is no longer wanted; a 'bit' just covering an awkward corner of a page is all that is requested. The managers declare that the public requires the representation of a public event or so, and is satisfied if it is correct and enter-

taining, caring nothing for its artistic qualities. Then Herkomer comes to the artists and says how much he regrets that nowadays it is but too often the wood-engraver and not the draughtsman who makes the pages beautiful. He spurs on the artists not to permit this, to draw soberly and strongly, so that the engraver will remain what he must be: the interpreter of the work of the draughtsman and not his master.

I say it is a great pity that there is little or no enthusiasm here for the art which is fittest for the general public. If the painters combined to take care that their work (which in my opinion is after all made for the people, at least I think this is the highest, noblest calling for any artist) was brought within everybody's reach, they might get the same results as those secured during the first years of the 'Graphic.'

The 'Graphic,' when strong enough to walk alone, rented one house, and began to print with six machines. For this I have complete respect; here I feel something sacred. I think of foggy London and the bustle in that small workshop. Moreover, I see in my imagination the draughtsmen in their several studios starting their work with the best kind of enthusiasm.

I see Millais running to Charles Dickens with the first number of the 'Graphic'; Dickens was then at the end of his life. Millais, whilst showing him the drawing of Luke Fildes, 'Homeless and Hungry' — poor people and tramps before a night asylum — said, 'Give him your "Edwin Drood" to illustrate,' and Dickens said, 'Very well.'

'Edwin Drood' was Dickens's last work, and Fildes, brought into contact with him through these small illustrations, enters his room on the day of his death, sees his empty chair standing there, and so it happens that one of the old numbers of the 'Graphic' contains that touching drawing, 'The Empty Chair.'

Empty chairs — there are many of them, there will be still more, and sooner or later in the place of Herkomer, Luke Fildes, Frank Holl, William Small, there will be nothing but empty chairs. Yet the publishers and dealers will continue to assure us that everything is all right, that we are getting on famously. But

how hard-hearted they are, how mistaken they are, if they think they can make everybody believe that material grandeur outweighs moral grandeur, and that without the latter any good can be accomplished. As it is with the 'Graphic,' so it is with many other things in the realm of art. Moral grandeur diminishes; material grandeur comes in its stead. But will the much-desired change come?

And I think that the painters, for their part, do not take the matter enough to heart. The definition that many a painter here in Holland gives to the question, 'What is a woodcut?' is: 'It's one of those things that they serve in the South Holland Café.' So they class them among the drinks; and those who make them, perhaps among the drunkards. It is very curious to hear some painters talk about what they call illustrators, about Gavarni, for instance, or Herkomer. Not knowing anything about the question is what forms a part of their so-called 'general information.' Much good may it do them!

My love and respect for the great draughtsmen, those of the time of Gavarni, as well as for those of the present, increases the more I come to know their work, and especially since I myself have tried to make something of what one sees every day on the street. What I appreciate in Herkomer, in Fildes, in Holl, and the other founders of the 'Graphic,' the reason that they are even more sympathetic to me than Gavarni and Daumier, is that while the latter seem to consider society with malice, the former, as well as men like Millet, Breton, de Groux, Israëls, chose subjects that were as true as those of Gavarni or Daumier, but that had a more serious sentiment.

That sentiment especially must remain, I think. An artist needn't be a clergyman or a church warden, but he certainly must have a warm heart for his fellow-men. It seems to me the duty of a painter to try to put an idea into his work, and I think it very noble that no winter passed without the 'Graphic's' doing something to arouse sympathy for the poor.

In the realm of art the summit has been reached. Certainly we shall still see beautiful things in the years to come, but anything

more sublime than we have seen already — no. Just think how
many great men are dead or will not be with us for long — Millet,
Brion, Rousseau, Daubigny, Corot; farther back, Leys, Gavarni,
de Groux; still farther back Ingres, Delacroix, Géricault; think
how old *modern art* already is. And I for my part am afraid that
perhaps in a few years there will be a kind of panic in this field.
Since Millet we have greatly deteriorated. Up to Millet and Jules
Breton there was always progress, in my opinion. Their genius
may be equalled in former, present, or later times, but to surpass
it is not possible. In that high zone there is an equality of genius,
but higher than the top of the mountain one cannot climb.

Do you know what effects one sees here at present early in the
morning? It is splendid — such as Brion painted in his picture at
the Luxembourg, 'La Fin du Deluge,' namely, that streak of red
light at the horizon with rain clouds over it.

This brings me to the landscape painters. Though I cannot
help admiring what is made now, the old landscapes please me
whenever I see them. There was a time when I passed a Schelfout,
for instance, thinking: That's not worth while. But the modern
way in the long run doesn't make that strong, deep impression,
and when one has been looking for a long time at new things, one
sees again with great pleasure a naïve picture like a Sege, a Jules
Backhuizen. It is really not intentional when I feel rather dis-
enchanted about progress; on the contrary, quite against my will
the feeling involuntarily develops in my thoughts, because I feel
more and more a kind of void which I cannot fill with things of
today.

In the many sketches in today's magazines it seems to me that
a not quite unconventional elegance threatens to replace that
typical, real rusticity of which the sketches of Jacque are an ex-
ample. Don't you think the cause of this lies also in the life and
personality of the artist? Do you find many people who like to
take a walk in grey weather? It also has struck me that when one
speaks with painters the conversation in most cases is not inter-
esting. Mauve has at times the great power of describing a thing
in words so that one sees it; but that peculiar open-air feeling

when you speak to a painter — do you think it is as strong as it used to be?

Here at The Hague there are clever, great men, I readily admit it; but in many respects what a miserable state of affairs, what intrigues, what quarrels, what jealousy! And in the personality of the successful artists who with Mesdag at their head give the tone, there certainly is also a replacing of moral grandeur by material grandeur. There is nowadays a hurry and bustle in everything that doesn't please me, and it seems as if life had gone out of most things. I wish your expectation would come true: 'That the desired change will come'; but to me it doesn't seem 'quite natural.'

Today and yesterday I drew two figures of an old man who is sitting with his elbows on his knees and his head in his hands. Long ago Schuitemaker sat for me, and I have always kept the drawing because I wanted to make a better one some day. How beautiful is such an old workman, with his patched fustian clothes and his bald head! This morning I drew a portrait of Blok, the Jewish book dealer, the little one who stands on the Binnenhof. I am very grateful for Blok; he reminds me of things of many years ago.

At times I feel a great longing to be in London again. I should so much love to know more about printing and woodcuts. I feel a power in me which I must develop, a fire that I may not quench but must keep ablaze, though I do not know to what result it will lead me, and shouldn't wonder if it were a gloomy one. In times like these what must one wish? What is relatively the happiest fate?

I have been busy drawing diggers, which I hope will lead to something. There is a people's paper here called 'The Swallow,' published by Elsevier of Rotterdam; I wondered lately whether they could not use such a digger. One page is published monthly. But it would cost me a trip to Rotterdam, and I am so afraid I should have to go home with the message: Business is too slack. Besides, I should much rather work longer, until I have got a good series together. But as I am so frequently hard up for money, I often think about trying to earn something. *Que faire?* I

think it possible that within a relatively short time there will be a greater demand for illustrators than there is at present.

For the last five or six days I have been literally without money. I work with the model to the limit of my purse. If I fill my portfolios with studies from the models I can get hold of or catch, I shall have some little outfit which I hope will help to get me employment. To keep up illustration work, as for example, Morin, Renouard, Jules Férat, one needs quite a lot of ammunition.

When I was in Brussels I tried to get employment with some lithographer, but was everywhere rebuffed. Simmonneau and Fouvey were the least unwilling. They said that the young men they had tried to instruct had given them little satisfaction, and business was so slack that they had employees enough. I mentioned the lithographs of de Groux and Rops, and they said, Yes, but such draughtsmen did not exist any more. The impression I got there and in other establishments was that lithography was clearly dying out. However, this new invention proves that they are trying to revive it. I am very sorry that I did not know about this process before.

Do I understand rightly that this new lithograph paper is such that when one makes a drawing on it, this drawing, just as it is, without the intermediary of a second draughtsman or engraver or lithographer, can be transferred to a stone, or a *cliché* can be made of it so that an indefinite number of copies can be drawn, the latter being facsimiles of the original drawing? What you write about the 'Vie Moderne,' or rather about the kind of paper that Buhot has promised you, is something that interests me very much.

At last it has happened that a painter came to see me, namely, Van der Weele, who stopped me on the street; I have also been to see him. That fellow has many fine things in his studio. He wanted me to make a composition of many studies of old men, but I feel I am not ready yet.

The weather has been very cold here, snow and frost; at present it is quite dark, grey, and gloomy, but it gives a rough aspect of *non ébarbé* to everything.

Today I have been working on old drawings from Etten, because I saw in the fields the pollard willows again in the same leafless condition, and it reminded me of what I had seen last year. Sometimes I long to make a landscape, just as I crave a long walk to refresh myself, and in all nature I see expression and soul, as it were. A row of pollarded willows sometimes resembles a procession of almshouse men. Young corn has something inexpressibly pure and tender about it which awakens the same emotion as the expression of a sleeping baby. The trodden grass at the roadside looks tired and dusty like the people of the slums. A few days ago, when it had been raining, I saw a group of white cabbages, standing frozen and benumbed, that reminded me of a group of women in their thin petticoats and old shawls which I had noticed early in the morning standing near a coffee stall.

When one is in a sombre mood, how good it is to walk on the barren beach and to look on the greyish-green sea with the long white streaks of the waves! But if one feels the need of something grand, something infinite, something that makes one feel aware of God, one need not go far to find it. Methinks I see something deeper, more infinite, more eternal than the ocean in the expression of the eyes of a little baby when it awakes in the morning, and coos or laughs, because it sees the sun shine in its cradle.

I hope there will always remain in us something of Brabant fields and heath, which years of city life will not be able to wipe out, the less so as it is renewed and strengthened by art.

I have with the help of Smulders's printer made a lithograph of the little old man. I shall be quite satisfied if there is in it some reminder of the old lithographs of that period when there was in general more enthusiasm for this branch of art than there is now. I made this as a result of my telling Smulders what you wrote me about that paper, and his saying that he had some of it in stock.

I should love to make, for instance, a series of about thirty figures. If we could show about thirty pages, not niggled but *sabré*, which we have printed at our own expense, this would give us more prestige in the eyes of the managers of the magazines. But you

needn't be afraid of my taking any other steps for the present than making the drawings. I must wait till I have some cash before I try any more experiments in lithography. But I think there is something in it. Wouldn't it be great if this proved a success!

I do not know whether you will think me conceited when I tell you that the workmen of Smulders from the other store on the Laan had seen the lithograph of the old man, and had asked the printer if they could have a copy to hang on the wall. No result could please me better than that ordinary working people should hang such prints in their room or workshop. For you — the public — it is really done, is a true word by Herkomer. Of course a drawing must have artistic value, but in my opinion this must not exclude the condition that the man in the streets shall find something in it.

Well, this very first print doesn't count as yet.

On what was left of the printing paper I made some other trials last week. By mail you will receive the very first print of 'Sorrow.' You will also receive the first proofs of a lithograph, 'A Digger,' and of a 'Man Who Drinks Coffee.' The drawings were better. I had worked hard on them; by transferring them onto the stone and by printing, something got lost. But what I think of these prints is that there is something rough and unconventional in them that I wanted there, and this partly reconciles me to the loss of things that were in the drawings. The drawing was not done with lithographic chalk alone, but was touched up with autographic ink.

I can tell you, I should like it enormously if I could succeed in making a fine series.

It is Sunday again. This morning I took a walk on the Ryswyk road; the meadows are partly flooded, so that there was an effect of tonal green and silver with the rough black and grey and green trunks and branches of the old trees distorted by the wind in the foreground, a silhouette of the little village with its pointed spire against the clear sky, in the background here and there a gate or a dungheap on which a flock of crows sat picking. How you would like such a thing:

It was extraordinarily beautiful this morning, and it did me good to take a long walk, for what with drawing and the lithography I had scarcely been outdoors this week. As to the lithography, I hope it will turn out well.

This morning I had to go to the printing office. I have now witnessed everything, the transferring onto the stone, the preparing of the stone, and the printing. I should love to learn the printing itself. The act of printing has always seemed to me a miracle, just such a miracle as the growing up of a tiny seed of grain to an ear — an everyday miracle, even the greater because it happens every day. One drawing is sown on the stone or the etching plate, and a harvest is reaped from it.

It has always been said that in Holland we cannot make prints for the people. I have never been able to believe this; I see now that it can be done. The whole thing started with a word from you: 'I met Buhot, who knows a certain way of lithographing. You ought to make some trials on the paper which he will send you.'

Now, such an enterprise as would be the drawing and printing of a series of, say, thirty pages of types of workmen, may one undertake it or not? The drawing, the stone, the printing, the papering expenses, but relatively speaking they are small. Such pages as the last I sent you, for instance, as well as a new one I finished last night, I think would do perfectly well for a popular edition, which is so very, very necessary, especially here in Holland.

If I were a man of means I shouldn't hesitate to decide. I shouldn't spare myself. I see that with persistence and perseverance this might become something decidedly good and useful. The question of prints for the people I have already been discussing for a long time with Rappard, in so far as he as well as myself is interested in it; he of his own accord said to me: 'I will give you a helping hand.' But may one involve and carry along others whom one needs, in an enterprise of which the success is doubtful?

As it is useful and necessary that Dutch drawings be made, printed, and spread, destined for the houses of workmen and for

farms, a few persons should unite in order to use their full strength
for this end. The reason for a society is that if the draughtsmen
had to stand for it alone they would have to bear everything, the
work as well as the expenses; the undertaking would be a failure
before it was half finished. So the burden must be equally divided.

This society must try to operate as practically as possible. The
price of the prints must not be more than ten cents, at the most
fifteen; the publication is to start when a series of thirty has been
made and printed and when the costs of stones, wages, and paper
have been paid. These thirty pages will be published together, but
can be bought separately; they will form a whole in a linen cover
with a short text. The profits of the sale will serve in the first
place to pay back the money to those who have furnished it, and
in the second place to pay each draughtsman.

These things being settled, the rest will be used for new publica-
tions to continue the work. Those who begin this work consider it
a duty, self-profit not to be their aim.

The first drawings are to be contributed by members who cannot
give money. I would take them all upon myself if there were no-
body else. By showing the first thirty pages to artists who could
do it better than I may hope to do, they might perhaps be induced
to join. But I should rather that better artists than myself took it
upon themselves.

The idea of drawing types of workmen from the people for the
people, to spread them in a popular edition, taking the whole as an
affair of love and charity, and a duty — that idea is such that I
believe, even if it didn't succeed at once, one might admit: 'The
thing is as true today as it was yesterday, and will be as true to-
morrow.'

I have said to myself that the duty that comes first to me is to
try my very best on the drawings, so that I have now made a few
new ones. In the first place a sower — a big old fellow with tall
dark silhouette against a dark ground. The man is a kind of cock
type, a clean-shaven face, rather sharp nose and chin, small eyes,
and sunken mouth. Then a second sower, with a light-brown fus-
tian jacket and trousers, so that this figure stands out light against

the black field bordered by a row of pollard willows. This is quite a different type, with a clipped beard, broad shoulders, rather thick-set, somewhat like an ox in that his whole frame has been shaped by his labour in the fields. Then a mower with a large scythe on a meadow. Then one of those little old fellows in short jacket and high old top-hat that one meets sometimes in the dunes; he carries home a basketful of peat.

These fellows are all in action, and that fact must especially be kept in mind in the choice of subjects, I think. You know how beautiful are the numerous figures in rest, which are made so much oftener than figures in action. It is always very tempting to draw a figure at rest; to express action is very difficult, and the former effect is in many people's eyes more 'pleasant' than anything else. But this 'pleasant' aspect must not detract from the truth, and the truth is that there is more drudgery than rest in life.

For Christmas, Harper has published a magazine illustrated by some painters who call themselves the 'Tile Club.' The best among the drawings are by Abbey; they are principally scenes from the former time when the Dutch founded New York under the name of New Amsterdam. Boughton is also a member, or an honorary mem-ber, of the club, but I think he himself is more serious than all the rest together, and doesn't make so much splurge. Abbey, however, is very beautiful. He has style, and that's a good thing. I write about it because I believe you will agree with me that not all Amer-icans are bad; that as everywhere else, there also extremes meet, and beside a lot of braggarts and daubers of the most detestable and impossible kind, there are characters who give the effect of a lily or a snowdrop between the thorns. I must compare these Amer-ican drawings with the pictures in 'Vie Moderne.'

Yesterday I happened to read a book by Murger, 'Les Buveurs d'Eau.' It has a fragrance of the time of the Bohemian, and for that reason it interests me, but in my opinion it lacks originality and sincerity. However, authors always seem to be unlucky with their types of painters: Balzac, among others (his painters are rather uninteresting) and Zola; even though Zola's Claude Lantier is real, one would like to see another kind of painter depicted by him

than Lantier, who seems to be drawn from life after somebody of that school which I think is called impressionistic. It is not they who form the nucleus of the artistic corps.

I often think that I should like to be able to spend more time on the real landscape! I often see things which I think splendid and which involuntarily make me say: I have never seen such a thing painted that way. But in order to paint it I should have to neglect other things.

Many landscape painters do not possess that intimate knowledge of nature which those have who from childhood have looked at the fields. Many landscape painters as men (though we appreciate them as artists) give something that satisfies neither you nor me. You will say that everyone has seen landscapes and figures from childhood on. The question is: Has everybody also been reflective as a child? Has everybody who has seen them also loved heath, fields, meadows, woods, and the snow and the rain and the storm? *Not* everybody has done that as you and I have; it is a peculiar kind of surroundings and circumstances that must contribute to such knowledge of nature; it is a peculiar kind of temperament and character, too, that must help to make it take root.

Indeed, in the field of landscape enormous gaps are beginning to appear, and I should like to apply here the words of Herkomer: The interpreters allow their cleverness to mar the dignity of their calling. And I believe the public will begin to say: Deliver us from artistic combinations; give us back the simple field. How much good it does one to see a beautiful Rousseau, on which he has laboured to keep it true and honest! The real thing is not to make an absolute copy of nature, but to know nature so well that what one makes is fresh and true; that is what is lacking in many.

Do you know that it is very, very necessary for honest people to remain in art? Hardly anyone knows that the secret of beautiful work lies to a great extent in truth and sincere sentiment. Smartness, as they call it here — the word is so much used — I myself do not know its real significance and have seen it applied to very insignificant things — smartness, is that what must save art?

There is a portrait of Millet by himself which I love — nothing

but a head with a kind of shepherd's cap, but the look, from half-closed eyes, the intense look of a painter, how beautiful it is; also that piercing gleam like a cock's eye, if I may call it so.

Carlyle rightly says, 'Blessed is he who has found his work.' I think a painter is happy because he is in harmony with nature as soon as he can express a little of what he sees. And that's a great thing; one knows what one has to do, there are subjects in abundance. If that work strives to bring peace, like that of Millet, then it is doubly stimulating — one is then also less alone, because one thinks: It's true I'm sitting here lonely, but whilst I am sitting here and keeping silent, my work perhaps speaks to my friend, and whoever sees it will not suspect me of being heartless.

But I tell you that dissatisfaction about bad work, the failure of things, the difficulties of technique, can make one dreadfully melancholy. I can assure you that I am sometimes terribly discouraged when I think of Millet, de Groux, Breton, Dupré, so many others; one only knows what these fellows are worth when one is oneself at work. And then to swallow that despair and that melancholy, to bear oneself as one is, not in order to sit down and rest but to struggle on, notwithstanding thousands of shortcomings and faults and the doubtfulness of conquering them — all these things are the reasons that a painter is not happy either.

The struggle with oneself, the trying to better oneself, the renewal of one's energy, all this is complicated by material difficulties. That picture by Daumier must be beautiful. It is a mystery why a thing that speaks so clearly is not understood, at least that the situation is such that you are not sure of finding a buyer for it, even at a low price. This is also for many a painter almost unbearable.

One wants to be an honest man; one is so, one works hard; but still one cannot make both ends meet; one must give up the work, there is no chance of carrying it out without spending more on it than one gets back for it; one gets a feeling of shortcoming, of not keeping one's promises. One is afraid of making friends; like an old leper, one would like to call from afar: Don't come too near me, for intercourse with me brings you sorrow and loss. One cannot present

oneself as somebody who comes to propose a good business or who has a plan which will bring great profit. On the contrary, it is clear that it will end with a deficit, and still one feels a power surging within; one has work to do and it must be done. One must set to work with a calm, everyday face, live one's ordinary life, get along with the models, with the man who comes for the rent, with everybody, in fact.

You must not think of me as afraid. To paint the Borinage, for instance, would be something difficult, even relatively so dangerous as to make life a thing far removed from any rest or pleasure. Yet I would undertake it if I could; that is, if I didn't know for sure, as I do now, that the expense would exceed my means. If I could find people who would interest themselves in such an enterprise, I would risk it. But just because you are really the only one for the moment who looks after what I do, the thing is put on the shelf. Yet I do not give it up so as to spare myself.

I begin to see more and more clearly that the magazines drift with the surface current, and I think they do not aim to be as good as they ought to. No, to fill the magazines with things which cost them neither time nor trouble, to give now and then a good thing, but reproduced in a cheap mechanical way; further, to pocket as much money as possible — that is the way they do. I do not think that method wise. I think it will make them bankrupt. In the meantime people push themselves in as employees who would never have been accepted in the difficult but noble days. It is what Zola calls '*le triomphe de la médiocrité.*' Snobs, nobodies come in the place of workers, thinkers, artists, and it isn't even noticed.

The public, for one part, is dissatisfied, but material greatness also finds applause. The 'Graphic' will give 'types of beauty' (large heads of women), as this prospectus says, I dare say to take the place of heads of the people by Herkomer, Small, and Ridley. I respect all kinds of work, I despise neither Obach nor Mesdag, but there are things which I rank infinitely higher than that kind of energy. I want something more concise, simpler, more serious. I want more soul and more love and more heart.

But is this the time to combine and to speak out? Or is it better,

as so many have fallen asleep and do not like to be aroused, to try to stick to things one can do alone, for which one alone is liable and responsible, so that those who sleep may go on sleeping?

That I shall not set up a cry against this state of things, that I shall not rebel against it, you may be sure. But it upsets me, and for myself I am completely at a loss as to what to do. What sometimes makes me sad is this: formerly, when I began, I used to think: If I have only made so or so much progress, I shall get a position here somewhere, and I shall be on a straight road and find my way through life. But now another thing turns up, and I fear or rather expect, instead of a position, a kind of jail — I expect such things as: Yes, some things in your work are rather good, but you see, we have no use for such work as you make, we need actualities (*vide* 'Graphic'; We print on Saturday what happened on Thursday). Actualities — if they mean by that such things as illuminations for king's birthdays, I should care very little for it; but if the gentlemen managers would consent to accept real actualities, scenes from the daily life of the people, I should gladly try my utmost to make them.

I begin to feel that if I went to England, for instance, I should certainly have a chance of finding a position which would help me to progress. To reach this was my ideal, and after all, is so still; it was this that urged me on to surmount enormous difficulties. But my heart gets heavy at times when I think of the way things go. Many positions which might possibly be within my reach would lead me to quite different things from those I aim at. These are out of my reach, for though I might at first be accepted, those who took me in would not be satisfied with me in the long run; they would sack me, or I should leave of my own accord as at Goupil's.

I have a strength in me which circumstances do not allow to develop as well as might be, with the result that I often feel miserable. There is a kind of internal struggle about what I must do. I love to do my best on my drawings, but all those editors, and to present myself there — oh, I hate the thought of it. You know, Theo, I should like to do work like that done by those who started the 'Graphic'; I should like to take a man or woman or child from the

street, and draw them in my studio; but no, they would ask me, 'Can you make chromos by electric light?'

Of course that state of business influences me directly only in so far as it makes my work more difficult or easier, but the making of the drawings themselves takes the largest place in my thought. And so in contrast to a feeling of depression there is the delightful sense of working at something that becomes more and more interesting the deeper one goes into it. I cannot do many things that I should like to do — which would only be possible if I had the money for them — but I do not mean at all to say that I do not appreciate the present, nor am I discontented; far from it.

A few years ago I walked with Rappard outside Brussels on a spot which they call la Vallée Josaphat, a neighbourhood where among others Roelofs lives. At that time there was a sand quarry where diggers were at work; there were women looking for greens, a farmer was sowing; we looked at all that, and I was almost in despair. 'Shall I ever succeed in painting what I admire so much?' Now I am despairing no longer; I can hit off those farmers and women better, and working on with patience I can succeed now in what I wanted to do then.

Breitner has got a position at the high school in Rotterdam. I saw an excellent unfinished drawing of his; perhaps it cannot be finished. There seems to be something fatal in occupying such positions; perhaps it is the very care, the dark, shadowy side of the artist's life, that is the best of it; it is risky to say so, and there are moments when one speaks differently; many perish through cares.

That trouble of last summer is really quite gone, but these days I am troubled with a bad toothache which sometimes affects my right eye and ear; perhaps the nerves are also to blame. If one has a toothache, one becomes indifferent towards many things, but it is curious that the drawings by Daumier, for example, are so good that they almost make one forget the toothache.

Today I was at Van der Weele's; he was rather pleased with the little old man with his head in his hands. In this print I have tried to express (but I cannot do it so well, or so strikingly as it is in real-

ity, of which this is but a weak reflection in a dark mirror) what seems to me one of the strongest proofs of the existence of '*quelque chose là-haut*' in which Millet believed, namely, the existence of God and eternity. In the infinitely touching expression of such a little old man, of which he himself is perhaps unconscious, when he is sitting quietly in his corner by the fire, there is something noble, something great, that cannot be destined for the worms.

In 'Uncle Tom's Cabin,' the most beautiful passage is perhaps that where the poor slave, knowing that he must die, remembers the words:

> Let cares like a wild deluge come,
> And storms of sorrow fall,
> May I but safely reach my home,
> My God, my Heaven, my all.

This is far from theology, simply a fact, that the poorest little wood-cutter or peasant on the heath or miner can have moments of emotion and inspiration which give him a feeling of an eternal home which he is near. Israëls has painted it so beautifully.

I have two new drawings now; one is a man who reads his Bible, and the other is a man who says grace before his dinner, which stands on the table. Both are certainly done in what you may call an old-fashioned sentiment. 'The Benedicite' is, I think the best, but they complete each other. In one there is a view through the window over the snowy fields. My intention in these two is to express the peculiar sentiment of Christmas and the Old Year. Both in Holland and England and in Brittany, and in Alsace, too, this is always more or less religious. Now, one need not agree exactly with the form of that religious sentiment, but it is a feeling one must respect if it is sincere. I, for my part, can fully share it, and the belief in God, too, though the forms may change — a change which is just as necessary as the renewal of the leaves in spring. If the drawing has any sentiment or expression, it is because I feel it myself.

How I wish we might be together these two Christmas days — I should so love to see you in the studio again. I have been working hard lately, just because I was full of that Christmas senti-

ment, and because the feeling is not enough: one must express it in one's work.

So I am now working on two large heads of an old man from the workhouse, with his wide beard and his old-fashioned top-hat. The fellow has the kind of wrinkled, witty face that one would like to have near a cosy Christmas fire. I am at present drawing large heads because I feel the need of a more intimate study of the structure of the skull, and the interpretation of the physiognomy. The work absorbs me greatly, and I have found a few things lately for which I had been seeking a long time.

Well, I hope you will enjoy nature somewhat these days, either in the aspect of the short winter days, or of the winter figures.

Before the year is gone, I feel I have to thank you again for all your help and friendship. I am sorry that I haven't succeeded this year in making a salable drawing. I really do not know where the fault lies.

Shall I in the New Year succeed better in making salable drawings, or in finding some work for an illustrated paper? How can I know whether I shall reach some goal — how can I know beforehand whether the difficulties will or will not be overcome? If one prospect is closed, perhaps another will open itself — some prospect there must be, and a future too, even if we do not know where it is. Some good must come by clinging to the right. Conscience is a man's compass, and though the needle sometimes deviates, though one often perceives irregularities in directing one's course by it, still one must try to follow its direction. Of one thing I am sure: wrestling with nature is no idle work, and though I do not know what will be the result, some result there must be.

I wish you could come to the studio again, especially because I am so afraid you will think I am not making progress. You would see that my work is slowly developing, and that I am aiming high. Thanks for all your faithful friendship, boy, which has sustained me again this whole year. I wish I on my side could give you some pleasure too. Sometime I shall succeed in this.

At this moment the woman and the children are sitting with me.

When I think of last year there is a great difference. The woman is stronger and stouter, has lost much of her agitated air; the baby is the prettiest, healthiest, merriest little fellow you can imagine; and the poor little girl — you see from the drawings that her former deep misery has not been wiped out, and I often feel anxious about her, but still she is quite different from last year. Then she was in a very bad state; now she is already looking more childlike.

A woman, no matter how good and noble she may be by nature, if she has no means, and is not protected by her own family, in present-day society runs a great and immediate danger of being drowned in the pool of prostitution. What is more natural than to protect such a woman? Our life is so dependent on our relations with women — and the opposite, of course, is also true — that it seems to me one must never think lightly of them.

There are things which we feel to be good and true, though in the cold light of reason and calculation many things remain incomprehensible and dark. And though the society in which we live considers such actions thoughtless, or reckless, or I don't know what else, what can we say if once the hidden forces of sympathy and love have been roused in us? And though it may be that we cannot argue against the reasonings which society usually brings in against those who allow themselves to be led by sentiment and to act from impulse, one would almost conclude that some people have cauterized certain sensitive nerves within them, especially those which, combined, are called conscience. Well, I pity those people; they travel through life without compass, in my opinion.

If one has such an encounter, it is to be expected that it will bring him into conflict, especially conflict with himself, because one sometimes literally does not know what to do. But are not this struggle and even the mistakes one may make better, and do they not develop us more, than if we kept systematically away from emotions? The latter is, in my belief, what makes many so-called strong spirits in reality but weaklings. To save a life is a great and beautiful thing. To make a home for the homeless,

yes, it is a thing that must be good; whatever the world may say, it cannot be wrong.

Well, though not exactly normal, the situation is much better than I dared to hope last year. My heart is full, and I think of you all the time; just now I have made another drawing for which the woman posed.

I can tell you, my experience of this year is that, though there are hard, very hard moments of care and difficulty, it is infinitely better to live with wife and children than without. To learn to know each other first, that is more sensible and more prudent, and I should have done the same if it could have been arranged, for it is a good thing when love ripens so that marriage becomes quite a subordinate thing, it is safer and doesn't hurt anybody; but there was no other home for her than mine. Well, one has to reckon with circumstances.

What a mystery life is; and love is a mystery within a mystery. Michelet says, curiously enough, that 'love at first is frail as a spider's web, and grows to be as strong as a cable; but only on condition of faithfulness.' He who wants variety must remain faithful. And he who wants to know many women must stick to one and the same; in one love, there are many different phases or metamorphoses.

At times I regret that the woman with whom I live can understand neither books nor art. But though she decidedly cannot do so, my being still so much attached to her — is that not a proof of something sincere between us? Perhaps she will learn later on, and it may strengthen the bond between us, but now with the children her hands are full. And through the children especially she comes in contact with reality and learns involuntarily. Books and reality and art are for me alike. One who stood outside real life would bore me, but one who is right in it knows and feels naturally.

If I did not look for art in reality, I should probably find her stupid. I rather wish it were otherwise, but I am after all contented with things as they are. If women do not always show in their thought the energy and elasticity of men, who have aimed at reflection and analysis, we cannot blame them, at least in my

opinion, because in general they have to spend so much more strength than we in suffering pain. They suffer more, and are more sensitive. And though they do not always understand our thoughts, they are sometimes capable of understanding when one is good to them; not always, but 'the spirit is willing,' and there is sometimes in women a curious kind of goodness.

I have often walked on the Geest of late, in those streets and alleys where I walked with the woman in the beginning. Everything was beautiful there then, and when I came home I said to the woman: 'It is just the same as last year.' You spoke of disenchantment; no, no, it is true that there is a withering and budding in love as in nature, but nothing dies entirely. There is an ebb and flood, but the sea remains the sea. And in love, either for a woman or for art, there are times of exhaustion and impotence. I consider love as well as friendship not only a feeling but an action, and as such it demands exertion and activity, of which exhaustion and impatience are the consequence.

And I believe people are wrong who think love prevents one from thinking clearly, for it is then that one thinks very clearly and is more active than before. There is the same difference in a person before and after he is in love as between an unlighted lamp and one that is burning. The lamp was there and it was a good lamp, but now it sheds light too, and that is its real function. And love makes one more calm about many things, and so one is more fit for one's work.

I do not know whether Heyerdahl, for instance, would find anything picturesque in the daily ways of the woman with whom I live. But Daumier certainly would.

The weather has been very stormy here these days, especially last night. It must be very rough at sea. How I should love to talk with you! I am at a standstill. I ought to have some intercourse with someone who sympathizes, and to whom I could talk; here just now there is not a soul I can take into my confidence. I do not mean that there are none here to be trusted — far from it — but unluckily I am not in touch with them.

I am making experiments in black and white. It occurred to me first to make a drawing with carpenter's pencil, and then to work in and over it with lithographic chalk. In this way I have made a drawing of an old man who sits reading with the light falling on his bald head, his hand, and the book. There is a certain facility which enables one to draw the selfsame figure which one admires in perhaps ten different poses, whereas in water-colour, for instance, or in painting one would only make one pose of it.

What is called black and white is in fact *painting in black* — 'painting' in this respect, that one gives in a drawing the depth of effect, the richness of tone value which must be in a picture. Every colourist has his own peculiar scale of colours. This is also the case in black and white; one must be able to go from the highest light to the deepest shadow, and this with only a few simple ingredients. Some artists have a nervous hand at drawing, which gives their technique something of the peculiar sound of a violin, for instance Lançon, Lemud, Daumier. Gavarni and Bodmer remind one more of piano-playing. Millet is perhaps a solemn organ.

I often disliked many things in England, but their black and white, and Dickens, make up for them all. It isn't that I disapprove of everything in the present — far from it — but still it seems to me that something of the fine spirit of that time that ought to have been kept has been lost — in art, especially. And also in life itself. I do not know exactly what it is, but it is not only the black and white that changed its course and deviated from the healthy noble beginning. There is rather in general a kind of scepticism and indifference and coolness, notwithstanding all activity.

I sometimes think of a year ago when I came here to The Hague. I had imagined that the painters formed a kind of circle or society where warmth and cordiality and a certain kind of harmony reigned. This seemed to me quite natural, and I didn't suppose it could be otherwise. Neither should I want to give up the ideas I had about it then, though I must modify them and distinguish between what is and what might be.

I cannot believe it a natural condition that there is so much

disharmony. What's the reason? As a painter one must avoid other social ambitions and not try to be in the movement with the people who live in the Voorhout, Willemspark. In the old, smoky, dark studios there was a cosiness and originality that was infinitely better than what threatens to come in its stead.

One of the stupidest things about the painters here is that they laugh at Thys Maris. I think that as terrible as suicide. Why as suicide? Because Thys Maris is so much the personification of everything high and noble that in my opinion a painter cannot mock at him without lowering himself. He who doesn't understand Maris, so much the worse for him; those who have understood him mourn for him, and regret that such a man has been broken.

I haven't seen de Bock for months, but met him a few days ago. He seems to be in very flourishing circumstances, judging from his fur coat; yet I cannot say he himself looked flourishing. Have you sometimes felt sympathy for a person whom you saw to be unhappy, but who pretended and was considered to be flourishing? And have you felt within you: If I tried to be friends with him, he would think I was making fun of him, and it would be almost impossible to gain his confidence — or even if I came so far, he would say, 'I have chosen my course and shall stick to it,' and we should have no influence on each other? It is in this way that I think of de Bock, and though I feel real sympathy for him and admire much of his work, I do not think that he and I would profit by each other's society; we have opposite views of life, especially, and of art too.

It is difficult for me to give up a friendship, but if I come into a studio and have to think: Speak about inane things and do not express your real feeling about art, that makes me more melancholy than if I stayed away altogether. Precisely because I want to find and keep real friendship, it is difficult for me to conform to conventional friendship. Where there is convention there is mistrust, and mistrust gives rise to all kinds of intrigue. It is almost unavoidable that bitterness should arise, for the very reason that one cannot feel free.

Meanwhile one gets used to existing conditions, but if it were possible to go back to a period of thirty, forty, or fifty years ago, I think one would feel more at home; that is to say, you and I, for instance, would feel more at home in it. Fifty years hence nobody will wish to go back to *this* period, or if there follows a time of antiquated decay or so-called 'time of *perukes* and crinolines,' people will be too dull to think about it at all; if there comes a change for the better, *tant mieux*.

I do not think it absurd to expect such a time of stagnation to arrive, for what in Dutch history is called 'the time of *perukes* and crinolines' also had its origin in the giving-up of principles, and in replacing the original by the conventional. The Dutch people, at their best, are the 'Syndics'; but if the salt loses its savour, there follows a time of stagnation, of '*perukes*.'

It is sometimes hard for me to believe that a period of, say, fifty years is sufficient to bring about a total change so that everything is reversed. But by simply recalling history one sees those relatively quick and continual changes, and I draw the conclusion from it that every man puts some weight in the scale, be it ever so little, and that it does make a difference how one thinks and acts. The battle is but short, and it is worth while to be sincere. If many are sincere and firm, the whole period becomes good — or at least energetic.

The truth is this, that whenever different people together love the same thing and work at it, union makes strength, and combined they can do more than if their different energies were striving each in a separate direction, though the personality of each need not be wiped out. And therefore I wish that Rappard were much better; we do not really work together, but we have the same thoughts about many things.

In the very first letter I had from him after his illness, he speaks again with great animation about woodcuts he has found, among others some of Lançon's. He is now so eager for them that I need not urge him, though at first he cared for them as little as others do. That he went to make studies in the asylum for the blind is the direct practical result of his love for draughtsmen like Herkomer and Frank Holl.

Please do not let it worry you that I have made nothing salable this year; you once said the same thing to me, and if I say so now, it is because I see in the future a few things within my reach which I didn't see before. You know well enough how little fit I am to cope either with dealers or with amateurs, and how contrary it is to my nature; I should like it so much if we could always continue as we do now, but it often makes me sad that I must always be a burden to you. I am too fond of a very simple life to wish to change. When there is bread in the house and I have money in my pocket to pay the models, what more can I want? My pleasure lies in the progress of my work, and that absorbs me more and more. But later on, in order to do greater things, I shall be obliged to have greater expenses too. I think I shall always work with a model — always and always and always. Yet who knows but in time it will come about that you will be able to find someone who takes an interest in my work, who will take from your shoulders the burden which you took upon yourself at a most difficult time?

I am very glad you think the old man's head typical — the model is really typical, I assure you. I am still busy making heads this week, especially women's heads. My intention is to try to form a collection of many such things which wouldn't be quite unworthy of the title 'Heads of the People.' I myself prefer studies, even though they are not quite finished and many things in them are neglected, to drawings which form a composition, because they remind me more vividly of nature itself. In the real studies there is something of life, and one who makes them does not think of himself, but of nature; so I prefer the study to what perhaps he may make of it afterwards, unless there may come quite a different thing as the final result of many studies, namely, the type concentrated out of many individuals. That's the highest thing in art, and there art sometimes rises above nature; in Millet's 'Sower,' for instance, there is more soul than in a common sower in the field.

Today I get a sou'wester for the heads. Heads of fishermen, old and young, that's what I have been thinking of for a long time,

and I have some already, but afterwards I couldn't get a sou'wester. Now I shall have one of my own, an old one over which many storms and seas have passed. I wonder if you will find some good in these fishermen's heads. The last one I made this week was of a fellow with a white clipped beard. Today I drew one in lithographic chalk. Then I flung a pail of water over the drawing, and in the moistness I began to model in pencil. It is a dangerous method which may turn out badly, but if it succeeds the result is quite *non ébarbé*, delicate tones of black which most resemble an etching.

I send you a roll with five heads. When you have looked at them for some time, I think you will find in them the same things as in the first two, for there *must* be something of nature in them, as I literally wrested them from nature and worked after the model from beginning to end.

What struck me most when I came here to the city was the Geest and the surrounding neighbourhood. And slowly it is taking form — but what a struggle to bring such a thing to an end! By working hard I hope to succeed in making something good; but in working so hard I get somewhat in arrears, and when I receive the money I have to pay out at once more than half of it. I cannot live more economically than I do; I have economized wherever possible, but the work develops, especially these last weeks, and I can hardly master it any longer, that is to say, the expenses it brings.

We've had snow again, which is thawing just now. It is very beautiful, this thawing weather. I peep through my window on the yard. Poetry surrounds us everywhere; everything has a certain air which gives one a longing to dash it down on paper; but to get it onto paper is, alas, not so easy as to look at it. It has been typical winter weather, the kind of weather that rouses old memories, and makes the most ordinary things have a look that reminds one of stories of the time of coaches and post-chaises. It was wonderfully beautiful with the snow and peculiar skies. All nature is an indescribably beautiful 'black and white.'

Today, while the snow is melting, one feels spring approaching,

as it were, from afar, and it will not be long before the lark sings again in the meadows. I long for the spring breezes to blow away the weariness from working indoors so long. I shall take a few weeks' rest, and be out-of-doors as much as possible to change my thoughts. I want to use my studies for water-colours, but at present it's no use.

I feel very weak of late. It may be I have caught cold, but I am afraid I have been overworking. I've had a very decided warning that I must be careful — my eyes have felt so tired sometimes, but I wouldn't pay any attention to it. Last night there was a rather strong secretion of the tear glands and the lashes stuck together; and my sight has been dim and troubled. My eyes and face look as if I had been on a spree, but that, of course, has not been the case — on the contrary; but who knows if somebody whom I meet on the street will not make the remark that I am evidently on the road to dissipation? Ever since the middle of December I have been toiling incessantly, especially on those heads. I shall take baths and wash my head often with cold water.

How miserable are those 'dregs' of the work, the depression after overexertion! Life has then the colour of dishwater; it becomes something like an ash-heap. On such days one would like to have the company of a friend; that sometimes clears up the leaden mist. In spite of this, I have been working on a water-colour, a sketch again of diggers, or rather road-menders, here on the Schenkweg, but it isn't good at all. I drew also a few figures in crayon, the whole thing sponged, and the shadows softened, the lights retouched, which I think are better.

Do you know what I have been thinking? That in the first period of a painter's life one unconsciously makes it very hard for oneself by a feeling of not being able to master the work, by an uncertainty as to whether one will ever master it, by a great ambition to make progress. One cannot banish a certain feeling of agitation, and one hurries oneself, though one doesn't like to be hurried. This cannot be helped, and it is a time which one must go through.

In the studies, too, one is conscious of a nervousness and a

certain dryness which is directly opposite to the calm, broad
touch one strives for; yet it doesn't work well if one applies oneself
too much to acquiring that broadness of touch. The trouble one
has at the beginning gives an awkwardness to the studies. But
I do not consider this a discouragement, because I have noticed
it in others who afterwards got rid of it naturally; sometimes one
keeps that painful way of working one's whole life, but not always
with so little result as in the beginning.

I sometimes think I shall make an experiment, and try to work
in quite a different way, that is, to dare more and risk more;
but I think that first I certainly must study the figure more,
directly from the model.

I sent Father a drawing which I had made according to his
suggestions about the first lithographic sketch of the old man.
This was not because I thought Father was exactly right, but
because I thought: Now I know how you would like to have it,
I will try and make it so for you. But I am afraid I didn't succeed.
Even though one tries hard, one doesn't always succeed in pleasing
other people.

Spring is coming fast here. We have had a few real spring days;
last Monday, for instance, which I enjoyed very much. I think
the poor people and the painters have in common this feeling for
the weather and the change of the seasons. In a neighbourhood
like the Geest and in those courts of so-called almshouses, the
winter is always a difficult, anxious, and oppressive time, and
spring is a deliverance. If one pays attention to it, one sees that
such a first spring day is a kind of gospel.

And it is pathetic to see so many grey, withered faces come
out-of-doors, not to do anything special, but as if to convince
themselves that spring is there. So all kinds of people, of whom
one doesn't expect it, throng the market around the spot where a
man sells crocuses, morning-stars, or other bulbs. Sometimes I
saw a dried-up government clerk, apparently a kind of Jusserand
in a threadbare, black coat, with greasy collar — his reaction to
the snowdrops was typical. Of course everybody feels it, but for
the well-to-do middle class it is not so important, and it doesn't

change the general frame of mind much. I thought it a character-
istic saying of a navvy: 'In winter I suffer as much from the cold
as the winter corn does.'

At sunset there are effects of dark clouds with silver linings that
are splendid, walking along the Bezuidenhout, perhaps, or along
the woodside. You will remember that from long ago. From the
window of the studio also it is beautiful. One feels now and then
that there is something balmy in the air. One cannot rest for the
very reason that one must.

In the meadows the colour often reminds me of Michel, the soil
yellowish-brown, withered grass with a muddy road full of pools,
black tree-trunks, a greyish-white sky, the houses at a distance in
tone, but with a little touch of colour in the red of the roofs. These
days Montmartre also will have these curious effects which Michel
has painted. They are striking enough, and Michel's secret (like
Weissenbruch's) lies in taking the proper measurements and
finding the correct proportion of foreground against background,
and feeling the exact direction in which the lines run in perspec-
tive.

Simple though it all may seem, there is a very expensive scien-
tific method behind it, as there is behind even more simple-looking
works — Daumier's, for example. These things are not found by
chance, and I think that Michel, before his time of success, must
have been perplexed and disappointed sometimes because things
wouldn't go right.

If my eyes do not improve, I'll bathe them with tea. As it is,
they are getting better, so for the present I'll leave them alone,
for they have never troubled me before; lately, indeed, they have
stood the fatigue of drawing better than at first — except once
this summer when I had a toothache; so I believe it is nothing but
strain and overwork. I hope to be able to work regularly again
this week.

A few weeks ago I read Fritz Reuter's 'From My Prison,' in
which is described, in the wittiest way, how Fritz Reuter and
others, who were confined in a fortress, tried to make their life as
comfortable as possible, and to obtain several privileges from the

major in charge. That book gave me the idea of attacking my
landlord about certain improvements.

There are three windows in the studio; they give far too much
light even when I cover them with cardboard, and I have been
thinking for a long time how to remedy this. But the landlord
refused to do anything unless I paid for it. Now, after a new at-
tack, I have six shutters and about six long boards. The shutters
are sawn through so that both the upper and lower halves can be
opened or closed and the light admitted or shut out either from
above or from below. The boards are for a big closet in the alcove,
in which to put away drawings, prints, and books, and to hang up
different blouses and jackets, old coats, shawls, hats, and, last but
not least, the sou'wester, on which the fish scales still stuck when
I got it.

How miserably the modern houses are constructed nowadays,
compared to what they might be if the builders tried to make
them a little more cosy! The attractiveness is lost more and more,
and in its place comes something cold, systematic, and methodical.
It often made me desperate when I saw a woman rummaging
around in a small room, and found in the figure something typical
and mysterious which disappeared when I had the same woman in
the studio. The old man also gave a much more beautiful effect in
a dark passage than in my studio. And that was exasperating.

Now I can get quite a different effect of light. Window num-
ber 1 is closed at the bottom and the rest partly so — like the door
of a little room in an almshouse; window number 2 is closed at the
top, and is like a window before which the figures are sitting; the
background to the left is dark, for window number 3 is quite
closed. Just think of the difference between the crude light which
the three windows would give at this moment without the shutters
and what it actually gives, and you will understand how infinitely
better I can work. Besides, there was an excessive reflection before
which neutralized all effects. Well, now, when I have seen a little
figure in some other house, I can easily find it back at home. How-
ever, the expense has been rather more than I expected, as the old
blinds had to be altered so much. I know you will understand that

the studio has been quite changed; oh, I am so glad about it; it has worried me so, because I couldn't get it right.

I think I shall probably dream tonight of fellows in sou'westers and oilskins, on which the light falls and makes piquant high lights, which accentuate the form.

I sent you yesterday afternoon a very rough sketch of a water-colour. A few months ago I started it. Since then, I have made a large number of studies of the figure, and especially of heads, with a view to just such a scene as this sketch represents, which must be finished by getting character and effect in heads, hands, and feet. I send it because you will see in it more clearly than in any others I have made that I have a good strong eye for colour — that I see it fresh, through a grey haze. However unfinished and defective it may be, this is a bit of street such as I need to represent the Geest or the Jewish quarter. All kinds of scenes I see I can finish thus, and get those relatively strong effects of colour and tone.

The large studies of heads must serve for such compositions as these. But I shall make many more failures still, for I believe that in water-colour much depends on great dexterity and quickness of touch. One must work in it before it is dry in order to get harmony, and one hasn't much time for reflection then. So the principal thing is not the finishing of each study at the time, but the working up to a higher point of knowledge and ability. One must put down those twenty or thirty heads rapidly and one after the other. Whistler said: 'Yes, I have done that in two hours, but I've studied for years in order to be able to do so.'

I have not been working in water-colour, but I love it too well ever to give it up entirely. After having drawn for a month I have made a few water-colours now and then by way of throwing out the plummet to fathom my depth. Each time I see that I have conquered some obstacles. By the change in the studio I can now study better the effects of *clair-obscur*, and I shall work more and more with the brush, even in black-and-white drawings, wash the shadows in with neutral tint, sepia, India ink, and Cassel earth.

and accentuate the lights with Chinese white. But spring is coming and I should like to take up painting again too, and the colours are really all used up; yet because of some relatively great expenses I am absolutely penniless.

Do you remember last summer you brought me a piece of hard crayon? There is in that crayon a soul and life — Conté pencil is dead, I think. Two violins may look the same from the outside, but in playing on them one sometimes finds in the one a beautiful tone which the other does not have.

Today I made another sketch with the rest of that little piece of crayon, and afterwards washed it in with sepia. If the little drawings are not according to your intention, though I remembered your hints when I made them, don't let it discourage you. I think I find in crayon all kinds of qualities which make it an excellent means to express things from nature. This morning I took a walk outside the town, in the meadows behind the Zuidbuitensingel where Maris first lived, and where the public dumping grounds are. I stood there a long time looking at a row of the most twisted, gnarled, sorry-looking pollard willows that I have ever seen. They bordered a patch of vegetable garden, freshly dug up, and they were mirrored in a dirty little ditch — very dirty, but in which some blades of spring grass were already sparkling. But that rough brown bark, the freshly spaded-earth, in which one could see the fertility, as it were — all this had something intensely rich in the dark deep tones that reminded me again of the crayon. So that as soon as I have some more of it, I hope to try my hand at landscape.

Though I no longer say so much about that plan of making workmen's types for lithography, I still keep it in mind. Recently I spoke to Smulders about lithographs; I met him on the street, and he asked me if I didn't intend to make some again — which is just what I should like to do; but I must speak to Rappard about it. He has promised to come to see me, and I wish I could make some arrangement with him for making a series which we should lithograph when they were good enough. But he must see my studies first. I have a sower, a mower, a woman at the washtub,

a woman miner, a seamstress, the almshouse men, a fellow with a wheelbarrow full of manure. But the very drawing of them does not make one satisfied with one's work; on the contrary, one says: Yes, that same thing, but better still, and more serious.

The lithographs by Émile Vernier after Millet and Corot and Daubigny possess qualities which I highly appreciate. How one would like to talk with somebody who is to some degree a master of his trade, not with the aim of making reproductions of pictures, but so as to understand better what may be done in lithography.

I am reading 'Les Misérables,' by Victor Hugo. The illustrations which Brion made for it are very good and very appropriate. It is good to read such a book again, for the very reason of keeping some sentiments and ideas alive, especially that of love for humanity, and the faith in, and consciousness of, something higher — in short, *quelque chose là-haut.* One might suppose that in every human being the foundation of everything would be love for humanity, but some pretend that there are better ones. I'm little curious to know them. The old foundation, having proved for so many ages to be the right one, is sufficient for me.

I was absorbed in the book for a few hours this afternoon, and then came into the studio about the time the sun was setting. From the window I looked down on a wide dark foreground — dug-up gardens and fields of warm black earth of very deep tone, diagonally across it a little path of yellowish sand, bordered with green grass and slender, spare little poplars. Behind it a grey silhouette of the city, with the round roof of the station, and spires, and chimneys; and right above it, almost at the horizon, the red sun. It was exactly like a page of Hugo.

Yesterday morning I was at Van der Weele's. He was working at a picture of diggers, horses, and sand wagons. It was beautiful in tone and colour, a grey morning haze; it was virile in drawing and composition; there was style and character in it — well, it was by far the strongest thing of his I have ever seen.

Do you know what pleases me? You remember Van der Weele came to see me this winter. I was then making studies of diggers.

He saw them, but they didn't seem to interest him — decidedly
not. But for his large picture he has had diggers pose for him, has
observed them while they were at work; in fact, he has closely
studied diggers from nature. *Now*, in looking over my studies,
when we came to the diggers he spoke quite differently about them
from the way he had months ago. More and more I begin to notice,
in myself as well as in others, how often one is mistaken in thinking
that this or that 'is not correct.' One thinks one knows it for sure,
and yet if one wants to be honest, one must take it back.

The greatness and unity of the picture is not found in the
studies. No wonder; they do not stand out and are not in their
right places; the surroundings are neglected. I hope you will keep
this in mind in seeing mine. I mean to say, do not think I look at
nature with a different eye with regard to space from Van der
Weele's, for example. Believe me, the aspect is not the hardest
thing; if my studies are good, I am quite confident of the rest.
Space, atmosphere, broadness are things which you mustn't think
I neglect, but one mustn't *begin* with them; first the foundation,
then the roof follows in time.

Thanks for your good wishes on my birthday. By chance it was
a very pleasant day, as I had just found an excellent model for a
digger. Sometimes I cannot believe that I am only thirty years old.
I feel so much older when I think that most people who know me
consider me a failure, and when it really may be so if some things
do not change for the better. And when I think it may be so, I
feel it so vividly that it makes me as downhearted as if it were
really so. In a more normal and calmer mood, I am sometimes
glad that thirty years have passed, and not without teaching me
something for the future; I feel strength and energy for the next
thirty years, if I live that long, and in my imagination I see years
before me of serious work, and happier than the first thirty. How
it will be in reality doesn't depend only on myself; the world and
circumstances must also contribute.

The age of thirty is, for the workingman, just the beginning of a
period of some stability, and as such one feels young and full of
energy. But at the same time a period of life has passed which

makes one melancholy, thinking that some things will never come back. And it is no silly sentimentalism to feel a certain regret. But one doesn't expect from life what one has already learned it cannot give; rather one begins to see more and more clearly that life is only a kind of sowing time, and the harvest is not here. Perhaps that's the reason that one sometimes feels indifferent towards the opinion of the world.

One thing I can assure you of: the work is more and more animating, and it gives me, so to speak, more vitality. I have a certain activity, but though one who possesses a certain activity works hard even when his work has no direct destination, it would be twice as stimulating if one could find a destination for it. You write in your letter: 'Sometimes I do not know how I shall pull through.' Now, I often feel the same, in more than one respect, not only in financial things, but in art itself, and life in general. Do you think that something exceptional? Don't you think every man with a little pluck and energy has those moments? Moments of melancholy, of distress, of anguish? It is a condition of every *conscious* human life. It seems some people have no self-consciousness, but those who have it are not unhappy, nor is it something exceptional that happens to them.

Know well, dear brother, how strongly and intensely I feel the enormous debt I owe you for your faithful help. It would be difficult for me to express my thought about it. It remains a constant cause of disappointment to me that my drawings are not yet what I want them to be. But a weaver who has to direct and interweave a great many threads has no time to philosophize about it; he *feels* more how things go than he can explain it. Even though neither you nor I in talking together would come to definite plans, perhaps we should mutually strengthen that *feeling* that something is ripening within us. And that is what I should like.

I received a letter from Father, very cordial and cheerful, with twenty-five guilders enclosed. He wrote he had received some money on which he had no longer counted, and wanted me to share it. But involuntarily a thought came into my mind. Can it be perhaps that Father has heard from someone or other that

I was very hard up? I hope that this was not his motive, for I think this idea of my circumstances would not be correct.

In my opinion I am often as rich as Croesus, not in money, but rich because I have found in my work something to which I can devote myself with heart and soul, and which gives inspiration and zest to life. Of course my moods vary, but I have a certain average serenity. I have a certain *faith* in art, a certain confidence, which is a powerful stream that drifts a man into harbour, though he must do his bit too. I may be in comparatively great difficulties, and there are gloomy days in my life, but I think it such a great blessing when a man has found his work that I cannot count myself among the unfortunate. I cannot do everything that I have the courage to undertake, the expenses are so great, beginning with a model and food and housing and ending with colours and brushes — and that is also like a weaving-loom where the different threads must be kept apart. But I am privileged above many others.

We all have to bear up against the same thing — but just because everyone who paints or draws has to bear it, and if alone would almost sink down under it, why shouldn't more painters join hands to work together, like soldiers in the rank and file? And why, especially, are those branches of art which are least costly so much despised? How beautiful are those two large etchings by Israëls — a man who lights his pipe, and an interior of a workman's home! I think it is so splendid of Israëls to go on with etching, the more so because all the others have given it up. But Father Israëls, notwithstanding his grey hairs, is still young enough to make progress, and great progress, too — and this I call real youth and ever-fresh energy. Confound it, if the others had done the same, what beautiful Dutch etchings would have been given to the world!

I mean to spend the twenty-five guilders on getting my water-colour things in good shape. Lately I have been working with printer's ink, which I dilute with turpentine and apply with a brush. It gives very deep tones of black. Diluted with some Chinese white, it also gives good greys. By adding more or less tur-

pentine, one can even wash it in very thinly. It sometimes seems to me that the prices of materials are terribly screwed up so that it prevents many a one from painting. I shall also pay off Leurs, and shall be able to arrange different things in the studio so as to make it still more practical. I love my studio as a sailor loves his boat.

I made a large drawing with the crayon you sent, combined with lithographic chalk. It is a digger — my model was the little old almshouse man. His bald head, bent over the black earth, seemed to me full of a certain significance, for instance, 'In the sweat of thy face shalt thou eat bread.' The drawings of the woman with the spade and this digger have such an aspect that one will not think they are made in some intricate way, but rather will not think at all about how they are made. By certain grey tints, by a certain richness and pith in the black, one avoids that dull and metallic aspect of the ordinary Conté pencil. And these little things are in my opinion worth the trouble of seeking for such material as crayon and lithographic chalk.

This morning a painter saw these two drawings, Nakken, who didn't intend to come to me. He knocked at my door thinking that Van Deventer lived here, but he lives in another street. I directed him, and asked if he wouldn't come and look at my studio, which he did. As I was drawing the digger, this was the first thing he saw on the easel, and he said, 'That is well drawn and seriously studied.' Take those words at their face value; they pleased me, anyhow, because I don't suppose Nakken would say that a figure was well drawn if it were not.

Van der Weele came to see me again. He may bring me in contact with Piet Van der Velden, whom I think you will know from his peasants' and fishermen's figures. I once met Van der Velden. There is something broad and rough in him that appeals to me very much — something of the roughness of torchon — a man who apparently doesn't seek culture in outer things, but who is inwardly much, very much farther along than most. He reminded me of the figure of Felix Holt the radical, of George Eliot. He is a real artist, and I wish I knew him, for I have confidence in him and I know that I should learn from him.

This week I have been working on the figure of a woman on the heath picking peat, and the kneeling figure of a man. One must know the structure of the figures thoroughly in order to get the expression, at least I cannot see it differently. Edelfelt is beautiful of expression; his effect lies not only in the faces, but in the whole position of the figures. These last days, or rather weeks, I have had the very pleasant company of a young land surveyor who tries his hand at drawing. He once showed me drawings and I told him why I thought them very bad. One day he came to me again: he had more leisure now, might he come with me to work outdoors? Well, Theo, the fellow has caught the drawing of landscape so well that at present he brings home really charming sketches of meadow and dune. His father does not want him to spend time on drawing; but in my opinion he can very well combine it with his profession of land surveyor. He is the kind of fellow Rappard was when we first knew him.

On your birthday I want you to receive a little word from me too. May it be a happy year for you, and may you have success. It is almost a year since you were here. Yes — I long very much for your coming. I have the work of this whole year to show you; we must talk about it in relation to the future. You write about some amateurs who would possibly take my work sometime, even though it wouldn't become exactly a current article. Well, I really believe so. If I can succeed in putting some warmth and love into my work, it will find its friends. The point is to continue to work.

The number of studies steadily increases. But from the studies new things must come forth. The time has now come when we can put more energy into them. For the present I am confining myself to a few models, but my ideal is to work with more and more models, quite a herd of poor people to whom the studio would be a kind of refuge in winter days, or when they were out of work; where they knew there was a fire, and food and drink, and a little money to be earned. That is so now, on a very small scale.

For the execution of my plans I ought to have more money than I have to spend. No matter how I contrive I cannot save more; if I began to do so I should have to give it up in the middle. It is a

melancholy thing to have to say, 'I could make such and such a thing if it were not for the expense.' An unsatisfied energy then remains which one would like to use instead of having to stifle it. But I do not want to complain — I say it for a better understanding, and to unburden my mind. The English say, 'Time is money,' and I sometimes think it hard to see the time pass by in which things might have been done if I had had the means.

I should like to be able to spend more on painting materials. Even if I should not sell a single one of my studies, I think they are worth the money I spend on them. The studio has become so much better and more convenient, but I have only steam enough for 'half-speed' and want to go 'full-speed.' You are also burdened above your strength. Well, we must make the best of it, and the things we cannot move by force must be undermined by patience.

There is another thing spurring me on, namely, that Rappard works at full speed, more than he used to do, and I want to keep up with him because then we can profit more from each other. He has painted much more than I, and has drawn longer, but we are both just about on the same level. I don't try to compete with him as a painter, but I will not let him beat me in drawing. He is going to send a large picture to the Amsterdam Exhibition. It represents four tile-painters around a table. Indirectly I heard much good said about it. Now, though it is not my intention to make large pictures for exhibitions, yet I shouldn't like the work less than Rappard. I even find something animating about the thought that one works in one direction, the other in another, and that even so each sympathizes with the other. Competition that arises from jealousy is quite a different thing from trying one's best to make the work as good as possible for the sake of mutual respect. I do not see any good in jealousy, but I should despise a friendship which did not call for some exertion from both sides to keep it on the same level.

At present I have been working only with brush and printer's ink. To tell you the truth, I am very hard up. I am so sorry that Rappard did not come up when he wrote he would. If I asked him to advance me something, I am sure he would not refuse, for he

himself proposed it this winter, but then fell ill. I remember his
father wrote: 'My son is ill, but I know about it; if you are perhaps
in difficulties, I will advance you the money.' I thought that so
delicate of Rappard's father that it would have been indelicate of
me to accept it at the moment. So I wrote to him: 'Thank you.
Let us wait for the recovery of your son.'

When your money arrived this morning, I had been absolutely
without a penny for about a week; besides, all my drawing material
was exhausted. I was negotiating with Smulders about a lot of
drawing paper and took it, though the expense did not suit me at
all at present; but I wanted it very much, together with printer's
ink for engravers and lithographic chalk. And I had to pay for
several things for the household and to lay in provisions, as well
as to pay models, which I had had meanwhile in order to be able
to go on with work.

I now have several things on hand which I must carry through.
If you send me another ten francs, this week will pass by without
a hitch; if not, there will be unpleasant damage done. But do not
be angry with me; it was a combination of expenses, all strictly
necessary, which I could not avoid. And if you cannot send it —
well, it will not kill us anyhow. The difficulties in small matters,
about small sums also, are often really brain-racking, and this is
such a case.

Next week I have an arrangement with Van der Weele to go and
paint in the dunes; he will show me a few things which I do not
know as yet. I have been working in the dunes for some days, but
I long for a model; otherwise I cannot go on.

There seems to be something the matter with the woman. I feel
rather worried.

Michelet rightly says: '*Une femme est une malade.*' They vary,
Theo, they vary like the weather. Now he who has eyes to see it
finds something beautiful and good in every kind of weather; he
finds the snow beautiful and the burning sun, finds the storm
beautiful and the calm, likes the cold and the heat, loves every
season and cannot spare one day from the year, and is in his heart
contented and resigned that things are as they are; but even if one

considers the weather and the changing seasons in this way, and in this way the changing feminine nature, believing at heart that there is a reason in its enigma too, submitting to what one cannot understand; even if one could consider it so, still our own character and opinion are not always and at every moment in harmony and sympathy with that of the woman to whom we are united; and one feels either care, dissatisfaction, or doubt, notwithstanding the courage, faith, and serenity one may have.

As the doctor who attended her in her confinement told me, it will take years before the woman has completely recovered her health. That is to say, the nervous system remains very sensitive. The great danger is that she will fall back into her former errors. That worries me continually and seriously. Her temper is at times so bad that it is almost unbearable, even for me — violent, mischievous. I can tell you, I am sometimes in despair. She comes round again, and she has often told me afterwards: 'I do not know myself at such times what I am doing.'

Sometimes there is a crisis, especially when I venture to criticize some fault of hers on which I have had my eye for some time — for example, in the mending and the making of clothes for the children. The result is that in this respect, as in many others, she has improved much. But these errors in her character must be corrected — habits of negligence, indifference, lack of activity and ability — oh, a lot of things. They all have one root: bad education, years of quite wrong views on life, the evil influence of bad company. How could it be otherwise?

I tell you this in confidence, you know; and not from discouragement, but so that you may understand that for me life is not a bed of roses, but something prosaic like a Monday morning. I must change so many things in myself too; she must find in me an example of diligence and of patience. That is deuced difficult, brother — to act so that one can indirectly be an example to somebody else — and I too fail sometimes; I must raise myself to a higher pitch in order to waken new impulses in her.

I think it well said, 'If one marries, one doesn't marry only the woman herself, but the whole family into the bargain'; which is

sometimes awkward and miserable enough when they are a bad
set. But it is a sad thought, indeed, that a thing like the relation
between mother and daughter can have a dark side, so that a man
who loves and seeks for light can be fatally thwarted by it. The
influence of a mother and conversation with friends sometimes
bring, more than anything else in women, a kind of backsliding
which prevents reform in thought and action — sometimes so
urgently necessary.

I can assure you, in my case nine tenths of the difficulties which
I had with the woman originated therein. And yet those mothers
are not exactly bad; they simply do not know what they are doing.
Women of about the age of fifty are often distrustful. I do not
know whether all women in getting older want to govern their
daughters, and do it exactly in the wrong way. In some cases
their system may have some *raison d'être:* but they ought not to
fix as a principle that all men are deceivers and fools, for which
reason women must cheat them and suppose they know every-
thing better. If, unluckily, the mother-system is applied to a man
who is honest and of good faith, he is indeed badly off.

Well, the time has not yet come when reason, in the meaning
of *la conscience*, is respected by everyone; to contribute towards
bringing about that time is a duty, and in judging character one
of the first things that humanity demands is to take into considera-
tion the circumstances of present society. Many people care more
for the outward than for the inward life of a family, thinking they
act well in doing so. A wife's mother is in some cases the repre-
sentative of a meddlesome, slandering, exasperating family, and
as such decidedly injurious and hostile, though she may not be so
bad herself.

I should prefer in the matter of relations between the woman and
her mother — in my case, where it has decidedly bad consequences
— that the mother come to live with us outright. She would be
much better off in my house than in the houses of other members
of her family, where she is very often brutally duped and so incited
to intrigues. I proposed it this winter when the mother was very
hard up. I said: 'If you are so much attached to each other, come

and live together'; but I believe she, though worse off herself, doesn't think good enough our simple way of living, which I desire on principle and to which I am forced by circumstances.

The little chap, however, is a miracle of vitality, and seems to oppose himself already against all social institutions and conventions. As far as I know, all babies are brought up on a kind of bread porridge, but this he has refused most energetically. Though he has no teeth as yet, he bites resolutely at a piece of bread, and swallows all kinds of eatables with much laughing and cooing; but for porridge he absolutely keeps his mouth shut. He often sits with me on the floor in a corner, on a few sacks; he crows at the drawings, and is always quiet in the studio because he looks at the things on the wall. Oh, he is such a dear little fellow!

Rappard has been here, and I borrowed twenty-five guilders from him, promising to pay them back in the autumn. I was very glad to see him; we spent the whole day looking at the studies and drawings. Tomorrow I go to him, to see his work and his studio. It was a very pleasant day. Personally, I like him now much better than before. He has become broader in the shoulders, and I think broader in his views on many things, too. His picture has now been accepted in Amsterdam.

The money he advanced me has helped me to many things which I urgently needed. I ordered large sketching blocks for working out-of-doors, and one for water-colours. I tried the latter at once — a cottage in the dunes with a wheelbarrow in the foreground and the small figure of a digger in the background. Oh, Theo, some day or other I shall surely get the knack of making water-colours.

I was also surprised by a very short visit from Father. I think he rather liked the workmen's figures I have on hand.

With great interest I saw an edition of 'Le Salon,' 1883 — the first series of illustrations reproduced in the new way. I subscribed to it notwithstanding all my other expenses, but with a view to what I am making myself just now with printer's ink and lithographic chalk. I firmly believe that some of my things would do well reproduced in this way.

And so the Salon has opened. I suppose you will have a visit from Mr. Tersteeg and C. M. one of these days. It is now almost a year since I had differences with Tersteeg. He may be sure that I hardly ever think of what has happened. But it is rather unpleasant for me that because of that quarrel with Tersteeg I must always discreetly avoid the Goupil gallery. When I reckon from May of last year, Theo, the year has not been exactly easy or free from care for me, has it? But that does not matter. What you send me is not little but much, yet to go on and to make progress with my work, and to keep the household going, is no child's play for the woman and for me. It is very hard sometimes that through such strained relations I must avoid the very persons with whom, for my work, I ought to be directly or indirectly in touch. Well, for the moment I cannot change things.

I have just come back from Utrecht, from my visit to Rappard. We talked much about new projects. I firmly intend to start a few large fusains with figures, too. It has certainly cheered me up to know that Rappard likes several things I made, and now that I have seen what his own work is like, I am still glad that some of my things have pleased him. Rappard's studio is a very good one, and very comfortable, and I see again how practical it is to use good stuff, to work often with the model. I am always afraid of not working enough; I think I can do much better still, and that is what I am aiming at — sometimes with a kind of rage.

I myself cannot judge whether some of my studies are finished enough to deserve being kept anywhere else but in my studio. However, I came back from Rappard full of plans, and full of hope, because there I saw the fruits of his studies, that is to say, combinations of different figures in more important compositions. *This is what I can expect too.* Let us keep courage and grind on.

Early tomorrow morning I go out with Van der Weele

Today is Sunday. I have been in a rage of work, and now I sit down quietly to write.

Do you remember that almost at the beginning I sent you some sketches, 'Winter Tale,' 'Shadows Passing'? You said at the time

that the action of the figures was not well enough expressed. For a few years I have done nothing but drudge on figures to get some action and structure in them. It is devilishly difficult to forge a figure. Indeed, it is the same as with iron — one works on a model, and goes on working, at first with no result; but at last it mellows and one finds the figure, like the iron, becomes malleable when it is hot; *then* one must go on working on it. Through that very drudgery I had somehow lost the stimulus to compose, and to let the imagination work; but when I was with Rappard, and he said with a certain warmth: 'Those very first drawings of yours were good; you ought to make some again in the same way,' my desire awoke.

This week I have been working hard on a large drawing. I think you will find repeated in it something of that earlier enthusiasm, but with more action. These are diggers of peat in the dunes. It is a splendid bit of nature from which one can draw an infinite number of subjects; I have been there very often of late, and have made all kinds of studies of it. Rappard saw them, but when he was here we did not yet know how to put them together. Since then I have found how to effect this composition. When I had once discovered the way, it came off pretty well, and at as early as four o'clock in the morning I was at work in my garret. Now the drawing is almost finished. I first made it in charcoal, then worked it over with brush and printer's ink, so there is some pith in it. When you come here, you must see how elaborate the studies are for the figures for the first draft of the sketch. I made them out-of-doors on a sand heap at a nursery. I think when you look at the drawing for a second time, you will find more in it than you did at first. I do want so much to make something stimulating, something that will make one think. I hope that when this is finished you will not mind taking it with you some day to show to the men who handle illustrations, and that it will please them more than my single studies.

Having once again started composition, I intend to go on with it. I was with Van der Weele in Dikker's dune, and there we saw the sand-digging; since then I have been there and had a model

every day, and now the second drawing also has been dashed off. It represents men with wheelbarrows and men who dig. I should like very much to have these reproduced. These two drawings I have had a long time in my heart, but I did not have the money to carry them out, and now through Rappard's money they have taken form. I should like also to draw woodcutting in the wood, and the refuse tipcart with the ash men, and the digging of potatoes in the dunes.

I have made preparations for this by ordering some stretchers and also a large wooden frame. These large compositions involve expense if one is to treat them conscientiously. It must all be done with the model; even if one uses studies, one must still retouch them again from the model. If I could have even more models, I should be able to make the compositions much, much better. So, my boy, the money from you is absolutely indispensable to me until I have found employment. Of what I had today I have to pay out exactly as much as I received.

I have before me two blank sheets for new compositions, and must set to work on them. I shall have to take a model again every day, and struggle hard till I have sketched them in. *Quand bien même*, I shall start, but you must understand that in a few days I shall be again without a penny, and then will follow those terrible eight long days of not being able to do anything but wait, wait for the tenth of the month.

Oh, lad, if we could only find somebody who would buy my drawings! For me, the work is an absolute necessity. I cannot put it off; I don't care for anything else; that is to say, the pleasure in something else ceases at once, and I become melancholy when I cannot go on with my work. I feel then as the weaver does when he sees that his threads have got tangled, the pattern he had on the loom has gone to the deuce, and all his exertion and deliberation are lost.

I have sent some small sketches of both compositions to C. M. I hope that as a result he will perhaps help me to carry out my plan of making a series of drawings of the work in the dunes. Could you not show the sketches to our friend Wisselingh, and tell him

I think they would look well framed in woodwork? At all events, urge him to visit my studio if perchance he comes to The Hague. For if he should find them adapted to this purpose, I can perhaps make an arrangement with him.

Do you recall from your time at The Hague any persons to whom I might show my work? I myself do not, except one, and that is Lantsheer, but for him it must be very very good, for this very reason: as I hope to sell him something later, I should not like to show him anything inferior now. Lantsheer is an uncle or some such relation of Rappard's. Rappard wrote to me once that he had shown him a little sketch of mine, and that he liked it.

This evening Van der Weele has been to see my drawings. His opinion is favourable, and I am very glad of it. I do not think you need be afraid of taking steps towards recommending my work, for it will not be a failure; we will find friends for it. Could you perhaps write a little word to Tersteeg telling him that I have these large drawings on hand?

And know that I long terribly for your coming. I think you will see, brother, that your faithful help and your sacrifices for me have borne some fruit, and will bear more still.

I wish you could meet Rappard again when you come to Holland. I think in his studio, as well as in mine, you will get an impression that reminds one more of what one used to see in the studios than of what one sees at present. I do think his work will interest you. I like it so much, and when I was with him he also said that being with me had done him good.

This morning I was already out-of-doors at four o'clock. I intend to attack the *chiffoniers*, or rather, the attack has begun already. This drawing requires studies of horses, and I made two of them today in the stables of the Rhine Station. That refuse tipcart is a splendid thing, but it's very complicated and difficult, and will cost me a lot of hard work. Very early in the morning I made a few sketches; one that gives an outlook on a sparkling little spot of fresh green will be the best, I think. Everything, even the women in the foreground and the white horse in the background, must stand out against that little bit of green, with a streak of sky

above it. In the tone of the chiaroscuro a group of women and a horse form the lighter parts, and the ash men and the dung-heaps the darker. In the foreground are all kinds of broken and discarded objects, bits of old baskets, a rusty street-lamp, broken pots.

Though I have hardly any money left, I have made arrangement with the models for this new drawing, and with what is left for the moment I shall perhaps get today a Scheveningen bonnet and cape. If I can get hold of that patched cape, lad, I have my woman's figure for the first plane of the drawing of the ash pit; I am sure of it.

Well, Theo, we must keep good courage and try to work ahead energetically. We may be hard up sometimes, and not know how we are to come through, but that cannot be avoided.

This morning I was in an almshouse to see a little woman (with whom I had to arrange about posing); she has brought up thus far two natural children of her daughter, who is a so-called 'kept woman.' I was deeply touched by the devotion of that little grandmother, and it struck me that when an old woman puts her wrinkled hands to such a thing, we men may not keep back ours. I saw the real mother, who dropped in, in untidy torn clothes, with unkempt, undressed hair. And, boy, I thought of the difference there is between the woman with whom I live as she is now and as I found her a year ago, and between the children here and those at the almshouse. Oh, if only one keeps the essentials in mind, it is clear as daylight that it is a good thing to take care of what would otherwise become parched and wither.

But *her* family tries to draw her away from me. The proposition is that she, with her mother, shall keep house for a brother of hers, who has divorced his wife and is rather an infamous scoundrel. The reason they have advised her to leave me is that I earn too little and am not good to her; that I keep her only for posing, but will eventually leave her in the lurch. *Nota bene*, she has hardly been able to pose all this year because of the baby. All these things were secretly talked over behind my back, and at last the woman told me about it. I said to her: 'Do just as you like, but I will never leave you unless you turn back to your former life.' The

worst of it is, Theo, that if we are hard up now and then, they try in that way to upset the woman, and that rascal of a brother tries to drive her back to her former life. Except for the mother, I have not meddled with any of them because I do not trust them. Well, I can only say about the woman that I should think it sensible and loyal of her if she broke off all relations with her family. I myself dissuade her from going there, but if she wants to, I let her go.

I have received a letter from home. It is a very kind one, and was accompanied by a parcel containing a woman's coat, a hat, a packet of cigars, a cake, and some money.

Today I was in the old people's asylum. From the window I sketched an old gardener near a twisted apple tree, and a carpenter's shop of the asylum where I took tea with two old almshouse men. In the men's ward I can come as a visitor; it was indescribably typical. One little fellow, for instance, with a long thin neck in an invalid's chair was capital. That carpenter's shop with a view into the cool green garden, with those two old men, was just the thing — it reminded me of that little picture by Meissonier of those two parsons seated at the table drinking. I have asked permission to make sketches of the women's ward and the garden, but it is not quite certain that I shall get it.

Last winter I saw the old almshouse in Voorburg. It is much smaller, but almost more typical. When I was there it was just at twilight, and the old people were sitting on benches and chairs round an old stove.

How beautiful these little old almshouses are! I cannot find words to describe them. And though Israëls does it in a perfect way, I think it strange that relatively so few have an eye for it. I see at The Hague every day a world which many people pass by, and which is quite different from what most of the painters make of it. And I shouldn't dare say so if I didn't know by experience that even figure painters really pass it by, and if I didn't remember walking with them, and hearing repeatedly when we met some figure that struck me: 'Oh, those are dirty people!' or, 'That kind of people!' — in short, expressions which one would not have expected from a painter. Yes, that often made me wonder; I re-

member among others such a conversation with Henkes, who often
has such a good eye. It seems as if they purposely avoid the most
serious, the most beautiful things; in short, that they voluntarily
muzzle themselves and clip their own wings.

Meanwhile, I have got the Scheveningen cape. It is superb, and
I set to work on it at once. The sketch of the refuse tipcart is
advanced so far that I have caught the sheepfold-like effect of
indoors in contrast to the open air and the light under the gloomy
sheds: and a group of women who empty their ash bins begins to
develop and take shape. But the moving to and fro of the wheel-
barrows, and the ash men with the dung-forks, the rummaging
under the sheds, must still be expressed without losing the effect
of light and brown of the whole; on the contrary, it must be
strengthened by it.

I have been drudging very hard on this drawing; it is a splendid
thing. The first version of it has already undergone many cor-
rections; it has been first white, then black on different spots, so
that I copied it on a second paper, because the first was too much
worn out. And I am working on it anew. I have to get up early in
the morning, for then I get the effects I need. If I could only fix
it as I have it in my mind. I wish I could talk it over with Mauve,
but I hardly know myself what is best. In the first place, painting
is not my principal aim, and perhaps I shall get ready for illustrat-
ing sooner by myself than if somebody who has no interest in il-
lustrating should give me advice about it.

I think you are quite right in what you say about too much
intercourse with painters being no good, but some intercourse
decidedly good. Indeed, one has a deep longing sometimes to talk
things over with people who know about one's craft. Especially if
two people work and search in the same spirit, they can strengthen
and animate each other greatly. One cannot always live away
from one's country; and one's country is not nature alone, but
there must be also human hearts who search for and feel the same
things. Only then the country is perfect and one feels at home.
For that reason I am glad Van der Weele is coming. But with
Rappard I get on best of all.

I was also at Scheveningen one day, and saw a beautiful thing there: men with a cart full of nets that had been spread out on the dunes. My Scheveningen cape is a splendid possession. I hope I can get a fisher's jacket with standing collar and short sleeves, and a woman's bonnet. Scheveningen drawings must be made also, and shortly, too.

The asylum has been a disappointment; they refused me permission to draw there — they said there were no precedents for it, and besides they were having a spring cleaning and new floors were being laid in the wards. Well, never mind; there are more almshouses, but in this one I know a man who has posed for me regularly.

I wrote some time ago: 'I am sitting before two large blank sheets and do not know how I shall get something onto them!' Since then I have made on one the refuse tipcart; and these last days I have also made good progress with the second one; that must represent a coal-heap as I see it from the window of the studio on the grounds of the Rhine Station. There are heaps of coal and men are working in them, and people coming with little wheelbarrows to buy sacks of coal, for which there is a great demand some days. Especially with the snow last winter it was a curious sight. I have been thinking it over a long time, and the sight was so splendid that one evening I made my sketch. I had as model a man who climbed on the coal-heaps and stood in different spots, so that I might see the proportion of the figure in different places.

While making these studies, the plan for a still larger drawing, namely, that of digging potatoes, has begun to take root, and I have it so firmly in mind that I think you will perhaps find something in it. I should like to start that drawing one of these days. I can show you the figures in large studies, and shall choose at leisure a fine potato field and make studies of it for the lines of the landscape. Towards the autumn, when they dig the potatoes, the drawing ought to be finished, and I should only have to put in the finishing touches. The figures ought to be such that the drawing would be true of life everywhere, rather than a study of costume.

Last year I saw the digging here; the year before last I saw it in

Brabant, where it was splendid, and the year before that in the
Borinage, where it was done by miners. So I have it fully and
exactly in mind. The row of diggers must be a row of dark figures,
seen only in the distance, but very elaborate and varied in move-
ment and type; for example, a simple young fellow beside one of
those typical old Scheveningen men, in a white and brown patched
suit with an old top-hat, a dull-black one; a short, sturdy woman's
figure, soberly clad in black, beside a tall grass-mower in white
trousers, light blue coat, and straw hat.

I am working with great animation these days, and compara-
tively speaking, without fatigue, because I feel so interested in the
work. I had long since restrained myself from composition, but a
revolution has taken place in me because the time was ripe for it,
and I breathe more freely now that I have loosened the bonds
which I had put on myself. But after all, I believe it has been a
good thing that I have drudged so long on the studies. I think
this such a fine saying of Mauve, who remarks, notwithstanding
all his work and experience: 'Sometimes I do not know the place
of the joints in a cow.'

Last year about this time I was in the hospital. The painted
studies of last summer are bad, I find; I think of it because I have
just been looking up an old painted study of those coal-heaps, to
see how I did things then. I now think them made too slovenly.
Since then I have concentrated anew on the drawing of the figure,
and think but very indirectly of painting.

It comes to about the same as what I said last year to some who
told me: 'Painting is drawing in colour'; to which I answered:
'Exactly, and drawing in black and white is, in fact, painting in
black and white.' They said: 'Painting is drawing.' I said: 'Draw-
ing is painting,' but I was then too weak in my technique to be
able to say this in anything but words; now I say it less in words,
but more in my work, silently.

I have received a characteristic letter from Rappard. I had told
him about my plan for a large drawing of potato-diggers. Well,
I started it the very same day, simply because Rappard's letter
had stimulated me; and the drawing has absorbed me so that I

worked at it almost all last night. I saw it clearly before me, and wanted to carry it through. It is the strongest drawing I have made as yet. I have approached the manner of some English artists, although without thinking of imitating them — probably because in nature I am attracted by the same kind of things.

You must not be surprised that I have made so many drawings in so short a time; in composing a drawing, almost more than in painting, thought and concentration play a part, and I for one find I get good results by plodding on for a day and half a night, as I did on this one. When one feels so much attracted by the work, one must stick to it till one drops, so to speak.

I always remember the strong impression made upon me by the first picture I saw of Butin (one of his later ones). I think it is called 'The Jetty': women on the lookout for boats that are expected to run in on a stormy night. Since then I have seen the one at the Luxembourg and several others. I find Butin very honest and serious, and I have observed that even when he has apparently drawn with a hasty hand, his drawing remains, *après tout*, no less reasonable and correct. He is one of the men I do not know personally; yet when I see his work I can imagine how he has made it. I hope so much to make my hand more dexterous through all this time of hard work.

I shall sleep little again tonight because of the drawing; it is very cosy smoking a pipe in the night when everything is quiet; and the break of day and the sunrise are wonderful.

It is not yet four o'clock. Last evening there was a thunderstorm, and in the night it rained. It has stopped raining now, but everything is wet and the sky is grey, yet broken here and there by darker or lighter masses of clouds, of neutral tint or yellowish-white, that are moving through the sky. Because of the early hour, the leaves look greyish and in tone; along the wet road a farmer comes in a blue smock, on a brown horse that he has fetched from the meadow.

The city in the background is a grey silhouette, also in tone, in which the wet red roofs stand out strongly. It looks more like a Daubigny than a Corot, through the variety of colour in the

ground and the green, the brightness of everything. There is nothing more beautiful than nature early in the morning.

Have a good time, boy; I also am, relatively speaking, having a good time, except for many financial cares, many worries. But with my work I am in luck: I work with enormous pleasure, and with a firm feeling of being 'on the right track.'

Yes, lad, if one perseveres and works on without minding the rest, if one tries honestly and freely to fathom nature, and does not lose hold of what one has in mind, whatever people may say, one feels calm and firm, and faces the future quietly. Yes, one may make mistakes, one may perhaps exaggerate here or there, but the thing one makes will be original. You have read in Rappard's letter the expression: 'I used to make things now in this, then in that style, without sufficient personality; but these last drawings have at least a character of their own, and I feel that I have found my way.' I feel almost the same thing now.

Your letter was no little welcome. Many thanks. I was very hard up this time; absolutely penniless. The woman has had no milk for nursing the baby these last days, and I too have felt very faint. As a last effort I went in my desperation to Tersteeg. I thought: I have nothing to lose by it; in fact, this may be a way to bring about a better state of affairs. So I went there with a large sketch I had made of a row of diggers, men and women, with a foreground of mounds of earth, and a glimpse of some roofs of a little village in the background.

I said to Tersteeg that I understood perfectly well that this sketch would not mean anything to him, but that I came to show it to him because it was so long since he had seen any of my work, and because I wanted to give a proof that I did not feel any ill-will about what had happened last year. Well, he said that he did not carry any ill-will either; as to the drawing, he had told me last year that I ought to make water-colours and he did not want to speak about it again. Then I told him that I had tried a water-colour now and then and had several of them in my studio, but that I had more heart for another kind of drawing, and felt more and more passion for strongly drawn figures.

He said he was glad to see that I was at least working, and I asked him if there was any reason for him to doubt that I was working. Then a telegram came for him, and I went away. But after all, I do not really know whether he liked the drawing or not. Well, yesterday I worked at it all day again to finish the figures better.

I should not be in the least surprised if he considered it absolutely absurd. But even if he does find it crazy, I think I must not let this upset me, or take his opinion as conclusive. I still think it possible that the time will come when Tersteeg will have another opinion of me, also of my actions now and last year. But I shall leave that to time, and if he persists in finding wrong in all that I do, well, I will take it coolly and go my own way. I told Tersteeg that I longed greatly to be on good terms again with Mauve, but he did not answer a word. I shall be very much astonished if in the long run some people do not change their minds as to my doing or planning absurd things.

I have now made four large studies for the digging of potatoes. I have a man who sticks his fork in the ground (the first movement) a woman's figure in the same action, and another man throwing potatoes into a basket. In this neighbourhood they dig with a short-handled fork, and the digger is kneeling. I imagine a fine thing might be made of these kneeling figures in a flat country, in the evening — something that would have a certain sentiment of devotion. Therefore I studied this scene closely.

Now, about these drawings, Theo: I don't think I shall be able to sell them, but I remember what Israëls said to Van der Weele about the latter's large picture: 'You will certainly not sell it, but that must not discourage you, for it will give you new friends and make you sell other things.'

From C. M. I had no answer to my letter. So you see, Theo, there is very little chance of my selling anything. It was no pleasant thing to go to Tersteeg, I assure you, but I did so thinking: Perhaps he will be inclined to forgive and forget everything, on both sides. But I believe it is still as you described it so well at the time: 'Sometimes he is annoyed by the very way I shake hands with him.'

You have written me from time to time that you found some-
thing in my work, and I think you were not mistaken, that Tersteeg
is not right with his absolute indifference, which borders on hos-
tility. That is the very first thing I value, that you, who from the
beginning have done so much, yes, everything for my work, may
continue to find some good in it. If I can bring this about, I shall
forget all the cares of the whole year.

While I am writing I think of that time — perhaps you remem-
ber it, though it is years ago — when you and I spent an evening
with Mauve when he still lived near the barracks, and gave us a
photograph of a drawing of his — a plough. Little did I then think
that I myself should become a draughtsman; nor did I dream that
difficulties would ever arise between Mauve and me. I always
wonder that they have not resolved themselves, the more so be-
cause really, if one considers it thoroughly, there is hardly any
difference in opinion between us.

However, it is so long ago now that I am beginning to get back
my good spirits with regard to my work, and confidence that it
will come right after all. I have had that before, notwithstanding
all, but involuntarily one gets upset and has a melancholy feeling
when such persons disapprove, or say that one is on a wrong track.

Well, I begin to feel quite at home here now, compared to the
beginning. I have so much to do that it quite absorbs me, and I
am full of ideas and plans. The dislike I had of working with
charcoal lessens every day. One reason for this is that I have
found a way to fix the charcoal and then work over it with printer's
ink. Some day, when I can afford it, I shall make on canvas an
elaborate sketch such as I have now made on paper, and shall try
my hand at painting again. I have a few things in mind that will
do well painted in oil.

Do you know what I long for sometimes? To make a trip to
Brabant. I should love to draw the old churchyard at Neunen,
and the weavers; to spend a month making studies of Brabant, and
come back with a lot of them for a large drawing, for example, of a
peasant funeral.

I hope you will write me in detail about 'Les Cent Chefs-

d'Oeuvre'; it must be gratifying to have seen such a thing. And one thinks how at that time there were persons whose character, intention, and genius were suspect in the public's opinion, persons about whom the most absurd things were told: Millet, Corot, Daubigny, who were regarded as the constable looks at a stray dog or a tramp without a passport; time passes, and *voici 'Les Cent Chefs-d'Oeuvre.'* And, as if a hundred were not enough, we have innumerable *chefs-d'oeuvre.* So what becomes of the constables? Very little remains of them, *except*, for curiosity's sake, a bundle of warrants!

Yes, I think it is a tragedy, the history of great men. They not only meet with constables in their lives, but usually they are dead by the time their work is publicly recognized; and during their lives they are under continuous pressure from the obstacles and difficulties of the struggle for existence. So whenever I hear of the public acknowledgment of the merits of such and such a one, I think the more vividly of the quiet, somewhat sombre figures of those with few friends; in their simplicity I find them *still* greater and more pathetic.

When you come I shall be able to show you a collection that might be called the chief work in wood-engraving of modern artists — a collection such as you will certainly not find everywhere. It represents the work of men whose names are unknown even to most connoisseurs. Who knows Buckmann, the two Greens? Who knows Régamey's drawings? Very few. Seen together, they make one marvel at their firmness of drawing, their personal character, at the serious conception and penetration and finish revealed in the commonest figures and subjects found in the street or the market, in a hospital or an almshouse.

I have worked some more on those potato-diggers. And I have started a second study of the same subject, with a single figure of an old man. Further, I have on hand a sower in a large field. Then I have studies of the burning of weeds, and of a man with a sack of potatoes on his back. When I think of Tersteeg's opinion that I must make water-colours and, supposing I myself am wrong,

try with all my good-will to change my mind, I cannot understand
how these figures of the man with the sack, of the sower, of the
old potato-digger would retain their personal character if I made
them in water-colour.

The result would be very mediocre — that kind of mediocrity
upon which I refuse to embark. There is at all events some charac-
ter in my work, something that — be it from afar — is in harmony
with what Lhermitte, for example, seeks. The secret of Lhermitte
must be no other, I think, than that he has a thorough general
knowledge of the figure — that is, the sturdy, serious workman's
figure — and that he takes his subjects from the very heart of the
people. For him who more especially wants to express the bold-
ness, the vigour, and the largeness of figures, water-colour is not
the most sympathetic means.

It is different when one seeks tone or colour exclusively; then
water-colour is an excellent thing. I must admit that from these
same figures one might make different studies, from the point of
view of tone and colour and with another intention. But the
question is this: If my sentiment and personal feeling draw me in
the very first place towards the character, the structure, the action
of the figures, can one blame me when, following this emotion, I
don't express myself in water-colour, but in a drawing with only
black and brown?

There are water-colours where the outlines are very strongly
expressed, for instance those of Régamey, those of Pinwell, and
Walker, and Herkomer — of which I think very often — those of
the Belgian Meunier; but even if I tried this, Tersteeg would not
be satisfied with them. He would always say: 'It is not salable,
and the salableness must have first place.' I think he means in
plainer terms: 'You are a mediocrity, and you are arrogant because
you don't give in and make little mediocre things: you are making
yourself ridiculous with your so-called "seeking."' I am afraid
Tersteeg will always remain for me 'the Everlasting No.' That is
what not only I, but almost everyone who seeks his own way, has
behind or beside him as an everlasting discourager.

Among the figures of popular types which I have made there

are several that are what many would call decidedly old-fashioned in character, as well as in sentiment; for instance, a digger who looks more like those one sees on the wooden bas-reliefs of the Gothic church pews than like one in a drawing of the present time. Very often I think of Brabant types, how very sympathetic they are to me. I wish I could go once more to Brabant to make some studies in the autumn. I should like to make studies of a Brabant plough, of a weaver, and of that village churchyard at Neunen. But that would all cost money again.

The thing which I should love immensely to make, which I feel I can make, is the figure of Father on a path through the heath; the figure seriously drawn, with character, and a patch of brown heath through which a narrow, white sand path leads, and sky just delicately tinged, yet somewhat passionately brushed. Then Father and Mother arm-in-arm, in an autumn landscape or against a hedge of beeches with withered leaves.

I should also like to draw Father's figure when I draw a peasant's funeral, which I certainly intend to do. Leaving out the difference of religious opinion, the figure of a poor country clergyman is, in type and character, for me one of the most sympathetic I know, and I should not be true to myself if I did not try it some day. What I want to make is a drawing that will not be exactly understood by everyone: the figure essentially simplified, with determinate neglect of those details which do not belong to the real character and are only accidental. For it must not be a portrait of Father, but rather the type of a poor village clergyman who goes to visit the sick. In the same way, the couple arm-in-arm must be the type of a man and a woman who have grown old together in love and faith, rather than the portraits of Father and Mother, though I hope they will pose for it. But they must know that it is a serious thing, which they would perhaps not see if the likeness were not exact.

The simplifying of the figure is a thing which greatly preoccupies me. Speaking about expression in a figure, I am coming more and more to the conclusion that it is to be found not so much in the features as in the whole attitude. There are few things I hate so

much as most of the academical *têtes d'expression*. I prefer to look at the 'Night' by Michelangelo, or a drunkard by Daumier, or even an old horse by Mauve.

I have been thinking lately that it would be well to move to the country, either to the seaside or to some place where the field labour is typical, because I think this would help me to economize. I am making progress with my figures, but in finances I am losing ground, and cannot keep it up. The work costs money, so the harder one works the deeper one gets into debt, instead of the work's helping one through so that the difficulties and expense may be surmounted by working harder.

The advantage here is that my studio is good. And one is not, after all, quite outside the world of art; one can hardly do without hearing and seeing something now and then. I love nature, yet there are many things that bind me to the city, especially the magazines, the possibility of reproduction. Not to see any steam engines would be no hardship to me, but never to see a printing press would be. And if you feel as I do, you have now and then a sudden longing to look up some fellow whom you have not seen for a long time.

This is the way I felt about de Bock. The first thing I saw at his studio was a very large sketch, an enormous windmill covered with snow; half romantic, half realistic — a combination of styles which I don't dislike; but very unfinished, though energetically put down, with a fine, strong effect in it. Then there were some delicately brushed pictures, several pretty studies. Some sketches were riper and more correct in tone and colour than last year, and the backgrounds are firmer, but in my opinion the relative proportions of the plane and masses are always left too vague, lacking that correctness of proportion which is the typical quality of Corot, and Rousseau, Dias, Daubigny, and Dupré. These men all have this in common: they are very careful as to proportion, and their backgrounds are also very expressive, and not so superficial. But there are very good points in de Bock's work, and one would look at it with more pleasure if the things were put down in a less visionary way.

Nor can I understand why he does not vary his subjects a little more; for instance, I have made this week a few landscape studies, one yesterday at the splendid potato field in the dunes behind the lighthouse which de Bock and I found; the day before a spot under the chestnut trees, another of a piece of ground with heaps of coal. It is very seldom that I draw landscapes, but now that I'm doing so I have three different subjects at the same time. De Bock being decidedly a landscape painter, why doesn't *he* do that more, instead of always painting a dune with a small tree and a little beach grass?

On the first of July our little chap was one year old, and he is the merriest, jolliest child you can imagine; I think it is the woman's own salvation that the youngster is doing well and is keeping her busy. For the rest, I sometimes think it would be well for her to live for a time in the country, far from the city and far from the family; it would help to bring about a thorough improvement. She is indeed what one may call an '*enfant du siècle*,' and her character has been so much influenced by circumstances that she will always bear the consequences in the form of a certain discouragement and indifference, and want of a firm faith in something.

I spoke with de Bock about houses in Scheveningen, but I had better not complain about the rent of my studio's being too high. De Bock pays four hundred francs a year, and I pay one hundred and seventy! If I wanted to live near the sea, Scheveningen would be out of the question, and I should have to go to some more remote place — perhaps the Hook of Holland, or Maarken.

I long very much to work on the beach, but I think I'll ask de Bock to let me have a corner of his garret to keep my drawing material in, so that I need not drag it along every time. If one has to walk and to carry everything, one arrives already tired, the work goes slack, and the hand is not very firm; if one did not have to work right away, one would of course not mind that slight fatigue. So that a *pied-à-terre* at de Bock's, and taking the car oftener, would perhaps enable me to make studies of the sea and Scheveningen with more concentration than I have up to now.

Last Sunday I was at Van der Weele's. He was working at a

picture of cows at a creek for which he has some studies. He is
going to the country for some time.

Do you know the Rousseau 'À Lisière de Bois,' in autumn after
the rain, with a glimpse of a wide stretch of swampy meadows, in
which cows are grazing, the foreground quite in tone? To me it is
one of the finest. It is more than nature; it is a kind of revelation.
And it seems to me one must feel complete respect for it, and not
join those who say that it is exaggerated or mere mannerism.

Yesterday appeared Breitner, whom I hadn't in the least ex-
pected. I was very glad, because at the beginning of my stay here
he was very pleasant to go out with — I do not mean in the coun-
try, but in the city — to look for types and curious models. There
is not a single person from The Hague with whom I ever did this.
Most of the painters find the city ugly; yet it is sometimes very
beautiful. Yesterday, for example, I saw in the Noordeinde work-
men busy pulling down that part opposite the palace, fellows all
white with chalk, with wagons and horses. It was cool, windy
weather, the sky was grey, and the spot was very characteristic.

Van der Weele has two rather curious little water-colours of
Breitner's with a certain *chic*, a '*je ne sais quoi*,' or what the English
call 'weird.' Well, we must wait and see what comes of it. Breitner
is intelligent enough, but it is a love of eccentricity that he carries
through. At times I like the work of Hoffmann and Edgar Allan
Poe ('The Fantastic Tales,' 'The Raven'), but this work of
Breitner's is impossible; its fancy is heavy-footed and without
meaning, and has no contact with reality. I think it very ugly.
The portrait of Van der Weele which he had started was bad.

Rappard is away; he wrote to me that after all he was using the
printer's ink as I told him, with turpentine, and that he got on
much better that way.

I don't think it decent of C. M. that he has never written a
syllable in reply to my letter. Neither is it decent of Tersteeg that
he did not come to see me, since on my side I tried to make up.
Mauve has quarrelled not only with me, but with Zilcken.

I am going to have a few drawings photographed. I shall begin
with 'The Sower' and 'The Digger of Peat' — one with many

small figures, the other with one large one. If they turn out well, I can always send you photographs of the drawings I have made, to show someone — perhaps Buhot, to see if he can find a buyer. We must stick to the point with Buhot. I must try to earn some money, so as to be able to start new things, and to try my hand at painting too, for I am just in the mood for it.

Well, de Bock has been to see me. It was rather a pleasant visit; he saw some of the painted studies of last year and liked them, but they please me less and less. I hope to make better ones this year. I hope I shall get on with de Bock a little better now; perhaps it would do neither of us any harm, and we might learn something from each other. I talked it over again with him, and I can leave my things at his house when I go to make studies at Scheveningen. I hope also to go to see Blommers some day soon.

I intend to work principally at Scheveningen for some time, going there early in the morning and staying all day, or, if I must be at home, to be at home at noon when it's too hot, and in the evening. I trust this will give me new ideas and a rest, not through idleness, but through a change of surroundings and occupation.

I have put my painting materials in order, as far as I could, have added what was needed, and have laid in a supply of tramway tickets. I am already penniless through these expenses, which were absolutely essential. As soon as I have looked around a little at Scheveningen, I shall take the woman with me now and then to pose, or at least to indicate the place and the size of the figures. I have a model, a peasant boy to whom I spoke about the painting of studies. He can manage to go with me very early in the morning, quite far into the dunes, if need be.

Last evening I received a present which pleased me enormously from the two land surveyors (for a second one has arrived since I last wrote you) — a typical Scheveningen jacket with standing collar, picturesque, faded, and patched. They are jolly, merry fellows.

The father of the first land surveyor deals in colours; he has Paillard's colours in stock, and has Mauve for a customer. For my lessons to the son I never got anything but many assurances

of good-will from the father; availing myself of these, I said to him
that undoubtedly he had some old tubes of paint in stock. I offered
to purchase them at net price Paillard if in future he would sell
me new tubes at the same price, that is, with a discount of one
third. He looked over his stock and we made the arrangement.
I get this reduction not only on oil paints, but on water-colours.
I am glad of it, because in this way it will be less difficult for me
to continue my painting.

I received your letter, and I cannot repress a feeling of sadness
at your saying: 'I can give you little hope for the future.'

If you mean this only as regards finances, I don't mind it so
much. You will remember that you wrote to me a month ago that
the times were bad, and my answer was: 'All right, the more reason
to try our utmost from both sides; you to try to send me the strictly
necessary, and I will do my utmost to make progress, so that per-
haps we can sell something to the magazines.' Since then I have
started several larger compositions, which had more of a subject
than the single-figure studies.

But if you mean this as regards my work, I do not understand
why I deserve it. I do not know what you mean by that expression;
how can I know? It hit me unexpectedly, right in the heart. I
should like to know whether or not you have seen that I wasn't
making progress. Evidently my first sending of photographs for
you to show to artists has to do with your saying, 'I can give you
little hope for the future.' Has anything happened?

It wouldn't make me so melancholy, brother, if you had not
added something that worries me. You say: 'Let us hope for
better times.' You see, that is one of those things one must be
careful of, it seems to me. To hope for better times must not be a
feeling, but an *action* in the present. For the very reason that I
felt strongly the hope for better times, I threw myself with all my
strength into the work of the present, without thinking about the
future, other than trusting that the work would find its wages.

At Scheveningen I have been working on 'Mending of Nets'
(Scheveningen fisherwomen). And there are two other large
compositions of labourers in the dunes, which, though they demand

hard work, are nevertheless the things I should most like to finish: long rows of diggers — poor people employed by the municipality — before a patch of sandy ground which must be dug. It is terribly difficult to execute.

When the question of going to Scheveningen to paint came up, I thought: All right, let's carry it through. But now I could almost wish I had not started it, lad, for the expenses are heavy and I cannot meet them. And yet I love painting so!

When you were here last summer you gave me money to lay in the necessary supplies, and I set to work. After some time you wrote that you expected some money to come in, and that when it did the colours and the painting box would be forthcoming. But this was not to be, for since that time you yourself have had some bad luck. However, in the beginning of the winter I received some extra money. Still, there was Leurs to pay off again. I had continued painting through those autumn days, even when it was stormy at Scheveningen; but winter was at the door, and I was afraid of running up new expenses, as there was more to pay for coal. So I took to models again; and since then I feel I have made progress in the figure.

But while making these figure studies, it was absolutely impossible to buy colours or make water-colours. Sometimes I tried to manage it when there was the least chance of doing so. I borrowed money from Rappard; I had an extra remittance from Father. But I was like the beetle that is bound to a thread and can crawl a little way, but is inevitably halted; so I have not always been able to do what was, and is, in my heart. What I have just started, what is really necessary more than anything else, is the painting of figure studies; but I don't see how I can afford it.

The weeks passed by, many, many weeks and months of late when the expenses every time were heavier than I could manage, with all my worrying and economizing, and however much I might rack my brains. As soon as your money arrives, not only must I manage to live ten days on it, but I have so many things to pay for at once that little will be left for the ten days that are ahead. Also the woman has to nurse the baby, and it often happens

that she has no milk for it. I also at times have to sit in the dunes or somewhere else with a faint feeling in my stomach because I can't get enough to eat; at such times the path through the dunes takes on the aspect of a desert. The shoes of the whole family are patched and worn out, and there are many more such small miseries which give one wrinkles.

Well, I should not care, Theo, if I could only stick to the thought that things will come out all right. But now that saying of yours is for me like 'the straw that broke the camel's back.'

What am I to do? I saw Blommers twice at Scheveningen and spoke to him, and he saw a few of my things and asked me to come to see him. I made a few painted studies there, a bit of the sea, a field with menders of nets, and, here in the studio, a fellow in the potato field planting cabbage in the empty spots between the potato plants; and I have on hand the large drawing of the mending of nets. While I was at it, some things of last year caught my fancy again, and as a result I have some other painted studies hanging in the studio. I long tremendously to *paint* the potato-diggers. It is exactly the right time now. I think it would be a good thing, and I have already made a few studies for it, but I have not been able to get enough models. If I could go on as I liked, autumn would not pass without my making those potato-diggers. And the sea, which I love, must be brushed in oil, otherwise one cannot get at it.

But I feel my ardour vanishing; one needs a stronghold somewhere. When you say, 'Put your hope in the future,' it sounds to me as if you yourself had no confidence in me. Is it so? I have no other friend but you, and whenever I am low in spirits I always think of you.

Theo, if when in the first place you spoke to me about painting we could have foreseen my work of today, should we have hesitated in deciding that I ought to become a painter — or draughtsman — what's the difference? I do not think we should have hesitated if we could have foreseen those photographs, for instance, should we? For surely it needs a painter's hand and eye to create such a scene in the dunes

It often happens that I feel so downhearted when people are hostile and indifferent that I lose all courage. Then I cheer up again, and go back to my work and laugh at it. And because I work in the present and let no day pass by without working, I believe that there is indeed hope for me in the future, though I do not *feel* it, for I tell you there is no space left in my brain to philosophize about the future, either to upset or to comfort myself. To stick to the present and not let it pass without drawing some profit from it, that's what I think duty is. Do you also try to stick to the present in regard to me, and let us persevere as far as we can persevere rather today than tomorrow.

A thing that has given me a great deal of courage lately is that though previously I had not painted for several months, the *painted* studies of today show progress, compared with those of last year. At that time I repeatedly tried to paint figure studies, but they turned out so badly that it made me desperate. Now I have begun it again, and there is nothing to keep me from carrying it out, because questions of drawing and proportion, which then gave me a lot of trouble, have now been mastered; as a result, when sitting before nature, instead of having to think of two things at once, drawing and painting, I have to think only of painting.

You say that the effect of the photographs is somewhat meagre. I am not in the least surprised when I think how a man's physique influences his work. Really, Theo, for the sake of the work we ought to have dined a little better, but I could not afford it, and it will remain so if some way or other I cannot breathe a little more freely. I think the drawings from which the photographs are taken not yet deep enough in tone; they do not express well enough the emotion stirred by nature; but if you compare them with what I made in the beginning, I think I am not mistaken in seeing progress.

I do not approve, Theo, of spending more than one receives, but when it is a question of strike or work on, I vote for working on to the utmost. Millet and other of my predecessors have worked on till the sheriff seized them; some have been in prison, or have had to move hither and thither, but I do not know that any one of them

has given up his work. And I am only at the beginning, but I see failure from afar as a dark shadow, and sometimes it makes my work gloomy.

Yes, Theo, you need not spare me if it is only a question of money; if as a friend and brother you keep a little sympathy for the work, salable or unsalable. If only I may keep your sympathy in this respect, I care very little for the rest, and we must calmly and deliberately find ways and means. In case of there being hope for the future as to the finances, I should propose to move to some village quite in the country, saving half the house rent; for the money one spends here on bad food we should have good and healthy food, necessary for the woman and the children, in fact for me too. Perhaps it would at the same time have advantages for getting models also.

I sometimes think of going to England. In London they publish a new magazine of importance, equal to the 'London News' and 'Graphic' — the 'Pictorial News.' Perhaps there I could find work and wages. I think I could learn a great deal in London if I came in contact with some artists there; and what beautiful things one could make at those dockyards on the Thames!

I have hung several of the studies I painted last summer, because while making new ones it struck me there was something in them after all. Indirectly that painting helped me in my drawing during the winter months and spring, and I carried this on as far as these last drawings. Now, however, I feel that it would be good to paint for a time. I intended to paint in rather large size the women sitting in the grass mending nets, but I shall give it up till I have seen you. I feel upset, and in doubt if I dare go on because of the expenses it entails. For the moment I have made seven water-colours of the summer landscape.

I am continually planning to make a large picture of the potato-diggers, though it might not be finished until next year, and but half finished this season. When Van der Weele comes back to town I hope to see much of him. I hear he got the silver medal at Amsterdam for his picture, 'The Loaders of Sand.' I believe those potato-diggers will take his fancy, and perhaps he would give me

some useful hints for the execution of my plan. But I know that I shall have to make many studies, and they will give me more trouble than the drawings; therefore much painting must be done this year, and then more light will come. Oh, Theo, I could make so much more progress if I could spend a little more. But I can't find the way out.

It may be feverishness, or nerves, or something else — I don't know — but I don't feel well. I think of that expression in your letter in regard to different things — I hope more than is necessary. And I have an uneasy feeling. Last night it kept me from sleep.

Early this morning it suddenly seemed as though all my troubles had crowded together to overwhelm me. I had to pay right and left, landlord, paint dealer, baker, grocer, Heaven knows who, and but little is left. But the worst of it is that after many such weeks one feels one's power of resistance diminishing, and is overcome by a great feeling of weariness. In such moments one would like to be made of iron, and regrets that one is only flesh and blood.

It became too much for me, because I could no longer look clearly into the future. I cannot say it in words, and I cannot understand why I should not succeed with my work. I have put all my heart into it, and for a moment at least that seemed to me a mistake.

But, lad, to what things in practical life shall one devote one's strength and thought and energy? One must take one's chance and say: I will do a certain thing and carry it through. Well, and then it may turn out wrong, and one may feel shut in as by a wall when people do not care for it; but after all, one need not mind that, need one?

And then I felt sorry that I had not fallen ill and died in the Borinage, instead of taking to painting. For I am only a burden to you; yet I cannot help it, for to become a good painter one must pass many periods, and what one makes in the meantime will not be entirely bad if one tries one's utmost; but there should be people who consider one's effort in its connection, tendency, and aim, and who do not ask the impossible.

Things are looking dark just now. If it were for me alone! But there is also the thought of the woman and the children, poor creatures whom one would keep safe, and feels responsible for. With them I cannot speak about it, but for myself it became too much today. Work is the only remedy; if that does not help, one breaks down.

You have the photographs now, and with those before you will be better able to imagine my state of mind. The drawings I make now are only a shadow of my intentions, but a shadow which has got a definite shape already; and what I see, what I aim at, is not vague but utterly real; it can only be achieved by patient and regular work. The idea that I should have to work by fits and starts is a nightmare to me. To work with as little money as possible is right, I think, but the thought of being left absolutely without the strictly necessary would make anybody melancholy.

The trouble is that the possibility of working depends on selling the work. When one does not sell, and one has no other income, it is impossible to make progress that otherwise would follow of its own accord.

I have an anxious and restless feeling. Shall I be able to go on? Well, I'm going to take a long walk to try to shake it off.

Oh, Theo, the work brings its troubles and cares, but what is it in comparison to the misery of a life without activity? So let us not lose courage, but comfort each other instead of distressing or disheartening one another.

I have spoken to Blommers about my painting, and he wants me to keep it up. I feel also that having finished those last ten or twelve drawings, I have now come to a point where I must change my course, instead of making more things in the same way.

Depression is the first thing to be conquered, that it may not become a chronic disease. I have been thinking of ways and means of overcoming it, but see no other way than to renew my energy and also my physical strength, for I am afraid it goes the wrong way. I need money badly, and must repair both my health and my painting box, otherwise I am afraid things will come to light afterwards that will be more difficult to remedy.

I could show you a like moment of depression in the history of many a one who has totally conquered it. Almost all the fellows who passed through the École de Rome and who have been drudging assiduously for a time on the figure, show at the end of the course relatively clever, relatively quite correctly drawn things which, however, are not pleasant to look at because there is something of '*une âme en peine*' in them — which they lose afterwards as soon as they can move and breathe a little more freely. Without being under the constraint of a definite course, and only for the sake of perfecting my drawing, I have forced myself to study the figure with assiduity, and through that very strain, by overworking myself, I have drifted into this depression.

Taking a rest is out of the question, so I keep at my work as best I can. Your idea of acting as Weissenbruch does is also mine. However, literally I simply cannot carry it out, because to go for two weeks to the polders would cost me more than to stay at home for two weeks, and I do not even know how to struggle through those two weeks at home. But I think it a good thing to find distraction in change of subjects and style. After these figure studies, I feel the need of looking at the sea, the bronzed potato foliage, the stubble fields, or ploughed earth; but the figure always draws me back.

These last days I have still been trying to paint several studies so that you may see them. The last-painted studies seem to me firmer and more solid in colour. So, for instance, a few I made in the rain of a man in a wet, muddy road express the sentiment better. Most of them are impressions of landscape — there is something in them, I think.

While painting I have felt of late a certain power of colour awakening in me, stronger and different from what I have felt before. It may be that my present nervousness has to do with a kind of revolution in my method of working for which I have been seeking, and of which I have been thinking for a long time.

I have often tried to work less dryly, but it has always turned out the same way, over and over again. Now that I let myself go a little and look more through the eyelashes, instead of looking at

the joints and analyzing the structure of things, it leads me more directly to seeing things like patches of colour against each other.

You have with you a painted study of last year, of a few tree-trunks in the forest. I do not think it is really bad, but it is not what one sees in the studies of the colourists. Some colours are correct, but though they are correct they do not give the effect they ought to give; and though the paint is here and there laid on thickly, the effect is too meagre. I take this study as an example. Now, I think that the ones which I have just finished, which are less thickly laid on, have become more solid in colour as the colours are more interwoven; and the strokes of the brush cover one another, so that the result is mellower and more like the downiness of the clouds or of the grass.

I wonder what this will lead to, and how it will develop. I have sometimes wondered that I was not more of a colourist, because my temperament seems decidedly to indicate it — but this has developed very little. Now I see clearly that my most recent painted studies are different. I am eager for you to see them, for if you also saw a change coming, I should not doubt but we were on the right track. I dare not trust my eyes as regards my own work.

These two new studies, for example, which I made while it was raining: when I look at them I find coming back the sentiment of that dreary rainy day, and in the figure, though it is nothing but a few patches of colour, is a kind of life that is not called forth by correctness of drawing — for there is, so to speak, no drawing. What I mean to suggest is that in these studies there is something of that mysteriousness one gets by looking at nature through the eyelashes, as outlines are simplified to blots of colour.

Only time can tell, but at present I see something different in colour and tone.

Well, I hope that perhaps a certain frenzy and rage of work may carry me through, as a boat is sometimes thundered by a wave over a cliff or sand bank, and profits by a thunderstorm to save itself from being wrecked. After all, if I fail, for what is lost in me I don't care so much. But in general one seeks to make one's life bear fruit rather than let it wither.

You must try to come soon, brother, for I do not know how long I shall be able to hold out. Things are getting too much for me, and I feel my strength failing. As long as I am busy I don't feel the weakness so much, but in the intervals when I am not before my easel, it overtakes me now and then. It is a kind of dizziness sometimes, and headache, too. It is not normal that I should be tired when I have walked only a little distance, as from here to the post office; yet that is actually the case. Oh, I don't give in, of course, but I must try to get new strength. My constitution would be sound enough if I had not to fast so long, but I have had continually to choose between fasting and working less, and so far as possible I have chosen the former.

You must not speak to others about this, Theo, for if certain persons knew it they would say: 'Oh, of course; that's what we foresaw and foretold long ago.' And not only would they not help me, but they would cut off all possibility of my patiently regaining my strength and getting back on my feet. I assure you that it is nothing but a prostration from overwork and too little nourishment; but some people who have spoken about me as though I had some kind of disease would start doing so again, and that is a slander of the worst kind.

Coming home from Scheveningen just now, I find your letter. Many things in it please me. In the first place, I am glad that the darkness of the future cannot change our friendship or interfere with it; further, I am glad that you find progress in my work. The division of your income, directly and indirectly, between no less than six persons is certainly remarkable. But the subdivision of my one hundred and fifty francs among four human beings, with all the expenses for models and drawing and painting materials is also rather remarkable, isn't it?

I am at my wits' end. This morning there came a man who three weeks ago had repaired a lamp for me, and from whom I bought at the same time some crockery which he forced upon me. He came to make a row because I had just paid his neighbour and not him, and accompanied it with the necessary cursing, noise, and

invectives. I told him that I should pay him as soon as I received money, but that for the moment I was absolutely without any. I begged him to leave the house, and at last I pushed him outside the door, but he, perhaps having waited for this, seized me by the neck, and threw me against the wall and then full length on the floor.

Now, you see, this is the kind of petty misery one has to face. Such a fellow is stronger than I, of course — he is not afraid. All the small tradesmen one has to deal with are of that same kind. They come of their own accord, but if unluckily the payment has to be put off for more than a week, they make a row. Well, what can one expect? They are sometimes hard up themselves.

I am harassed, brother; life is impossible here because of just that little that is lacking. I am afraid I shall have to give it up Circumstances have been too much for me of late, and my plan to regain former friends by working assiduously and sensibly has fallen to pieces. What I told you about my feeling rather weak is true. It has settled into a pain between the shoulders, and in the veins, which I used to have at times; I know from experience one ought to be careful then, otherwise one cannot get over it so easily; and I have palpitations of the heart too. I am afraid that the heart will finally prove to be affected. Well, I do not know much about it. I am not competent to distinguish in how far my illness has a physical cause or is only the consequence of overstrained nerves.

Involuntarily I add a thought that often occurs to me. Not only did I begin drawing relatively late in life, but it may also be that I shall not live for so very many years to come. It is in the nature of things that I cannot possibly know anything definite about it, but in comparison with different persons whose lives one may happen to know about, or with whom one is supposed to have many things in common, one can draw some conclusions that are not altogether without foundation.

Therefore, as to the time I have still before me in which I can work, I think I may assume without rashness that my body will keep a certain number of years — say, between six and ten. This is the period on which I am counting; for the rest, it would be pure

speculation to attempt to be definite; for much depends on the, let us say, first ten years. If one wears oneself out in those years, one will not pass forty.

I do *not* intend to spare myself, nor to avoid emotions or difficulties. I don't care much whether I live a longer or a shorter time; besides, I am not competent to care for my physique as a physician can.

When I wrote to Rappard that I did not believe my only aim in life could be to preserve my health, I meant that there are circumstances when one has to choose between working and eating. I prefer the former, and I do not think I am wrong, for our work remains, but we do not, and the principal thing is to create. And I said to Rappard then that I thought there was truth in the mysterious saying: 'Whosoever will save his life shall lose it, but whosoever will lose his life for my sake shall find it.'

Thus I go on knowing this one thing: '*In a few years I must finish a certain work.*' I need not hurry myself unduly; there is no good in that. But I must work on in full calmness and serenity, as regularly and concentratedly as possible, as briefly and concisely as possible. The world concerns me only in so far as I feel a certain debt and duty towards it, because I have walked on that earth for thirty years, and out of gratitude want to leave some souvenir in the shape of drawings or pictures, not made to please a certain tendency in art, but to express a sincere human feeling. So this work is the aim — and through concentration upon that one idea, everything one does is simplified. Now the work goes slowly — a reason the more to lose no time.

It is in this way that I regard myself: if I live longer, *tant mieux;* but I do not count on it.

Theo, there is one thing we must settle. I do not mean that it will happen at once, but the days may become gloomier still. My studies and all the work that is in the studio are decidedly your property. It might happen, for instance, because of my not paying my taxes that they would sell my things; in that case I should like to get my work safely out of the house — my studies, which I need for my later work, things which have cost me a lot of trouble to

make. In this street there has not until now been a single one who pays taxes, though they are all put down for different sums. So am I, and twice the tax-valuers have come to the house, but I showed them my four kitchen chairs and rough deal table. I told them that I had no *articles de luxe*, but children in the house. Since then they have left me alone.

I wish I knew where to store my studies. I always feel a certain hope that when you come to the studio you will find things that may be to somebody's liking, though they may have no fixed market value. At de Bock's I left two small marines, one with a stormy sea, one with a calm one. I should love to go on with that kind of thing; I ought to be able to work at it with all my might. This morning's incident gave me a clear hint that it is my *duty* to find a way, and to go and live in a smaller house in the country. On the other hand, the sea is a thing one does not find everywhere.

Adieu, lad; I am rather in the dumps. You see from what I tell you about my skirmish of this morning that people use very little consideration towards me. If one wore a top-hat and the like, they would probably keep more at a distance. One has after all a feeling of self-respect, and such things are not pleasant. I should see the future less darkly if I were less awkward in dealing with people.

I tell you frankly that of all the ideas about art which I picked up in that period at Goupil's — though my taste has not changed — very few have stood the test of practice. Things are not made as the art dealer thinks they are, and the life of painters is different; the study is different.

I must go on with my work. It is not a matter of losing courage, but of having spent more strength than there was to spare. Taken all in all, the principal thing is that a good understanding shall remain between us and that we shall keep our friendship warm. If ill luck comes, we'll brave it; but, brother, let us keep faithfully together. I am the one who wins, for without you I should not have been able to get as far as I am now. You don't win anything by it, except the feeling of helping somebody to a career who would otherwise have been without one. And who knows what we may accomplish together afterwards?

You write about the conflict one feels sometimes regarding the question whether one is responsible for the unlucky results of a good action, if it would not be better to act in a way one knows to be wrong, knowing at the same time that one will come off unhurt. I know that conflict too. If we follow our conscience — conscience is for me the highest reason, the reason in the reason — we are tempted to think we have acted wrongly or foolishly when more superficial people jeer at us, because they are so much wiser and more successful. Yes, it is sometimes difficult, and when circum stances occur which make difficulties rise to an overflowing tide, one is almost sorry to be as one is, and would wish to have been less conscientious.

When I am at work I feel an unlimited faith in art, and am sure I shall succeed, but in days of physical prostration I feel that faith diminishing, and a doubt overwhelms me which I try to conquer by setting to work again at once. It is the same thing with the woman and the children; when I am with them, and the little chap comes creeping towards me on all fours, crowing for joy, I have not the slightest doubt but that everything is right. How often has that child comforted me! When I am at home he can't leave me alone for a moment; when I am at work he pulls at my coat or climbs up against my leg till I take him on my lap. The child is always happy. If he keeps this temper all his life, he will be cleverer than I am.

What shall we say as to the fact that there are times when one feels there is a certain fatality that makes the good turn out wrong, and the bad turn out well? I think one may consider such thoughts as partly a consequence of overwrought nerves, and if one has them, one must not think it one's duty to believe that things are really as gloomy as one supposes; if one did so, it would make one mad. On the contrary, it is better to strengthen one's physique, and afterwards to set to work like a man, and consider that melancholy as a fatal thing. One must always continue to use these two means. In the long run one will then feel one's energy increasing and will bear up against troubles. Mysteries remain, sorrow or melancholy remain, but that everlasting negative is balanced by

the positive work which is thus after all achieved. If life were as simple and things as little complicated as Goody Goody's story, or the hackneyed sermon of the average clergyman, it would not be so very difficult to make one's way. But it is not so, and things are infinitely more complicated, and right and wrong do not stand separately, any more than black and white do in nature.

One must take care not to fall back upon opaque, black, deliberate wrong, and still more one must avoid white as of a whitewashed wall, which means hypocrisy and everlasting pharisaism. He who tries to follow reason and to keep honest can scarcely lose his way altogether, I think, though he will not get off without mistakes, blunders, and failures, and will not reach perfection. And I think it will give him a deep feeling of pity and benevolence broader than the narrow-mindedness which is a special quality of clergymen.

One may be counted among the mediocrities and feel oneself thoroughly an ordinary man among ordinary people, yet in the end one will obtain after all a rather steady serenity. One will succeed in raising one's conscience to a state of development so that it becomes the voice of a better and higher self, of which the ordinary self is the servant. And one will not return to scepticism or cynicism, and not belong to the foul mockers.

One sees the same thing in Jesus too, who first was an ordinary carpenter and raised himself to something else, whatever it may have been, a personality so full of pity, love, goodness, seriousness that one is still attracted by it. Generally, a carpenter's apprentice becomes a master carpenter, narrow-minded, dry, miserly, vain; whatever may be said of Jesus, he had another conception of things than my friend the carpenter of the back yard, who has raised himself to house-owner, and yet is much more vain and thinks more of himself than Jesus did.

What I want to do first is to renew my strength. I wish I could bring it so far that I had plenty of health and strength, which is after all not impossible when one is much out-of-doors and has a work that one loves; and I think when my strength has returned, I shall get new ideas for my work, and for overcoming its dryness.

For it is a fact that all my work is too meagre and too dry. That has become as clear as daylight to me, and I don't doubt in the least that a thorough general change is necessary.

If London were nearer, I should try it there. Somewhere there must be work to do which I can do just as well as anybody else.

Yesterday and the day before I strolled about in the neighbourhood of Loosduinen. I walked from the village to the beach, and found there lots of cornfields; they are not so beautiful as those in Brabant, but there must be mowers, sowers, and gleaners, all those elements that I have missed this year.

I had never been there before. On the beach there were some fences or moles, piers, jetties, and very picturesque ones too, made of weather-beaten stones and twisted branches. I sat down on one of them to paint the rising tide, till it came so near me that I had to rush away with my things.

The dunes around The Hague and Scheveningen have lost much of their typical character in the last ten years, and have got another and more frivolous aspect more and more each year. Going back not only ten, but thirty, even fifty years, one comes to the period when artists began to paint the dunes in their real aspect. At that time things were more Ruysdael-like than now. If one wants to see things of a Daubigny, a Corot sentiment, one must go farther, where the soil is untrodden by bathing guests. Undoubtedly Scheveningen is very beautiful, but nature is no longer virginal there; but that same virginity of nature struck me enormously during my walk near Loosduinen.

Rarely of late has silence, has nature alone impressed me in such a way. The very spots where nothing is left of what one calls civilization, where all that is completely left behind, are the ones needed to calm one down.

I found these surroundings full of a strong, stimulating power. When you come it will be fun to go there together, with nothing of civilization around us — only a poor rickety shell cart on the white road, and for the rest, shrubs. I think if we were together there it would get you and me into such a mood that we should

not hesitate about the work, but should feel firmly decided about
what we have to do.

Was it a casual harmony of my rather gloomy mood with those
surroundings, or shall I find the same impressions there in future?
I do not know, but when I feel the need to forget the present and
to think of the time when the great revolution in art began, of
which Millet, Daubigny, Breton, Troyon, Corot are the leaders,
I shall go there again.

Coming home just now, the very first thing I want to do is to
beg a favour of you — which will show you that my intentions are
the same as yours. It is, not to hurry me in the several things we
cannot settle at once, for I need some time to decide. Between
you and me there is a bond, that is, art, and I hope we shall in spite
of everything continue to understand each other. And let us not
forget that we have known each other from childhood, and that
thousands of other things can bring us more and more together.

I am awfully sorry that I am a burden to you; perhaps things
will clear up, but if the situation is too much for you, tell me so
plainly; I should rather give up everything than put too heavy a
burden on your shoulders. If that is the case I will go to work at
once at *n'importe quoi*, be it even carrying parcels, and will leave
art till better times, at least painting and having a studio. Let the
friendship remain, even though you may help me less in money
matters. I will grumble now and then — but it will be without
mental reservation, and more to give vent to my feelings than to
expect you to do everything, which you know I should not do, lad!

I am afraid I have said something to you about the work which
I ought to have said differently, and I have a vague feeling of
having hurt you, because when you left there seemed to be some-
thing amiss.

Dear brother, don't think of me in any other way than as an
ordinary painter who stands before ordinary difficulties, and do
not consider it as anything unusual if there are troubles. Don't
think of the future as a blackness nor as a dazzling light — it will
be better to trust in the grey.

As to my work, what has become clearer and clearer to me since I began to notice it is the dryness of execution. I have also seen only too clearly of late that my physical condition is a factor therein. The fault is so continuous, and it is so urgent to correct it, that we must try to take such measures as will bring us tranquillity. That must be the first thing. Of one thing I hope you will be convinced; that it is impossible to do more than stint oneself in food, clothes, every comfort, every necessity. When one has skimped in everything, there can be no question of ill-will, can there? And though I stick to my conviction that the work demands more, and also that I ought to be able to spend a little more on food and other necessities, yet if I must do with less, be it so. After all, my life is perhaps not worth the money; why should I worry about it?

As to my clothes, I wear what has been given me; I have worn clothes from Father and from you which sometimes do not fit as they ought, because of the difference in our sizes. I will remain content with what I have if you will drop the question of defects in my dress, though of course in after-times I hope to remind you of it and say: 'Theo, do you remember the time when I walked about in a long parson's coat of Father's?' It seems to me that it is infinitely better to take things as they are, and afterwards, when we shall have made our way, to laugh about it together, rather than to quarrel about it now.

The only thing I want you not to doubt is my good-will, my zeal. I want you to grant me some common sense, and not suspect me of doing absurd things, and to let me live on quietly in my own way. I wish I had Mauve or Herkomer as a friend. However, that is not the most important thing; nor would they consider it so. By working ahead faithfully, sooner or later one will meet among the painters a friend for life. And perhaps it will come sooner if one works on quietly than if one begs for it, or visits people — which for me has the lesser chance of success because of eccentricities in me, which you notice even more than I, though I notice them myself too now and then; but I do not think them so bad as not to be astonished at finding people unsympathetic.

And now I will tell you once more what I think about selling my work. My opinion is that the best thing would be to work on till amateurs feel drawn to it of their own accord. I am so afraid that any steps I might take to introduce myself would do more harm than good. It is so painful to me to speak to other people. I am not afraid of it, but I know I make an unfavourable impression, and I wish I could avoid it.

My notion of earning money is as simple as can be; it is that it must come through the work. Let me go on as I have till now, if possible. If not, and if you want me to go and see people with my work, I shall not refuse to do so. But, brother dear, the human brain cannot bear everything; there is a limit. Look at Rappard, who got brain fever, and had to travel as far as Germany to recover. It makes me more nervous than is good for me to try to talk with people about my work. And what is the result? A refusal, or being put off with fair promises. I assure you I feel less energy for my work when I have been among people. If we do not lose time now by that kind of thing, we'll make slow but sure progress.

More and more it seems to me that the most practical and direct way is not to look too far or aspire too high. When I think of London, that is an animating thought, but the question is only: Is it *now* to be done? Is *this* the right moment? Is it not better, in fact, to say frankly to myself: You have not matured enough; what you mean is not yet comprehensible enough to others; they are more or less frightened by it. Go on still, work faithfully and firmly after nature; seek it once more on the heath or in the dunes.

As to my work, I do not hesitate. All my ideas are so well ordered, so decided, that I think you will do well to accept what I say; my drawings will become good, even if we continue as we have till now. You must not let yourself be deceived about my real character by my conduct when I left Goupil's. If business had then been for me what art is now, I should have acted more firmly. But I was in doubt then whether it was my career or not, and I was more passive. When they said to me: 'Hadn't you better go?' I replied: 'You think I had better go, so I go' -– no more. I have already told you that discretion is not always under-

stood. I do not doubt that my work has its faults, but neither do I doubt that I am not quite wrong, and that I shall succeed, be it only after long seeking. And I do believe that it is dangerous to look for success elsewhere.

I think there is a difference between art appreciation today and that of earlier years. There used to be more passion both in the making and in the judging of works of art. This or that work was chosen deliberately; one side or the other was energetically taken. There was more animation. Now I think there is a spirit of capriciousness and satiety; people are in general more lax. Some time ago I wrote that I had noticed there was since Millet a marked decline, as though the summit had been reached and decadence had begun. This has its influence on everybody and everything.

If I were only a little more advanced, so that my work were more salable, I should certainly say: 'I leave the business part to you; I will not have anything to do with the selling. I will live quite outside that circle.' But, alas, I cannot speak as yet. That is not your fault, but for both our sakes, and for the sake of peace, I beg you to have patience; not to give up before the end, not to doubt. If we stick to that, I do not know to what extent we shall have financial success, but of one thing I feel sure: we shall live always in unison and in harmony; sometimes not selling anything and having hard times, but at other times selling and living more comfortably.

There is one step which seems sensible to me, precisely because of its simplicity; that is for me to go and live more cheaply somewhere in the country, where the scenery is characteristic.

I am now once more quite absorbed in my work. Do what you can for me; think for yourself what can be of use to us and hasten our success. I do not doubt of your good-will and your friendship.

I am anxious to know whether Father or you sympathize with my feelings about staying with the woman. I wish that instead of sending her back to the street we might respond to her promise to better herself, by a genuine pardoning and forgetting. It is better that she be saved than that she be ruined.

This morning she said to me: 'As to what I did formerly, I do

not even think of it, and have not spoken of it to Mother either; I only know that if I have to go I shall not earn enough, especially as I shall have to pay board for the children, and if in that case I walk the street, it will be because I must, not because I want to.' I made her promise several things, that she would be more orderly, more zealous, pose better, not go to her mother. When I did so I said to her: 'In three ways it is a kind of prostitution when you go there; in the first place because you used to live with your mother, and she herself set you on to walk the street; secondly, because she lives in a very low neighbourhood, which you more than any-one else have reason to avoid; and finally your brother's mistress lives in the same house.'

And now I have completely forgiven and forgotten, without hidden thoughts, and shall take her part just as I did before. I feel a pity in my heart so strong that everything gives way before it; I cannot act otherwise than as I did last year in the hospital, and I say to her now as I said then: As long as I have a crust of bread and a roof above me, it is yours. It was not passion then, it is not passion now; it is understanding each other's wants as vital facts.

Theo, as things are with her she does improve, but one has to assure her over and over again, and she can make one discouraged. But when — as rarely happens — she tries to say what she means and thinks, it is wonderful how pure she is, notwithstanding her prostitution. It is as though, far deep in the ruin of her soul, and heart, and her mind, something had been saved. In those rare moments her expression is like that of a 'Mater Dolorosa' by Delacroix, or like certain heads by Ary Scheffer. That is what I believe in, and now that I have seen it again, I respect her depth of feeling.

Now, by acting according to what we feel, firmly and decidedly, we may make mistakes and meet with deception; but we shall be saved from great evil and from despair if we ask what our duty is — and do what ought to be done as well as we can. There is no anguish greater than the soul's struggle between duty and love, both in their highest meaning. When I tell you I choose my duty you understand everything.

Whether I shall be happy with the woman in the future, I do not know. I may not be — certainly not perfectly; — but happiness is not a thing for which we are responsible.

At this moment you are at Neunen. I wish, brother, there were no reasons why I should be absent. I wish we were walking there together in the old village churchyard, or looking in at a weaver's. I do not quite understand it, when you as well as Father feel ashamed merely to walk with me, and think it is rather going too far. For my part I keep away, though my heart longs to be with you. Because I cannot spare that one little moment of seeing you or Father without mental reservations, and only for the sake of indissoluble ties, I wish we might never again speak about the question of manners or dress when we meet. You see, in everything I draw back as far as possible instead of pushing myself forward. Do not let decorum breed a general estrangement. That one bright moment of seeing each other once a year must not be darkened.

I hope you will see a few beautiful sunsets over the silent, quiet country before you go back to the city.

I have had a visit from Rappard, who saw the large drawings and spoke warmly of them. When I told him I felt rather weak, and that I thought the making of the drawings might have something to do with it, he did not seem to doubt this being very probable. We spoke about Drenthe together. He is going there again one of these days.

I should love to go there; so much so that I have already gathered information as to whether it would be easy or difficult to move the furniture thither; though these things of mine are of little or no value, it would be a great expense if I had to buy them all over again. My plan would be to go with the woman and the children. Once there, I think I should remain permanently in that country of heath and moorland, where more and more painters settle down; so that perhaps, after a time, a kind of colony of painters might spring up. I think I should save at least a hundred and fifty or two hundred guilders a year. And the heaviest expense, that for models, would be different there: either I should have for the same

money more and better models, or with less money would have just as many.

This morning I was at Van der Weele's and saw the studies he had brought from Gelderland; and my longing to go to Drenthe grew no less by what I heard from him. As luck would have it, he knew of one of the villages I had in mind; the landscape there is beautiful and full of character.

I said to him again that I was sorry I had not learnt more about painting this year. His answer was: 'Oh, don't bother about that. In the first place everybody has his own weak points; if he learns from somebody else, the result is often that he gets the faults of his master besides his own. Go your own way quietly and without worrying about that.' Well, at heart I think exactly the same.

Today I have sent a number of studies to C. M.

I can hardly tell you how pleased I am with your *revised* opinion about the work. It tallies with that of Rappard; Van der Weele also thinks there is something in it. I myself believe that there is in every painter's life a period of making absurdities. In my case I think that period is already long past. Further, I think that I am making progress; there is already something of truth and simplicity in the work; as you yourself express it, a manly conception and sentiment.

Last year Weissenbruch said something like this to me: Go quietly your own way, and in your old age you will look with satisfaction on your first studies.

To paint much is the principal thing now. I am glad you are of the opinion that it would be unwise to take some outside job in hand at the same time. This leads to half measures which make half a man of one.

How unstable the woman's character is! Notwithstanding her recent firm promise not to go and see her mother again, she has been there after all. I asked, if she could not keep such a promise even for three days, how could she expect me to find her fit to keep ~romise of faith forever? For I think this very mean of her, and I ~ost suppose that she belongs more to those people than to ~ that she is very sorry — but tomorrow she will do

it again. That's what I begin to think of it, but she says, 'Oh no.'

It is not absolutely impossible that when she lives for some time in the country, away from all that family, she will keep straight, but who can give me the assurance that yonder she will not say: 'What a miserable hole! Why did you bring me here?' She makes me fear such things, even when I try my utmost to avoid the extremity of leaving her.

I pity the woman more than ever because I see she is more restless than ever. I think she has, for the moment, no better friend than I, who would help her with all my heart, if she would let me. But she does not seek my confidence, and renders me absolutely powerless by trusting those who are in reality her enemies. I am amazed that she does not see that she acts wrongly — or does not want to see it.

What you said — that you believe it would do her good if she left me — is a thing which I myself would think probable if she did not go back to her people. It is a case for which I see no way out. She wants to stay with me and is attached to me, but she does not understand how she is estranging herself from me; and when I say anything about it she answers: 'Yes, I know it quite well; you don't want me to stay with you.'

Well, that's in her good moods, and the bad ones are more exasperating still. Then she says openly: 'Yes, I am indifferent and lazy, and I have always been so, and that cannot be helped'; or, 'Yes, it is true I am an outcast, and the only end for me will be to drown myself.'

The period when her faults made me angry is past; I went through it last year. When I now see her falling into the same errors, I am no longer astonished, and if I knew it would save her, I think I should put up with them; for my opinion of her is such that I do not think her bad. She has never seen what was *good;* how can she be good? You will understand that I should love so much to save her that if I could do so by marrying her, I should do so now. But would it save her?

The thing I hope you will not object to, under the circumstances,

is my intention to stay with her if she herself does not make it absolutely impossible, and to carry out at once the plan of going to Drenthe. Whether the woman goes with me or not depends on herself; I know she discusses it with her mother. I do not know what they say, and do not ask to know; but if she wants to come, let her. To leave her is to drive her back to prostitution; how can this be done by the same hand that tried to save her from it?

I have talked over everything again with Van der Weele. He has spent an afternoon in the studio and has seen my studies one by one; several of them we have painted over together. Wisselingh also came to see me one morning. It was very pleasant. He said I was more advanced than he expected; we lunched together and talked about old times.

He greatly encouraged me, and so did Van der Weele, but I must paint much. I must — let me say it openly — try to paint a hundred serious studies. I must carry that through. And those studies must have practical subjects too — bits of characteristic nature. Wisselingh will buy something from me some time, perhaps very soon, and we have agreed that this autumn or toward winter, when I shall have been for a time quite in the country, I will send him something, and will continue to do so, so that he will remain in touch with me, whether he buys or not. I said to him: 'Write me about what I am to send you; then I will continue in the line you think most practicable.'

Today I had a quiet time with the woman. I talked with her seriously, and explained fully how things stand with me, that I must have a year of light expenses in order to make up for a past that has been rather too much for me; that I foresaw that if I stayed with her I should soon be unable to help her any more, and should get into debt again here, and there would be no way out; so that, in short, she and I must be wise, and separate as friends; that she must get her people to take the children and look for a place.

And it is so evident that I cannot go on here that even she understands it. I told her: 'Perhaps you will not be able to keep quite straight, but go as straight as possible; I will try to do the

same. As long as I know that you try your best and don't lose hold of everything, and that you are good to the children as you know I have been to them; if you only act so that the children always find in you a mother, though you are but a poor servant, though you are but a poor whore, with all your damned faults, you will always in my eyes be *good*.'

Oh, brother, you see how it is; we should not part if we didn't have to. Have we not forgiven each other's faults each time and made it up again? We know each other so well that we can see no evil in each other. Is it love? I do not know, but there is something between us that cannot be undone.

Then I went out into the country far away to have a talk with nature. I walked to Voorburg and from there to Leidschendam. You know the scenery there — splendid trees, majestic and serene, side by side with horrible green toy summer-houses, and all the absurdities the heavy fancy of retired Dutchmen can imagine in the shape of flower-pots, arbours, and porches. Most of the houses are very ugly; some, however, are old and stately. At that moment, high over the meadows, boundless as the desert, one mass of clouds after the other came sailing on, and the wind broke against the row of country-houses with their clumps of trees on the other side of the canal. Those trees, they were superb; there was drama — in each *figure*, I was going to say, but I mean in each tree. But the whole scene together was more beautiful still than those scourged trees viewed apart, because at that moment even those absurd little summer-houses assumed a curious character, dripping with rain and dishevelled.

It seemed to me a symbol of how even a man of absurd manners and conventions, or another full of eccentricities and caprice, may become a dramatic figure of peculiar type, if only real sorrow strikes him — a calamity touches him. And the thought crossed my mind how society today in its fall, at moments seen against the light of a renewal, stands out as a great, gloomy silhouette.

Yes, for me the drama of storm in nature, the drama of sorrow in life, are the most impressive. Oh, there must be a little bit of light, a little bit of happiness, just enough to indicate the shape,

to make the limbs of the silhouette stand out, but let the rest be dark.

I want to work on, straight on, vigorously — I do not know how the result will be for her or for me, but the work will certainly turn out better when I cut myself a path alone. For when I say we part as friends, it is true — but the parting is final, and after all I am more resigned than I thought. I do believe there is some good latent in her still, but the trouble is, *it ought already to have been aroused.*

Dear brother, if you could know my feelings exactly, how I have devoted part of myself to the woman, forgetting every other thing and concentrating myself on saving her — if you could feel how I have put my faith in 'worship of sorrow' and not in illusions, then perhaps, even for you, brother, my inmost soul would be different and more detached from life than even you can now imagine.

You wrote me not long ago: 'Perhaps your *duty* will make you act differently.' That is a thing I have directly pondered over, and because my work so undoubtedly requires my going away, my opinion is that my work *is* my duty, more directly so than even the woman, and that the former must not suffer because of the latter.

Last year it was different; *now* I am *just* ready for Drenthe, but one's feelings are divided.

The decision once taken, I want to leave here as soon as possible. As soon as I can pay the fare, I go: without luggage, without company, a way for study. The moment of the autumn effects is already there, and I must catch hold of some of them.

You will ask me if I intend to come back to The Hague. No, but in half a year, or a year, I shall have to get in touch again with some painters here. You will agree with me that The Hague is a very peculiar place. It is in fact the centre of the world of art in Holland. My intention is to make so much progress in painting in Drenthe that when I come back I shall be qualified for the Society of Draughtsmen.

I have provided myself with a passport, valid for twelve months. With this I have the right to go where I want, and to stay in a

place as long as I like. A farmer in Drenthe charges a guilder a
day for board and lodging. In the beginning I should like to send
the woman a little money, and the rest for the work.

I received your letter just now, coming home from the dunes
behind Loosduinen, wet through, for I had been sitting in the rain
for about three hours. I came back with a study of twisted, gnarled
little trees, and another of a farm after the rain. Everything is
coloured bronze. Everything is what one can see in nature only
at this time of the year, or when one looks at some pictures of
Dupré, for instance; and it is so beautiful one can hardly imagine
it.

Theo, on leaving I certainly have a very melancholy feeling,
much more so than would be the case were I convinced that the
woman would show energy, and if her good-will were not so doubt-
ful. I must push on, otherwise I should break down under this
melancholy, without bringing her any further. But the children,
of whom I am so fond? I could not do everything for them, but
only if the woman had been willing.

I have a little map of Drenthe lying before me. I see on it a
large white spot without names of villages; it is crossed by the
Hoogeveen canal, which ends suddenly, and I see the words
'Peat Fields' written across the blank space. Around that space,
a number of black dots with names of villages, a red one for the
little town of Hoogeveen. Near the border, a lake — the Black
Lake — a name full of suggestions; I imagine all kinds of dredger
men on its banks.

I start tomorrow.

I AM STAYING at a village inn, quite near the station. From the train I saw some beautiful bits of the Veluwe, but by the time we arrived in these parts everything was dark. I am sitting in the large inn-parlour like those in Brabant, where a woman sits peeling potatoes — rather a pretty little figure.

In the village harbour I saw some very typical peat barges, and figures of bargemen's wives dressed as they are in the hayfield — very picturesque. In the village there are four or five canals. If one sails down them one sees here and there a curious old mill, farmyard, wharf, or lock, and always the bustle of the peat barges. I have been talking to the people here, and one of these days I shall sail by barge all the way down the Hoogeveen canal, through the peat fields, as far as the Prussian border and the Black Lake. The village or little town is just a long row of houses along the harbour.

I got up very early this morning because, as you can imagine, I am very curious to see it all. The weather was splendid; the air is clear and bracing, as in Brabant. The country is for the greater part meadowland, with here and there little trees. To the north there seems to be a beautiful heath right up to Assen. As soon as I have more colours, I shall begin that excursion and shall go from one village to another. But I think I did well by taking Hoogeveen for my starting-point.

Now that I have been here a few days, and have strolled about in different directions, I am beginning the attack. My first painted study is a cottage on the heath — a cottage made only of sods and sticks. While I was painting it, two sheep and a goat came to

browse on the *roof.* The goat climbed on the top, and looked in at
the chimney. Hearing something on the roof, the woman rushed
out and threw her broom at the goat, which jumped down like a
chamois. Inside those cottages, dark as a cave, it was very beauti-
ful. I saw the interior of about six of this kind, and studies will
follow.

The two hamlets where I have been are called Sand Drift and
Black Sheep. You can imagine the originality here, as after all
Hoogeveen is a town, and yet quite near-by there are shepherds,
kilns, peat huts. One of the many things which gives me new
sensations and feelings on my excursions is that one sees peat
barges in the very middle of the heath, drawn by men, women,
children, white or black horses, just as in Holland, or on the
Ryswyk towpath.

One can see on the faces of many that they are not in good health,
perhaps because of foul drinking water. I have seen a few girls of
seventeen, or younger still, who look very beautiful and youthful,
but generally they are very soon faded. But that does not inter-
fere with the noble aspect of the figures of some who are already
very faded. The men wear short breeches, which show off the shape
of the leg, and make the movements more expressive.

Theo, when I meet on the heath a poor woman with a child on
her arm, or at her breast, my eyes get moist. It reminds me of *her.*
Her weakness, her untidiness, too, contribute to make the like-
ness stronger.

At The Hague everything came off well. That land surveyor
came to say good-bye at the station. Of course the woman and her
children were with me to the last, and the final parting was not
very easy.

I often think with melancholy of the woman and the children —
if they were only provided for! Oh, it is the woman's own fault, one
might say, and it would be true, but I am afraid her misfortunes
will prove greater than her fault. That her character is spoilt I
knew from the beginning, and now that I ponder over some things
I saw in her, it seems to me more and more that she was too far
gone for improvement. That only makes my feeling of pity the

greater, and it becomes a melancholy feeling, because it is not in my power to redress it.

I *know* that I have the fullest right to act as I do, that I could not stay with her yonder, that I really could not take her with me, that what I did was sensible and wise, but for all that it pierces through me when I now see such a poor little figure, feverish and miserable, and it makes my heart melt within me. How much sadness there is in life! Nevertheless one must not become melancholy. One must seek distraction in other things, and the right thing is to work; but there are moments when one finds rest only in the conviction: 'Misfortune will not spare me either.'

Yesterday I found one of the most curious cemeteries I have ever seen. Imagine a patch of heath, with a hedge of thick-grown little pine trees around, so that one would think it just an ordinary little pine wood. There is an entrance however, and then one sees a number of graves grown with grass and heather, many of them marked with white posts bearing the name. It is very beautiful to see the real heather on the graves. The odour of turpentine has something mystical about it; the dark stretch of pine wood which borders the cemetery separates a sparkling sky from the rugged earth.

It was not easy to paint; I shall try some more effects of it; with snow, for instance, it must be very curious.

It is beautiful grey weather this morning; no sun for the first time since I got here, but for all that it will be just as fine, so I am going to set out.

The heath is much more extensive than in Brabant, a little monotonous in the afternoon, and especially when the sun shines, but I would not miss that very effect, which I tried in vain to paint a few times. Neither is the sea always picturesque; but those moments and effects too must be studied if one does not want to be deceived as to their real character. At the hot midday hour the heath is sometimes very trying — as fatiguing as the desert, and as inhospitable and hostile. To paint it in that blazing light, and to render the vanishing of the planes in the infinite, is a thing that makes one dizzy to attempt.

However, that same exasperating, monotonous spot — in the evening when a poor little figure moves through the twilight — when that extensive sun-scorched earth crust stands out darkly against the delicate lilac hues of the evening sky, and the very last little dark blue line at the horizon separates earth from sky — it can be as sublime as a Jules Dupré. And the figures, the men and the women, they have that very same characteristic; they are not always interesting, but when one looks at them with patience, one discovers their Millet-like side.

I am making a study of a red sun between the little birches on a marshy meadow, from which the white evening damp rises; beyond the meadow one can just discern at the horizon a bluish-grey line of trees with a few roofs. For the rest, I am drawing, but you know that painting must as far as possible be the principal thing. I had hoped to be able to lay in a little supply of colours and other materials, but my money is almost gone. If you have not done so already, write a little word to C. M. to tell him that I am now *alone* in Drenthe. The fact is that I need money before I can expect any good results from an excursion through the southeast corner of Drenthe.

I hope to send you soon studies from here; please consider whether some of them might perhaps be the thing for Wisselingh.

I have also started a few water-colours. I have begun some pen drawings, too, solely with a view to painting; for with the pen one can enter into such details as are impossible for painted studies, and it is advisable to make two studies, one drawn solely for the composition, and one painted for the colour.

At first I had some bad luck here with my models. They laughed at me, and made fun of me, and I could not finish some studies of the figure I had started through their ill-will, notwithstanding I paid them well. However, I did not give it up, and concentrated on one single family, from which I can now have an old woman, a girl, and a man as models.

I have had a letter from Rappard from West Terschelling; he is very hard at work there. I hope to go and see him this winter, and make a few studies, unless it is difficult to cross to Terschelling.

As far as I can make out, the journey there and back will cost about three guilders. In six months I hope to have saved as much, and in the meantime I will stay here in the neighbourhood. I see that I have lighter expenses here than at The Hague. To undertake excursions would be too reckless if one did it without the necessary precautions, and before undertaking them I want to repay Rappard. But it is certainly worth the cost to be with a painter again, and it will break my solitude.

The country air and life here do me much good. The people with whom I board are excellent; the man works at the depot; the fellow has a face that has sometimes the colour of red cabbage — a real coolie. The woman is very active and neat; she has three children. They will probably give me a back garret for a studio.

Last week I was deeper in the peat fields. I think it more and more beautiful here. Only very elaborate work can give an exact idea of the scenes as they are in reality, in their serious, sober character.

I long to hear from you, for notwithstanding the beautiful scenery I feel gloomy. I am overcome by a feeling of discouragement and despair. Though I wish it were not so, I am extremely sensitive as to what is said of my work, as to what impression I make personally. If I meet with distrust, if I stand alone, I feel a certain void which cripples my initiative. What I want is an intelligent sincerity, which is not vexed by failures. Two persons must believe in each other, and feel that the work can be done and must be done; in that way they are tremendously strong. They must keep up each other's courage.

I take it deeply to heart that I do not get on better with people in general; it quite worries me, because on such contacts depends so much of my success in carrying out my work.

When I look around me, everything seems too miserable, too insufficient, too dilapidated. We are having gloomy days of rain now, and when I come to the corner of the garret where I have settled down, it is curiously melancholy there; through one single glass pane the light falls on an empty colour box, on a bundle of

brushes the hair of which is quite worn down. It is so strangely
melancholy that it has, luckily, almost a comical aspect — enough
not to make one cry over it.

Last year ended with a greater deficit than I told you, and
though for the moment I have paid off everything that was in the
least urgent, I cannot buy colours. I dare not take anything on
credit, because after some time that would again run up a high bill.
During your visit we were not exactly in a mood to say more, but
now I declare to you that The Hague has been too much for me.

It is true that I am here now, and I have almost made up my
deficit; and nature is beautiful here, more so than I expected.
But I am far from being well and settled and at ease, for the glimpse
I gave you of my little garret is taken from nature.

I should, if I could afford it, send for my things from The Hague,
and arrange this garret for a studio by letting in a little more light.
The models refuse to pose when there are other people around, and
a studio is necessary. I had models in the barn, but with very
difficult light. And I should like also to replenish all my materials.
I wish I could do this thoroughly for once, and if somebody would
help me to do so, my greatest cares would be relieved. A painter
cannot do without credit, a credit which not only the painter's
profession demands, but which the carpenter or blacksmith would
demand as well.

I came here in too great a hurry, and only now I feel what I
lack, and that I acted rather too rashly. But what else could I do?
I ought to have come here last year with the woman when she left
the hospital; then there would have been no deficit, and we should
not have had to part. If I had known beforehand that I should
have to part from her after all, I should probably have done so six
months ago — but even though I still have to smart for it, I am
glad I was faithful to the woman too long rather than too short a
time. I have not heard anything from her; I told her that I would
send my address to the carpenter next door. I am anxious, though
I believe if she were in need she would have written.

As long as the weather was fine I did not mind my troubles, be-
cause I saw so many beautiful things; but with this rainy weather,

which we must expect to continue for months, I see more clearly how I have got stuck here, and how handicapped I am. This morning the weather was a little better, so I set out to paint. But it was impossible; four or five colours were lacking, and I came home so miserable.

I must tell you frankly that of late I have been sorry I paid off debts with the money you sent. I do not know whether one may not think of oneself first in order to keep one's energy free, for before the winter I shall not be able to get the necessary studies painted, and who will thank me for it?

You remember, perhaps, how it was with me in the Borinage? Well, I am rather afraid it will be the same thing here all over again. I did not see any good at the time, nor do I now, in coming to such a point of destitution, of actually having no roof over my head, of having to wander and wander forever like a tramp, without finding either rest or food, without any possibility of working. It is just these extremes, brother, to which I should come if I risked myself far in the country without some security.

I, who like to take the initiative — a proof that one does not deal in words but with actions — though I have come as far as Drenthe, I shrink back from taking the next step. The expeditions I should like to make are impossible, and foolish to be undertaken without supplies. They are very risky without a surplus of ready money for unforeseen circumstances. One must not undertake them without a thorough conviction that one will not be frustrated everywhere; one must not expect to be distrusted at every inn. So everything is prosaic, everything is calculation, as regards a plan that, after all, has poetry for its end.

Besides, the fate of the woman and the fate of my poor little chap and the other child cut me to the heart. I should like to keep on helping them, but I cannot. Father wrote to ask if he could help me, but I have kept all my cares to myself, and I hope that you, too, will not speak to him about it. He has his own troubles.

I am at a point where I need some credit, some confidence and warmth; but I find no confidence. Everything falls on you. This is the circle in which my thoughts turn: I have worked and econ-

omized, and yet I have not been able to avoid falling in debt; I have been faithful to the woman, and yet I have had to leave her; I have hated intrigues, and yet I find nobody who trusts me. I ask myself if I must not tell you: 'Leave me to my fate; it is too much for one person, and there is no chance of getting help from any other source. Is that not proof enough that we must give it up?'

Oh, lad, I am so melancholy — I am in a splendid country, I want to work, I absolutely need it; at the same time, I am absolutely at a loss how to surmount the difficulties.

I am writing from the very remotest part of Drenthe, New Amsterdam, where I came after an endless sail on the barge through the moors. I am powerless to describe the country as it ought to be done — words fail me; but imagine the banks of the canal as miles and miles of Michel's, or Th. Rousseau's.

Level planes or strips of different colour, getting narrower and narrower as they approach the horizon, are accentuated here and there by a turf shed or small farm, or a couple of meagre birches, poplars, oaks; there are heaps of peat everywhere, and one constantly sails past barges loaded with bulrushes from the marshes. The figures which now and then appear sometimes have an exquisite charm. There are a lot of Ostade types among them, physiognomies which remind one of pigs or crows, but now and then a little figure that is like the lily among thorns.

Today I saw a funeral in a barge; that was very curious — six women wrapped in coats in a boat that was pulled by the men along the canal through the heath, the clergyman in a three-cornered hat and breeches following on the other side.

Well, I am very pleased with this excursion, for I am full of what I have seen. This evening the heath was inexpressibly beautiful. The sky was of delicate lilac white, a single rent through which the blue gleamed. At the horizon a glittering red streak, under it the dark stretch of brown moor, and standing out against it a number of low-roofed little huts 'weird' and 'quaint,' Don Quixote-like mills, or curious huge bulks of drawbridges, in fantastic silhouettes against the vibrating evening sky. Such a village in the evening,

with reflections of lighted windows in the water, or in the mud and puddles, looks sometimes very snug. There are very often curious contrasts of black and white, a canal with white sandy banks across a pitch-black plain. Here you will still find large, very old turf huts that have not even a partition between the stable and the living-room.

In the barge I drew several studies, but I stayed a while here to paint some of them.

Before I started from Hoogeveen I had had some paint sent from Furnoe, as I thought that if I absorbed myself in work my mood would change; and it has already greatly improved. Father sent me a postal order for ten guilders, which together with the money from you makes me able to paint a little now.

At times — like those moments when you think of going to America — I think of enlisting for the Indies, but these are miserable, gloomy moments, when one is overwhelmed by circumstances, and I wish that then you might see these silent moors; for such a thing calms one, and inspires more faith, resignation, and steadiness in labor. How I wish we could walk here together, and paint together! It seems to me absolutely and entirely beautiful — I mean, there is peace here.

Do you know, I think I have found my little kingdom.

Dear brother, I cannot count the grains in a sack of corn just by smelling it; I cannot look through the planks of a stable door; but I can see sometimes by the lumps whether there is a sack of potatoes inside, or a sack of corn; and though the stable door be closed, I can hear by the squealing when the pig is killed. In the same way, I can and will judge the circumstances in which you find yourself for the moment, only from the indications I have. Am I mistaken when I conclude from some symptoms that there has arisen one of those serious crises which at times occur in large businesses?

I hope you feel in hours of melancholy that you are not without a friend. My dear lad, you know how things are with me, but if you are miserable about one thing or another, don't feel *alone*. Do not despair. I think I can assure you that you can trust me.

I have been thinking over what you wrote about America, and I cannot approve of that plan, even in case you may have the finest connections there, for instance with Knoedler. I can perfectly well understand that it must be very unpleasant at Goupil's. To my surprise I read in your letter: 'The gentlemen made things almost impossible when I spoke to them this week.' There is certainly an enormous difference between the house as it was when Uncle Vincent was still a partner, and now. I, who was one of the lowest employees, even now, after at least ten years, still feel how part of my heart is in it. I think it very, very sad that since then, although the number of employees has increased, it represents less and less persons who really understand the business. In Uncle Vincent's time they started with a few employees. Then there was real co-operation. For you personally, it is indeed particularly difficult; your heart is in it, and you are more faithful to them than any of the others.

Some things seem so queer to me that I think business must be out of joint. All those departments, officious as well as official, all that bookkeeping — it's nonsense, and that's not the way to do business. To do business is surely an *action*, a measure of personal insight and energy. That does not count now — thence the complaint: There are not pictures enough. Personal activity, personal energy, Tersteeg has it, you have it, and at the same time you have a position, yet in case of a change it might not be of any use to you, and you would bruise yourself everywhere against *le triomphe de la médiocrité*.

You will say, perhaps: Yes, but your painter's business is still more wretched and insecure, and there too it may happen that personal energy or activity cannot do everything, for instance provide one with food for some time. All right, but if I could have just a little luck, if I could find a few who are friendly to my work — then, then I should speak differently.

For the very reason that I owe to you my having been able to work, I want to tell you that I do not doubt for a moment you would consider it a delightful thing to have a handicraft, and though it might bring you at first into the most impossible relation

with your real position in life, it would give you a future which, though it does not entirely depend on personal activity, yet has more direct connection with it than business. A thing that would help you a good deal is that you would come fresh from the world of art, from which I had been excluded a long time when I began my work.

And you must not think, 'I am no artist,' for in so far as energy and intellect are needed, be assured you possess them. How often in London did I stand drawing on the Thames Embankment when I went home in the evening from Southampton Street. If there had been somebody to tell me what perspective was, how much misery would have been spared me, how much further should I be now!

You say, 'I used to feel myself a part of nature; now I do not feel so any longer.' Let me tell you, brother, that I myself experienced so deeply, so very deeply what you mention. It is the street, and the office, and the nerves that make it so.

Not only did I feel hardened instead of sensitive towards nature, but, much worse still, I felt exactly the same towards people. They said I was out of my mind, but I knew that it was not true, for the very reason that I felt deep in myself my own disease, and tried to remedy it. I spent myself in hopeless efforts — without any success, it is true, but because of that fixed idea of regaining a normal standpoint, I never mistook my own desperate doings. I always felt: 'Let me do something. I will rise above it; let me have patience to redress things.' I have often thought them over, those years of grubbing, but I do not see how in those circumstances I could have been different from what I was.

Think how the ground gave way under my feet; think how miserable it must make one, whoever it may be. I had been six years at Goupil's. I was rooted there, and I thought that if I left them I could look back on six years of honest work, and that if I presented myself elsewhere I might with full assurance refer to my past. By no means so. One is simply 'somebody out of employment.' At once, suddenly, fatally, everywhere, that is how it is. One applies for a new position fully intending to put one's hand to the plough,

but a person out of employment becomes by and by an object of
suspicion. You may go to England, you may go to America; it does
not matter. Everywhere you are like an uprooted tree. Goupil and
Company, where you have been rooted since your earliest years,
though indirectly they brought you to grief because as a boy you
thought them the finest, the best, the biggest in the world — if
you came back to them, they would turn a cold shoulder on you.

Sail by that whirlpool at a great distance. Do you think me
foolish for daring to say: Change your course enough *now* to restore
the harmony between yourself and nature? The longer you remain
in this mood, the more you foster nervousness, your constant enemy
and mine. I have more experience than you of what tricks it can
play.

Do not be angry with me when I say that your soul is sick at
this moment. It is true. Redress the relation between you and
nature and people. And if that can be done in no other way than
by your becoming a painter, well, do so then, notwithstanding all
objections and obstacles.

Believe me, lad, at the moment I write this I am again taking
pleasure in mills; especially here in Drenthe, I feel very much
as I did at the time when I first began to see the beauty in art.
You will agree with me in calling that a normal mood, won't you?
— to admire the things of nature, to be calm enough to draw them,
to paint them.

It strikes me as rather curious that there is a change in me of
late. I find myself in surroundings which so entirely engross me,
which so order, regulate, renew, that I am quite wrapped up in
them. I am eager to try all kinds of things which till now I have
left undone. I know that circumstances are so undecided that it is
far from certain I shall remain here. Perhaps it may turn out dif-
ferently. I cannot help imagining the future, with not myself
alone, but you and me as painters, working together as comrades
here in this moorland.

I see in you, as a man, something that is in contradiction to
Paris. I do not know how many years of Paris have passed over
it; yes, a part of your heart is rooted there, but a something — a

je ne sais quoi — is virgin still. That's the artistic element. If you
became a painter, for the first time you would have company,
friendship, a certain footing. Now, art dealers have certain preju-
dices which I think it possible you have not yet shaken off, particu-
larly the notion that painting is inborn. Yes, it *is* inborn, but not
as is generally supposed; one must put out one's hands and grasp
it; that grasping is a difficult thing — one must not wait till it re-
veals itself. There is something to be discovered, but not what
most people suppose. By painting, one becomes a painter.

The whole art business is rotten — I doubt if these enormous
prices, even for masterpieces, will remain. A time in which prices
are run up so high draws drafts, as it were, on the future. You,
who are clever as Uncle Vincent, will not be able to do what Uncle
Vincent did because there are too many Arnolds and Tripps in the
world — insatiable money-wolves, compared to whom you are
but a sheep. It is better to be a sheep than a wolf, better to be
slain than to slay. And I hope — or rather, I am sure — that I
am no wolf either.

Is this of great influence on artists? Not at all; for the greatest
of them for the most part profited but very little from these
excessive prices in their last period when they were already famous.
And they — Millet and Corot — would not have painted less, or
less beautifully, without that extreme advance. I should rather
have one hundred and fifty francs a month as a painter than
fifteen hundred francs a month in another position, even as an art
dealer. As a painter I think one feels more a man among other
men than in a life that is founded on speculation, and in which one
has to mind the conventions.

Take, for example, the painters of Barbizon. Not only do I
understand them as men, but everything, to the smallest, most
intimate details, sparkles with humour and life. The 'painter's
family life' with its calamities, its sorrows and griefs, has this
advantage, of possessing a certain good-will, a certain sincerity, a
certain real human feeling; just that *not* keeping up a certain stand-
ing; leaving the so-called civilized world of progress for what it is,
namely, a *delusion*. Do I say this because I despise culture? On

the contrary; I consider and respect as civilization the real human feelings, life in harmony with nature, not against nature. I ask: What makes me the better man?

The death of Cousin A. touched me. I often thought she was not very happy. I think one can hardly be happy as the wife of a banker, in the present time least of all. You will say that's not true — but my thoughts on these subjects are pretty well fixed. There is a certain sphere which one had better avoid, in my opinion.

When I compare the population of a city with the people here, I do not hesitate for a moment to say that the population of the heath, the bog workers, seem to me better. Recently I had some conversation on the subject with the man with whom I board, who is a farmer himself. It happened by chance when he asked me how things were in London, he had heard so much about it. I told him that I thought a simple farmer, who worked, and worked intelligently, was *the* civilized man; that it has always been so, and always will remain so. In the city one finds among the very, very rare best people a few men who are almost as noble, though in quite a different way. But in general there is more chance of finding a reasonable human being in the country than in the city. And the nearer one comes to the large cities, the farther one gets into the darkness of degeneration and stupidity and wickedness.

How wrong fundamentally is the man who does not realize he is but an atom! Is it a loss to drop a notion impressed on us in childhood, that keeping up a certain rank, or certain conventions, is the most important thing? I myself do not even think about it. I know by experience alone that those conventions, all those studied little manners and ideas do not hold good, and often are fatally, decidedly wrong. I conclude that I do not know anything, but at the same time I feel sure that this life is such a mystery that the system of 'conventionality' is certainly too narrow.

Now they tell me: 'You are unprincipled when you have no aim, no aspirations.' My answer is: 'I didn't tell you I had no aim, no aspirations; I said it was in the highest degree futile to try to force one to define what is indefinable.' Live — do something — that is

more positive. One must give society its due, but must feel one-self absolutely free, believing not in one's own judgment but in 'reason.' My judgment is human; reason is divine; but there is a link between them.

Let us suppose that you and I are really like sheep among our fellow-creatures. All right, it is not impossible that we shall be devoured some day. This may not be so very agreeable, but there is no reason to lose one's serenity if one realizes that one may have to lead a poor life, even though one has all the qualities, the knowledge, the capacities that make other people rich. I am not indifferent to money, but I do not understand the wolves.

Of two people I know the soul's struggle: Am I a painter or not? I mean Rappard and myself. The struggle is hard sometimes; it creates a difference between us and certain other people who take things less seriously; we feel wretched at times, but each fit of melancholy brings a little light, a little progress; character develops. Those who seek real simplicity are themselves quite simple, and their view of life is full of good-will and courage, even in hard times.

There is a saying by Gustave Doré which I have always admired: '*J'ai la patience d'un boeuf.*' I find in it a certain virtue, a certain resolute honesty. It is the word of a real artist. Ought one not to learn patience from nature, learn patience from seeing the corn slowly ripen, seeing things grow? Should one think oneself so absolutely dead as to imagine one will grow no more? Should one deliberately thwart one's own development?

Hardly a day passes now that I do not produce one thing or another. I cannot but make progress; each drawing one completes, each study one paints, is a step forward. It is the same as on a road: one sees the church spire at the end, but as the ground is undulating, when one thinks to have arrived there is another bit of road one did not see at first, and which must be covered. But one comes nearer and nearer. Sooner or later, I shall arrive at the point of beginning to sell. All right; when once I am so far, it won't be by halves, for I don't work by halves.

Theo, I am obsessed with the thought that you should take up

painting too. Among the old masters as well as among the modern ones, one meets with the same instance of two brothers being painters, in whose work there is more resemblance than difference — the Ostades, the Van Eycks, Jules and Émile Breton.

I have been lying awake half the night, Theo, after writing.

I wish that Brabant might be no longer closed to me. You remember the reason why I left home: at bottom, a misunderstanding of each other in almost everything. I think it best not to go there except in the event of a catastrophe; in that event, Father has a house that costs no rent. Can we live together in such a case? Yes, for a time, if it must be. I mention this because circumstances may demand that you have your hands free, and if my living at home for a time might further that, I think Father and I must agree to it at once.

We are having by turns beautiful, clear autumn days and stormy ones. It is difficult to walk out-of-doors then when the weather is bad, and sometimes quite impossible. I am taking care of myself, and feel better than those last months at The Hague when I suffered much from nerves. I now have a large room where a stove has been put; there chances to be a small balcony from which I can see the heath with the huts, and in the distance a very, very curious drawbridge.

Downstairs there is the inn, and a farmer's kitchen with a peat fire on the hearth. It is the best place for meditation, such a fireplace with a cradle beside it. When I feel melancholy or worried about something, I simply run downstairs for a little while.

Indirectly I have heard something about the woman. I could not imagine why she did not write to me. So I wrote to the carpenter asking if the woman had not been there to ask my address. And the scoundrel answered: 'Oh yes, sir, but I thought you wouldn't like her to know your address, so I pretended not to know it.' I wrote at once. I should rather write her at the address of her family than seem in any way to be hiding. I also sent her some money; that may have had bad consequences, but I can't help it.

Today I have been walking behind some men who were ploughing a potato field, with women trudging behind to pick up a few

potatoes that were left. This was quite a different field from the one I did yesterday, but that is a curious thing about this country; it is always exactly the same, and yet there is just enough variety, as in the pictures of artists who work in the same genre and yet are different.

I am still working on a burner of weeds, which I have in a painted study so that it gives a better idea of the immensity of the plain, and the falling of twilight, the fire with a bit of smoke being the only spot of light. I went again and again in the evening to look at it.

The country is splendid, splendid; everything calls to you: Paint! It is so typical and so varied. Look here, lad, is it not true that however things go, there are always financial obstacles, and where or how on earth can a time of struggle lead to a more definite peace — to a great peace which nothing on earth can disturb?

For myself, I have a simple plan: I go out and paint what strikes me, steep myself in the fragrant air of the heath, and believe that in time I shall become fresher, newer, better.

So, lad, do come and paint with me on the heath, in the potato field; come and walk with me behind the plough and the shepherd; come and sit with me by the fire — let the storm that blows across the heath blow through you.

Break loose from your bonds. I do not know the future, in what way it would be different, or if everything would go smoothly with us; but don't seek happiness in Paris; don't seek it in America, which is always the same, for ever and ever exactly the same. Make a thorough change; try the heath.

This morning I received your letter. It surprises me a little that you should credit me with the least insight into business, as I am considered a dreamer in that respect. You say: 'Think over whether there is not also much to be said for my staying at Goupil's.' Well, on that subject I have thought formerly as well as now.

Brother, I should think it mean of myself if I were to say that the money from you must continue, inducing you in that way to

stay with Goupil and Company. If you arrive at that decision, I shall be absolutely against it. I warn you emphatically: the art business will betray you in the end.

Certainly there has been a crisis at home as well as in my own life. We have all been literally saved from ruin by protection and support received from you; for me the situation was especially critical. But if you bind yourself for good to Goupil's it will get you into a position of which you might say: I wish I had never accepted it. At the same time you would think: Why did my brother and my parents push me into it? I should not want to thrive if you were the loser by it. I should not want to develop the artist in me if you had to suppress your artistry for my sake.

I am afraid you think my words idle. How should I manage, then? Well, I should try to get a job, of course trying at the same time to make and sell drawings and pictures, and after that, manage to get back to Drenthe.

I admit it is very difficult to know what one must do. Money plays a brutal part in society. But I feel such a vivid hope that painting will set free our real energy, and keep us afloat, though the first years may be very difficult. My policy is always to risk rather too much than too little; if one is defeated by risking too much — well, be it so. In short, I don't want my needs to be a reason for you to stay; if you want to stay, do so, but not for my sake, as I think that would be decidedly the wrong way for you to proceed.

Of course I should like very much to spend some time in Paris; I think that there are things for me to learn there. If I could get some work in a printer's office that would be a help rather than a hindrance; and I am willing to try my hand at anything of that kind, especially if a living is to be earned. But the greatest attraction for me in Paris, the thing which would help me most to make progress, is being with you, and the friction of ideas with somebody who knows what a picture is, and who understands the reason of my trials. Because you are in Paris, I approve of Paris, but on these beautiful moors I have not the least longing for it. It is splendid here, and while painting I think I learn to paint

somewhat better. *And my heart is in it;* I need not tell you that. But be sure that I shall not have the least objection to going to Paris whenever you think it would be of any use. I shall find things to paint everywhere.

Some time ago you wrote to me about a certain difference in our physiognomies, and your conclusion was that I was more of a thinker. What can I say to that? I do feel in myself a faculty for thinking, but that faculty is not what I feel specially organized in me. I think myself to be something else than fundamentally a thinker. When I think of you I see very characteristic action, accompanied by so much sentiment, and real thought too, that for me the conclusion is that there is more resemblance than difference between us.

When I consider our temperament I find pronounced similarity between the Puritans and ourselves. I mean the people from Cromwell's time, the little group of men and women who sailed in the *Mayflower* from the old world to America and settled there, firmly resolved to live simple lives.

Times are different: they cut down woods; we would seek it in painting. I know that the initiative taken by that small group called in history the Pilgrim Fathers had great consequences; as to ourselves, I think we philosophize little about consequences, and look only for a path to travel through life as straight as possible. To meditate about consequences is not our way.

If I speak of the Pilgrim Fathers, it is because of their physiognomy: to show you that certain reddish-haired people, with square foreheads, were not thinkers only, nor men of action only, but had both elements in combination. In one of Boughton's pictures, I know a little figure of one of those Puritans for which I should think *you* had posed. I can show you myself too, but my profile is less characteristic.

I have considered this matter of being a thinker, but have understood better and better that it was not my vocation; and because of the unfortunate misbelief that a man who feels the need to philosophize is *not* practical, and belongs only among the dreamers — a misbelief is greatly respected in society — I often bumped

my head because I didn't keep things enough to myself. But since then, the history of the Puritans, as shown by Cromwell and by Carlyle, has made me see that thinking and acting do not exclude each other.

I confess that I don't object to thinking if only at the same time I can draw and paint. And *my* aim in *my* life is to make pictures and drawings, as many and as well as I can; then at the end I hope to pass away, looking back with love and tender regret, and thinking: 'Oh, the pictures I might have made!' Theo, I declare I prefer to think how arms, legs, head are attached to the trunk than whether I myself am or am not more or less an artist.

It is snowing here today in the form of enormous hailstones. I call it snow because of the effect.

I have made a trip to Zweeloo, the village where Lieberman stayed a long while, and where he made studies for his picture of the last Salon, that with the washerwoman; where Termeulen and Jules Backhuyzen have also been for a long time.

Imagine a ride across the heath, at three o'clock in the morning in an open cart (I went with the landlord, who had to go to the market at Assen), along a road, or 'diek' as they call it here, which had been banked with mud instead of sand. It was more curious even than going by barge. At the first glimpse of dawn the sheds spread all over the heath, an old stumpy tower in a churchyard, with earthen wall and beech hedge, the level landscapes of heath or cornfields — it all, all became exactly like the most beautiful Corots. A quietness, a mystery, as only he has painted it.

When we arrived at Zweeloo at six o'clock in the morning it was still quite dark. The entrance to the village was splendid: enormous mossy roofs of houses, stables, sheepfolds, barns. At Zweeloo, however, I didn't find a single painter, and people said that in winter none ever came. I, on the contrary, hope to be there this very winter.

As there were no painters, I decided not to wait for the return of my landlord, but to walk back and make some drawings on the way.

The whole country around Zweeloo is for the moment entirely

covered, as far as the eye can reach, by young corn, the tenderest green I know. A black patch of earth — infinite; from that earth sprouts the young corn; it is almost mouldy-looking with that corn. When one has walked for hours and hours through that country one feels that there is really nothing but that earth, that corn or heather, that infinite sky.

I saw ploughers very busy, a sand cart, a shepherd, road-menders, dung carts. Horses and men seemed no larger than fleas. In a little inn on the road I drew an old woman at the spinning-wheel, a dark little silhouette as from a fairy tale.

And then twilight fell! Imagine a broad muddy road, all black mud, with an infinite heath to the right, and an endless heath to the left, and a few black triangular silhouettes of turf huts, through the little windows of which shines the red light of the little fires; imagine this puddle in the evening twilight, with a white sky over it, everywhere the contrast of black and white, and in the puddle a rough figure, the shepherd; a heap of oval masses, half wool, half mud, that jostle each other — the flock. You see them coming, you find yourself in the middle of them, you turn round and follow them. Slowly and reluctantly they trudge along the muddy road. However, there looms in the distance the farm.

The sheepfold is also like the silhouette of a triangle — dark. The door is wide open, like the entrance to a dark cave. Through the chinks of the boards at the back gleams the light of the sky. The whole caravan disappears in this cave; the shepherd and a woman with a lantern shut the doors behind them.

That coming home of the flock in the twilight was the finale of the symphony I heard yesterday. The day passed like a dream; I had been so absorbed in that pathetic music that I had literally forgotten even food and drink; I had taken a piece of brown bread and a cup of coffee in the little inn where I drew the spinning-wheel. From dawn till twilight, or rather from one night till the other, I had forgotten myself in that symphony.

I came home, and sitting near the fire I felt I was hungry — yes, very hungry. But now you see how it is here. What does one bring home from such a day? Only a number of scratches. Yet

there is another thing one brings home — a calm ardour for work.

Painting out-of-doors is over; it is too cold of late. I have made a large painted study and a large sketch of a drawbridge, and even a second painted one of it, with another effect. As soon as there is snow I hope to use them to get the snow effect more exactly; that is to say, keeping the same lines and structure.

I have had a letter from the poor woman. It is incoherent, and her writing is almost undecipherable. She was glad that I wrote to her, but she worries about the children, and goes out working as a charwoman. She is obliged to live with her mother, poor thing; and she seems to be sorry about some things in the past. My pity and affection for her are certainly not dead, though I do not see the possibility or the good of living again together; pity perhaps is not love, but for all that it can be rooted deeply enough.

Yesterday I heard from home that they had had a good letter from you, from which I conclude that the crisis has been averted. This would be a confirmation of your words to me: 'I believe that for the present things will remain as they are.'

What you took for an ultimatum from me: 'If you stay, then I shall refuse your financial support,' referred to your saying: 'Let me stay where I am, for I must provide for those at home' — and myself, though you did not name me — a delicacy on your part which I had to repay with 'I do not want such a sacrifice.' The real meaning, I hope, will always remain my conviction, either in prosperity or in 'agony.'

There was a moment when you were very melancholy and wrote to me: 'My employers are making the situation almost impossible for me, and I even believe they would rather dismiss me than let me take my leave' (the latter exactly my case at the time). And you said some things about painting's at least not being uncongenial to you. But now I say: If your rigged ship is in good order, stay on it. If you stay because you 'take a renewed pleasure in it,' all right. I suppose the best thing to have happen would be for you to be more appreciated by your directors, and for them to grant you more liberty to do business as you think best. But I be-

lieve that, after all, knowledge of a handicraft is the solidest pro-
fession.

Because of your silence, and because I connected it with pos-
sible new difficulties on the side of the directors, and because I
myself was hopelessly hard pressed, I wrote a note to Father.
This is the first time you have skipped a term, but the difference
of twenty-five guilders may handicap me for six weeks. I readily
believe that you can't imagine this — you *cannot* know how each
difficulty, very small in itself, makes a thing possible or impossible.

Last week I got a note from my former landlord threatening to
seize the things I left behind (among them all my studies, prints,
and books) if I did not send him ten guilders as a payment for the
use of a garret for the things, and a debt of the woman's; it was
doubtful whether he had the right to claim the latter, but I yielded
on condition of an arrangement to store my things. And around
New Year's, I shall have still other debts to pay, including that to
Rappard. Since I came here I have had to put my materials in
good order, to supply myself with colours, to make trips; I have
had to pay for board and lodging, to send something to the woman,
and to pay off some debts.

Add to this the peculiar torture of loneliness. I say loneliness,
and not solitude; I mean the loneliness a painter has to bear who
in some unfrequented region is regarded by everyone as a lunatic,
a murderer, a tramp. This may be a slight misery, but it is a sorrow
none the less — a feeling of being outcast, particularly strange and
unpleasant, though the country be ever so stimulating and beauti-
ful.

What you wrote me about the painter Serret greatly interests
me. Such a man, who finally produced something with pathos, as
the blossom of a hard and a difficult life, is a wonder, like the
black hawthorn, or, better still, the crooked old apple trunk that at
a certain moment bears blossoms which are among the most deli-
cate and most virginal things under the sun.

When a rough man bears blossoms like a flowering plant — yes,
that is beautiful to see, but before that time he has had to stand
a great deal of winter cold, more than those who afterwards sym-

pathize with him can know. The artist's life, and what an artist
is, that is very curious. How deep it is — how infinitely deep!

There is beyond doubt a field of action for me in Drenthe, but
I must be able to undertake it somewhat differently. We have
arrived at the point when I say, momentarily: I cannot go on here.

PERHAPS you were rather astonished that I had made up my mind to come home for a while. This is a thing that I was very loath to do, but for the last three weeks I had not felt quite well — all kinds of little troubles from having caught cold, and from nervousness. One must try to break up such a condition, and I felt it would get worse if I did not get a change.

My journey began with a good six hours' walk across the heath to Hoogeveen, on a stormy afternoon in rain and snow. That walk greatly cheered me up; or rather, my feelings were so in sympathy with nature that it calmed me. I thought that perhaps my going back home would give me a clearer insight into questions of how to act. Drenthe is splendid, but one's being able to stay there depends upon many factors, depends upon whether one is able to stand the loneliness.

Now I am sick at heart that coming back after two years' absence, I found the welcome home in every respect kind and cordial, yet that at bottom there was not the least, least change in what I must call blindness and ignorance as to our mutual position. And again I feel almost unbearably disturbed and perplexed. Instead of a ready understanding, I feel in everything a hesitation and delay that clog my own ardour and energy like a leaden atmosphere; everything you are doing becomes three-quarters useless owing to them. It is stupid, brother.

I sense how Father and Mother instinctively — I do not say *sensibly* — think about me. They feel the same dread about taking me in as they would about taking in a big rough dog: he will run into the room with wet paws; he will be in everybody's way; and he barks so loud. The dog feels that if they kept him, it would only be tolerating him in 'this house.'

All right, but the beast has a human history, and though but a dog he has a human soul, even a very sensitive one that makes him feel how people think of him. The dog is in fact Father's son, and has been left rather too much in the street, where he could not but become rougher and rougher. But as Father forgot that years ago, there is no use in mentioning it.

You think I hurt Father; you take his part, and give me a good scolding. I appreciate this in you, though you are fighting against somebody who is neither Father's nor your own enemy. There is in Father and in you and me a desire for peace and reconciliation; yet we seem unable to bring it about. I wish it might yet happen, but you people do not understand me, and I am afraid you *never* will.

And yet, you know that I consider you to have saved my life. I shall never forget that. I am not only your brother, your friend, but at the same time I have infinite obligations of gratitude to you. Money can be repaid, but not kindness such as yours.

Simply for the sake of the study of character, I point out how it was last summer. I see two brothers walking through The Hague. One says: 'I must keep up a certain standing; I must stay in business; I don't think I shall become a painter.' The other says: 'I am getting like a dog; I feel that the future will probably make me uglier and rougher; and I foresee that "a certain poverty" will be my fate; but — but — *I shall be a painter.*'

And I see those brothers in former years, when you had just entered the world of pictures, when you had just begun to read. I see them near the Ryswyk mill, or on a walk in winter to Chaam across the snowy heath early in the morning — feeling, thinking and believing so exactly alike that I ask myself: Are these the same brothers? The question is: How will things turn out? Will they separate forever, or will they forever follow the same path?

Look here, I have thought it over for four years more than you. I have come to the conclusion that what was shown to me formerly as duty was a *spectre* of duty. They said: 'Earn money and your life will be straight.' Millet says to me: '*Make your life straight* (try at least to make it so, try to wrestle with the naked truth), and *even* the earning of money will come in due course, and you will not become dishonest.'

Neither Father nor Tersteeg has given me rest for my conscience, and they have not freed me, have not even approved of my want of freedom and of plain truth, and my feeling of ignorance and darkness. Now, left to myself, I have not yet attained light and

what I want — I grant it; but I have a certain hope that my aspira-
tions will not be in vain. I shall see that soft light for which I
know no better name than the white radiance, or the good, before
my eyes close. Whatever soul's anguish I may have had about my
failures, I have never regretted having said that I found the dark-
ness black and that I have avoided it. All the influences of the
past separated me more and more from nature. My youth has
been gloomy and cold and sterile under the influence of the dark-
ness — and, brother, your youth too.

I think it has been taken rather too much for granted that I
acted wilfully or recklessly, while in reality, as you know even
better than I do, I was forced into some situations, and could
not act in any other way. In daytime, in ordinary life, I may look
as tough-skinned as a wild boar, and I can perfectly well understand
that people think me coarse. When I was younger I thought much
more than now that things depended on chance, on small things,
or misunderstandings that had no reason. But as I get older I
come more and more to feel it differently, and to see deeper motives.

My views may sometimes be out of proportion, but there *must*
be some truth in their character, and action, and direction. As
little as the weathercocks can change the direction of the wind,
so little can opinion change certain basic truths. The weather-
cocks do not make the wind east or north; neither can opinion
make the truth true. There are things as old as humanity itself,
which will not as yet disappear.

Mauve once said to me: 'You will find yourself if you go on
painting, if you penetrate deeper into art than you have done till
now.' He said it two years ago; of late I have been thinking often
about these words of his.

Have patience with me, brother, and do not suspect me of ill-
will. You will point out to me that I myself know full well that in
many respects I am very difficult to deal with. Yes, that is true,
and I too have to reckon with this. There is, however, an excuse
for me; that is the passion and the frequent absorbedness which
everyone who paints, writes, or composes must needs have.

I am softened in my opinion; I respect old age and its weakness

as you do, though it may not seem so. I also think of the word of
Michelet (who learned it from a scientist): '*Le mâle est très sauvage.*'
And as at this period of my life I know myself to have strong pas-
sions — which I think it is right to have — I look upon myself as
indeed 'a savage.' Yet my passion abates when I stand before a
weaker one, and I do not fight then.

Lad, it is so difficult for me, it has become such a burden on
my conscience that perhaps I am too great a burden upon you,
that I may be abusing your friendship when I accept money for an
enterprise which perhaps will not pay. I believe, firmly believe,
about myself that even if I became very clever (which I am not as
yet), I shall always be very poor, that the most I can expect is to
keep out of debt.

You see how agitated I am; one moment I think it can be done,
the next, that it cannot.

Our life is an appalling reality, and we ourselves are driven on
infinitely; things are — as they are, and whether we take them
more or less gloomily does not in any way alter their nature. I
think about it thus at night when I lie awake, or in the storm on
the heath, or in the evening in the dreary twilight.

It was not so lonely on the heath as in this house, notwithstand-
ing all kindness.

I have spoken with Father again. My decision not to stay here
was almost taken, but then the conversation was given another
turn by my saying: 'I have now been here for two weeks, and do
not feel a bit more advanced than I did the first half hour. If we
had understood each other better, we should have had things in
order by now. I have no time to lose, and I must make a decision.
A door must be either open or closed.'

I proposed that the room that can most easily be spared be used
to keep my things in, and eventually as a studio in case not only I
but you and I think it necessary and fit that I should work at
home for a time. Business is business, and to you and me it is
clear enough that this is a good arrangement. This will be my
studio in times when we have no money to be elsewhere.

The result is that the little room at home where the mangle stands will be at my disposal.

I appreciate the fact that both you and Rappard approve of my coming here. This gave me courage at a moment I myself was hopelessly discouraged and was deeply regretting it. Rappard once said to me: 'A man is not a lump of peat; he cannot bear to be flung away in an attic and be forgotten' — and he thought it a great misfortune for me that I could not live at home.

That I tried to get Father to take me in again, even to let me have a studio here, was not done in the first place out of egotism. I see that though we do not understand each other in many things, there will be, either always or by fits, a harmonizing good-will between you, Father, and myself. I will go my own way quietly, and follow your advice not to speak with Father about several things — if only I may find in you the person to whom I *can* speak about them.

As to your saying that I might become quite isolated, I shall be content if life remains bearable. But I declare to you that I should not consider this a fate I deserve, for I believe that, after all, I have never done and never shall do anything to make me lose the right of feeling myself one with my fellow-creatures.

I often prefer to be with people who do not even know the world, such as peasants and weavers. That's lucky for me: so since I came here I have been absorbed in the weavers.

I know only very few drawings of weavers. I began by making three water-colours of them. These people are very hard to draw, because in the small rooms one cannot take enough distance to draw the loom. But I have found a room here where it can be done. Those looms will cost me a lot of hard work. They make splendid subjects — all that old oak wood against a greyish wall. But we must try to get them so that they will harmonize in colour and tone with other Dutch pictures.

I hope soon to start another water-colour where the weaver does not sit behind the loom but is arranging the threads of the cloth. I have seen them weaving in the evening by the lamplight, which gives very Rembrandtesque effects. Nowadays they use a kind of

suspension lamp, but I got from a weaver a little lamp like the one in 'La Veillée' by Millet. The weavers used to work by such lamps.

The other day I saw coloured pieces of cloth woven in the evening. When I saw it they were arranging the threads, so that dark, bent figures against the light, standing out against the colour of the cloth, cast big shadows on the laths and beams of the loom, and on the white walls.

Since it has been arranged to let me use the laundry for a studio and storage place, I went to The Hague to pack up and send off my studies, prints, and painting materials, and am already settled in that new studio, where I hope I shall be able to make progress.

I have seen the woman, a thing I had greatly longed for. Once separated, we remain so, but after all we regret not having chosen a middle course. Though it would be difficult to find now, it would be more humane and less cruel.

The woman has behaved well; she has worked as a washerwoman to earn a living for herself and the children, so that she has done her duty, notwithstanding great physical weakness. You know that I took her into my house because at her confinement the doctor in Leyden advised her to stay in some quiet place. There was anemia, and perhaps a beginning of consumption. Well, as long as I was with her she did not grow worse, but in many respects stronger, so that several ugly symptoms disappeared. But now everything has changed for the worse and I fear for her life; and the poor little baby too, which I cared for as if it were my own, is no longer what it was.

I have encouraged her and tried to comfort and strengthen her on the path on which she now goes. But my heart goes out to her in great pity. As to my opinion how far one may go in a case of helping a poor, forsaken, sick creature, I can only repeat what I told you already: infinitely.

This year '83 has been a hard, sad year for me, and especially the end has been bitterly, bitterly sad.

Mother has hurt her leg; the thigh bone has been broken right

beneath the joint. I was painting at the farm when they sent for me, and I assisted at the setting, which came off comparatively well. The doctor assures us that there is no real danger, but considering Mother's age, I am afraid it will be a long time before she recovers. It is a great misfortune indeed.

As I have had no expenses since getting here, I have paid for the clothes Father bought because mine were not good enough, and at the same time have returned the twenty-five guilders to Rappard. Before the accident happened, I had settled with Father that I should have free board and lodging for some time so that I might use the money you sent me at New Year and about the middle of January to pay off debts. But as there will be many extra expenses, of course I told Father he was welcome to use it and the other things could wait; fortunately I had not yet sent the money away.

Theo, think over well whether you cannot find some way or other for me to earn something. And we must also consider once more the chances of selling my work. Money will be needed, and if I could only pay the expenses of my work myself, you could give to Mother what you would otherwise give to me.

I have no head for writing now, and have little time for it, for when I am not with Mother I am near-by at the weavers'. Under the circumstances I was glad to be at home, and as the present accident has pushed quite into the background some questions in which I differ from Father and Mother, we get on pretty well; the result may be that I shall stay longer at Neunen than I had thought possible at first. As a matter of course, I shall be able to lend a helping hand, especially later on when Mother will have to be moved oftener. Taking into consideration her difficult position, I am glad to say her spirits are very even and bright. And she is amused by trifles; the other day I painted for her the little church with the hedge and the trees.

Since the excitement of the first days has worn off a bit, I can do my work pretty regularly; I am busy painting every day studies of the weavers, which I think are technically better than the painted studies from Drenthe. The last study I made is of a man

who sits at a loom of old, greenish, browned oak, in which the date 1730 is cut. Near that loom, before a little window, stands a baby-chair, and a baby in it sits looking for hours at the flying to and fro of the shuttle. I have painted the thing exactly as it was in nature, the loom with the little weaver, the window and the baby-chair, in the miserable little room with clay floor.

Today I sent you three little panels and nine water-colours. Please tell me if there is anything among them which pleases you much better. Whenever you come I shall take you into the cottages of the weavers. Their figures and those of the women who wind the thread will certainly strike you. These subjects of the looms, with their relatively complicated machinery and a figure sitting in the middle, will lend themselves also to pen drawings, and I will make some, as you suggest.

Please write me details about the Manet exhibition. I am sorry to have seen so very few of his pictures; I should like especially to see his nude women figures. I have always found his work very original, and I do not think it exaggerated that some people, for instance Zola, rave about him, although I, for my part, cannot agree with Zola's conclusion, as if Manet were a man who opens a new future to modern ideas of art: I consider not Manet but Millet to be that essential modern painter who has opened a new horizon to many. I do not think Manet can be reckoned among the very, very first of this century, but his is a talent which certainly has its *raison d'être*, and that is in itself a great thing.

In reply to your letter in which you mention pen and ink drawings, I can send you five weavers which I drew after my painted studies, and which are a little different — and I think more vigorous of technique than the pen drawings of mine you have seen heretofore. I work at them early and late, for besides the painted studies and the pen and ink drawings I have some new water-colours of the weavers on the easel.

I think what you say is true, that my work must get much better still. As to its being salable or unsalable, that is an old file on which I do not intend to blunt my teeth — but at the same time I will tell you frankly that your energy to sell them might also be

more sustained. You have *never sold a single one* for me — neither for much nor for little. In fact, you *did not even try*.

I am not angry about it; I send you new ones, and very willingly I will go on doing so — I ask no better; but we must call things by their right names. You on your side may also continue to speak out frankly, but I insist on your telling me quite frankly whether in the future you intend to interest yourself in my work, or whether your dignity does not allow it. Leaving the past for what it was, I must face the future, and I decidedly intend to try to sell. I must make my own way, Theo; as far as you are concerned I am exactly where I was a few years ago; what you now say about my work, that 'it is almost salable, *but*—' is literally the same as what you wrote to me when I sent you *my first Brabant sketches* from Etten.

A dealer cannot be neutral towards painters; it makes exactly the same impression whether you say 'No' with or without compliments; it is perhaps even more irritating when it is said in such a complimentary way.

Now, if I only saw that, finding me not far enough advanced, you were doing something to help me to make progress; for instance, now that Mauve is out of the question, that you were putting me in touch with some other solid painter — in short, *anything*, some sign that proved to me you really believed in my progress, or wanted to further it. Instead there is — the money, yes, but for the rest, 'Just plod on.' You will reply that other dealers will treat me exactly as you do, except that you pay me money and that other dealers certainly will not do so; and that without money I cannot yet live. In reality, things do not stand out so sharply.

Are those studies from Drenthe so very bad, then? You reproach me for those that are painted simply and quietly from nature, trying *to say nothing but what I saw*. You say: 'Doesn't Michel preoccupy you too much?' (I speak here of that study of the cottage in twilight, and of the largest of the turf huts, the one with the green plot in the foreground.) You would certainly say exactly the same of the old churchyard. And yet neither before

the churchyard nor before the turf huts did I think of Michel. I thought only of the subject I had before me — a subject by which I, indeed, think Michel would have been arrested in passing. But imitate Michel is something I decidedly do not do.

If you ask me how it is that you never hear me say, 'I wish I were like this or like that,' it is because I think that those who cry loudest, 'I wish I were like this or like that' try least of all to reform themselves. Those who talk so much about it generally do not do it.

At this moment it seems to me that the water-colours, the pen and ink drawings of weavers, the last pen and ink drawings at which I am working now are not so altogether dull that they are worthless.

You must not take offence at my speaking about this, brother; I want in my work something sober and characteristic; I approve as little of its being neglected as I want to see my work in golden frames, in first-class galleries.

Yesterday evening I received your letter with enclosed one hundred francs. I am now at a point of being able to cover my deficit of last year. I am very glad no bill is now left unpaid. Furnishers of paint and other materials have all been treated honestly and been paid. I draw your attention to this so that you may see I hate carelessness in business as much as you do, and that I make a point of fulfilling my obligations to other people.

To you, however, I owe a great debt, and if I continued in exactly the same way, it would grow worse and worse. Now, I want to make you a proposal for the future. Let me send you my work, and keep for yourself what you like, but the money which I shall receive from you after March, I insist on considering as money that I have earned. And I quite approve of its being in the beginning less than I have received till now.

On coming home I was struck by the fact that the money I receive from you is considered in the first place as a risk, and secondly as alms given to a fool. This opinion has even been communicated to people who have nothing absolutely to do with it, for instance the respectable natives of this region. As a result, I am

asked at least three times a week by absolute strangers: 'How is it that you do not sell your work?'

It is very awkward for me always to be in a false position; wherever I come, and especially at home, I am always watched to see what I do with my work, and whether I get paid for it; in society almost everybody always looks out for the latter, and wants to know all about it. How far one's daily life can be pleasant under such circumstances, I leave for you to decide.

For the moment it is of much more importance to me to *earn* five francs than to get ten francs by way of protection. For the very reason that we began as friends, and with a mutual feeling of respect, I will not suffer our relationship to degenerate into protection.

Think it over, lad; I do not hide my deepest thoughts from you — I weigh and balance one side as well as the other. A wife you cannot give me; a child you cannot give me; work you cannot give me. Money, yes; but your money remains sterile because it is not used in the way I always wanted: for a home. Let it be a labourer's home if need be, but if one does not see that one gets a home of one's own, it fares badly with art. And as I told you plainly enough when I was younger, if I cannot get a good wife, I should take a bad one; better a bad one than none at all. I know people who are just as afraid to have children as I am to have no children. And, though a thing may turn out badly many a time, I do not easily give up a principle.

My life must become more animated if I want to get more *brio* in my work. I hate so much to be alone. Except the few years, which I could hardly understand myself, when I was confused by religious ideas — a kind of mysticism — I have always lived with a certain warmth. Now it is getting grimmer, colder, emptier, and duller around me.

So after this I shall accept absolutely as little money as possible from you for which I do not give some work in return. In short, in order to have some answer when in daily life they accuse me of being without any 'source of income,' I want to consider the money I may receive from you as money that I have earned! I will send you my work every month. That work is your property

then, and I fully agree with you that you have the full right to do anything you wish with it. I for my part, needing money, am obliged to accept it, even if somebody says to me: 'I want to put away that drawing of yours,' or 'I want to throw it in the fire.' Under the circumstances I should say: 'All right, give me the money; there is my work, I want to get on.'

But I say most decidedly that what I have so far received from you I consider as a debt which I shall pay. For the present there can be no question about it, so we will not speak of it. I hope also that you and Father will not thwart me in my taking no other studio for the present than the little mangle room here. I shall not live with Father any longer, as soon as my work brings in enough money to afford my again taking a house.

One of these days I will send you another pen and ink drawing of a weaver — larger than the five others, with the loom seen from the front. It will make this little series of drawings more complete. It would rather disappoint me if you sent me back these little weavers. And if none among the people you know would care to take them, I should think you might take them yourself as the beginning of a collection of pen and ink drawings of Brabant artisans which I should love to make.

Towards March I will send you some water-colours. If you do not want them, I will take them to somebody else. These water-colours will have their faults, yet I do not think it foolish of me to begin to show my work, to bring it before the public eye. I call it silly when you tell me how the jury of the Salon would judge my work when I never said a syllable about sending it to the Salon. But I did speak to you at the time about the people who take illustrations, especially Buhot.

However, if you seriously meant that after another period of hard work on my side you will try to show my drawings, I should perfectly agree not to bring them before the public before we had some thoroughly good ones. Will you see to it that my work is brought under the eyes of those people who if not now, then later on, must become its buyers? All right, then; I have only to occupy myself with the painting.

Today I brought home my ninth painted study of a weaver. Since I have been here not a day has passed, I think, that I have not been working from morning till night with the weavers or the peasants.

That losing oneself in the present, that being quite carried away and inspired by the surroundings in which one chances to be, how can one help it?

You must by no means suppose that I have great illusions about the appreciation of my work; I think one must be satisfied to convince a few people of the seriousness one aims at, and to be understood by them without flattery. For the rest, if there is anything more than that, so much the better, but one must think as little as possible about it. Still, I believe the work must be seen, because from the very stream of passers-by, its few friends will be drawn.

This month I have for you some pen and ink drawings. Rappard has seen them and he liked them all, especially admiring the sentiment in 'Behind the Hedges' and 'The Kingfisher' and 'Winter Garden.' Besides those, I have a few painted studies which are your property which I will send you if you like, but if you don't care to have them I will ask you if I may keep them some time, as I need them for my work; one is a large weaver who weaves a piece of red cloth; the little church in the cornfields; a view of a little old village here in the neighbourhood. I have also started to paint the church tower.

Today I just finished arranging a spacious new studio which I have rented. Two rooms, a big one and a smaller one adjoining. It is large and quite dry. That kept me pretty busy the last two weeks. I think I shall be able to work there much better than in the little room at home, and I have space enough once more to be able to work from a model. It is of course a great advantage that I need not pay board and lodging, otherwise I should not have been able to paint as much as I have of late. I hope when you see the studio you will approve of the measures I have taken.

Yesterday Mother came in her little carriage to see my new

studio. Of late I am getting on better with people here than I did at the beginning, which is of great importance to me, for one decidedly needs some distraction; if one feels too lonely the work always suffers from it; however, perhaps one must be prepared for this not lasting. But I feel quite optimistic about it. Perhaps after some time I shall agree with you that the change of last year has improved my position, that it has been a change for the better. Brabant of one's dreams — reality comes very near it sometimes! But I shall always regret that I had to give up a thing which I should have liked to carry on.

As to the Society of Draughtsmen, I quite forgot it. I have done nothing but painting of late. I am not very keen on it, and as I told you, I can only expect a refusal of my application for membership. I have not one water-colour on hand, and should have to start new ones in a hurry. And when I tell you that I am just now quite absorbed again in two new large studies of weaver interiors, you will understand I am in no mood for it.

Just now I finished a figure of a weaver standing before a loom; one sees the machine in the background. And I am working on a view of the pond at the back of our garden. Last winter you wrote to me that you found in my water-colours of that time some parts which you thought more satisfactory in colour and tone than before. I am curious to know whether you will find something in my painting when you come.

As to my palette, you will not find in my work here the silvery tones, but rather brown ones (bitumen, for instance, and bistre), of which I do not doubt some people will disapprove. It has annoyed me long since, Theo, that some of the painters of the present rob us of the bistre and the bitumen with which so many splendid things have been painted; which, well applied, make the colouring ripe and mellow and generous.

As to drab colours, in my opinion one must not judge the colours of a picture separately; a drab colour, for instance, side by side with a strong brownish-red, a dark blue, or an olive-green may express the very delicate, fresh green of a meadow, or a cornfield. I believe de Bock, who baptized certain colours as 'drab,' would

certainly not contradict this — for I heard him say once that in some pictures by Corot, in the evening skies, for instance, there are colours which in the picture are very *luminous*, and considered apart are in fact of a rather dark greyish tone.

In the first place, a dark colour may seem light; this is more a question of tone. Then, as regards the real colour, a reddish-grey, relatively little red will appear more or less red according to the adjoining colours. And with blue and yellow it is the same; one need put but a very little yellow in a colour to make it seem very yellow if one puts that colour next a violet or lilac tone.

I sometimes think that people when they speak about *colour* really mean *tone*. And perhaps there are at present more tonists than colourists.

I have read with great pleasure 'Les Maîtres d'Autrefois' by Fromentin. And in that book I frequently found the questions treated which have greatly preoccupied me of late, since I indirectly heard when I was late at The Hague things that Israëls had said about making relatively dark colours seem light; in short, expressing light by opposition with black. I know what you are going to say about 'too black,' but at the same time I am not quite convinced as yet that, for instance, a grey sky must always be painted in the local tone. Mauve does it, but Ruysdael does not, Dupré does not.

With figure painting it is the same as with landscape. I mean Israëls paints a white wall quite differently from Regnault or Fortuny; consequently the figure stands out quite differently against it.

I have been working hard on the figure of a spinning woman. It is fairly large-sized, and painted in a dark tone; the figure is dressed in blue, with a mouse-coloured shawl. Also one of an old man at the shuttle wheel. With regard to black, by chance I did not use it in these studies, as I needed some stronger effects than black, and indigo with terra sienna, Prussian blue with burnt sienna, give much deeper tones than pure black itself. When I hear people say, 'In nature there is no black,' I sometimes think: In colours there is in fact no black either.

Another new large study is an interior with three small windows looking out on the yellowish green, contrasting with the blue of the cloth that is woven on the loom, and the blouse of the weaver, which is again of another blue.

The laws of the colours are unutterably beautiful, just because they are not *accidental*. If you meet with good books I should be very glad if you bought some. I certainly intend to study the theory seriously.

The same thing that I attempted in the spinning woman and the old man winding thread I shall try to do much better later on. But in these two studies from life I have been a little more myself than I succeeded in being in most of the other studies — unless in some of my drawings.

I quite agree with you that in the present days it is often very hard to find satisfaction for the need of talking with people who know how to give advice. Well, but *nature* is a thing about which one can learn to know a great deal.

Rappard has been here some ten days, and he sends you his best regards. As you can imagine, we paid many a visit to the weavers, and took many a trip to all kinds of beautiful spots. Think whether it is correct that you who know Rappard have seen nothing of his work, do not even know what he makes but from what I tell you; that you do not take the least notice of him.

What has struck me most in nature of late I have not started yet to reproduce. The half-ripe cornfields are at present of a dark golden tone, ruddy or gold bronze. Imagine in such a background women's figures, very rough, very energetic, with sun-bronzed faces and arms and feet, with dusty, coarse indigo clothes and a black bonnet in the form of a beret on the short-cut hair; on the way to work they pass between the rows of corn along a dusty path of ruddy violet with green weeds, carrying rakes on their shoulders, or a loaf of black bread under the arm. Very rich, and at the same time very sober, very refined, artistic. I am quite absorbed in it.

But my colour bill has run up so high that I must be wary of starting new things in a big size, the more so because it will cost

me much in models; if I could only get fit models, just the type I
want (rough, flat faces with low foreheads and thick lips, not
sharp, but full and Millet-like and with those very same clothes).
For it demands great exactness; one is not at liberty to deviate
from the colours of the costume.

It would be a thing that gave a good impression of summer. I
think summer is not easy to express, at least a summer effect is
often either impossible or ugly. Spring is tender — green young
corn and pink apple blossoms. Autumn is the contrast of yellow
leaves against violet tones. Winter is the snow, with black sil-
houettes. But if summer is the opposition of blues against an
element of orange in the gold bronze of the corn, one would paint a
picture which expressed the mood of the seasons in each of the
contrasts of the complementary colours (red and green, blue and
orange, yellow and violet, white and black).

Last week I was in the fields every day during the harvest, of
which I made a composition. I made it for somebody in Eindhoven
who wants to decorate a dining-room. He is a former goldsmith
who three times has collected a very important collection of
antiques and then sold it. He is rich now, and has built himself a
house that is full of antiques, and furnished with some very beauti-
ful oak chests.

He insists on having 'painting' in the dining-room. He intended
to have compositions of diverse saints, but I begged him to con-
sider whether the appetite of the worthy people who would have
to sit down at that table would not be more stimulated by six
illustrations from peasant life of the Meierij — at the same time
symbolizing the four seasons. And after a visit to the studio the
man became quite enthusiastic about it. He wants to paint those
panels himself, but I am to design and paint the compositions in
reduction. I gave him preliminary sketches of a sower, plougher,
shepherd, harvest, potato gathering, ox wagon in the snow.

Something terrible has happened, Theo, which hardly anybody
here knows, or suspects, or may ever know. To tell you every-
thing I should have to fill a volume — I can't do it. Miss X. has

taken poison in a moment of despair, when she had a scene with her family and they slandered her and me.

I had already consulted the doctor about certain symptoms of hers three days before; I had secretly warned her brother that I was afraid she would get brain fever, and that I was sorry to state that in my eyes the X. family acted extremely imprudently in speaking to her as they did. This had no effect, at least no other than that they told me to wait two years, which I decidedly refused to do, saying that if there was a question of marriage it must be very soon or not at all.

Well, Theo, you have read 'Madame Bovary'; do you remember the first Madame Bovary, who died in a nervous attack? It was something like that, but complicated by the girl's having taken poison. She had often said when we were walking quietly together, 'I wish I could die now,' but I had never paid any attention to it.

One morning, however, she slipped to the ground. At first I thought it was only weakness, but her state became worse and worse. It was strychnine she took, but the dose was too small, or perhaps with it as an anodyne she took chloroform or laudanum, the exact antidote for strychnine.

She has been sent off immediately to a doctor in Utrecht. I think it probable that she will get quite well again, but I am afraid a long period of nervous suffering will follow. Now that she has tried suicide and failed, I think it has given her such a fright that she will not easily try it a second time. But if she gets brain fever or nervous fever, then.... Much depends on her surroundings and family, who in fact cannot do her a better turn than to treat her kindly, as if nothing had happened. She is well taken care of now.

You will understand how cast down I am by this accident. It was such a terrible fright, boy; we were alone in the fields. The cause of her desperation was the way in which they reproached her, that she was *too old*, and that sort of thing. For Heaven's sake, what is the meaning of that social position and that religion which the respectable people keep up? Oh, they are perfectly *absurd* things, which make of society a kind of lunatic asylum, a perfectly topsy-turvy world!

Well, within a short time, probably in a fortnight or three weeks, we shall know whether or not a dangerous nervous disease will develop.

These last few days everything else slipped through my mind, I was so absorbed in this sad story. Theo, boy, I am so upset by it. I speak to *nobody* here of it.

I have been to Utrecht to visit the patient; I spent almost the whole day with her. I had an interview with the physician with whom she is staying, because I wanted no other advice than that of a physician about what I must or must not do for the sake of her health and future — whether I must continue our relation, or break it off. According to him she has always had a very frail constitution; she is too weak to marry, at least now, but at the same time a separation would be dangerous too. So some time will have to pass before a decision is made. Of course I shall always remain her friend; we are perhaps too much attached to each other.

I think it deeply pathetic that this woman (while yet so weakened and defeated by five or six other women that she took poison) says in a kind of triumph, as if she had gained a victory and had found *rest:* 'I too have loved, at last.' She had never really loved before.

It is a pity that I did not meet her ten years ago. Now she gives the impression of a Cremona violin which has been spoilt by bungling repairers, and the condition in which she was when I met her proved to be rather too much damaged. But originally it was a rare specimen of great value.

Je préfère crever de passion, que de crever d'ennui. It is not only I who say this in spite of difficulties, but she too; that is why I saw something noble in her from the very beginning; but it is a confounded pity that in her youth she let herself be dominated by disappointment — dominated in this sense, that her orthodox family thought they had to suppress the active, ay, genial element in her, and made her passive to the utmost. If only they had not broken her. Or if only they had stopped at suppressing her, and five or six women fighting her alone had not driven her distracted.

Now there are people who say to me: 'Why did you meddle with

her?' There are people who say to her: 'Why did you meddle with
him?' Both she and I have sorrow enough, and worries enough,
but neither of us feels regret. Look here, I believe or know for sure
that she loves me. I believe that I love her; that feeling has been
sincere. Has it been foolish? Perhaps so, if you like, but the wise
people who never do a foolish thing, are they not more foolish in
my eyes than I am in theirs? That's my answer to other people's
arguments.

It remains a mystery to me how it must end, but neither she nor
I will do *foolish* things. With forethought I have always respected
her concerning a certain point that socially would have dishon-
oured her (though if I had wanted it, I had her in my power); so
that she can perfectly maintain her position. But I am afraid the
old bigotry will again benumb and freeze her with that damned
icy coldness which once long years ago almost killed her. Oh, I
am no friend of the present Christianity, though its Founder was
sublime. The present Christianity I know but too well; that icy
coldness bewitched *me* in my youth.

The only thing I ever saw again of K. was a picture taken a
year later; was she changed for the worse? On the contrary, she
was more interesting. Disturbing the *tranquillity* of a *woman*, as
theological people call it, is sometimes the breaking of stagnation
or melancholy, which steals upon many people, and is worse than
death itself. To hurl them back to life, to love, some people think
terrible. *Woman* is for one party always heretical and devilish.

Oh, Theo, why should I change myself? I used to be very pas-
sive and very soft-hearted, and quiet; I am so no more, but it is
true I am no longer a child. These days are full of anguish that
can neither be diverted nor stilled. I tell you, if one wants to be
active, one must not be afraid of failures, one must not be afraid
of making mistakes. Many people think they will become good
by doing no harm; that's a lie, and you yourself used to call it a lie.
It leads to stagnation, to mediocrity.

You will say that I have no success. I don't care; to conquer
or be conquered, in any case one is in emotion and action — and
those are nearer being the same thing than appears. Just dash

something down if you see a blank canvas staring at you with a certain imbecility. You do not know how paralyzing it is, that staring of a blank canvas which says to the painter: You don't know anything. Many painters are afraid of the blank canvas, but the blank canvas is afraid of the real passionate painter who dares.

Life too always turns towards a man an infinitely vacant, discouraging, hopeless blank side on which nothing is written. But however vacant and vain and dead life may present itself, the man of faith, of energy, of warmth, who knows something, does not let himself be led astray. He steps in, and acts, and builds up — *ruins*, they call it. Let them talk, those cold theologians!

Of late I have been working very hard; I believe that between this and my other emotions, I have overworked myself. I cannot eat, and I cannot sleep, that is to say not enough, and that makes one weak. But I shall get over it simply because I have fairly good news from Utrecht, though I am still far from at ease about her. The tone of her letters is much more self-conscious, much more normal; at the same time there is something like the wail of a bird whose nest has been robbed. Towards society she is perhaps less indignant than I am, but she too sees in it 'the boys who rob the nests' for fun.

This winter, perhaps next month, I intend to go away for a time. I have thought of Antwerp. I want some city life, some change of surroundings, having been for a full year or more either in Drenthe or at Neunen. I believe this will be a good distraction for me and for my spirits, which, especially of late, have not been and could not be as cheerful as I should like.

You told me once that I should always be isolated. I don't believe it. And I do not at all intend to think and live less passionately than I do. I may meet with rebuffs, I may often be mistaken, often be wrong — but only as far as that goes; at bottom I am not wrong. They are neither the best pictures, nor the best people, that have no faults.

I let people say and think of me what they like, more than you perhaps suppose. But be sure of this: when a thing turns out wrong, that's no reason for me to admit that I ought not to have

begun it; on the contrary, if it fails many a time it is a reason for me to try again; even if the very same thing is not possible, I can always try again in the same direction, as my views are well-considered and calculated, and have their *raison d'être*.

I know well enough that the future will always remain very difficult for me. I know that I shall have a hard fight, that both my work and myself will meet with much opposition, and will make a bad impression in many cases, though *not in all*. The younger people *now do not want me*. However, I do not care; as men, and as painters, I like the generation of '48 better than that of '84; but from that of '48 *not* the Guizots, but the revolutionaries — Michelet, and the peasant painters of Barbizon.

I think that Father feels, as I do, that it is rather fatality than downright intention when there is a decided difference of opinion between us. But I wish that I didn't *hit* other people, that Father had not been standing right before me at times.

I always regret, Theo, that I am standing on one side of a certain barricade, you on the other — a barricade which is not visible on the pavement, but socially does certainly exist and will continue to do so.

As to my work, every day I become keener on it. I am now working on the figure of a shepherd with a wide cloak; and besides, a study of two pollard willows, with the yellow leaves of poplars behind, and a glimpse of the fields. It is extraordinarily beautiful here at present, with the autumn effects. In a fortnight's time we shall have the real *chute des feuilles*, when all the leaves on the trees fall within a few days. If I have luck, with that shepherd, it will become a figure in which there will be something of the very old Brabant.

This winter I hope to make several drawings — a series of Brabant scenes — and to send them to the 'London News,' which is now often better than the 'Graphic,' and has just reproduced among other things a very beautiful Frank Holl.

I have not earned anything by doing that work for Hermans: nor have I asked for it. On the contrary, because my work pleased him from first to last I consider myself sufficiently paid. Precisely

when people are satisfied one must lower the price rather than raise it. If I succeed, it will be perhaps for the very reason that I work more cheaply than others, and make it easier for dealers. I find in Hermans a very pleasant, jovial friend, and it is really touching to see a man of sixty trying to learn to paint with the same youthful enthusiasm as if he were twenty. He is certainly rich, but he has always been stingy rather than generous.

Hermans has so many beautiful old jars and other antiques that I want to ask you if I could oblige you by painting for your room a still-life of some of these objects, for instance of Gothic things; only today, he told me that if I wanted to I could take some things with me to the studio.

I now have three people in Eindhoven whom I am teaching to paint still-life. Last week I painted with them day after day. It is true that I can't have any financial success with my work here, but I am making really good friends. I don't see that I am the loser by it, as I work with more animation when I have some conversation.

Rappard is here again, and after talking it over with him it may be that I shall stay and work on here. There are so many things in my mind which I should like to produce that I can hardly put off setting to work on them. Besides, I want to settle my bill for colours before the New Year, and can't afford any extra expenses. If I went to Antwerp I should want to work hard there, and should need models, which I am afraid would be too expensive for the moment. We have made long excursions and visited house after house, and have also discovered some new models. Perhaps some more painters will come into this neighbourhood next year.

We have been talking a good deal about impressionism. Here in Holland it is rather difficult to find out what impressionism really means, but both Rappard and I are very interested in the tendencies of the present day. And it is a fact that unexpected, new conceptions are beginning to arise; that pictures are being painted in quite a different tone from that of some years ago.

The thing I have made last is a large study of an avenue of poplars with yellow autumn leaves, the sun casting sparkling spots

here and there on the fallen leaves on the ground. the bright spots
contrasting with the long-cast shadows of the stems. At the end
of the road is a small cottage, and over it all the blue sky. Since
you were here a change has come in my colour, as you will see in
some studies that will be finished in a couple of months. They will
prove undoubtedly that merely in the matter of colour I have
achieved something. I think that in a year, if I spend it painting
much and constantly, I shall change further in my method of
painting and in colour, but that I shall become darker rather than
lighter.

When you write that you are standing again before your bad
half-year, that is not exactly pleasant news for you to write, nor
for me to receive. We must try to remedy it, try to make it better
for both of us. I have already done a thing which I don't think
you will approve of: I have tried once more to renew relations
with Mauve, and if possible with Tersteeg also. To Tersteeg I said
as strongly as I could: Give me another opportunity to make a few
studies at Mauve's! I have learned new things, but I need Mauve
or somebody else who is very clever to give me courage, which
oozes away if things drag too long; and I have been a full year and
longer quite without any connection with the world of art. It is
quite possible, of course, that I shall not hear anything from either
Mauve or Tersteeg.

It is very true that this year I have spent more for my work than
I did last year. What I have gained by it is that in one morning I
now easily brush a head from the model; my colour is becoming
more and more solid, and more correct, and there is more character
in my technique. The bills for colours take much from what I get.
As for myself, I had to buy an overcoat simply because I am more
particular about my clothes than formerly.

It is not my fault that at the moment I am short of money be-
cause I have painted more than I could really afford. There can
be no economizing now. In some respects I have decided to push
on rather with passion than with prudence, because this is more in
my character. And yet I calculate, too; Tersteeg and Mauve may
be won over with colour.

I *know* it's a hard time for you, but we must push on, and surely there will come a change for the better. Perhaps one might say: '*L'artiste est la désolation du financier*,' and its reverse: '*Le financier est la désolation de l'artiste.*'

What you say is perfectly true: that if I made good pictures it is more likely I should achieve something than by discussing revolutionary questions. But in your letter this sentence is followed by your asking whether I can perhaps point out to you some new ideas for reform in the art trade. Shall I point out one to you which is in your, as well as in my, personal interest? Back my advances to Mauve and Tersteeg. Help me to get afloat, and to earn money, not only by sending your money but also by your influence. There is strength enough in me to accomplish something, and to earn, too. Then later on, when I shall be somewhat better off, I shall be glad to try to give you some fresh hints about that question of reform in the art trade arising from my own experience of what hinders the progress of the painters.

Though it has been freezing pretty hard here for the last few days, I am still at work out-of-doors on a large study of an old water mill at Gennep, on the other side of Eindhoven. It will certainly be the last I shall paint out-of-doors this year. While I can get all kinds of models, during the winter months with comparative ease, I must paint about fifty heads. Now more than ever I paint as long as I have money for models.

Do you remember how at the very beginning I kept telling you of my great respect and sympathy for the work of Father de Groux? Lately I have been thinking of him more than ever. One must not see only his historical pictures; one must see his '*Le Banc des Pauvres*,' and above all the simple Brabant types. He met with violent opposition. If it had pleased de Groux at that time to dress his Brabant characters in mediaeval costumes, he would have run parallel with Leys in fortune. However, he did not do so, and *now*, years afterwards, there is a considerable reaction to that mediaevalism. The realism not wanted then is in demand now, and there is more need of it than ever — the realism that has character and a serious sentiment. I could tell you the names of people who are

hammering again on the same old anvil on which de Groux has hammered!

I think that if one has tried to follow attentively the great masters, at certain moments one finds them all back deep in reality. I mean their so-called *creations;* one will see them in reality if one has the same eyes, the same sentiment. And I believe that if the critics and connoisseurs were better acquainted with nature their judgment would be more correct than now, when the practice is merely to live in *pictures,* and to compare them mutually. As one side of the question that is good in itself, but it lacks a solid basis if one forgets nature. Is it not a pity that you, for example, seldom or hardly ever come into these cottages, or associate with these people, or see that sentiment in landscape which is painted in the pictures you like best?

Many thanks for what I received for Saint Nicholas. These last days of the month, when I must sometimes stop things which I want to finish, I can't tell you how impatient and how wretched it makes me. Yesterday I brought home my study of the water mill at Gennep, which I painted with pleasure, and which has procured me a new friend at Eindhoven, who wants to learn to paint, and to whom I paid a visit when we set to work at once. He is Anton Kerssemakers, a tanner who has time and money, and is about forty years old. I intend to make people pay something gradually, not in money but in tubes of paint; for I want to paint from morning till night.

Hermans has promised after all to give me a trip somewhere. If I want to go to Antwerp I can keep him to his word, and this winter I shall try and get some connections there, though I may not succeed the first time. Perhaps you are right in saying that I had better find my own way for my work, and become my own dealer.

Mauve and Tersteeg have very 'pertinently' refused to have anything to do with me. This does not discourage me; I consider that it is as though I had sent a picture to an exhibition and it had been refused. For the moment I am almost glad. Understand me well! It is because I feel the power within me to win them over

after all. In the very fight I shall feel my strength grow, and by criticism, by ill-will, even by opposition, I shall learn more.

In two or three days you will receive twelve little pen and ink drawings from study heads. After all, I feel most in my element when I am working at the figure. But the figure always stands in some surroundings, and involuntarily one is led to reproduce those surroundings too. I do not know yet what I shall do with these heads, but I shall derive the composition from the characters themselves.

At home I hear that you have had a good year, and had an offer of one thousand francs per month, which you refused. I can understand that being once of Goupil and Company, you prefer to stay there.

Hardly ever have I begun a year of gloomier aspect, or in a gloomier mood. It is dreary outside; the fields are a mass of lumps of black earth and some snow, with days mostly of mist and mire: the red sun in the evening, and in the morning crows, withered grass, and faded, rotting green; black shrubs, and the branches of the poplars and willows rigid like wire against the dismal sky. This is what I see in passing, and it is quite in harmony with the interiors, very gloomy these dark winter days.

It is also in harmony with the physiognomy of the peasants and weavers. They have a hard time of it. A weaver who works steadily weaves a piece of sixty yards. While he weaves a woman must spool for him, so there are two who work and have to live on it. On that piece of cloth he makes a net profit of four francs fifty a week, and when he takes it to the manufacturer nowadays he often gets the message that not before one or two weeks' time can he take another piece home. So not only are wages low, but work is pretty scarce.

It is often pathetic here; the people are quiet, and nowhere have I heard anything resembling rebellious speeches. But they look as little cheerful as the cab horses or the sheep transported by steamer to England. It is, however, a better spirit from that of the *charbonniers*, with whom I lived in a year of strikes and many accidents: that was still worse.

In 'Illustration' for October 24, 1884, there is a drawing by Paul Renouard, a strike of weavers at Lyons: an old man and some women and a child sitting idle in a weaver's cottage, where the looms stand still. There is so much life and depth in it that I think this drawing might hold its own beside Millet, Daumier, Lepage. When I think how Renouard rose to such a height by working from the very beginning from nature, without imitating others, and how he is yet in harmony with the very clever people, even in technique, though from the very first he had his own style, I find a proof that by truly following nature one's work improves every year. And I am daily more convinced that people who do not in the first place do so, *never* succeed.

I have also drawn some again. Perhaps you would find something in it, perhaps not. I can't help it; I know no other way. But I can't understand your saying: 'Perhaps later on we shall admire even the things made now.' If I were you I should have so much self-confidence and independent opinion that I should know whether I could see *now* what there was in a thing.

If I make better work later on I shall certainly not work *differently;* it will be the same apple, though riper. I shall not change my mind about what I have thought from the beginning, and that is the reason why I say, for my part: If I am no good now, I shall be no good later on either; but if later on, then now too. For corn is corn, though people from the city may take it for grass at first.

Though the month is not quite past, my purse is quite empty. But this will not go on forever, for I work too hard and too much that I shouldn't get at least so far as to defray my expenses without being in a dependent position. For my painting I must stay here somewhat longer still. By having fixed my studio here I have made it possible to have money enough for painting; if I had done otherwise I should have had to drudge at least three years more before I had definitely overcome the difficulties of colour and tone, solely because of the expense. It is now exactly a year ago since I came here, driven by necessity; it is not for my pleasure that I live at home.

You write that if I have anything ready which I think fit you will try to send it in for the Salon. I appreciate your being willing to do so. I have nothing now that I should care to send in; of late I have almost exclusively painted heads, and they are studies in the real sense of the word. However, I will send some because I think it might be well, when you meet a good many people on the occasion of the Salon, to have something to show — be it only studies. For more than a full year I have applied myself almost exclusively to *painting;* I dare claim these to be somewhat different from the first painted studies which I sent. You will receive a young woman's head. Had I known about the Salon six weeks sooner, I should have made of it a spinning woman, or a woman winding thread — a whole figure.

As to your feelings about various conceptions of heads, I believe that these which come straight from a cottage with a moss-grown thatched roof will not seem to you entirely out of place. I can perfectly well understand that there are painters who paint heads of girls such as our sisters; Whistler did it well several times, and Millais and Boughton. It all depends on how much life and passion an artist can express in his figure; if there is life in it, then a lady's figure by Alfred Stevens, or some Tissots, are indeed just as beautiful.

I, however, am not the personality to have much chance of getting on a sufficiently intimate footing with girls of that sort, so that they would be willing to pose for me — especially not with my own sisters. Perhaps I am prejudiced, too, against women who wear dresses; my territory is more those who wear jackets and petticoats. But what you say I think is true: that they *can* very well be painted; though Chardin was a Frenchman and painted *Françaises*, and the respectable Dutch women, in my opinion, very, very often lack the charm that French women frequently have. As a result, the so-called respectable class of Dutch women is not particularly attractive to paint, or to think of. Ordinary servant-girls, on the contrary, are very Chardin-like.

When there was snow I painted a few studies of our garden. The landscape has changed much since then; we now have evening

skies of lilac with gold over dark silhouettes of the cottages, above which the spare black poplars rise, while the foregrounds are of a faded green, varied by strips of black earth along the ditch edges.

I certainly see all this too — I think it just as superb as anybody else, but I am still more interested in the proportion of a figure, the division of the oval of the head, and I have no hold on the rest before I have a better grip on the figure. Again, I can understand that there are people like Daubigny and Harpignies and Ruysdael and many others who are absolutely and irresistibly carried away by the landscape itself; their work satisfies us fully because they themselves were satisfied with sky and ground and a pool of water and a shrub.

I am seeking for blue all the time. The peasant's figures are as a rule blue here. That blue, in the ripe corn or against the withered leaves of a beech hedge, is very beautiful, and has struck me from the very first. The people here instinctively wear the most beautiful blue that I have ever seen. It is coarse linen which they weave themselves, warp black, woof blue, the result of which is a black-and-blue-striped pattern. When this fades, and becomes somewhat discoloured by wind and weather, it is an infinitely quiet, delicate tone which just brings out the flesh colours.

I am now painting not only as long as there is daylight, but even into the evening by the lamp in the cottages, when I can hardly distinguish anything on my palette, so as to catch if possible something of the curious effects of lamplight.

Thanks for the splendid woodcut after Lhermitte. Here I never see anything, and I need, after all, to see some beautiful things now and then. I know very well that I am still far from making such a thing myself, but in my views and way of working, namely always directly from nature or in the smoke-grimed, squalid cottage, seeing his work encourages me. For I see how artists such as Lhermitte must have studied the peasant figure from very close by, not while they created and composed with ease and assurance, but before they did so.

'*On croit que j'imagine. Ce n'est pas vrai — je me souviens.*'

Now, as for me, I cannot yet show a single *picture*, hardly a

single *drawing* yet. But I *do* make studies, and that's just why I can very well imagine the possibility of there coming a time when I shall also be able to compose easily. Moreover, it is hard to say where study ends and picture begins.

I am brooding over a couple of larger, elaborate things, if I should happen to get a clear idea of how to reproduce the effects.

I am still greatly under the impression of what has happened. Indeed, those were days we shall not easily forget. And yet the total impression was not terrible, only solemn. Life is not long for anybody, and the question is only to make something of it.

I felt as you did when you wrote that you could not work the first days. Today I painted better again; I have worked on a still-life with honesty; in the foreground are Father's tobacco pouch and his pipe. If you care to have it, you may, and welcome.

As Father's death has caused you much extra expense, I have thought that in case you should not be able to give me the extra allowance which I used to receive every spring and summer, and which I cannot do without, don't you think it would be fair if I received a sum of, for instance, two hundred guilders as my share in the inheritance, which for the rest I gladly leave to the younger ones, and will be able to do so if you continue to help me? In fact I do not consider it as if *I* left them my share, but that it is you who make it possible for them to get my part.

Every year about this time I have been able to pay off my debts and buy some new painting materials. This year I have painted so much the last months that I really need them more than ever. Neither in February nor in March did I say a word about it. But they have been no easy months for me.

I am on good terms with Mother and the sisters; yet I think I shall go and live in the studio. I see that it is better so, for in the long run it would hardly be possible to live together; for this I can neither blame them nor myself, but rather the incongruity of ideas between persons who want to keep a certain rank and a peasant-painter who does not think of such things.

It makes things still more complicated for me, but I am quite

sure that it is better for the others. I shall move about the first of
May. Probably Mother will go next year to Leyden; then I shall
be the only one of us staying in Brabant. And it does not seem at
all improbable that I shall stay here for the rest of my days.

When I call myself a peasant-painter, that is a real fact, and it
will become clearer and clearer to you in the future. I feel at home
in the country, and it has not been in vain that I spent so many
evenings with the miners, and peat diggers, and weavers, and
peasants, musing by the fire — unless I was too hard at work for
musing. By witnessing peasant life continually, at all hours of the
day, I have become so absorbed in it that I hardly ever think of
anything else. In fact I have no other wish than to live deep, deep
in the heart of the country, and to paint rural life. I feel that my
work lies there, so I shall keep my hand to the plough and cut my
furrow steadily.

I believe you think differently about it, that you would prefer
my taking another course. When you were here I did not want to
talk about it, or contradict you. You said that I should not always
stay here any more than Mauve had always stayed at Bloemen-
daal; it may be true, but I myself see no good in moving: here one
can work more, and has fewer expenses. I sometimes think that you
place more value on what can be done in the city, while I, on the
other hand, think it more important to live in the very midst of
what one paints.

I shall have a hard time of it yet before I can make people accept
my pictures, but I am not going to let myself be discouraged. I
remember what I once read of Delacroix, how seventeen pictures of
his were refused. What damned brave fellows they were, those
pioneers! But the battle must be carried on even in the present, and
for all the little I may be worth I shall carry on my own fight.

You write that the indifference towards the work of Millet is
not encouraging, neither for the artists nor for those who have to
sell the pictures. Millet himself has felt and known this. You
say: How is it that *when people from the city* paint peasants, their
figures, splendidly painted though they may be, involuntarily re-
mind one of the suburbs of Paris? Is not this because the painters

personally have not entered deeply enough into the spirit of peasant life? De Groux painted real peasants; he is one of the good masters *in the style of Millet.* Though he is not acknowledged by the public at large, and remains in the background like Daumier, like Tassaert, there are people, for instance Mellery, who at present are painting *in his style.* As to *general* sympathy, years ago I read in Renan that he who wants to accomplish something really good or useful must not count on the approval or appreciation of the public in general, but, on the contrary, can only expect that perhaps a very few hearts will sympathize and take part in it.

As far as I am concerned, I am firmly convinced that there are a few people who, having been drawn into the city and kept in bonds there, yet retain unfading impressions of the country, and remain all their lives homesick for the fields and the peasants. I remember how I used to walk for hours in the city, past the show windows, to get a glimpse of some bit of the country, never mind what.

And so, Theo, I hope we shall continue from both sides what we started anew. While toiling on more important compositions, I send you the studies straightway as they come from the cottages. Between now and the time you are coming again this summer there are three months. If I work hard every day, I can have by that time twenty studies for you, and twenty more to take to Antwerp some day, if you like.

Do not let the time pass in vain; help me to work as much as possible. Let us paint as much as we can and be productive, and *be ourselves, with all our faults and qualities.* I say *us* because the money from you, which costs you trouble enough to procure for me, gives you the right when there is some good in my work to consider half of it your own creation. From now on keep all the studies together. I do not want to sign any of them yet, for I do not wish them to circulate as pictures. But some day we shall find somebody who wants to make a collection of studies. I hope that by and by they will give you new courage.

This week I started a composition of peasants around a dish of potatoes in the evening. I just came home from this cottage, and

have been working at it by lamplight. I have been on it for three days continually, from morning till night; Saturday night the paint got into a condition which forbade all further work until it had become quite dry.

I made this sketch on a rather large canvas. I am sure C. M. would find fault with the drawing. Do you know what is a positive argument against that? That the beautiful effects of light in nature demand a very quick hand in drawing. I know quite well that the great masters knew both how to elaborate in the finishing, and how at the same time to keep a subject full of life. But that is certainly beyond my power for the present. As far as I have got now, however, I see a chance of giving a true impression of what I see; not always literally exact, rather never exact, for one sees nature through one's own temperament. And what I am trying to acquire is not to draw a *hand*, but the *gesture;* not with mathematical correctness a head, but the *expression* — for example, when a digger looks up and sniffs the wind or speaks. In short, *life*.

Of the sketch of the potato-eaters I painted in the cottage I should like to make, with a few alterations, a definite picture. This may prove to be one which Portier could show, or which we could send to an exhibition. I was very glad to hear Portier's opinion of my work; that he found 'personality' in it. I try more and more to be myself, caring relatively little whether people approve or disapprove. I don't mean to say that I should not care if Mr. Portier stuck to his good opinion; on the contrary, I shall try to make things which strengthen him in it.

I have now made a lithograph of this sketch of the potato-eaters. Please give Mr. Portier as many copies as he wants. It is different from lamplights by Dou or van Schendel; it is perhaps not superfluous to point out to him how one of the most beautiful things of the painters of this country has been the painting of *black* which yet has *light* in it.

There is a school, I believe, of Impressionists; but I know very little about it. I do know who are the original and most important masters, around whom, as round an axis, the landscape and peasant painters will turn: Delacroix, Corot, Millet, and the rest. I mean

there are, rather than persons, rules or principles or fundamental truths for drawing, as well as for colour, upon which one falls back when one finds out an actual truth. So I want to tell Portier my decided belief in Eugène Delacroix and the people of that time.

How typical is that saying about the figures of Millet: '*Son paysan semble peint avec la terre qu'il ensemence!*' How exact and how true! And how important it is to know how to mix on the palette those colours which have no name, and yet are the real foundation of everything. Art dealers speak so vaguely and arbitrarily about it.

I cannot advise you strongly enough to study for yourself the various theories of Delacroix about colour. Though I am not up to date and have been outside the world of art so long — put outside because of my wooden shoes — the important thing remains: that in your capacity of expert, you as well as the painters shall know certain rules of colour and perspective. Excuse me, but what I say is true: that this will be of practical use to you, and will raise you above the common rank of art dealers.

I, too, believe that if Henri Pille had had to decide, 'Le Chat Noir' would perhaps not have refused this sketch. I believe the fuller of sentiment a thing one makes is, and the truer to nature, the more it is criticized and the more animosity it raises. But in the end it gets the better of criticism. The 'Potato-Eaters' is at least a subject which I have felt. I could point out its weak points, and some outright errors; but there is certain life in it, perhaps more than in some pictures that are absolutely faultless.

In order to paint rural life one must be master of so many things. On the other hand, I don't know anything at which one works with so much calm, in the sense of serenity, however much struggle one may have in material things. I mean painting is a *home;* one does not feel homesickness, and I was sick of the boredom of civilization. One is happier — one feels that at least one is really alive.

And it is a good thing in winter to be deep in the snow, in the autumn deep in the yellow leaves, in summer among the ripe corn, in spring amid the grass; it is a good thing to be always with the mowers and the peasant girls, in summer with a big sky overhead,

in winter by the fireside, and to feel that it has always been and will always be so. One may sleep on straw, eat black bread — well, one will be only the healthier for it.

Today I took a splendid walk of some hours. I do not say that in Brittany, or at Katwijk, or in the Borinage, nature is not more striking still, and more dramatic; but after all, the moors and the villages here are very, very beautiful too.

I am working at the 'Potato-Eaters' again. I have painted new studies of the heads, and especially the hands are greatly altered. I wonder what Portier will say about it when it is finished. I shall not send it unless I *know for sure* there is *something* in it. But I am getting on with it, and I think there are quite other things in it than you ever can have seen in my work — at least so distinctly. I mean especially the life. Perhaps you will now find in it what you wrote some time ago; that though it is personal, yet it will remind you of other painters — with a certain family likeness.

I should have liked to send you the picture on your birthday. Though the actual picture has been painted in a relatively short time, it has taken a whole winter of painting study heads and hands. And as to the few days in which I have painted it, it has been a regular battle, but one for which I feel great animation.

I have tried to make it clear how these people, eating their potatoes under the lamplight, have dug the earth with those very hands they put in the dish; and so the painting speaks of manual labour, and how they have honestly earned their food. I wanted to give the impression of quite a different way of living than that of us civilized people. Therefore I am not at all anxious for everyone to like it or to admire it at once.

All winter long I have had in hand the threads of this fabric, and have searched for a definite pattern; and though it has taken on a rough, coarse aspect, nevertheless the threads have been selected carefully and according to certain rules. And it may prove to be a real *peasant picture. I know it is.*

But he who prefers to see the peasants in their Sunday best may do as he likes. I for my part am convinced that I get better results

by painting them in their roughness than by giving them a conventional charm. I think a peasant girl is beautiful in her dusty and patched blue petticoat and bodice, which gets the most delicate hues from weather, wind, and sun. But if she puts on a lady's dress she loses her typical charm. A peasant in his fustian clothes in the fields is more typical than when he goes to church on Sunday in a kind of dress coat.

In the same way it would be wrong, I think, to give a peasant picture a certain conventional smoothness. If a peasant picture smells of bacon smoke, potato steam, all right, that's not unhealthy; if a stable smells of dung, that belongs to a stable; if the field has an odour of ripe corn or potatoes, or of guano or manure, that's healthy, especially for people from the city. Such pictures may *teach* them something. To paint peasant life is a serious thing, and I should reproach myself if I did not try to make pictures which raise serious thoughts in those who think seriously about art and about life. I see in the 'Salon' number so many pictures which as to technique are faultlessly drawn and painted, if you like, yet bore me terribly because they give me food neither for the heart nor for the mind.

The last days are almost dangerous for a picture, as you know, because when it is not quite dry one cannot work in it with a large brush without the great chance of spoiling it. And the alterations must be made quietly and calmly with a small brush. Therefore I have simply taken it to a friend of mine at Eindhoven and told him to take care that I should not spoil it in that way, and after three days or so I shall go and wash it there with the white of an egg and give it those finishing touches. The man had seen the study from which I had made the lithograph, and said he had not thought I could have carried the drawing and colour at the same time to such a pitch.

It is very dark, and in the white hardly any white has been used, but simply the neutral colour. That colour in itself is a pretty dark grey, but in the picture it seems white. I will tell you why I have it so.

Here the subject is a grey interior, lit up by a little lamp. The

dirty linen tablecloth, the smoky wall, the dirty caps in which the women have worked in the field, all this *when seen through the eye-lashes* in the light of the lamp proves to be very dark grey, and the lamp, though a yellow reddish blaze, is lighter still, even much lighter, than the white in question.

As to the flesh colours, I know quite well that considered superficially they seem what is called flesh colour. At first in the picture I tried to paint them so with yellow ochre, red ochre, and white. But that was ever so much too light and was decidedly wrong. What was to be done? All the heads were finished, and even finished with great care, but I repainted them straightway, unmercifully, and the colour in which they are painted now is like *the colour of a good dusty potato, unpeeled.*

I have painted this *from memory on the picture itself.* In the picture I give free scope to my own head in the sense of *thought* or imagination, which is not the case in studies where no creative process is allowed, but where one finds food for one's imagination in reality, in order to make it exact. This is the second time that a saying by Delacroix has meant much to me: the first time it was his theory about colours; now it is his theory about the *creation* of a picture. He pretended that the best pictures are made from memory. '*Par coeur!*' he said. But how many times I have painted the heads! And then I ran over every night to hit off some details on the spot.

I have now taken the painting back to the cottage to give it some last touches from nature. I think it is finished — always spoken comparatively, for in reality I shall never think of my own work as finished.

I wonder whether you will find in this picture something to please you. I hope so. I think you will see from it that I have my own way of looking at things, but that there is some conformity with others, certain Belgians. And so, though painted in a different style, in another century than the old Dutch masters, Ostade, for instance, it comes also from the heart of the peasant's life, and is original.

I highly appreciate Portier's saying that he did not retract any-

thing from what he said; nor do I mind that it came out that he had not hung those first studies. But if I send a picture for him, he can only get it on condition that he will show it. As to Durand Ruel, though he did not think the drawings worth-while, do show him this picture; he may sneer at it, but show it to him nevertheless, so that he may see there is some energy in our work. You will hear: '*Quelle croûte!*' You may be sure of that; so am I. Yet we must continue to give something *typical* and *honest*.

The 'Potato-Eaters' is a picture that shows well in gold, but it would show equally well on a wall papered in the deep colour of ripe corn. Against a dark background it shows poorly, and not at all against a dull background. This is because it gives a glance into a very grey interior. In reality it also stands, as it were, in a gold frame, because towards the actual spectator there are the hearth and the glow of the fire on the white walls, which now stand outside the picture, but in reality throw the whole thing back. This coupling it to a gold tone gives, at the same time, a brightness to spots where you would not expect it, and takes away the mottled aspect it gets when unluckily put against a dull or black background. The shadows are painted in blue, and a gold colour stimulates this.

I have been so absorbed in the picture that I literally forgot my moving, which has to be looked to, after all.

I dare maintain that in connection with later pictures, the 'Potato-Eaters' will keep its value, and that you will see from it that I can do better. I have loved to make it, and I have worked at it with a certain animation. It has not bored me; perhaps for that reason it will not bore others. Because I believe this, I send it to you.

They have been pulling down the old tower in the fields of which I have just finished a water-colour. I wanted to express how for ages the peasants have been laid to rest in the very fields which they dug up when alive. I wanted to say what a simple thing death and burial is, just as simple as the falling of an autumn leaf — just a bit of earth dug up, a wooden cross. The fields where the grass

of the churchyard ends form a last line against the horizon. Am I wrong when I think there is some good in this old tower?

Afterwards there was an auction of timber and old iron, including the cross. And now those ruins tell me how a faith and a religion mouldered away — strongly founded though they were — but how the life and death of the peasants remain for ever the same, budding and fading regularly, like the grass and the flowers growing there in that churchyard ground.

I started another large water-colour of the churchyard, but it did not turn out well. Yet I have well in mind what I want to express. I have just sponged out the two failures — and perhaps I shall get what I mean onto the third sheet of paper.

I work as hard as I can, because I am thinking of going to the Antwerp exhibition, if I can manage it. It is not directly urgent, but it is a fact that one needs both nature *and* pictures; and I should like to take some work with me to show there, if possible.

My moving is over now. Those at home are not as you imagine them; and what they say is that I 'followed my own head.' Well, never mind; I'd rather not speak about it.

I am very pleased to hear the remarks Portier and Serret made about the 'Potato-Eaters,' that they found good things in it. As to what you write of Portier, 'He is perhaps more enthusiast than merchant,' and your doubting whether he can do anything with my work, I think that neither you, nor I, nor he can decide that at once. What shall I say? The future and experience will repeat some day that for which I cannot find the right words: that enthusiasm sometimes calculates better than even the cool heads who reckon themselves 'above such things.'

The only thing to do is to follow one's own way, to try one's best to make the thing live. One must not work in a 'thousand fears,' and yet that is what many do who are so anxious to get hold of the right colours and tones that through this very anxiety they become like tepid water. The real artists say, 'Just dash the colour on.' Let the enthusiasm remain; otherwise, we reach the summit of wisdom when nobody has any daring left.

Tell Portier my idea is that part of the public in Paris will not

always remain the dupe of convention, however attractive it may be, but that, on the contrary, things which keep the dust from the cottages or from the field will find some very faithful friends — though I cannot say why or how.

Whether he may or may not be the man who can do something with my work, we want him now, at any rate. And this is what I believe. After having worked for a year or so we shall have a larger collection, and I am sure that my work will show the better the more I complete it. A fact which pleases me enormously is that exhibitions of the work of one person are being arranged more and more or — the work of a very few who belong together. This is a fact in the world of art which I am sure contains more promise for the future than any other.

Serret may agree with you that to paint good pictures and to sell them are two separate things. But this is not in the least true. When at last the public saw Millet, all his work together, then both at Paris and London it was enthusiastic. And who were the persons that had made obstructions and refused Millet? The art dealers, the so-called experts.

What you say of the figures in the 'Potato-Eaters' is true, that as figure studies they are not what the heads are. That's why I thought of trying it in quite a different way, beginning from the torso instead of the head. But then it would have become quite a different thing. About their sitting, however, don't forget that these people do not sit on chairs like those in the Café Duval.

I am daily working hard on drawing figures; I shall make a hundred of them before I paint them, as this will save me time and money. I think they are getting rounder and fuller than at first. But the expenses of painting cannot always be avoided. If one hesitated to take models or to buy the necessary painting materials, no serious work could result.

Among the next pictures I send, you will find a head which I painted involuntarily after reading Zola's 'Germinal.' I once travelled those same parts on foot. If all goes well — and if I earn a little more, so that I can travel more — I hope to go and paint the miners' heads some day. I do not know if we shall earn money,

but if it is only enough to let me work terribly hard, then I am satisfied; the point is to do what one wants to do. I think 'Germinal' splendid.

Tomorrow I am going to paint a spot in another village. I think I shall make a picture of it, the subject is so striking: two half-mouldered cottages under one and the same thatched roof, which remind me of an old couple, worn with age, that have grown into one and are seen supporting each other; for you see there are two cottages and a double chimney. I found it last Sunday on a long expedition made in company with a peasant boy in order to find a wren's nest. We found six of them, and they were all nests from which the young birds had flown out, so one could take them without too much scruple.

While I was working at those cottages — perhaps you will call them imitations of Michel, though they are not — I found such splendid huts that I cannot help painting some variations of the 'peasants' nests,' which remind me so much of the wren's nest, but are still more beautiful. The interiors are splendid, and I have now made some friends there among the people, where I am always free to be. I have four large ones interiors and a few smaller ones. The little house in which Millet lived I have never seen, but I imagine that those four little human nests are of the same kind. One is the residence of a gentleman who is known under the name of the 'mourning peasant'; the other is inhabited by a 'good woman,' who when I came there did nothing more mysterious than to dig her potato pit; but she must also be able to do witchcraft, at any rate she bears the name of 'the Witchhead.' What I want is more beautiful huts far away on the heath.

I wish you had been with me last Sunday when we took that long walk. I came home quite covered with mud, for we had to splash through a brook for half an hour. But painting becomes exciting to me, like hunting — in fact it *is* a hunt for models and beautiful spots.

It is already late, and at five o'clock in the morning I must set out on my work. I am dog-tired every day because I have to go far, far across the heath!

Van Rappard, with whom I have been friends for years, after keeping silent for about three months, has written me a letter so haughty and so full of insults, and so clearly written after he had been in The Hague, that I am almost sure I have lost him forever as a friend. Today I had a visit from Wenkebach, a painter from Utrecht who is a friend of his; he received a medal in London at the same time with Rappard. I told him I was sorry to say there had been misunderstandings between Rappard and me, which I could hardly explain otherwise than that he had been chaffing at my work with other people from The Hague.

I showed Wenkebach figures which Rappard used to like, and at the same time new ones, and told him that indeed I had changed in some respects, and would change still more, but that what I was now making was certainly not inferior. He said that he did not doubt but Rappard would take back what he had written.

Then I showed him that, as to colour, I certainly do not want to paint *always* dark — some of the cottages are even quite clear — but that my aim is to proceed from the primary colours, red, blue, yellow, and not from grey.

You know how much I like the luminous painters, but you see they are going too far. They begin to find heresy in every effect against a strong and coloured light, in every cast shadow. They seem never to walk early in the morning, or in the evening by sunset — they want to see nothing but full daylight, or gaslight, or even electric light! Now on me the effect of all this is that I sometimes detect in myself a longing to see an old Leys, a Dias. Perhaps you will call this nothing but my being always with the opposition.

As to the 'luminous' pictures of the present, you see so many of them, I none at all, but every day I think about it. Corot, Millet, Daubigny, Israëls, Dupré paint luminous pictures, though the gamut be ever so deep. Mauve — when he paints brightly — and the other luminous Dutch painters of good quality do not use other colours than do the present French painters, but here in Holland they use more white.

Wine contains particles of water. I do not pretend to say that

one can or must paint light without white, any more than I should
ever pretend wine must be dry. But I do say that one must take
care on our clear and bright days not to mix too much white in the
wine of the colour, lest the effects become too tame and weaken
the whole thing.

Don't suppose I do not like bright pictures — to be sure I do; I
know a Bastien Lepage, a bride who is painted quite *blanc sur blanc*
with a little brown face, splendid; and so many Dutch pictures with
snow, mist, and sky, splendid. I only want to point out that one
may do as one likes; Jaap Maris, who is sometimes very lumi-
nous, next day paints a view of the city by night in the darkest
gamut.

I am not a man who always doubts. On the contrary, in some
people I have a very strong confidence; you do not hear me utter
pessimistic doubts about Lhermitte. Theo, my objection to Uhde's
picture is that there is a certain coldness in it, as in the new brick
houses, and the schools and churches of the Methodists. After a
few things of character, it will be the very technique that plays
him false; he will become more and more correct in his work and
more and more dry. I assure you that Uhde's 'Christ' is very, very
poor indeed. I cannot stand such a Santa Claus as Uhde painted
in that little school. Uhde himself I am sure knows it quite well,
and has only done as he has because the honourable people in the
country where he lives want a subject and something (conven-
tional) to think about; otherwise he would have to starve.

You say that the silvery grey of Uhde is so beautiful, and that
if I saw the picture I should think differently about it. No, lad, I
have seen so much grey in my life that such a bit of silver-grey
cannot easily bring me round. Painting grey as a *system* becomes
intolerable, and we shall certainly get the reverse side of the shield.
There are too many examples of the very luminous painters be-
coming afterwards chalky or oily. Yet in order to convince you
that I want to appreciate its good qualities, and have nothing
against it, I also have a grey picture in hand.

Wenkebach liked the picture of the old tower for its colour and
technique; he said he found it quite original. The same with the

water mill, the plough with oxen, the avenue with autumn effects. But what pleased me most of all was that he liked the figures.

I have written to Rappard that actually we have to fight other things than each other, and that at this moment those who paint rural life and the people must join hands, because union is strength.

What rather worries me is that I hardly know how to get to the end of the month. I am literally without a penny. And it is about harvest time, when I must make a campaign for models, both for reaping corn and digging potatoes. At that time it is twice as hard to get models, yet it is necessary. It is here as everywhere; people do not like to pose, and if it were not for the money nobody would do so. But as they are for the greater part very poor, I can somehow manage to get them. To paint what I want, and especially to improve the figure, is a question of money.

I assure you that if my constitution had not become in all winds and weather like that of a peasant, I should not be able to stand it; for as regards my own comfort absolutely nothing is left. But I don't want comfort for myself, just as many peasants don't want to change their way of life. What I do ask is for colours, and especially models.

If the month turns out a little better than you expected, and if you can send me some extra, I shall send you the large pictures. I have not the money to send them, and I don't want to send them uninsured at a time when you may be pinched for funds. But if I keep them here long, I might paint them over again; and when I send pictures just as they come from the open air or from the cottages, there will be now and then one among them which is no good, but the figures will be kept together, which would not be the case if they were often repainted.

It worries me that you have all that money trouble. For you alone, it is hard to hold out, and I cannot do anything to lessen expenses; on the contrary, I wish I could take more models still. What is to be done? At times it makes me quite melancholy that the result remains always 'unsalable'; it is not easy to keep it up, but one must not call it fighting the impossible, for others have won, and we too shall win.

One sees that Delacroix and others of that period who are rightly called 'the valiant,' when placed before connoisseurs who neither understood nor would buy, did not call it fighting the impossible, but went on painting. If we take that as a starting-point, we must still paint a lot. I am forced to be the most disagreeable of all persons; that is, I have to ask for money. And as I do not think things will at once take a turn for the better as to selling, this is bad enough.

I do not know the future, Theo; I do know the eternal law that everything changes. But the thing one does remains; painting rural life is a thing that will keep its value. It is no bad idea that in France they are decorating the town halls with subjects from rural life; better still is it that the pictures of peasants are coming into the *houses* in magazines and other reproductions. So it is only a passing fit when I feel discouraged. I do not know how people manage to fill the Salon with yards and yards of canvas.

I beg you to talk it over with Portier and Serret, to tell them that I am rather hard up, to stimulate them to try their best, to assure them that I for my part shall try to send them new things. When you come over to Holland, would it not be best to try Tersteeg once more?

Of late when I come home, after I have been sitting in the sun all day, I don't feel like writing. Today being Sunday, I write again.

I have here before me some figures; a woman with a spade seen from behind; another bending to glean the corn ears; another seen from the front, her head almost on the ground, digging carrots; a woman winding sheaves. I have been watching these peasant figures here for more than a year and a half, especially their action, just to catch their character.

The time is gone when it was sufficient for a figure to be academically, conventionally correct; or rather, though many still ask for this, a reaction is coming. The artists are calling for character; well — the public will do the same.

These Moorish, Spanish things, cardinals, all these historical paintings which they keep on painting and painting, yards upon

yards, what is the use of it, and why do they do it? After a few years it gets musty and dull, and more and more uninteresting. Well! Perhaps they are well painted; they may be. But nowadays when critics stand before a picture such as one of Benjamin Constant's or a reception at the cardinal's by I don't know what Spaniard, it is the custom to speak with a philosophical air about 'clever technique.'

I care less and less for that so highly praised but so inexpressibly dreadfully dry technique of the Italians and Spaniards. Now, I ask you: What kind of man, what kind of prophet, or philosopher, or observer, what kind of human character is there behind certain paintings the technique of which is praised? In fact, often *nothing*. But standing before many pictures of almost unknown artists one feels they are made with a *will*, a *feeling*, a passion, and love. And if one considers these things, am I then so far wrong when I criticize the criticism of those critics who in these days talk humbug about this so often misused word, 'technique'? With the selfsame air these very critics would come before a picture of rural life and would criticize the 'technique.'

The technique of a painting from rural life, or of one, such as Raffaelli's, from the heart of the city workmen, presents quite other difficulties than those of the smooth painting and pose of a Jacquet or a Benjamin Constant. In Paris all kinds of Arabic and Spanish and Moorish models are to be had if one only pays for them, but he who paints the rag-pickers of Paris, *in their own quarter*, has far more difficulties and his work is more serious.

You think perhaps I am wrong to criticize this, but it strikes me that all those foreign pictures are painted *in the studio*.

But go and paint out-of-doors on the spot itself! Then all kinds of things happen. From the four paintings which you will receive, I had to wipe off at least a hundred and more flies; not counting the dust and sand; not counting that when one carries them for some hours across the heath and through the hedges, some thorns will scratch them; not counting that when one arrives on the heath after some hours' walk in the weather, one is tired and exhausted from the heat; not counting that the figures do not stand still like

professional models, and the effects one wants to catch change
with the passing day.

To paint direct from life means to live in those cottages day
by day, to be in the fields as are the peasants; in summer to stand
the heat of the sun, in winter to suffer from snow and frost, not
indoors but outside, and not just during a walk, but day after day
like the peasants themselves.

*Apparently nothing is simpler than to paint peasants, rag-pickers,
and labourers of all kinds, but — no subjects in painting are so diffi-
cult as these everyday figures!*

So far as I know there is not a single academy where one can
learn to draw and paint a digger, a sower, a woman who puts the
kettle over the fire, or a seamstress. But in every city there is an
academy with a choice of models for historical, Arabic, Louis XV
figures — none of them with any real existence.

When I send to you and Serret some studies of diggers or peasant
women who weed or glean, it may be that either you or he will
discover faults in them, of which it will be useful for me to know.
But I want to point out something which is worth while. All
academical figures are constructed in the same way — irreproach-
ably faultless. They do not reveal to us anything new.

A drawing of a peasant woman by a Parisian who has learned
drawing at the Academy will always indicate the limbs and the
structure of the body in one selfsame way, sometimes charming —
correct in proportion and anatomy. But when Israëls, or Daumier
or Lhermitte, or especially Delacroix, draws a figure, the shape of
the figure will be felt much more, yet the proportions will some-
times be almost *arbitrary*, the anatomy and structure often quite
wrong 'in the eyes of the academician.' But the figure will *live*.

Rather than to say there must be character in a digger, I cir-
cumscribe this by saying that the peasant *must* be a peasant, that
the digger *must* dig, and then there will be something essentially
modern in them — then a figure will not be superfluous. To draw a
figure in action, that implies an essentially modern figure, the very
heart of modern art, which neither the Greeks nor the Renaissance
nor the old Dutch school have done. Do you know in the old

Dutch school a single digger, a single sower? Did they ever try to paint 'a labourer'? No. The figures in the pictures of the old masters do not *work*. Even the figures by Ostade and Terburg are not in action like those painted nowadays. They started a peasant's and a labourer's figure as a genre; the simple nude but modern figure, as Henner and Lefèvre renewed it; but peasants and labourers are after all not nude.

Indeed, even in this century how relatively few among the innumerable painters want to *paint the action for the sake of the action*, so that the picture or the drawing shall be a drawing of a figure for the sake of the figure, and the form of the human body shall be inexpressibly harmonious in line and modelling, yet at the same time show a picking of carrots in the snow.

I am rather busy, as they are mowing the corn in the fields; this lasts but a few days, and it is one of the most beautiful things one can see.

Those who paint rural life or the life of the people, though they may not belong to the men of the moment, are likely in the long run to hold out longer than the painters of exotic harems and cardinals' receptions.

I myself am convinced that in this respect one can put one's faith in modern art. The fact that I have a definite belief concerning art makes me sure of what I want in my own work, and I shall try to reach it even at the risk of my own life.

You recently wrote to me that Serret had spoken to you 'with conviction' about certain faults in the structure of the figures of the 'Potato-Eaters.' I pointed out that this was an impression after my having seen the cottage in the dim lamplight for many evenings, after having painted forty heads, and so it was clear that I had started from a different point of view.

Tell Serret that I should be desperate if my figures were academically correct; that if one photographed a digger he certainly would not appear to be digging. Tell him that I adore the figures of Michelangelo, though the legs are undoubtedly too long, the hips and the backsides too large. Tell him that for me Millet and Lhermitte are the real artists, for the very reason that they do not

paint things as they are, traced in a dry analytical way, but as
they — Millet, Lhermitte, Michelangelo — *feel* them. Tell him
that my great longing is to learn to make those very incorrect-
nesses, those deviations, remodellings, changes of reality, that they
may become — yes, untruth if you like — but more true than the
literal truth.

These last two weeks I have had a lot of worry from the priest,
who told me, evidently with the best intentions, that I ought not
to get too familiar with people below my rank — expressing him-
self to *me* in these terms, but using towards the 'people of lower
rank' quite a different tone, namely, forbidding them to have
themselves painted.

A girl I had often painted was with child, and they suspected me,
though it was not so. I heard from the girl herself the real state of
affairs, and it was a case in which a member of the priest's congre-
gation had played a very ugly part.

I simply told the Burgomaster about it at once, and pointed out
to him that it was a thing that did not concern the priest at all,
who should keep to his own territory of more abstract things. You
will ask: What's the use of making yourself disagreeable? But
sometimes it cannot be avoided. If I had argued gently with this
priest, he would undoubtedly have got the better of me. And when
he hinders me in my work, I sometimes do not see any other way
than to exact eye for eye. The priest even went so far as to promise
the people money if they refused to be painted, but they answered
quite pertly that they would rather earn money from me than beg
some from him. But you see they do it only for the sake of earning
money; they do *nothing for nothing* here.

At all events, he stopped his opposition for the moment. Of
course there will always remain God-fearing natives in the village
who will persist in suspecting me, for one thing is sure: the priest
would only too gladly throw the whole blame of that affair on me.
Happily for me, he is getting rather unpopular, and this winter I
hope to keep the very same models, who are thoroughly typical of
the old Brabant race. I now have a few more drawings, but I have

been utterly unable to get anyone to pose for me in the fields the first few days, and if this continues I shall have to move.

With the peasants in whose home the incident occurred, where I often used to paint, I have remained on good terms, and I am as welcome there as I ever was.

Yesterday I received a letter from Rappard, and our quarrel has been made up. He had seen Wenkebach, and there was no longer any trace of the tone which he had adopted at first. He sent me a sketch of a large picture of a brickyard which he is painting. You ask me if Rappard has ever sold anything. I know that for some time he took models for the nude daily; that recently, for the sake of making a picture of a brickyard, he rented a small house on the spot, and had it improved with a skylight. I know that he has made another trip through Drenthe, and that he will go to Terschelling again. The money for it must come from somewhere, though he may possess some money of his own. Perhaps his family pays, or his friends.

That colour dealer Leurs writes to me that I may send him the pictures, but he wants them as soon as possible because there are many foreigners at The Hague just now. He begs me to send him more than one in order to have more than one chance of selling. He offers me his two show-windows, and as he himself is very much in need of money, he will not spare trouble. So when I received your twenty francs I sent off to him a few cottages, the old church-tower, and some smaller studies with figures. I also wrote to Wisselingh that I had sent these pictures, and asked him to go to see them.

Nevertheless, I am sorry that these pictures did not go to you; that we did not pay off Leurs. If you had too many of one kind, we might have picked out some from the different sendings to show in Holland, and the things that you kept would have been the very best. But as you say, it is no use crying over spilt milk.

I have been very busy painting still-life lately, and I like it immensely. I know such things are hard to sell, but the practice is deucedly valuable, and I shall continue it this winter. You will receive a large still-life of potatoes, in which I have tried to ex-

press the material in such a way that they become heavy, solid lumps; also a still-life of fruit; of a brass kettle, which I painted with a special view to modelling with different colours; and of birds' nests — I think some people who are good observers of nature might like them because of the colours of the moss, the dry leaves, and the grasses.

I should like Portier to see these still-lifes, which are studies in colour. After a while they will get darker, when being dry to the core, they get a solid varnish. If you have a number of my studies, the old ones as well as the new, pell-mell on a wall of your room, I think you will see that there is a relation between them — that the different colours harmonize. The more I see of these pictures, in a cold, childish gamut, the gladder I am that my studies are found to be too black. Perhaps by and by your own *study* of art, which I am glad you are taking up again, will change you too.

I have been to Amsterdam this week. I was there for only three days, so I had scarcely time to see anything but the museum. I am *very* glad that I went, and have made up my mind not to go so long again without seeing pictures. When I look at the old masters, whose technique I understand now much better than before, I need very little conversation.

I painted two small panels there in a flying hurry: one in the waiting-room of the station when I was too early for the train, the other in the morning before I went to the museum at ten o'clock. They are unfortunately somewhat damaged; they got wet on the way, then warped while drying, and dust stuck on them. But I send them to show you that if I want to dash off an impression in an hour's time, I am learning to do so in the same way as others who analyze their impressions, and who account for what they see. It is pleasant work to dash off something in a rush.

To paint in one rush — as much as possible in one rush! What struck me most on seeing the old Dutch pictures again was that most of them had been painted quickly; that Frans Hals, Rembrandt, Ruysdael dashed off a thing from the first stroke, and did not retouch it very much. And — if it was right, they left it as it was. What joy to see a Frans Hals! How different it is from those

pictures — there are so many of them — of the smooth polishing
of faces, hands, and eyes! He is a colourist among the colourists;
a colourist like Veronese, like Rubens, like Delacroix, like Velas-
quez. I have always been very fond of Jules Dupré, and he will
become even better appreciated than he is now. For he is also a
real colourist, always interesting, and extremely powerful and
dramatic. Millet, Rembrandt, and for instance Israëls, it has truly
been said, were harmonists rather than colourists.

I saw a sketch by Rubens and a sketch by Dias at almost the
same time; they have in common the belief that colour expresses
form, if well applied and in harmony. The best pictures, and from
a technical point of view the most complete, when seen from
near-by are but patches of colour next to each other, and give an
effect only at a certain distance. That is what Rembrandt stuck
to, notwithstanding all the trouble it caused him.

I must refer once more to certain pictures of the present, that
become more and more numerous. About ten or fifteen years ago
people began to talk about 'clearness,' about 'light.' Originally
this was right; it is a fact that beautiful things were produced by
that system. But when this degenerates into an overproduction of
pictures that have the same light all over the canvas, in all the
four corners — I think they call it day tone, and local colour — is
this right? What they call clearness is in many cases an ugly studio
tone of a cheerless city studio. The dawn of the morning or the
twilight of the evening does not seem to exist; there seems to be
only midday, from eleven o'clock to three o'clock — a very decent
period indeed, but often as insipid as a milksop. They even bring
on the market colours purposely mixed with pure white, for the
sake of artists who paint in what they call a 'distinguished' light
gamut.

A great lesson taught by the old Dutch masters is to consider
drawing and colour as one. But this many painters do not do;
they draw with everything *except* a healthy colour.

It is a bad thing for me when they say that I have 'no technique';
it is possible that as I am making no new acquaintances among the
painters this will blow over. It is true, on the contrary, that those

who talk most about technique are in my eyes weakest in it! When I show something of mine in Holland, I know beforehand what will be said, and by what kind of critics. Meanwhile I go quietly to the old Dutch masters, and to the pictures by Israëls, and those who stand in direct connection with him.

I saw two pictures by Israëls, 'The Fisherman of Zandvoort,' and — one of his very latest — an old woman huddled like a bundle of rags near the bedstead on which the corpse of her husband is lying. Both pictures are masterpieces. There is a great deal more of healthy, sound technique in 'The Fisherman of Zandvoort,' with its splendid chiaroscuro, than in the technique of those who are always and everywhere equally smooth, flat, and distinguished in their frigid colour. Let them jabber about technique in pharisaical, hollow, hypocritical terms — the true painters are guided by that conscience that is called sentiment; their soul, their brain are not subject to the pencil, but the pencil to their brain. These are the things in which I believe.

In 'The Syndics' Rembrandt is true to nature, even though there as always, he soared aloft. It is the most beautiful Rembrandt; but Rembrandt could do more than that — if he was not compelled to be *literally* truthful as in a portrait, and was free to *idealize*, to be a poet. That's what he is in 'The Jewish Bride' — not ranked so high, but what an infinitely sympathetic picture it is, painted *d'une main de feu.*

Do you object to my thinking Rubens's conception and sentiment of his religious subjects theatrical? Take the 'Penseroso' of Michelangelo. It represents a thinker, but the feet are small and swift, the hand has something of the lightning quickness of a lion's claw, and — that thinker is at the same time a man of action. One sees that his thinking combines concentration with alertness. Rembrandt does it differently. Especially is his Christ in the 'Emmaus Pilgrims' more soul in a body; still — the gesture of persuasion, there is something powerful in it.

Put a Rubens beside it — one of his many figures of meditative persons — and it becomes a person who has retired to a corner for purposes of digestion. So it is with everything religious or philo-

sophical; there he is flat and hollow. But what he can paint is —
women. There especially he gives one most to think and is deepest.
With combinations of colours what he can do is paint a queen, a
statesman, well analyzed, just as they are. But the supernatural
— where magic begins — no, unless one means putting something
infinite in a woman's expression — which, however, is not dramatic.

Indirectly, while in Amsterdam I asked some questions here and
there, being curious to see what was becoming of the art trade. I
don't think you are exactly overwhelmed by pictures — are you?
Indeed, too much courage and enthusiasm are not the faults of
today.

Today I received your letter. I am very pleased with what you
write about the study of a basket with apples. It is very well
observed! Does this observation come from you? You used not
to see that kind of thing — we are on the way to agreeing better
about colours. To explain how that study has been painted; Green
and red are complementary colours; now there is in the apples a
red in itself very vulgar, and beside it some greenish things. But
there are also one or two apples of another colour, a pink, which
makes the whole thing right. That pink is the broken colour ac-
quired by mixing the red and the green; that is why there is har-
mony between the colours. I am awfully glad that you notice a
combination of colour, be it through direct or indirect personal
feeling.

The birds' nests have been painted on purpose against a black
background because I want to express openly in these studies
that the objects do not appear in their natural surroundings, but
against a conventional background. A *living* nest in nature is
quite different; one hardly sees the nest itself, one sees the birds.

You think that when the shadows are dark, ay, black, it is all
wrong. I don't think so. For then 'The Fisherman of Zandvoort,'
the 'Dante' of Delacroix, would be wrong, since their greatest
strength lies in bluish or violet blacks. Rembrandt and Hals, did
not they use black? And Velasquez? Not only one, but twenty-
seven blacks, I assure you. So as to 'one must not use black,' think
it over well; you may come to the conclusion that you have under-

stood this question of tone quite wrongly, or rather vaguely. Delacroix and others of this time will teach you better in the long run.

If you come across some good book on theories of colour, send it to me. It is a fact that by studying the laws of colour one can pass from instinctive belief in the great masters to the analysis of why one admires — what one admires. And that is indeed necessary at the present time, when one realizes how terribly arbitrary and superficially people criticize.

Just now my palette is thawing and the frigidness of the first beginning has disappeared. It is true I often blunder still when I undertake a thing, but the colours follow of their own accord, and taking one colour as starting-point, I have clearly before my mind what must follow, and how to get life into it: that is, always and intelligently to make use of the beautiful tones which the colours form when one breaks them on the palette; for to start from one's palette, from one's knowledge of the harmony of colours, is quite different from following nature mechanically and severely.

I retain from nature a certain sequence and a certain correctness in placing the tones. I study nature so as not to do foolish things, to remain reasonable; however, I don't mind so much whether my colour is exactly the same, so long as it looks beautiful on my canvas — as beautiful as it looks in nature.

I paint an autumn landscape, trees with yellow leaves. All right — when I conceive it as a symphony in yellow, what does it matter whether the fundamental colour of yellow is or is not the same as that of the leaves? It matters very little. *Much, everything* depends on my perception of the infinite variety of tones of one single family.

Do you call this a dangerous inclination towards romanticism? An infidelity to 'realism'? A caring more for the palette of the colourist than for nature? Well, *que soit.* Delacroix, Millet, Corot, Dupré, Daubigny, Breton, thirty names more, are they not the heart of the art of painting of this century, and are they not all rooted in romanticism, though they *surpassed* romanticism? Romance and romanticism are of our time, and painters must

have imagination and sentiment. Luckily realism and naturalism
are not free from it. Zola does not hold up a mirror to things; he
creates wonderfully, but *creates, poetizes*. That is why the result
is so beautiful. Be it in figure or in landscape, the painters have
always tried to convince people that the picture is something
different from nature in a mirror, different from imitation, re-crea-
tion. In the work of Millet, of Lhermitte, reality is also at the
same time symbolic; these men are different from those who are
known as 'realists.'

Far truer is a portrait by Courbet — manly, free, painted in all
kinds of beautiful deep tones of red-brown, of gold, of colder violet
in the shadow with black as *repoussoir*, with a little bit of tinted
white linen as a repose to the eye — finer than a portrait by whomso-
ever you like, who has imitated the colour of the face with horrible
preciseness. A man's head or a woman's head contemplated well
and at leisure is divinely beautiful. Well, that *general harmony* of
tones in nature one loses through painfully exact imitation; one
keeps it by re-creating in a *similar* colour gamut, but the result
may not be exactly like the model.

When Veronese painted the portraits of his *beau monde* in the
'Noces de Cana,' he spent on it all the richness of his palette.
Then he thought of a faint azure and pearly white. He thundered
it on in the background — and it was right; insensibly it blended
into the surroundings of marble palaces and sky. So beautiful is
that background that it arose spontaneously from a calculation
of colours. Is it not painted in a different way from what would
have resulted if the creator had thought at the same time of the
palace *and* of the figures, as one whole? All that architecture and
sky is conventional and subject to the figures; it is calculated to
make the figures stand out beautifully. Surely *that* is real painting:
to think of one thing and to let the surroundings belong to it, and
follow from it.

To study from nature, to wrestle with reality — I don't want
to do away with it for years and years. I should not like to have
missed that *error*. One starts with a hopeless struggle to follow
nature, and everything goes wrong; one ends by calmly creating

from one's palette, and nature agrees with it, and follows. But these two contrasts do not exist separately. The drudging, though it may seem in vain, gives an intimacy with nature, a sounder knowledge of things.

I have made another autumn study of the pond in the garden at home. There decidedly is a picture in that spot. I am sure people will find it too black and too dark; but the time for making dark studies is always too short.

Don't let it trouble you when I leave the brush strokes in my studies. For the sake of conserving and preserving the colours of a picture, it is necessary that the light parts especially be painted solidly. If one leaves them for a year and then scrapes them off quickly with a razor, one gets a much more solid colour than would be the case after painting flimsily. And this scraping has been done by the old masters as well as by the French painters of today.

You yourself have made the observation that my studies became rather better than worse in colour by time. When a painting is a year old, the little oil which it contains has evaporated, and the solid part remains. This question of painting so that the colours will last is rather important; it is a pity that some durable colours like cobalt are so expensive. The reason why the colour of the 'Potato-Eaters' is not good is the fault of the paint. I was reminded of it because I painted a large still-life in which I sought similar tones, and as I was not satisfied with it I painted it anew. Judging from this experience it would have been much better with the mineral blue I now have than with what I had before.

I do not know what to think of the chromates and dark carmines, but I can quite understand that especially paintings of American sunsets, which are obtained by glacis of chromates, last an exceedingly short time.

Last night something happened to me. I had been at work on those three pollard oaks at the bottom of the garden at home for three days; the difficulty was the tufts of havana leaves; how to model them and give them form, colour, tone. I had toiled on them for the fourth time. In the evening I took the work to an acquaintance of mine in Eindhoven who 'has rather a stylish

drawing-room, where we put it on the wall. Well, never before was I so convinced that I shall make things that do well, that I shall succeed in calculating my colours and achieving effects. I had used havana, soft green and white, even pure white, direct from the tube. (You see that I speak of black, but have no prejudice against the other extreme.)

Now, though this man has money, I felt such a glow when I saw that the work was good, and that as it hung there it created an atmosphere by the soft, melancholy harmony of that combination of colours, *that I could not sell it.* As he had a fancy for it I gave it to him, and he accepted it just as I had intended, without many words — little more than 'The thing is damned good.' When someone of clear intelligence paints still-life and works out-of-doors daily, if only for a year, he will not need to be an art critic or feel himself to be a painter in order to observe more originally than many others.

At present I like nothing better than to work with the brush, and draw with it too, instead of making a sketch in charcoal. The last thing I painted is rather a large drawing of an old mill on the barren heath, a dark silhouette against an evening sky.

The other day I had a letter from Leurs about my pictures. He wrote that Tersteeg and Wisselingh had seen them, but did not care for them. As to the heads which I sent you, there must be some good ones amongst them, I am almost sure of it.

This month I gave notice to leave my studio. In this studio, right next to the priest and the sexton, trouble will never end; that is clear. I am greatly handicapped by the neighbours, and people are afraid of the priest. The best thing is a radical change. But I know the country and the people too well, and love them too much, to think of leaving them for good. I shall try to rent a room where I can put my things, and shall be safe in case I get homesick for the country. The general nickname I have in this neighbourhood is "*l schildermenneke*" (the little painter). And it is not without a certain touch of malice that I go yonder.

Wouldn't it be best for me to spend the next two months, December and January, in Antwerp? At present I am rather in a

fix with my work here: it is freezing hard, so work out-of-doors is impossible, and it is better not to take models at all as long as I live in this house. I have discovered the addresses of six art dealers, so I shall take some things with me, and further, I intend as soon as I get there to paint a few views of the city and exhibit them at once. I had also thought of Drenthe, but that is more difficult to carry out. Should the things here sooner or later have success, I should go on with the same kind of things from Drenthe.

I must say, I am longing for Antwerp. It is deuced hard to stand quite outside the painter's world and the world of pictures, and to have no contact with others; but all is not lost that is delayed. As I have worked utterly alone for years, I imagine that though I want to and can, learn from others, and even copy technical things, I shall always see through my own eyes, and render things originally.

I fancy it will be beautiful there this winter, especially the docks in the snow. I shall take with me a good supply of the paint that I get rubbed myself, but it will certainly be a good thing if I can get some paints there of a better quality. I shall also take along drawing material and paper, so that whatever happens I shall always have something to do.

In Amsterdam I stayed for fifty cents in a people's hostel. I should do the same yonder. To accustom oneself to poverty, to see how a soldier or a labourer lives and thrives in wind and weather, with the ordinary people's fare and dwelling, is just as practical as earning a few guilders more a week. And then, don't forget that I am not a born hypochondriac.

For the sake of painting I will if I must put up with being always in difficulties. After all, one is not in the world for one's own comfort, and one does not need to be better off than one's neighbour. We cannot prevent the days of our youth from slipping past us; but the real thing that makes one happy, materially happy, is to be young, and to remain so for a long time. And for my part, I think that one has the greatest chance of remaining strong and renewing oneself under the *tiers état* of the present day. Well, I try to find my happiness in painting, without by-thoughts.

I shall do well to keep my eye on portrait painting if I want to earn something. In the city the respectable citizens, and certainly not less the *cocottes*, attach great importance to portraits. Millet discovered that sea-captains even 'respect' somebody who knows how to paint them (probably these portraits are destined for their mistresses ashore). At Havre, Millet kept himself afloat in this way.

I know it is difficult to satisfy people about the 'likeness,' and I do not dare to say beforehand that I feel sure of myself on that point. But I don't think it entirely impossible, for the people here are not very different from people elsewhere. Now, the peasants and the people from the village don't make mistakes, but straightway say: This is Reinie de Greef; that is Toen de Groot. And they even sometimes recognize a figure seen from behind.

As to that 'by-job,' from the very beginning Tersteeg had bothered me about it. And that was nonsense. Those who talk most about it, however, are unable to decide what kind of job it is to be. If I should take up a 'by-job,' it would have to have something to do with pictures. Occupations immediately connected with painting are an exception, and as a rule a painter must be only a painter.

As to my feeling the loss of a studio at Antwerp; yes, I certainly shall. But I must choose between a studio without work here, and work without a studio there. I am afraid I shall not succeed in getting as many models as I want, and properly so, but shall have to find the money through making other things, either landscapes or town views or portraits, or even signboards and decorations. There will certainly be some people there who hire nude models, and with whom one might make an arrangement for sharing the expense.

Meanwhile my power has somewhat ripened, so that I feel more independent. In The Hague, I was rather weaker than the rest with my brush — I don't say in my drawing — and as they only asked for painting and colour, I was more easily overwhelmed than would be the case now.

I believe you would like the landscape I am taking with me —

the one with the yellow leaves. The horizon is a dark streak against a light streak of sky of white and blue. In that dark streak little patches of red, bluish, and green or brown form the silhouette of the roofs and orchards; the field is greenish; the sky higher up, grey, with the black saplings and yellow leaves against it; the foreground completely covered with yellow leaves, in which are two little black figures and a blue one. To the right, a birch trunk, white and black, and a green trunk with red-brown leaves.

I shall leave on Tuesday next. It is a rather sudden leaving. If I had not had trouble with the models, I should have passed the winter here, but though I dare stand my ground, people hesitate, and are more frightened than I thought they would be. And I am not going to undertake it unless I am quite sure that they are not afraid. It may help to have me go away for a couple of months.

Well, with every new year time seems to go more quickly, more things seem to happen, things go with a greater rush; often I have to fight against serious obstacles. But the more unfavourable outward circumstances become, the more the inner resources — that is, the love for the work — increase.

ANTWERP, *November,* 1885

I AM in Antwerp. I have taken a little room for twenty-five
francs a month, Rue des Images No. 194, over a paint dealer's
shop.

I like Antwerp, and have explored the city in every direction. I
have already walked along the docks and the quays several times.
Especially when one comes from the sand and the heath and the
quiet of a peasant village, and has for a long time been in none but
quiet surroundings, the contrast is curious. I should like to walk
there with you, just to find whether we see alike. It is an un-
fathomable labyrinth; at every moment interesting contrasts pre-
sent themselves.

Through the window of an elegant English bar one looks out on
the dirtiest mire, and on a ship where merchandise, such as hides
and buffalo horns, is being unloaded by huge dock hands or
foreign sailors; a dainty young English girl is standing at the
window looking out.

There are Flemish sailors with almost too healthy faces, with
broad shoulders, strong and full, and typical Antwerp folk, eating
mussels or drinking beer; there is much noise and movement; by
way of contrast, a tiny figure in black with her little hands against
her body comes stealing noiselessly along the grey walls. Framed
by raven-black hair, a small oval face — brown? — orange-yellow?
I don't know. For a moment she lifts her eyelids and looks with
an askant glance from a pair of jet-black eyes. She is a Chinese
girl, mysterious, quiet, small-buglike in character.

Now one sees a girl who is splendid of health, and who looks
loyal, simple, and jolly; then again a face so sly and false that it
makes one afraid — not to mention the faces damaged by small-
pox, which have the colour of boiled shrimps, with pale grey eyes,
without eyebrows, and sleek thin hair the colour of pig's bristles.

There are pubs of all nationalities, shops with eatables, seamen's
clothes — motley and crowded. One passes through a very narrow
street. This street is long; you are walking, looking about, and
suddenly there arises a hurrah and all kinds of shouting. In broad

daylight a sailor is being thrown out of a public-house by the girls, and is followed by a furious fellow and a bunch of women of whom he seems rather afraid — at least, he scrambles over a heap of sacks and disappears through a warehouse window.

It would be fine to work there, but how and where?

When one has had enough of all this tumult, at the end of the piers where the Harwich and Havre steamers lie at anchor, one sees nothing but an infinite expanse of flat, half-inundated fields, awfully dreary and wet, waving dry rushes, mud; the river with a single little black boat; the sky foggy and cold, grey — quiet as a desert.

At one moment the scene is more tangled and fantastic than a thorn hedge, so confused that one finds no rest for the eye and gets giddy, is forced by the whirling of colours and lines to look first here, then there, without its being possible to distinguish one thing from another, then one stands on a spot where one sees the most beautiful quiet lines.

I have crossed quite a number of streets and back streets without meeting with adventures, and I have sat and talked quite jovially to various girls who seemed to take me for a skipper. I think it not improbable that I shall get hold of good models, with the idea of making portraits and having them paid for by posing.

Well, Antwerp is very curious, and fine for a painter.

This morning I had a walk in the pouring rain, to fetch my things from the custom-house. My studio is not bad, especially as I have pinned a lot of little Japanese pictures on the wall, which amuse me very much: little women's figures in gardens or on the beach, horsemen, flowers, knotty thorn branches. I shall not exactly live in luxury these days, but I feel safe now that I have a little den where I can sit and work when the weather is bad. By spending a few francs more I have a stove and a lamp. I hope not to sit still this winter.

The park is nice, too; I sat and drew there one morning. Last week I painted three studies, one with backs of old houses seen from my window, two in the park. One of these I have exhibited at a dealer's. The picture dealers live in private houses, with no

shop window on the street. Further, I have given the paintings I brought from the country in commission to two dealers, and at another's I can exhibit a view on the quay as soon as the weather permits me to make it. These dealers are not the biggest ones in Antwerp, but at each of their places, among many things I did not like, I saw things which pleased me. All these gentlemen complain bitterly that trade is so slack, but that is no news. I am afraid that in trade, metaphorically speaking, death is always at the door. But there is a good old Dutch proverb: 'Never despair.'

It strikes me at once that if sooner or later you decide to start in for yourself (independent of the Goupils), Antwerp might perhaps be the place. Business might be done by showing good things — something that other firms do not understand. The prices, the public, everything needs renovation, and the future lies in working cheaply for the people.

I have been to see the dining-hall of Leys: 'The Walk on the Ramparts,' 'The Reception'; and the Musée Moderne. In two collections of modern pictures I saw several fine things by Henri de Braekeleer. He is at least as original as Manet. I don't count him amongst those who look for mother-of-pearl effects everywhere, because his is a curious, very interesting endeavour to be literally truthful, and he stands quite apart. Of portraits, those I remember best are the 'Fisher Boy' by Frans Hals, 'Saskia' by Rembrandt, a number of smiling or weeping faces by Rubens.

Ah, a picture must be painted — and why not then simply? When I look into life itself, I get the same kind of impression. I see the people in the street — very well, I often think the workmen more interesting than the gentlemen; in those common fellows I find power and vitality. If one wants to express them in their peculiar character, they must be painted with a firm brush stroke, with a simple technique.

I go to the Museum fairly often and I look at little else but a few heads and hands of Rubens and of Jordaens. I am fairly carried away by Rubens's way of drawing the lines in a face with dashes of pure red, or of modelling the fingers in the hands by the same kind of dashes. I know he is not so intimate as Hals and

Rembrandt, but they are so alive, those heads! Rubens is a man who tries to express, and really succeeds in expressing, a mood of cheerfulness, of serenity, of sorrow by the combination of colours — though his figures may sometimes be hollow.

It is curious that my painted studies made in town seem darker than those made in the country. Is that because the light everywhere in town is not so bright? I don't know, but it may make a greater difference than one would say at first glance. I can understand that the things you have look darker than I thought they were in the country. However, they don't come out badly for all that.

I have made the acquaintance of Tyck, the best paint manufacturer here, and he has been very kind in giving me information about some colours. It is a real delight to work with a better kind of brush, and to have cobalt and carmine, and the right yellow brilliant and vermilion; the most expensive colours are in fact the cheapest. Although the quality of the colour is not everything in a picture, it is the thing that gives it life.

Today I received the supply of paints which they forwarded to me from Eindhoven — and had to pay more than fifty francs for it. It is hard, terribly hard, to keep on working when one does not sell, and when one literally has to pay for one's colours from what would not be too much for eating, drinking, and lodging, calculated ever so strictly. They are building state museums for hundreds of thousands; meanwhile the artists can go to the dogs.

Yesterday I was at the Scala café-concert, something like the Folies Bergères; I found it very dull — but the public amused me. There were splendid women's heads, really extraordinarily fine, among the good folk on the back seats, and on the whole I think it true, what is said of Antwerp, that the women are handsome. Most of the German girls one sees at the café-concerts leave me quite cool; one would say they are all manufactured after one model. One sees that same race everywhere, just like Bavarian beer; it seems to be an article exported wholesale. I find terribly annoying all those German elements which nowadays flock wherever you go. It is sure to be just the same in Paris; they are intruding everywhere. But this is an unpleasant thing to talk about.

Antwerp is beautiful in colour. One evening I saw a popular ball for sailors at the docks; it was most interesting. There were several very handsome girls, the finest of whom was ugly — I mean that a figure that struck me as a splendid Velasquez — or Goya — was one in black silk, most likely a barmaid, with an ugly and irregular face, but liveiy and piquante *à la* Frans Hals. She danced perfectly in an old-fashioned style, once with a well-to-do little farmer, who carried a big green umbrella under his arm even when he waltzed. Other girls wore ordinary jackets and skirts and red scarves. Sailors and cabin boys and nice jolly types of pensioned sea-captains came to take a look.

My thoughts are full of Rembrandt and Hals these days, because among the people here so many types remind me of their time. I shall go often to these popular balls to see the heads of the women and of the sailors and soldiers. One pays the entrance fee of twenty centimes and drinks a glass of beer, for they drink very little spirits, and one can amuse oneself a whole evening — at least I do. It does one good to see people actually enjoy themselves.

If I were better known; if only I could get hold of the models I have seen! But I have secured them elsewhere, so I shall here. The women's figures make a tremendous impression on me, much more to paint them than to possess them — though indeed I should like to do both.

I have noticed many photographers here; they seem to be quite flourishing. One finds portraits also in their studios which are apparently painted on a photographed background. But always those same conventional eyes, noses, mouths, waxlike and cold; always *lifeless*. A real painted portrait has a life of its own which comes straightway from the artist's soul. There seem to be a lot of beautiful women in this city, and I feel sure money is to be earned by painting portraits.

I have also an idea for a kind of signboard; for instance, for a fishmonger, a still-life of fishes; or flowers for a florist; or vegetables for a restaurant.

Today for the first time I feel rather faint. I had painted a picture of 'Het Steen' and went to show it to some dealers. Two were

not at home, one did not like it, and one complained bitterly that
in a fortnight literally not a single person had shown his face in
the shop. I showed it to another dealer, who liked the tone and
the colour of it, but was too engrossed in making up his inventory;
he asked me to come back after New Year's. This is not very en-
couraging, especially when the weather is chilly and gloomy, and
when one has changed one's last five-franc piece and doesn't know
how to get through the next two weeks. I am not a bit better off
than I was that winter in Brussels. I received fifty francs less then;
but painting now costs me much more than fifty francs more.

The picture of 'Het Steen' is rather elaborate; it is just the
thing for foreigners who want to have a souvenir of Antwerp, and
for that reason I shall make still more city views of that kind. But
I like so much better to paint the eyes of people than to paint
cathedrals; for there is something in the eyes that is not in the
cathedral, however solemn and imposing it may be; a human soul,
be it that of a poor beggar or a woman of the street, is more inter-
esting. Though painting the figure presents more difficulties be-
cause of the models, it offers more opportunities, as there are
comparatively few who can do it.

I feel a power in me to do something; I see that my work holds
out against other work, and that gives me a great love of working.
Painting is expen.ʼve, yet one must paint a great deal. What I
cannot understand is why people like Portier and Serret, even if
they cannot sell my things, do not at least see some way of getting
me work. I notice that Portier does not seem to care for my things
any more. Why, after his first favourable impression of my work,
has he become so absolutely indifferent to it?

It has been snowing, and the city was splendid early this morn-
ing; fine groups of crossing-sweeps.

I have discovered a woman — she is old now — who used to
live in Paris and provided the painters with models; for instance,
Scheffer, Gigoux, Delacroix, and another who painted a 'Phryne.'
Now she is a washerwoman and knows a lot of women, and can
always supply some for models.

I took a beautiful model and painted the head of it life-size. It

is quite light, yet it stands out simply against a background in which I tried to put a golden shimmer of light. It is a girl from the *café-chantant*. She had apparently been very busy the last few nights, and she said something that was rather characteristic: '*Pour moi le champagne ne m'égaye pas, il me rend tout triste.*' Then I understood, and I tried to express something voluptuous and pathetic at the same time. If I paint peasant women I want them to be peasant women; for the same reason, if I paint harlots I want a harlot-like expression. That was why the harlot's head by Rembrandt struck me so much. This is for me a new thing; Manet has done it, and Courbet. Damn it! I have the same ambition.

I made a second study in profile. Then I made the portrait that was promised, and painted a study of that head for myself. What rather pleased me was that the girl wanted me to paint again for her the portrait of her which I had made for myself. And she has promised as soon as possible to let me paint a study of her in her room, in a dancer's dress. She cannot do this now because the owner of the café objects to her posing. I fervently hope she will come back, for she has a characteristic face and is witty. At present I am accustoming myself more and more to talk to the models while painting, to keep their faces animated.

There is no denying that they are sometimes damned beautiful, and that it is the spirit of the time that that kind of picture is wanted more and more. And even from the highest artistic point of view, nothing can be said against it; to paint human beings — that was the old Italian art; that was what Millet did, and what Breton does. The question is only whether one shall start from the soul or from the clothes: whether the form shall serve as a clothes-peg for ribbons and bows, or whether one is to consider it the means whereby to express feeling and sentiment — or, if one models for the sake of modelling, because it is so infinitely beautiful in itself. The first is ephemeral; the latter are both high art.

I am working on my portraits all the time, and have at last made two which are decidedly good 'likenesses.'

Now you say, to my disappointment: 'I have so much to pay that you must try to manage till the end of the month.' Am I less

than your creditors? Who must wait, they or I? Do you realize
how heavy for me are the burdens which the work demands every
day? Do you realize that sometimes it is almost impossible for
me to keep going? That I *must* paint; that too much depends on
my continuing to work here immediately without loss of time?
My situation is threatened from every side, and it can only be
saved by working ahead vigorously. The colour bill is a millstone
round my neck, and yet I must *go on!* I, too, must keep people
waiting, and without mercy; they will get their money, but they
will have to wait — it cannot be helped. If I have the weakness to
pay all the time even though I cannot afford it, I do myself too
much harm, and make myself unfit for my work.

Do you know that, as long as I have been here, I have had but
three warm meals — that for the rest my breakfast has come from
the people where I live, and my supper has been a cup of coffee
and bread in the dairy, or else a black loaf that I have in my trunk?
In this way one becomes more vegetarian than is good for one, just
as it was in Neunen for half a year. So when I receive your money,
my stomach cannot digest the food I buy with it. As long as I am
painting, it is more than sufficient, but when the models have left,
there comes a feeling of weakness; when I am out-of-doors, the
working in the open air is too much for me, and I feel too faint.

You wrote that if I fell ill we should be worse off; I hope it will
not come to that. Because I need all my good spirits, all my vi-
tality, I must confess I am afraid to feel physically weak. Painting
is a thing that wears one out. But Van der Loo, the physician at
Eindhoven, told me when I went to see him shortly before I came
here that I was fairly strong, that I need not despair of reaching the
age which is necessary for producing a life's work. Something
about my constitution which made me very glad was that a doctor
in Amsterdam took me for an ordinary workingman, and said: 'I
suppose you are an iron-worker.' That is just what I have tried to
change in myself; when I was younger, I looked like one who has
been intellectually overwrought, and now I look like a skipper or
an iron-worker. But I must be careful withal, and try to keep
what I have, and gain in strength. I am getting thinner every day.

I shall have in any event at the end of this year four or five days of absolute fast. Perhaps you will not be able to understand, but it is true that when I receive the money my greatest appetite is not for food, though I have fasted. Instead, the appetite for painting is stronger still, and I set out at once to hunt for models, and continue until all the money is gone. And my clothes are getting in bad condition, for I have worn them for two years.

I know, Theo, that you also may be rather hard up. But your life has never been so hard as mine these last ten or twelve years. Can you then make allowances for me when I say that perhaps it has now been long enough? Meanwhile I have learnt something which I did not know before, and I protest against my being constantly put back into the country. What can I do there unless I go there with money for models and paint?

To think how many people there are who exist without ever having the slightest idea what care is, and who always keep on thinking that everything will turn out for the best, as if there were no people starving or altogether ruined! It grieves me when I am always in a bad fix. What colour is in a picture, enthusiasm is in life; therefore, it is no little thing to try to keep that enthusiasm.

The other day I saw for the first time a fragment of Zola's new book, 'L'Oeuvre.' I think that this novel if it penetrates into the artists' world may do some good. I will admit that when working strictly from nature something more is needed — facility of composition, knowledge of the figure — but after all, I do not believe I have been drudging for absolutely nothing all these years. Wherever I may be I shall always have an aim, the painting of people as I see them and know them. Whether impressionism has already had its last say or not — to keep to the expression 'impressionism' — I always fancy that in figure drawing many new artists will arise, and I begin to find more and more that one must seek one's security in the deeper understanding of the highest art.

So let me struggle along in my own way, and for Heaven's sake do not lose courage, and do not slacken. I do think you cannot reasonably expect me to go back to the country for the sake of a possible fifty francs a month less, when my whole future depends

on the relations which I must make in town, either here in Antwerp, or later in Paris.

And I wish I could make you understand how probable it is that there will be great changes in the art trade. And in consequence many new chances will come too, if one has something original to show.

For the sake of the models I shall go this month and see Verlat, who is the director of the Academy here. I must see what the conditions are: whether one can work from the nude there, and whether I shall be allowed to paint from the model all day. I shall take a portrait and some drawings with me. But I must be prepared, so that when Verlat says I have to provide myself with painting materials, I shall have the means to do so.

I have now been painting at the Academy, and I must say I like it pretty well; especially because there are all kinds of painters there, something I never before experienced — to see others work. The models are good, and being there will avoid a great deal of expense.

When Verlat saw the two landscapes and the still-life which I had brought from the country, he said: 'Yes, but that does not concern me.' When I showed him the two portraits, he said: 'That is different; if it is figure drawing you can come.' I should like to get on with Verlat. Many of the things he makes I think both hard, and wrong in colour and paint; but I know that he has his good days also, that he paints a better portrait than most of the rest.

When I compare my painted study with those of the others, it is curious to see that theirs have almost nothing in common with mine. Theirs have the same colour as the flesh, so that seen from near-by they are very correct, but if one stands back a little they appear painfully flat — all that pink and delicate yellow, soft in itself, produces a harsh effect. As I do it, from near-by it is greenish-red, yellowish-grey — but when one stands back a little it stands out from the paint; there is atmosphere around it, and there falls on it a certain vibrating light.

The root of all figure painting depends enormously on the

modelling directly with the brush. With Géricault and Delacroix the figures have backs even when one sees them from the front; there is atmosphere around the figures — standing out from the paint. It is to find this that I am working.

This week I painted a large thing with two **nude** torsos — two wrestlers posed by Verlat — and I like it very much.

I draw also in the daytime in the class for the nude, and the teacher there, who makes portraits at present and gets well paid for them, has asked me repeatedly if I had taught myself to draw. He concludes: '*Je vois que vous avez beaucoup travaillé. Vous ne serez pas long à faire du progrès.*' There is one fellow of my age to whom he does *not* say that, though he also has painted a long time. Then he said that Verlat had told him there was some good in my work, which Verlat did not say to me. In this class they draw without background; this makes awfully dry drawing.

Some of the fellows have seen my drawings. One of them, induced by my peasant figures, began at once to draw the model with a much stronger modelling, putting the shadows down firmly. He showed it to me, and we talked it over; it was full of life, and the finest drawing I have seen here of any of the fellows. The teacher, Sibert, sent for him and said that if he dared to do it again in the same way it would be considered that he mocked the teacher. So you see how things are.

However, it does not matter, and one must not get angry about it, but pretend that one would like to cure oneself of the bad habit; unluckily, however, one keeps falling back into it.

I find here the friction of ideas which I want. I get a fresh view of my own work, can judge better where the weak points are; and the cheapest way is to stay at the studio; especially for the more elaborate nude studies it is impossible to provide the models oneself. But I think it not impossible that in the long run, especially if the other fellows involuntarily begin to draw stronger shadows, Verlat will seek a row with me, even if I systematically avoid it.

I have arranged with Vinck (a pupil of Leys) to draw in the evening from the antique. I must say that I believe that for the making of peasant figures it is very useful to draw from the casts;

but, please, not as it is usually done. The sentiment of what antique sculpture is — damn it, not one of them has it. The drawings I see there are all in my opinion remarkably bad, and entirely wrong. Well, time must show who is in the right; probably the academical gentlemen will accuse me of heresy. For years I have not seen any good ancient casts, and during all those years I have always had the living model before me; on seeing them again, I am dumbfounded by the wonderful knowledge and the correctness of feeling of the ancients.

After this class, from half-past ten till half-past eleven, I work from the model at a club; I have become a member of two of these clubs.

So I have been tremendously busy. I think none of these things will do me harm, and at all events it is an attempt to get into touch with people. In the classes are several people of my age. It interests me after having drawn from clad models to see the nude again, and the ancients, and to verify things; to be accepted somewhere in Paris one must have worked somewhere else before, and one always meets with people who for a longer or shorter time have already worked at an academy.

The advice Verlat and Vinck give me is very severe; they strongly advise me to draw for at least a year, if possible to draw only from casts or the nude.

It is very cold here, and I am far from well most of the time, but as long as the painting flourishes I feel in high spirits. It refreshes me to be in an environment the exact opposite of that of the country.

When I compare myself to the other fellows there is something stiff and awkward about me; I look as if I had been in prison for ten years. It is a fact that I must change my outward appearance. I am busy having my teeth seen to; there are no less than ten teeth which I either have lost or may lose; that is too many, and it gives me a look of over forty which is not in my favour. This work will cost me one hundred francs, but it can be done now, while I am drawing, better than at any other time.

At the same time I ought to take care of my stomach; during

the last month it has begun to trouble me a great deal; I have begun to cough continually too. I went to live in my own studio in Neunen on the first day of May, and I have not had a hot dinner more than six or seven times since. I lived then, and I do so here, without money for dinner because the work costs me too much, and I have trusted too much to my being strong enough to hold out. I shall not tell Mother that I am not well, for perhaps she would begin to worry about me, thinking that it was not kind to let things happen as they did, and that I should have stayed at home so as to avoid these consequences. I have made things worse by smoking a great deal, which I did because then one does not feel an empty stomach so much.

I began to feel worried when more and more teeth broke off; my mouth being generally painful, I swallowed my food as quickly as possible. You see, I am no stronger than other people, and if I neglect myself too much it would be the same with me as with so many painters (so very many, if one thinks about it), and I should catch my death, or — worse still — become crazy or an idiot. What the doctor tells me is that I absolutely must take better care of myself. It is a complete breakdown.

The main thing is not to fall ill this month. If my condition grew worse and took a serious turn, it might develop into typhus. I do not think this will happen, because I have had much fresh air; I have lived and eaten too simply for my condition easily to become malignant. But, Theo, this indisposition is a bad thing just now, though you must not worry about it, for neither do I; I have a certain calmness and serenity notwithstanding all. And one must not think that the people whose health is damaged are no good for painting. One may have all kinds of ailments, yet the work need not suffer from it. On the contrary, nervous people are more sensitive and refined.

Delacroix said he had learned the secret of painting: '*Lorsqu'il n'avait plus ni dents ni souffle.*' But I also know that from that moment he took care of himself, and that without his mistress he would have died ten years or more sooner than he did.

Like you, I have been on 'Père la Chaise.' I have felt respect

beside the humble tombstone of Béranger's mistress, which I looked for on purpose (if I remember, it is in a corner behind his own), and there I remembered also Corot's mistress. Quiet muses, these women were, and in the emotion of those gentle masters, in the intimacy, the pathos of their poetry, I always feel the influence of a woman's element.

I believe more and more that to work for the sake of the work is the principle of all great artists: *not* to be discouraged even though almost starving, and though one feels one has to say farewell to all material comfort. Israëls himself was quite unknown and poor, even to dry bread — yet he wanted to go to Paris. One sees from the de Goncourts how obstinacy is needed; society will not thank them for it.

Do not be angry with me at the expense. It is not at all pleasant, but necessity breaks laws, and if one wants to paint pictures one must try to keep alive.

I am longing to hear about your apartment. If I come to Paris I shall be perfectly contented with a cheap little room in some re- mote quarter (Montmartre) or a garret in an hotel. As to the plan of living together and taking a rather good studio where one can receive people, I feel great, great sympathy for it. It would not surprise me if once having got hold of the idea you will find it more and more strange that for ten years we have been so little together.

For you to come home in the evening to a studio I think would do you no harm; what I am not sure of is whether we shall agree personally. I must say about myself the same as what you write about yourself: *You will be disappointed in me.* But not in every- thing, not in my way of looking at things. In your judgment of me you rely too much on commonplaces and on prejudices, which are too superficial and too incorrect for me to believe you will stick to them always. The thing is perhaps for us to combine, and the result may be a much better understanding.

As to a studio, if we could find in the same house a room with an alcove and a garret or corner of an attic, then you could have the room and alcove, and we could make ourselves as comfortable as possible. During the daytime the room could serve as a studio.

But if it is expensive, and we are hard up, perhaps the most sensible thing would be to wait before taking a studio. If we work for another year, if we repair our health, both you and I — *then* we can resist things so much better than now. I have heard painters complain: 'I have taken an expensive room to induce people to come to me, but since then nobody has come, and I myself do not feel at home in it.' Let me draw for a year at Cormon's; do you meanwhile once more thoroughly investigate business. Then I think we may risk it; and in that year we should learn to know each other better and more intimately, which may bring a great change.

And such a studio — in starting it one must realize that it will be a battle and that people in general will be absolutely indifferent; so that one ought to begin it feeling confident of some power — wanting to be somebody, wanting to be active, so that when one dies one can think: I go thither where go all those who have dared something. We can try two things: make some good things ourselves, and collect and deal in the things we admire of other people's. If we keep to the positive fact of wanting to produce and to be somebody, then we can talk over facts without getting angry, even if they stand in direct relation with the Goupils or our family. I must tell you at the beginning that I wish both of us might find a wife before long, for it is high time. It is one of the first requisites for our healthier life, and in intercourse with women especially one learns so much about art.

What pleases me is that you yourself now propose the plan of going to Cormon's. They say that one is relatively freer in Paris; one can choose one's subjects more than one does here. And you know clever fellows who would not refuse to correct my work and give me some hints.

For the rest, Cormon would probably say the same thing as Verlat: that I must draw from the nude or from casts for a year, just because I have always been drawing from life; then I shall know the man's figure and the woman's almost by heart. And when people like Verlat or Cormon demand that of a fellow, I assure you it is not a bad sign. For there are plenty of those whom Verlat simply leaves to drudge on.

He who can draw a figure from memory is much more productive than he who cannot. They hardly ever use nude women models at this academy; at least in the class not at all, and rarely privately. Even in the antique class there are ten men's figures to one woman's. In Paris, of course, this will be better, and it seems to me that one learns so much from the constant comparing of the masculine with the feminine figure, which is in everything so different. It may be supremely difficult, but what would art, and what would life, be without difficulties?

Nor must you suppose that my years of drawing out-of-doors have been thrown away. For that is exactly the thing that those who have only worked at academies and studios lack — the vision of the reality in which they live. At Cormon's I shall have to do with people who have drawn from casts for years; if I do it for months, it will not be too long. I am perhaps more daring in dashing things down and grasping the *ensemble* than many others because I have worked from nature, but the others probably have more knowledge of the nude, for which I have not had the opportunity.

Drawing, in itself, the technique of it, comes to me easily enough. I begin to do it as I do writing, with the same ease. But at that very point it becomes more interesting if one aims seriously and thoroughly at originality and broadness of conception.

You speak about clever fellows at Cormon's studio — I should damn well like to be one of them.

I finished yesterday the drawing which I made for the competition of the evening class. It is the figure of Germanicus. I am sure I shall be the last, because the drawings of all the others are just alike, and mine is absolutely different. But the drawing which they will think the best, I have seen it made; I was sitting just behind it. It is correct, but it is *dead*. And that is what all the drawings are that I saw.

The teacher, Sibert, deliberately sought a row with me, perhaps with the aim of getting rid of me. The matter behind it was that the fellows of the class talk about my work, and that I have said outside the class to some of the fellows that their drawings are **absolutely wrong**.

I can tell you that if I went to Cormon, and sooner or later got into trouble with either the teacher or the pupils, I should not mind it. Even without a teacher I might go through a course of drawing from the ancients, by going to draw at the Louvre.

The course here finishes on the thirty-first of March. If it must be, I am willing to go to Neunen to see how things are there, but to return to Brabant is a roundabout way, a loss of time. No money is left to take painting materials there from here, and the same story will begin all over again: I shall train myself by taking models; I do not think that would be right. As I *must* go on, and as I am at the same time ill, I cannot but ask you to allow me to stay here until I go to Paris, but I want to tell you that it would calm me greatly if you would approve of my coming earlier than June or July.

I should come straight to Paris after March and begin to draw either at the Louvre or at the École des Beaux Arts; I could then finish at once what is most pressing — those studies from the ancients, which certainly will help me a great deal when I go to Cormon's; and by that time I should feel at home again in Paris.

I should like it so much. I will rent a garret, and then we can talk over so much better the taking of a studio about June. I also continue to believe that there will be some work for me, though I have not been lucky in that respect.

My time here has at all events come almost to an end. My health is improving a little. I do not get on with my work, but I do not force it; I want to keep my strength for that first time in Paris. I should like to come there in good condition.

After all, Antwerp has pleased me very well. Of course I wish I had arrived here with the experience which I now have at the moment of leaving. I hope to come back sometime. This is a city that resembles Paris because it is the centre for people of all nationalities: for the sake of business, and for its liveliness and the fact that one can amuse oneself here. I have not seen Antwerp in its usual flourishing condition, for one hears that it used to be much livelier.

Yesterday I heard that Sibert had told somebody that I had a

good idea of drawing and that he had been rather too hasty. As he does not come to class often, I had not seen him for a few days. I have now finished another drawing from a cast; Sibert said it had not been his intention to offend me, and he even said that my drawing of today needed hardly any correction of proportion, and none at all of tone.

I am working at the moment on a woman's bust. It is more distinguished in modelling and less brusque than the first drawings from the casts, where the figures remind one of peasants or woodcutters.

Today is almost a spring day. I think in the country they will have heard the lark sing for the first time. This morning I took a long walk alone all through the city, in the park, along the boulevards. There was something of resurrection in the atmosphere, yet what depression there is in business and among the people!

I do not think one exaggerates if one is pessimistic about the strikes everywhere. For succeeding generations they will certainly prove not to have been useless, for *then* they will have proved a success. But now it is hard for anybody who must earn his bread by his work, the more so because we can foresee that it will get worse and worse from year to year. The labourer against the bourgeois is as justifiable as was the *tiers état* against the other two a hundred years ago. And we are still far from the end.

So though it is spring, how many thousands and thousands walk about in desolation!

As well as does the greatest optimist, I see the lark soaring in the spring air, but I see also the young girl of about twenty who might have been in good health a victim to consumption; and who perhaps will drown herself before she dies of her illness. If one is always in respectable company, among rather well-to-do bourgeois, one does not notice this, perhaps, but if one has dined for years on *la vache enragée*, as I did, one cannot deny that great misery is a factor that weighs down the scale.

All the time I was here I had a comrade, an old Frenchman, whose portrait I painted — of which Verlat approved. For this old man the winter was still worse than for me, because of his age.

I was with him at the doctor's, and he will probably have to undergo an operation; at least I persuaded him to go to the hospital. It is possible that for his sake I shall stay here a few days longer. After all, there is nothing in the world as interesting as people, and one can never study them enough. That is why people like Turgenev are such great masters: they teach us to observe.

Corot, who had more serenity than anybody else — was he not all his life as simple as a workingman? And so sensitive to all the miseries of others? When he was already very old in '70 and '71, he certainly looked at the bright sky, but at the same time he visited the field-hospital where the wounded lay dying.

Illusions may fade, but the sublime remains. If one should doubt of everything, one has no doubts of people like Corot and Millet and Delacroix. And I think that in moments when one does not care any more for nature, one still cares for humanity.

You, too, are neither happy nor in good enough spirits, you have too much care and too little prosperity. When one stands isolated and misunderstood, and has lost all chance of material happiness, this one thing remains — *faith*. One feels instinctively that many things are changing, but it is already something to scent the unhealthy closeness and oppressiveness of the hours that precede the thunderstorm, and to say: We still feel the closeness, but the following generations will be able to breathe more freely.

A Zola and a de Goncourt believe this, with the simplicity of grown-up children; they, the most rigorous analysts, whose diagnosis is both so callous and so exact. And Turgenev and Daudet, they do not work without an aim or without a glance beyond. You see, the thing that supports one is the realization that one is working and thinking with others. That increases one's strength, and one is infinitely happier.

There may sooner or later come a moment when you will know *for sure* that all chance of material happiness is lost, fatally and irrevocably, but know also that at the same moment there will be a certain compensation in feeling in oneself the power to work.

One cannot predict anything with certainty. But if one analyzes one sees that the greatest and most energetic people of the century

have always worked *against the grain*, and have always worked
from personal initiative — both in painting and in literature. I do
not know anything about music, but I suppose it has been the
same there. To begin on a small scale, to persevere *quand même*,
to have character instead of money, more audacity than credit —
that was typical of Millet and Sensier, of Balzac, Zola.

The amount of work the de Goncourts have achieved is enor-
mous. It is such a splendid idea, this working and thinking to-
gether. And daily I find proof for the theory that the chief reason
for much misery among the artists lies in their mutual discord, in
not co-operating, in not being true to each other, but false.

What I find moving is the great serenity of the great thinkers
of the present. Voltaire, Diderot — they were the men who made
the Revolution. It is the work of a genius to dominate one's time,
and to make the minds that are thoughtless and passive strive in
one direction and after one aim.

I think of the last walk of the two de Goncourts, the last days
of old Turgenev too. Sensitive, subtle, intelligent as women;
sensitive to their own suffering also, yet always full of life and
self-confidence — no indifferent stoicism, no contempt for life.
These fellows die as women die: no fixed idea about God, no ab-
stractions, always on the firm ground of life itself, and attached
only to that.

Meanwhile we have not yet come so far; we have first to work,
first to live, be it without happiness in the ordinary sense; painting
has, after all, the secret of being able to give one a second youth.
Carlyle is also one who dared a great deal and had a different in-
sight into things from the rest; the more of their lives I trace, the
more I find always the same story: lack of money, bad health, op-
position, isolation, trouble from beginning to end.

All my attention is concentrated on gaining what I wish to
gain — free scope to make my career. That means to overcome
obstacles instead of giving way under them.

It is a pity that as one gradually gains experience one loses one's
youth. If that were not so, life would be too good.

BOOK IV

March 1886–July 1890

D O NOT be cross with me for having come all at once like this; I have thought about it so much, and I believe that in this way we shall save time. We shall fix things up, you will see.

I got your letter this morning, and I think it is all to the good that you have broached the subject to our uncles in Holland. And I do not think I was wrong in my 'It must be full speed ahead.'

I have painted the sequel to those flowers that you have. A branch of white lilies — white, pink, green — against black, something like black Japanese lacquer inlaid with mother-of-pearl; then a bunch of orange tiger lilies against a blue background; a bunch of dahlias, violet against a yellow background, and red gladioli in a blue vase against light yellow.

I am quite willing to make an exchange for two water-colours by Isabey, especially if there are figures. Try to make an exchange for the sequel I have here. Would it not be possible to get the Otto Weber from Prinsenhage, that beautiful 'Autumn'? I would give them a series of four in exchange. We need pictures more than drawings.

I have two louis left, but I am afraid I shall not be able to manage from now till your return. When I began to work at Asnières, I had plenty of canvases, and Tanguy was very good to me. To do him justice, he is just as good still, but his old witch of a wife got wind of what was going on and opposed it. All the same, he will do whatever I want of him.

I saw de Lautrec today; he has sold a picture, I think through Portier.

And now I have been to the Tambourin. Not going there looked

like funking it. I said to the Segatori that I did not judge her in this business, but that it was for her to judge herself; that I had torn up the receipt for the pictures, but that she ought to return everything; and that since she had not come to see me, I took it that she knew they were trying to pick a quarrel with me, and that she had tried to warn me when she said, 'Go away,' which I did not understand at the time, and perhaps didn't want to understand.

She answered that the pictures and all the rest were at my disposal, but that it was I who had tried to pick a quarrel — which doesn't surprise me, knowing that if she took my part they would treat her abominably. I did not want to take the pictures straight off, but I said that when you came back we could talk about it because the pictures belonged to you as much as to me.

She did not look well, and was as white as wax. Although I should not say this openly, my opinion is that she has procured an abortion. I do not blame her, for she is in a bad way: she is neither a free agent nor mistress in her own house, and worst of all, she is ill and in pain.

In two months' time she will be better, I hope, and then perhaps she will be grateful to me for not bothering her. I know her well enough to trust her still. And, mind you, if she manages to keep her place going, from the point of view of business I should not blame her for choosing to be top-dog and not under-dog. If in order to get on, she tramples on my toes a bit — well, she has my leave. When I saw her again, she did not trample on my heart, which she would have done if she had been as bad as people said.

But you can be sure that I shall not try to do any more work for the Tambourin. As for the Segatori, that's very different. I have still some affection for her, and I hope she still has some for me.

I saw Tanguy yesterday, and he has put a canvas I've just done in his window. I have done four since you left, and I have a large one on hand. I know that these long canvases are difficult to sell, but later on people will see that there is open air in them, and that they are in a good vein.

The whole lot would do for decorations for a dining-room or a

country-house. And if you fall very much in love and get married, it doesn't seem to me out of the question that you will rise to a country-house yourself some day, as so many other picture dealers have done. If you live well you spend more, but you gain ground that way, and perhaps one gets on better these days by looking rich than by looking shabby. It's better to have a gay life of it than to commit suicide.

I was touched by what you wrote about home: 'They are fairly well, but still it is sad to see them.' A dozen years ago you would have sworn that at any rate the family would always prosper. It would be a great satisfaction to Mother if you were to marry, and for the sake of your health and your work, you ought not to remain single.

As for me, I feel that I am losing the desire for marriage and children, and now and then it saddens me that I should be feeling so at thirty-five, just when it should be the opposite. And sometimes I have a grudge against this rotten painting. It was Richepin who said somewhere:

L'amour de l'art fait perdre l'amour vrai.
(The love of art means loss of real love.)

I think this is terribly true, but on the other hand, real love makes you disgusted with art. At times I feel old and broken, yet still enough of a lover not to be a real enthusiast for painting.

To succeed one must have ambition, and ambition seems absurd. It depresses me to think that even when it's a success, painting never pays back what it costs. What will come of it I don't know; I should like above all things to be less of a burden to you; and that is not impossible in the future, for I hope to make such progress that you will be able to show my stuff boldly without compromising yourself. Then I shall take myself off somewhere down South, to get away from the sight of so many painters that as men disgust me.

THERE'S a depth of about two feet of snow everywhere, and more still falling. Arles doesn't seem to me any bigger than Breda or Mons.

Before getting to Tarascon, I noticed a magnificent country of huge yellow rocks piled up in the strangest and stateliest forms. In the little village between these rocks were rows of small, round trees with olive-green or grey-green leaves; but here at Arles the country seems flat. I have seen some splendid red stretches of soil planted with vines, with a background of mountains of the most delicate lilac. And the landscapes in the snow, with the summits white against a sky as luminous as the snow, were just like the winter landscapes that the Japanese have painted.

During the journey I thought of you at least as much as I did of the new country I was seeing. I said to myself that later on you might be coming here often yourself. It seems to me almost impossible to work in Paris unless one has some place of retreat where one can revive, and regain one's tranquillity and poise. Without that one would get hopelessly brutalized.

I now have a study of a landscape in white with the town in the background; also two little studies of a branch of almond already in flower in spite of the snow. This is more than I could have managed in Paris these days. I could not have stood it much longer. I have thought now and then that my blood is actually beginning to think of circulating. I am better, except that it is real forced labour to eat, as I have a touch of fever and no appetite; but it's only a matter of time and patience.

I can hardly manage to live any cheaper here than in Paris, worse luck; I reckon the cost at five francs per day.

I have had a letter from Gauguin telling me that he has been in bed for a fortnight; that he is on the rocks, as he has had to pay some crying debts. He wants to know if you have sold anything for him; he is so pressed for a little money that he would be ready to reduce the price of his pictures still further.

Poor Gauguin has no luck. I am very much afraid that in his

case convalescence will be even longer, and I am heartily sorry for his plight, especially now that his health is shaken. He hasn't the kind of temperament that profits by hardships; on the contrary, this will only knock him up, and that will spoil him for his work. My God! Shall we ever see a generation of artists with healthy bodies?

He says that in all the variety of distresses that afflict humanity nothing maddens him more than the lack of money; yet he feels himself doomed to perpetual beggary. The only thing to do is to write to Russell. After all, we have already tried to make Tersteeg buy one of Gauguin's things. But what is to be done? Would you risk taking the seascape from him for the firm? If that were possible, he would be safe for the moment.

How difficult for many of us — and assuredly we ourselves are among the number — the future is still! I firmly believe in victory at last, but will the artists themselves have any advantage from it, and will they see less troubled days? It would be some comfort if one could think that a generation of more fortunate artists was to come.

Now about Reid, the English art dealer; for us to say that we have never gained any advantage from his acquaintance would be rather unfair, since he has made us the present of a very fine picture; he has sent up the price of the Monticellis, and since we own five, it follows that these have gone up likewise; he was right good company for the first few months.

On our side, we tried to get him into a far bigger thing than the Monticelli; our interest in the dead painter is only from the money standpoint, so there can be no doubt of our good faith towards him. But it is not enough to be fond of the pictures; Reid seems to me to have no feeling for the artists. And as for the impressionists, if we are to keep the right to be masters of our own ground it is fair that they should be introduced into England through your agency.

But you need the support of other employees of the firm. You must speak to Tersteeg at once. In view of the lowness of the price compared with the interest the pictures offer, Tersteeg could easily

get rid of fifty or so in Holland; besides, he will be obliged to have some of them, because, if they are being talked of already at Antwerp and Brussels, they will likewise be talked of at Amsterdam and The Hague before long.

And as Tersteeg is as much at home in English business as a fish in water, I think now that he ought to start the impressionist exhibition in England. Tersteeg should be told about Reid and know that he has a rival for the English business, and that we should rather he did it — though this isn't my business, but that of the Boussod Valladon firm, to which you and Tersteeg belong.

But the association of the artists will come about the more easily, since Tersteeg will have no objection to our having the artists' interests at heart, and above all our wanting to raise the net price of the picture. The whole crux of the matter in England is this: either the artists will give away their work at a wretched price to the dealers there, or else they will combine and choose for themselves intelligent agents who will not fleece them. We must speak out boldly now, don't you think? And Mesdag and the rest must give up chaffing the impressionists.

If only Tersteeg would take the initiative in introducing the impressionists into England. But he must see plenty of them for himself first. Propose to him that you will pilot him round the studios, and he will see that next year people will be talking and will go on talking about the new school.

If Tersteeg refuses, we still have Reid or Wisselingh as English agents. But in any case, if Wisselingh ever took it up, at once Tersteeg could reproach you: 'And why, sir, when you took up the impressionists, did you keep the firm that employs you in the dark?'

Tersteeg has something about him which convinces collectors. I should be so glad to hear that you had managed to persuade him; but we must be patient.

What do you think of the news of the Emperor William's death? Will this hurry up things in France, and is Paris going to stay quiet? And what will be the effect of all this on the picture trade? There seems to be some idea of abolishing the customs on pictures going into America.

Perhaps it will be easier to get dealers and collectors to agree to buy the impressionist pictures than to get the artists to agree to go equal shares in the price of the pictures sold. The artists couldn't do better than to combine, hand over their pictures to the Association, and share the proceeds of the sale, so that the Society could at least guarantee its members a chance to live and to work.

If Degas, Claude Monet, Renoir, Sisley, and Pissarro would take the initiative and say: 'Look here, we five give each ten pictures, and we undertake to give each year ... And we invite you, Guillaumin, Seurat, Gauguin, Bernard, Anquetin, Lautrec, Van Gogh, "The Painters of the *Petit* Boulevard," to combine with us ...'

Thus the great impressionists of the *Grand* Boulevard would keep their prestige, and the others could no longer reproach them for keeping to themselves the advantages of a reputation acquired in the first place by their personal efforts and individual genius, but a reputation that is growing, buttressed, and actually maintained by the pictures of a whole battalion of artists who up to now have been working in continual beggary.

Saturday evening I had a visit from two amateur artists, a grocer who sells painting materials as well, and a magistrate, who seems a nice fellow and intelligent.

I have made the acquaintance of a Danish artist, Mourier Petersen, who some time ago saw the exhibition of the impressionists in the Rue Lafitte. I now have company in the evening, for he is a decent soul; his work is dry, correct, and timid, but I do not object to that when the painter is young and intelligent. He has read Zola, de Goncourt, and Guy de Maupassant, and has enough money to do himself well.

It is a very good thing that you have taken in young Koning. I am so glad that you are not going to be alone in your flat. In Paris one is always as down in the mouth as a cab horse, and if on top of that one has to stay all alone in the stable, it's too much. Indeed, it will do you good to take breakfast. I do it here myself, and eat two eggs every morning. My stomach is very weak, but I am really much better already than I was in Paris.

This morning, at long last, the weather turned milder — and
likewise I have already had an opportunity of learning what a
mistral is: I have been for several walks in the country round here,
but in this wind it is impossible ever to do anything. The sky is a
hard blue, with a great bright sun which has melted almost all the
snow, but the wind is cold, and so dry that it gives you goose-flesh.
But I have seen lots of beautiful things — a ruined abbey on a
hill covered with holly, pines, and grey olives. We'll have a try
at that soon, I hope. The almond trees are beginning to flower
everywhere.

I have just finished a study like the one of mine that Lucien
Pissarro has, but this time it is oranges. That makes eight studies
so far. But this really doesn't count, because I haven't yet been
able to work in any comfort or warmth. I hope that the work will
now go ahead steadily, and that in a month I shall be able to send
you a first consignment. I want to send you only the best.

Today I brought back a canvas of a drawbridge with a little
cart going over it, outlined against a blue sky — the river blue as
well, the banks orange-coloured, with green grass and a group of
washerwomen in smocks and many-coloured caps. And I have
another landscape with a little country bridge and more washer-
women; also an avenue of plane trees near the station.

Old chap, I feel as though I were in Japan. I say no more than
that, yet I have not seen anything in its usual splendour. That is
why — even though I'm vexed that just now expenses are heavy
and the pictures worthless — I don't despair. Here I am seeing
new things, I am learning; if I go ahead slowly, my body doesn't
refuse to keep me going. I must reach the point when my pictures
will cover what I spend. I don't make a success of everything, I
admit, but I'm getting on.

So far you have not complained of my expenses here, but I warn
you that if I continue to work at the same rate, I shall have great
difficulty in managing. I have spent more on my paints and canvas
than on myself. As soon as I can pay for packing-case and carriage
charges, I shall send you the studies. Haven't a penny at the
moment.

I am rather curious to know what you will think of my first batch, which will certainly contain at least ten canvases.

I am sending you an order for paints; if you order them at Tasset's, it would be well, since they know me, to tell them that I expect a discount at least equal to the cost of sending. Also you will please ask old Tasset for his absolutely lowest price for canvas?

I have been getting my paints and canvases either at the grocer's or at a bookshop, and they have not everything I should like. The colour merchant here makes me absorbent canvas, but he is slow about it. *Whilst I was waiting* for one absorbent canvas, I painted two on canvas that was non-absorbent. The blossoming season is so soon over, and this kind of subject delights everybody.

But if there should be a month or a fortnight that you were hard-pressed, I should set to work on some drawings. You must not put yourself out unnecessarily; there is so much to do here — not as it is in Paris, where you can't sit down wherever you want.

Do as you think best about showing the two big landscapes of the Butte Montmartre at the exhibition of the independents. I am counting more on this year's work. And thank you very much for all the steps you have taken towards the exhibition of the independents.

Though it doesn't in the least matter this time, in future my name ought to be put in the catalogue as I sign it on the canvas, Vincent, and not Van Gogh, for the simple reason that they do not know how to pronounce the latter name here.

I congratulate you on the purchase of the Seurat; with what I shall send you you must try to arrange another exchange with Seurat as well. When I write to Russell I shall talk to him about his pictures and ask him to exchange one with me. We shall want to show his pictures as soon as the question of the New Renaissance comes up. Has de Lautrec finished his picture of the woman leaning on her elbows on a little table in a café?

Has that confounded Tersteeg written to you yet?

Now I've seen the streets of this town full of excited crowds, and indeed it was a fine sight. I was present at the inquiry into a crime committed at the door of a brothel here; two Italians killed two

zouaves. I took the opportunity to go into one of the brothels in
a small street called '*des ricolettes*.' That is the extent of my
amorous adventures among the Arlésiens.

The zouaves, the brothels, the adorable little Arlésiennes going
to their first communion, the priest in his surplice who looks like a
dangerous rhinoceros, the people drinking absinthe — all seem
to me creatures of another world. The women here are beautiful,
no humbug about that; but the Museum at Arles is a horror and
ought to be at Tarascon. There is also a museum of antiquities,
but these are genuine.

Every day is a good day now — not as to the weather; on the
contrary, there are three windy days to one that's quiet, but the
orchards in blossom that there are to paint! I have great difficulty
because of the wind, but I fasten my easel to pegs driven into the
ground and work in spite of it.

I have been working on a canvas in the open air in an orchard —
lilac ploughland, a reed fence, two rose-coloured peach trees
against a sky of glorious blue and white. Probably the best land-
scape I have done.

I had just brought it home when I received from our sister a
Dutch notice in memory of Mauve. Something — I don't know
what — took hold of me and brought a lump to my throat, and I
wrote on my picture:

> Souvenir of Mauve
> Vincent and Theo.

And if you agree, we two will send it, such as it is, to Madame
Mauve. I don't know what they will say of it at home, but that
does not matter.

It seemed to me that everything in memory of Mauve must be
at once tender and gay, and not a study in any graver key.

> O never think the dead are dead:
> So long as there are men alive,
> The dead will live, the dead will live.

That is how I feel it. Nothing sadder than that. But his death was
a terrible blow to me.

Congratulations on Tersteeg's letter; I think it is absolutely satisfactory. Has he taken into account the resulting depreciation in value of pictures now highly priced that will come as soon as the impressionists' stock rises? Dealers in expensive pictures ruin themselves by opposing for reasons of policy the advent of a school which for years has shown an energy and perseverance worthy of Millet, Daubigny, and the rest.

Tersteeg says he is prepared to buy a good Monticelli for his own collection. What if you were to say to him that we have in our collection a bunch of flowers which is a better piece of painting and more beautiful than one by Dias? That Monticelli sometimes made a bunch of flowers an excuse for gathering together in a single panel the whole range of his richest and most perfectly balanced tones? And that you must go straight to Delacroix to find anything equal to his orchestration of colours?

He has written you: 'Send me some impressionists, but only those pictures that you yourself think the best'; and since you sent a picture of mine in that consignment, I find myself in the not very easy position of having to *convince* Tersteeg that I am actually a genuine impressionist of the *Petit* Boulevard, and that I intend to remain so.

Well, he shall have a picture of mine in his own collection. It is the drawbridge with the little yellow cart. Believe me, Tersteeg will not refuse the picture. I have made up my mind that it and the one for Jet Mauve must go to Holland.

I keep on thinking that we must do something in Holland. Suppose we give to the Musée Moderne at The Hague, since we have so many memories of The Hague, the two views of Montmartre exhibited at the Independents'; and that we also give a study to our sister Wil. I have been more moved than perhaps I had any reason to be these last few days, thinking about Mauve and Weissenbruch, Tersteeg and Mother and Wil, and it steadies me to say to myself that there'll be some pictures painted to go there. Afterwards I shall forget them, and think only of the *Petit* Boulevard.

I'm very curious to know what the result will be at the end of a year. I hope that by that time I shall be less bothered with sick

turns. At present I am pretty bad some days, but I don't worry about it; it is nothing but the reaction after last winter, which was out of the ordinary. And my blood is coming right again, that is a great thing.

This month will be hard on both you and me. I am using a tremendous lot of colours and canvases, but I hope it isn't a waste of money. If you can manage, it will be to our advantage to make the most we can of the orchards in bloom. I am well started now, and I think I must have ten more. Out of four canvases perhaps one will make a *picture*, like the one for Tersteeg or Mauve, but the studies I hope will come in useful for exchanges. I hope Pissarro will make an exchange with us some day.

The weather today has been fine. This morning I worked at an orchard of plum trees, yellowish-white, with thousands of black branches. All at once a fierce wind sprang up, an effect I had never seen before, and returned at intervals. Between times the sun shone, and all the little white flowers sparkled.

It was so lovely. My friend the Dane came to join me, and at the risk every moment of seeing the whole show on the ground, I went on painting.

I have finished a group of apricot trees in a little orchard of fresh green — apricot trees of a very pale rose. It is as good as the rose-coloured peach trees. You will see that the rose-coloured peach trees were painted with a sort of passion.

But as to the execution of what one paints outside like this, what will people say? Well, we shall see.

After dinner I set to work on the same picture that Tersteeg is to have, the 'Pont de l'Anglais,' for you. If I can manage to learn to work out on a fresh canvas studies taken from nature, we should profit by it so far as a likelihood of selling is concerned.

You were right to tell Tasset that he must put in the geranium lake. Of all the colours I ordered, the three chromes (orange, yellow, lemon-yellow), the Prussian blue, the emerald, the crimson lakes, the malachite green, and the orange lead, hardly one of them is to be found on the Dutch palette, in Maris, Mauve, or Israëls. They are only to be found in Delacroix, who had a passion

for the two colours which are most condemned, lemon-yellow and Prussian blue. I think he did superb things with them. *All the colours that the impressionists have brought into fashion are unstable,* so there is all the more reason to use them boldly too crude; time will tone them down only too well.

I was sorry afterwards not to have asked old Tanguy for the paints; not that there would have been the least advantage in doing it — rather the other way — but he's such a comical old soul, and I think of him many a time. Don't forget to say how d'you-do for me if you see him; and tell him that if he wants pictures for his window, he shall have some from here, and the best, at that.

Oh! it seems to me more and more that *people* are the root of everything, and though it will always be a melancholy thought that you yourself are not in *real* life — I mean that it's more worth while to work in flesh and blood itself than in paint or plaster, more worth while to make children than pictures, or carry on business — you feel that you're alive when you remember that you have friends who are out of real life as much as you are.

You will say that in that case it would be a good thing to do without art and artists. That is true at first sight, but then the Greeks and the French and the old Dutchmen have accepted art; we see how art always comes to life again after inevitable periods of decadence, and I do not think that anyone is the better for holding artists and their art in contempt. At present I do not think my pictures are worthy of your kindness to me. But once they are worthy, I insist that you will have created them as much as I, and that we are fashioning them together.

You are kind to painters, and I tell you the more I think, the more I feel that there is nothing more truly artistic than to love people. If what one is doing looks out upon the infinite, and if one sees that the work has its vital principle and continuance beyond, one works with more serenity. So you have a double right to that serenity.

And just because it is what people have in their hearts that matters, and because it is at the heart of all business too, we must make friendships in Holland, or rather revive them; more especially

since as far as the impressionist cause is concerned there is little fear now but that we shall win.

I am in the middle of 'Pierre et Jean,' by Guy de Maupassant. It is good. In the preface he declares the liberty of the artist to exaggerate, to create in his novel a world more beautiful, more simple, more consoling than ours, and goes on to explain what Flaubert perhaps meant when he said that 'Talent is long patience, and originality an effort of will and of intense observation.'

I believe in the absolute necessity for a new art of colour, of design, and — of the artistic life. And if we work in that faith, it seems to me that there is a chance that our hope will not be in vain.

I have had a letter from Bernard with some sonnets he has concocted, and some among them really come off. He will manage to write a good sonnet yet — a thing I could very nearly envy him.

It is important news — your journey to Brussels. You will be able to judge how the old high-priced stuff is going there. We talked about it before I left, and agreed that Bouguereau, Lefèvre, Benjamin Constant, the whole set, should go to Boussod's to complain, and to insist that they count on the firm of Boussod Valladon (the best in the world) remaining true and faithful to the principles of that art which is in truth the most civilized and most attractive — that is to say, their own pictures. It is pretty disquieting. And things would be serious if you quarrelled with these gentlemen. What a business!

I am working at the two pictures of which I want to make copies. The pink peach tree gives me the most trouble. I have also just now a little pear tree — the ground violet, in the background a wall with straight poplars and a very blue sky; a violet trunk and white flowers, with a big yellow butterfly on one of the clusters. This is perpendicular between two canvases, horizontal. That will make six canvases of orchards in bloom. I dare to hope for three more, matching in the same way. I try every day to touch them up and make them hang together.

There, now you have the details of this decoration scheme of trees in blossom that I am planning for you. I want to paint a Provençal orchard of astounding gaiety. I must also have a starry

night with cypresses. There are some wonderful nights here. I
am in a continual fever of work. Then I must do a *tremendous* lot
of drawing, because I want to make some drawings in the manner
of Japanese prints.

The air here certainly does me good. I wish you could fill your
lungs with it; one effect it has on me is comical enough: one small
glass of brandy makes me tipsy here, so that I don't have to fall
back on stimulants to make my blood circulate.

But I shall be all in when the orchards are over, for they are
canvases of twenty-five, and thirty and twenty. We should not
have too many of them even if I could bring off twice as many.

I think I can assure you that the work I'm doing here is better
than that in the Asnières country last spring. I hope to make great
progress this year, and indeed I need to. These orchards, with
the 'Pont de l'Anglais,' will make the first of a series. They are
now on a covered terrace to dry.

I think what Kahn said is very true, that I have not sufficiently
considered values, but they'll be saying very different things in a
little while — and no less true.

It isn't possible to get values and colour. Th. Rousseau did it
better than anyone else, and with the mixing of his colours the
darkening caused by time has increased, so that his pictures are
now unrecognizable. You can't be at the Pole and the Equator at
the same time.

You must choose your line, as I hope to do, and it will probably
be colour.

I have just sent you a roll of small pen-and-ink drawings — a
dozen, I think. These drawings were made with a reed sharpened
the way you would a goosequill. You know what you must do with
them — make sketch-books with six or ten or twelve, like the books
of original Japanese drawings. I very much want a book like this
for Gauguin, and one for Bernard.

All this talk from the Boussod Valladon people is rather an in-
dication that impressionism hasn't taken on enough. I broke off
from painting at once. I said to myself that a quarrel with these

people would mean that you must have less expense on my account. Happily for me, I believe it's possible to produce a work of art at less cost than one must incur through painting.

I am seriously uneasy sometimes lest you may be 'done' by this Valladon crew, with the annoyance they're giving us. But I'm for fighting it out. It seems to me that what they ask of you would be reasonable enough if they first agreed to give you a year's leave to regain your health. Should you like me to go to America with you? But I should rather see you independent of the Goupils, and dealing with the impressionists on your own account, than leading this other life of travelling about with expensive pictures belonging to these people.

You will find among the drawings a hasty sketch on yellow paper of a lawn in the square as you come into the town, and a building at the back. Today I've taken the right wing of this concern, which contains four rooms — or rather two, with two closets. It is painted yellow outside, whitewashed inside. I have taken it for fifteen francs a month.

I have vexations I don't think I can get rid of as long as I stay at the hotel where I am. For the people are trying to make me pay high for everything, on the pretext that I take up more room with my pictures than their other clients do.

Now, my idea would be to furnish one room of this house, that on the first floor, so as to be able to sleep there. This would leave the studio for my whole campaign in the South, as long as it lasts, and I should be independent of all the tricks of innkeepers; they're ruinous and they make me wretched. Supposing you leave these worthies; I must then manage to live without spending more than one hundred and fifty francs a month; at present I could not do it, but in two months I shall be settled and shall have a permanent studio, where if necessary I can put up another painter. Strangers are exploited here, and from their point of view the natives are in the right; it is considered a duty to get whatever they can.

As I must make a move, would it suit you better if I went to Marseilles now? I could do a series of seascapes there, like the series of orchards in bloom here, and at Marseilles I'd make it my busi-

ness to get hold of a window in which to show the impressionists. If not, the address from now on will be:

Place Lamartine 2.

It cost me positive agony to decide on a definite step, for I reminded myself that at The Hague and at Neunen I had tried to have a studio, and see how badly that turned out. I hope I have fallen on my feet this time; you take it in — yellow outside, white inside, with all the sun so that I shall see my canvases in a bright interior. The floor is red brick; outside, the garden of the square.

It will sound funny to you that the lavatory is next door, in a fairly big hotel which belongs to the same proprietor. In a southern town I feel I have no right to complain of it, since these arrangements are few — and dirty; one cannot help thinking of them as nests of microbes. What is delightful is the garden opposite.

We'll put off doing any repairs or furnishings; this will be wiser, especially because, if we have cholera here in the summer, I may pitch my camp in the country; the thing is now to go and sleep there. Yesterday I went to the furniture dealer's to see if I could hire a bed. Unfortunately they would not rent one, and even refused to sell on the terms of monthly payments. On thinking it over, I believe it would be best simply to get a rug and a mattress and make a bed on the studio floor; for during the summer it will be so hot that this will be more than enough. I shall put some Japanese things on the wall.

Bernard has just written me that he also has a whole house, but he gets his for nothing. What luck!

I don't see the future black before me, but I do see it bristling with difficulties, and sometimes I ask myself if they won't be too much for me. But this is mostly in moments of physical weakness, and last week I had such a fierce toothache that much against my will I had to waste time. I should be afraid of nothing if it weren't for my cursed health. Here the wine is bad, but I drink very little of it. And so it comes about that, with eating hardly any and drinking hardly any, I am pretty weak.

You know, if I could only get really strong soup it would do me

good straight off: it's preposterous, but I *never* can get what I ask
for, even the simplest things from these people here.

But it is not hard to cook potatoes?

Impossible.

Then rice, or macaroni?

None left, or else it is messed up in grease, or else they aren't
cooking it today and they'll explain that that's tomorrow's dish,
there's not room on the range, and so on. It's absurd, but that is
the real reason why my health drags along.

I could quite well share the new studio with someone, and I
should like it. Then the cooking could be done in one's own place.

In any case, the studio is too public for me to think it might
tempt any little woman, though a petticoat crisis couldn't easily
end in a *liaison*. Morals here seem to be less inhuman, and less
contrary to nature, than in Paris; but with my disposition, to go
on the spree and to work are in no way compatible, and in the
present circumstances one must content oneself with painting
pictures. It is not really living at all, but what is one to do? And
indeed this artistic life, which we know is not *the* real life, seems to
me so vital that one would be ungrateful not to be content with it.

I was certainly going the right way for a stroke when I left Paris.
I paid for it nicely afterwards! When I stopped drinking, when I
stopped smoking so much, when I began again to think instead of
trying not to think — Good Lord, the depression and the prostra-
tion of it! Work in these magnificent natural surroundings has
helped my morale, but even now some efforts are too much for me.

My poor boy, our neurosis comes, it's true, from our way of liv-
ing, which is too purely the artist's. But it is also a fatal inheri-
tance; we must acknowledge that we belong to the number of those
who suffer from a neurosis which has its roots far in the past.

I often think of Doctor Gruby. I think he is in the right about
such cases: the wisest course is to eat well, to live well, and to see
little of women. Can you visualize Gruby's face when he shuts his
mouth tight and says: 'No women!'? It would make a fine Degas,
that. But there is no answering back, for when you have to work
all day with your brain, calculating, considering, planning, you've

had as much as your nerves can stand. In short, to live beforehand exactly as if one were already suffering from disease of the brain and disease of the spine, is certainly taking the bull by the horns. Degas did it, and made good.

All the same, don't you feel with me that it is frightfully hard? And doesn't it do one all the good in the world to listen to the wise advice of Pangloss, that excellent optimist of the right jovial Gallic strain, who leaves you your self-respect?

However, if we want to live and work, we must be very sensible.

Hearing about your visits to Gruby had distressed me, but I am relieved that you went. Take some pains to get well; I am indifferent about most things, but not about this. My dear fellow as for that Moslem idea that death comes only when it must, I think that we have no proof of any direct determination from above in this matter. On the contrary, I think there is proof that to obey the laws of health not only prolongs life, but above all can make it more serene, a clearer stream.

Do you realize that I should far rather give up painting than see you killing yourself to make money? If you understand so well that 'to prepare oneself for death,' the Christian idea (happily for him, Christ himself, it seems to me, had no trace of it, loving as he did people and things beyond all measure, according to the folk who can only see him as a little cracked) is idle — can't you see in the same way that self-sacrifice, living for other people, is a mistake if it involves suicide? For in that case you actually make your friends into murderers.

So if it has come to this, that you have to travel about with never any peace; it robs me of any desire to get back my own ease of mind. If you agree to these proposals, all right — but ask these Goupils to take me on again, at my old wages, and take me with you on these journeys. People matter more than things, and the more trouble I take over pictures, the more pictures in themselves leave me cold. The reason I try to make them is so as to be among the artists.

If you could only have one year living in the country and with nature just now, with pure air and warmth, it would make Gruby's

cure much easier. I wish you had someone near you more crudely, warmly alive than the Dutch. Koning is better than most, but I should like you to have some friends as well among the French.

I do very well down here, but it is because I have my work, and nature; if I hadn't these I should grow melancholy. If work had any attraction for you where you are, and if the impressionists were getting on, it would be a very good thing. For loneliness, worries, difficulties, the unsatisfied need of kindness and sympathy — these are the things hard to bear; the mental suffering of sadness or disappointment undermines us more than dissipation — us, I say, who find ourselves the happy possessors of failing hearts.

I have found a better restaurant, where I can get a good meal for one franc, and the result tells on me at once. I am infinitely better — circulation good and my stomach digesting. It was chiefly the bad food that kept me back, and the wine, which was regular poison.

We are having a tremendous lot of wind and mistral here just now, three days out of four, though the sun shines; this makes it difficult to work out-of-doors, so I have done a dozen little drawings, which I have sent you.

I have had a visit from McKnight, Russell's friend. I am to go to see him and his work, of which I have so far seen nothing. He is a Yankee; is probably a much better painter than most Yankees, but a Yankee all the same. And I have had a letter from Russell; he has bought a Guillaumin and two or three Bernards. And, what gives me enormous pleasure, he also writes suggesting an exchange of studies.

I think there would be something to do here in portraits. But before I dare start off along that line I want first to have my nerves steadier, and also to be settled, so that I can have people at my studio.

Although the people here are blankly ignorant about painting in general, they are much more artistic than in the North in their own persons and in their manner of life. I have seen here figures quite as beautiful as those of Goya or Velasquez. They will pin a touch of rose on a black frock, or devise a garment of white, yellow,

and rose, or else green and rose, or else *blue and yellow*, in which
there is nothing to be altered from the artistic point of view. Seurat
would find some very picturesque men's figures here, in spite of
their modern clothes.

It is a filthy town, in the old streets. As for the women of Arles
that there's so much talk about — there is, isn't there? — they
are no longer what they must have been, for they are in their de-
cadence; but that doesn't prevent them from being beautiful —
I'm talking now of the type in the Roman style, rather boring and
commonplace. Yet what exceptions there are!

There are women like a Fragonard and like a Renoir, and some
that can't be labelled by anything that's been done yet in painting.
The thing to do would be to make all kinds of portraits of the
women and children. But I don't think that I am the man to do
it; I'm not enough of a M. Bel Ami for it. I should be heartily glad
if a kind of Guy de Maupassant in painting came along to paint
light-heartedly the beautiful people and things that there are here.
But this painter who is to come, I can't imagine him living in little
cafés, working away with false teeth, and going to the zouaves'
brothels, as I do.

As for me, I shall go on working, and here and there amid my
work there will be things which will last. I hope that later on other
artists will rise up in this lovely country and do for it what the
Japanese have done for theirs. I have no fear but that I shall al-
ways love this countryside. It is rather like Japanese art; once
you love it, you never go back on it. I am convinced that nature
down here is exactly what one needs to give one colour.

And the painter of the future will be *such a colourist as has never
yet been*. Manet was working towards it, but the impressionists
have already got stronger colour than Manet. I think I am right
in feeling that we must work as we can to that end, without doubt-
ing and without wavering.

I am glad you have sold a Degas. You will see some lovely
things at Claude Monet's. Who will be in figure painting what
Claude Monet is in landscape? And you will think what I send very
poor stuff in comparison. At present I am dissatisfied with myself

and dissatisfied with what I do, but I have a glimmer of hope that I'm going to do better in the end.

When I tried to settle my bill at the hotel I had yet another proof of how I've been swindled. I suggested coming to an agreement; they wouldn't hear of it, and when I wanted to take away my things, they would not let me.

I have had to pay fifty-seven francs forty centimes instead of the forty francs which I owe them; but I stipulated on the receipt that this payment was made only to regain possession of my belongings, and that the exorbitant bill should be submitted to the magistrate. I am not sure of winning, though I have undoubted right to a deduction. So you see I dare not buy my mattress, and must go and sleep in some other hotel. I should like to ask you to let me have enough money to buy a mattress.

This is a great nuisance, for it is upsetting me considerably in my work, and the weather is splendid just now. I am sorry I did not take this studio sooner; with the extra money these people have got out of me, it would have been furnished by now. But in the end it will be for the best, because all this has driven me to make the decision. First, I had a period of absolutely absorbing work; then I was so exhausted and so ill that I let things go. They have calculated this bill from the time when I was paying them more because I was ill and had asked them for better wine.

After all this I have almost nothing left. I had bought things to make a little coffee and soup at home, and two chairs and a table; also three strong linen shirts and two pairs of stout shoes. However, I think that by now I have pretty well paid my tribute to ill luck; it's better to do it first than last. And at the end of the year I should be a different man. I should have a home of my own and peace to get back my health. I feel sure that I'll soon have several new canvases on the easel. Only it is discouraging to work hard and to see one's profits going into the hands of people whom one loathes.

I am sending you in a case all the studies I have except a few that I have destroyed, but I am not signing all of them; there are a dozen that I have taken off the stretchers, and fourteen on stretchers.

The first thing you will find in the case are the pictures I did for Jet Mauve and Tersteeg. If, meanwhile, you have come to the conclusion that Tersteeg would be offended by receiving his, and that I had better have nothing to do with him, then keep it yourself. You can scrape off the dedication, and we can exchange it for something from the crowd. Or if you find among the others a study that seems to you more suitable for him, you can put it in without a dedication. Perhaps it is better to give him one without any dedication; then, if he would rather not have anything from me, he can pretend that he hadn't realized it was a present, and can send it back without saying anything. I offer him one to show that I have some zeal for the cause, and that I appreciate his taking it up.

If you would put the best things on one side, and consider these pictures as payment from me, then, when the day comes that I shall have brought you in something like ten thousand francs in this way, I shall feel happier. In this consignment there are the rose-coloured orchard, the white orchard, and the bridge. Take these three, then, for your own collection, and do not sell them, for they will each be worth five hundred francs later on.

If we dare believe that the impressionist pictures will go up, we must paint plenty of them. All the more reason for concentrating quietly on the quality of the work, and not wasting time. At the end of several years' work we may be able to make up a bit for the past. I am still far from that; but I feel that in these surroundings there is everything one needs to do good work. So it will be my own fault if I don't succeed.

As for frames, I think the two yellow bridges with the blue sky would do well in the dark blue they call royal blue, the white orchard in dead white, the rose-coloured orchard in a rather warm creamy white.

There is a little landscape with a hovel, white, red, and green, with a cypress beside it; I did the whole painting of it in the house. A big study without stretchers, and another on stretchers where there is a lot of stippling, are unfinished. I am sorry, for the composition gave the general effect of the big orchards here surrounded

by cypresses, only I thought one study too soft and the other too harsh; neither came off. It was partly the changeable weather, and I was like the Russian who tried to gobble up too much of the country in one day's march.

I hope that what I have sent will arrive before Tersteeg comes to Paris. And I am anxious to know what you will say of what I have sent. If there are any really too bad among them, don't show them!

Will you do something which will give me great pleasure? My Danish friend, who is leaving on Tuesday for Paris will give you two little pictures which I should like to give to Madame la Comtesse de la Boissière at Asnières. She stays in the Boulevard Voltaire. Would you care to take them for me in person and say that I had hoped to see her again this spring, and that even here I have not forgotten her? I gave them — her and her daughter — two little ones last year. I hope that you will not regret having made the acquaintance of these ladies, for it is a real family.

Yesterday and today we have had the mistral again. I have done two still-lifes for this week.

The first shows a coffee-pot in blue enamel, a cup on the left, royal blue and gold, a milk jug in squares of pale blue and white; a cup on the right of white with a blue-and-orange pattern, on an earthen plate of greyish-yellow; a jug in earthenware, or majolica, blue with a pattern in reds, greens, and browns; and lastly two oranges and three lemons. The table is covered with a blue cloth, the background greenish-yellow, so that there are six different blues, and four or five yellows and oranges. This canvas absolutely kills all the others; it is only a still-life, but it stands quite by itself — no doubt because of the drawing.

The other still-life is a majolica pot with wild flowers.

I was at Fontvieille yesterday, at McKnight's. He had a good pastel and two water-colours begun, and I found him working on the head of an old woman in charcoal. He is in the state when new theories of colour plague him; while they prevent his working on the old system, he is not sufficiently master of his new palette to succeed in this one. He seemed very shy about showing me his things.

I have been to see the gentleman that the Arab Jew in 'Tartarin' calls '*le Zuage de paix.*'

I have got back twelve francs, and the innkeeper was reprimanded for holding back my luggage. If he had won his case, it would have injured me, for he would not have failed to say everywhere that I could not pay; whereas now he says he lost his temper and did not mean to insult me. I think myself that this is likely just what he was trying to do, seeing that I had had enough of his shanty and that he could not manage to keep me. So that's that. I consider that I am after all a workman and not a foreigner travelling for pleasure, and it would be feeble on my part if I let myself be exploited as such.

I have not yet been able to make my bargain with the furniture dealer. I have seen a bed, but it was dearer than I expected. I feel that I must polish off some more work before spending more on furnishing. I have bought some more linen, as I was very short of it.

I have now done two new studies: a farm by the highroad among cornfields, and a meadow full of very yellow buttercups, a ditch with irises, green leaves and purple flowers, the town in the background, some grey willows, and a strip of blue sky. If the meadow is not cut I should like to do this study again, for the subject was a very beautiful one, and I had difficulty in getting the composition right. A little town in the midst of a countryside all flowered over with yellow and purple, just — can't you see it? — a Japanese dream.

I have also another bridge, and the side of a highroad. In character many subjects here are exactly like those in Holland; the difference is in the colour. There is that sulphur yellow everywhere the sun lights. Perhaps it is something to have found plenty of subjects — provided that the pictures are worth what they cost.

We saw a magnificent Renoir of a garden of roses. I was expecting to find subjects like that here, and indeed while the orchards were in bloom it was so. Now the appearance of things has changed and become much harsher. But the green and the blue! I must say several landscapes of Cézanne give this very well. The

other day I saw a subject exactly like the lovely Monticelli land-
scape with the poplars.

Today we have a gale and rain, but it will do good. Tomorrow
I must go and look for a new subject.

Bit by bit as my blood quickens the thought of success quickens
too. It is precisely the sense of stupefaction which I'm getting rid
of. I do not feel so much the need of distraction; I am less harassed
by my passions, and can work more calmly; I can be alone without
being dull. I have come through it rather older in the way I look
at things, but not sadder.

There it is, and there it will remain, and every now and then
returns in the full tide of the artist's life — the homesick longing
for that real life that can never come true. And sometimes you lack
any desire to throw yourself heart and soul into art, and to get well
for that. You know you are a cab horse, and that it's the same old
cab you'll be hitched up to again; that you'd rather live in a
meadow with the sun, and a river, and other horses for company,
likewise free.

And perhaps to get to the bottom of it, heart disease comes from
that; it would not surprise me. One does not rebel against things,
one is not resigned to them either, one's ill because of them, and
one gets no better, and it's hard to be precise about the cure.

I do not know who it was who called this condition struck by
death and immortality. The cab you drag along must be of some
use to people you do not know. And so, if we believe in the new
art, and in the artists of the future, our faith does not cheat us.
When good old Corot said a few days before his death, 'Last night
I saw in a dream landscapes with skies all rose' — well, haven't
they come, those skies of rose, and yellow and green into the bar-
gain, in the impressionist landscapes? All of which means that
there are things one feels are to come, and they come, in very
truth.

As for us who are not, I incline to think, nearly so close to death,
we feel nevertheless that this thing is greater than we are and its
life of longer span than ours.

We do not feel we are dying, but we do feel the truth that we are

of small account, and that in order to be a link in the chain of artists, we are paying a high price, in health, in youth, in liberty, none of which we have any joy of, any more than the cab horse that hauls along a coachful of people out to enjoy the spring.

There is an art of the future, and it is going to be so lovely and so young that even if we give up our youth for it we must gain by it in serenity. Perhaps it is very silly to write all this, but I feel it so; it seems to me that, like me, you have been suffering to see your youth pass like a drift of smoke, but if it springs up again and comes to life in what you do, nothing has been lost, and the power to work is another youth.

I should like to get some sort of little retreat here where the poor cab horses of Paris — that is, you and several of our friends, the poor impressionists — could go out to grass when they got too done up.

I have had a letter from Gauguin, who says he has got from you a letter enclosing fifty francs, which touched him greatly. He seems to be very depressed.

He says he knows by experience that when he was with his friend Laval at Martinique they managed much better than when they were alone, so that he readily agrees as to the advantages there would be in living together. But he speaks of some hope he has of finding the capital to set up a dealer for impressionist pictures. I should not be surprised if this hope is a Fata Morgana of destitution. I think myself that the solidest asset Gauguin now has is his painting, and the best business he could do — his own pictures.

Do you know, I think a society of impressionists could be created, and that while it lasted we could live courageously and produce, and that the gains as well as the losses should be taken in common. I am hoping to maintain my argument of last winter, when we talked of an association of artists. Not that I have still any great desire for it or hope to realize it, but as it was seriously thought out one must hold one's ground. But if Gauguin and his bankers came tomorrow and asked me for but ten pictures for a society of *dealers*, on my word I do not know whether I should have

confidence to give them, though I should willingly give fifty to a society of artists.

The great revolution: art for the *artists!* Lord, Lord! Perhaps it is Utopia — then so much the worse for us. I feel that life is so short and goes so fast — well, being a painter one must still paint. You can't send Gauguin what will keep him going in Brittany, and me what keeps me going in Provence, but you may think it a good idea for us to share, and fix a sum — say two hundred and fifty francs per month — if every month in addition to my work you get a Gauguin.

It will be a great risk to take Gauguin, and we must consider that helping him will be a long business — it would not be Gauguin's salvation any more than mine to sell a few canvases; it may be years before the impressionists have a steady value. But I believe in the victory of Gauguin and the other artists; meanwhile he may crash like Meryon, disheartened. It is bad that he is not working — he has such a great gift.

If Gauguin were to come here there would be in addition to the hotel and travelling expenses his doctor's bill as well, so that it would be pretty steep. And there are two beds or two mattresses which we absolutely must buy. But if he is agreeable, and if there is only the difficulty of moving to get over, it would be better not to keep him hanging on.

I think he ought to leave his debt in the lump, and some pictures as security. I was obliged to do the same thing to get to Paris, and though I lost a lot of things, it is better to step out, no matter how, than to atrophy where you are. So I have written, though I hardly had time, as I have two canvases on the easel.

Perhaps Thomas would buy something from Gauguin if he knew of the alliance that we have in hand. If Russell takes nothing it is because he cannot. I told him that if I ventured to press him to buy, it was *not* because nobody else would if he didn't, but because, Gauguin having been ill, it all came rather heavily on us.

I am very curious to know what Gauguin will do, but to risk persuading him to come — no. If he would rather go again into business, and if he really hopes to do something in Paris, good

Lord! let him. I certainly do not want to cramp any individuality, and if he is hankering after some such plunge I should not like to deter him. Perhaps it is more his duty to try to bring off something that would bring in enough to let him take on his family again. But I think that he would be wise to come here.

The worst of it is this blasted journey; if we persuade him to take it, and afterwards things do not suit him, we shall be in a hole.

Altogether Tersteeg's visit was not all that I had dared to hope, and I do not conceal from myself that I made a false calculation based on the likelihood of his co-operation.

And in the business with Gauguin too, perhaps. Let's think about it. I thought: He is on the rocks, and here am I with money while this lad who does better work than I do has none. So I say he ought to have half, and let him, if he likes. But if he isn't on the rocks, then I am in no great hurry.

You know that I have always thought it idiotic for painters to live alone, and it worries me to spend so much money on myself. But to remedy it the only thing is for me to find a woman with money, or some fellows who will join with me to paint. I don't see the woman, but I do see the fellows. My personal wishes are subordinate to the interests of others, and someone else might profit by the money that I spent. Without counting the extra work done, you would have the satisfaction of keeping two or three going instead of one.

And this would be the beginning of an association. Bernard, who is also coming South, will join us, and truly I can see you yet at the head of an impressionist society in France. If I can be of any use in getting them together, I should willingly see them all better men than I. Gauguin says that when sailors have to move a heavy load or raise an anchor, they all sing together to keep them up and give them vim. That is just what artists lack!

But the problem is simply this: If I looked about for someone to chum with, would it be a good thing, would it be to my brother's advantage and mine, and would the other fellow lose by it or would he gain? My mind is running on these questions, but they'd have to come up against reality to become facts.

I judged that you wanted to help Gauguin, just as I myself am distressed at his being ill. We cannot suggest anything better than this, and others would not do as much.

It would so please me if you had the Gauguins first. It is quite certain that if, in exchange for the money given Gauguin, one could buy his pictures at their present price, there would be no risk of losing money. And the time may come later when we shall not be so hard up. I say to myself that we can begin to hope that in a little I shall sell one or two pictures a month, *for they are improving.*

I read a notice in 'L'Intransigeant' that there is to be an exhibition of impressionists at Durand Ruel's — there are sure to be some remarkable things there.

I congratulate you on having the Monet exhibition in your place; I am very sorry not to see it. The only way I can console myself for not seeing it is to look around and see so many things in nature that I have hardly time to think of anything else. It is great that Monet has managed to paint those ten pictures between February and May. Quick work doesn't mean less serious work; it depends on one's self-confidence and experience.

Certainly it will not do Tersteeg any harm to see this exhibition; he will come round to it yet, but, as you thought too, it will be too late. Certainly it is odd that he has changed his mind about Zola; I know from experience that once he couldn't bear to hear a word about him. Lord, what a pity that you and he don't see eye to eye in business *now!* But that's that; it is what I think is called fatality.

I read that Bing is giving a Japanese exhibition. I find it dreadful sometimes not to be able to get hold of another lot of Japanese prints. The only thing I really owe is to Bing. I still have ninety francs' worth of Japanese stuff on commission.

Today I bought some paints here and some canvases, for with the weather we are having I must go at it. It is good and hot, I can tell you. I have come back from a day at Mont-Majour, and my friend the second lieutenant was with me. We explored the old garden together and stole some excellent figs. If it had been bigger

it would have made me think of Zola's Paradou — green reeds, vines, ivy, fig trees, olives, pomegranates with lusty flowers of the brightest orange; hundred-year-old cypresses, half-broken flights of steps, ogive windows in ruins.

One evening I saw a red sunset, its rays falling on the trunks and foliage of pines growing among a tumble of rocks, colouring the trunks and foliage with orange fire. It was superb.

I went also one day to Tarascon, but unfortunately there was such a bright sun and so much dust that I came back with an empty bag.

I keep on finding very beautiful and interesting subjects here, and in spite of the worry of the expense, I think there is a better chance in the South than in the North. I see nothing here of the Southern gaiety that Daudet talks so much of; on the contrary, I observe insipid airs and graces and a rather squalid casualness. But the country is beautiful in spite of it. What surprises me is the scarcity of flowers; there are no cornflowers in the wheat, and seldom poppies.

I have a new subject in hand: fields green and yellow as far as the eye can reach. I have already drawn it twice, and am beginning it again as a painting; it is exactly like a Philip de Koninck — the pupil of Rembrandt who painted vast level plains.

Today I am sending you three drawings by post. The one with the ricks in a farmyard you will think too bizarre, but it was done in a great hurry as a suggestion for a picture. The 'Harvest' is rather more serious, and that is the subject I have worked at this week on a thirty canvas. It kills everything else I have except that still-life, and can bear the surroundings of red, very red brick with which my studio is paved. When I put it on the floor, the colour of the picture does not become hollow or bleached.

I want to get my drawing more spontaneous. I'm trying now to exaggerate the essential, and, of set purpose, to leave the obvious vague. What Pissarro says is true: You must boldly exaggerate the effects either of harmony or discord which colours produce; exact drawing, exact colour, is not the essential thing because the reflection of reality in a mirror, if it could be caught, colour and

all, would not be a picture at all, no better than a photograph.

And I think I have more chance of success if I don't cramp myself by working on too small a scale. For that very reason I think I shall take a bigger format in canvas, and launch out boldly into the thirty square.

I must manage to get the firmness of colouring that I got in that still-life. I'm thinking of what Portier used to say, that seen by themselves the Cézannes he had looked nothing, but bring them near other pictures and they washed the colour out of everything else. He used to say, too, that the Cézannes did well in gold, which means that the gamut of colour was pitched very high. So perhaps, perhaps I am on the track, and am getting my eye in for this kind of country. We must wait and make sure.

Instinctively these days I keep remembering what I have seen of Cézanne, because he has exactly caught the harsh side of Provence. It has become very different from what it was in spring, and yet I certainly have no less love for this countryside burnt up as it begins to be from now on. Everywhere is old gold, bronze — copper, one might say — and this with the green azure of the sky blanched with heat: a delicious colour, extraordinarily harmonious with the blended tones of Delacroix.

The country near Aix where Cézanne works is the same as this; it is still the Crau. If coming home with my canvas I say to myself, 'Look! I've got the very tones of old Cézanne!' I only mean that Cézanne is so absolutely part of the countryside, and knows it so intimately, that you must make the same calculations in your head to arrive at the same tones. Of course if you saw them side by side they would go together, but there would be no resemblance.

McKnight and one of his friends saw this last study and said it was the best I had done. But then says I, 'The rest must certainly seem damn bad.' It appears that McKnight was not very pleased with me, but that Russell told him to hold his tongue.

Just now I am working on a landscape with cornfields which I think as well of as, say, the white orchard; it has solidity and style. The days when I bring home a study I say to myself, If it

were like this every day we might be able to get on. But the days when you come back empty-handed, and eat and sleep and spend money all the same, you don't think much of yourself; you feel a fool and a good-for-nothing.

Early last week I started for Saintes-Maries on the shore of the Mediterranean, and stayed there till Saturday evening. You go by diligence across the Camargue, grass plains where there are herds of bulls and of little white horses, half-wild and very beautiful.

The Mediterranean has the colours of mackerel — changeable, I mean. You don't always know if it is green or violet; you can't even say it's blue, because the next moment the changing light has taken on a tinge of rose colour or grey. The shore is sandy — no cliffs, nor rocks — like Holland without the dunes, and bluer. I had three canvases with me and covered them: two seascapes and a view of the village; then I did some drawings.

A very fine gendarme came to interview me there, and the curé too — the people can't be very bad, because even the curé looked almost like a decent fellow.

One night I went for a walk by the sea along the empty shore. It was not gay, but neither was it sad; it was — beautiful. The deep blue sky was flecked with clouds of a blue deeper than the fundamental blue of intense cobalt, and others of a clearer blue, like the blue whiteness of the Milky Way. On the blue depth the stars were sparkling, greenish, yellow, white, rose, brighter, flashing more like jewels than they do even in Paris. The sea was a very deep ultramarine.

A family is a queer thing — quite involuntarily and in spite of myself I thought of our sailor uncle, who must many a time have seen the shores of this sea.

Just when I was going to start home in the morning, very early, I made a drawing of the boats. I have been here only a few months, but tell me this: Could I in Paris have done the drawing of the boats *in an hour?* And without the frame? I do it now without measuring, just letting my pen go.

Now that I have seen the sea here I am absolutely convinced of

the importance of staying in the Midi, and of piling on, exaggerating the colour — Africa not so far away. I have the conviction that simply by dint of staying on here I shall set my indiviauality free.

I should like to earn a lot of money so as to get good artists to come down here, instead of shivering in the mud of the *Petit* Boulevard, as too many of them are.

I wish you could spend some time here; you would feel it after a while. One's sight changes; you see things with an eye more Japanese, you feel colour differently. The Japanese draw quickly, very quickly, like a lightning flash, because their nerves are finer, their feeling simpler.

If the other drawings that I have in my mind are like these I have sent, you will have an epitome of a very beautiful corner of Provence. Why move about much? When I see the orchards again, shan't I be in better condition, and won't it be something fresh, a fresh attack and a new season on the same subject? And that goes for the whole year — for the harvest, and the vineyards, and everything.

Anquetin and Lautrec — I think — will not like what I am doing; an article has appeared in the 'Revue Indépendante' on Anquetin which calls him the leader of a new tendency in which Japanese influence is still more apparent. But the leader of the *Petit* Boulevard is undoubtedly Seurat, and in the Japanese style young Bernard has perhaps gone further than Anquetin. Tell them that I have done a picture of boats that, with the 'Pont de L'Anglais,' goes as far as Anquetin.

It was very nice of Guillaumin to come to look at what I have sent; I am very sensible of it, but I myself am on the whole still dissatisfied with everything I do.

It is just now harvest time, and I have had a week's hard, close work among the cornfields in full sun. The cornfields have been a reason for working, just as were the orchards in bloom; I have only just time to get ready for the next campaign, that of the vineyards, and between the two I should like to do some seascapes. The orchards meant rose and white, the cornfields yellow, and the

seascapes blue. Perhaps I shall begin now to look about a bit for greens. There's the autumn, and that will give the whole range of the lyre.

The present result is some studies of cornfields, landscapes — and a sketch of a sower: a ploughed field with clods of violet earth climbing towards the horizon; a sower in blue and white; on the horizon a field of short ripe corn; over all a yellow sky with a yellow sun.

You can tell from this simple naming of the tones that it's a composition where colour plays a very important part. And the sketch, such as it is, torments me, making me wonder if I should not take it up seriously and make a tremendous picture of it. I hardly dare to think about it. I have had a longing for such a long time to do a sower, but the things I've wanted for a long time never come off; so I am almost afraid of it. And yet, after Millet and Lhermitte what still remains to be done is — a sower in colour. My word, I do want to! But I keep asking myself if I have vigour enough to carry it out.

Let us talk of something else. I have a model at last — a zouave, a lad with a small face, with the neck of a bull and the eye of a tiger. A half-length I did of him was fearfully hard; blue uniform, the blue of enamelled saucepans, with braid of a faded reddish-orange, and two pale lemon stars on his breast; an ordinary reddish cap against a green door and the orange bricks of a wall. It's a savage combination of incongruous tones, not easy to manage.

The study I made seems to me very harsh, but all the same I should like to be always working on common, even loud portraits like this. It teaches me something, and that above all is what I want of my work. But I am dissatisfied with this study because it is very ugly.

Bernard sends me today a rough sketch of a brothel. There is a poem behind the drawing in just the same tone as the drawing; I should not be surprised if he wanted to exchange it for my zouave's head.

We have had torrential rain these last two days, which has gone on all day and will alter the appearance of the fields. It came ab-

solutely unexpectedly and suddenly, while everyone was at the harvest. So I worked yesterday and today at the sower, which is now completely rehandled. The sky is yellow and green, the ground violet and orange. There is certainly a picture to be painted of this splendid subject, and I hope it will get done some day by me or by another.

It makes you as absent-minded as a sleep-walker. And yet if one could do something good! Well, let's keep up heart. I hope soon to send you this attempt along with some others.

I have just scraped out a big painted study, an olive garden with a figure of Christ in blue and orange, and an angel in yellow. I scraped it out because I tell myself that I must not do figures without a model.

I have a view of the Rhone — the iron bridge at Trinquetaille, in which the sky and the river are the colour of absinthe, the quays a shade of lilac, the figures leaning on their elbows on the parapet blackish, the iron bridge an intense blue, with a note of vivid orange in the blue background, and a note of intense malachite green. Another very rough effort, and yet I am trying to get at something utterly heart-broken and therefore utterly heartbreaking.

I must warn you that everyone will think I work too fast. Don't you believe a word of it. Is it not emotion, the sincerity of one's feeling for nature, that draws up? And if the emotions are sometimes so strong that one works without knowing one works, when sometimes the strokes come with a sequence and a coherence like words in a speech or a letter, one must remember that it has not always been so, and that in the time to come there will again be heavy days, empty of inspiration.

If my health does not betray me, I shall polish off my canvases, and among the lot there will be some which will do.

I work with less trouble in the full heat than I did in the spring. I think the heat is still doing me good, in spite of the mosquitoes and flies, the grasshoppers — not like ours at home, but like those you see in Japanese sketch-books — and Spanish flies gold and green in swarms on the olives. The grasshoppers (I think they are called *cicidas*) sing as loud as frogs.

Not half of the fifty canvases are yet fit to be shown in public, and I must do them all this year. I am concentrating on making my pictures have some value. You know that I have but one means to arrive at this end — that is, by painting them. But I tell myself that if I can manage to do fifty studies at two hundred francs this year, in a way I shall not have been very dishonest in having eaten and drunk as though I had a right to it. That is pretty steep, because, though I have at the moment about thirty studies in paint, I do not reckon them all at that price. All the same, some among them must be.

You can understand, therefore, that I have a certain ambition — it's not the number of canvases, but simply that the very mass of them represents real labour, on your part as well as on mine.

Do you remember in Guy de Maupassant the gentleman who hunted rabbits and other game for ten years, and who was so exhausted by running after the game that when he wanted to get married he found he was no good, which caused the greatest embarrassment and consternation? Without being in the same case as this gentleman as to its being my desire to get married, I begin to resemble him in physique. According to the worthy Ziem, man becomes ambitious as soon as he becomes impotent. Now, though it's pretty much all one to me whether I am impotent or not, I'm damned if that's going to drive me to ambition. But I think that the money which I shall need in the future depends rather on the vigour of my efforts now.

If I am alone — I can't help it; but I have less need of company than of headlong work, and that is why I go on boldly ordering canvas and paints. It's the only time I feel I am alive. If I had company I should feel it less of a necessity; I should work at more complicated things. But alone, I count only on the exaltation that comes to me at certain moments, and then I let myself run into extravagances.

What often vexes me is that painting is like having a bad mistress who spends and spends and never has enough; and I tell myself that even if from time to time a tolerable study comes of it, it

would have been much cheaper to buy it from somebody else. And the cost of its execution leaves me very, very poor.

I shall need a fresh batch of paints, since these studies of cornfields and zouaves have fairly devoured my tubes.

As for Tanguy, I beg you not to risk the new pictures with him, but to withdraw them as a reply to his presenting an account. Tanguy has still a study of mine which he expected to sell, and at the most I owe him only that; I do not owe him a penny of money. I have been thinking, too, that I painted old Tanguy's portrait, and that he has also the portrait of the old lady (which he has sold), and of his friend; it is true that I got twenty francs from him for the latter.

If Tanguy is behaving like this, he is playing false to me; but, believe me, you have the Tanguy woman to deal with. To argue about it would mean an argument with her which no mortal could stand.

Xanthippe, Mother Tanguy, and some other good ladies have by some queer freak of nature heads of silex or flint. Certainly these ladies are a good deal more dangerous in the civilized world they go about in than the poor souls bitten by mad dogs who live in the Pasteur Institute. And old Tanguy would be right a hundred times over to kill his lady; but he won't do it, any more than did Socrates. Old Tanguy has more in common, in resignation and long-suffering, with the ancient Christians, martyrs, and slaves than with the present-day rotters of Paris. That does not mean that there is any reason to pay him eighty francs, but it is a reason for never losing your temper with him, even if he loses his.

I should like to send you the thirty studies just now, as this may make it easier to find the money for Gauguin's coming. I think it is well to start to work, especially at drawing, and to arrange to have paints and canvas in reserve for him when he comes.

It certainly is a strange phenomenon that all the artists, poets, musicians, painters are unfortunate in material things — the happy ones as well. Guy de Maupassant is a fresh proof of it. That brings up the eternal question: Is the whole of life visible to us, or isn't it rather that this side of death we see one hemisphere only?

Painters — to take them only — dead and buried, speak to the next generation or to several succeeding generations in their work. Is that all, or is there more besides? In a painter's life death is not perhaps the hardest thing there is.

For my own part, I declare I know nothing whatever about it; but to look at the stars always makes me dream as simply as I dream over the black dots of a map representing towns and villages. Why, I ask myself, should the shining dots of the sky not be as accessible as the black dots on the map of France? If we take the train to get to Tarascon or Rouen, we take death to reach a star. One thing undoubtedly true in this reasoning is this: that while we are alive we cannot get to a star, any more than when we are dead we can take the train. So it seems to me possible that cholera, gravel, phthisis, and cancer are the celestial means of locomotion, just as steamboats, omnibuses, and railways are the terrestrial means. To die quietly of old age would be to go there on foot.

I feel more and more that we must not judge God on the basis of this world; it's a study that didn't come off. What can you do, in a study that has gone wrong, if you are fond of the artist? You do not find much to criticize; you hold your tongue. But you have a right to ask for something better. It is only a master who can make such a muddle, and perhaps that is the best consolation we have out of it, since then we have a right to hope that we'll see the same creative hand get even with itself. And this life of ours, so much criticized, and for such good and even exalted reasons — we must not take it for anything but what it is, and go on hoping that in some other life we'll see a better thing than this.

Now I am going to bed, because it is late, and I wish you good night and good luck.

Your letter brings great news: that Gauguin agrees to our plan. I only want to say this, that not only am I enthusiastic about painting in the South, but equally so about the North, because I feel better in health than six months ago. So that if it is wiser to go to Brittany where you get board and lodging so cheap, from the

point of view of expense I am certainly ready. But it would be good for Gauguin to come to the Mid., especially as it will be winter in the North in four months. And it seems to me that two people doing precisely the same work ought to be able to live at home. The difficulty is to eat at home *alone*. Economies will be possible if we both set up house in the studio instead of living in cafés.

If Gauguin says: 'I am at the height of my powers and my talent,' why should I not say the same? But we are not at the height of our finances, so we must do what comes cheapest. Lots to paint, little to spend; that is the line we must take. Whatever plans one makes, there's a radical difficulty somewhere; if I really dwelt on the chances of disaster I could do nothing. Let us hope that there will be a way out for him and for us.

I throw myself headlong into my work, and come up again with many studies. The Picards and the Leonardo da Vincis are not less beautiful because they are few; on the other hand, the Monticellis, the Daumiers, the Corots, the Daubignys, and the Millets are not ugly because there are relatively a good many of them. As for landscapes, I begin to find that some done more rapidly than ever before are my best. For instance, the harvest and the ricks: it is true that I have to retouch the *whole*, to regularize the composition a bit and make the touch harmonious, but all the essential work was done in a single long sitting, and I touch it as gingerly as possible on coming back to it.

But when I come home after a spell such as that, I assure you my head is so tired that if that kind of work keeps recurring I become hopelessly absent-minded and incapable of heaps of ordinary things. If the storm within gets too loud, I take a glass too much, to distract me. Cracked, of course, when you look at what one *ought to be*. But in the olden days I used to feel myself less a *painter*. My concentration becomes more intense, my hand more sure. That is why I dare almost swear to you that my painting will improve: because I have nothing left but that. I hope the desire to succeed is gone, and I work *because I must*, so as not to suffer too much mentally.

Very often I think of that excellent painter Monticelli, who they said was such a drinker and off his head, when I come back from the mental labour of balancing the six essential colours. Sheer work and calculation, with one's mind utterly on the stretch, with a hundred things to think of in a single half-hour.

I'd like to see a drunkard in front of a canvas. It is too gross a lie, all the malicious Jesuitical tales of the Roquette woman about Monticelli. Monticelli, the logical colourist, able to pursue the most complicated calculations, subdivided according to the ranges of tones that he was balancing, certainly overstrained his brain at his work just as Delacroix did, and Richard Wagner. After that the only thing to bring ease and distraction is to bemuse oneself in a good drinking bout or by heavy smoking. Not very virtuous, no doubt, but if they hadn't got drunk, I for one am inclined to believe their nerves would have rebelled and played them other tricks. Jules and Edmond de Goncourt said the very same thing: 'We used to smoke very strong tobacco to stupefy ourselves' in the furnace of creation.

Don't think that I would artificially keep up a feverish condition, but I am in the midst of a complicated calculation which results in canvases quickly executed, but calculated *long before-hand;* when anyone says that such and such a work was done too quickly, you can reply that he has looked at it too quickly.

During the harvest my work was not any easier than what the peasants were doing who were actually at the harvesting. Far from complaining of it, it is just at these times in the life of art that I feel almost as happy as I could be in real life. But it is at times like these that the prospect of not being alone is not disagreeable. Often whole days pass without my speaking to anyone except to ask for dinner or coffee, and it has been like that from the beginning.

But the loneliness has not worried me, because I have found the brighter sun and its effect on nature so absorbing. So do not push on the affair with Gauguin on my account; *be very sure of that.* You understand, we must not give up the idea of coming to his aid, but we do not *need* him.

Yesterday at sunset I was in a stony heath where some very

small and twisted oaks grow, in the background a ruin on the hill
and corn in the valley. It was romantic, like a Monticelli; the sun
was pouring bright yellow rays upon the bushes and the ground,
a perfect shower of gold, and all the lines were lovely. You would
not have been a bit surprised to see knights and ladies suddenly
appear coming back from hunting, or to hear the voice of some old
Provençal troubadour. I brought back a study, but it is very far
below what I tried to do.

I have just sent off to you five big pen drawings. You have a
sixth of that series of Mont-Majour — a group of very dark pines
and the town of Arles in the background.

Since just at the moment when we are entering on this alliance
with Gauguin, I cannot help at all with money. I have done all I
could by my work to show that I have the plan at heart. In my
opinion the two views of the Crau and of the country by the banks
of the Rhone are the very best things I have done in pen and ink.
If Thomas should happen to want them, he cannot have them for
less than one hundred francs each, even if I have to give him the
three others as a present.

Believe me, I am tired out by these drawings. But the fascina-
tion that these huge plains have for me is very strong, so that I feel
no *weariness* in spite of the really wearisome circumstances, the
nagging malice of this constant mistral and the mosquitoes. If a
view makes you forget these annoyances, it must have something
in it. You will see, however, that there is no attempt at effect; at
first sight it is like a map.

I walked there with a painter and he said, 'There is something
that would be boring to paint.' Yet I went fully fifty times to
Mont-Majour to look at this flat landscape, and was I wrong? I
went for a walk there as well with someone who was not a painter,
and when I said to him, 'Look, to me that is as beautiful and as
infinite as the sea,' he said — and he knows the sea — 'For my
part I like this better than the sea, because it is no less infinite,
and yet you feel that it is inhabited.'

What a painting I should make of it if there were not this
blasted wind! That is the maddening thing here, no matter where

you set up your easel. And that is largely why the painted studies are not so finished as the drawings: the canvas was shaking all the time.

Have you read Loti's 'Madame Chrysanthème'? It gave me the impression that the real Japanese have nothing on their walls, the drawings and curiosities all being hidden in drawers; and that is how you must look at Japanese art: in a very bright room, quite bare and open to the country. Here I work in a bare room, four white walls and red-paved floor. Would you like to experiment with these two drawings of the Crau and the banks of the Rhone, which do not *look* Japanese, but really are so, perhaps more than others? Look at them where it's clear and blue and with nothing else in the way. It will give you a true idea of the simplicity of nature here.

To my amazement, I am already in sight of the bottom of my purse. You realize that when I have taken out money for food and lodging, all the rest goes for canvas and paints.

I think you are right in your idea of settling Bing's bill for the Japanese prints. I went three times myself at the New Year to his place to settle up, but found it shut. Then a month later, just before I left, I hadn't the money, and I had given a fair number of prints to Bernard when I exchanged with him. But I think it would be a mistake to have done with Bing. Ah, no; we get the prints so cheaply, and can give pleasure to so many artists with them. I should not be surprised if Gauguin wanted to have some of them here as much as I do; your rooms would not be what they are without its Japanese prints.

Keep the three hundred Hokusai views of the holy mountain as well as the pictures of Japanese life; there is an attic at Bing's house with millions of prints piled up, landscapes and figures. Let me commend to you that attic of Bing's. I learnt there myself, and I made Anquetin and Bernard learn there too. That manager is a very nice fellow, and decent to anybody who is genuinely interested.

I have lost rather than gained in my business with Bing as far as money goes, but it has given me a chance to look at a lot of Japanese stuff long and steadily. All my work is in a way founded on

Japanese art, and we do not know enough about Japanese prints. In decadence in its own country, pigeon-holed in collections, already impossible to find in Japan itself, Japanese art is taking root again among the French impressionist artists. Fortunately we know more about the Japanese of France.

It is their practical value for artists that naturally interests me in Japanese things more than the trade. And if I had a single day in which to see Paris again, I should call at Bing's to see those Hokusais. Do not get rid of any fine prints — for that matter, it would pay us better to get more. Some that we have are certainly worth five francs, and they cost us three sous. There isn't much to be made out of them; that is why no one takes them up. Nevertheless in a few years all these will become very rare, and will sell more dearly. And they will get you a Claude Monet and other pictures, because, if you take the trouble to ferret out the prints, you can use them as exchanges with painters.

So, to wind up our connections with Bing — oh, never! Japanese art is a thing like the Primitives, like the Greeks, like our old Dutchman — Rembrandt, Hals, Ruysdael. I cannot understand why you do not keep the lovely Japanese things at the Boulevard Montmartre.

I always wanted when I was in Paris to have a showroom of my own. Even though that fell through, the exhibition of prints I had at the Tambourin influenced Anquetin and Bernard a good deal. As for the trouble we took over the second exhibition in the room in the Boulevard de Clichy, I regret it still less; Bernard sold his first picture there, and Anquetin sold a study, and I exchanged with Gauguin.

Bernard still owes you a study, but it's all to be expected — the difficulty of working in Paris! It's a queer town, Paris, where you can only live by killing yourself, and where so long as you are not half-dead you can do nothing. I have just read Victor Hugo's 'L'Année Terrible.' There is hope there, but — that hope is in the stars. And if all the other stars were the same, that would not be much fun — nothing for it but to begin all over again. But in art, for which one needs *time*, it would not be so bad to live more

than one life. And it isn't without attraction to think of the Greeks, the old Dutch masters, and the Japanese continuing their glorious school on other orbs.

I must send you a new order for paints and canvas — rather a heavy one. What is really urgent is the canvas, because I have just taken thirty painted studies from the frames, and I ought to be putting new canvas on them. Just now I have a sort of exhibition at home: I have nailed all the studies to the wall to finish drying. You will see that when there are a lot of them and one can choose among them, it comes to the same thing as if I had studied them more and worked on them longer; because to paint and repaint a subject on the same or several canvases comes in the end to the same thing.

Nothing would help us more to place our canvases than if they could get general acceptance as decoration for middle-class houses — the way it used to be in Holland. I keep thinking of Holland, and across the twofold remoteness of distance and time gone by these memories have a kind of heart-break in them.

Down here in the South it would do one's heart good to see pictures against the white walls. But go and look: everywhere great coloured Julien medallions — horrors. And alas, we can do nothing to change this state of things. However, there are the cafés; perhaps later on we shall get to decorating them.

Well, here's another Sunday got through in writing. I must say, however, I haven't found it long.

Many thanks for your letter, which gave me great pleasure, arriving just when I was still dazed with the sun and the strain of managing a rather big canvas. I have a new drawing of a garden full of flowers, and two painted studies as well. Truly I can't tell if I shall ever paint pictures that are peaceful and quietly worked out. I think that the continual wind here must have something to do with the haggard look the painted studies have; because in Cézanne you see it too. And not only my pictures but I myself of late have become haggard, almost like Hugo van der Goes in the picture by Emil Wauters. Only having got all my beard carefully shaved off, I think that I am as like the placid priest in the same

picture as the mad painter so intelligently portrayed therein. And
I do not mind being rather between the two, for one must live,
especially because it is no use blinking the fact that there may be a
crisis some day or other.

You talk of the emptiness you feel everywhere; it is that very
thing that I feel myself. Taking, if you like, the time in which we
live as a great and true renaissance of art, the worm-eaten official
tradition still alive but really impotent and inactive, the new
painters alone, poor, treated like madmen and because of this
treatment actually becoming so, at least as far as their social life
is concerned: then you must know that you are doing exactly the
same work as these primitive painters, since you provide them
with money which makes them able to produce. If a painter ruins
his own personality by working hard at painting a thing which
leaves him useless for many other things, if therefore he paints
not only with colours, but with denial and renunciation, and with
a broken heart — as far as you are concerned, your own work is not
only no better paid than his, but costs you exactly what the
painter's costs him; this effacement of individuality, half-voluntary,
half-accidental.

The more hopelessly you become a dealer, the more you become
an artist. And the same is true of me. The more I am spent, ill,
the cracked pot, by so much the more am I the artist — the creative
artist. These things are surely so, but this eternally living art and
this renaissance, this green shoot springing from the roots of the
old cut-down trunk, these are such abstract things that a kind of
melancholy remains with us when we think that one could have
made life for oneself at less cost than making art.

And there we are again. I am getting old; it's sheer imagination
if I think that art is old lumber too. You ought, if you can, to make
me feel that art is living, you who love art perhaps more than I do.
I tell myself that that depends not on art but on myself; that the
only way to get back my confidence and peace of mind is to *do
better*. And these painter's fingers of mine grow supple, even
though the carcass is going to pieces. My ambition is to be less of
a burden to you; if no actual obelisk of a catastrophe comes along,

and there isn't a rain of frogs in the meantime, I hope to get there sometime.

Why, a canvas I have covered is worth more than a blank canvas! That — believe me, my pretensions go no further — that is my right to paint, my reason for painting, and by the Lord, I have one!

All it has cost me is a carcass pretty well ruined and wits pretty well crazed for any life that I might and should live from the philanthropic standpoint. It has cost you fifteen thousand francs which you have advanced to me. If I remind you what painting costs us, it is only to emphasize what we ought to say to ourselves: that we have gone too far to turn back; that's all I harp on. For material existence apart, what else henceforth shall I ever need?

My dear brother, if I were not bankrupt and crazy with this blasted painting, what a dealer I should make just for the impressionists! If I were younger I should want to suggest to old Boussod that he send you and me to London with no other pay than credit; you to get half the profit on the impressionist pictures. But our carcasses are no longer young, and to undertake a journey to London to scrape together some money for the impressionists would be a job for Boulanger or Garibaldi or Don Quixote. But I should rather see you going to London than to New York.

Now, for us who work with our brains, our one and only hope of not being too soon done for is this artificial eking-out by an up-to-date regimen of health rigorously applied; but I for one do not do everything I ought. And a bit of cheerfulness is better than all the other remedies. As for drinking too much — if it is bad, I can't tell. Look at Bismarck, who is in any case very practical and very intelligent: his little doctor told him that he was drinking too much, and that all his life he had overworked his stomach and his brain. Bismarck immediately stopped drinking. After that he got run down and couldn't pick up. He must have a good joke on his doctor that luckily for him he did not consult him sooner.

So at last our Uncle Prinsenhage's sufferings are over. I received the news this morning from our sister. How short life is, and how like smoke! We are right to care more for the artists than for the pictures.

I think you were right to go to his funeral. The best way to treat a death is to swallow the illustrious dead, whatever he was, as being the best man in the best of all possible worlds, where everything was for the best. As our sister said, from the moment people are gone you remember only their good moments and their good qualities. But the great thing is to try to see them while they are still with us.

I am glad that our brother Cor has grown bigger and stronger than the rest of us. And he must be stupid if he does not get married, for he has nothing but his strength and his hands. With that and his hands, or his hands and that, and what he knows of machinery, I for one should like to be in his shoes, if I had any desire at all to be anyone. Meanwhile I am in my own hide, and my hide within the cogwheels of the Fine Arts, like corn between the millstones.

All those things — family, native land — are perhaps more attractive in the imaginations of such people as we are, who pretty much do without native land or family either, than they are in reality. I always feel I am a traveller, going somewhere and to some destination. If I tell myself that the somewhere and the destination do not exist, that seems to me very reasonable, and likely enough.

Be it so. I shall find then that not only the Arts but everything else were only dreams, that oneself was nothing at all.

Whence comes it that in the present instance of our uncle's death the face of the dead was calm, peaceful, and grave, while it is a fact that while living he was rarely thus, either in youth or age? I have often observed a like effect as I looked at the dead as though to question them. And that for me is one proof, though not the most serious, of a life beyond the grave. In the same way, a child in the cradle, if you watch it at leisure, has the infinite in its eyes.

It is rather curious that Uncle as well as Father believed in the future life. Ah — but then they were more assured than we are, and got angry if you dared to go deeper.

Yes, the artists perpetuate themselves by handing on the

torch — Delacroix to the impressionists — but is that all? If the kind old mother of a family, with ideas pretty well limited and tortured by the Christian system, is to be immortal as she believes, why should a consumptive or neurotic cab horse like Delacroix or de Goncourt, with vast ideas, be any less immortal? Granted that it seems just that the most destitute should feel most the springing of this unaccountable hope. But living in the full tide of civilization, of Paris, of the Arts, why should not one keep this 'I' of the old woman?

But the doctors will tell us that not only Moses, Mahomet, Christ, Luther, Bunyan, and others were mad, but also Frans Hals, Rembrandt, Delacroix, and also all the dear narrow old women like our mother. Ah — that's a serious matter. One might ask these doctors: Where, then, are the sane people?

It would be so simple, and would account so well for the terrible things in life which now amaze and wound us so, if life had yet another hemisphere. To those who make this grave and moving journey, our best wishes and sympathy.

And now, if you know what a '*mousmé*' is (you will when you have read 'Madame Chrysanthème'), I have just painted one. A *mousmé* is a Japanese girl — Provençal in this case — twelve to fourteen years old. The work took me the whole of the week; I have not been able to do anything else, not having been very well either. That is what annoys me: if I had been well, I should have slashed at some landscapes in between times, but to do the *mousmé* well I had to reserve my mental energy.

The girl is against a background of white strongly tinged with malachite green; her bodice is striped blood-red and violet; the skirt is royal blue with broad stippling of yellow-orange. The flat flesh tones are yellowish-grey, the hair tinged with violet, the eyebrows are black and the eyelashes, the eyes orange and Prussian blue. A branch of oleander is in her fingers, for the two hands are shown.

That makes two portraits — this and the zouave.

I have had a letter from Russell; he says that he would be pleased if I would go and spend some time with him. He is again insisting

that he wants to repaint my portrait. He says too: 'I should have
gone to Boussod's to see Gauguin's "Negresses Talking" if I had
not been hindered.' I wish that Russell would do something.
However, he has a wife and children, and a studio and a house
being built, and I can quite see how a man, even a rich one, cannot
always spend one hundred francs on pictures.

He does not refuse to buy one, but makes it clear that he does
not want anything of a lower quality than the one we have. I
shall say to him: Look here, you like our picture, but I believe that
we shall see *still* better work from the artist; why don't you have
faith in the whole man such as he is, and like everything he does?

And the same for Guillaumin. I wish he would take a figure
from Gauguin. He says that he has had a very beautiful bust
from Rodin of his wife, and that he lunched on this occasion with
Claude Monet, and saw the ten pictures of Antibes. He criticizes
the Monets very ably, begins by liking them heartily — the at-
tack on the problem, the unfolding tinted air, the colour. After
that he shows what there is to find fault with — the total lack of
construction — one of his trees has far too much foliage for the
thickness of the trunk — and so always and everywhere, from the
standpoint of lots of natural *laws*, he is exasperating enough.

I think it would make a tremendous difference to me now if
Gauguin were here, for days pass without my speaking a word to
anyone. If you are alone too long in the country you get stupid,
and not yet, but this winter, I may become sterile because of it.
If he came, there would be no lack of ideas. Besides that, pro-
vided we keep on good terms and are determined not to quarrel,
we shall be in a stronger position as far as reputation goes.

I have already told you that I have always to fight against the
mistral, which makes it absolutely impossible to be master of my
stroke. You will tell me that instead of drawing the studies I ought
to paint them again on fresh canvases at home. I think so myself
now and then, for it is not my fault that the execution lacks a
livelier touch. What would Gauguin say about it if he were here?
Would he advise my seeking a more sheltered place?

I have only taken the house till Michaelmas. Am I to take it

again or not for a half-year? That is what I should very much
like to decide after Gauguin has seen it. This week will be pretty
steep. I could not pay my rent on the first as I had had a model
all the week. It was then, when I put off the fellow till next Mon-
day, that he said he had another tenant for the house if I had not
decided to keep it on. I'm not much surprised, since I have had it
repaired myself and it is worth more.

I have now two figures in hand of the same model, a postman
in a blue uniform trimmed with gold, a big bearded face, very like
Socrates'. A man more interesting than most. I do not know
whether I can paint Roulin as I feel him; this man is like old
Tanguy in that he is a revolutionary. He is probably thought a
good republican because he whole-heartedly detests the republic
which we now enjoy, and because in the end he begins to doubt,
to be a little disillusioned as to the actual republican principle it-
self. But I once watched him sing the 'Marseillaise,' and I thought
I was watching *eighty-nine — not next year*, but that of ninety-nine
years ago. It was a Delacroix, a Daumier, straight from the old
Dutch.

One portrait is the head, and one a half-length with the hands.
These are more important to me than anything else. The good
fellow, as he would not accept money, cost more eating and drink-
ing with me, and I gave him besides the 'Lantern' of Rochefort.
But that is a trifling evil considering that he posed very well, and
that I expect to paint his baby very shortly — for his wife has just
been brought to bed.

The alteration that I am going to try to make in my pictures is
to do more figures. There is no better or shorter way of improving
your work than doing figures. And I always feel confident when
I am doing portraits, knowing that that work has much more
depth — it isn't the right word, perhaps, but it is the thing that
enables me to cultivate whatever is best and deepest in me. Alto-
gether it is the only thing in painting which moves me to the
depths, and which more than anything else makes me feel the
infinite.

Bernard has sent me ten sketches like his brothel; three of them

were *à la* Redon; the enthusiasm he has for that I do not al-
together share. But there is a woman washing herself, very Rem-
brandtesque, and a landscape with figures, very strange. Today
I sent him six drawings from painted studies. I have promised
him six more, and have asked for some sketches from his painted
studies in exchange.

I have just sent off three big drawings. The third garden is the
one from which I made some painted studies as well. Under the
blue sky the splashes of orange, yellow, red of the flowers take on
an amazing brilliance, and in the limpid air there is a something
or other happier, more lovesome than in the North. The little
cottage garden done lengthwise has in itself amazing colour: the
dahlias are a rich and sombre purple; the double row of flowers is
rose and green on one side, and orange with hardly any leaves on
the other. In the midst is a dwarf white dahlia, and a little pome-
granate with flowers of the most vivid reddish-orange, with
yellowish-green fruits, in the morning in full sunshine, in the
evening drowned in shadow thrown by the fig trees and the reeds.

If only Quost were here, or Jeannin! What's to be done? To
embrace everything it needs a whole school of men completing one
another like the old Dutchmen, portrait painters, painters of
genre, painters of landscape, of animals, painters of still-life.

Well, you have damn good reason to say: Let us go quietly on
our way working for ourselves. You know, whatever this sacro-
sanct impressionism may be, all the same I wish I could paint
things that the generation *before* Delacroix, Millet, Rousseau,
Corot, could understand. Ah, Manet has been very, very near it,
and Courbet — the marrying of form and colour.

If the work gets on and our courage does not fail, we may hope
to see some very interesting years to come.

You are shortly to make the acquaintance of Master Patience
Escalier, a sort of 'man with a hoe,' formerly cowherd of the
Camargue, now gardener at a house in the Crau. The colouring of
this peasant portrait is not so black as in the 'Potato-Eaters' of
Neunen, but our highly civilized Parisian Portier — probably so
called because he chucks pictures out — will find his nose con-

fronted by the same old thing. You have changed since then, but you will see that he has not.

I do not think it would be an insult to the de Lautrec you have to put my peasant beside it, and I am even bold enough to hope that the de Lautrec would appear still more distinguished in the simultaneous contrast, and that mine would gain by the odd juxtaposition because that sun-steeped, sunburnt quality, tanned with burning sun and swept with air, will show up still more beside all that rice powder and elegance.

What a mistake Parisians make in not having a palate for crude things! But there, what I learnt in Paris is leaving me, and I am returning to the ideas I had in the country before I knew the impressionists. And I should not be surprised if the impressionists find fault with my way of working, for it has been fertilized by the ideas of Delacroix rather than by theirs. I use colour more arbitrarily so as to express myself forcibly. Well, let that be as far as theory goes, but I am going to give you an example of what I mean.

I should like to paint the portrait of an artist friend, a man who dreams great dreams, who works as the nightingale sings, because it is in his nature. He'll be a fair man. I want to put into my picture my appreciation, the love that I have for him. So I paint him as he is, as faithfully as I can.

But the picture is not finished yet. To finish it I am now going to be the arbitrary colourist. I exaggerate the fairness of the hair; I come even to orange tones, chromes and pale lemon-yellow. Beyond the head, instead of painting the ordinary wall of the mean room, I paint infinity, a plain background of the richest, intensest blue that I can contrive, and by this simple combination of the bright head against the rich blue background I get a mysterious effect, like a star in the depths of an azure sky.

In the portrait of the peasant, again, I worked in this way, but without wishing in this case to produce the mysterious brightness of a pale star in the infinite. Instead, I think of the man I have to paint as terrible in the furnace of the full harvest, the full South; hence the stormy orange shades, vivid as red-hot iron, and hence the luminous tones of old gold in the shadows.

Oh, my dear boy! — and the nice people will only see the exaggeration as caricature. But what has that to do with us? We have read 'La Terre' and 'Germinal,' and if we are painting a peasant we want to show that what we have read has in the end come very near to being part of us.

Yesterday McKnight broke his silence by saying that he very much liked my last two studies (the garden of flowers), and he talked about them for a long time. Bock is staying with McKnight. He is a young man whose appearance I like very much — a face like a razor blade, green eyes, and a touch of distinction. McKnight looks very common beside him. I have seen the work of this Bock; it is strictly impressionist, but not powerful. It is the stage when this new technique still so preoccupies him that he cannot be himself.

The village where they are staying is real Millet — poor peasants and nothing else, absolutely rustic and homely. This quality completely escapes them. The natives are like Zola's poor peasants, innocent and gentle beings. I think that McKnight has some money, so they taint the village; only for that I should go there often to work. They know the station-master and a score of 'sticky' people. Naturally the simple and artless country folk laugh at them and despise them. But if they did their work without taking up with these village loungers, they could go into the peasants' homes and let them earn a few pence; then this blessed Fontvieille would be a mine for them. Probably McKnight will soon be making little landscapes with sheep, for chocolate boxes.

McKnight and Bock see nothing but heat, or rather nothing at all. Now, even if I begin to see things a little clearer, it needs a very long stay to do them. The painted studies lack clearness of touch. That is another reason why I felt it necessary to draw them.

Today I am probably going to begin the interior of the café where I eat, by gaslight, in the evening. It is what they call here a *café de nuit*, staying open all night. Night-prowlers can take refuge there when they have no money to pay for a lodging, or are too tight to be taken to one.

This morning I was at a washing-place with figures of women

as big as Gauguin's Negresses, one especially in white, black, and red, and another all in yellow; there were about thirty of them, old and young.

These days, so far as material things go, are cruelly hard. Living, no matter what I do, is pretty dear — almost like Paris, where you can spend five or six francs a day and have very little to show for it. If I have models, I suffer for it. But it does not matter; I am going to continue. The only choice I have is between being a good painter and a bad one. That is why painting ought to be done at the public expense, instead of the artists' being overburdened with it. But there, we had better hold our tongues, because no one is forcing us to work, indifference to painting being unluckily widespread and by way of being eternal. I can assure you that if you happened to send me a little extra money sometimes, it would benefit the pictures but not me.

Here there is still one advantage over the North during penniless days, that is the fine weather (even the mistral is fine weather *to look at*), perfectly glorious sunshine in which Voltaire dried up as he drank his coffee. You feel Zola and Voltaire everywhere involuntarily. The South is so alive! Like Jan Steen, like Ostade. Here farms and low pubs are less dreary and less dramatic than in the North, since the warmth makes poverty less harsh and melancholy. Oh, these farm gardens with their lovely big red Provençal roses, and the vines and the fig trees! It is all a poem, and the everlasting bright sunshine too, in spite of which the foliage keeps very green.

Fortunately my digestion is so nearly all right again that I have lived for three weeks of each month on ship's biscuits with milk and eggs. It is the blessed warmth that is bringing back my strength, and I was certainly right in going at once to the South instead of waiting until the evil was impossible to remedy. Yes, really, I am as well as other men now, which I have never been except momentarily at Neunen, and it is rather pleasant. By other men I mean men like the navvies, old Tanguy, old Millet, the peasants.

If you are well you must be able to live on a bit of bread while you are working all day, and have enough strength to smoke and

drink your whack at night — that's all in the bargain — and at the same time feel the stars and the infinite high and clear above you. Then life is after all almost enchanted. Oh! those who do not believe in this sun here are the real infidels.

I am happier to feel my old strength returning than I ever thought I could be. What Gruby says about doing without women and eating well is true, for if your very brain and marrow are going into your work, it is pretty logical not to spend yourself more than you must in love-making. But this is easier to put into practice in the country than it is in Paris.

The desire for women that you catch in Paris, isn't it the effect of that very enervation of which Gruby is the sworn enemy rather than a sign of vigour? So, you feel this desire disappearing just at the moment that one is oneself again. The root of the evil lies in the constitution itself, in the fatal weakening of families from generation to generation, and besides that in one's unwholesome job and the dreary life of Paris, and there's no cure for it. Provided the impressionists produce good stuff and make friends, there is always the possibility of a more independent position for you later on. It's a pity that it cannot be from now on.

Unfortunately, along with the good god sun, three quarters of the time there is the devil mistral. But I think it likely that we shall now have extreme heat without wind, since the wind has been blowing for six weeks. If so, it is a very good thing that I have a supply of paints and canvas, because already I have my eye on half a dozen subjects, especially the little cottage garden.

I have just received the ten metres of canvas. If on it I paint only masterpieces half a metre in size, and sell them cash down and at an exorbitant price to distinguished connoisseurs of the Rue de la Paix, nothing will be easier than to make a fortune from this packet!

Well, I must go on and work. I saw a very quiet and lovely thing the other day: a girl with a coffee-tinted skin darker than the rose of her bodice, under which you could see the breasts, shapely, firm, and small. This against the emerald leaves of some fig trees. A woman as simple as the fields, every line of her virginal

It isn't altogether impossible that I shall get her to pose in the open air, and her mother too — a gardener's wife — earth colour, the figure in dirty yellow and faded blue thrown up in strong sunlight against a square of brilliant flowers, snow-white and lemon-yellow.

It's not a bad place, the South. In the end I think I shall come to belong to the country altogether. And I should very much like to see Gauguin here for a good long time.

Oh! I keep wishing for the day to come when you will see and feel the sun of the South!

Just now we are having a glorious strong heat, with no wind — just what I want. There is a sun, a light that for want of a better word I can only call yellow, pale sulphur-yellow, pale golden yellow. How lovely yellow is!

I am afraid that I shall not get that beauty of a model. She promised; then — as it appears — earned some ha'pence by going gay. She was extraordinary, the figure primitive and strange. Difficulties with models keep on with the same tenacity as the mistral here. It is maddening.

If I painted prettily as Bouguereau paints, people would not be ashamed to let themselves be painted; I think I have lost models because they thought that they were 'badly done,' because I made 'only pictures full of painting.' The poor little souls are afraid that they will be compromised, and that people will laugh at their portraits.

Well, I must have patience and look around for others. Above all, a few pence always in your pocket will naturally go some way towards it. It is a terrible loss to me that I don't speak the Provençal patois.

There is always something driving me on to do as many figure studies as ever I can. I feel that even at this late hour I could be a very different painter if I were capable of having my way as to models; but also I feel the possibility of seeing the day of one's capacity for artistic creation go by, just as in the course of life a man loses his virility.

I am now working on a study of two boats seen from the quay
above; they are of rose-colour, tinged with violet; the water is
bright green; no sky; a tri-colour flag on the mast. A workman
with a barrow is unloading sand.

I spent yesterday evening with my friend the second lieutenant
of zouaves, who is going to Paris. He offered to take charge of a
parcel I have for you. The roll he brings contains thirty-five
studies. There is a rough sketch I made of myself laden with
boxes, props, and canvas on the sunny road to Tarascon. There
is a view of the Rhone in which the sky and water are the colour of
absinthe, with a blue bridge and figures of little black urchins;
there is the 'Sower'; and a washing-place. I think that the picture
of the old peasant's head is as strange in colour as the 'Sower,' but
the 'Sower' is a failure, and the peasant still more.

The head of the postman was done *at a single sitting*. But that's
what I'm good at. I should always do it — drink with the first
comer and paint him, and that not in water-colours but in oils, on
the spot. If I did a hundred like that there would be some good
ones among them. And I should be more of a Frenchman, more
myself, and more a drinker. It does so tempt me — not drinking,
but painting loafers. What I gained by it as an artist, should I
lose as a man?

If I had the faith to do it, I should be a notable madman; now
I am an insignificant one, but you see I am not sufficiently am-
bitious of that fame to set a match to the powder. I should rather
wait for the next generation, who will do in portraiture what
Claude Monet does in landscape — the rich, gallant landscape of
Guy de Maupassant. I know that I am not — not their pitch;
but did not the Flauberts and Balzacs make the Zolas and Mau-
passants? So here's to — not us, but the generation to come.

I had begun to sign canvases, but I soon stopped because it
seemed too foolish. On one seascape there is a clamorous red
signature because I wanted a red note in the green.

I am very glad to have these sent off. Our sister will see my
studies, and that makes a difference to me, for in this way she will
share in something that is essentially part of our life in France;

she will see painting in the raw. But to do me a great pleasure, show her one or two studies put on stretchers and framed in white.

I hope always that through us Willemien will manage to marry an artist. To bring that about she ought to be a little in the movement. Certainly it is not out of the question that she might come and live with us. It speaks well for her taste that she likes sculpture; I was very glad to hear it. Painting as it is now promises to become more subtle — more like music and less like sculpture — and above all it promises *colour*. If only it keeps this promise!

Don't let my stuff take up too much room. Later on — when the hundred are done — we will choose out of the number ten or fifteen to be framed.

You are a good enough judge of painting to see and understand what I may have of originality, and also to see the uselessness of presenting to the modern public what I am doing because the others surpass me in cleanness of touch. That is more the fault of the circumstances under which I work, with the mistral, the fatal conditions of youth that's vanished, and comparative poverty. For my part I am in no way set on changing my position, and I count myself only too happy to be able to go on as I am. Only this much is positive; it is not we of the present time who are decadent. Gauguin and Bernard talk now of 'painting as children' paint — I should rather have that than 'painting as decadents do.' How is it that people see something decadent in impressionism? It is very much the reverse.

What has happened to the 'Souvenir' of Mauve? I have been inclined to think that Tersteeg must have said something to the effect that it would be refused, or some such unpleasantness. Needless to say, I shan't fret over it if this is so.

After such a coolness it is certainly not bad of Uncle to have left you a legacy; I cannot easily get it out of my head that C. M. and he did not actually condemn you to penal servitude for life when they refused to lend you the necessary capital to set you up in business on your own. It's very good of you to promise the two of us, Gauguin and me, that you'll put us in the way of carrying out our alliance.

With all our feeling for Gauguin, I think that we must behave like the mother of the family and work out the actual expenses. If one listened to him, one would go on hoping for something vague in the future, and meantime stay on at the inn and go on living in a hell, with no way out. I should rather shut myself in a cloister as the monks do, free as the monks are to go to the brothel or the wineshop if the spirit moves.

Altogether Gauguin leaves me quite in the dark. I'm not coming to Pont-Aven if I have to stay at the inn with the English and the people from the École des Beaux-Arts that one must argue with every evening. It's a storm in a teacup. For our work we need a home. We must contrive to have the absolute necessities to stand the siege of failure which will last all our lives, but we must live almost as monks or hermits, with *work* for our master passion.

I had a note from Gauguin to say that he is quite ready to come South as soon as the opportunity offers. I think that Gauguin would rather mess about with his friends in the North. They are enjoying themselves very much painting, arguing, and fighting with the worthy English. And if by good luck he sells one or more pictures, he may have other plans than coming to join me.

Have I not, with less desire than he for the struggle in Paris, the right to go my own way? Seeing that for six months Gauguin has managed to muddle along by himself, I am ceasing to believe in the urgent necessity of helping him. Nature and fine weather are the advantages of the South, but I think that Gauguin will never give up the fight in Paris; he has it too much at heart and believes in a lasting success. That will do me no harm; if I had the same ambitions as he, we should probably not agree. I do not care about either success for myself or happiness; I do care about the permanence of this vigorous attempt by the impressionists. I do care about the question of shelter and daily bread for them.

I do not insist on what Gauguin ought to do. Already we can see that he would have left us in the lurch if Laval had had ever so little money — the arrival of his friend Laval opened momentarily a new resource for him; if all goes well, Gauguin will take up again with his wife and children. Certainly I should wish that for him,

but from the point of view of money the business is taking on serious proportions.

If Gauguin does not lose sight of his own interest, it is only fair that you should not lose sight of yours. You offer him hospitality here; but if he demands, over and above that, that you should pay his way, at least he ought to make you a frank offer of pictures and address himself to you in terms less vague than 'Every day I go deeper and deeper into debt, and the journey becomes more and more out of the question.' It would be more to the point if he said: I should rather leave my pictures in your hands, since you are kind to me, and incur debts with you who are my friend.

If this thing is to come off, we must have loyalty from him. Faithful he will be if it is to his advantage; if he does not come, he will find something else, but he will find nothing better. I feel by instinct that he sees himself at the bottom of the social ladder, and wants to win a position by honest means, but very politic ones. Gauguin little knows that I am able to take all this into account. And perhaps he does not know that it is necessary for him to gain time, and that with us he will gain that if he gains nothing else.

I reply to him exactly as I feel, but I do not want to say depressing or dismal or malicious things to so great an artist.

Russell has replied negatively about buying a Gauguin, yet he asks me to go and stay for a while with him; but the beginning and end of that is the cost of the fare.

Gauguin said that Bernard had made an album of my sketches and had shown it to him. He speaks well of Bernard's work, and Bernard's letter is steeped in admiration for Gauguin's talents. He says he finds Gauguin so great an artist that he is almost afraid. I am keeping all Bernard's letters. They are sometimes really interesting, and there is quite a bundle already. Bernard says it grieves him to see how Gauguin is often prevented from doing what he otherwise could do, from wholly material lacks — paints, canvas. Well, in any case that can't go on.

I think the autumn is going to be absolutely amazing. It promises to give so many magnificent subjects that I simply do

not know whether I am going to start five canvases or ten. It will be just as it was in the spring with the orchards in bloom.

I am hard at it, painting with the enthusiasm of a Marseillais eating *bouillabaisse* — which won't surprise you when you know that what I'm at is the painting of some great sunflowers.

I have three canvases on hand: first, three huge flowers in a green vase, with a light background; the second, three flowers — one gone to seed, one in flower, and the third a bud, against a royal blue background. This has a 'halo'; that is, each object is surrounded by a glow of the complementary colour of the background against which it stands out. The third, twelve flowers and buds in a yellow vase. This last is, therefore, light on light, and I hope will be the best.

I am now at the fourth, a bunch of fourteen flowers against a yellow background, like a still-life of quinces and lemons that I did some time ago. Only, as it is much bigger, it gives a rather singular effect; and I think this one is painted with more simplicity.

Do you remember the very extraordinary Manet, some huge pink peonies with their green leaves against a light background? As much the open air and as much a flower as anything could be, yet painted in perfectly solid *pâte*. That is what I call simplicity of technique.

I have heaps of ideas for new canvases, but I am beginning to try more and more for a simple technique, which is not, perhaps, impressionist. I should like to paint in such a way that everybody, at least everybody with eyes, would see it.

Stippling and making haloes and other things are real discoveries, but this technique must not become a universal dogma. That is a reason why Seurat's 'Grande Jatte, the landscapes with broad stippling by Signac, and Anquetin's boat will in time become still more individual and still more original.

I am endeavouring to find a brush work that is nothing but the varied stroke. But some day you will see.

Now that I hope to live in a studio of my own, I want to make decorations for it; nothing but big flowers. If I carry out this idea there will be a dozen panels. The whole thing will be a symphony

in blue and yellow, and I am working at it every morning from sunrise, for the flowers fade so soon, and the thing is to do the whole at a flash. I have a good dinner and supper, so I have been able to work hard and long without feeling myself weaken.

I am going to send you a big order for paints. To me it seems as though the more finely a colour is pounded, the more it becomes saturated with oil, and needless to say we don't care overmuch for oil. If we painted as do Monsieur Gérôme and the other stereoscopic photographers, we should doubtless ask for very finely powdered colours; but we do not object to the canvas's having a rough look. If, then, instead of pounding the colour on the stone for God knows how many hours, it were crushed just long enough to make it manageable, I am almost certain that at much less cost I should get colours which would be both fresher and more lasting. I am sure this could be done.

What a pity that painting costs so much! I shall have spent the hundred-franc note in a single week, but at the end of this week I shall have my four pictures. But there, we live in days when what we do makes no running; not only does it not sell, but, as you see with Gauguin, when you want to borrow on the pictures you can get nothing, even when it is a trifling sum and the work important. That is why we are the prey of every happening, and I am afraid that it will hardly change in our lifetime. Provided we are preparing richer lives for the painters who will follow in our footsteps, that will be something; but life is short, and shorter still the number of years that you feel bold enough to face everything.

I have said to Gauguin that if we painted in the style of Bouguereau, we could hope to make money, that the public likes only easy, pretty things. With a more austere talent you cannot count on profit from your work; most of the people intelligent enough to like and understand impressionist pictures are, and will remain, too poor to buy them.

Shall Gauguin or I work the less for that? No — but we shall be forced to submit deliberately to poverty and social isolation, though I very often despair in my heart when I think of what Gauguin will say about this country in the end. The isolation of this place is pretty serious.

What touches me most deeply in Zola's 'L'Oeuvre' is the figure
of Bongrand-Jundt. He says: 'You think, you poor souls, that
when an artist has established his talent and his reputation, he
is safe. On the contrary, it is now denied him henceforth to
produce anything which is not absolute. At the least sign of weak-
ness the whole jealous pack will fall on him and destroy that very
reputation.'

And even stronger than this is what Carlyle says: 'You know the
glow-worms in Brazil that shine so that ladies in the evening
transfix them with pins in their hair; well, fame is a fine thing, but
look you, it is to the artist what the hairpin is to the insect. You
want to succeed and shine, but do you know what it is you desire?'

So I have a horror of success. But it is a gloomy enough prospect
to have to say to myself that perhaps the painting I am doing will
never be of any value whatever. If it were worth what it cost to
do, I could say, I never bothered my head about money. But if
when one is younger one can believe that it's possible to get a liv-
ing by unremitting work, it becomes more and more doubtful now.

I often hold back from planning a picture because of what the
colours would cost. That is rather a pity, for the simple reason
that we may have power to work today, but we do not know
whether it will last till tomorrow. All the same, far from losing
my physical strength, I am regaining it, and my stomach especially
is stronger. And fortunately for me I do not hanker after victory
any more. All I ask in painting is a way of escaping from life.

Thank you for the copy of 'La Fin de Lucie Pellegrin.' It is
quick with life. Why should it be forbidden to handle these sub-
jects? The unhealthy and overexcited sexual organs seek pleasures
and delights such as da Vinci's. Not I, who have hardly seen any-
thing but the kind of woman at three francs originally destined
for the zouaves, but the people who have leisure for love-making
want the da Vinci mysteries. I realize that these loves are not for
everyone's understanding, but from the point of view of what is
allowed, one could write books treating of worse aberrations of
unhealthy sex than Lesbianism.

At all events, law and justice apart, a pretty woman is a living

marvel, whereas the pictures of da Vinci and Correggio only exist on other counts. Why am I so little an artist that I always regret that the statue and the picture are not alive? Why do I understand the musician better? Why do I see better the living principle of his abstractions?

Look here, as soon as you can, will you not lend me for a year three hundred francs at one sweep? You send me at present two hundred and fifty francs a month; you would only send me two hundred after this until the three hundred was paid off. And it would be a gain of three hundred francs a year, for I pay one franc every night to my landlord. Then I should buy two decent beds. That would mean that I could sleep at home.

How I should like to settle down and have a home! And indeed, indeed, it is the only condition for working. Once settled, we should stay there all our lives. It's a poor way of doing things to wait till one is very rich. The de Goncourts ended by buying their home and their tranquillity for one hundred thousand francs. But we should have it at less than a thousand, so far as it meant having a studio in the South where we could give someone a bed — to deliver me and some of the crowd from this cancer that is gnawing at our work, this being forced to live in these cut-throat inns. A home of one's own, a *pied-à-terre* which frees the mind from the dismalness of feeling oneself in the streets. That is nothing when you are an adventurer of twenty, but it is bad when you are turned thirty-five. If we must make a fortune first — we shall be complete nervous wrecks when we enter into our rest, and that is worse than our present condition in which we are still able to stand the racket.

To be carefree, to hope that some day or another one will be free from want — what a dream! I should think myself very happy to work for a wage just sufficient to keep me in peace in a studio all my life.

I had two models this week: an Arlésienne, and the old peasant. I am doing him this time against a background of vivid orange, which, although it does not pretend to be the image of a red sunset, nevertheless gives a suggestion of one. I am afraid that the little Arlésienne will not turn up for the rest of the picture. She asked

me for all the money I had promised her for posing, in advance. But some day or other she is bound to come back; it would be rather too thick if she failed me altogether.

I spent yesterday with the Belgian Bock. It was not fine, but a very good day for talking. He is going to Paris, and if you put him up you will be doing him a good turn. Thanks to him I have at last a first sketch of that picture which I have dreamt of for so long — the poet. He posed for me. His fine head with that keen gaze stand out in my portrait against a starry sky of deep ultramarine; for clothes, a short yellow coat, a collar of unbleached linen, and a spotted tie. He gave me two sittings in one day.

My dear boy, sometimes I know so well what I want. I can do without God both in my life and in my painting, but I cannot, ill as I am, do without something which is greater than I, which is my life — the power to create. And if, defrauded of the power to create physically, a man tries to create thoughts in place of children, he is still part of humanity.

In a picture I want to say something comforting, as music is comforting. I want to paint men and women with that something of the eternal which the halo used to symbolize, and which we seek to give by the actual radiance and vibration of our colourings.

Ah! portraiture, portraiture with the thought, the soul of the model in it, that is what I think must come.

So I am always in one of two currents of thought: first, the material difficulties, turning round and round to make a living; and second, the study of colour. I am always in hope of making a discovery there, to express the love of two lovers by a marriage of two complementary colours, their mingling and their opposition, the mysterious vibrations of kindred tones; to express the thought of a brow by the radiance of a light tone against a sombre background; to express hope by some star, the eagerness of a soul by a sunset radiance. Certainly there is nothing in that of stereoscopic realism, but is it not something that actually exists?

I am having two oak frames made for my new peasant's head, and for my poet study.

The sunflowers are getting on; there is a new bunch of fourteen

flowers on a greenish-yellow ground. And I have a still-life of an
old pair of shoes. Counting the sunflowers, I have at the moment
another fifteen new studies.

Ideas for my work come to me in swarms, so that although soli-
tary I have no time to think or to feel; I go on like a steam-
engine at painting. I think there will hardly ever be a standstill
again. And my view is that a living studio you will never find
ready-made; it is created from day to day by patient work.

After some worrying weeks I have just had one of the very best.
And just as worries do not come singly, neither do joys.

Because I am always bowed down under this difficulty of paying
my landlord, who after all isn't a bad fellow, I swore at him and
told him that to revenge myself for paying him so much money for
nothing, I would paint the whole of his rotten shanty. Then to the
great joy of the landlord, of the postman, of the visiting night-
prowlers, and of myself, for three nights running I sat up to paint
and went to bed during the day.

In my picture of the 'Night Café' I have tried to express the
idea that the café is a place where one can ruin oneself, run mad,
or commit a crime. I have tried to express the terrible passions of
humanity by means of red and green. The room is blood-red and
dark yellow, with a green billiard table in the middle; there are
four lemon-yellow lamps with a glow of orange and green. Every-
where there is a clash and contrast of the most alien reds and
greens in the figures of little sleeping hooligans in the empty dreary
room, in violet and blue. The white coat of the *patron*, on vigil in
a corner, turns lemon-yellow, or pale luminous green.

So I have tried to express, as it were, the powers of darkness in a
low wine-shop, and all this in an atmosphere like a devil's furnace
of pale sulphur — all under an appearance of Japanese gaiety and
the good nature of Tartarin.

The 'Night Café' carries on the 'Sower,' and so also the head of
the old peasant, and of the poet, if I manage to do this latter pic-
ture. It is colour not locally true from the point of view of the
stereoscopic realist, but colour to suggest the emotion of an ardent
temperament.

When Paul Mantz saw the violent and inspired sketch of Dela-
croix, 'The Barque of Christ,' he turned away from it, exclaiming:
'I did not know that one could be so terrible with a little blue and
green.' Hokusai wrings the same cry from you, but he does it by
his *line*, his *drawing*. When you say in your letter, 'The waves are
claws, and the ship is caught in them,' you feel it. If you make the
colour exact, or the drawing exact, it won't give you sensations like
that.

But what would Monsieur Tersteeg say about the 'Night Café,'
when he said before a Sisley — Sisley, the most discreet and gentle
of the impressionists — 'I cannot help thinking that the artist who
painted that was a bit tipsy'? If he saw my picture, he would say
that it was delirium tremens in full career.

I am greatly pleased that Pissarro thought something of the
'Young Girl.' Has he said anything about the 'Sower'? After-
wards, when I have gone further in these experiments, the 'Sower'
will still be the first attempt in that style; and the idea of it con-
tinues to haunt me all the time.

Exaggerated studies such as the 'Sower' and the 'Night Café,'
usually seem to me atrociously ugly and bad. The picture of the
'Night Café' is one of the ugliest I have done. It is the equivalent,
though different, of the 'Potato-Eaters.' But when I am moved
by something, as now by a little article on Dostoievsky, these are
the only ones which appear to have any deep meaning.

I see absolutely nothing to object to in your suggestion of ex-
hibiting once at the Revue Indépendante, provided, however, I
am not a hindrance to the others who usually exhibit there. So far
hardly any but the 'Sower' and the 'Night Café' are attempts at
finished pictures.

I now have a study of an old mill painted in broken tones like the
oak tree on the rock, that study you were saying you had had
framed with the 'Sower,' and a third study of a landscape with a
factory and a huge sun in a red sky above red roofs, a day with a
wicked mistral when nature seems to be in a rage.

Yesterday I was busy furnishing the house. Just as the postman
and his wife told me, the two beds to be substantial will come to

three hundred and fifty francs apiece. They are country beds, big double ones instead of iron ones. That gives an appearance of solidity, lastingness, and quiet; if it takes a little more bedding, so much the worse, but it must have character. Naturally this has swallowed up the greater part of the money. With the rest I have bought twelve chairs, a mirror, and some small necessary things.

The room you will have — or Gauguin if he comes — will be the prettier room upstairs, which I shall try to make as much as possible like the boudoir of an artistic woman. It will have white walls with a decoration of great yellow sunflowers, twelve or fourteen to the bunch. In the morning when you open the window you will see the green of the gardens and the rising sun, and the road into the town.

I am in a public garden, quite close to the street of the pretty women. Mourier would hardly enter it, although almost daily we walked in the gardens, but on the other side. It is just this that gives a touch of Boccaccio to the place. This side of the garden is also, for the same reason of chastity or morality, destitute of any flowering bushes such as oleanders. There are ordinary plane trees, pines in stiff clumps, a weeping tree, and the green grass. But it is all so intimate. Manet has gardens like this.

Then there will be my own bedroom, which I want extremely simple, but with large solid furniture, the bed, the chairs, and table all in white wood. I am going to paint my own bed; there will be three subjects on it; perhaps a nude woman or a child in a cradle; I have not decided, but I shall take my time over it.

Downstairs there will be the studio — the red tiles of the floor, the walls and ceiling white, rustic chairs, white wood table, and I hope a decoration of portraits. It will have a feeling of Daumier about it, and I think I can promise you it will not be hackneyed.

Henceforth you can feel that you have your country-house at Arles; for I am very keen to arrange it so that you will be pleased with it, and so that it will be a studio in an absolutely individual style. I want to make it really an *artist's house* — nothing precious. but with character in everything, from the chairs to the pictures. If in a year, say, you come here and to Marseilles for your holidays,

the house will be ready, and as I intend it will be full of pictures from top to bottom. You shall have a picture some day or other of the little house itself in bright sunshine or with the windows lit up, and with a starry sky. And do look for some lithographs of Daumier's for the studio, and some Japanese things.

Last night I slept in the house, and though there are some things still to be done, I feel very happy in it. At present it reminds me of the interiors of Bosboom. Its surroundings, the public garden, the night cafés, and the grocer's are not Millet, but short of that they are Daumier, absolute Zola. And that is quite enough to supply one with ideas, isn't it?

But my idea is that at the end of it all we shall have founded and left to posterity a studio where one's successor could live, where one finds one works more tranquilly. In other words, we are working for an art and for a way of things which will last not only our lifetime, but which can still be carried on by others after us.

Now, if I set up a studio and refuge right at the gates of the South, it's not such a daft scheme. Why did the greatest colourist of all, Eugène Delacroix, think it essential to go south and right to Africa? Obviously because not only in Africa but from Arles onwards you are bound to find beautiful contrasts of red and green, of blue and orange, of sulphur and lilac. All true colourists must come to this, must admit that there is another kind of colour than that of the North.

Will my work be worse because by staying in the same place I shall see the seasons pass and repass among the same subjects, shall see the same orchards every spring, in summer the same fields of corn? Involuntarily I shall see my work blocked out for me beforehand, and shall be better able to make plans.

In my work I already feel myself freer and less harried by unnecessary annoyances than I have been. But as I have still more things to add — and I am speaking only of what is strictly necessary — you must again send me one hundred francs instead of fifty. Very fortunately I have a faithful charwoman; only for that I should not dare to begin living at home; she is quite old and has many and various youngsters, and she keeps my tiles clean and

red. As to my clothes, they are beginning to be the worse for wear, but only last week I bought a black velvet jacket of fairly good quality for twenty francs, and a new hat, so there is no hurry.

I went for a splendid walk by myself today, all through the Tartarin and Daumier side of this queer country. There is a great deal of Greek still, and a Venus of Arles as well as of Lesbos, and one feels youth in spite of it all.

We have had two or three perfect days, very hot and no wind. The grapes are beginning to ripen. When we have the mistral, it is the exact opposite of a sweet country, for the mistral sets one on edge. But what amends, what amends when there is a day without wind! What intensity of colour, what pure air, what vibrant serenity!

I have such a joy in the house and in my work that I dare even to think that the joy will not always be solitary, but that you will have a share in it and the zest of it too. My dear Theo, you will see the cypresses and the oleanders here, and the sun — the day will come, you may be sure.

This afternoon I had a select public — four or five hooligans and a dozen street arabs who were especially interested in seeing the paint come out of the tubes. Well — there is fame. Or rather, I mean to laugh at ambition and fame, as I do at these street arabs, and at the loafers on the banks of the Rhone and in the Rue du Pont d'Arles.

I have a new canvas of thirty square — a corner of a garden with a weeping tree, grass, round clipped bushes of cedar and an oleander bush. There is a lemon sky over everything, and the colours have the richness and intensity of autumn. It is in heavier paint than the rest, plain and thick. That is the first picture this week.

The second represents the outside of a café, with a terrace lit up by a big gas lamp in the blue night, and a corner of starry blue sky. I often think that the night is more alive and more richly coloured than the day.

The third is a portrait of myself, *almost colourless*, in grey tones against a background of pale malachite. I had bought of set pur-

pose a mirror good enough for me to be able to work from myself in default of a model; because if I can manage to paint the colouring of my own head, which is not to be done without some difficulty, I shall likewise be able to paint the heads of other good souls, men and women. So this week I have done absolutely nothing but paint and sleep and take my meals. That means sittings of twelve hours, of six hours, and then a sleep of twelve hours at a time.

This makes three pictures of the garden opposite the house. Then there are the two cafés, and the sunflowers; then the portraits of Bock and of myself, the red sun over the factory, the men unloading sand, and the old mill. Leaving out the other studies, you see that I have got some work behind me. But my paints, my canvas, and my purse are all completely exhausted today.

Is it quite out of the question for Thomas to lend me two or three hundred francs on my studies? That would let me gain a thousand on them, for, as I cannot tell you often enough, I am ravished, ravished with what I see. It gives one enthusiasm that makes the time pass by without one's feeling it, and — beware the morning after the night before, and the winter mistral.

I wrote early this morning; then I went away to go on with a picture of a garden in sunshine. Then I brought it back and went out again with a blank canvas, and that also is finished. And now I write again.

I have never had such a chance; nature here is so *extraordinarily* beautiful. Everywhere and over all the vault of the sky is a marvellous blue, and the sun sheds a radiance of pale sulphur that is soft and lovely. What a country!

I cannot paint it as lovely, but it absorbs me so much that I let myself go, never thinking of a single rule; I have no doubts, no hesitation in attacking things. I am beginning to feel that I am quite a different creature from the one I was when I came here. I am returning to what I was looking for before I came to Paris; I have got back to where I was at Neunen when I made a vain attempt to learn music, so much did I feel the relation between our colour and the music of Wagner.

I do not know whether anyone before me has talked about suggesting colour. Delacroix and Monticelli, without talking about it, did it, and it is true that I see in impressionism the resurrection of Eugène Delacroix, but the interpretations of it are so divergent and in a way so irreconcilable that it will not be impressionism that will give us the final doctrine. I myself remain among the impressionists because it binds you to nothing, and as one of the crowd I have not to declare my formula. At the same time I think it is right to see in the impressionist movement a tendency towards great things, and not *only* a school which would confine itself to optical experiment. And after all, our own personal future we know nothing really about, but we feel that impressionism will last.

Good Lord, how you have to mess about in life! I ask only for time to study, and do you yourself really ask for anything but that? I am so afraid of taking it from you by my demands for money.

What is Seurat doing? I should not dare to show him the studies already sent, but the ones of the sunflowers, and the cabarets, and the gardens, I should like him to see.

What days these are, not for what happens in them, but I feel so strongly that you and I are not in our decadence, nor done for yet, nor shall we be in the end. But, you know, I do not contradict the critics who will say that my pictures are not — *finished.*

Since seven o'clock this morning I have been sitting in front of a clipped round bush of cedar growing amid grass. A row of bushes in the background are oleanders raving mad; the blasted things are flowering so riotously they may well get locomotor ataxia. They are loaded with fresh flowers, and heaps of faded flowers as well, and their green is continually renewing itself in fresh, strong jets, apparently inexhaustibly. A funereal cypress stands above them, and some small figures are sauntering along a rose-coloured path.

This garden has a fantastic character that makes you quite able to imagine the poets of the Renaissance, Dante, Petrarch, strolling over the flowery grass. It is the garden just in front of my house.

And it shows perfectly that to get at the real character of things here you must look at them and paint them for a long time. Perhaps you will see nothing from the sketch except that the line is very simple.

What I am sure of is that to make a picture which will be really of the South, it is not enough to have a certain cleverness. It is looking at things for a long time that ripens you and gives you a deeper understanding. If we study Japanese art, we see an artist who is wise, philosophic, and intelligent, who spends his time — how? In studying the distance between the earth and the moon? No. In studying the policy of Bismarck? No. He studies a single blade of grass. But this blade of grass leads him to draw the plant, and then the seasons, the wide aspects of the countryside, the animals, then the human figures. So he passes his life.

Come, now, isn't it almost an actual religion which these simple Japanese teach us, who live in nature as though they themselves were flowers? We must return to nature in spite of our education and our work in a world of convention. And you cannot study Japanese art without becoming gayer and happier.

I envy the Japanese the extreme clearness which everything has in their work. Their work is as simple as breathing, and they do a figure in a few strokes, with ease. Oh! I must manage some day that in a few strokes the figure of a man, a youngster, a horse, shall have head, body, legs, all in keeping.

I have a letter from Gauguin, who seems very unhappy and says that as soon as he has sold something he will certainly come. He says that the people where he lodges have been wonderful to him, and that to leave them would be an outrage; but that I should be turning the knife in his heart if I were to think that he would not come straight off if he could. He says, too, that if you could sell his pictures at a low price he would be content.

I have just bought a dressing-table with everything necessary, and my own little room is complete. The other room needs still a dressing-table and a chest of drawers, and downstairs I shall need a big frying-pan and a cupboard. I am also thinking of planting two oleanders in tubs in front of the door.

I have arranged in the studio all the Japanese prints and the Daumiers, and the Delacroix and the Géricault; and lastly the little etching of Jacquemart after Meissonier, the 'Man Reading' — a Meissonier that I have always admired.

I shall need time, but I am obsessed with the idea of painting such decorations for the house as will be worth the money spent on me during the years in which I was unproductive. If you see Seurat tell him that I have in hand a scheme of decoration which has now got to fifteen canvases and which will take at least fifteen others to make a whole, and that in this more spacious work it is often the memory of his personality and of the visit we made to his studio to see his beautiful great canvases that encourages me.

I now have a canvas representing the house and its surroundings in sulphur-coloured sunshine. The subject is frightfully difficult, but that is just why I want to conquer it. The house on the left is pink with violet shutters; that is the restaurant where I go for dinner. My friend the postman lives at the end of the road between the two railway bridges.

Milliet thinks this horrible, but when he says he cannot understand anyone amusing himself doing such a dull grocer's shop and stark stiff houses, I think to myself that Zola did a certain boulevard at the beginning of 'L'Assommoir,' and Flaubert a corner of the Quai de la Villette, and neither of them is junk yet. And it does me good to do difficult things.

That does not prevent my having a terrible need of — shall I say the word? — religion. That Benedictine father you tell of must have been very interesting. I only wish that they would manage to prove us something that would tranquillize and console us, so that we might stop feeling guilty and wretched, and could go on just as we are without losing ourselves in solitude and nothingness.

There is a book of Tolstoi's called 'My Religion.' He does not seem to believe in a resurrection either of the body or the soul. Above all he seems not to believe in heaven — he reasons just as a nihilist reasons, but he attaches great importance to doing whatever you are doing, since probably it is all there is in you. And if

he does not believe in the resurrection, he seems to believe in the
equivalent — the continuance of life, the progress of humanity —
the man and his work almost infallibly continued by humanity
in the next generation. Himself a nobleman, he turned labourer,
could make boots and frying-pans, guide the plough. I can do
nothing of that, but I can respect a human soul vigorous enough
to mould itself anew.

Good God! we must not complain of living in an age of nothing
but slackers when we are side by side with such specimens of
mortality as this, and with no great faith in heaven at that. Tolstoi
believes in a peaceful revolution caused by the need of love and
religion, which must appear among men as a reaction to scepticism,
and to that desperate suffering that makes one despair.

I go out at night to paint the stars, and I dream always of a
picture like this of the house with a group of living figures of our
own crowd.

Today again, from seven o'clock in the morning till six in the
evening, I worked without stirring except to eat a bite a step or two
away. That is why the work is getting on fast. But what will you
say to it? And what shall I think of it myself a little while from
now? I have a lover's clear sight or a lover's blindness.

These colours give me extraordinary exaltation. I have no
thought of fatigue; I shall do another picture this very night, and
I shall bring it off. I have a terrible lucidity at moments when
nature is so beautiful; I am not conscious of myself any more, and
the pictures come to me as in a dream. I can only let myself go
these days that are free from wind, especially as I think the work
is getting rather better than the last sent you.

I want as far as possible to make sure of enough pictures to keep
my end up when the others make a great show for the year '89.
I am rather afraid that this will mean a reaction and depression
when the bad weather comes, but I shall try to avoid it by study-
ing this business of drawing figures from memory. The one thing
I do hope is that by working hard at it I shall have enough pictures
to have a show if you wish it at the time of the exhibition. I need
not exhibit, but we should have work of mine in the house that

would prove one isn't either a slacker or a rotter, and I should be content.

Milliet was pleased with what I had done today — the 'Ploughed Field'; generally he does not like what I do, but because the lumps of earth are as soft in colour as a pair of sabots, it did not offend him.

I shall not be surprised if you like the 'Starry Night' and the 'Ploughed Field'; there is more quiet about them than in the other canvases. If the work always went on like that, if the technique kept on growing more harmonious, I should be less worried about money, for it would be easier for people to take to my paintings.

I have ten new canvases in hand now. If you can't see these lovely days here, you shall see the pictures of them. And I am trying to express more than the others. They are done with a single coat of *pâte*. The touch is not much divided and the tones are often blended; altogether I am obliged to lay the colours on thick in Monticelli's way. Sometimes I think I really am a continuation of that man, only I have not yet done the figures of lovers as he did. Madame de Laréby Laroquette said to me once: 'But Monticelli, Monticelli, why, he was a man who ought to have been at the head of a great studio in the South.'

Well, don't you see, we are founding it. What Gauguin does, what I do, will be in line with that fine work of Monticelli's, and we shall try to prove to the good folk that Monticelli did not wholly die sprawled over the café tables of the Cannebière, but that the good old chap is still alive. The thing won't end even with us; we shall set it going on a pretty solid basis. I believe that a new school of *colourists* will take root in the South, as I see more and more that those in the North rely on ability with the brush, and the so-called 'picturesque,' rather than on the desire to express something by colour itself. Here, under a stronger sun, I have found true what Pissarro said, and what Gauguin wrote to me as well: 'The simplicity, the gravity of great sunlight effect. Never in the North do you come near suspecting it.'

When I left you at the station to come South, very miserable,

almost an invalid, and almost a drunkard, I felt that that winter
we had put our very heart into our discussions with so many in-
teresting people and artists, but I did not dare to hope. After
continued effort on your part and mine, something now begins
to show on the horizon: Hope.

More and more I come to think that the true and right way in
the picture trade is to follow one's taste, what one has learnt from
the masters — one's faith. It is no more easy, I am convinced, to
make a good picture than it is to find a diamond or a pearl. It
means trouble, and you risk your life for it as dealer or as artist.
But, once you have some good stones, you must never doubt
yourself again. This thought encourages me to work, even while
I naturally suffer at having to spend money.

I want two things: I want to earn as much as I have already
spent, so as to give it to you, and I want Gauguin to have peace
and quiet in which to produce, and be able to breathe freely as an
artist. The more Gauguin realizes that when he joins with us he
will have the standing of headship of a studio, the sooner he will
get better, and the more eager he will be to work.

It does not matter if you stay with the Goupils or not; you are
in it head and shoulders. You will be the first dealer-apostle. I
am overjoyed to hear what you tell of your two new friends, the
painter Meyer de Haan and his friend Isaacson. The Dutch artists
have spoken of you as *the dealer in impressionist pictures*. We
must not lose sight of that. And what did they tell you about
Dutch art, Breitner, and Rappard, and others? And lastly, what
do they say about Tersteeg?

Yes, I can see my own painting coming along, and I shall urge
every man who comes in reach of me to produce; I will set them
an example myself. All this, if we stick to it, will help to make
something more lasting than ourselves.

For the second time I have scraped off a study of Christ with the
angel in the Garden of Olives; because here I can see real olives.
But I cannot, or rather I will not, paint any more without models.
But I have the thing in my head, a starry night, the figure of Christ
in blue, and the angel blended lemon-yellow.

I have had a very thin time of it these days. My money ran out on Thursday and I have lived for four days on twenty-three cups of coffee, with bread for which I still owe. And I have left today for the week, and after four days of strict fasting at that, just six francs. I ate at noon, but this evening I shall sup on a crust of bread. It makes me sick to have to ask you again for money, but I cannot help it, for I am knocked up again.

It is not your fault; it is mine if anyone's, because I was wild to see my pictures in frames, and ordered too many for my budget. I have had two walnut frames made for the two of the 'Poet's Garden,' which do very well, and I am looking for a frame in yellowish chestnut. Pine also goes well with the 'Furrows' and the 'Vineyard.'

Oh! my study of vineyards! I have worked like a slave over it, but I have got it, both as a canvas and as a subject for the decoration of the house. If you could see the vines! There are bunches that actually weigh a kilo. The grapes are magnificent this year because of the fine autumn days. The vines I have just painted are green, purple, and yellow, with violet bunches and branches of black and orange. On the horizon are some grey willows, the winepress a long, long way off, and the lilac silhouette of the distant town. In the vineyard there are little figures of women with red parasols, and other little figures of men working at the vintage with their cart.

I venture to think that if you saw the studies you would say I was right in working at white heat as long as the weather is fine. The work grips me, and I am sure I shall not lose by it if I can go on like this; the big canvases are all good. But they are exhausting too. But do not worry, the bad weather will pull me up only too soon, as it did today, yesterday, and the day before yesterday too. We had mud and rain. Between now and the short winter there will be another spell of magnificent weather and magnificent effects; then the thing will be to make another headlong spurt.

This winter I intend to draw a great deal. If only I could manage to draw figures from memory, I should always have something to do. Weavers and basket-makers often spend whole seasons alone

with their trade as their only distraction. But what makes these people stay in one place is the feeling of the house, the reassuring familiar look of things.

I think I shall end by not feeling lonesome, and that during the bad days and the long evenings I shall find some occupation that will take all my attention. And then, too, the time will come when I shall have someone. I have little doubt of that.

I have received a letter from Gauguin paying me heaps of undeserved compliments, and adding that he has been ill and dreads the journey. What can I do about it? — is it such an annihilating journey when the worst lung cases undertake it?

That is great about Bague! Tell him that I am very pleased he has bought that Gauguin study, and that I have told you I have a 'Starry Night,' the 'Furrows,' the 'Poet's Garden,' the 'Vineyard' — in short, romantic landscapes — and that I do want him to come and see them.

Yesterday I painted a sunset.

I have no more canvas at all; and I need two hundred francs for paints. But you will say, 'These paints?' Well, yes, I am ashamed of it, but I am vain enough to want to make a certain impression on Gauguin by my work, so I cannot help wanting to do as much work as possible before he comes. His coming will alter my way of painting and I shall gain by it, I believe, but it is my great desire not to undergo his influence before I can show him indubitably my own individuality. And I am rather keen on my decorations, which are almost like pottery.

I should like him to feel it all in keeping, and I wish we could manage, you by your money and I with the general effect and arrangement of things, to have the studio complete, a setting worthy of the artist Gauguin who is to be at its head.

Thinking and thinking these days how all these expenses of painting weigh on you, you can imagine how disquieted I am; and that you have not the place in the sun that you might have because the Paris work at Goupil's is too exhausting. When I think of all this, I get into a mercenary frenzy. I feel that we are getting hot for selling or finding help so as to give us a chance to breathe.

I have better and more salable stuff than the paintings I have sent you, and I feel that I can go on producing it. I have confidence at last; I know that it will do some people's hearts good to find poetic subjects again — the 'Starry Sky,' the 'Vines in Leaf.'

There I go, thinking that it is quite near, and it may still be far off. So cry halt if I am going too fast. Do not think that I care more for my work than for our well-being, or at least than for our peace of mind, above all.

I have done another canvas, 'An Autumn Garden,' with two cypresses, bottle-green, shaped like bottles, and three little chestnut trees, a little yew with pale-lemon foliage, two bushes blood-red with scarlet purple leaves; some sand, some grass, and some blue sky. I had sworn to myself that I would not work, but it is like that every day: just going along I come sometimes on things so lovely that I have to try to do them after all. The falling of leaves is beginning; you can see the trees turning yellow, and the yellow increasing every day. It is at least as beautiful as the orchards in bloom.

I am determined to do ten thousand francs' worth of painting for the house. Have you ever read 'Les Frères Zemganno,' by the de Goncourts? If I come to grief in the attempt, it will do me no harm. In that case I still have a resource, for either I should go into trade or should write — but so long as I am painting ——

Do you remember that wonderful page in 'Tartarin,' the complaint of the old Tarascon diligence? Well, I have just painted that red and green vehicle in the courtyard of the inn. You shall see it; a simple foreground of grey gravel, a background very, very simple too; the two carriages brightly coloured, green and red, the wheels — yellow, black, blue, and orange. You used to have a very fine Claude Monet showing four coloured boats on a beach. Well, here they are carriages, but the composition is in the same manner. There will be a thousand things in it to criticize, but that's all right, provided I manage to get some verve in it.

Then I have two more canvases, the Trinquetaille bridge and another bridge along where the railway line is. This canvas is a little like a Boshoom in colour. The Trinquetaille bridge, with all

the steps, is a canvas done on a grey morning; the stones, the asphalt, the pavements are grey, the figures coloured.

I am nearly dead with painting that Tarascon diligence, and I see that I have not the brains to draw. I am going to have dinner.

My dear lad, look here — if you complain of having nothing in your noddle in the way of producing good stuff — I could not do even one scrap without you, and we must not go and hang ourselves over what the two of us manage to produce, but just smoke our pipes in peace and not torment ourselves into melancholia because we are not productive separately and less painfully.

Let us accept, since for the moment we can do nothing to change it, this fate, that you on your side are condemned always to trade without rest or change, and that I on my side have likewise a job without rest; in such moments, after hard work, I feel my own noddle empty too. So now.

If I let myself go, nothing could be easier than to hate what I have just done, and put my foot through it a few times as old Cézanne did. After all, why put my foot through it? Let's leave the studies in peace. In a year I hope you will feel that between us we have produced a work of art. After all, don't let's meditate too deeply on good and bad, they're always relative. That is exactly the effect of the Dutch, to call one thing absolutely good and another absolutely bad. There's nothing in existence as hard and fast as that.

Just now I am not ill, but I should get ill without the slightest doubt if I did not take plenty of food, and if I did not stop painting for days at a time. As a matter of fact, I am pretty nearly reduced again to the madness of Hugo van der Goes. And if it were not that I have almost a double nature, as it were that of a monk and of a painter, I should have been reduced, and that long ago, completely and utterly to the condition aforesaid. Yet even then I do not think that my madness could take the form of persecution, since my feelings when in a state of excitement lead me rather to the consideration of eternity, and eternal life. But in any case I must beware of my nerves. I have a fixed intention not to paint for at least three days. Perhaps I shall rest myself by writing.

My last canvas is a row of green cypresses against a rose-coloured sky, with a crescent moon in pale lemon. An indefinite foreground, earth and gravel and some thistles; two lovers, the man in pale blue with a yellow hat, the woman with a pink bodice and a black skirt. That makes the fourth canvas of 'The Poet's Garden,' which is the scheme of decoration for Gauguin's room.

I think that the town of Arles was once infinitely more glorious as regards its women and the beauty of its costumes; now everything has a worn and sickly look about it. But when you look long at it, the old charm revives; again and again I think of Monticelli — colour plays such a tremendous part in the beauty of the women here. The special charm lies in the grand lines of the costume, vivid in colour and admirably carried; the *tone* of the flesh rather than the shape. But I shall have some trouble before I can do them as I begin to see them.

Milliet has luck; he has as many Arlésiennes as he wants, but then he cannot paint them, and if he were a painter he would not get them. I must bide my time. If Milliet posed better he would give me great pleasure, and he would have a more distinctive portrait than I can manage now, though the subject is good — the flat pale tints of his face, the red soldier's cap against an emerald background.

Mother's portrait gave me very great pleasure because you can see that she is well and because she has such a lively expression. But I cannot look at the black, colourless photographs. I am trying to do a portrait of her in a harmony of colour as I see her in my memory, and I am writing home for Father's portrait also.

I am nearly dead with the work of the past week. There is a very violent mistral sweeping along the dead leaves in a rage, so I am forced to keep quiet. I have just slept sixteen hours at a stretch, and it has restored me considerably. Tomorrow I shall have recovered from this queer turn. But I did a good week, truly, with five canvases. If that rather takes its revenge on this week, well, it's natural. If I had worked more quietly you can easily see that the mistral would have caught me again. If it is fine here, you must make use of it; if not, you would never do anything.

I have just received the portrait of Gauguin by himself and the portrait of Bernard by Bernard, and in the background of the portrait by Gauguin there is Bernard's on the wall, and *vice versa*. The Gauguin is of course remarkable, but I like Bernard's very much. It is no more than the suggestion of a painter — a few abrupt tones, a few dark lines — but it has the distinction of a real true Manet. The Gauguin is more studied, carried farther.

So now at last I have a chance to compare my painting with what the crowd are doing. My portrait which I sent to Gauguin in exchange holds its own with it, I am sure of that. It is ashen grey against a pale malachite (no yellow). The clothes are the brown coat with a blue border, but I have exaggerated the brown into purple. The head is modelled in light colours painted in thick *pâte* against the light background, with hardly any shadows. But I have made the eyes slightly *slanting* like the Japanese eyes.

I have written to Gauguin that if I might be allowed to exaggerate my own personality in a portrait, I had done so in trying to convey in my portrait not only myself but an impressionist in general. And when I put Gauguin's conception and my own side by side, mine is as grave, but less despairing. Bernard says that he would like to have one like it, though he already has one of me. I am pleased that they did not dislike what I have done in figure painting.

What Gauguin's portrait says to me above everything is that he must not go on like this, he must become again the richer Gauguin of the 'Negresses.' The portrait gave me absolutely the impression of its representing a prisoner. Not a shadow of gaiety. Not the slightest relief of flesh, though one can confidently put that down to his determination to make a melancholy effect. The flesh in the shadows is gone a dismal blue. One must not do flesh with Prussian blue because then it ceases to be flesh; it becomes wood. I venture to think that with regard to colouring the other Breton pictures will be better.

I am very glad to have these two portraits, for they faithfully represent our lot at this state; they will not remain like that, they will come back to a serener life. And I see clearly that the duty

laid upon me is to do everything I can to lessen our poverty. Gauguin looks ill and tormented! You wait; that will not last, and it will be very interesting to compare this portrait with the one he will do of himself in six months' time. He must eat and go for walks with me in lovely surroundings; pick up a nice girl now and then; see the house as it is, and as we shall make it; and altogether enjoy himself.

Today I am all right again. My eyes are still tired, but I have a new idea in my head. Another canvas — this time it's just simply my bedroom, but colour is to do everything, and giving by its simplification a grander style to things is to be suggestive here of *rest* or of sleep. In a word, to look at the picture ought to rest the brain, or rather the imagination.

The walls are pale violet. The ground is of red tiles. The wood of the bed and chairs is the yellow of fresh butter, the sheets and pillows greenish-lemon, the coverlet scarlet, the window green, the toilet table orange, the basin blue, the doors lilac. The broad lines of the furniture again must express inviolable rest. Portraits on the walls, and a mirror and a towel and some clothes. The frame — as there is no white in the picture — will be white.

I shall work at it again all day, but you see how simple the conception is. It is painted in free flat washes like the Japanese prints. No stippling, no hatching, nothing — only flat colours in harmony. It is going to be a contrast with the 'Tarascon Diligence' and the 'Night Café.' Tomorrow very early I am going to begin in the cool morning light, so as to finish my canvas.

My handwriting isn't making much headway. I am really falling asleep and I cannot see any more, my eyes are so tired. But here's to the country of good old Tartarin; I enjoy myself in it more and more, and it is going to be our second Fatherland. Not that I forget Holland — the very contrasts make one think of it many a time.

Gauguin writes that he has already sent off his trunk and promises to come about the twentieth of this month; that is within a few days. My whole mind, as yours, is set on Gauguin now. It is high time that he came. I must try to get to know him better.

Gauguin has arrived in good health. He seems to me even better than I am.

He is naturally very pleased with the sale you have effected, and I no less, since in this way certain expenses absolutely necessary for the installation have no need to wait, and will not weigh wholly on your shoulders. He is very interesting as a man, and I have every confidence that with him we shall do heaps of things. He will probably produce a great deal here, and perhaps I shall too.

I hope that the burden will be a *little* less heavy for you, and I dare to hope *much* less heavy. I realize, even to the pitch of being mentally crushed and physically drained by it, the necessity of producing, because I have, after all, no other means of ever getting back what we have spent. I cannot help it that my pictures do not sell.

The time will come when people will see that they are worth more than the price of the paint and my own living — very meagre, after all — that are put into them. But, my dear lad, my debt is so great that when I have paid it, the pains of producing pictures will have taken my whole life from me, and it will seem to me then that I have not lived. The only thing is that perhaps then the production of pictures will become a little harder for me, and as to numbers there will not always be so many.

I had for a while rather a feeling that I was going to be ill, but Gauguin's arrival has so much taken my mind off it that I am sure it will pass; I should have got ill if my expenses had had to go on. For I was in agony lest I should be forcing you to make an effort beyond your strength, but I thought I could not do better than carry through the thing we had begun in persuading Gauguin to join us.

Now I hope to breathe at last, since we have all had a tremendous bit of luck in your being able to sell for Gauguin. One way and another all three of us, he and you and I, can pull ourselves together a bit so as to reckon up quietly what we have done. I must not neglect my food for a time, that is all; have no fear for me.

We shall not spend together more than two hundred and fifty francs a month. And we shall spend much less on paint, since we

are going to pound it ourselves. So do not have any anxiety for us, and have a breathing space as well; you need it badly. I venture to hope that in six months Gauguin and you and I will all see that we have founded a little studio that will last, and that will remain an outpost necessary, or at least useful, for all who want to see the South. You will have my work and a picture from Gauguin as well each month.

If only you were not too much pinched by my bringing nothing in, I should so much rather be able to say squarely that you prefer to keep my work for ourselves and not sell it. If what I am doing should be good, then we shall lose nothing, for it will mature quietly like wine in the cellar.

As to having framed a little canvas of mine of a pink peach tree, I imagine to send to Boussod Valladon and Company; I don't want to leave any doubt as to what I think of that. If it is your wish to let them have something of mine, good or bad, upon my honour, if it can give you pleasure now or later, you have absolute *carte blanche*. But if it is to please me, then, on the contrary, I'm of the opinion that it is absolutely unnecessary. And I think it is incompatible with my previous conduct to come back to them with a canvas as innocent as this little peach tree. I do not want Boussod ever to have the chance of saying, 'That little canvas isn't too bad for a young beginner.'

No. If in a year or two I have enough for an exhibition of my own, say thirty canvases, and if I say to them, 'Will you do it for me?' Boussod certainly would send me about my business. I know them, alas, rather too well. So I should rather never sell than go to them otherwise than as a pure matter of business. Understand that the more clear-cut we have this, the more they will come to you to see the canvases.

As you yourself do not sell, by showing my work you are not doing business outside the firm, so you will be acting quite correctly. Don't make any deal for me outside your own company. And as far as I am concerned, I shall either never go inside the Goupils' door again, or else I shall go in boldly, which is hardly likely.

If you asked me what would please me, it's this: that you keep for yourself in the flat whatever you like of my work and sell none of it now. Send the others back here, since the flat is small.

Gauguin and I are going to have our dinner at home today, and we feel as certain that it will turn out well as that it will be cheaper. He knows how to cook perfectly. I think I shall learn it from him; it is very convenient.

On Sunday if you had been with us you would have seen a red vineyard, all red like red wine. In the distance it turned to yellow, and then a green sky with the sun, the earth after the rain violet, sparkling yellow here and there where it caught the reflection of the setting sun.

Gauguin has already nearly found his Arlésienne, and I could wish I had got to that length, but for my part it is the landscape that comes to me. I regret as always the scarcity of models and the thousand contrarinesses in overcoming that difficulty. We intend to tour the brothels pretty often so as to study them.

Our days pass in working, working all the time. In the evening we are dead beat, and go off to the café, and after that, early to bed! That is the life. Of course it's winter here with us, too, though it still keeps on being very fine from time to time.

I have made portraits of a whole family, that of the postman — the man, his wife, the baby, the little boy and the son of sixteen, all characters and very French, though the first has the look of a Russian. I feel in my element. I hope to press this and to be able to get more careful posing paid for by portraits. If I manage to do this whole family better still, at least I shall have done something to my liking and something individual.

Just now I am in a perfect mess of studies, studies, studies — such a disorder that it breaks my heart, and yet it will provide me with some property when I'm forty. You always told me to work more for quality than for quantity. Now nothing hinders us from having a good many studies reckoned as such.

I think I shall not be able to refrain from sending you some canvases soon. There are some which Gauguin really likes — the sower, the sunflowers, and bedroom. Gauguin has brought a

magnificent canvas which he has exchanged with Bernard — Breton women in a green field.

Gauguin, in spite of himself and in spite of myself, has rather brought me to see that it is time I was varying my work.

I am very anxious some day to know de Haan and Isaacson. If they ever came here, he would certainly say to them: Go to Java for impressionist work. For Gauguin, though he works hard here, is still homesick for hot countries.

He has in hand a portrait of me which I do not reckon among his fruitless undertakings; just now he is doing some landscapes, and lastly he has a good canvas of washerwomen, very good, I think. You will see that some people will soon be reproaching him with being no longer an impressionist.

He is invited to exhibit at the Vingtistes. His imagination already leads him to think of settling at Brussels, and that would certainly be a means to his being able to see his Danish wife again. I fear that there is entire incompatibility between his wife and himself, but he cares more for his children, who are very pretty, according to the portraits.

We aren't so gifted in that quarter.

In the meantime Gauguin is having plenty of luck with the Arlésiennes. He is married, but has very little look of it. I have received a letter from Monsieur C. Dujardin on the subject of the exhibition of my pictures in his black hole. I am so disgusted at the idea of handing over a canvas in payment for the proposed exhibition that there is really only one possible answer to our gentleman's letter: that I have changed my mind. So no exhibition at the Revue Indépendante.

We have hardly exhibited, have we? There have been a few canvases first at Tanguy's, another at Thomas's, and then at Martin's. I tell you I can see no use in it. Without hurrying ourselves I can go on down here getting ready the stuff for a more serious exhibition, and with a little more work behind me I shall have enough not to need to exhibit at all; that is what I aim at.

Guillaumin has written to Gauguin. He seems to be very hard up, but he must have done some fine things. He has a child now,

but he was terrified by the confinement, and he says that he has the red vision of it always before his eyes.

We have wind and rain here now, and I am very glad not to be alone. I work from memory on bad days, and that would not do if I were alone. Gauguin gives me courage to imagine things, and certainly paintings from the imagination take on a more mysterious character. I have worked on a memory of our garden at Etten, with cabbages, cypresses, dahlias, and figures. I do not dislike trying to work from imagination, since that allows me to stay in.

Gauguin has finished his canvas of the 'Women at the Vintage.' It is as fine as the 'Negresses.' He has also almost finished his night café, and is working at a very original nude woman in the hay with some pigs. It promises to be very fine, and of great distinction. He is a very great artist, and very interesting as a friend.

I, too, have finished a canvas of a vineyard, all purple and yellow, with small blue and violet figures and yellow sunlight. I think that you will be able to put this canvas beside some of Monticelli's landscapes.

And I have an Arlésienne at last, a figure slashed on in an hour, background pale lemon, the face grey, the clothes black, black, black, with perfectly raw Prussian blue. She is leaning on a green table and seated in an armchair of orangewood.

I have also done a rough sketch of a brothel; I quite intend to do a brothel picture. And the last two studies I have are odd enough: a wooden rush-bottomed chair all yellow and red tiles against a wall (daytime). Then Gauguin's armchair, red and green night effect; on the seat two novels and a candle, on thick canvas with thick *pâte*.

We find it very easy to make frames with plain strips of wood nailed on the stretcher and painted, and I have begun doing this. I think that we shall end by passing our evenings drawing and writing; for there is more work to do than we can manage.

I know you will be pleased to hear that I have had a letter from Jet Mauve to thank us for the picture. A very nice letter, in which she speaks of old times. And what will also please you, we have an addition to the collection of portraits of artists — the portrait

of Laval by himself, extremely good. It is very bold, very distinguished, and will be one of the pictures you speak of that one gets hold of before other people have recognized their quality.

I am rather sorry to have my room full of canvases and to have nothing to send when Gauguin sends his. It is because he has told me how to get rid of the grease in the things painted in *pâte* by washing from time to time. If I sent them to you now, the colours would be duller than they will be later. But you will lose nothing by waiting for my work a little; we will leave the dear old crowd in peace to despise the present ones. Fortunately for me, I know well enough what I want, and am at bottom utterly indifferent to the criticism of working too hurriedly.

Gauguin was telling me the other day that he has seen a picture by Claude Monet of sunflowers in a great Japanese vase, very fine, but — he likes mine better. I don't agree; but if by the time I'm forty I have done a picture of figures such as the flowers he was speaking of, I shall have a position in art beside anyone, no matter who. So, perseverance!

We went yesterday to Montpellier to see the gallery there. There are pictures by Delacroix, Courbet, Giotto, Paul Potter, Botticelli, Th. Rousseau — very fine. We were in the midst of magic, for as Fromentin well says, Rembrandt is above all else a magician.

Gauguin and I talked a lot about Delacroix and Rembrandt. Our arguments are terribly *electric;* we come out of them sometimes with our heads as exhausted as an electric battery after it is discharged.

I think myself that Gauguin is a little out of sorts with the good town of Arles, the little yellow house where we work, and especially with me. As a matter of fact there are bound to be for him as for me grave difficulties to overcome here too. But these difficulties are rather within ourselves than outside. Gauguin is very powerful, strongly creative, but just because of that he must have peace Will he find it anywhere?

[On the following day, December twenty-fourth, a telegram arrived from Gauguin that called Theo to Arles. Vincent, in a state of

terrible excitement and high fever, had cut off a piece of his own ear, and had brought it as a gift to a woman in a brothel. There had been a violent scene; Roulin, the postman, managed to get him home, but the police intervened, found Vincent bleeding and unconscious in bed, and sent him to the hospital. Theo found him there and stayed over Christmas. Gauguin went back with Theo to Paris. By December thirty-first the news was better. JOHANNA VAN GOGH.]

I write in the office of Doctor Rey, the house surgeon. He has made me go down to his office for a little chat, and wants to re-assure you for his part on my account. He is happy that his predictions have been realized and that the overexcitement has been only temporary. He is firmly convinced that I shall be myself in a few days.

I shall stay here at the hospital some days more, then I think I can count on returning quite quietly to the house. The char-woman and my friend Roulin have taken care of it and have put everything in order. Roulin has been truly kind to me, and I dare to think that he will remain a lasting friend. I shall have need enough of that, for he knows the country well.

When I come out I shall be able to take the little road again; the fine weather will be coming and I shall begin on the orchards in bloom.

My dear lad, I am so terribly distressed at your journey. I could have wished you had been spared that, for after all no harm came to me, and there was no reason why you should be upset. What would I not have given for you to have seen Arles when it was fine; now you have seen it in mourning!

I do beg of you one thing only, not to worry, because that would cause me one worry too much. Set your mind at rest about my health; it will completely cure me to know that things are going well with you. I have read and re-read your letter about your meeting the Bongers. It is splendid. We cannot alter what has happened, but tell the Bongers how much I regret having in-voluntarily caused delay, and that your journey to Holland has not yet come off.

I hope I have had simply an artist's freak, and then a lot of fever after very considerable loss of blood, as an artery was sev-

ered; my appetite came back at once, my digestion is all right, and my blood revives from day to day, so that from day to day serenity returns to my brain. I think I shall yet see calmer days here than in the year that is gone.

I got back home today. Roulin and I had our dinner together. He is to be employed at Marseilles, and leaves about the twenty-first. The increase in pay is microscopic, and his wife and children will not be able to follow him till much later because the expense of a whole family will be heavier at Marseilles. Both he and his wife are heart-broken.

They have told me that during my absence the owner made a contract to give a tobacconist my house. This has rather upset me, for I am not much disposed to have myself turned out of this house practically in disgrace, when it was I who had it repainted inside and out, and had gas put in — in fact who made habitable a house which had been shut up and uninhabited for a considerable time.

There were several days when I could not write, but that is past now, and I have taken the first opportunity to write to Gauguin a few words of very deep and sincere friendship. I often thought of him in the hospital, even in the height of fever and comparative weakness. Have I scared him? Why doesn't he give me a sign of life? Have you seen the portrait of me which he has? And the portrait which he made of himself just those last few days? If you compare that portrait with the one which he sent me from Brittany, you will see that on the whole he got rested here.

I have written a line to Mother and to Wil, with the intention of setting their minds at rest in case you have said anything of my having been ill.

I am going to set to work again tomorrow. I shall begin by doing one or two still-lifes so as to get back the habit of painting, and as soon as I feel myself fairly up to it I intend to make a portrait of Monsieur Rey. He has heard of a picture by Rembrandt, the 'Anatomy Lesson.' I told him that we should get him the engraving of it for his study. It would please him immensely.

This morning I was at the hospital to get another dressing, and

I walked for an hour and a half with Monsieur Rey. We talked a bit about everything, even about natural history. I told him that I should always regret not being a doctor, and that those who think painting is beautiful would do well to see nothing in it but a study from nature.

Physically I am well; the wound is healing and the great loss of blood is getting made up for. What is most *to be feared* would be insomnia. The doctor has not spoken to me about it, nor have I spoken of it to him. But I am fighting it myself by a very, very strong dose of camphor in my pillow and mattress. I was very much afraid of sleeping alone in the house, and I have been fearing that I should not be able to sleep, but that is quite over, and I dare to think that it will not reappear. The suffering from this in the hospital was frightful, and yet I can tell you as a curiosity that through it all I kept thinking about Degas. Gauguin and I had been talking about him, and I had pointed out to Gauguin that Degas had said, 'I am saving myself up for the Arlésiennes.'

Just tell Degas that up to the present I have been powerless to paint them, the women of Arles, and that he must not believe Gauguin if Gauguin speaks well of my work before its time, for it's only a sick man's so far. If I recover I must begin again, and I shall not again attain the heights to which sickness partially led me.

Even before receiving this very moment your kind letter, I had had a letter this morning from your fiancée announcing the engagement. So I have already sent her my sincere congratulations, and I repeat them to you in this. My fear that my indisposition might hinder you from that very necessary journey which I had so much and so long hoped for having now disappeared, I feel myself again quite normal.

It always seemed to me that you owed it to your social position and to the position you have in the family to get married, and for a number of years it has been our mother's wish. By thus doing what you ought to do, you will perhaps have more peace, even amidst a thousand and one difficulties, than before.

The great thing is that your marriage should not be delayed.

With your wife you will not be lonely any more, the house will not be empty. Perhaps there will be others in the family.

Whatever I think of them in other ways, our father and mother were exemplary as married people — like Roulin and his wife. And I shall never forget Mother at Father's death, when she said only one word; it made me begin to love dear old Mother more than before.

During my illness I saw again every room of the house at Zundert, every path, every plant in the garden, the views in the fields roundabout, the neighbours, the church, our kitchen garden behind — down to a magpie's nest in a tall acacia in the graveyard. That is because I have earlier recollections of those first days than any of the rest of you. There is no one left who remembers all this but Mother and me.

You do know how happy I shall be when your marriage has taken place. And if for your wife's sake it would be well to have a picture of mine from time to time at Goupil's, you can if you like exhibit the two pictures of sunflowers. You will see that these canvases catch the eye. It is a kind of painting that changes rather to the eye, and takes on a richness the longer you look at it.

You know that the peony is Jeannin's, the hollyhock belongs to Quost, but the sunflower is mine in a way.

Life is not easy for me. What would I not have given to be able to spend a day here with you and show you the work in the doing, and the house! Now I should rather you had seen nothing of what I have than that you should have carried away an impression of it under such distressing conditions.

And now, if you agree — now that Gauguin has gone — we will put the month back again at one hundred and fifty francs. Perhaps we ought to go into the expenses of the present month. In every way it has been altogether lamentable. But what is to be done? It is unfortunately complicated. My pictures are valueless, though it is true they caused me extraordinary expense, perhaps even in blood and brain at times. The day I came out of the hospital we had already arrived at a forced expenditure on my part of over a hundred francs, to which I must add that that day I had

a gay dinner with Roulin at the restaurant, quite cheerful and with no dread of renewed suffering.

Considering the hospital bill, and that all the house was upset by this happening, and all the linen and clothes soiled, is there anything extravagant, if I paid as soon as I got back what was *owing* to people almost as poor as myself; did I do wrong, or could I have been more economical?

The result was that about the eighth I was on the rocks. A day or two after I borrowed five francs. That brings us barely to the tenth. Now, as your letter did not arrive till today — January seventeenth, the time between has been a most rigorous fast, the more painful because I cannot recover under such conditions.

I had nevertheless begun work again, and I have already three studies done in the studio, besides the portrait of Doctor Rey, which I gave him as a keepsake. So there is no worse harm done this time than a little more suffering and its attendant wretched- ness. But I feel weak, and rather uneasy and frightened.

They told me that to be very impressionable was enough to account for the attack I had had, and that I was really only anaemic, that I must feed myself up. I took the liberty of asking Doctor Rey, if the first thing for me now was to get back my strength, if by pure chance it happened that I had to suffer a strict fast for a week, would he be good enough to remember on occasion that for the moment I am not yet mad.

As to the expense caused you by Gauguin's telegram, does Gauguin himself claim that it was a masterly step to take? Sup- pose that I was as wild as you like, why, then, wasn't our illustrious partner more collected?

Let's talk about our friend Gauguin. How can he pretend that he was afraid of upsetting me by his presence, when he can hardly deny that he knew I was asking for him continually, and that he was told over and over again that I insisted on seeing him at once — just to tell him that we would keep it between him and me without upsetting you? He would not listen.

I cannot commend you enough for paying Gauguin in such a way that he can only congratulate himself on any dealings he has

had with us. There, again, is by ill hap another expenditure perhaps greater than it should have been.

Should he not begin to see that we were not exploiting him, but on the contrary were anxious to secure him a living, possibly work and — and — decency? If that is not up to the grandiose prospectus of the association of artists which he proposed, if it is not up to his other castles in the air, why not, then, consider him as not responsible for the trouble and waste which in his blindness he may have caused both you and me?

If Gauguin were to examine himself thoroughly, or have himself examined by a specialist, I don't honestly know what the result might be. I have seen him on various occasions do things which you and I would not let ourselves do, because we have consciences, and I have heard one or two things of this kind said of him. But having seen him at very close quarters, I think that he is carried away by imagination, perhaps by pride, but — irresponsible. One good quality he has is the marvellous way he can portion out expenses from day to day. While I am often absent-minded, preoccupied with aiming at *the goal*, he has far more money-sense for each day as it comes. But his weakness is that by a sudden kick or a stupid outbreak he upsets everything he has arranged.

I have complained of the queer phenomenon of Gauguin's behaviour in choosing not to speak to me again, and clearing off. Dissecting the situation in all boldness, there is nothing to hinder us from seeing him as the little Bonaparte tiger of impressionism as far as — I don't quite know how to say it — his vanishing, say, from Arles would be comparable or parallel to the return from Egypt of the Little Corporal, who also presented himself afterwards in Paris, and who always left the army in the soup.

In the matter of settling his bill, I see that you have acted with higher ideals.

Gauguin is physically stronger than we are, so his passions must be much stronger than ours. He is a father, he has a wife and children in Denmark, and at the same time he wants to go to the other end of the earth, to Martinique. It is frightful, all the conflict of incompatible desires and needs which this must cause him.

I took the liberty of assuring him that if he had kept quiet here with us, working at Arles without wasting money, and earning since you were looking after his pictures, his wife would certainly have written to him, and would have approved of his stability. There is more besides; he had been in pain and seriously ill, and the thing was to find the disease and the remedy. Here his disorders had ceased.

Gauguin has a fine, free, and absolutely complete imaginary conception of the South, and with that imagination he is going to work in the North! My word, we may get some fun out of it yet.

I think it is rather strange that he claims a picture of sunflowers from me, offering me in exchange, I suppose, or as a gift, some studies he left here. I will send him back his studies, which will probably have a use for him that they would in no way have for me. And I am definitely keeping my sunflowers. He has two of them already; let that content him. If he is not satisfied he can take back his little Martinique canvas, and his portrait sent me from Brittany, and at the same time give me back both my portrait and the two sunflower canvases which he has taken to Paris. Gauguin has had experience in what he calls 'banking in Paris' and thinks himself shrewd at it. Perhaps on that side you and I are too careless.

It wearies me to go over all this. I have been miserable because just at this moment you have had this expense, which did no good to anyone. It is past now with the rest, and is one more proof of the proverb that misfortunes never come singly. So many difficulties certainly do make me rather worried and timorous, but I haven't given up hope yet.

When I saw my canvases again after my illness, the one that seemed the best to me was the bedroom. I have been working today on my own empty chair, a chair of white wood with a pipe and a tobacco pouch. It is a fellow to Gauguin's chair. In these two studies I have tried for an effect of light by means of clear colour.

If I am not taking much thought for direct sale, it is because my tale of pictures is not yet complete; but it is getting on, and I have set to work again with a nerve like iron.

I have a new portrait of myself for you. And I have just finished a new canvas which has almost what you would call *chic*, a wicker basket with lemons and oranges, a cypress branch, and a pair of blue gloves. You have already seen some of these baskets of fruit of mine.

I have good and ill luck in my turnout, but not ill luck only. If our Monticelli bunch of flowers is worth five hundred francs to a collector — and it is — I dare swear to you that my sunflowers are worth five hundred francs too to one of those Scots or Americans. During your visit you must have noticed the two canvases of sunflowers in Gauguin's room. I have just put the finishing touches to copies, absolutely identical replicas of them.

My health and my work are getting on not so badly. It astonishes me when I compare my condition with what it was a month ago. I knew that one could fracture one's legs and arms and recover, but I did not know that you could fracture the brain in your head and recover after that too. I still have a sort of 'What is the good of getting better?' about me, even in the astonishment that getting well arouses in me. But the unbearable hallucinations have ceased, and have now reduced themselves to a simple nightmare, by dint of my taking bromide of potassium, I think.

Since it is winter still, leave me to go quietly on with my work. I do so dread a change or removal, because of the fresh expense. I have not been able for a long time to get a breathing-space. I am not giving up work, because it has its moments when it really gets going, and I believe that the pictures will pay back the money sunk in making them.

Either shut me up right away in a madhouse — I shan't oppose it in case I'm deceiving myself — or else let me work with all my strength, while taking precautions. If I am not mad, the time will come when I shall send you what I have promised you from the beginning; if it is not absolutely necessary to shut me up in a cell, I am still good for paying at least in stock what I am reckoned to owe. And I go headlong at it from morning till night to prove to you (unless my work is another hallucination) that we have a light before our feet in the powerful work of Brias of Montpellier, who did so much to create a school in the South.

By continuing during February and March, I shall hope to have finished simple repetitions of a number of studies I made last year. We have gone out for the impressionists, and now as far as in me lies I am trying to finish canvases which will secure me the little corner among them that I have claimed.

I am asking for two months' work before making the arrangements which will have to be made at the time of your marriage.

After that, the spring, and you and your wife will found a commercial house of several generations; it will not be too easy. That settled, I ask only the position of a painting employee, so long at least as there is enough to pay for one. You have gone on being poor all the time in order to support me, but I will give you back the money or give up the ghost. Meantime, this tender-hearted wife of yours will have come, and will make us old fellows almost young again. Indeed, as long as this world lasts, so long will there be artists and picture dealers, especially those who like you are at the same time apostles.

Roulin left yesterday. I have in hand the portrait of his wife, which I was working on before I became ill. In it I have ranged the reds from rose to orange, which rises through the yellow to lemon, with light and sombre greens. If I could finish it I should be very glad, but I am afraid she will not want to pose with her husband away.

And though now everyone will be afraid of me, in time that may disappear. We are all mortal, and subject to all the ailments there are, and if the latter aren't of a particularly agreeable kind, what can one do about it? The best thing is to try to get rid of them.

What you tell me of Gauguin gives me tremendous pleasure; that he has been invited to exhibit in Belgium, and is having some success in Paris. I like to think that he has found his feet.

With this little country of mine I have no need at all to go to the tropics. I shall always believe in the art that is to be created in the tropics, but personally I am too old and (especially if I have an ear put on in *papier mâché*) too much a thing of pasteboard to go there. Will Gauguin do it?

We are nothing but links in a chain. Old Gauguin and I at

bottom understand each other, and if we are a bit mad, what of it? Aren't we also thorough artists enough to contradict suspicions on that head by what we say with the brush? Perhaps some day everyone will have neurosis, Saint Vitus's dance, or something else. And does not the antidote exist? In Delacroix, in Berlioz, and Wagner. As for the artist madness of all of us, I maintain that our antidotes and consolations may, with a little good-will, be considered as ample compensations. But what it proves once more is that worldly ambition and fame pass away, but the human heart beats the same, in as perfect sympathy with the past of our buried forefathers as with the generation to come.

Yesterday I went to the Folies Arlésiennes, the budding theatre here. They were giving (it was a Provençal literary society) what they called a *Noël* or *Pastorale*, reminiscent of the Christian theatre of the Middle Ages. It was the first time that I have slept without a bad nightmare.

By what I am told I am very obviously looking better; inwardly my heart is rather too full of many and various feelings and hopes, for I am amazed to be getting better. It has been a magnificent day with no wind, and I have such a longing to work that I am astonished, as I did not expect it any more. There are still signs in my talk of previous overexcitement, but that is not surprising since everyone in this good Tarascon country is a trifle cracked.

The neighbours are particularly kind to me, as everyone suffers here either from fever or hallucination or madness; we understand each other as if members of the same family. I went to see the girl I had gone to when my wits went astray. They told me there that in this country such things are not unusual. She had been upset by it and fainted, but had recovered her calm. And they spoke well of her, too.

The chief superintendent of police paid me a very friendly visit today. He told me as he shook hands that if ever I needed him I could consult him as a *friend*. I am far from refusing that, and I may soon be in just that position if they raise difficulties about the house.

I know that several people would ask me for portraits if they

dared. Roulin, quite a poor fellow and small employee though he is, is much respected, and it is known that I have done all his family. The doctor has given me strict orders to go out to walk without doing any mental work, but work distracts me, and I *must* have some distraction; or rather work keeps me in control, so that I don't deny myself it. I say to the people here who ask after my health that I shall start off by dying among them, and after that my malady will be dead. If you catch the disease of the country, my word, afterwards you cannot catch anything else. By which I mean that I have no illusions about myself any more.

When I came out of the hospital with kind old Roulin, I thought that there had been nothing wrong with me, but *afterwards* I felt that I had been ill. Well, well, there are moments when I am wrung by enthusiasm or madness or prophecy like a Greek oracle on the tripod. And then I have great readiness of speech and can speak as do the Arlésiennes.

But with all this I feel so weak. It will be all right when my bodily strength comes back, but I have told Rey that at the slightest grave symptom I shall come back and put myself under the mental specialists at Aix, or under him. I shall always in future need a doctor from time to time, and because he knows me well now it would be another reason for me to stay here.

Can anything come of it but trouble and suffering if we are not well, either you or I? So completely has our ambition foundered. Then let us work on very quietly; let us take care of ourselves as well as we can.

Will this be appreciated by the society to which you belong? Perhaps not, any more than the artists ever suspect that I have sometimes worked and suffered for the community. It seems to me now pretty improbable that impressionism will organize and steady itself. Perhaps I take these things too much to heart, and perhaps they sadden me too much.

You will do your duty and I shall do mine; as far as that goes, we have already paid in other ways than words, and at the end of the march we may meet each other again with a quiet mind. As for that delirium of mine in which everything I dearly loved was

shaken, I do not accept it as reality, and I am not going to be a false prophet. Illness or death, indeed they have no terrors for me.

But how comes it that you are thinking at the same time of the clauses of your marriage settlement and of the possibility of dying?

I had a letter from Gauguin full of alternative and varying projects, and already he sees the end of his money on the horizon. I have not yet answered him. One thing, luckily, is certain; Gauguin and I are by nature fond enough of each other to be able if necessary to begin again together.

I should like in case Gauguin, who has a perfect infatuation for my sunflowers, takes one of these two pictures from me, for him to give your fiancée or you two of his own, not just average but better than the average.

And as for the independents, the 'Harvest' and the 'White Orchard' are enough, with the little 'Provençal Girl' or the 'Sower' if you like. I don't mind about that. The one thing I have set my heart on is some day to give you a more heartening impression of this painting job of ours by a collection of thirty or so more serious studies. These I am working on now, and with some canvases you have already had from me, such as the 'Harvest' and the 'White Orchard,' they will make a tolerably firm foundation. Alas, now the pictures are bound to be dispersed, but when you see the whole that is in my mind I dare to hope that you will get a feeling of consolation from it.

About the little yellow house, when I paid my rent the landlord's agent was very nice, and behaved like an Arlésien by treating me as an equal. Then I told him that I had no need of a lease. So I am keeping the house provisionally, since for the sake of my mental recovery I need to feel that I am in my own home.

But as for considering myself as altogether sane, we must not do it. You are well, or you are ill. That doesn't mean I shall not have long spells of respite, but people here who have been ill as I have tell me the truth: there will always be moments when you lose your head. So I do not ask that you say of me that there is nothing wrong with me, or that there never will be.

I will do what the doctor tells me as much as I can, and I con-

sider that as a part of the work and the duty which I have to fulfil. They are well up in all this already at the hospital here, and provided you have no false shame and say frankly what you feel, you cannot go wrong.

[In February Vincent was again taken to the hospital. He had imagined that people wanted to poison him. Doctor Salles, the Protestant clergyman in Arles whom Theo had interested in Vincent during his visit in December, wrote asking what was to be done. Doctor Rey wired on February thirteenth: 'Vincent much better, keeping him here.' J. v. G.]

I have been so altogether out of sorts mentally that it would have been useless to write. Today I have come home provisionally, I hope for good.

I feel quite normal so often that I should think that if what I have is only a malady peculiar to this place, I must wait quietly till it is over, even if it returns again (and let's say that it won't) But I told Doctor Rey that if sooner or later it is desirable that I should go to Aix, as has already been suggested, I consent beforehand.

But in my character as a painter and a workman it is not permissible for anyone, even you or a doctor, to take such a step without warning me and consulting me about it; also, since up till now I have always kept comparative presence of mind in my work, it would be my right then to say (or at least to have an opinion on) whether it would be better to keep my studio here or to move altogether to Aix.

The advantages I have here are what Rivet used to say, 'They are a sickly lot, all of them,' so that at least I do not feel myself alone. And I have already found such friendliness from my neighbours, from Doctor Rey, that really I should rather be always ill here than forget the kindness there is in the very people who have the most incredible prejudices against painters and painting. The people here have some superstition that makes them afraid of painting, and they have talked about it in the town.

The unfortunate thing is that I am rather inclined to be affected by the beliefs of others, and cannot always laugh at the

foundation of truth that there may be in the absurdity. But I have already stayed here more than a year, and have heard almost all the ill that could be said about myself, Gauguin, and painting in general. Then they know me now at the hospital, and if it comes on again nothing would be said, and they would know what to do. I have no desire at all to be treated by other doctors nor, in a way, any need to be. So why should I not take things as they come and wait for the upshot here, where I have twice been in the madhouse?

You must not think too much about me, nor fret yourself. It probably must take its course, and we cannot change much in our fate by taking precautions; once more let us try to gulp it down, whatever it is. And I shall get along better if I know you have peace of mind.

The only thing is, I should like to be able to go on earning with my hands what I spend. We have days of sun and wind here; I walk a lot to get fresh air. Yesterday and today I began to work.

At another time, if I were less impressionable, I should probably poke a good deal of fun at what seems to me topsy-turvy and off the rails in the ways of this country. At present it doesn't make me particularly gay. Well, well, after all there are so many painters who are cracked in one way or another, that little by little I shall console myself. I understand more than ever what Gauguin must suffer, for in the tropics he caught the very same thing, this excessive sensitiveness.

I do not dare to persuade painters to come here after what has happened to me; they run the risk of losing their wits; this applies to Koning and to de Haan and Isaacson. Let them go to Antibes or Nice; or perhaps Mentone is healthier.

You are very kind to say I could come to Paris, but I think the excitement of a big town would never do for me.

[On February twenty-seventh Vincent was again taken to the hospital, this time without any cause. For a whole month he keeps the deepest silence. J. v. G.

I seem to see so much brotherly anguish in your kind letter that I think it my duty to break my silence. I write to you in full pos-

session of my faculties and not a madman, but as the brother you know. This is the truth.

A number of people here addressed to the mayor a petition (there were more than eighty signatures) describing me as a man not fit to be at liberty. The inspector of police then gave the order to shut me up again. So here I am shut up the livelong day under lock and key, and with keepers in a cell, without my guilt being proved, or even capable of proof. Needless to say, in the secret tribunal of my soul I have much to reply to all that. Needless to say, I cannot be angry, and to excuse myself I think is to accuse myself in such a case. Only I want to let you know.

You understand what a staggering blow between the eyes it was to find so many people here cowardly enough to join together against one man, and that man ill. And since I had really done my best to be friendly with people, and had no suspicion of it, it was rather a bad knock.

As far as my mental state is concerned, I am greatly shaken, but I am recovering a sort of calm in spite of everything. Strong emotion can only aggravate my case; while I am absolutely calm at the present moment, I may easily relapse into a state of overexcitement on account of fresh mental emotion. And if I did not restrain my indignation I should at once be thought a dangerous lunatic. Besides, humility becomes me after the experience of repeated attacks. So I am being patient. I am myself rather afraid that if I were at liberty outside I should not always keep control of myself if I were provoked or insulted, and then they would be able to take advantage of that. Here, except for liberty, I am not too badly off.

The main thing is that you should keep calm too, and let nothing upset you in your business. A settled home for you is a great gain for me too — and that accomplished we can perhaps find another more peaceful way of things after your marriage.

Meanwhile, I do beg you to leave me here quietly. I am persuaded that the mayor as well as the inspector are really rather friendly, and that they will do what they can to settle all this. I told the mayor that I was quite prepared to chuck myself into the

water if that would please these good folk once for all; but that in any case if I had in fact inflicted a wound on myself, I had done nothing of the sort to them. Besides, I told them that we were in no position to bear the expense. I cannot move without expense, and for three months I have not worked, and, mind, I could have worked if they had not vexed and worried me.

It is a shame — and all, so to speak, for nothing. I will not deny that I should rather have died than have caused and suffered such trouble. Well, well, to suffer without complaining is the one lesson which has to be learnt. The best we can do perhaps is to make fun of our petty griefs, and in a way of the big ones of human life too. Take it like a man, go straight to your goal. In existing society we artists are only the broken vessel. The thing is to swallow the real facts of your destiny, and then, there you are.

As I have nothing else to distract me — they even forbid me to smoke, though it is allowed to the other patients — I think all day and all night long about all the people I know. I do so wish I could send you my canvases, but all are under lock and key, police and keepers. If, say, I should become definitely insane — I certainly don't say that this is impossible — in any case I must be treated differently, and given fresh air and my work. Then — honestly — I will submit. But do not be afraid of anything, my dear lad; I am quite calm now. Perhaps it is a sort of quarantine they are making me keep.

The management of the hospital is — how shall I put it? — Jesuit; they are very, very able, very clever, very powerful, they are even impressionist, they know how to make inquiries of unheard-of subtlety. In fact, that is in a way the cause of my silence. So keep yourself distinct from me in business, and meanwhile I am a man, after all, so you know I shall shift for myself in matters of conscience which concern myself alone.

The news is now that Monsieur Salles is setting about finding me a flat in another part of the town. I approve of this, for in this way I should keep some sort of niche — and then I could go for a trip to Marseilles or farther to find something better. But let us think well before going to another place. You see that in the South

I have no better luck than in the North. It's pretty much the same everywhere. And as for what you call the 'real South,' I leave that, as is right, to men who are better balanced, more of a piece than I. I am only good for something intermediate, and second-rate and half-effaced.

Monsieur Salles is very kind and very loyal.

As far as I can judge, I am not properly speaking a madman. And you will see that the canvases I have done in the intervals are restrained, and not inferior to the others. I *miss* the work more than it tires me. And, believe me, if nothing intervenes I shall be able to do the same work, and perhaps better, in the orchards that I did the other year. All I would ask would be that people do not meddle with me when I am busy painting, or eating, or sleeping, or taking a turn at the brothel, since I haven't a wife. Now they are meddling with everything.

But in spite of everything I could make fun of it all if it were not for the grief that I am very unwillingly causing you, or rather that they are causing — and for the delay in the work. These repeated and unexpected agitations, if they should continue, may change a passing and momentary mental disturbance into a chronic disease. The best thing for me would certainly be not to live alone, but I should rather live forever in a cell than sacrifice another life to mine. So just now I want to go in and out freely at the hospital. If I were a Catholic I should have the resource of turning monk.

I have seen Signac, and it has done me quite a lot of good. We went to the studio, and he was so good and downright and simple when the difficulty of opening the door by force presented itself. In the end we got in. I found him very quiet, though he is said to be so violent; he gave me the impression of someone who has balance and poise. Rarely or never have I had a conversation with an impressionist so free on both sides from discord or conflict.

Doubtless you had a hand in his coming to stiffen my morale a bit; and thank you for it. I gave him as a keepsake a still-life which had annoyed the good *gens d'armes* of the town of Arles because it represented two smoked herrings, and they, the *gens*

d'armes, are still called that, as you know. You remember that I did this same still-life in Paris two or three times, and exchanged it once for a carpet.

There are several canvases to send you, as Signac was able to affirm; he did not take fright at my painting so far as I saw.

I took advantage of my outing to buy a book, 'Ceux de la Glèbe,' by Camille Lemonnier. I have devoured two chapters of it — it has such gravity, such depth. This is the first time for several weeks that I have had a book in my hand. That means a lot to me, and does a good deal towards my cure.

Signac thought, and it is perfectly true, that I looked healthy. Doctor Rey says that, instead of eating enough and at regular times, I have been keeping myself going by coffee and alcohol. I admit all that, but it is true, all the same, that to attain the high yellow note that I attained last summer, I really had to be pretty well strung up. The artist is a man with his work to do.

Am I to suffer imprisonment or the madhouse? Why, did not Rochefort, Hugo, Quinet, and others give an eternal example of suffering exile, and the first even a convict prison? This is a thing above the mere question of illness and health. I do not say mine is an equal case, being in a very inferior and secondary place to theirs, but I do say it is a parallel one.

I am thinking of frankly accepting my rôle of madman, as Degas took the character of a notary. But there it is; I do not feel that I have strength enough for such a part.

At the hospital these days they are very attentive to me, and this, like many other things, upsets me and makes me rather confused. These last three months do seem so strange to me. There have been moods of indescribable mental anguish, sometimes moments when the veil of time and of inevitable circumstance seemed for the twinkling of an eye to be parted. After all, you are certainly right, damn well right; even making allowance for hope, the thing is to accept the probably disastrous reality. I am hoping to throw myself once again wholly into my work, which has got behindhand.

Just now things are going well. The day before yesterday, and

yesterday, I went out into the town to get things to work with; and I am sending you an order for paints. This is in the event I should shortly set to work again on the orchards. Oh, if only nothing had come to mess me up!

I have in my room at the hospital the famous 'Portrait of a Man' — the wood engraving — the 'Blade of Grass' from Bing's sketch-book, the 'Pietà' and the 'Good Samaritan' by Delacroix, and the 'Reader' by Meissonier.

I am reading just now Balzac's 'Médecin de Campagne,' which is very fine; there is a character of a woman in it, not mad but too sensitive, which is very attractive. I have sent for a few more books so as to have a few solid ideas in my head, and I have read again 'Uncle Tom's Cabin' and Dickens's Christmas books.

For the fifth time I am taking up my portrait of the 'Woman Rocking a Cradle.' When you see it you will agree with me that it is nothing but a chromolithograph from the cheap shops, and again that it has not even the merit of being photographically correct in its proportions. But I want to make such a picture as a sailor who could not paint would imagine when he thought of his wife ashore.

When I went home I was able to ascertain that the real neighbours, those whom I knew, were not among those who got up that petition. However it may be in other quarters, I saw that I still had friends among them.

Our friend Roulin came to see me, and he told me to give you many messages for him and to congratulate you. I presume you are getting married at Amsterdam. It is a sort of nervous affliction with me that on festive occasions I generally find difficulty in formulating good wishes, but you must not conclude from this that I wish your happiness less earnestly than anyone else. I wish you and your wife a great deal of happiness.

Roulin's visit gave me a lot of pleasure. He often has to carry loads you would call very heavy, but it doesn't hinder him from always looking well and even jolly; and for me, what a lesson for the future it is when one gathers from his talk that life does not grow any easier as one gets on in it.

I talked to him so as to have his opinion as to what I ought to do about the studio — which I ought to leave in any case at Easter, according to the advice of Monsieur Salles and Doctor Rey. Considering that I have done a good many things to put the house in a better state than when I took it, and that they are forcing me to leave — very well — but I should be pretty well justified in removing the gas connections and standing out for damages, only I haven't the heart to do it. The only thing I feel I can do in this business is to tell myself that it was an attempt to make an abiding-place for unknown successors.

Roulin said, or rather hinted, that he did not at all like the disquiet which has reigned at Arles this winter, considered even quite apart from what has befallen me. After all, it is rather like that everywhere: business not too good, resources exhausted, people discouraged, and — as you said — not content to remain spectators but growing mischievous through being out of work.

Roulin, though he is not quite old enough to be like a father to me, has all the same a silent concern and tenderness for me such as an old soldier might have for a young one. All the time — but without a word — he seems to say, 'We do not know what will happen to us tomorrow, but whatever it may be, think of me.' This does one good when it comes from a man who is neither embittered, nor sad, nor perfect, nor happy, nor always irreproachably right. But such a good soul, and so wise, so full of feeling, so trustful!

I tell you I have no right to complain of anything whatever about Arles, when I think of some things I have seen there which I shall never be able to forget. Roulin expects to stay at Marseilles.

And now, my dear lad, I do believe I shall soon not be ill enough to have to stay shut up. I am well now, except for a certain undercurrent of vague sadness difficult to define; and anyway I have gained rather than lost in physical strength, and I am working. If I had to stay for good in an asylum, I should make up my mind to it, and I think I could find subjects for painting there as well. However intense my feelings may be, or whatever power of expression I may acquire at an age when physical passions are less

powerful, never on such a mouldy, shattered past can I build an imposing structure. So it is more or less all the same to me what happens — even to staying here — I think that in the end fate will even things up.

Fortunately the weather is fine and the sun glorious, and people here quickly forget all their griefs for the moment, and are brimming over with high spirits and illusions.

Just now I have on the easel an orchard of peach trees beside a road with the Alps in the background. I have six studies of the spring, two of them big orchards. I have been obliged to ask Tasset for ten metres of canvas and some tubes. It is very urgent because these effects are so short-lived. Thank you for the despatch of the numbers of 'Le Fifre' with drawings by Forain; they made our stuff seem very sentimental in comparison.

It is a rather difficult problem to decide to take a new flat, and is not very cheering or convenient, especially as there seems no prospect anywhere of any better luck. I've taken two little rooms *belonging to Doctor Rey.* They are not dear, but the place is nothing like the other studio. Before I could manage the move or send you some canvases I had to pay the other proprietor. Out of the sixty-five francs which I owe, I have paid him twenty-five francs, three months' rent in advance (for a room which I shan't be living in but where I have sent my furniture), and expenses of ten francs for removal.

After I have settled up at the hospital today, there will be almost enough for the rest of the month from the money I have still on deposit.

At the end of the month I should like to go to the hospital at Saint-Rémy, or another institution of this kind of which Monsieur Salles has told me. Forgive me if I don't go into details to argue the pros and cons of such a step. It would absolutely split my head to talk about it. It will be enough, I hope, if I tell you that I feel quite unable to take a new studio, here at Arles or elsewhere — it is all one for the moment. To begin again that painter's life isolated in the studio often and without any other means of dis-

traction than going to a café or a restaurant — I can't face it. To go and live with another person, say another artist, with the responsibilities of keeping up a studio — difficult, very difficult; it's taking too much on oneself. I should be afraid of losing the power to work which is coming back to me now. For the time being I wish to remain shut up, as much for my own peace of mind as for other people's. So let's try three months to begin with, and afterwards we shall see.

What comforts me a little is that I am beginning to consider madness as a disease like any other, and accept the thing as such, whereas during the crises themselves I thought that everything I imagined was real. You understand that if alcohol has been one of the great causes of my madness, then it came very slowly and will go slowly too, supposing it does go, of course. Or if it comes from smoking, the same thing is true.

(We are already ordered not to lie, or steal, and not to commit other crimes, great or small; things would get too complicated if it was absolutely indispensable to have nothing but virtues in the society in which we are very undeniably planted, whether it be good or bad.

I assure you that during those queer days when many things seem odd to me, because my brain is agitated, through it all I don't dislike old Pangloss.)

I shall do a little painting and drawing without putting such frenzy into it; then I should be very keen, if it is possible, to be able to go out in the daytime to draw or paint. Seeing that here I go out every day now, I think that this could continue. Ordinary food would suit me quite well, especially if I were given a little more wine, as I am here, usually a half-litre instead of a quarter. The company of other patients is not at all disagreeable to me; on the contrary, it distracts me. But a private room — it remains to be seen what the arrangements of an institution like that would be.

Do not be grieved at all this. Sure enough these last days with all the removing, taking away all my furniture, packing up the canvases that are going to you, were sad, but the thing I felt saddest about was that all these things had been given to me by you

with such brotherly love, and that for so many years it was always you who supported me; and then to be obliged to come back and tell you all this sorry tale — but I can't say it as I felt it.

So do what Rey and Monsieur Salles say. After all, we must take our share of the diseases of our time — in a way it is only fair that having lived some years in comparatively good health we should have our share of bad health sooner or later. I should not exactly have chosen madness, if I had had a choice, but once you have an affair of that sort, you can't catch it again. And there will perhaps be this consolation if one is able to go on working a bit at painting.

I do not know whether I shall write very often, because not all my days are clear enough to write fairly logically.

All your kindnesses to me, they seemed to me greater than ever today. I assure you that that kindness has been good metal, and if you do not see any results from it, my dear brother, don't fret about that; your own goodness abides. As much as possible transfer this affection to your wife. I assure you that I am much calmer now that I can say to myself that you have a companion for good. Above all, do not imagine that I am unhappy.

I am sorry to give trouble to Monsieur Salles and Doctor Rey, and above all to you, but what is one to do? My head isn't steady enough to begin working again as before — the thing is not to create any more scenes in public. Being a little calmer now, I feel sure that I was mentally and physically in an unhealthy condition; that this had been working upon me for a very long time, and that other people, seeing symptoms of derangement, naturally had apprehensions better founded than my own certainty that I was thinking normally, which was not the case. This has greatly softened many of the judgments which I have too often passed with more or less presumption on people who nevertheless wished me well. Anyhow, it is certainly a pity that with me these reflections reach the *stage of feeling*, and that I can alter nothing in the past.

I shall be very glad to hear any news you can give me of our mother and sister, if they are well; tell them to take this affair of mine — I mean it — as nothing to be inordinately distressed

about, because I may be comparatively unfortunate, but after all, in spite of that I may have some almost normal years still before me. Almost everyone we know among our friends has something wrong with them. So is it worth talking about? Besides, as to my future, it is not as if I were twenty; I have turned thirty-six.

I want you to consider this going into an asylum as a pure formality, and in any case the repeated attacks seem to me to have been serious enough to leave no hesitation. The power of thought is coming back to me gradually, but I am absent-minded and cannot for the present direct my life. Poor egotist as I have always been and still am, I can't get the idea out of my head that it is really best for me to go into an asylum right away. I think that in my case nature by herself will do much more for me than any remedies.

I was very glad to hear that you feel more ease of mind since your marriage; one thing that gave me great pleasure was your saying that Mother looked as though she were growing younger. Very soon her mind will be running on seeing you with a child — perhaps it is already.

I shouldn't be unhappy or discontented if some time I could enlist in the Foreign Legion for five years (they take one up to forty). My health from the physical point of view is better than it used to be and perhaps it would do me more good than anything to serve; but I don't say that we can do this without thinking it over and consulting a doctor. If I don't enlist, of course I can still do painting or drawing as long as it works; and I do not in the least say No to that. As for coming to Paris or going to Pont-Aven, I do not feel able to.

Except for this, most of the time I have no very keen desire or keen regret. Sometimes, just as the waves crash themselves against the sullen, hopeless cliffs, I feel a tempest of desire to embrace someone, a woman of the domestic type, but we must take this for what it is, the effect of hysterical overexcitement rather than the vision of actual reality. Rey and I have laughed about it sometimes, for he says that love is a microbe too, which

does not surprise me much, and could not annoy anyone, it seems to me. Isn't Renan's Christ a thousand times more comforting than so many *papier-mâché* Christs that they serve up to you in the Duval establishments called Protestant, Catholic or something or other churches? And why should it not be so with love? As soon as I can I am going to read Renan's 'Antichrist.'

Oh, my dear Theo, if you could see the olive groves just now! The leaves like old silver, and silver turning to green against the blue, and the orange-coloured ploughed earth. It is something quite different from your idea of it in the North. It is like the pollard willows of our Dutch meadows or the oak bushes of our dunes; the rustle of an olive grove has something very secret in it, and immensely old. It is too beautiful for us to dare to paint it or to be able to imagine it.

I shall shortly send two cases of pictures, of which you must not hesitate to destroy a good number.

Tomorrow being the first of May, I wish you not so bad a year, and above all health. I should so like to be able to pass on to you some physical strength. At the moment I feel that I have more than enough. That doesn't mean that my head is still all that it ought to be.

Today I am busy packing pictures and studies. One of them is flaking off, and I have stuck some newspapers on it; it is one of the best, and I think that when you look at it you will see better what my now shipwrecked studio might have been. This study, like some others, has got spoiled by the damp during my illness. A flood came up to within a few feet of the house, and when I came back the walls were oozing water and saltpetre.

That touched me to the quick — not only the studio wrecked, but even the studies which would have been a souvenir of it ruined. It was so final, and my enthusiasm to found something very simple but lasting had been so strong. I felt I was fighting the inevitable; or rather it was weakness of character on my part, for I am left with feelings of profound remorse, difficult to describe. I think that is the reason why I have cried out so much during the attacks — because I wanted to defend myself and could not man-

age to. For it was not to myself, it was to painters, other unfortunates, that that studio would have been some use.

Well, at least we haven't been the only ones. Brias of Montpellier gave a whole fortune, a whole life to collecting paintings, and without the least apparent result. Yes — a cold room in the municipal gallery, where you see a heart-broken face and many fine pictures; where you are certainly moved, but moved, alas, as in a graveyard. The pictures are fading like flowers — even some of the Delacroix have suffered. What are we worth, we painters? I think Richepin is often right when he consigns us all to a madhouse.

Monsieur Salles has been to Saint-Rémy. They are not willing to let me paint outside the institution, nor to take me for less than one hundred francs. On the one hand, if I am shut up and not working I shall recover with difficulty; on the other, they would make us pay one hundred francs a month during the whole long life of a madman

This situation is pretty bad. If I could get out of it by enlisting for five years in the Foreign Legion, I think I should prefer that. But will they be willing to take me as a soldier? What I am afraid of is that, as my accident is known in the town here, they would refuse me. I know of no asylum where they would be willing to take me for nothing, even supposing I assumed all the expenses of my painting and left the whole of my work to the hospital. This seems rather unjust.

I feel very tired after my conversation with Monsieur Salles, and I do not quite know what to do. If I were without your affection they would drive me without remorse to suicide, and however cowardly I am, I should end by doing it. There is a point at which we have a right to protest against society and defend ourselves.

If I cannot work unless under surveillance, and in an institution — good Lord, is it worth paying money for that? I could work just as well in a barracks and even better. If I had some acquaintance who could work me into the Legion I should go. But I don't want this to be thought a fresh act of madness on my part, and that is

why I speak of it to you, as well as to Monsieur Salles, so that if I did go it would be in all serenity and after due consideration.

My life is 'in a hole,' and my mental condition not only *is*, but *has been*, vague. I cannot think things out so as to balance my existence. Where I have to follow a rule, as here in the hospital, I feel at peace; and if I were serving in the ranks it would be more or less the same thing. Now if I run a great risk here of being refused, because they know I am an idiot or an epileptic, probably chronic (though according to what I have heard there are fifty thousand epileptics in France, four thousand of whom are confined, so my case is not extraordinary), perhaps in Paris by speaking to Détaille I could soon be settled.

You must put aside any idea of sacrifice in this. All through my life, or most of it anyhow, I have sought something other than a martyr's career, for which I am not cut out. If I find trouble or cause it, honestly, I am aghast at it. It is all so uncertain and so strange; and you know how doubtful it is that we shall ever get back what it costs to go on painting. Outside of that, I think that physically I am well.

Do bear in mind that to go on spending money on my painting, when things might reach such a pitch that you would be short of money for housekeeping, is atrocious; and you know perfectly well that the chance of success is pitiably slight. Indeed, I am convinced that an irresistible power has frustrated me.

Having taken the precaution of paying thirty francs in advance to the bursar, I am still here, but they cannot keep me indefinitely, and it is more than time to decide. To shut me up in an asylum will come high, though probably less so than taking a house; and the thought of beginning to live alone again is an absolute horror to me. I could perhaps go and stay again in the night café where I have stored my furniture, but I should be in daily contact there with the very people who used to be my neighbours. A decision must be made, and it is better that you and Monsieur Salles should make it for me. But mind, I shan't say No to anything, not even to going to Saint-Rémy, in spite of the obstacles of higher terms and of not having full liberty to go outside to paint.

Meanwhile I am doing what I can; I am working a little. I have an avenue of pink flowering chestnuts in hand, a little cherry tree in flower, a wisteria plant, and a path in the park splashed with light and shade. It has been very hot today, and that always does me good. I have worked with more spirit than I have had yet. In the town nobody says anything to me now, and I actually paint in the public garden without being much bothered by anything but the curiosity of passers-by. But the money painting costs crushes me under a feeling of debt and worthlessness, and it would be a good thing if this state of things could cease.

After all, for you as for me, in the long run what is it to us to have a little more or a little less to contend with? Certainly, if we come to that, you went to work a good deal sooner than I did at the Goupils', where you had some pretty bad moments. Father was a bit on the rocks with that big family; everything had to be kept going, and you threw your whole self into it. I have been thinking over all these things with a good deal of emotion during my illness. The main thing is to feel our closeness to one another, and that is still unshaken.

Your kind letter did me good today, honestly. So now here's for Saint-Rémy. As an artist you are only a link in a chain, and whatever you find or whatever you do not find, you can comfort yourself with that. Society being what it is, we naturally cannot expect it to conform to our personal needs. And so, though I am very very glad to be going to Saint-Rémy, nevertheless for men like myself it would be really fairer to shove them into the Legion.

Physically it is amazing how well I am, but that isn't enough for any hope that it's the same with me mentally.

I shall be terribly in need of old Pangloss when in the natural course of things I happen to turn amorous again. Alcohol and tobacco after all have this virtue — or defect; it's purely relative — that they are, so to speak, anti-aphrodisiacs — something not to be despised in the exercise of the arts.

Well, this is going to be the test, and one mustn't forget to humbug plenty. For virtue and temperance, I am only too afraid, will lead me again into regions where the compass is apt pretty

quickly to go overboard, and where this time I must try to have less passion and more good humour. The passionate factor is no great matter to me as long as the power remains, as I dare to hope, of feeling attachment to the fellow-creatures with whom one lives.

I have a sort of hope that with what I know of art, the time will come when I shall produce again, even in the asylum. What use to me would be the more artificial life of an artist in Paris? I should never be more than half taken in by it, and so should lack the primary enthusiasm indispensable to start me off.

All this stir will naturally be good for 'impressionism,' but you and I as individuals will suffer. As my good friend Roulin says: 'It is to act as a stepping-stone for others'; at least one would like to know for whom and for what.

Listen: do not become altogether and exclusively impressionist; after all, if there is any good in anything, let us not lose sight of it. Certainly colour is progressing through the impressionists, even when they go astray, but Delacroix has reached more completeness than they. And confound it all, Millet, who has hardly any colour, what work his is! Madness is salutary in this way, that one becomes less exclusive. So many distinctions in impressionism have *not* the importance that people have chosen to see in them.

One must not fail to appreciate what is good in those who are not impressionists — men like Jourdan, Perrin, all the people we used to know so well when we were younger. Why forget them? Why attach no importance to their equals? Why are not Daubigny and Quoist and Jeannin colourists, for instance? I am not sorry that I chose to go into this question of the theories of colour a bit technically. After all, in figure Delacroix, Millet, and several sculptors have done far better than the impressionists — even than J. Breton.

In short, my boy, let us be fair; I tell you, we are getting too old to rank ourselves among the younger men, since in our time we have loved Millet, Breton, Israëls, Whistler, Delacroix, and Leys. For myself, I am pretty well convinced that I shall see no future beyond this — or desire one.

We shall always keep a sort of passion for impressionism, but

I am returning more and more to the ideas I had before I came to Paris. Now that you are married we need not live any longer for great ideas, but, believe me, for small ones only. And I find that a distinct relief; I don't complain of it at all.

Ah! What you say about Puvis and Delacroix is damned true; those two have indeed demonstrated what painting could be. But don't let us confound things that are leagues apart. I as a painter shall never stand for anything of importance, I feel it utterly. But if all were changed, character, education, circumstances, things might be different.

I sometimes regret that I did not keep to the Dutch palette with its grey tones, and brushed away at landscapes of Montmartre with no ado. I am also thinking of again beginning to draw more with a reed pen, which, as in last year's views of Mont-Majour, costs less and diverts my mind just as much.

Today I made a drawing which turned out to be very dark, and rather too melancholy to be one of spring.

It is only too true that heaps of painters go mad; it is a life that makes you, to say the least, very absent-minded. If I throw myself fully into my work again, very good; but I shall always be cracked. It is all the same to me. They have lots of room here in the hospital; there would be enough to make studios for a score or so of painters.

Now I am packing my trunk, and probably Monsieur Salles will go over with me as soon as he can. I hope that in the heap of canvases I have sent you there will be some which give you pleasure. If I go on being a painter, sooner or later I shall probably be in Paris again, and I promise myself in that case to give a good overhauling to some old canvases.

I THINK I have done well to come here, for by seeing the actual *truth* about the life of the various madmen and lunatics in this menagerie, I am losing the vague dread, the fear of the thing. And the change of surroundings is doing me good.

The idea of work as a duty is coming back very strong, and my faculties for work will also come back to me fairly quickly. Yet work often so absorbs me that I think I shall remain absent-minded and awkward in shifting for myself the rest of my life.

I have a little room with greenish-grey paper, with two curtains of sea-green with a design of very pale roses, brightened by slight touches of blood-red. These curtains, probably the relics of some rich and ruined defunct, are very pretty in design. From the same source probably comes a very worn armchair, recovered with an upholstery splashed like a Dias or a Monticelli, with brown, red, white, black, forget-me-not blue, and bottle green. Through the iron-barred window I see a square of corn in an enclosure, a perspective like van Goyen, above which I see in the morning the sun rising in his glory. In addition to this room — as there are more than thirty empty — I have one to work in.

The food is so-so. It naturally tastes rather mouldy, as in a shoddy restaurant in Paris or a boarding-house. As these poor souls do absolutely nothing (not a book; nothing but a game of bowls and a game of draughts), they have no other daily distraction than to stuff themselves with chick peas, haricots, lentils, and other groceries in set quantities and at fixed hours. The room where we stay on wet days is like a third-class waiting-room in some dead-alive village, the more so as there are some distinguished lunatics who always wear a hat, spectacles, cane, and travelling cloak.

Formerly I felt repulsion for these creatures, and it was a harrowing thought for me to reflect that so many of our profession, Troyon, Marchal, Meryon, Jundt, M. Maris, Monticelli, and heaps more had ended like this. Now I think of it all without fear; that is to say, I find it no more frightful than if they had been stricken with some other ailment. These artists, I see them

take on their old serenity, and is it a little thing to rediscover the ancients of our profession? That is a thing I am profoundly thankful for.

Though there are some who howl or rave continually, in spite of that people get to know each other very well, and help each other when their attacks come on. They say we must put up with others so that others will put up with us; and between ourselves we understand each other very well. I can, for instance, sometimes chat with one of them who can only answer in incoherent sounds, because he is not afraid of me. And it is the same with those whose mania is to fly into frequent rages. The others interfere so that they do themselves no harm, and separate the combatants, if combat there is.

It is true there are some whose condition is more serious, who are either dirty or dangerous; these are in another courtyard.

There is another thing I am grateful for. I gather from others that they have heard during their attacks strange sounds and voices, as I have, and that to their eyes too things seemed to be changing. That lessens the horror that I had at first of my attacks, which when they come on one unawares cannot but frighten one beyond measure. Once you know that this is part of the disease, you take it like anything else. If I had not seen other lunatics close to, I should not have been able to free myself from constantly dwelling upon it.

Indeed, the anguish and suffering are no joke once you are caught by an attack. Most epileptics bite their tongue and wound themselves. Rey told me that he had seen a case where someone had wounded himself as I did, in the ear. Once you know what it is, once you are conscious of your condition, and of being subject to attacks, you can do something yourself not to be so taken aback by the suffering or the terror. For five months my suffering has been lessening, and I have good hopes of getting over it, or at least of not having attacks of such violence.

There is someone here who has been shouting and talking as I do *all the time* for a fortnight; he thinks he hears voices and words in the echoes of the corridors, probably because the nerves of the

ear are diseased and oversensitive; in my case it was sight and
hearing at once, which according to what Rey told me one day is
usual in the beginning of epilepsy. The shock was such that it
sickened me even to make a movement, and nothing would have
pleased me better than never to have wakened again. At present
this *horror of life* is less strong and the melancholy less acute. But
from that to will and action there is still some way to go.

It is rather queer, perhaps, that as a result of this last terrible
attack there is hardly any very definite desire or hope left in my
mind, and I wonder if this is the way one thinks when, with the
passions dying out, one descends the hill instead of climbing it.
Of *will* I have none, and of everything belonging to ordinary life;
the desire, for instance, to see my friends, although I keep thinking
about them, I have almost none of. That is why I am not yet at
the point when I can think of leaving here. I should have this
depression anywhere. By staying here, the doctor will naturally
be better able to see what is wrong, and will be more reassured as
to my being allowed to paint.

I am having a bath now twice a week, and stay in it two hours;
my stomach is infinitely better than it was a year ago, so as far as
I know I have only to go on.

I do not notice in the others, either, any very definite desire to
be somewhere else, but this may well come from the feeling that
we are too thoroughly shattered for life outside. What I cannot
quite understand is their absolute idleness; but that is the great
fault of the South and its ruin. Yet what a lovely country, and
what lovely blue, and what a sun! So far I have only seen the
garden, and what I can look at through my window. When I am
working in the garden they all come to look, and I assure you they
have more sense, and the politeness to leave me alone, than the
good people of the town of Arles.

It is a whole month since I came here. My hope is that at the
end of a year I shall know better what I can do and what I want
to do. Little by little the idea of a fresh start will come to me. To
come back to Paris, or go anywhere at all, in no way takes my fancy
at present.

Extreme enervation is what most of those who have been here for years suffer from. My work will in a certain measure preserve me from that. And though the pictures cost the price of canvas and paint, at the end of the month it is more profitable to spend a little more in this way and make use of what after all I have learnt, than to abandon them, since anyhow you have to pay for my keep. That is why I am working.

It is only too doubtful whether painting has any beauty or use. But what is to be done? There are people who love nature even though they are cracked or ill; those are the painters. Then there are those who like what is made by man's hands, and these even go so far as to like pictures.

Since I came here the deserted garden, planted with large pines beneath which grows the grass, tall and unkempt and mixed with various weeds, has sufficed for my work, and I have not yet gone outside. However, the country round Saint-Rémy is very beautiful, and bit by bit I shall go and stay at places.

When I send you the four canvases of the garden I have in hand you will see that considering life is spent mostly in the big garden, it is not so unhappy. Here at any rate we have splendid sunshine.

Yesterday I drew a very big, rather rare night moth called the death's head, its colouring of amazing distinction, black, grey, cloudy white tinged with carmine, or shading indistinctly to olive-green; it is very big. To paint it I had to kill it, and it was a pity, the insect was so beautiful.

What you say about the 'Woman Rocking' pleases me; it is very true that the common people, who are content with chromos and melt when they hear a barrel organ, are in some vague way right, perhaps more sincere than certain men about town who go to the Salon. I have a new canvas, once again as ordinary as a chromo in the little shops, which represents the eternal nests of greenery for lovers; some thick tree trunks covered with ivy, the ground also covered with ivy and periwinkle, a stone bench and a bush of roses pale in the cold shadow. The problem is to get distinction into it.

This morning I saw the country from my window a long time before sunrise, with nothing but the morning star, which looked very big. Daubigny and Rousseau have done just that, expressing in their work all that the scene has of intimacy, all its vast peace and majesty, but adding as well a feeling so individual, so heartbreaking. I have no aversion to that sort of emotion.

Give Gauguin, if he will accept it, a copy of the 'Woman Rocking,' and another to Bernard as a token of friendship. I hope that you will destroy a lot of the things that are too bad in the batch I have sent you from Arles, or at least only show what is most passable. As for the exhibition of the Independents, just act as if I weren't here; to avoid seeming indifferent, yet not exhibit anything too mad, perhaps the 'Starry Night' and the landscape with yellow leafage. Since these two are done with contrasting colours they might give somebody else the idea of doing such night effects better than I have.

I am always filled with remorse, terribly so, when I think of my work as so little in keeping with what I should have liked to do. I hope that in the long run this remorse will lead me to do better things.

I am going off tomorrow to see a little of the country, and since it is the season when there are plenty of flowers and consequently colour effects, it would perhaps be wise to send me five metres more of canvas. For the flowers are short-lived and will be replaced by the yellow cornfields. These especially I hope to catch better than I did at Arles. The mistral (since there are some mountains) seems much less tiresome here than there, where you always get it first-hand.

You absolutely must set your mind at rest about me now. My health is all right, so I feel happier with my work than I could be outside; I shall have learnt regular habits, and in the long run the result will be more order in my life and less susceptibility. That will be so much to the good. I went once, accompanied, to the village, but the mere sight of people and things had such an effect on me that I thought I was going to faint, and felt very ill. There must have been some all-powerful emotion within me to upset me

like that, and I have no idea what can have caused it. Face to face with nature, it is the feeling for work that holds me.

I have two landscapes in hand, views taken among the hills; one is the country that I see from the window of my bedroom; in the foreground a field of corn ruined and dashed to the ground after a storm, a boundary wall, and beyond it the grey foliage of a few olive trees, some huts, and the hills. It is a landscape of extreme simplicity in colouring, it will make a companion-piece to the study of the 'Bedroom,' which has got damaged. When the thing represented is in point of character absolutely in agreement with the manner of representing it, isn't that just the element that gives a work of art its quality? This is why a mere loaf of bread, as far as painting goes, is especially good when it is painted by Chardin.

As I wish to preserve the study of the 'Bedroom,' I am going to repaint it. I wanted at first to have it recanvased, because I did not think I could do it again. But as my brain has grown calmer since, I can quite well do it up now. The thing is that among the number of things you make, there are always some that you felt more, or put more into, and that you want to keep in spite of everything.

I have seen the announcement of the exhibition of impressionists, listed as Gauguin, Bernard, Anquetin, and others. So I am inclined to think that a new sect has again been formed, not less infallible than those already existing.

When I see a picture that interests me I always ask myself involuntarily: 'In what house, room, corner of a room; in whose home would it do well and be in the right place?' Thus the pictures of Hals, Rembrandt, van der Meer are only at home in an old Dutch house. Now as to the impressionists, if an interior is not complete without a work of art, a picture is not complete either if it is not at one with the surroundings originating and resulting from the period in which it was produced. I do not know whether the impressionists are better than their time, or are not so good. Are there minds and interiors of homes more important than anything that has been expressed by painting? I am inclined to think so.

If the impressionists dare to call themselves primitives, certainly they would do well to learn a little about being primitives as *men* before pronouncing the word 'primitive' as a title which gives them a right to anything whatsoever.

I think that you were right not to show any pictures of mine at that exhibition. It is reason enough for my keeping out of it, without giving them offence, that I am not yet recovered.

But I think it unquestionable that Gauguin and Bernard have great and real merit; and that for beings like them, young and very vigorous, who must live and try to hack out their way, it would be impossible to turn all their canvases to the wall until it should please people to admit them into something — into the official stew. By exhibiting in cafés, you cause a stir. I do not say it is not bad taste to do it, but I myself have this crime on my conscience and twice repeated, as I exhibited at the Tambourin and at the Avenue de Clichy, without counting the upset occasioned to eighty-one worthy anthropophagi of the good town of Arles and their excellent mayor.

So in any case I am worse and more to blame than they in causing a stir — my word, quite involuntarily. After all, neither Bernard nor Gauguin are artists who could ever look as if they were trying to get into an exhibition by the back stairs.

The shrubbery with the ivy is completely finished, and I have a landscape with olive trees and also a new study of a starry sky. Though I have not seen either Gauguin's or Bernard's last canvases, I am pretty well convinced that these are parallel in feeling. When you have looked at them for some time, they will perhaps give you a better idea than words could of the things Gauguin and Bernard and I used to talk about, and which we've thought about a good deal; it is not a return to romantic or religious ideas; no. Nevertheless, by going the way of Delacroix more than appears, by colour and more spontaneous drawing one can express the nature of a countryside which is purer than the suburbs and cabarets of Paris.

One should try to paint human beings also that are more serene and purer than those Daumier had before his eyes, but to follow

Daumier in the drawing. After all, while the Chat Noir draws women after its fashion, and Forain in a fashion that's masterly, we do some of our own; and less Parisian as we are, but not less fond of Paris and its graces, we try to prove that something very different exists as well.

Gauguin, Bernard, and I may stay at that point perhaps, and not conquer, but neither shall we be conquered; we may seek neither the one thing nor the other, but to give consolation or prepare the way for a style of painting that will yield greater consolation. However, as I have said many a time to Gauguin, we must not forget that others have done it already.

I am very pleased that Isaacson has found some things to please him in my consignment. He and de Haan seem very faithful, and that is rare enough in these days for one to appreciate it. And I am pleased too to hear that someone else has turned up who actually saw something in the woman's figure in black and yellow. That does not surprise me, though I think that the merit is in the model and not in my painting.

I despair of ever finding models. Ah, if I had now and then someone like that, or like the woman who posed for the 'Woman Rocking,' I should do something very different. I feel tempted to begin again with the simpler colours, the ochres, for instance. Is a van Goyen ugly because it is painted entirely in oils with very little neutral colour, or a Michel?

In this country there are many things that often make you think of Ruysdael, but the figures of the labourers are lacking. Everywhere at home and at all times of the year you see men, women, children, and animals at work, and here not a third as many; besides, they are not like the downright worker of the North. They seem to work here with slack and clumsy hands, with no spirit in them. Perhaps this is a wrong idea I have got hold of, not belonging to the country; I hope so.

We have had some glorious days, and I have taken still more canvases in hand. There are twelve on the stocks, and two studies of cypresses of that difficult bottle-green shade. I have worked their foregrounds with thick layers of white lead, which gives

firmness to the ground; on that you put other colours. Very often
the Monticellis were prepared like this. I have been out for several
days to work in the neighbourhood, and I am a little low, but do
not fear that I shall rush myself to dizzy heights.

I get bored to death sometimes after working. It is queer that
every time I try to reason with myself to get a clear idea of things,
why I came here, and that after all it is only an accident like any
other, a terrible dismay and horror seizes me and prevents me
from thinking. It is true that this is tending to diminish slightly,
but it is astounding to be afraid of nothing like this, and not be
able to collect yourself. You may be sure I shall do all I can to
become active again and perhaps useful — in this sense at least,
that I want to do better pictures than before. But if some month
or other it should be too burdensome to send me paint and canvas,
then do not send them; for believe me, it is better to live than to
work at art in the abstract. And above all your home must not
be sad. That comes first, and painting after.

What I should like very much to have to read here now and then
is something by Shakespeare.

I have received — probably from one of our sisters — a book
by Rod which is not bad, but the title 'Le Sens de la Vie' is really
a little pretentious for the contents, it seems to me. It certainly
is not very cheering. I think the author must suffer a good deal
from his lungs, and consequently a little from everything. Any-
way, he admits that he finds consolation in the companionship of
his wife, which is all to the good; but after all for my own use he
teaches me nothing about the direction of life, any direction
whatever. I find him a little trite, and am surprised that he has
had a book like that printed these days and gets it sold at 3:50
francs. On the whole I prefer Alphonse Karr, Souvestre, and Droz,
because they are a bit more alive than this. It seems that this
book has made a great impression on our good sisters; Wil had
spoken of it to me. But good women and books are two different
things.

I have read again with much pleasure 'Zadig, *ou la Destinée*,' by
Voltaire. Here the mighty author gives at least a glimpse of the

possibility that life may have some direction, though it is agreed that things in this world do not always go as the wisest wish!

As for me I do not know what to wish, to work here or elsewhere seems to come to very much the same thing, and being here, to stay here seems the simplest thing to do. The days are all the same, ideas I have none, except to think that a field of corn or a cypress is well worth the trouble of looking at close to.

To learn to suffer without complaint, to learn to look on pain without repugnance, it is exactly in that that you run the risk of vertigo; nevertheless you catch a glimpse of a vague likelihood that on the other side of life we shall see good reason for the existence of pain, which seen from here sometimes so fills the horizon that it takes on the proportions of a hopeless deluge. About this we know very little, and it is better to gaze at a field of corn, even in the form of a picture.

I have been painting in the cornfields in the hottest part of the day, without having much trouble from it. But I notice that the sun sometimes has a strong effect on the grain, which soon becomes very yellow.

One never sees buckwheat or rape here, and there is in general less variety of grains than with us. I should like so much to paint a buckwheat field in flower, or the rape in bloom, or flax; maybe I shall have an occasion for this later in Normandy or Brittany. Also one never sees here those moss-covered roofs on the barns or huts, nor beech hedges with their white crossed old stems, nor the real heather and heather birches which were so beautiful in Neunen. But what is beautiful in the South are the vineyards. I like as much to see a vineyard as a cornfield. The hills, too full of tyme and other pungent-smelling plants, are very nice, and owing to the clearness of the air one sees much further from the heights than we do at home. And the blue sky never tires me.

I have a cornfield very yellow and very light, perhaps the lightest canvas I have done. And the cypress is always occupying my thoughts; it is as beautiful in line and proportion as an Egyptian obelisk, and the green has a quality of high distinction. It is a splash of *black* in a sunny landscape, but it is one of the most in-

teresting of the black notes, and the most difficult to strike exactly that I can imagine. But then you must see the cypress against the blue, *in* the blue rather. To paint nature here, as everywhere, you must have lived in it a long time.

I should like to make something of the cypresses like the canvases of the sunflowers; it astonishes me that they have never been done as I see them.

I think that of the two canvases of cypresses, the one I am making now will be the best. The trees in it are very big and massive, the foreground very low with brambles and brushwood; behind some violet hills a green and rose sky with a crescent moon. The foreground especially is painted very thick. This work will take up the days. The great problem here is to find occupation through the day.

I am sending you a dozen drawings today, all from canvases in hand. They seem to me to have little colour this time, and for that the extreme smoothness of the paper is a little responsible. The latest begun is the 'Cornfield,' in which there is a little reaper and a big sun. A canvas which is almost the same in subject is different in colouring, being of a greyish-green, with a white and blue sky.

I have also a canvas of cypresses with some ears of corn, some poppies, a blue sky like a piece of Scotch plaid; the other cypress canvas is painted with a thick *pâte* like the Monticellis, and the cornfield in the sun, which expresses the extreme heat, is very thick too. I think that these would make it clear to Reid that he could not lose much by remaining friends with us.

How I think of Reid when I am reading Shakespeare, and how often I thought of him while I was worse than I am now! I decided that I had been much too hard on him and too discouraging when I claimed that it was better to care for the painters than for the pictures.

It is not within my power to make distinctions like this, even faced with the problem which we see our contemporaries suffering from: the lack of enough money to live and pay for paints with, and on the other hand the high prices paid for canvases of dead

painters. I was reading in a newspaper a letter from a collector of
Greek things to one of his friends in which this phrase occurred:
'You who love nature, I who love everything the hand of man has
made, this difference in our taste is at bottom a unity.' I thought
that this was better than my argument.

Shakespeare is so fine. I have begun to read the series of which
I knew least, which formerly, distracted by other things or not
having the time, I could not read: the historical plays.

I read without wondering whether the ideas of the people of
those times were different from our own, or what would become of
them if you set them over against republican and socialist beliefs,
and so on. But what touches me, as in some novelists of our day,
is that the voices of these people, which through Shakespeare
reach us from a distance of several centuries, do not seem unfamiliar
to us. They are so much alive that you think you know them.
And so what Rembrandt has alone, or almost alone among paint-
ers, that tender look which we see, whether in the 'Pilgrims of
Emmaus' or the 'Jewish Bride' — that heartbroken tenderness,
that glimpse of a superhuman infinite that seems so natural there
— in many places you come upon it in Shakespeare.

I am lucky to be able to read or reread this at leisure; and I very
much hope to read Homer at last.

I talked a little this morning with the doctor here. He told me
exactly what I had thought already: that I must wait a year before
considering myself cured, since anything at all might bring on
another attack. Then he offered to house my furniture, so that we
should not be paying double.

I live soberly because I have a chance to; I drank in the past
because I did not know how to do otherwise. Deliberate sobriety
leads to a state of being in which thought, if you have any, moves
more readily. It is like painting in grey or in colours. I am in fact
going to paint more in grey. I have a feeling rather like the one I
had when I was younger, when I was very sober — too sober, they
used to say, I guess.

Jo's letter gave me a great piece of news this morning; I con-
gratulate you on it. I was much touched when you said that

neither of you being in such good health as seems desirable on such an occasion, you were worried, and that a feeling of pity for the child who is to come passed through your heart. But has the child before his birth been any less loved than the child of very healthy parents? Certainly not. Roulin's child came to them smiling and very healthy, when they were in straits. So take it as it comes; wait in confidence and possess your soul in patience, as a very old saying has it, and with good-will. Let nature alone.

The fact that in Paris you take on as it were a second nature, which over and above the preoccupations of business and art makes you less strong than the peasants are, does not prevent you from linking yourself by the bonds of wife and child with this simpler and truer nature, the ideal of which keeps haunting us. In my life as a painter, and especially when I am in the country, it is less difficult for me to be alone, because in the country you feel more easily the ties that unite us all. But in town, as you have been ten years on end with the Goupils, it is impossible to exist alone.

You will be much taken up with the thought of the child who is to come, and I am very glad it is so; in time I dare to think that you will find a good deal of inward tranquillity so. I am going to send you some canvases from Arles as soon as possible to try to give you, even though you are in town, a peasant's thoughts.

As for being godfather to a son of yours, when to begin with it may be a daughter, honestly, in the circumstances I should rather wait until I am away from here. Mother would certainly have set her heart on its being called after our father. I for one think that more appropriate under the circumstances.

Tomorrow I shall send you a roll of canvases. I am putting in some which are studies from nature rather than subjects for pictures. It is so always; you must make several before you can get one that has character. Now for the subjects: 'Irises,' 'View from the Asylum at St. Rémy,' 'Peach Trees in Bloom' (Arles), 'Meadows' (Arles), 'Olives' (St. Rémy), 'Old Willows' (Arles), 'Orchard in Bloom.'

The next parcel will be made up mostly of cornfields and olive

gardens. The last canvas I have done is a view of mountains with a dark hut at the bottom among some olive trees. Outside, the cicadas are singing fit to burst — a harsh cry, ten times stronger than that of the crickets — and the burnt-up grass takes on lovely tones of old gold. The beautiful towns of the South are in the state of our lifeless towns along the Zuyder Zee, that once were astir. In the decline and decadence of things the cicadas dear to the good Socrates abide; and here they still sing in ancient green.

I have been to Arles to get the canvases that were still there; the warder here accompanied me. We went to M. Salles's house, but he had gone on his vacation; and to the hospital to see M Rey, whom I did not find either. We spent the rest of the day with my former neighbours, among them my old charwoman. You get very fond of people who have seen you ill, and it has done me a world of good to see again some people who were kind and gentle with me then.

[Several days after his return from Arles, Vincent suffered another attack.]

It was very difficult for me to write, my head was so disordered. For many days I have been *absolutely wandering* as at Arles, quite as much if not more, and for four days I have been unable to eat because of a swollen throat.

This new attack, my boy, came on me in the fields when I was in the midst of painting on a windy day. I will send you the canvas. I finished in spite of it. And truly it was a more sober attempt, in blended greens, reds and rusty ochre yellows; for as I told you, I feel sometimes a great desire to begin again with the same palette as in the North.

As you can imagine, I am terribly distressed that the attacks have come back, when I was already beginning to hope they would not; and it is to be presumed that they will come back again in the future. It is *abominable.* I tell you these details to show you that I am not yet in condition to go to Paris or to Pont-Aven. If I get better, or in the intervals, I can sooner or later come back to Paris or into Brittany for a time. But I see no further possibility of

having courage or hope. Well, after all it wasn't only yesterday that we found this job of ours wasn't a cheery one.

If I had confidence in the management of this place, nothing would be better or simpler than to bring all my furniture here to the hospital and go quietly on. But first of all it is very expensive here; they inquire a great deal too much for my liking about what not only I but you earn; and just now I am afraid of the other patients. Altogether, heaps of reasons make me feel that I haven't had any luck here either. Perhaps I exaggerate in my wretchedness at having again been bowled over by my illness, but I am sort of afraid.

You will say — as I say to myself, too — that the fault must be within me and not in circumstances or in other people. It is not cheery, but I really must try to take things passively and have more patience. Doctor Peyron is very kind to me, and as he has had much experience I do not doubt that he says and judges rightly. I am in a very low state of mind.

I feel like a fool to go and ask permission from doctors to make pictures. The work on my pictures seems essential to my recovery, for these days without anything to do, and without being able to go to the room they had allotted to me to do my painting in, are almost intolerable. Work strengthens the will, and consequently leaves less hold for my mental weaknesses; it distracts me infinitely better than anything else. If I could once really throw myself into it with all my heart it might be the best remedy.

Perhaps it would be well for me to stay at a farm, for a time at least; I might do good work there.

The doctor here said to me of Monticelli that he had always thought him an eccentric, but that as for madness he had only been a little that way towards the end. Considering all the wretchedness of Monticelli's last years, is there any reason to be surprised that he gave way under too heavy a load, and has one any right to conclude from this that artistically speaking he failed in his work?

It is curious that Maus had the idea of inviting little Bernard and me for the next exhibition of the Vingtistes, and it made me

think a good deal about the Belgian painters when you told me of Maus's having been to see my canvases. Then memories came over me like an avalanche, and I tried to reconstruct that whole school of modern Flemish artists, until I was as homesick as a Swiss; which does no good, because our way lies — forward, and to retrace one's steps is forbidden and impossible.

I should very much like to exhibit there, though I feel my inferiority beside so many of the Belgians, who have tremendous talent. This Mellery, now, is a great artist. He has been so for a number of years already, but I should do my best to try to do something good this autumn.

I think very often of the other fellows in Brittany, who are certainly busy doing better work than I. If with the experience I have now it were possible for me to begin again I should not go to see the South; were I free and independent, I should nevertheless have kept my enthusiasm, because there are some beautiful things to be done.

The song of the cicadas in the extreme heat here has the same charm for me as the crickets on the hearth of the peasants at home. Old man, don't let us forget that the small emotions are the great captains of our lives, and that we obey them without knowing it. If to take courage from my faults past and future, which must be my cure, is hard for me, do not forget that henceforth neither our spleen nor our melancholy, nor yet our feelings of good nature or of common sense, will be our sole guide, nor above all our final protection; and if you too find yourself faced with heavy responsibilities, let us not be too much concerned about each other, since it happens that the circumstances of living in a state of things so far from our youthful conception of the artist's life must make us brothers in spite of everything, as being in many ways companions in fate.

Things are so linked together that here you sometimes find cockroaches in the food as if you were in Paris, while in Paris you sometimes catch a real feeling of the fields. It is not much, but after all it is reassuring. So accept your fatherhood as a good soul from our old heaths would accept it — those heaths which still

through all the noise, tumult, and agony of the towns remain with us, as inexpressibly dear, however shy our tenderness may be. That is to say, accept your fatherhood, exile and stranger and poor man as you are; henceforth hark back with the instinct of the poor to the real life of your fatherland.

Sooner or later we find our lot, such as it is, but surely it would be a sort of hypocrisy for me to forget all the fun, the happy-go-lucky carelessness of the poor devils that we were. You will have a child, and that will bring you a fair amount of the little worries of human life — but as some serious worries will disappear for ever, it is this way things should go.

I think the emotions which must move the future father of a family, the emotions which our good father so liked to talk about, must be with you, as with him, strong and fine. Realities of this kind must be, after all, like a good mistral, not soothing, but purifying. I assure you that this gives me much pleasure too, and will contribute much to taking me out of my mental fatigue and perhaps my indifference. After all, it is something to get back one's interest in life, as when I think that I am about to become uncle to this boy your wife plans for; I find it very droll that she feels so sure it is a boy.

Above all, old man, I beg you not to fret, or be worried or unhappy about me; the ideas you might get into your head of this necessary and salutary quarantine would have little justification when we need slow and patient recovery. If we can grasp that, we shall save our strength for this winter.

Here I imagine the winter must be rather dismal, but I must try to occupy myself all the same. I often think that I might retouch a lot of last year's studies. Thus, having lately slowed down on a big study of an orchard which had given me great difficulty, I set myself to work it over again from memory, and have found the way to convey better the harmony of the tones.

I am working with a will in my room; it does me good and drives away abnormal ideas.

They say — and I am very willing to believe it — that it is difficult to know yourself, but it isn't easy either to paint yourself.

I am working on two portraits of myself at this moment — for lack of another model, because it is more than time I did a little figure work. One I began the day I got up; I was thin and pale as a ghost. It is dark violet-blue and the head whitish with yellow, so it has a colour effect. Since then I have begun another one, three-quarter length on a light background. Altogether I am working from morning till night, and the work is going pretty well. So let's take things with a sort of Northern phlegm. This blasted life of art is shattering. My strength returns from day to day, and I fear I have almost too much of it. For to stick assiduously to the easel it isn't necessary to be a Hercules.

Here we are in September already; we shall soon be right in the autumn and then the winter.

Yesterday I began again a little thing that I see from my window — a field of yellow stubble that they are ploughing. I have a canvas in hand of a moonrise over the field, and am struggling with a canvas begun some days before my indisposition — a 'Mower.' The study is all yellow, terribly thickly painted, but the subject was fine and simple. For I see in this mower — a vague figure fighting like a devil in the midst of the heat to get to the end of his task — the image of death in the sense that humanity might be the corn he is reaping. So it is — if you like — the opposite to that sower I tried to do before. But there's nothing sad in this death; it goes its way in broad daylight, with a sun flooding everything with a light of pure gold.

There I am at it again, but I don't let go my hold, and with a new canvas I shall try again. Ah, I could almost believe that I have a new period of light before me.

And what to do — to go on through the months here or to move — I don't know. The point is that the crises when they occur are no joke, and to risk having an attack like that with you or other people is a serious business. So to leave now, when I judge a new attack probable in the winter, that is to say in three months, would perhaps be too risky. But a few more months, and I shall be so flabby and stupid that a change will probably do a lot of good.

I shall go on working very hard. Then if about Christmas the attacks return we shall see; that over, I can see nothing to keep me from sending the management here to blazes, and returning to the North for an indefinite time. That is provisionally my idea on this business, but of course it isn't hard and fast.

My dear brother, it is always in between my work that I write; I am working like one actually possessed. I think this will help to cure me. And perhaps something will happen to me like what Eugène Delacroix spoke of: 'I discovered painting when I had no more teeth or breath,' in the sense that my unhappy illness makes me work with a dumb fury — very slowly — but from morning till night, without slackening — and — the secret is probably here: Work long and slowly. How can I tell? But I think I have one or two canvases in hand that are not so bad; the 'Reaper,' and the portrait against a light background. That will do for the Vingt-istes, if indeed they remember me when the time comes, but then, it is all one to me whether they forget me or not. For I do not forget the inspiration it gives me to let my thoughts dwell on some of the Belgians. That is positive, and the rest quite secondary.

I am struggling with all my energy to master my work, thinking that if I win, that will be the best lightning-conductor for my illness. I take extreme care of myself, shutting myself up carefully. It is egotistical, if you like, not rather to accustom myself to my companions in misfortune and go and see them, but I find myself none the worse for it, for my work is progressing and we have need of that; it is more than necessary that I should do better than before — for that was not enough.

Now my thoughts come in order and I feel perfectly normal, and if I think over my condition with the hope of having periods of clearness and of work between the attacks — if unfortunately they return from time to time — I must continue firmly on my poor career as a painter. Monsieur Peyron said only: 'Let us hope it will not return,' but for my own part I *expect* that it will for a good long time, at least for several years.

Altogether I should rather have a downright illness like this than to be as I was in Paris while this was brewing. You will see

this when you put the portrait with the light background that I have just finished beside those that I made of myself in Paris, and perceive that *now* I look saner than then, much more so. I am even inclined to think that the portrait will reassure you — my face is much calmer, though my look is vaguer, than formerly, it seems to me. It cost me some trouble to do. Show it to old Pissarro if you see him.

Yesterday I began the portrait of the head warder, and I may do his wife too, for he is married and lives in a little house a few steps away from the establishment. A very interesting face, and if it were not a good deal tempered by an intelligent look and an expression of kindness, it would suggest a veritable bird of prey. He was at the hospital at Marseilles through two periods of cholera, and altogether is a man who has seen an enormous lot of suffering and death; in his face there is a sort of contemplative calm. But he is of the people, and simple. It is very much a Southern type. Anyway, you will see if I succeed with it.

The desire I have to make portraits just now is acute, indeed Gauguin and I talked about this and other analogous questions until our nerves were so stretched there wasn't a spark of heat left in us. But from that, good pictures must arise, and we shall look out for them. Will it not be better, if sooner or later I come back again from here, that I come back definitely capable of doing a portrait that has some character? But that is clumsily expressed, for you may well say that I know how to make a portrait without telling a lie — because that is infinite.

I have had a letter from Gauguin, and I am very curious to see some day what they are doing. They must, I think, be doing good work in Brittany.

Keep carefully my portrait by Russell that I am so fond of.

There! The 'Reaper' is finished. It is very, very simple, and I think it will be one of those you keep at home. It is an image of death as the great book of nature speaks of it, but what I have tried for is the 'almost smiling.' It is all yellow except a line of violet hills, a pale, fair yellow. I find it queer that I saw it like this from between the iron bars of a cell.

I think I can promise you at the end of the month twelve canvases of 30, but they will be virtually the same thing done twice: the study and the final picture. Perhaps my sojourn in the South will yet bear fruit.

It is six weeks since I last put my foot outside, even in the garden. Next week, however, when I have finished the canvases in hand, I am going to try. I get great pleasure from going into the mountains to paint the whole day, and I hope they will let me do it.

Do you know what I hope, as soon as I let myself begin to hope? It is that a family will be for you what nature, the clods of earth, the grass, the yellow corn, the peasant are for me; that is to say, that you may find in your love for people something *not only to work for*, but to console and restore you when there is need.

It is a very serious thought that wherever I lived here for any length of time, I should perhaps have to deal with popular prejudices — I do not even know what these prejudices are — which would make my life with them insupportable.

My dear brother, you know that I came to the South and threw myself into my work for a thousand reasons: wishing to see a different light, thinking that to look at nature under a bright sky might give us a better idea of the Japanese way of feeling and drawing, wishing also to see this stronger sun, because one feels that without knowing it one could not understand the pictures of Delacroix from the point of view of execution and technique, and that the colours of the prism are veiled in the mist of the North.

All this is still pretty true. And when to this is added the natural inclination towards this South which Daudet described in 'Tartarin,' and that here and there I have besides found friends and things which I love, can you understand that while finding this malady horrible, I have formed links with the place that are perhaps too strong — links that may later make me hanker to work here again?

Yet in spite of everything it may be that in a comparatively short time I shall return to the North. Yes, for I will not hide from you that in the same way that I take my food now with avidity, a terrible desire comes over me to see my friends and the northern

countryside again — even though my work is going very well, and I am finding things that I have sought in vain for years.

When I realize that the attacks upon me here tend to take an absurd religious turn, I almost think that this *necessitates* a return to the North.

You understand that I have tried to compare the second attack with the first, and it has seemed to me to arise from some influence or other from outside rather than from within myself. I may be mistaken, but I think you will feel it quite right that I have a horror of all religious exaggeration. I am astonished, with my modern ideas, and being so ardent an admirer of Zola and de Goncourt, and caring for art as I do, that I have attacks such as a superstitious man might have, and get confused and frightening ideas about religion such as never came into my head in the North.

On the supposition that I am very sensitive to surroundings, my already prolonged stay in these old cloisters, the Arles hospital, and the house here would alone be enough to explain these attacks. I really must not live in such an atmosphere, though even in my suffering religious thoughts sometimes bring me great consolation. Thus, during my last illness a misfortune happened to me: that lithograph of Delacroix, the 'Pietà,' with some other plates, fell into some oil and paint and was ruined. I was very much distressed. But at odd times I have occupied myself with painting a copy of it which I hope has some feeling.

To think that I am a prisoner under a management which fosters these religious aberrations when the thing is to cure them! Better to go, if not into a prison at least into the army.

Yes, we must finish with this place; I cannot do both things at once: work, and take no end of pains to live with these queer patients here — it is upsetting. In vain I tried to force myself to go downstairs, it is nearly two months since I have been in the open air. In the long run I shall lose the faculty for work, and that is where I begin to cry a halt.

I reproach myself for my cowardice; I ought rather to have defended my studio, had I had to fight with the gendarmes and the neighbours. Others in my place would have used a revolver,

and certainly if as an artist one had killed some rotters like that one would have been acquitted. I should have done better so. As it is I have been cowardly and drunk — and ill as well. Faced with the suffering of these attacks, I feel very frightened too — like someone who meant to commit suicide but, finding the water too cold, struggles to regain the bank.

During the attacks I feel a coward before the pain and suffering — more of a coward than I ought, and perhaps this very moral cowardice, while formerly I had no desire to get better, makes me now eat like two, work hard, and spare myself in my relations with the other patients for fear of a relapse.

To avoid doing or having the appearance of doing anything rash — after having thus warned you of what I may come to wish, that is, a removal to a home not directed like this by sisters, however excellent they may be — having a very serious reason for wishing to move, I feel calm and confident enough to wait and see whether a new attack materializes this winter.

I am very pleased that you too had already thought of old Pissarro. You see, there is still a chance for me — if not there, then elsewhere. I very much wish that when your child comes I could be back, not with you — certainly not, that is impossible — but in the neighbourhood of Paris with another painter.

Monsieur Peyron does not give me much hope for the future, and this I think right; he makes me realize that *everything* is doubtful, that one can be sure of nothing beforehand. I myself rather expect my attacks to return.

You ask me about going into a home in Paris. I answer Yes to that, with the same calm and for the same reasons that I came into this place — even if this home in Paris should be a last resort, which might easily be the case. But if sooner or later I make such a move, let us behave as though nothing were wrong, being very cautious, but not taking immediate and extreme measures, as though everything were lost.

With another year of work I may attain command of myself from the artistic point of view. But for that I must have some luck.

Life passes like this; time does not return; but I am dead set on my work, simply because I know that the opportunity to do it will not return — especially in my case, where a more violent attack may destroy forever my power to paint.

Yesterday I asked Monsieur Peyron to his face: 'Since you are going to Paris, what would you say if I suggested your taking me with you?' He replied evasively — it was too sudden. But he is very kind and very indulgent to me, and while not the absolute master here — far from it — I owe many liberties to him.

If old Pissarro would like to take me to live with him ——

After all you must not only make pictures, you must also see people, and from time to time through the company of others recover your balance and store yourself with ideas. I put aside the hope that my attacks will not come back. On the contrary, we must assume that from time to time I shall have one; but at such times it would be possible to go to a nursing home or even into the town prison, where there is generally a cell.

The treatment of patients in this hospital is certainly simple; one could follow it even while travelling, for the authorities do absolutely *nothing;* they leave us to vegetate in idleness and feed us with stale and slightly spoiled food. I will tell you now that from the first day I refused to take this food. Until my attack I ate only bread and a little soup, and as long as I remain here I shall continue thus. It is true that after this attack Monsieur Peyron gave me some wine and meat, which I accepted willingly, but he didn't want to make an exception to the rule for long, and he is right to consider the regular rule of the establishment.

But I don't see any advantage for myself in enormous physical strength; if I were to get absorbed in the thought of doing good work and wishing to be an artist, and nothing but that, it would be more logical.

The idleness in which these poor unfortunates vegetate is a pest, but it is a general evil in the towns and countryside in this warmer climate; having learnt a different way of things, it is certainly my duty to resist it.

I know well that healing comes — if one is brave — from within.

through profound resignation to suffering and death, through the
surrender of your own will and of your self-love. But that is of
no use to me; I love to paint, to see people and things and every-
thing that makes our life — artificial, if you like. Yes, real life
would be a different thing, but I do not belong to that category of
souls who are ready to live and also at any moment ready to suffer.
I am everything but courageous in sorrow, and everything but
patient when I am not feeling well, though I have rather a good
deal of patience in keeping to my work.

Grief must not gather in our hearts like water in a swamp.

I have a great desire to do the 'Reaper' once again for Mother,
for I am persuaded that she would understand it — for it is in fact
as simple as one of those coarse engravings on wood that you find
in country almanacks. If not, I shall do her another picture for
her birthday. I think it is a good idea to set about some pictures
of Holland for Mother and our sister. And there is still another
person for whom I shall do one too. I will work with as much
pleasure as I do for the Vingtistes, and with more calm. It does
one good to work for people who do not know what a picture is.
I am taking the best there are of the twelve subjects, so that the
things they are to get will be really studied and deliberate.

What a queer thing *touch* is, the stroke of the brush! In the open
air, exposed to wind, to sun, to the curiosity of people, you work
as you can, you fill your canvas anyhow, you catch the real and
essential — that is the most difficult. But when after a time you
again take up this study and arrange your brush strokes, it is more
harmonious and pleasant to look at, and you add whatever you
have of serenity and cheerfulness.

I have finished the portrait of the warder. This makes a curious
contrast with the portrait I have made of myself, in which the
look is vague and veiled. He has something military in his small
quick black eyes.

I have made him a present of it, and I shall do his wife too if she
likes to sit. She is a faded woman, an unhappy, resigned creature
of small account, so insignificant that I have a great wish to paint
that blade of dusty grass. I have talked to her sometimes when I

was doing some olive trees behind their little house, and she has told me that she did not believe that I was ill — and indeed you would say it yourself now if you could see me working, my brain so clear and my fingers so sure that I have drawn that 'Pietà' of Delacroix without taking a single measurement.

Ah, I shall never be able to convey my impressions of some faces that I have seen here. Certainly this is the road on which there is something new, the road to the South, but men of the North had difficulty in penetrating into it. I can see myself in the future, when I shall have had some success, regretting my wretchedness here, when I saw from between the iron bars of the cell the reaper in the field below. Misfortune is good for something.

To succeed, to have lasting prosperity, you must have a temperament different from mine, I shall never do what I might have done and ought to have wished and pursued. And since I have this dizziness so often, I cannot live except in the fourth or fifth rank of artists. When I realize the worth and originality and the superiority of Delacroix and Millet, I am bold enough to say, Yes, I am something, I can do something. But I must have a foundation in those artists, and apply the little which I am capable of in the same direction.

I still think that Gauguin and I may work together again. I know that Gauguin is capable of better things than he has done, but to make that man comfortable! I am still hoping to do his portrait. Have you seen the portrait that he did of me painting some sunflowers? My face has got much brighter since then, but it was really I, very tired and overstimulated, as I was at that time.

To see the country you must live with the poor people, and in the little houses, and public-houses. That is what I said to Bock, who was complaining of seeing nothing that tempted or impressed him. I went for walks with him for two days, and showed him how to make thirty pictures as different from the North as Morocco would be.

Do you know why the pictures of Eugène Delacroix have such a hold on one? Because when he did a 'Gethsemane' he had first been to see on the spot what an olive grove was, and the same for

the sea whipped by a strong mistral; and because he must have said to himself: These people of whom history tells us, doges of Venice, crusaders, holy women, were of the same character and lived in a manner analogous to that of their present descendants. You will see this in the 'Woman Rocking,' however much a failure, and however feeble that attempt may be. Had I had the strength to continue I should have made portraits of saints and holy women from life which would have seemed to belong to another age. They would have been middle-class women of the present day, yet they would have had something in common with the first early Christians.

However, the emotions which this rouses are too strong, and I shall stop here. But later on, later on I do not say that I shall not return to the charge.

You are right a thousand times over: I must paint — were it only studies of cabbages and salad to get calm, and after getting calm, then whatever I am capable of. When I see them again I shall make duplicates of that study of the 'Tarascon Diligence,' of the 'Vineyard,' the 'Harvest,' and especially of the 'Red Cabaret,' that night café which is the most characteristic of all in its colour. But the white figure right in the middle must be done again as to colour, and better built. That, I venture to say, is the real Midi, and a designed combination of greens and reds.

My strength has been exhausted too quickly, but I see in the future the possibility of others doing an infinite number of fine things. Again and again this truth comes home to one: that to make the journey easier for others it would have been well to found a studio somewhere in this neighbourhood.

I have now seven copies out of the ten of Millet's 'Work in the Fields,' and you will be surprised to see the effect it takes on in colour. I am going to copy the 'Good Samaritan' by Delacroix too. It interests me enormously to make copies, and in spite of having no models for the moment, I shall not lose sight of the figure. Although copying may be the *old* system, that makes absolutely no difference to me. What I am seeking, and why it seems good to me to make copies, I shall try to tell you:

We painters are always asked to compose of ourselves, and not to be compositors only. So be it. But in music it is not like that, and if some person or other plays Beethoven he adds his personal interpretation; in music, and more especially in singing, the interpretation of the performer is something, and it is not a hard and fast rule that only the composer shall play his own composition. I pose the black and white of Delacroix or Millet before me as a subject and improvise colour on it, not, you understand, altogether as myself, but searching for memories of *their* pictures — the memory, 'the vague consonance of colours which are at least right in feeling'; that is my own interpretation.

Heaps of people do not copy; heaps of others copy. I started it by chance, and I find it teaches me things; above all, it sometimes gives me consolation. My brush goes between my fingers as a bow would on the violin, and absolutely for my pleasure. Today I tried the 'Woman Shearing Sheep' in a gamut ranging from lilac to yellow.

In this bad weather I am going to make a lot of copies, for really I must do more figures. Yes, misfortune is good for something; you gain time for study.

Tomorrow I am sending you some canvases. I rather like the 'Entrance to a Quarry.' I was working at this when I felt the attack beginning. The sombre greens go well to my mind with the ochre tones; there is something sad, which is health, and that is why it does not bore me. That is true perhaps of the 'Mountain' too; they will tell me that mountains are not like that, and that there are black outlines of a finger's width.

The 'Olives,' with white cloud and background of mountains, as well as the 'Moonrise' and the night effect, are exaggerations from the point of view of arrangement; their lines are distorted as in ancient woods. The olives are more in character, as in the other study, and I tried to express the time of day when you see the green cetonias, and the cicadas flying about in the heat. I am adding to another roll of canvases a study of flowers — nothing much, but after all I do not want to tear it up.

Altogether I think nothing *at all* good except the 'Field of Corn,'

the 'Mountain,' the 'Orchard,' the 'Olives' with the blue hills, and the portrait, and the 'Entrance to a Quarry'; the rest tell me nothing, because they lack individual intention and feeling in the lines.

Where these lines are close and deliberate it begins to be a picture, even if it is exaggerated. That is what Gauguin and Bernard feel; they do not ask at all the correct shape of a tree, but they do insist that one should say whether the shape is round or square — and honestly, they are right; they are exasperated by the photographic and empty perfection of certain people. They will not ask the correct tone of the mountains, but they will say: By God, the mountains were blue, were they? Then chuck on some blue, and do not tell me that it was a blue rather like this or that, but it was blue, wasn't it? Good — make the mountains blue, and it's enough!

Gauguin is sometimes like a genius when he is explaining this, but the *genius* Gauguin has he is very fearful of showing, and it is touching how he likes to say a thing that will really be of some use to the young ones. What a queer creature he is!

When you say that I am a devil for work, no, I cannot agree. I am myself very, very dissatisfied with my work, and the only thing that consoles me is that people of experience say you must paint ten years for nothing. Now a better period may come.

Do you know what I think of pretty often? That if I do not succeed, all the same what I have worked at will be carried on; not directly, but one isn't alone in believing in things that are true. And what does it matter personally then? I feel so strongly that it is with people as it is with corn; if you are not sown in the earth to spring there, what does it matter? You are ground between the millstones to become bread. The difference between happiness and unhappiness! Both are necessary and useful; and death or disappearance, they are so relative — and life the same. Even face to face with an illness that breaks me up and frightens me, that belief is unshaken.

I am sending you soon some smaller canvases with the four or five studies that I want to give to Mother and our sister. These

studies are drying now; they are small copies of the 'Cornfield' and the 'Cypresses,' 'Olives,' the 'Reaper,' and the 'Bedroom,' and a little portrait of me. That will give them a good start, and I think it will please you as it does me to arrange for our sister's having a little collection of my pictures.

As for the 'Reaper,' I thought at first that it was bad. But no, when the weather is cold and sad it is precisely that that brings back to my memory the furnace of summer over the white-hot corn; so it is not so much exaggerated after all. I am also doing some small copies of better canvases for Mother and Sister; I should like them to have as well the red and green 'Vineyards,' the pink 'Chestnut Trees,' and the night effect you exhibited. I fear these things will disappoint them, and one thing or another may seem unimportant and ugly. But Mother and Wil can do what they like with the paintings; in case they feel like giving some to the other sisters, I am sending a few more. Is it necessary to have them framed? Because they are not worth it.

From the portrait of myself which I add, Mother will see that though I saw Paris and other large cities for many years, I still look more or less like a peasant of Zundert, Toon for instance, or Piet Prins. Sometimes I imagine that I also feel and think like them; but the peasants are of more use in the world; only if one has time to rest does one get a feeling for pictures and books. I consider myself decidedly below the peasants.

Well, I am ploughing on my canvases as they on their fields. What makes us keep working is love for Nature, and if one has taken all the pains to master the brush, *one cannot keep from painting.*

You will see that I am gaining a little in patience, and that perseverance will be one result of my illness. I now feel quite normal, and do not remember the bad days at all. With the work, and regular food, this will probably last a pretty long time, and anyhow I shall go on working as I am unless an attack comes. By the end of the month you will receive another dozen studies.

There are lovely autumn effects to do; the olive trees are very characteristic, and I am struggling to catch them. They are old

silver, sometimes nearer blue, sometimes greenish, bronzed, whitening over a soil which is yellow, rose, violet-tinted or orange, to dull red ochre. Very difficult, very difficult. But that suits me and draws me on to work right into gold or silver. Perhaps one day I shall do a personal impression of them like what the sunflowers were for the yellow. If I had had some of them last autumn! But this half-liberty often prevents me from doing what I nevertheless feel I could.

Patience, you will tell me. And I must have it.

We are having some superb autumn days, and I am taking advantage of them. I have a mulberry tree yellow all over on stony ground, outlined against the blue of the sky; in this study I hope you will see that I am on the track of Monticelli.

It surprises me very much that Monsieur Isaacson wants to write an article on my studies. There isn't anything about my work now worth mentioning. When I am back, at the worst it will form a sort of whole, 'Impressions of Provence.' But what could he say now, when I have still to get the accent of the olives, the fig trees, the vines, the cypresses, all the other typical things, such as the Alps, which must be given more character?

I should be glad to persuade him to wait; his article will lose absolutely nothing by it, and with yet another year of work I can, I hope, put before him some more individual things, with more definite drawing, and more knowledge of motive with regard to the Provençal South.

Now that I am staying on here provisionally, and as far as we can see shall stay the winter, till spring, shan't I stay here too till the summer? That will depend mostly on my health.

I have a study of two yellowing poplars against a background of mountains, and a view of the park here, an autumn effect where the drawing is a little more naïf and more — at home. Altogether it is difficult to leave a country before you have done something to prove that you have felt and loved it. For you must feel the whole of a country. Isn't it that which distinguishes a Cézanne from anything else?

What you say of Auvers is a very pleasant prospect, and sooner

or later — without looking further — we must fix on that. If I come North, even supposing that there were no room at this Doctor Gachet's house, it is probable that after your recommendation and old Pissarro's he would find me either board with a family or quite simply at an inn. The chief thing is to know the doctor, so that in case of an attack you do not fall into the hands of the police and get carried off by force to an asylum.

I assure you that the North will interest me like a new country.

If I return, I propose to make heaps of Greek studies — you know, studies painted with white and blue and a little orange only, as if in the open air. I must draw, and try for style. In spite of what you said, that the search for it often harms other qualities, I feel much inclined to seek — for style, if you like, but I mean by that a more masculine and deliberate drawing. If that makes me more like Bernard or Gauguin, I can't help it. And Guillaumin, he has so much style and individuality in drawing.

I have not dared to ask leave to go to Arles lately, which I very much want to do; not that I suspect that Monsieur Peyron saw any connection between my previous journey and the attack that closely followed it. There are some people there that I feel the need of seeing. While not having, like the good Prévot, a mistress in the Midi who holds me captive, I involuntarily get attached to people and things.

I have just brought back a canvas on which I have been working for some time representing the same field as in the 'Reaper.' Now it is clods of earth and the background of parched land, then the cliffs of the Alps. In the foreground a thistle and some dry grass; a peasant dragging a truss of straw in the middle. It is a harsh study, and instead of being almost entirely yellow, it makes a canvas almost entirely violet. But I think this will complete the 'Reaper' and will make clearer what the latter is. For the 'Reaper' looks as though it were done at random, and this will give it balance.

I have also two views of the park and the asylum, where this place looked very pleasing. I tried to construct the thing as it might have been, simplifying and accentuating the haughty, un-

changing character of the pines and cedar clumps against the blue. Besides this I have a rain effect in hand, and an evening effect with some big pines. You will see that there is more character to the pines than in the previous ones.

But I am indifferent to that. What I am not indifferent to is that a man who is very much my superior, Meunier, has painted the 'Scloneuses' of the Borinage, and the shift going to the pits, and the factories, their red roofs and their black chimneys against a delicate grey sky — all things that I have dreamed of doing, feeling that it had not been done and that it ought to be painted. And there is still an infinity of subjects there for artists; one ought to go down into the mine and paint the effects of light.

Gauguin has written me a very nice letter, and talks with animation about de Haan and their rough life at the seaside. But I can see clearly that he is not altogether at the top of his form. And I know quite well what that is due to: they are too hard up to get models, and living as cheaply as they thought to at first cannot have lasted. That is the terrible thing about the impressionists: the development of the thing hangs fire, and they remain for years held back by obstacles over which the previous generation triumphed.

Lately I have seen the women picking and gathering the olives, but as I had no way of getting a model, I have done nothing at it.

I am not an admirer of Gauguin's 'Christ in the Garden of Olives,' of which he sends me the sketch. As for Bernard's, he has probably never seen an olive tree. He fails to get the least idea of the potentiality or the reality of things. No, I do not take any stock in their biblical interpretations. If I stay here I shall not try to paint 'Christ in the Garden of Olives,' but the glowing of the olives as you still see it, giving nevertheless the just proportion of the human figure, that would make people think, perhaps. Rembrandt and Delacroix have done this admirably, even better than the primitives.

Now I must tell you that I have been to Arles and that I have seen M. Salles. M. Peyron said to me that there was a considerable improvement and that he had good hope of me — and that

he saw no harm in my going to Arles just then. I stayed two days there; it is a good thing to show yourself there from time to time. At present no one has any feeling against me, as far as I can see; on the contrary they were very friendly, and even welcomed me. And if I stayed in the country I should have a chance to acclimatize myself little by little, which is hardly easy for strangers, and would have its use in painting here. But we will wait a little first to see if this journey will provoke another attack. I almost dare to hope it won't.

I think M. Peyron is right when he says that I am not, strictly speaking, mad; for my mind is absolutely normal in between times, even more so than formerly. Fortunately these abominable nightmares have stopped tormenting me. But in the attacks it is terrible, and I lose consciousness of everything. But that spurs me on to work, and in earnest, as a miner who is always in danger makes haste in what he does. Yet very often terrible fits of depression come over me, and besides, the more my health comes back to normal and the more my brain can reason in cold blood, the more foolish it seems to me to be doing this painting, which costs us so much and brings in nothing, not even the net cost. Then I feel very unhappy; and the trouble is that at my age it is damnably difficult to begin anything else.

But what's to be done? If my health remains stable, and if while I work I again start trying to sell, to exhibit, to make exchanges, on the one hand I may make some progress in being less of a burden to you, and on the other I may recover a little more zest. For I will not conceal from you that my stay here is very wearisome because of its monotony, and because the company of all these unfortunates, who do absolutely nothing, is enervating. In the evening I am bored to death. Good Lord, the prospect of the winter isn't very cheery.

If I had known in time that there were trains from here to Paris for only twenty-five francs, I should certainly have come. It is because of the expense that I have not done it. I think that in the spring it would be good to come in any case and get another look at people and things in the North. For this life here is terribly

stupefying, and in the long run I shall lose my energy. I had hardly dared to hope that I should be so well again as I am. However, everything depends on whether this suits you or not, and I think it is wise not to be in a hurry. Perhaps if we wait a little we shall not even need the doctor at Auvers nor the Pissarros. But we must not make any assumptions in my case; I still make too many as it is. Anyhow, I will do as best I can. I am going to make a long trip among the mountains to look for points of view. Now that most of the leaves have fallen the countryside is more like the North, and it is often cold here; however, we are a little more sheltered by the mountains from the mistral.

I have to thank you very much for a parcel of paints, which was accompanied also by an excellent woollen waistcoat. How kind you are to me, and how I wish I could do something good, so as to prove to you that I should like to be less ungrateful! As for winter clothes, I haven't anything much, but they are warm enough, and we can wait till spring for that. If I go out it is to work, so I put on what is most worn, and I have a velvet jacket and trousers for wearing here.

I have worked on a study of the mad ward at the Arles Hospital, but having had no more canvas these last days, I have been taking long walks in all directions across the country. Ah, now certainly you are yourself deep in nature, since you say that Jo already feels her child quicken. It is much more interesting even than landscape, and I am very glad that things should have so changed for you.

How beautiful that Millet is, 'The First Steps of a Child'!

In some Dutch newspapers which you put in with the Millets I notice some Paris letters which I attribute to Isaacson. No need to tell you that I think what he says of me in a note extremely exaggerated, and it's another reason why I should prefer him to say nothing about me.

I have worked this month in the olive groves because Bernard and Gauguin have maddened me with their 'Christs in the Garden,' with nothing really observed. Of course with me there is no question of doing anything from the Bible — and I have written to Bernard and Gauguin too that I considered that to think, not to

dream, was our duty, so that I was astonished to see from their work how they had let themselves go. It is not that it leaves me cold, but it gives me a painful feeling of collapse instead of progress.

Well, morning and evening these bright cold days, but with a very fine and clear sun, I have been knocking about in the orchards, and the result is five canvases of 30. With the three studies that you have, they make at least an attack on the problem. The olive is as changing as our willow or pollarded tree in the North. And what the willow is at home, that is just the significance of the olive and the cypress here.

What I have done is a rather hard and coarse reality beside Bernard's and Gauguin's abstractions, but it will give the sense of the country and will smell of the soil. The thing is that they have rarely been painted, the olive and the cypress, and from the point of view of placing the pictures, my painting *ought* to go in England; I know well enough what they look for there.

However that may be, I am almost sure that in this way I'll do something tolerable from time to time. It is more and more as I said to Isaacson: If you work diligently from nature without saying to yourself beforehand, 'I want to do this or that,' if you work as though you were making a pair of shoes, without artistic pre-occupation, you will not always do well, but the days you least expect it you will find a subject which holds its own with the work of those who have gone before us. You will learn to know a country which at bottom is quite different from what it appears on first sight.

It is the experience and the poor work of *every day* which alone will ripen in the long run, and allow one to do something completer and truer. We *must* work as much and with as few pretensions as a peasant, if we want to last.

As for the exhibition in Brussels, it does not leave me indifferent, because I shall have a few pictures in it from here, which, though made in a quite different region, remain just as if they were painted, say, in Zundert; and I think they could also be understood by people who have no knowledge of painting, as it is called.

I hope to get used to working in the cold — in the morning there

are very interesting effects of white frost and fog; and I have a great desire to do for the mountains what I have just done for the olives. I have a sterner study than the previous one of the mountains — a very wild ravine where a small stream winds its way along its bed of rocks. It is all violet. Yes, I could certainly do a whole series of these Alps, for having seen them for a long time, I am more up to it.

What you tell me about a publication of coloured lithographs with text on Monticelli is very interesting, and gave me very great pleasure. I hope that they will reproduce in colour the bouquet of flowers you have.

I should much like some day to do a plate or two in this style myself from my canvases. I am working at a picture this moment, women gathering olives, which would lend itself to that, I think. The whole is in a very discreet gamut of colour. It is a canvas worked at from memory after the study of the same size done on the spot, because I want something far away, like a vague memory softened by time.

I still have in my heart a desire to paint a bookshop with the frontage yellow and rose, at evening, and the black passers-by — it is such an essentially modern subject. Because it seems to the imagination such a focus of light — I say, there is a subject that would go well between an olive grove and a cornfield, the seed time of books and prints. Yes, there is a way of seeing Paris as beautiful.

In spite of the cold I have gone on working outside till now, and I think it is doing me good, and the work too. There is a mistral, but towards sunset it generally grows a little calmer; then there are superb sky effects of pale lemon, and the mournful pines with their silhouettes stand out in relief against it with effects of exquisite black lace.

Yesterday I sent off three parcels by post. Other studies, canvases of thirty, were not yet dry, and will follow later; these are mostly studies of autumn and are giving me a lot of trouble. Sometimes I think they are ugly, sometimes they seem good to me. There are a dozen of them. The last study I did is a view of the village where men were at work — under some enormous plane

trees — repairing the pavements. So there are heaps of sand, stones, and the gigantic trunks — the leaves yellowing, and here and there a glimpse of a house front and some small figures.

It is a year since I fell ill. But last year towards this time I certainly did not think that I should have got over it as much as this. In the beginning when I became ill I could not resign myself to the idea of having to go into a hospital. Now I agree that I should have been treated even earlier; but to err is human.

You tell me not to worry *too* much, and that better days will yet come for me. I should tell you that these better days will begin when I can glimpse the possibility of in some fashion completing my work, so that you will have a series of really sympathetic Provençal studies. If I could one day prove that I have not impoverished the family, that would comfort me.

Often I have much self-reproach about things in the past, my illness coming more or less through my own fault. In any case I doubt if I can make up for faults in any way. But reasoning and thinking about these things is sometimes so difficult, and more than ever my feelings overwhelm me. I think too of the past.

Mother and Father have been even more to me, if possible, than to the others, so much, so very much, and I seem not to have had a happy character. I discovered that in Paris. How much more than I you have done your best to help Father practically, so that your own interests were often neglected. Well, you had more self-sacrifice than I, and that is deeply rooted in your character. And after Father was no more and I came to you in Paris, you got so attached to me that I understood how much you had loved Father. And now I say to you, it is good that I did not stay in Paris, for we should become too interested in each other. Life does not exist for this. I cannot but tell you how much better I think it is for you this way than before.

[At this point Vincent suffered another attack.]

I wish you and Jo a Happy New Year, and regret that I have perhaps, though very unwillingly, caused you worry; for Monsieur Peyron must have written to you that my mind has once more

been deranged. But since this attack was over in a week, what is the use of thinking that it may come back again? First of all, you do not know, nor can you foresee, how or under what form. Above all I must not waste time. I am going to set to work again as soon as Monsieur Peyron permits it; if he does not permit it, then I have done with this place. It is the work that keeps me comparatively well-balanced.

Yesterday I was agreeably surprised by a visit from Monsieur Salles, but I am quite upset that he put himself out for me, the more so because I hope that for a time I have recovered my presence of mind. I was quite well when he came, so we were able to talk calmly.

It is to be feared that the attacks will return, and that Monsieur Peyron will dare less than ever to commit himself as to the possibility of my living as I used to. But what would be infinitely worse would be to let myself get into the condition of my companions in misfortune who do nothing all day, every week, month, year. I have said this to Monsieur Salles also, urging him strongly never to recommend this asylum; for the crowding of these lunatics into this old cloister is a dangerous thing, since one risks losing the sanity that one may still have kept.

Odd that I had been working perfectly calmly at some canvases that you will soon see, and that suddenly, without any reason, my wandering seized me again. I have never worked with more calm than in my last canvases.

For the moment I am overcome by a great discouragement. I can foresee absolutely nothing; I see no way out. I also see that my stay here cannot go on indefinitely. But it is perfectly true that last year when the attacks returned at various times, it was precisely by working that my normal condition returned bit by bit; and it will probably be the same this time too. I shall soon have an opportunity of going out when the weather is not cold, and I rather set my heart on trying to finish the work I have begun here. Just now I have pictures ripe in my brain, and I see in advance the places that I still want to do. Why should I change the means of expression? Let us go on working as much as possible as if nothing had happened.

While I was ill there was a fall of damp and melting snow. I got up at night to look at the country. Never, never had nature seemed to me so touching and so full of feeling.

Today I sent off some canvases. The 'Ravine' is the study done on a day of mistral — I had stacked up my easel with big stones. The picture is not dry; it has a closer drawing and there is more controlled passion and more colour. And there is the 'Ploughed Field,' the 'Women Gathering Olives,' the 'Fields,' 'Olive Trees,' copies after Millet: the 'Diggers,' 'La Veillée.' Then there is the chief street or boulevard of Saint-Rémy, a study from nature; and I am forgetting 'Rain.' Please do not look at them without putting them on stretchers and framing them in white.

Once away from here — suppose — we must really see whether something cannot be done with my canvases. I should have a certain number of mine, a certain number of others, and perhaps try to do a bit in business.

Monsieur Peyron came while I was ill to tell me that he had heard from you and to ask whether or not I wanted to exhibit my pictures. I told him that I should rather not exhibit them. There was no justification for that, so I hope that they went all the same, since you say that it starts on the third of January.

Yesterday I sent two canvases to Marseilles; I made a present of them to my friend Roulin: a white house among the olives, and a cornfield with a background of lilac mountains. To Monsieur Salles I gave a little canvas with some pink and red geraniums against a perfectly black background, as I did before in Paris.

Just now I have done a little portrait of one of the servants here which he wants to send to his mother. That means that I have already begun to work again, and if Monsieur Peyron had seen any objection he would probably not have let me do so. What he said to me was: 'Let us hope that there will be no renewal of attacks' — exactly the same thing as ever. He talked to me very kindly, and said that he left me quite at liberty to distract myself, and that I must fight against depression as much as I can, which I do gladly. As for him, these things hardly surprise him, and since there is no quick remedy, perhaps time and circumstances alone

can have any influence. Thus, even half shut up, I shall be able to occupy myself.

I should like very much to go to Arles again, not immediately but towards the end of February, first of all to see my friends again, which always revives me, and then to see whether I can risk the journey to Paris. When I go there I shall have to pay three months' rent for the room where my furniture is. This furniture, I think, will be useful, if not to me then to another painter who wants to establish himself in the country. Would it not be wiser to send it to Gauguin, who will probably spend some more time in Brittany, than to you, who will not have any place to put it? By giving up three heavy old chests of drawers to someone I could get out of paying the rest of the rent and perhaps the expenses of packing. They cost me about thirty francs.

I shall write a line to Gauguin and de Haan to ask if they intend to stay in Brittany, if they would like me to send the furniture, and if they wish me to go there too.

Gauguin proposed, very vaguely, it is true, to found a studio in his name — he, de Haan and I; but now he is insisting on going through with his Tonkin project, and seems to have cooled off greatly, I do not exactly know why, about continuing to paint. And he is just the sort to be off to Tonkin in earnest; he has a sort of need of expansion, and he finds — and there's some truth in it — the artistic mean of life. He writes with much reserve, more gravely than last year, and if you saw the letter you would be touched to see how rightly he thinks; for a man so powerful to be almost helpless is unfortunate. And Pissarro, too, and Guillaumin the same. What a business, what a business!

I have just written another line to Russell to remind him of Gauguin, for I know that Russell as a man has much gravity and strength. He and Gauguin are countrymen at heart; not uncouth, but with a certain innate sweetness of far-off fields, more so probably than you or me; that is how they look to me.

I hope Gauguin will feel that you and I are indeed his friends without counting on us too much.

I am pleased at what you say of the copy after Millet, 'La

Veillée.' The more I think it over the more I think that there is justification for trying to reproduce some of Millet's things which he himself had no time to paint in oil. In working thus either on his drawings or on his wood engravings, it is not copying pure and simple that you do. It is rather translating — in another language, that of colour — the impression of light and shade in black and white. What the impressionists have found in colour will develop still more, but there is a tie that many forget which binds them to the past, and I shall strive to show that I have little belief in a rigorous separation between impressionists and others.

This will be another lesson to me to work straightforwardly and without too many hidden meanings which disturb one's consciousness. A picture, a book, must not be despised, and if it is my duty to do this, I must not hanker after something different. Only we mustn't forget that an old crock is an old crock, so that I have in no case the right to any pretensions.

[Doctor Peyron writes on January 29 that Vincent has again had a crisis after a trip to Arles. J. v. G.]

I am feeling better, but have had again a few days like the others when I did not know exactly how things were, and was upset.

Today I received your good news that you are at last a father, that the most critical time is over for Jo, and that the little boy is well. This has done me more good and given me more pleasure than I can put into words. Bravo — and how pleased Mother is going to be! As for the little boy, why don't you call him Theo in memory of our Father? To me certainly it would give so much pleasure.

I started right away to make a picture for you to hang in your bedroom — big branches of white almond-blossom against a blue sky.

I was extremely surprised at the article on my pictures by Albert Aurier in the 'Mercure de France.' I needn't tell you that I do not paint like that; but I do see from this article how I ought to paint. For the latter is very correct in that it indicates the gap

to be filled; I think that the writer wrote it to guide not only me but the other impressionists as well. So he proposes an ideal collective self to the others quite as much as to me; he simply tells me that here and there there is something good in my work which is at the same time very imperfect; this is the consoling side of his criticism, which I appreciate, and for which I hope to show I am grateful. But it must be understood that my back is not broad enough to accomplish such an undertaking; I think they ought to say things like that of Gauguin, and of me only secondarily. In concentrating his article on me there's no need to tell you how flattered Aurier makes me feel; in my opinion it is as exaggerated as what a certain article by Isaacson said about you, that at present the artists had given up squabbling and that an important movement was silently taking place in the little shop on the Boulevard Montmartre.

So if some sort of reputation comes to you and to me, the thing is to try to keep some sort of calm and if possible presence of mind; from the beginning you must beware of getting your young family too much into an artistic setting.

I am grateful for the article, or rather '*le coeur à l'aise*,' as the song in the *Revue* has it, since one may need it, as one may need a medal. Besides, an article like that has its own merit as a critical work of art. Would it not be well to send Reid, and perhaps Tersteeg too, or rather C. M., a copy of it? It does us real service against the day when we shall be obliged, like everybody else, to try to recover what the pictures cost. If you see Monsieur Aurier thank him very much for his article; I will send you a line for him, of course, and a study.

I hope that Monsieur Lauzet, who does the lithographs after Monticelli, will come; I have a great wish to make his acquaintance. When he speaks of Provence he touches on the difficulty, and indicates rather a thing to be done than a thing already done. Landscapes with cypresses! Ah, it would not be easy. Aurier feels it too when he says that even black is a colour; as for their appearance of flame, I think about it but don't dare to go further, and I say with the cautious Isaacson, I do not feel that we have yet got to

that. When I had done these sunflowers I looked for the opposite and yet the equivalent, and I said: It is the cypress. I will say no more.

Anyway, the good news you have sent me, and this article and heaps of other things, have made me feel quite well today. If I stayed some time with you it would do much to counteract the influence which the company I am in here necessarily exercises. But we must consider coolly whether this is the moment to spend money on the journey; perhaps by giving up the journey we could do something for Gauguin or Lauzet.

So Gauguin has returned to Paris. He wrote me that he had exhibited in Denmark and that this exhibition had been a great success. It seems a pity that he did not stay on here a bit longer; together we should have worked better than myself all alone this year. I should think that if Gauguin liked we could work together again here if his present attempts to find a place do not succeed.

These last days we have had rather bad weather, but today was a real day of spring; the fields of young corn, with the violet hills in the distance, are so beautiful, and the almond-trees are beginning to bloom everywhere.

I feel at times very much cheered up by it. Moreover, you write me today that you have sold one of my pictures at Brussels for four hundred francs. Compared with other prices, also the Dutch ones, this is little, but I shall try to be productive, so as to be able to go on working at a reasonable cost. Did you notice in the paper you sent me an article about the productiveness of certain artists — Corot, Rousseau, Dupré? Do you remember how many times we talked about the same thing — the necessity of producing a lot — and that shortly after I came to Paris I said that until I had two hundred canvases I should be able to do nothing?

I have strongly in mind to take advantage of the good luck of selling this picture by going to Paris to visit you. And thanks to the physician here, I am going feeling calmer and healthier than when I came.

[On February 24 Vincent again had an attack after spending two days in Arles. He had been brought back in a carriage to Saint-Rémy,

and it was not known where he had spent the night. The picture representing an Arlésienne which he had taken along with him to Arles was never found. On the first of April Doctor Peyron wrote that the attack was lasting longer this time, and that it finally proved that these trips were bad for him. J. v. G.]

I take this up again to try to write; it will come bit by bit. The trouble is that my head is so bad — without pain, it is true, but altogether stupefied.

My work was going well, the last canvas of branches in blossom — you will see, it was perhaps the best, the most patiently worked thing I had done, painted with calm and with a certainty of touch. And the next day, down like a brute. Difficult to understand things like that, but, alas, it is like that.

I myself do not know what to do, what to think, but I have a great wish to leave this house. I do not want to go into details, but please remember that I warned you almost six months ago that if I had another attack of the same nature I should wish to change my asylum. And I have already delayed too long, having let an attack go by meanwhile. I was then in the midst of work and wanted to finish some canvases in hand; but for that I should not be here now. But where to go?

There are, as far as I can judge, others who have the same thing wrong with them that I have, and who after having worked during part of their life are reduced to helplessness. Between four walls it isn't easy to learn much; that is natural, but it is true that there are people who can be no longer left at liberty as though they had nothing wrong with them. I am almost in despair about myself. Perhaps, perhaps I might really recover if I were in the country for a time.

If I return to Holland, aren't there institutions where one works, and where it is not dear, and which we have a right to take advantage of? I think that at home in Holland they always more or less value painting, so that in an institution they would hardly make any difficulty in letting me do it. The rather superstitious ideas they have here sometimes depress me more than I can tell you, because it is at bottom fairly true that a painter as man is

too much absorbed by what his eyes see, and is not sufficiently
master of the rest of his life.

Yesterday I wanted to read the letters that have come for me,
but I was not clear-headed enough to be able to understand them.
Russell wrote to me, and letters from home have come too which
I have not yet had courage to read, I feel so melancholy. Our
sister writes extremely well, and describes a landscape or a view of
the town as it might have been in a page of a modern novel. I
always urge her to occupy herself rather with household matters
than with artistic things, for I know that she is too sensitive, and
at her age she would find it difficult to develop herself artistically.
I am very much afraid that she suffers from a thwarted artistic
desire, but she is so full of vitality that she will get over it.

While I was ill I did some little canvases from memory, mem-
ories of the North; I have just finished a corner of a sunny meadow
which I think is fairly vigorous, and I am thinking of doing again
the picture of the 'Peasants at Dinner,' with the lamplight effect.
That canvas must be quite black now; perhaps I could do it again
altogether from memory; and the 'Women Gleaning,' and the
'Diggers'; then, if you like, the old tower of Neunen and the
cottage.

I fell ill at the time that I was doing the almond-blossom. As
you will understand, if I had been able to go on working I should
have done other paintings of trees in bloom. Now the trees in
bloom are almost over; really, I have no luck.

Please ask Monsieur Aurier not to write any more articles on my
painting. Insist upon this: that to begin with he is mistaken about
me, since I am too overwhelmed with trouble to face publicity. To
make pictures distracts me, but if I hear them spoken of it gives
me more pain than he knows.

Now you propose and I accept a return to the North. I am
almost certain that there I shall get well quickly, even while still
apprehensive of a relapse in some years' time — but not at once.
As soon as I got out into the park, I got back all my lucidity for
work; I have more ideas in my head than I could ever carry out,
but without its clouding my mind. The brush strokes come

mechanically. So relying on that, I dare to think that I shall find my balance when once delivered from surroundings and circumstances which I do not understand, or wish to understand. I have led too hard a life to die of it or to lose the power of working.

I will leave my furniture temporarily as it is in Arles. It is with friends, and I am sure that when you want it they will send it, but the carriage and packing would be almost as much as it is worth. I think of it as a shipwreck — this journey. Well, we cannot do what we like, nor what we ought, either.

I think a fortnight at the most should be enough to take the necessary steps to move. I will have myself accompanied as far as Tarascon — or even one or two stations further, if you insist; once arrived in Paris, you would come and fetch me at the Gare de Lyon. I reject categorically what you say about its being necessary to have me accompanied. Once in the train I run no more risk; I am not one of those who are dangerous. Even supposing an attack comes on, are there not other passengers in the coach, and don't they know in every station what to do in such a case? You make yourself so uneasy about this, and it weighs on me so that it discourages me. I dare to believe that my balance will not fail me. I am so distressed to leave like this that my distress will be stronger than my madness, so I shall have, I do think, the necessary balance. As I have just pointed out to Monsieur Peyron, the attacks such as I have just had have always been followed by three or four months of complete quiet. So I want to take the opportunity of this period to move. I want to move in any case; my need to leave here is imperative.

If I left now I should have the necessary leisure to make the acquaintance of the other doctor. Then if some time from now the malady should return, we should have provided against it, and according to its seriousness we should consider whether I could continue at liberty or must shut myself into an asylum for good. In the latter case I should go into a home where the patients work in the fields and the workshop. I think that there I should find subjects for painting.

This I think you should do, without delay: write to our future

friend, the doctor in question: 'My brother has a great desire to make your acquaintance, and prefers to consult you before prolonging his stay in Paris, so I hope you will approve of his staying some weeks in your village, where he will come to make some studies; he has every confidence that he will come to an understanding with you, believing that by a return to the North his illness will diminish, while by a more prolonged stay in the South it would threaten to become more active.'

It would be best to go and see this Doctor Gachet in the country as soon as possible. I shall undertake to prove to him that I can still work rationally and he will treat me accordingly, and since he likes painting there is really a chance that a lasting friendship will result. I should not stay with you more than say two or three days; then I should leave for the Doctor's village, where I should begin by first staying at the inn. I shall be outside there — I am sure that the longing for work will devour me and make me insensible to everything else, and cheerful. I am at the end — at the end of my patience, my dear brother. I can't stand any more — I must move, even for a last shift. My surroundings here begin to weigh on me more than I can express — my word, I have had patience for more than a year — I need air; I feel overwhelmed with boredom and depression. I assure you it is something to resign yourself to living under surveillance, even supposing it were sympathetic, and to sacrifice your liberty, keep yourself out of society. That has hollowed out wrinkles which will not soon be effaced. Now that it is beginning to weigh on me too heavily I think it is *only fair* that it should come to a stop. I have the right to change houses if I like; it is not my full liberty that I demand. And there is a chance that the change will do me good.

The paints and canvases from Tasset arrived, and I cannot be too grateful to you for them, for if I had not had my work I should long ago have been even more broken. At present things continue for the better; I continue to be well, and the whole horrible attack has disappeared as a storm does. I do not think that Monsieur Peyron will oppose a very prompt departure.

In Paris — if I feel strong enough — I wish very much to do at

once the picture of a yellow book shop which I have had for so long
in my mind. You will see that the day after my arrival I shall be
fit for it. I tell you, I feel my head absolutely calm for my work,
and the brush strokes come to me and follow each other logically.

I am looking forward so much to seeing the exhibition of Japan-
ese prints again. And I don't at all despise seeing the Salon,
where I think there must still be some interesting things, though
the account in 'Figaro' left me pretty cold.

A strange thing: just as that day we were so struck by Seurat's
canvases, these last days here are like a fresh revelation of colour
to me. As for my work, my dear brother, I feel more confidence
than when I left, and it would be ungrateful on my part to miscall
the Midi; I confide to you that it is with great grief I come away
from it.

The day of my departure depends on when I have packed and
finished my· canvases, and I am working at them with such en-
thusiasm that packing seems to me more difficult than painting.
Anyway, it will not be long.

I have done two canvases of the fresh grass in the park, one
of which is extremely simple, the grass with white flowers and
dandelions, a little rose tree. And· I have just finished another
canvas of pink roses against a yellow-green background in a green
vase; and a canvas of roses with a light green background; and
two canvases representing big bunches of violet iris flowers, one
lot against a pink background in which the effect is soft and
harmonious because of the combination of greens, pinks, violets.
In the other the violet bunch stands out against a startling lemon-
yellow background, with other yellow tones in the vase and the
stand on which it rests, so it is an effect of tremendously unlike
complementaries which heighten each other by their opposition.
These canvases will take almost a month to dry, but the attendant
here will undertake to send them off after my departure. I hope
that they will make up to us for the cost of the journey.

This morning I saw the country again after the rain — quite
fresh, and all the flowers —— Oh, if I could have worked without
this accursed malady, what things I should have done, isolated

from others, following what the country said to me! The one thing we can always claim is that you and I did make an attempt here in the same direction as some others, who were understood no better and have had their hearts broken by circumstances. Anyway, what consoles me is the great, the very great desire I have to see you again, you and your wife and child, and the many friends who remembered me in misfortune, as indeed I too do not cease to think of them.

I hope to be in Paris before Sunday so as to spend the day you have free quietly with you.

Yes, I also feel that there is a very long stretch of time between the day when we said good-bye at the station and now.

I WRITE in French because after two years in the South I think
that by so doing I shall say better what I have to say.

Auvers is very beautiful. There is among other things a lot of
old thatch, which is getting rare. One is far enough from Paris for
it to be real country, but nevertheless how changed since Daubigny;
but not changed in an unpleasant way — there are many villas
and various modern bourgeois dwelling-houses very radiant and
sunny and covered with flowers. I find them almost as pretty as
the old thatched cottages, which are falling into ruin.

This is a lush country at the moment, when a new society is
developing in the old, and it is not at all unpleasing; there is so
much well-being in the air. I see or think I see in it a quiet as in a
Puvis de Chavannes; no factories, but lovely greenery in abun-
dance and well kept. There is a lot to draw here, and there is much
colour — I already feel that it has done me good to go South, the
better to see the North. It is as I thought: I see more violet
wherever it exists. You will see clearly that to come to an under-
standing of a country and its way of life, to see other countries,
is all to the good.

Mmes. Daubigny and Daumier are still staying here, at least
I am sure the former is.

I have seen Doctor Gachet, who gives me the impression of
being rather eccentric, but his experience as a doctor must keep
him balanced enough to combat the nervous trouble from which
he certainly seems to me to suffer at least as seriously as I do.
However, the impression I got of him was not unfavourable; when
he spoke of Belgium and the days of the old painters his grief-
hardened face grew smiling again. I think I shall end by being
friends with him.

He piloted me to an inn where they asked six francs a day. But
I found one where I shall pay three francs fifty a day, and it was
in vain he said that I should be quieter at the other — enough is
enough.

The address is Place de la Marie, at Ravoux's, and until a fresh

arrangement is made I ought to stay there. When I have done some studies I shall see if it would be better to move, but it seems to me unfair when you wish and are able to pay and work like any other labourer to have to pay nevertheless almost double because you work at painting.

Doctor Gachet said that I must work boldly on and not think at all of what went wrong with me. I hope that if I settle down to do some canvases of Auvers there will be a chance of recovering the expenses of my stay — for really it is profoundly beautiful; it is the real country, characteristic and picturesque, so much so that I think it will pay better to work than not to work, in spite of all the bad luck which is to be looked for in the pictures.

Not to work or to work less would cost double, that is all I can see; and it would if we looked for any other road to success than the natural road of work. Old fellow, having thought it over I do not say that my work is good, but the thing is that I can do less bad stuff. And still, still some canvases will one day find purchasers. Everything else — relations with people — is very secondary, because I have not the gift for that. I can't help that at all. Look here, if I work, people who are here will come to my house without my going to see them on purpose, just as much as if I took steps to make acquaintances. It is by working that you meet people, and that is the best.

Please tell me sometime what the picture is that Mademoiselle Bock has bought. I must write to her brother to thank them, and I shall then suggest exchanging two of my studies for one of each of theirs; for I thought that they really paid comparatively dear for the canvas, they being friends.

I already have one study of old thatched roofs with a field of peas in flower in the foreground and some corn; a background of hills — a study which I think you will like.

Yesterday and today it has been wet and stormy, but it is not unpleasant to see the wet effects again.

Today I saw Doctor Gachet, and I am going to paint at his house on Tuesday morning; then I shall dine with him, and afterwards he will come to see my painting. He seems very sensible, but he

is as discouraged about his job as a doctor as I am about my
painting, yet he is very much the doctor, and his profession
and faith still hold him. He seems as ill and distraught as you
or I; he is older, and lost his wife several years ago. We are great
friends already; as it happens he already knew Brias of Mont-
pellier, and has the same idea of him that I have: that in him you
have someone significant in the history of modern art. I am going
to do his portrait, and I shall most probably do the portrait too
of his daughter, who is nineteen years old.

About my malady I can do nothing. I suffer a little just now —
the thing is that after that long seclusion the days seem to me like
weeks. I felt very strongly in Paris that all the noise there was
not for me; but as my work gets on a bit, serenity will come. How-
ever that may be, I do not regret being back. I feel happy not to
be far from you two and my friends any longer, and for many
reasons it would be well if we could be together again for a week
of your holidays.

Doctor Gachet said to me that if the depression or anything else
became too great for me to bear he could quite well do something
to diminish its intensity, and that I must not think it awkward to
be frank with him. Well, the moment when I shall need him may
come; however, up to now all is well. And it may be better yet; I
think that it is mostly a malady of the South that I have caught,
and that the return here will be enough to dissipate the whole thing.

Doctor Gachet has a very fine Pissarro, and two fine flower
bunches by Cézanne, also another thing by Cézanne, of the village.
And I in my turn will gladly, very gladly do a bit of brushwork
here. Some pictures present themselves vaguely before me, and it
will take time to get them clearly, but they will come bit by bit.
I have a drawing of an old vine of which I intend to make a canvas,
and a study of pink chestnuts and one of white chestnuts. If cir-
cumstances allow me, I hope to work a little at the figure. I must
send you an order for some paints.

I have not yet found anything interesting in the way of a studio.
It is unfortunately expensive here in the village, but Gachet tells
me that it is the same in all the villages in the neighbourhood, and

that he himself suffers much from it. For some time to come I must stay in the neighbourhood of a physician whom I know. I can pay him in pictures, and I could not do that to another in case anything happened.

Anyway, I am living a day at a time; the weather is so beautiful, and I am absorbed in my work. I am well; I go to bed at nine o'clock, but get up at five most of the time. I hope that it will not be unpleasant to come to oneself again after a long absence. I also hope that this feeling I have of being much surer of my brush than before I went to Arles will last. Monsieur Gachet says he thinks it most probable that it will.

I saw at your home among the heap of canvases under the bed a lot that I can touch up with advantage. I have painted two studies at Gachet's which I gave him last week, an aloe with marigolds and cypresses; then last Sunday some white roses, vines and a white figure. At his house I can do a not too bad picture every time I go, and he will continue to ask me to dinner every Sunday or Monday. But though it is pleasant to do a picture there, it is rather a tax on me to dine and lunch there, for the good soul takes the trouble to have dinners of four or five courses, which is as dreadful for him as for me — for he certainly has not a strong digestion. The thing that has prevented me from protesting about it is that this recalls to him the old times when there were those family dinners, which you and I know so well.

Altogether old Gachet is very — yes, very — like you and me.

I am working at his portrait: the head with a white cap, very fair, very light, the hands also light flesh tint, a blue frock coat and a cobalt blue background, leaning on a red table on which are a yellow book and a foxglove plant with purple flowers. It has the same feeling as the portrait of myself which I took when I left for this place. Gachet is absolutely *fanatical* about this portrait, and wants me to do one for him if I can, exactly like it; I should like to. He has now got to the point of understanding the last portrait of the Arlésienne. He always comes back to these two portraits when he comes to see the studies, and he accepts them utterly, yes utterly, just as they are. He told me also that

it would give him great pleasure to have me copy for him the 'Pietà' by Delacroix, which he looked at for a long time.

In the future he will probably give me a hand about models. I feel that he understands us perfectly, and that he will work with you and me without any second intention, for the love of art for art's sake, with all his ability. And he may get me some portraits to do. I did those studies for him to show him that if it is not a case in which he is paid in money, we will still compensate him for what he does for us.

His house is full, full like an antique dealer's of things that are not always interesting, black antiques, black, black, black, except for the impressionist pictures. But there is this advantage, that there is always something for arranging flowers in, or using for a still-life. He has a very old portrait of Guillaumin by himself, dark but interesting, and a nude woman on a bed, also by Guillaumin, which I think very fine.

I am frightfully anxious to copy once more all the charcoal studies by Bargue — the nude figures. I can draw them comparatively quickly — the sixty plates, say, in a month. If I neglect to study proportion and the nude again I shall be badly caught out. Do not think this absurd or useless.

The pleasure of seeing you again and making the acquaintance of Jo, who seems to me sensible and cordial and simple, and my new little namesake, and further to be back amongst painters and interested in all the struggle and discussions, and especially in the work of the little world of painters in itself — all this distraction works as it seems to me favourably, in so far as the symptoms of the malady have quite disappeared these days; though, as I have learned, one may not count too much on this.

[Theo and his family came out from Paris to visit Vincent.]

Sunday has left me a very pleasant memory, and I hope that we shall see each other often. Since then I have done two studies of the house in the trees. As for taking this house or another, this is how it is. Here I pay one franc a day for sleeping, so if I had furniture the difference between three hundred and sixty-five francs

and five hundred would be no great matter; and I should very much like you two to have a *pied à terre* in the country along with me.

But I am beginning to think that I must consider the furniture as lost. My friends where it is will not, as far as I can see, put themselves out to send it to me, as I am no longer there. It is mostly the traditional laziness and the old tradition that passing strangers leave temporary furniture in the places where it is, and once you are in Paris you might as well be in another world; but it is more because they do not want to mix themselves up any further with this business, which has been so much talked of in Arles.

I now have a new study in the style of the 'Harvest,' which is in your room where the piano is; some fields seen from a height with a road and a little carriage on it. And I am working on a field of poppies in Lucerne.

By the side of the house where I am a whole colony of Americans have just established themselves; they are painting, but I have not seen yet what they are doing. And Demoulins, the man who has some Japanese pictures at the Champ de Mars, has come back here; I hope to meet him. Some day or other I shall find a way to have an exhibition of my own in a café; I should not mind exhibiting with Cheret, who certainly must have ideas on the subject. And I should very much like a little later to come to Paris for several days just to go and see Quost once, and Jeannin, and one or two others.

I was very glad to hear that Gauguin is going away with de Haan. I told him that he would do well to go to Brittany, and you are certainly right in thinking that this is better for him than staying in Paris.

The future of painting is in the tropics, either in Java or Martinique, Brazil or Australia, and not here, but you know that I am not convinced that you, Gauguin or I is the man of that future. But be assured, there and not here, on some probably far-off day impressionists will be at work who will hold their own with Millet and Pissarro.

It gives me enormous pleasure that the Arlésienne's portrait,

which was founded strictly on Gauguin's drawing, is to his liking.
I tried to be religiously faithful to it, while nevertheless taking the
liberty of interpreting by the medium of colour the sober character
and the style of the drawing.

It is a synthesis of the Arlésiennes, if you like; and as syntheses
of the Arlésiennes are rare, take this as a work belonging to both
of us as a summary of our months of work together. For the doing
of it I paid for my part with a month of illness. But I know that it
is a canvas which will be understood by Gauguin and very few
others, as we would wish it to be understood. Doctor Gachet has
taken to it completely after brief hesitation, and says: 'How diffi-
cult it is to be simple!'

Very well. I want to underline the thing again by engraving it
as an etching; then let it be.

I am writing to Gauguin that I stayed in Paris only three days,
and the noise had such a bad effect on me that I thought it wise
for the sake of my head to be off to the country; but for that I
should have run round to see him. He will understand that ar-
riving there a bit confused, I have not yet seen his canvases. It is
very likely that — if he will allow me — I shall go to Brittany for
a month to join him, to do a seascape or two, but especially to see
him again and make de'Haan's acquaintance. Then we will try to
do something decisive and serious, as our work would have probably
become if we had been able to carry on in the South.

I hope he does some etchings of the Southern subjects, since I
can print them without cost at Monsieur Gachet's. This certainly
ought to be done, and we will do it in such a way that it will form
a sort of sequel to the Lauzet-Monticelli publication, if you ap-
prove; Lauzet liked the head of the Arlésienne. Gauguin will
probably engrave some of his canvases in conjunction with me.
Monsieur Gachet is coming to see my canvases in Paris, and we
can then choose some of them for engraving.

At the moment I have two studies in hand, one a bunch of wild
plants, thistles, ears of corn, and sprays of different leaves, one
almost red, another bright green, a third turning yellow; the other
study is of a white house in the trees with a night sky and an

orange light in the window, dark greenery and a note of sombre rose-colour. I have an idea of making a more important canvas of Daubigny's house and garden, of which I have already a little study.

At last I have heard of my furniture. The man where it is has been ill all the time, having got a blow from the horn of a bull, so his wife writes to me that it was for this reason they put it off from one day to another; but on Saturday, that is today, they will send them. They have had no luck, the wife has been ill too, but there was not a word of reproach in the letter except that it had pained them that I did not come to see them before leaving; that pained me too.

The canvases have arrived from Saint-Rémy; the painting of the irises is quite dry, and I do hope you will see something in it; there are also the roses, a cornfield, a little canvas with mountains. Finally there is a cypress with a star, a last attempt — a night sky with a moon without radiance, the slender crescent barely emerging from the opaque shadow cast by the earth — a star with exaggerated brilliance, if you like, a soft brilliance of rose and green in the ultramarine sky across which are hurrying some clouds; below, a road bordered with tall yellow canes, behind these the blue lower Alps, an old inn with yellow-lighted windows, and a very tall cypress, very upright, very sombre; on the road a yellow cart with a white horse in harness, and two late wayfarers. Very romantic, if you like, but Provence also, I think. I shall probably engrave this as an etching and other landscapes, memories of Provence; I shall look forward to giving Gauguin one. Meantime I have a portrait of Doctor Gachet with the heartbroken expression of our time — something like what Gauguin said of his 'Christ in the Garden of Olives,' not meant to be understood, but there; anyhow, we follow him.

Yesterday and the day before I painted Mademoiselle Gachet's portrait, which you will soon see, I hope; the dress is red, the wall in the background green with an orange spot, the carpet red with a green spot, the piano dark violet. It is a figure that I painted with enjoyment — but it is difficult.

I have noticed that this canvas goes very well with another horizontal one of corn, but we are still far from the time when people will understand the curious relations which exist between one fragment of nature and another, which nevertheless explain each other and set each other off. Some, however, feel it silently, and that is something. There is this improvement, that in dress you see combinations of very pretty light colours, and if you could have the people you see passing, and do their portraits, it would be as pretty as any period whatever in the past; I even think that there is often in nature the grace of a picture by Puvis — between art and nature.

Doctor Gachet has promised to make his daughter pose for me another time with the small organ. And perhaps I shall have a country girl to pose too.

I am trying to do some studies of corn — nothing but ears of corn with green-blue stalks, long leaves like ribbons of green shot with rose, ears that are just turning yellow, edged with pale rose by the dusty efflorescence — a rose-coloured bind-weed at the bottom twisted round a stem. The thing is greens of a different quality, of the same value, so as to form a whole of green, which by its vibration will make you think of the gentle rustle of the ears swaying in the breeze. Above this against a very vivid but yet tranquil background I should like to paint some portraits.

Then I have a canvas of cornfields, and one which is a fellow to it of undergrowth, lilac poplar trunks, and underneath them grass with flowers, rose, yellow, white, and greens. Lastly an evening effect — two pear trees quite black against a yellowing sky, with some corn, and in the violet background the château surrounded by sombre greenery.

I have just received the letter in which you say that the child is ill; I should very much like to come and see you, but what holds me back is the thought that I should be even more powerless than you in your present state of anxiety. I am afraid of increasing the confusion.

What can I say as to the future, perhaps, perhaps without the Boussods? My impression is that all of us being overwrought,

there is little point in insisting on having a clear definition of our position. You rather surprise me by seeming to wish to force the situation.

Can I do anything at all about it? At least, can I do anything at all that you would like?

[Theo had talked about a plan of giving up his position and setting up on his own account. So much was needed. A few days later Vincent went to Paris.]

Often, very often I think of my little nephew. Is he well?

Jo — like us — is tired. Worries bulk too large, and are too numerous, and you are sowing among thorns.

I am far from having reached any kind of tranquillity. I am trying to do as well as I can, but I will not conceal from you that I hardly dare to count on always having the necessary sanity. If my malady returns, you will forgive me. I very much fear that I was distraught, and find it strange that I do not in the least know under what conditions I left — if it is as formerly at one hundred and fifty francs per month. I left in such confusion; would there be a way of seeing each other again more calmly? I hope so.

I am sure we are all thinking of the little one. Since you were good enough to call him after me I should like him to have a soul less unquiet than mine, which is foundering.

I think we must not count on Doctor Gachet at all. First of all, he is more ill than I am — or shall we say just as much? Now, when one blind man leads another blind man, don't they both fall into the ditch? I don't know what to say. Certainly my last attack, which was terrible, was due in large measure to the influence of the other patients; and the prison was crushing me, but old Peyron paid not the least attention to it, leaving me to vegetate with the rest, all deeply tainted.

I can get a lodging, three small rooms at one hundred and fifty francs per year. That, if I find nothing better, is in any case preferable to the lice-ridden hole at Tanguy's; I should find a shelter for myself and the canvases, and by keeping them in good condition, there will be a better chance of getting some profit out

of them. I don't speak of my own, but of the canvases of Bernard, Prévot, Russell, Guillaumin, and Jeannin, which were going to ruin there. Canvases like these — once more I do not speak of my own — are merchandise which has and keeps a certain value, and to neglect it is one of the causes of our mutual straits.

But one more reason, *putting aside all ambition,* why we can live together for years without ruining each other. With the canvases that are still at Saint-Rémy there are at least eight; I am trying not to lose the knack. It is the absolute truth, however, that it is difficult to acquire a certain facility in producing them, and by ceasing to work I shall lose it more quickly and more easily than the pains it has cost to arrive at it. The prospect grows darker; I see no happy future at all. I can only say at the moment that I think we all need rest — I feel done for. So much for me — that is the lot which I accept, and which will not alter.

I am working hard and have four painted studies and two drawings. You will see a drawing of an old vineyard with the figure of a peasant woman. I intend to make a big canvas of it. And I have a canvas of 30, one of a peasant woman, big yellow hat with a knot of sky-blue ribbons, very red face, rich blue pelisse with orange spots, background of ears of corn. It is a bit coarse, I'm afraid. Then the horizontal landscape with fields, a subject, as it might be, for Michel, but the colour is soft green, yellow and green-blue.

I have received rather a gloomy letter from Gauguin; he talks vaguely of having quite decided on Madagascar, but so vaguely that you can see that he is only thinking of this because he really does not know what else to think of. And just now I have received Jo's letter. It was really like a gospel to me, a deliverance from the agony which had been caused by the hours I had shared with you, which were a bit too difficult and trying for us all. It was no slight thing when we all felt our daily bread in danger; no slight thing when for other reasons than that we felt that our life was fragile.

Back here I felt very sad, and continued to feel the storm which threatens you weighing on me also. What was to be done?

You see, I generally try to be fairly cheerful, but my life too is threatened at the very root, and my steps too are wavering. I feared — not altogether but yet a little — that being a burden on you, you felt me rather a thing to be dreaded, but Jo's letter proves to me clearly that you understand that for my part I am in toil and trouble as you are.

There — once back here I set to work again — though the brush almost slipped from my fingers; and knowing exactly what I wanted, I have since painted three more big canvases. They are vast stretches of corn under troubled skies, and I did not need to go out of my way to try to express sadness and the extremity of loneliness. I hope you will see them soon — since I almost think that these canvases will tell you what I cannot say in words, the health and strengthening that I see in the country. Just for one's health it is very necessary to work in the garden and to see the flowers growing.

The third canvas is Daubigny's garden, a picture I have been meditating since I came here.

I am now quite absorbed by the immeasurable plain with cornfields against the hills, immense as a sea, delicate yellow, delicate soft green, delicate violet of a ploughed and weeded piece of soil, regularly chequered by the green of flowering potato plants, everything under a sky with delicate blue, white, pink, violet tones.

I am in a mood of nearly too great calmness, in the mood to paint this.

I should rather like to write to you about a lot of things, but to begin with, the desire to do it has left me completely, and again I feel it is useless.

I still love art and life very much, but as for ever having a wife of my own, I have no great faith in that. I am — at least I feel — too old to go back on my steps or to desire anything different. That desire has left me, though the mental suffering from it remains. I fear that towards say forty — or rather, say nothing — I know nothing, absolutely nothing as to what turn this may take. As for what concerns me, I apply myself to my canvases with all

my mind; I am trying to do as well as certain painters whom I have much loved and admired.

Painters have their backs more and more to the wall. Very well, but is not the moment for trying to make them understand the usefulness of a union rather gone by? Perhaps you will say that some dealers would unite for the impressionists; that would be very transient. Altogether I think that personal initiative is still powerless, and having had experience of it should we begin it again?

I have a new study of some old thatched roofs, and two canvases representing vast stretches of corn after the rain. Since the thing that matters most is going well, why should I say more about things of less importance? Before we have a chance to talk business more collectedly, there is likely to be a long way to go. The other painters, whatever they think, instinctively keep themselves at a distance from discussions about the actual trade. Well, the truth is, we can only make our pictures speak.

Yet, my dear brother, there is this that I have always told you — and I repeat it once more with all the earnestness that can be given by an effort of a mind diligently fixed on trying to do as well as one can — I tell you again that I shall always consider that you are something other than a simple dealer in Corots, that through my mediation you have your part in the actual production of some canvases which even in the deluge will retain their peace.

For this is what we have got to, and this is all or at least the chief thing that I can have to tell you at a moment of comparative crisis — at a moment when things are very strained between dealers in pictures of dead artists, and living artists.

Well, my own work, I am risking my life for it and my reason has half-foundered. That's all right — but you are not among the dealers in men. You can still choose your side, acting with humanity, but what's the use?

<div align="right">With a handshake in thought.</div>

<div align="right">*Vincent*</div>

July 27, 1890